ZURBARAN

ZURBARAN

1598-1664

BIOGRAPHY AND CRITICAL ANALYSIS BY

JULIÁN GÁLLEGO

CATALOGUE OF THE WORKS BY

JOSÉ GUDIOL

TRANSLATED FROM THE SPANISH BY

KENNETH LYONS

Alpine Fine Arts Collection, Ltd.

Publishers of Fine Art Books

London

A Cromwell Edition

© *Ediciones Polígrafa, S. A.*

ISBN 0-88168-115-6

Published in 1987 by:
ALPINE FINE ARTS COLLECTION (U.K), LTD.
9 Gunter Grove
London SW10 0UN England

This book was produced in Spain, printed by
La Polígrafa, S. A., Barcelona
Dep. Legal: B. 28.365 - 1987

CONTENTS

INTRODUCTION

Even in the lives of those who live with us there are areas of which we know nothing, and sometimes they are the deepest, most essential areas. Thanks to the dismal bureaucratic mystique of the *curriculum vitae,* moreover, our own lives are full of data which, though authentic, do not correspond exactly to our identities and are of even less value in explaining them. And when we try to learn all about a person from the past like Francisco de Zurbarán through such documentary data, we are in danger of burying his personality underneath them. Appointments or contracts can have no significance for us except through the intentions — about which we know nothing — of the persons concerned. We should also remember that any such significance may have changed in the course of the years.

Consider, for instance, the proven fact that Zurbarán was married three times in twenty-seven years (between 1617 and 1644), a fact which in our century might seem exceptional and, therefore, revealing. But in his time it may have been quite normal. How many times was Velázquez' son-in-law, Juan Bautista Martínez del Mazo, married? And yet he continued to live in his father-in-law's household, even after Francisca Velázquez' death and his own remarriage, with the children of both unions. The only thing that Zurbarán's propensity to matrimony seems to indicate is a corresponding disinclination for the cloistered life.

For the fact that the greater part of Zurbarán's contracted work was done for religious orders does not necessarily afford us any certainty of his identification with these orders, or even of the piety of his sentiments, since the monks were simply his most important clients, and as far as we know, the painter never refused a commission from any other kind of patron for work of a different sort. He painted both mythological subjects and scenes from profane history whenever required to do so, just as he produced numerous portraits of emperors and ancestors for the families of the nobility. And all in a similar style, apart from the vicissitudes of execution that characterize his work as a whole.

We find Zurbarán's style suitable for the representation of sacred themes in much the same way as we find the ogival style the proper one for Christian architecture or that of Johann Sebastian Bach for church music. And yet the Gothic style in the Castle of Bellver or in the Town Hall of Barcelona is very similar to that of the churches built in the same period, while Bach's style is analogous in his sacred and profane cantatas. Thus, Zurbarán is Zurbarán, with all his gravity of volume and tone, as much in a still life, a portrait or a scene from history as in an altar-piece or any other religious work. No Christian artist, from the catacombs on, has employed separate aesthetic vocabularies to differentiate the sacred and the profane in his work; he has used the same one for both, though with different intentions. This does not prevent a Gothic cathedral, an oratorio by Bach or a Virgin by Zurbarán from being entirely suitable to their spiritual task. But we must not suppose that their creators are necessarily would-be friars.

Written documents are particularly precious when they save us from falling into error or building up impossible hypotheses. Unfortunately, however, they are never sufficient, even when — as in the case of Velázquez — they provide us with a meticulous account of a well-ordered life. The inevitable enigmas and

lacunae will always have more weight than these certainties. What was Velázquez doing in Rome, for instance, during his second journey to Italy? What was it that made him put off his return to Madrid as long as possible, even against his royal master's wishes? Knowing the answer to these questions would mean as much to us, at least, as knowing the date of his appointment as a Gentleman of the Chamber. We do not even know whether he loved his wife, though he never left her except on these journeys. That she loved him may be supposed likely enough, since she followed him so quickly to the grave.

But then we have no very exact idea of what conjugal love really meant in the seventeenth century. Was it the life we read about in the charming pages of Lope de Vega's *Peribáñez* or the comfortable existence described in *Isidro*? Consider Alonso Cano, for instance, who created in painting and sculpture an exquisite type of womanhood. Did he love his own wives? Can it be true, as was rumoured at the time, that he murdered the second one? Asking these questions is essential to our knowledge of the man, if we are not content simply to admire his works. And looking at Cano's works, so tender and so delicate, who would imagine "a life filled with fits of rage and disastrous events", to quote the phrase used by Camón Aznar, who goes on to underline the contradiction with "the most delicate and exquisite art"? To what extent was an artist of the golden age of Spanish painting concerned with satisfying his patrons' demands rather than his own inclination? Ever since Goya we have found it natural for a painter to reveal himself in his works. But such an idea would have seemed absurd in the seventeenth century. And even in our age, and among the artists we know, is it easy to distinguish between what their temperament demands that they paint and what is forced on them by their patrons? In theme or technique we are constantly seeing deviations into the abstract or the representational, into density or smoothness, into the delirious or the photographic — sometimes in the course of a very few months. Can we, sincerely and infallibly, explain these mutations with their varied content of individuality, imitation, concession? And, if we cannot, how can we hope to know the motivations lurking in the background at the mysterious moment of creation of the great works of the past?

If, then, the documentary data from the archives are not enough, if the several aspects of the pictures' style or theme are not unequivocal, what method can we use to gain a real knowledge of the man hidden, or half-hidden, behind them? Little signs and traces, detective-story clues. Sometimes an absence can be as revealing as a presence, lacunae as significant as abundance. Why are there so few examples in Zurbarán of certain themes profusely dealt with by his contemporaries? Why has he painted no scenes from Christ's Passion and very few martyrdoms of saints? Why, when he does paint them, does he avoid representing blood, so much so that even such a very gory scene as the martyrdom of St Sebastian becomes almost a still life under his brush? Why does he prefer to allude to the sufferings of Christ so indirectly, through the premonitions of the Child Jesus? And speaking of Zurbarán's Child Jesus (who, on pricking his finger with a thorn, begins to think of what lies in store for him), how can we explain the artist's lack of enthusiasm for painting episodes from the gospels and the pleasure he took in apocryphal or purely devotional themes? How can we reconcile this effeminacy of religious sensibility with the manly vigour of his style? It can hardly be explained by his commissions, for they came far more often from monks than from nuns. How, again, can we reconcile his constant use of symbolic objects with his scant enthusiasm for parables? And why do we find so many attractive women, and so sumptuously dressed, on the walls of his churches and monasteries?

As for his art properly so called, by which I mean here his professional technique, the enigmas are still more baffling. How are we to explain the contrast between the mastery of some of his youthful works and the clumsiness of paintings done in all the fullness of maturity? Are we to blame his assistants and apprentices for all the bad things, so frequently mingled with very good things in one and the same canvas? The pictures

traditionally attributed to Zurbarán by the catalogues are absolutely disconcerting. How can we find an excuse for the awkward execution of the paintings for the Charterhouse of the Caves? By dating them, as María Luisa Caturla suggests, at an early stage in the painter's career? José Gudiol, author of the new catalogue which has given rise to the publication of this book, has advanced the ingenious idea of a much later date, during those years of silence and decline that preceded Zurbarán's move to Madrid. But this does not mean that these works, though they may have been produced in a studio in decline, are not characteristic of Zurbarán's style. His collaborators, moreover, never achieved a distinct, personal accent of their own, so that it would be just as temerarious to hold them responsible for the good parts as for the bad; in either case the master of the studio was Zurbarán himself. But to what extent did he work on these canvases with his own hands?

Even while gratefully admitting María Luisa Caturla's theory of the five "circles" of possible works by Zurbarán (i.e. works executed entirely by the painter himself; works done with the help of pupils; works carried out by the latter on a theme chosen by the master; independent works by the pupils; works by imitators and plagiarists), it is not easy to know just where and how to place Zurbarán. As César Pemán has pointed out, "it is universally acknowledged that in certain very important and essentially personal works, such as those intended for the Sacristy of the Monastery of Guadalupe, most of which he signed, side by side with admirable pieces of painting we find examples of hasty workmanship, faulty perspective and areas that are inexpressive, anodyne or vacuous. Since it is hardly very likely that in paintings like these the master would leave parts of the work to one of his assistants, sometimes only for a patch of canvas, a half-hidden background figure or some architectural detailing, it would seem more reasonable to regard such solecisms as the result of negligence or scamping on the part of the painter himself" (see "El taller y los discípulos de Zurbarán", in the catalogue of the Zurbarán exhibition in Madrid, 1964). The same writer points out that, despite the artist's penchant for painting cloth, and his skill in that line, "there are innumerable minor compositions in which the brocades seem to have been painted from a pattern, sometimes using a stencilling technique, on top of which there is a naive and ineffective attempt to suggest the draperies by means of scumbling" (ibid.). And here Pemán adds a highly disturbing comment: "Such vulgar and anti-artistic stratagems cannot be the master's personal work, unless we are to suppose him to have yielded to totally commercial considerations in works done for clients he neither appreciated nor respected." Pemán himself, it would seem, does not venture to suppose anything so offensive to the great painter we all admire so much; and yet the suspicion cannot be altogether suppressed, especially when we recall those dozens and dozens of saints pouring out of his picture-factory on their way to distant corners of the Indies. Indeed, the difficulties Zurbarán experienced in being paid for some of those works might easily have their origin in the resentment felt by colonial clients at being, as they saw it, less attentively catered for than the artist's Spanish patrons. As for the Guadalupe paintings, bearing in mind that documentary evidence makes them contemporary with those done for the Charterhouse of Jerez, and that in barely two years Zurbarán produced about forty pictures for the two monasteries, some of them large-scale works, it would be hardly surprising if he left the task of completing some of his canvases to other hands. And still less so when we recall that before he finished these works the death of his second wife had affected him to such a degree that he seriously entertained the idea — or so tradition tells us — of giving up the world and retiring to a monastery (though not, incidentally, either of the two mentioned for which he was working at the time).

Regarding the thorny question of Zurbarán's real share in the responsibility for the works traditionally attributed to him, I will leave the reader in the much more capable hands of Professor Gudiol, who has examined them all very thoroughly before including them, wholly or partially, in the new catalogue which

forms the latter part of this book. In the eight chapters which follow, after a brief biography containing all the proven data we possess regarding the artist's life (mainly thanks to the unremitting efforts of Señora Caturla), but without inflating them, lest Zurbarán the man be buried under their abundance, we will make as objective a study as possible of the iconography of this great Spanish artist and its connection with his patrons, lay or religious, his way of composing and presenting pictures, scenes, characters and objects, of selecting them, of expressing (with hardly any recourse to atmospheric values) the situation in an interior or an exterior: what Zurbarán's style consists of, in short, as we see it today.

Though this last indication — I mean, of the temporary nature of our opinions — may seem obvious, it is often forgotten in our belief in our own age, which leads us into making dogmatic assertions that may well make our descendants smile. But they should beware of smiling too broadly, for every man is the prisoner of his age, and the most he can aspire to is to know that his bars exist, though he may be so unconscious of them that he thinks he is free. Each age is so blinkered, as it were, as to see those aspects of the past that most resemble it, and the technology of our own century is gradually extending, whether we like it or not, to our way of looking at art. Thus we are inclined to dismiss as nonsensical the idea of the French Romantics, to whom the Zurbarán they found in Louis-Philippe's Spanish collection was the tortured ascetic described in Théophile Gautier's verses:

> Moines de Zurbarán, blancs Chartreux qui, dans l'ombre
> glissez silencieux sur les dalles des morts,
> murmurant des Pater et des Ave sans nombre...

If unverifiable assertions are to be deplored as imprudent in any study with scientific pretensions, they are even less pardonable in the history of art — which is, after all, a branch of the history of taste. After the later Romantics, Zurbarán was to go through a period of ostracism that would be more or less complete, depending on place and facility of information (there are, or have been, some places so far removed from the mainstream that their adoration or detestation of the painter lasted years, or even centuries, after such feeling had disappeared in the great centres of culture), until the appearance of the Cubists, whose enthusiasm for geometrical forms in space was to bring about a rapid rise in the popularity of the "volumetric" painters like Paolo Uccello, Piero della Francesca or Francisco de Zurbarán, just as it plunged into an abyss of incomprehension or even derision such flowing, airy masters of the Baroque age as Rubens or Murillo. But that generation, too, has passed. And since the fame of Zurbarán has remained unimpaired, in spite of any subsequent fluctuations in taste (or even thanks to them, as in the case of the movement known as Hyper-Realism, for instance), we may perhaps hope that the time has come when this painter can at last be fitted into the approximate place he is to occupy in future . . . Or, at least, for the next fifty years.

Shall we, like the Spanish authors of the 1950s, continue to believe in the mysticism of Zurbarán? Or shall we conclude — like one of those authors, Bernardino de Pantorba — that Zurbarán "lacks the winged spirit, mystical aspiration", that what predominates in his work is "corporeal strength, tactile qualities", that "Zurbarán is not a mystic... or a visionary. He is, like Philip II, a Catholic in the Spanish mode, strong and serene in his faith, a loyal, unswerving servant of the Church of Rome for which he works, upright, sober, dry, virile, firmly attached to his native soil and without any tormenting dreams or unhealthy vanities..."? (*Zurbarán*, Barcelona, 1953).

In the years following the Spanish Civil War, this kind of "Hispanic" exaltation was much in vogue. But is it likely to be continued in our time? Ever since Martín S. Soria brought the attention of the historians to the

fact that in Llerena, where the painter had voluntarily spent a large part of his youth, there had previously been a considerable group of the Spanish heretics known as the Illuminati, Zurbarán has frequently been considered to have been at least a "fellow-traveller" of this sect, without any more cogent proof, simply because heterodox attitudes are in fashion at present. Indeed, in one of the most recent studies of the painter from Fuente de Cantos (*L'opera completa di Zurbarán,* Milan, 1973, p. 9), Mina Gregori, protesting against the superficial comparisons drawn between Zurbarán's style and the passivity of the quietists, writes that any identification of the painter's work with such attitudes would be quite improper, "nonostante i suoi probabili rapporti con gli 'alumbrados'..." Is it possible that this man, regarded by Pantorba only a quarter of a century ago as the very glass of orthodoxy, was in fact a heretic? It is, as we shall see, highly improbable, and all the more so in a painter who lived almost exclusively on his commissions from the clergy. There are still echoes in Italy, apparently, of the reputation of the Spaniards as heretics — "eretici, cismatici e maladetti di Dio", in the words of Pope Paul IV, as recorded by Benedetto Croce (*La Spagna nella vita italiana durante la rinascenza,* Bari, 1949, pp. 212 ff.), and never without "nel capo qualche poco di eresia", according to a character in Ludovico Dolce (ibid.). With the best will in the world, however, this is no excuse for describing as "probable" the relationship between Zurbarán and a band of heretics who had lit up the quiet squares of Llerena with the soaring flames of their fires at various times in the preceding century.

By now Mina Gregori would seem to have lost her illusions regarding such ideas, perhaps in order to embrace others no more enduring. For my part, rendered cautious by the fate of others, I will make no attempt to bear witness to Zurbarán's faith or lack of it, or even to his sincerity. I have no intention of trying to reveal his secret, remembering Professor Camón Aznar's injunctions that we should never try to dispel an artist's mystery, but rather to increase it and thus bring it closer to the spectator who had not suspected it. And Zurbarán is sufficiently mysterious in himself to need no increase of this order. My purpose here is to try to define just where his mysterious fascination lies, how he creates such poetry out of elements so simple. For above all the fluctuations of taste, all the classifications of his personal intentions, the painter Zurbarán is somebody, somebody with a character and a power of attraction so peculiar to him that they have given rise to an adjective — Zurbaranesque — that describes anything that has, or seems to have, his exclusive stamp.

"Zurbaranesque" has in our time come to have a generally accepted meaning. Though an artist of whom so little is known that we are not even sure whether he was a "master" in the strict sense of a qualified practitioner of his art, he succeeded in creating a world that belongs to him alone and in no way resembles the European painting of his time: a body of work in which volume, materials, colour, and we might almost say smell and taste, are easily distinguishable from the works of other artists. In the seventeenth century, whether in Spain or in other countries, there were painters who were his superiors in technique, drawing, colour, impasto, in culture, intellectual concern or openness to new ideas; but none of these had what we might call his style. Their paintings may be excellent, but they are not unforgettable, as are those works Zurbarán so painstakingly nails into our memory with little gilt-headed pins.

It has been said that if just fifty pictures had to be saved out of all the cultures of mankind, at least one would be a Zurbarán. (And the most curious thing about this dictum is that it admits the eligibility of a false Zurbarán.) In the following pages we will attempt to define that Zurbaranesque style which, despite all the obscurities and polemics that surround his work and his life, makes Zurbarán an artist who is by now a classic, beyond all possible dispute and without ceasing to be, for all his appearance of coldness, a much-loved Spanish painter.

I

BIOGRAPHICAL DATA

In beginning this brief outline of the life of Zurbarán, I should like first of all to express my abiding gratitude to that great historical researcher María Luisa Caturla, for it is to her intelligence and tenacity that we owe most of what is known for certain of that life which, though spent largely in the shadow of monastery walls, was in itself far from conventual. For Zurbarán was married three times, the third to a woman eighteen years younger than he, and only once — according to the rather flimsy evidence of tradition, as recorded by Matute in his *Adiciones* to Ponz's *Viaje por España* — did he entertain the idea of entering a monastery: on the death of his second wife. From this dejection, however, he recovered and, five years later, sought consolation in his third marriage. I think that in considering these few and simple facts, the critic should be very chary of garnishing them or filling them out with excessive supposition to make them agree with his own preconceived image of the painter, an image often derived from his works. "By their works ye shall know them" is an evangelical maxim that is less applicable to art than to morals. What we know of the lives of Perugino or Cano, for instance, seems the negation of the angelical quality of their pictures and sculptures. Nor must we suppose that, just because Zurbarán knew so well how to represent, and even crystallize, an elevated aspect of the devotional feeling of his time, he was therefore a holy man himself, let alone a saint. But let us first examine the documented facts, after which the reader may draw his own conclusions.

7 November 1598, saw the christening, in the parish church of Fuente de Cantos, in Extremadura, of a child who received the name of Francisco, the legitimate son of Luis de Zurbarán, trading as a haberdasher in the town, and his wife, Isabel Márquez. His father, said to have been of Basque origin, must have been fairly well-to-do, for he lived in the main square of the village, the

entrance to his premises being in the Calle de los Mártires; "a house of his own and of the first consideration", according to Professor Caturla, who ventures the opinion that the haberdasher may have been of noble lineage. But such genteel origins hardly seem to accord with his means of subsistence, unless we are to suppose that, being of a Basque family, his nobility came to him by royal privilege, as in the case of the Biscayan character in *Don Quixote*. The painter's mother was of local origin, and there are records of a landowner called Francisco Márquez who may have been grandfather to the young Francisco. At all events the latter was given the same Christian name, which he was later to glorify in his pictures of the saint of Assisi.

Fuente de Cantos was a village of barely seven hundred inhabitants, so the haberdashery can hardly have been a very important establishment. But perhaps it also sold such things as lace collars, scents, spices and colours, as such shops did in larger towns. Professor Caturla, indeed, thinks that it was very possibly with colours stocked by his father that Francisco first tried his hand at painting.

Towards the end of 1613 (on 19 December, to be precise), Luis de Zurbarán authorized Pedro Rebolledo, of Seville, to make arrangements to have his son Francisco bound apprentice to a painter in that city. By 15 January 1614, the obliging Delgueta had already found such a painter, and Luis had the articles drawn up for the three-year apprenticeship of his son, then aged fifteen, to Pedro Díaz de Villanueva. Zurbarán was not precocious: he was never one of those artists especially favoured by the gods, child prodigies who astonish their families with a command of art that nobody has taught them. But fifteen years waiting to choose a profession were a long enough time in the seventeenth century. How did Francisco spend those years? Was he his father's

assistant in the haberdashery in Fuente de Cantos or had he already begun to show his vocation for painting by imitating the Gothic or Mannerist altar-pieces to be found in his native region? He is supposed to have had some obscure teacher, who worked in the Mannerist style which had been made popular in Extremadura by the great Luis de Morales; and that would explain certain reminiscences of Morales to be found in Zurbarán's composition, colours and even textures, reminiscences that never wholly left him. But we have no evidence for all this. Palomino does allude to a pupil of Morales who gave Zurbarán his first lessons, but there is no trace of this hypothetical teacher in the local records.

Very little is known of Díaz de Villanueva, for apparently he did not sign his works. He may have been from Extremadura, which would help to explain his being chosen as Zurbarán's master in Seville; around the end of the sixteenth century, at least, there was a certain Nicolás Díaz de Villanueva who (according to Rodríguez Moñino) supplied the artists of Badajoz with their materials. Pedro, in any case, seems to have been the brother of the joiner and altar-piece architect Jerónimo Velázquez (the difference in surnames between two brothers was normal at the time), who was to work with Zurbarán in 1631 on the retable for the College of St Thomas Aquinas in Seville and whom the painter was to recommend in 1636 for the architectural part of the retable in the church of Our Lady of the Pomegranate, patroness of Llerena, in which the artist himself was to paint the canvases. Professor Caturla thinks that Pedro Díaz de Villanueva may have been the painter of a work entitled *The Angel's Kitchen* discovered by the Marqués de Lozoya in the Palacio de Oriente in Madrid, an important Sevillian painting of the first quarter of the seventeenth century and roughly contemporary with another canvas on the same theme, painted in 1616 by Francisco Pacheco and identified by Professor Caturla herself (cf. the catalogue of the 1964 Zurbarán exhibition in Madrid, p. 16). If she is referring to *Christ's Meal after Fasting in the Wilderness*, which does indeed adhere closely to the iconography recommended by Pacheco years later in his *Arte de la Pintura*, other historians tend to attribute it to Roelas. We cannot, however, quite dismiss the hypothesis that the young apprentice may have had a hand in this picture, which contains a magnificent *bodegón*, with almost tactile volumes, that might be taken as prefiguring the full flowering of Zurbarán's closed forms.

It cannot be other than revealing that in his *Arte de la Pintura*, finished in 1638 and published in 1649, the industrious Pacheco makes no mention of Zurbarán among the many painters dealt with in the book. It is impossible that he did not know him, for Zurbarán was a friend of Pacheco's son-in-law, Velázquez, and bore witness that he was acquainted with the latter and his family in the proceedings initiated for the admission of Philip IV's great painter to the Order of St James. Zurbarán himself was later admitted to this Order (though without any of its pecuniary advantages), possibly in recognition of his work in the Buen Retiro Palace in 1634, and this Pacheco must have known too. Just as he must have known that there was a painter in Seville so successful, from 1626 on, that he carried off more than his fair share of the commissions from monasteries on which Pacheco himself depended for his living. Was this silence due to professional jealousy? Another illustrious biographer of our painter, Paul Guinard, suggests that Pacheco may have omitted Zurbarán's name in order to avoid spreading the reputation of a possible rival to his son-in-law. But José M. Carrascal remarks, and rightly, that the painter from Extremadura can hardly have represented much of an obstacle to Velázquez, well established in Madrid since 1623. Whatever his reason (for there must have been some reason, and it may yet be discovered one day), Pacheco's omission deprives us of additional details regarding this apprenticeship, which Palomino, as usual with him, was to decorate with adulatory padding to make up for the absence of contemporary data. We must not pay too much attention to the old Andalusian historian when he assures us, a century later, that Zurbarán, "after his first steps in Extremadura with some pupil of the Divine Morales... went on to finish his training in Seville, at the school of Doctor Pablo de las Roelas (today more usually known as Juan de las Roelas), where he proved such an apt pupil that he soon won the reputation of being an excellent painter..." Zurbarán's "apprenticeship" to Roelas cannot really have been more than the admiration felt by the tyro for the established painter, and in any case Roelas was in Madrid in 1615-16, apart from the fact that his "Parma-Venetian" style has little in common with the younger man's precise, objective temperament.

He was to be more noticeably influenced, in fact, by the traditionally admired masters of the earlier, Romanist generation: Luis de Vargas, Pedro de Campaña,

Hernando Sturm — who anticipates in his work the sumptuously dressed saint-virgin-martyr type that Zurbarán was to turn out so copiously in later years — and the painter known as "Frans Frutet", author of a *Virgin and Child* in the Museum of Seville which, in its meticulous architecture and sweeping draperies, is the forerunner of such compositions by Zurbarán as *Fray Gonzalo de Illescas* (Figs. 158, 159 & 511). Apart from these, the young man would have studied the works of Herrera the Elder, echoes of which, as Martín S. Soria points out, can still be heard in the *Apotheosis of St Thomas Aquinas* (Figs. 79 & 80), the picture which established Zurbarán's fame in 1631; and he must, of course, have known (though their author may pretend not to have known him) the works of Pacheco, the most cultivated artist in Seville, whose dogmatic opinions on the proper iconography of the Immaculate Conception or Christ Crucified (with four nails) are reflected in Zurbarán's treatment of these themes. In some of the pictures mentioned by Soria, such as the *Embarkation of St Peter Nolasco,* generally supposed to be by Pacheco (though Professor Hernández Díaz, in the catalogue of the Fine Arts Museum of Seville, ascribes it to Alonso Vázquez), or the Roelas *Our Lady of Ransom* in the Cathedral of Seville, there is an evident hint of early works by Zurbarán. But the painter who seems to have had the greatest influence on Zurbarán, and in whose works we can find forerunners of some of Zurbarán's types and even compositive arrangements, is undoubtedly Fray Juan Sánchez Cotán; it appears highly probable that the young painter from Fuente de Cantos at some time saw the works of the great Carthusian painter (works now divided between the Charterhouse and the Granada Provincial Museum) at the latter's monastery in Granada, at least when he signed a contract to paint similar themes for the Charterhouse of the Caves at Seville.

Soria, quite rightly, stresses the importance of polychrome sculpture in Zurbarán's early development, for at the time of his apprenticeship this art had reached a degree of maturity in Seville which painting was still far from attaining. In this he is by no means the exception; indeed, I myself have written elsewhere of a similar influence on the young Velázquez. But Zurbarán, with his more conservative temperament, was never to lose that sculptured feeling in his figures, as though of polychrome carvings, that Velázquez was gradually to renounce in favour of atmospheric values. In this aspect Montañés, and his pupil and assistant Juan de Mesa, were also Zurbarán's masters.

In a later chapter we will be dealing with Zurbarán's indebtedness (for he was not so exclusively limited to local influences as is usually supposed) to the prints of works by various European painters which formed a sort of pattern-cum-reference book in common use by all seventeenth-century Spanish artists. Throughout his career he found inspiration in engravings by Callot, Bolswert, Galle, Sadeler and Ribera, as well as Flemish and German Mannerist prints, which he was to discover in Pedro Díaz's studio. Nor should we underestimate the influence on the young man — as on all the painters of his generation, and even of the one before it — of the works of Caravaggio (which were likewise known in Seville through copies or prints) and especially of the master's device of slanting illumination on a dark background, which Zurbarán was to use on several occasions. The works of Ribalta and Ribera (particularly the latter, well known in Andalusia since 1620, thanks to the splendid collection — still in its original setting today — in the Collegiate Church of Osuna) were later to influence the course followed by Zurbarán; and, more eclectic than one might suppose, the painter from Fuente de Cantos was only too pleased to accept advice from his friend Velázquez (as can be seen in the works painted for the Buen Retiro) and even from his younger rival, Murillo, whom he imitated in his last works. But Zurbarán himself was also destined to influence both his contemporaries and his successors, down to our own time.

The first work he signed, before he was really entitled to do so, was a *Virgin as a Child* (Figs. 1, 2 & 504) in 1616, formerly in a Sevillian monastery and now in the Valdés Collection, which shows the Virgin floating on her base of cherubs' heads above a frieze of angel choristers, in which the Italian influence (particularly that of Guido Reni) has been pointed out by Pérez Sánchez. Shortly after painting this work, on 15 January 1617, his apprenticeship in Seville came to an end and he returned to Extremadura.

A few months later, in Llerena — a more important town than Fuente de Cantos, and one in which Zurbarán was to reside, except for brief absences, for the next ten years — he married a woman called María Páez Jiménez, nine years older than the painter himself, who was not yet twenty. The reasons for this marriage are not very clear. María's father was a pig-gelder by trade, which

was regarded as a very base occupation. But there are indications that she was the "poor relation" of a well-to-do family. When María Páez Barrial, a councillor's widow, drew up her will in 1616, she left five hundred reales to her namesake, "as a contribution to a wedding portion", her reason for the bequest being that she had had the young woman in her house "and she has kept me company... and not because she is my relation". This last phrase gives the impression that the councillor's widow had no great opinion of her family, and that poor María had probably been some sort of servant of hers. The "contribution", at all events, had its effect, for a suitor for the poor spinster's hand soon presented himself: our young painter, lately returned from Seville in such haste that he had not time even to take the compulsory master-painter's examination that would set the official seal on his three-year apprenticeship to Pedro Díaz de Villanueva. "We may suppose Zurbarán's first wife to have been sweet-tempered, patient and self-denying, and also accustomed to a comparatively prosperous situation in life and a genteel standard of manners," writes Professor Caturla — which is quite a feat of supposition. As for Carrascal, he believes that this marriage was arranged by Luis de Zurbarán. "Llerena is very near Fuente de Cantos and contacts between the two towns were frequent. I suspect that it was the clerical friends of the two families who first hinted at the desirability of this marriage" — which is suspecting rather a lot.

María and Francisco had three children: another María, born in the following year (1618); Juan, born in 1620, who was later to become a painter himself and assistant to his father, but died before the latter, in 1649; and Paula-Isabel, who in later life proved so unfilial as to bring a lawsuit against her father over some property, and whose very birth, in 1623, appears to have caused her mother's death. Poor María's rich relatives may have helped the young couple at first. In 1618 the Town Hall of Llerena commissioned Zurbarán to design a fountain for the main square (which still survives, though in a rather battered condition) and, in 1619, an image of the Virgin for the "Gate of Villagarcía". In 1622 he had two more commissions, this time from his own native village: a picture of Our Lady of the Rosary surrounded by her Mysteries (a composition of the "partitioned compartments" type, giving a sort of cloisonné effect — see my article, "Los compartimientos tabicados", in *Revista de Occidente,* No. 110, Madrid, 1972), which we may suppose to have been a very mannerist work, and the decoration of a processional image. There was a notable boom in processions during Zurbarán's youth, when many new confraternities were founded, and this probably accounts for the processional look to be seen in many of the painter's "walking saints" and the air of "images for dressing" that we find in some of his religious paintings.

Zurbarán married again in 1625, his second wife being a widow, Beatriz de Morales, of good family and also eight or nine years older than her new husband. It was only natural that the widowed painter should seek a mother for his little orphaned children; natural, too, that he should seek a rich one. "The Morales family was a wealthy and very important clan in Llerena," Professor Caturla tells us. The new household settled down in one of the houses known as the "Casas de Morales", situated in the main square and among the best in Llerena. Francisco and Beatriz had only one child, a daughter named Jerónima, who did not live very long. In the same year as his second marriage the artist painted a canvas for the church of the nearby village of Montemolín, but nothing is known of its subject-matter. And then, on 17 January 1626, he was commissioned by the Dominican monks of San Pablo el Real, in Seville, to paint twenty-one pictures, fourteen of them on the life of St Dominic, the other seven being pictures of St Bonaventure, St Thomas, St Dominic himself and the four Fathers of the Church. As Guinard has pointed out, the fee agreed upon — 4000 reales — was very modest in comparison with the 1650 reales paid in the following year to the obscure painter Francisco Varela for just three not very big canvases. Zurbarán undertook to finish the work in eight months and to correct anything with which the monks found fault. Of these paintings two remain in their original place (i.e. the church of St Mary Magdalen in Seville), namely the *Apparition of the Virgin to the Monks of Soriano* (Figs. 4 & 6) and the *Miraculous Cure of Blessed Reginald of Orleans* (Figs. 5, 7 & 86), besides three of the Fathers of the Church, which are in the Museum of Seville: *St Jerome* (Fig. 8), *St Gregory* (Fig. 9) and *St Ambrose* (Figs. 10 & 11). A magnificent *Christ Crucified* dated in 1627, which is now in the Art Institute of Chicago (Fig. 12), was also originally in the Monastery of San Pablo el Real, or so Paul Guinard believes, at least. Professor Caturla is not quite convinced of this identification, but she does consider that in this Christ we have a good example of the type Zurbarán was painting at this time, in which there is very evident

influence of the chiaroscuro of Caravaggio. This "athlete with a gentleman's head and a workman's hands", to use José Milicua's felicitous phrase, is the first of an almost sculptural type of Christ on the Cross.

On 29 August 1628, Zurbarán signed a contract with the Mercedarian Friars of Seville for twenty-two paintings on the life of St Peter Nolasco. This contract specifies that Zurbarán shall move to Seville "with all such persons as he may need", while the monastery undertakes "to supply food, drink, shelter and beds, as well as all things necessary to painting", for him, his assistants "and such other persons as may likewise participate". This document reveals the existence, even at this early stage, of a whole working studio, a team of painters, to use the modern expression. But how and when did Zurbarán form this team? Were they all men from Llerena? Did he already call in specialists for certain details which he felt would be too difficult? Here we have more questions without any very certain answers. The painter was to be paid 1500 ducats for this immense task, of which we still have two pictures in the Prado (Figs. 15, 16, 19 & 506), another four in Mexico (Fig. 20), Cincinnati (Figs. 21 & 23), Bordeaux (Figs. 14 & 18) and Eccleston (Fig. 24), apart from other canvases painted for various rooms in the monastery, such as the portraits of friars in the Academy of San Fernando in Madrid (Figs. 201-206 & 209) or the sublime *St Serapion* in Hartford (Fig. 13), one of the artist's finest pictures. The price paid for all these paintings was four times what he had received from the Dominicans, which proves the growing reputation of the master.

The master? As we have seen, Zurbarán did not in fact take the prescribed master-painter's examination at the end of his apprenticeship. And this omission was to be a source of vexation to him in a country as full of envious people as this one, where men usually resort to legal texts to preserve their own privileges rather than to see that justice is done. What happened, in fact, was that in June 1629 the Town Council of Seville formally invited the painter to make his home in that city, "and the city will take good care to favour him and help him in all circumstances"; a very flattering invitation, but one which could not fail to ruffle some tempers among the local artists. Indeed, "this event may have been the reason for Pacheco's enigmatic silence", suggests Professor Caturla. Alonso Cano, however, was not content with silence, for he protested that if Zurbarán wished to practise as a painter in Seville he first had to take his examination. But this Zurbarán refused to do, alleging that the Town Council's description of him as "a man of renown" was sufficient guarantee of his competence — a fortunate excuse for a haughtiness which may have concealed some secret qualms. For Zurbarán was not, and would never be, a "magistral" master-painter like Cano or Velázquez, however superior he might be to any official judge that might examine him; and he must have known his Achilles heel, which would be the first thing to be attacked by any ill-disposed critic wanting to topple him from his great position. The strange thing is that he was able to practise his profession thereafter without any further difficulties, and he even became one of the Royal Painters. A year later the Town Council commissioned Zurbarán to paint an image of the *Immaculate Conception* for its lower chamber. If, as is now supposed, this was the one that hangs in the Colegio del Carmen in Jadraque, Guadalajara (Figs. 38 & 40), then the painter's "mastery" was more than sufficiently demonstrated, for it is one of the most beautiful versions of this theme in the whole of Spanish painting, and not even Cano could have done anything better.

Zurbarán, then, moved to Seville with all his family and assistants. According to a census schedule discovered by Santiago Montoto (undated, but earlier than 1630), the painter set up his household at number 27 in the Callejón del Alcázar, where he lived with his wife, a sister, his daughters María and Paula, his son Juan, no fewer than four male servants (though this may have meant studio assistants), two ladies with the "doña" of gentility prefixed to their names, who may have been a duenna for the girls and a housekeeper, and two other women (without this "doña") who were probably housemaids. This was a prosperous household for a successful painter.

1629 was likewise the year in which Zurbarán signed and dated one of the pictures (incidents in the life of St Bonaventura) painted for the Franciscan school in Seville (Figs. 25-29), to complete the series begun by Herrera the Elder; but he is also recorded as having collaborated with an obscure painter called Pedro Calderón on the altar of San José de la Trinidad Calzada (Figs. 31-37). In 1630 he signed and dated one of his most beautiful works, the *Vision of Blessed Alonso Rodríguez,* commissioned by the Jesuits and now in the Academy of San Fernando in Madrid (Figs. 39, 41 & 508). In 1631 he was commissioned by the Rector of the Dominican College of St Thomas Aquinas to paint the famous

Apotheosis of St Thomas Aquinas (Figs. 79 & 80). And in 1633 he signed and dated the *St Peter* (Fig. 89) of the Apostle series in the Museu Nacional de Arte Antiga of Lisbon, possibly a gift to the Lisbon monastery of San Vicente de Fora from Philip IV, who had spent some time there. He also worked for the Carmelite monastery of San Alberto (according to the much later text of Palomino), in competition with Pacheco, Cano and Juan del Castillo. Some historians say that it was also around this time that he painted two series of works, the dating of which is much disputed. The first is the series for the retable of the chapel of St Peter in the Cathedral of Seville (Figs. 68-73), which Cean dated around 1625 (and thus prior to the Town Council's invitation to Zurbarán to settle in Seville) and which Guinard, at first agreeing with Cean, later put back to 1630-35, in which he agrees with Lafuente Ferrari, who dates the series around 1633, and Soria (1633-36 and even, at first, 1638), while Tormo suggests 1637. The other series in dispute is that of the Charterhouse of the Caves, now in the Museum of Seville (Figs. 289-294), for which the time limits suggested are as far apart as 1623 and 1655. In any case, these were years of great activity and undeniable success in Seville, a success soon ratified by Philip IV's order to Zurbarán to move to Madrid and take his place among the painters working on the decoration of the Buen Retiro, an appointment the artist probably owed to the good offices of his friend Velázquez. At the Buen Retiro Zurbarán painted ten pictures of the Labours of Hercules which are now in the Prado (Figs. 103-112) and two large canvases for the series of contemporary battles which includes Velázquez' *Surrender of Breda*. These were *The Defence of Cadiz against the English* (Figs. 101 & 102), which is also in the Prado, and *The Expulsion of the Dutch from the Island of San Martín,* now lost. These pictures were paid for in November 1634 and Zurbarán returned to Seville, where shortly afterwards he painted a little boy from Carmona, *Alonso Verdugo de Albornoz* (Fig. 113), who reached the age of twelve in February 1635, as an inscription on the canvas tells us. This portrait hung latterly in the Kaiser Friedrich Museum in Berlin and was destroyed in an air raid in April 1945. It showed very clearly the influence of Velázquez' portraiture for the Court.

Life in Seville continued placidly enough (or so it would appear) for Zurbarán, who undertook commissions in Llerena and Arcos de la Frontera, in Marchena and in Seville itself, and who gave his daughter María a dowry of 2000 ducats when she married the Valencian José Gassó. His position in society seems to be confirmed by the fact that he refused to accept any payment for the retable of the *Virgin of the Pomegranate* (Figs. 187, 190 & 191) in Llerena, because of his devotion to this patroness of the town. As we have seen, the joiner who constructed the framework for this retable was Jerónimo Velázquez, the brother of Zurbarán's master Pedro Díaz, and Zurbarán had made this collaboration a condition of his painting the works for nothing. This work was done in 1636 and in the same year the painter sold the "Casas de Morales" in Llerena, probably because he thought he would not live in them again rather than from any necessity. He had been duly empowered to sell this property by its owner, his wife Beatriz de Morales, though this did not satisfy his quarrelsome daughter Paula-Isabel, who was later to bring a claim for the ownership of these houses, based on a legacy in the will of her stepmother, who died in 1639.

This was a crucial moment in our artist's career, for he was now finishing his two greatest series of paintings: those for the retable and sanctuary of the Charterhouse of Jerez (Figs. 127-155, 185 & 512) and those for the sacristy of the Hieronymite monastery of Guadalupe in his native region (Figs. 157-184, 186 & 511). Even with the help of his son and his other assistants, it seems impossible that a painter could conceive and carry out, almost at the same time and in less than two years (1637-1639), the twelve canvases of the Jerez retable, the ten panels of the sanctuary corridor in the same monastery, the eleven huge paintings of the Guadalupe sacristy and the eight little panels that accompany them. In this brief period he did some of his best work; only rarely, indeed, was he to reach these heights again. The Guadalupe pictures, fortunately, are still in the place for which Zurbarán (from Seville) painted them; those done for the Jerez Charterhouse, long since abandoned, have passed into various collections (museums in New York, Cadiz and Grenoble, besides a couple of images of the Virgin, now in Edinburgh and Warsaw respectively, which apparently hung in the choir).

The death of Beatriz, who was buried on 28 May 1639, seems to have caused a crisis in the painter's life. It is said, though there is no proof of this, that Zurbarán retired to the Mercedarian monastery of San José, possibly with the intention of joining this Order. At all events, he decided against it. He may have finished his

work for Guadalupe by then, but Guinard does not think so. This crisis of his second widowing just when he was on the threshold of middle age, rounding as it were the cape of the storms that characterize a man's life at the age of forty, must have been deepened by the lawsuit brought by Paula-Isabel and also by the wedding of his son Juan, who married the daughter of a wealthy tradesman and left his father's house. A widower for the second time, with two of his children married and himself involved in litigation with the third, Zurbarán must have felt very lonely; and it seems (as Guinard shrewdly hints) that he could never bear loneliness. In February 1644 he was married yet again, this time to Leonor de Tordera, the young widow of a certain Diego de Sotomayor who had died in Puebla de los Angeles, in the Indies. Was Leonor de Tordera rich? Was she beautiful? She may have been both; Carrascal, at any rate, has ventured the attractive hypothesis that the model for the extremely beautiful *Immaculate Conception* in the Museo Cerralbo in Madrid (Fig. 303) was Zurbarán's third wife. Her father was a goldsmith, her first husband had been a colonial merchant. But to judge from the poverty that was to be endured by Zurbarán and herself in the years to come, the money she brought to the marriage by way of dowry was soon spent, largely because of the economic crisis then afflicting Spain, and particularly Seville, and the parallel crisis of Zurbarán's reputation, for he was beginning to appear old-fashioned to the eyes of the younger generation, all fervent admirers of Murillo. These difficulties soon swallowed up the 27.300 reales that the bride's brothers had given her to replace the dowry she had received from her father and had lost (for Diego de Sotomayor had left her absolutely nothing). From this time on, the couple was constantly moving from one house to another.

The plague of 1649, which caused over fifty thousand deaths in Seville alone, was like a knell that signalled the end of prosperity for Zurbarán, who struggled to keep the wolf from the door with a profusion of commissions for Latin America: Mexico, Lima, Guatemala, Buenos Aires, etc. Only really needy painters ventured to send their works overseas, exposing them to all the risks of loss, sinking, shipwreck or piracy, not to mention the possibility of having to wait years to be paid for one's work — or even of never being paid at all. The final payments for the canvases painted for Guadalupe were still unsettled in 1647, when Zurbarán signed a power of attorney for the collection of payments

due for twelve pictures of Roman emperors which he had sent to Peru.

These contretemps, however, did not affect the couple's fecundity, for Leonor presented her no longer young husband with one child after another: Micaela-Francisca in 1645; José Antonio in 1646; Juana-Micaela in 1648; Marcos in 1650; Eusebio in 1653; Agustina-Florencia in 1655. And their christenings alternated with those of the painter's grandchildren, the children of his son Juan and the latter's wife, Mariana de Quadros: Francisco-Máximo in 1642; Antonia in 1644. Less robust than his father, Juan died in 1649, a victim of the plague of that year. But in the 1658 census the only persons recorded as residing in Francisco de Zurbarán's house are the painter himself, his wife Leonor, only one daughter and three servants.

Probably in search of work, the sixty-year-old Zurbarán was now to attempt the experience of Madrid, an experience which had apparently not interested him in 1634, and of which he had failed to take advantage in 1638, when the city of Seville presented Philip IV with a pleasure boat for his fêtes on the lake in the gardens of the Buen Retiro — *El santo Rey don Fernando*, decorated by Zurbarán. Though it would appear that he had never felt at ease in the world of the Court, he now decided to endeavour to repair his fortunes there; but it was too late. It would have been easier for him, and much more sensible, to retire to his native region of Extremadura, where his work might still pass itself off as modern. For the whole notion of painting had changed: the harsh Caravaggio-inspired style in fashion at the beginning of the century had by the middle of that same century yielded to an art of luminous, atmospheric effects which Zurbarán was incapable of achieving, however hard he tried. The patches of colour of Velázquez no longer startled — indeed, hardly even surprised — the art-lovers of Madrid in 1658. Velázquez' son-in-law, Mazo, and his pupils (except Pareja) all endeavoured to imitate this loose and sketchy style — Alonso Cano, indeed, managed it amost as well as its inventor. The only question that was still a matter of bitter dispute was whether the profession of painting was a base occupation or not, and whether those who practised it, even by order of the King, were worthy to be admitted into the Order of St James. Thus Zurbarán's journey to Madrid made it possible for him to be called as a witness in the proceedings initiated by the Council of Orders with the object of deciding whether Velázquez should or should

not be permitted to wear the coveted scallop shell of the knights of St James. And in this ignoble battle for the nobility of painting, Zurbarán was given the most thankless role: that of the false witness. For surely that is the only name we can give to a man who swears, on 23 December 1658, that the candidate "neither in the said city of Seville nor in this Court has engaged in any trade except that of painter to His Majesty... nor has he ever been known to keep a shop or workshop like other painters", when we know from documents that in 1620 Velázquez appeared in the apprenticeship articles of his pupil Melgar as a "painter of Images". (see *Varia Velazqueña* II, pp. 219 & 331).

According to Professor Caturla, Zurbarán "must have felt at ease in the atmosphere of the Court, or in hopes of earning enough to live on there, for he finally sent for his wife to join him, with Micaela, the only daughter left to them... But Micaela, too, died." However, from a power of attorney sent to Seville in September 1660, for the collection of the payments due for some canvases in Buenos Aires, we learn that Zurbarán was still legally resident in Seville. Despite the many pictures he was painting, he probably did not feel very sure of continued success in Madrid. And he may well have felt even less so by then, just a month after the deaths of Velázquez and his wife Juana, Pacheco's daughter, two of the very few people Zurbarán knew in Madrid who might help him.

Old age and fashion, between them, now brought Zurbarán to a style of sentimental effusiveness in his painting — hitherto architectonic but now soft and amiable. It was a kind of "Murillism without Murillo", to use Paul Guinard's expression, though Guinard himself is one of those who think that this last stage in Zurbarán's career should be re-evaluated. In these paintings, in fact, Guinard finds a very special timbre, a melancholy, withdrawn quality that saves them from insipidity, a kind of dreaming anguish. The influence of Murillo blends with that of Raphael and Titian, both

discovered late in his life by the painter from Extremadura. As Professor Caturla writes, "a great softness has crept into his art. All the harsh contrasts of light and shade have disappeared." And undoubtedly pictures like the half-length *St Francis* in the Munich Pinakothek (Fig. 471), the *Christ after the Scourging* in the parish church of Jadraque (Fig. 460), the *Virgin and Child with St John* in the Museum of Bilbao (Fig. 461), which is like an echo, nearly half a century later, of the *Virgin as a Child* he signed in 1616, before he was entitled to sign any work (a perspicacious echo, made harmonious with new lights and with a greater depth of feeling), must rank among the very best works, not only by Zurbarán but by any Spanish painter of his century.

But who was left to buy or commission pictures from him? Very few patrons indeed. In 1662 he was still trying to get some money for over fifty paintings he had sent to Buenos Aires in 1649, but for these pictures he was fated never to be paid. The inventory of his property drawn up after his death shows that Leonor had pawned the few silver ornaments they still had, in order to pay the expenses of her husband's last illness. They had little furniture, few and shabby clothes, a handful of pictures (among them a "Santa Susana", which may have been that *Susanna in the Bath* that Zuloaga is supposed to have seen, the nudity in which would make it a dangerous possession) and six dozen prints, a collection the old painter had refused to abandon just in case he might be given a commission involving a difficult composition. Those last years in Madrid were bitter ones indeed. Francisco de Zurbarán died on 27 August 1664, just a few months short of his sixty-sixth birthday. He was buried in the monastery of Recoletos, which gave its name to one of Madrid's most beautiful avenues but which has long since vanished, with all its dead, like so many others. A sad ending, perhaps, but not if we remember that, as Paravicino wrote of El Greco, Francisco de Zurbarán "in his death began to achieve eternities".

II

ICONOGRAPHICAL CONSIDERATIONS

Before embarking on our examination of Zurbarán as a painter, of those stylistic and purely plastic values of his which have earned him such an honoured place today in museums all over the world, it might be as well to stop for a moment and consider something that may seem of secondary importance from a twentieth-century viewpoint, but which was an essential in Zurbarán's own age: what his paintings meant to the people of his time. For painting — a language for "idiots" (in the sense of illiterates as it is used by Borghini) or a universal language — possesses, like oral or written language, the power to transmit a message or other information.

This role may have seemed of little account at the beginning of the present century, when there was an unquestioning belief in the worth of "art for art's sake" and in "plastic values". When the advocates of Cubism first conceived their admiration for Zurbarán, it was no longer on account of that mysterious thrill of almost medieval religiousness that so attracted the French Romantics who saw some of his works in Louis-Philippe's Spanish gallery, but because of a way of arranging certain planes and volumes which — dismissing as irrelevant anything the pictures "represented"— made his works worthy to figure in the pages of the avant-garde reviews, side by side with the still lifes of Braque or Juan Gris, or with one of Picasso's views of Horta de Ebro. The feeling of the time was that what mattered least was that the painter, to earn his living or to please a community of friars, should have represented a martyrdom, an apotheosis or a *bodegón,* and that the only really important point was "the picture in itself", the "picture as object", which was entirely sufficient in itself and did not play the secondary role of a transmitter of something that had nothing to do with its essence of forms and colours.

Undoubtedly it is this essence that at all times gives an eternal value to a work which, in other aspects, is subject to variations in opinion and ideology: a much attenuated eternity, however, which causes values to rise and fall incessantly with the thermometer of the salerooms. But it must be admitted that there is something enduring in the beauty of a work of art which survives the immediate intentions of its creator. We do not need any knowledge of the religious reform of Akhenaten to be enchanted by the face of his wife, Nefertiti, and the form and colour of a Chinese celadon vase gives us a better idea of the essence of a people than any number of historical treatises. Thus an agnostic, or even a militant atheist, of today may find a devotional image by Zurbarán an admirable work of art despite its piety, despite the fact that it represents a story or a myth in which he does not believe. Here, however, I should draw the reader's attention to a contradiction frequently to be observed in the first half of this century, especially in its first two decades: the only aspect of Zurbarán that interested art-lovers then was his plastic values, everything else being regarded as irrelevant; and yet his popularity as a subject for books at that time was infinitely less than that of other painters not so committed to Catholicism. Not so many years ago I asked a well-known international publisher of monographs on the Old Masters why he had published nothing about such an eminent figure as Zurbarán, to which he replied quite frankly that the fact that Zurbarán's subject-matter was confined almost exclusively to Catholic themes made it distasteful to many possible readers, a distaste which would have an adverse effect on sales. I am pleased to record that in the last few years ideas in this respect would seem to have changed. And the comparative abundance of recent books on the

painter (a notable example is Mina Gregori and Tiziana Frati's *L'opera completa di Zurbarán* in Rizzoli's "Classici dell'Arte" series, which has had such a great popular success on the international market) shows either that these prejudices have been overcome or that an attempt has been made to dissipate them with the somewhat less than proven sympathy Zurbarán is supposed to have felt for the Illuminati heretics of Llerena in the sixteenth century (a hypothesis suggested by Soria, recorded without much conviction by Mina Gregori and attacked by Guinard), or even, quite simply, that the normal viewer, Christian or not, respects the ideas of this seventeenth-century painter and admits his intentions, without making any attempt to brand him, retrospectively, as an agnostic.

That is why it is important to study Zurbarán's career as it is related to the themes he paints before examining how he paints them. Paul Guinard, in one of the most important works written on the painter (*Zurbarán et les peintres espagnols de la vie monastique*, Paris, 1960), considers Zurbarán in relation to other Spanish painters of monastic life and examines his subject-matter in great detail. What we must ask about any painter is: what themes has he painted and why, which of them were painted for a commission received, which on a business basis, which simply because he wanted to paint them? And these are difficult questions to answer, even when dealing with a painter of our own time, apparently so free of prejudices and yet caught up as much as in any other age in the web of rules, laws and what the neighbours will say, torn between the urge to novelty and the wish to be intelligible, between obsolescence and incomprehension. And with Zurbarán the answer is still more complex, in the first place because in his time the artist was still an artisan (see my study, *El pintor, de artesano a artista*, University of Granada, in the press), not the demigod proposed by Vasari and finally admitted by the Romantics: an artisan commissioned to paint a picture on a theme established in detail by the patrons (and in this the monks, our artist's most important patrons, were extremely precise). Secondly, because a large part of the painter's personal work is unknown to us, either because it is impossible to gauge the extent to which the master has worked on a picture produced in a large studio-workshop or, more simply, because much of his work has been lost for ever in the ruin and dispersal of so great a part of Spanish monastic painting.

To this subject Paul Guinard has devoted an attention that will undoubtedly be appreciated by all those interested in such questions, both in his book and in other studies on the depredations committed in the pictorial heritage of Spain by the agents of foreign collectors (see, for instance, his excellent work on Dauzats and Blanchard). As this is not the place for dealing with such problems, I will simply mention in passing that after the dispersal and abandonment of the eighteenth century, so tardily combated by Carlos III, the Napoleonic invasion, the subsequent anticlericalism and, finally, the 1835 Act depriving the clergy of their lands, all led to the expatriation of an enormous number of paintings, catalogued in a study by Gaya Nuño which is now a classic (*Pintura española fuera de España*, Madrid, 1954). Apart from such works — lost to Spain but not to the world at large — we must remember those that have been destroyed or have otherwise disappeared, in certain cases of which we have evidence from literary sources (such as the pictures of saints by Zurbarán formerly in the monasteries of El Carmen or San Antonio in Seville, of Our Lady of Ransom and San Pablo in Córdoba, of the Capuchins in Jerez or of Our Lady of Ransom in Villagarcía) and in many other similar cases, in which paintings have vanished without leaving a trace. Nor should we forget that it was not until the beginning of this century that historical researchers were granted access to the archives of notarial documents, the principal source for evidence of contracts for the execution of paintings. Until then the only records of works painted by Zurbarán were those to be found in the exiguous lists published by Palomino or in Cean Bermúdez' *Diccionario histórico*, which is partly based on Ponz's *Viaje por España*. Towards the end of the nineteenth century, Rodríguez-Marín, Gestoso and Pérez published the first original documents on Zurbarán. In response to the interest aroused by the 1905 exhibition in the Prado, the first exhibition devoted exclusively to Zurbarán, Elías Tormo published some interesting articles and José Cascales the first monograph on the painter (*Francisco de Zurbarán: su época, su vida y sus obras*, Madrid, 1911). The Sevillian historians Celestino López and Santiago Montoto gradually increased this stock of reliable data, which was given much greater coherence by the works of Kehrer, Mayer and Soria. Among the many contemporary writers who have made notable contributions to the study of Zurbarán, I should also mention César Pemán, Angulo

Iñiguez, Hernández Díaz, the Marqués de Lozoya, Xavier de Salas, Manzano Garias, José Milicua, Orozco Díaz, Father José Sebastián, López Jiménez, Pérez Sánchez, Bonet Correa, Sánchez Cantón, María Elena Gómez Moreno, Pita Andrade, Martín González, Gaya Nuño, Hernández Perera, Rogelio Buendía, Camón Aznar and, most particularly, Paul Guinard and María Luisa Caturla, to whose patience and sagacity we owe most of the fundamental data now available.

As we have seen in the preceding chapter, however, despite all these efforts the historical figure of Zurbarán is still obscure; and the catalogue of the works he painted or in which he intervened directly or indirectly, whether stil extant or vanished, is full of gaps, obscurities and lacunae, which makes any general opinion of his subject-matter a rash undertaking. Among his themes there may have been one we know nothing about, but which gave him occasion for a masterpiece. It should be remembered that until quite recently works by Zurbarán now considered to be of fundamental importance were practically unknown or attributed to other artists. The wonderful *Holy House of Nazareth* in the Museum of Cleveland (Figs. 257 & 259) was discovered only very recently by Professor Guinard. The exquisite *Immaculate Conception* in Jadraque (Figs. 38 & 40), though identified by Beruete, remained unknown to public and critics alike until the great exhibition in the Casón del Buen Retiro in 1964. *The Defence of Cadiz against the English* in the Prado (Figs. 101 & 102) was thought to be by Eugenio Caxés until 1927, when Longhi first suggested its attribution to Zurbarán, an attribution later confirmed by Professor Caturla. And there are other, no less famous works by Zurbarán — like the *Still Life* donated to the Prado by Cambó (Fig. 484) or the series of haughty female martyrs in the Museum of Seville (Figs. 388-396) — the authorship of which is still disputed. In time this list, like all such lists, will surely be suitably amended. But for the moment we must work on the little we know.

How are we to define the kind of subject Zurbarán painted? And how — an equally important question — the kind he did not paint? Let us first attempt to define the artist's position within the painting of his time and of his country. We know that this painting was basically religious. Seville, where Zurbarán spent almost the whole of his working life, was one of the largest and most pious cities in the Peninsula; and we must not forget that the number of friars in Spain in the reign of Philip IV was reckoned to be about ninety thousand. The Benedictines and Cistercians, who presided over the age of Romanesque and the transition to Gothic, were followed by the Dominicans, the Franciscans (in their several varieties) and the Carthusians in the Middle Ages, at the end of which the Hieronymites were founded, one of the most influential orders in Spain. To these we must add the Carmelites, Mercedarians, Augustinians, Jesuits and Trinitarians, many of them with both male and female communities, whether discalced or more traditionally shod. Zurbarán is often regarded as the painter of friars. And yet, as Guinard points out, monastic themes do not account for even half of the works still extant.

Guinard also reminds us that the painter's great monastic series were carried out during a comparatively brief period — the ten years between 1629 and 1639 — in quite a long career. To this it should be added that, to judge from the little we know of his life, Zurbarán was far from being a mystic or ascetic with a fatal attraction to the cloisters. Despite the traditional belief I have already mentioned, that the painter retired to the monastery of the discalced Mercedarians for a time after the death of his second wife in 1639, he certainly did not stay very long either in the monastery or in his widowed state, for in 1644 he married a young widow who was to present him with numerous progeny. It may be reasonably supposed that in different circumstances — if, for instance, he had had a more resounding success in Madrid with his paintings for the Buen Retiro— Zurbarán would have become a painter of secular subjects, as Velázquez did on being summoned to the Court eleven years later. It was thanks to these providential circumstances, in fact, that Velázquez escaped from Seville and a range of commissions that did not suit him (see my *Velázquez en Sevilla,* Seville, 1974), while Zurbarán found himself obliged to go on working on this limited range and in an equally limited cultural world until his ill-fated second attempt to succeed in Madrid, an attempt that led to nothing but poverty, illness and his death in 1664.

For which friars did Zurbarán paint? Principally for the Dominicans, Mercedarians and Carthusians, rather less for the Franciscans and Hieronymites. But the importance of the works commissioned by the last two orders makes up for the difference in number between them and the other three. On a few occasions he painted for the Carmelites, the Augustinians and the Jesuits. He received no commissions from Benedictines,

Cistercians, the Friars Minor or the brothers of St John of God. If saints from these orders are found in his work, it is usually in series or collections of Holy Founders, the iconography of which was probably decided by his patrons. It is a curious fact that he never had any commissions from nuns, though he dealt with subjects, such as the holy childhoods of the Virgin, Jesus and St John, which would seem eminently suited to their taste. It should be remembered that one of the most talented monastic painters of his time, the Italian Angelo Nardi, created his greatest masterpiece for the church of the Bernardine nuns of Alcalá de Henares and that Zurbarán's successors in the favour of the Seville art world, Murillo and Valdés Leal, both worked frequently for nuns. It is all the more strange as Zurbarán "does not get tied up with anybody", as the popular Spanish expression has it, and certainly does not use a style peculiar to any order. He is more apt, indeed, to use the iconography of one in a commission from another, as in the *Our Lady of the Carthusians* (Fig. 145), copied from a print representing Augustinians, or in the scenes from the life of *St Bonaventura* (Figs. 25-29), which are inspired by prints of St Norbert.

In this "Golden Age" of Spanish painting, frequent use was made of such "transfers", which enabled the same composition of forms to be used for different ideological contents. I have written elsewhere (*Visión y Símbolo...,* Madrid, 1972, pp. 36-37) of how the Licenciado Viana's Castilian version of the *Metamorphoses* of Ovid (Valladolid, 1589) is illustrated by compositions on pagan themes which are perfectly applicable to Christian uses: Phaeton before the Palace of the Sun evokes the Annunciation; a Triton and a female figure assume the attitudes of Christ and the Woman of Samaria; a woman standing in front of a tent resembles Judith, etc. If, as I then pointed out, "there are not two pictorial languages, sacred and profane, but only one, which is adapted to suit circumstances", it may be even more emphatically asserted that there are no different languages for the different episodes or series of episodes in devotional painting, or even different languages for the different religious orders. As I said later on in the same work (p. 219), "I do not believe that there is a style peculiar to each religious order. We might find particular themes, like Elijah in his fiery chariot for the Carmelites, who considered him their founder, or St Jerome for the Hieronymites for the same reason... We might find differences in the points of view: a tendency to sentiment

in Franciscans and Capuchins, to mystical elevation in Carmelites, to the patristic and theological among the Jesuits or to rhetoric and dialectic with the preaching orders... but the dividing lines between these tendencies are frequently blurred. There are no differences in theory, or even in practice, among the orders; when the Jesuits are in difficulties, they are defended by Dominicans like Fray Domingo de Valtanas, or Franciscans like Fray Diego Murillo; the Jesuit group of Gandía, presided over by St Francis of Borja, is very close to the ideas of the Franciscans. What I mean is that we cannot speak of a Franciscan style of painting, or a Dominican or Carmelite or Mercedarian style, unless it be in the choice of themes. An artist like Zurbarán works for one order or the other without distinction and without changing his style. The tender Murillo may seem the most suitable of painters for the sons of St Francis of Assisi, but that does not prevent him from working for other orders. Espinosa, Coello, nearly all the other religious painters (except those who, like Cotán, have taken their vows in a particular order) show the same eclecticism in their acceptance of commissions, the same faithfulness to themselves in the style of their works. Valdés Leal, indeed, whose themes and the way he treats them make him seem the ideal painter for Jesuits, was not to work for them until near the end of his life, and then less inspiredly than when he had painted for the Carmelites or the Hieronymites."

I trust the reader will forgive this long quotation, for I believe it expresses my opinion on the subject. We may say that Zurbarán, whether from some penchant of his own or driven by the tyranny of his commissions, is unequalled in the art of painting monks' habits, especially white ones. When we come to deal with the great painter's use of colour, I shall be speaking of those glowing whites which are not white but a delicate blend of colours. In discussing the Zurbarán in the cloister of the monastery of Our Lady of Ransom, Palomino (*Museo Pictórico,* Ed. Aguilar, p. 937) marvels at "the habits of the monks, which, though they are all white, can be distinguished from one another according to the plane on which they are situated, with such admirable propriety in drawing, colour and execution that they seem more lifelike than the living model; for so industrious was this artificer that he did all the stuffs from a draped figure and the flesh from living models..." He was the painter of white friars and monks, but not of all of them: not of the Cistercians, nor of the Bernard-

ines, nor of the Trinitarians. In his work there is a considerable difference between the whites of the Charterhouse of the Caves, which are full of white lead, and the extraordinary refinement of those of the Charterhouse of Jerez; sometimes in one and the same series — as in the series of Mercedarian friars, now mostly in the Academy of San Fernando (Figs. 201-206 & 209) — the habit worn by one figure is of a quality so different from the others that one can hardly believe they are from the same studio.

For the Dominicans (white habits, with black cloaks or scapulars), Zurbarán painted on three occasions. They were, as Guinard expresses it (op. cit., p. 125), "the young painter's first patrons, the ones who set his foot in the stirrup, as it were, and to whom he remained faithful". The same author goes on to say, very shrewdly, that the founder of the order, St Dominic himself, appears only "in a marginal way, like a sort of extra". Of the series painted for San Pablo el Real in Seville — later to be transformed into the exuberantly Baroque church of St Mary Magdalen, as if fate wished thus to honour two of the painter's most delicate and enigmatic female figures, the Magdalens who appear in the canvases that hang there — only two remain in their original position: the *Apparition of the Virgin to the Monks of Soriano* (Figs. 4 & 6) and the *Miraculous Cure of Blessed Reginald of Orleans* (Figs. 5, 7 & 86), neither of which enables us to form any idea of the other twelve scenes representing the themes chosen by the friars. Of great interest, considering their early date (1626-27), as featuring for the first time in the artist's career some of the most attractive of his favourite themes, which we shall be studying later (the landscape in the portrait of St Dominic, in the first; the oblique table with the cup of water and the rose, in the second; and the gentle female figures, i.e. the "walking saints", in both), they are also notable demonstrations not only of the painter's difficulties in composition (another subject we shall be touching on later), but also his awkwardness in narration. In this aspect, it may seem surprising that Zurbarán should have had any success, if we compare his unintelligible way of telling a story with the facile narrative style evolved by his contemporaries: Pacheco (*Life of St Peter Nolasco*, in collaboration with Alonso Vázquez, for the Mercedarians of Seville, 1600-03), Angelo Nardi (*Life and Miracles of St Bernard* and *Life of Christ*, for the Bernardine nuns of Alcalá, 1620), Cotán himself, who had such a direct influence on our painter (*Life of St*

Bruno and scenes of the martyrdoms of Carthusians in the countries of the Reformation, for the Charterhouse of Granada, 1615, 1616, etc.) and, most particularly, Vicente Carducho, who had at his fingers' ends all the tricks of the great studio-workshops for expressing feelings and recounting episodes without any possibility of confusion — as examples of his work we might mention the scenes from the *Life of St Bruno* and his order painted for the Charterhouse of El Paular in 1632, some of them now in the Prado. These, possibly influenced by Lanfranco (through Kruger's engravings), may have inspired Le Sueur's series on the same theme, as has been pointed out by Janine Baticle (see "Les peintres de la Vie de Saint Bruno", in *La Revue des Musées de France,* Paris, 1958). In this regard it is interesting to compare a theme painted by Carducho with the same theme as treated by Zurbarán — for instance, *St Bruno Renouncing the Bishopric of Reggio,* clearly expressed by Carducho (in the Prado) through the attitudes and gestures of the two chief characters, Pope and Saint, on both sides of the episcopal insignia, and so woodenly painted by Zurbarán (in the Museum of Seville) that the picture (Fig. 294) is popularly known as *Visit of St Bruno to Urban II,* with such silent, motionless figures that they might be talking of bishoprics or of anything else in the world.

To return to the pictures painted for San Pablo el Real, nobody not previously acquainted with their subject-matter could distinguish the figures who have appeared miraculously from those of flesh and blood. If in one of them it is quite clear that a woman, whose sceptre and crown make it easy to identify her as the Queen of Heaven, but who might equally well be the Queen of the Earth, is pointing to the portrait of a friar with the attributes of St Dominic — except for the dog with the burning brand — for the benefit of another, kneeling friar, with no indication of there being anything miraculous or visionary about the scene (except for a couple of conventional angels, as far removed as possible from the scene), the other picture was until quite recently thought to be a *Death of St Dominic* instead of a miraculous cure.

It is true, of course, that this incapacity or possibly scorn for narrative is not peculiar to Zurbarán, for it also appears in other great painters, such as El Greco and Velázquez. If one were not familiar with the subjects already, it would be difficult to make out the meaning of works like El Greco's *Martyrdom of St Maurice* and

Burial of the Conde de Orgaz, or of Velázquez' *St Anthony Abbot and St Paul the Hermit* or *Jesus in the House of Martha and Mary.* But neither of these two painters was a monastic painter like Zurbarán, almost wholly engaged in painting for friars or their illiterate congregations scenes from a story or a legend. From the narrative point of view, not only Cotán or Carducho, but even Cano and Murillo (for instance, in the *Suckling of St Bernard,* a theme on which there are pictures by both in the Prado, and one that is very difficult to understand without foreknowledge) and certainly Valdés Leal and Claudio Coello, are infinitely more explicit.

It is rather curious that this incapacity of Zurbarán's for narrative did not seem to hamper his career; in fact, it appears rather to have favoured it. As everybody knows, an excess of explanation can lead to confusion or to resigned acceptance. The events painted by Zurbarán appear so compact in their isolated elements and so incomprehensible in their articulation that they possess a curiously magic sort of presence, like some strange scene we happen to see but whose meaning escapes us. Even one of his clumsiest pictures in all aspects, like the *Pope Urban II and St Bruno, His Confessor,* affords us infinitely more enchantment than Carducho's slick, explanatory version, which we look at once, make out without any trouble and then turn away from as something *déjà vu.* It would not be strange if the friars, intimately acquainted with all the episodes in their history (I myself have attended meals with Hieronymites which were accompanied by the reading in Gregorian tones of Father Sigüenza's *History of the Order,* a book which the friars of Guadalupe probably knew by heart), appreciated in Zurbarán's representations an air of authenticity based on this very absence of rhetoric. Similarly, the fragmentary *St George* by Jaume Huguet in the Art Museum of Catalonia (Barcelona) is one of the most popular images of that godlike horseman, very possibly because his intelligent peasant's face could be that of the saint; a *St George* with a face of celestial ecstasy is not so convincing, even when painted by Mantegna. Zurbarán's saints are saints because God willed it so; their miraculous scenes are quite everyday in feeling. For that very reason those aware of their meaning may find them more real and substantial. And we should not forget that the pictures in monasteries were often accompanied by explanatory inscriptions.

Thus it is impossible that there should be a character peculiar to each order in the pictures painted for them by Zurbarán, for neither in his earliest works, done with great care to please his patrons and get on in the world, nor certainly in those painted in later years with the help of a well-organized workshop, does he seem to have worried about telling his story well or even attending to the traditional conventions for his themes. From his stock of prints, which he was to keep carefully until his death, he took as he needed them the compositions he thought more or less suitable to what he had to paint. For him a St Norbert could easily stand for St Bonaventure, while St Augustine protecting his monks readily became the Virgin sheltering the Carthusians. Despite their simplicity, his most narrative "stories", such as the episodes in the life of St Peter Nolasco in the Museum of Cincinnati and the Academy of San Carlos in Mexico (Figs. 20, 22 & 23), have required infinite patience to interpret. In the Prado (Figs. 15, 16, 19 & 506), the main character, whose physical identity provides the only link between the successive scenes in the series, appears older in the *Vision of St Peter Nolasco,* in which he should really be younger. Paradoxically, we are much less moved when Zurbarán obeys the rules of the game and for once arranges a composition that cannot be faulted from either the story-telling or the plastic point of view: his *Apotheosis of St Thomas Aquinas* (Figs. 79 & 80), painted for the church of the Dominican college founded by Fray Diego de Deza, in which Heaven and Earth combine to tell us that the Angelic Doctor is worthy to figure among the saints of the Church, as Rome had just declared, and in the glory of the chosen, where he has been preceded by the founder of his order, St Dominic; while on earth — in Seville — Fray Diego and Charles V create this college for students in order to disseminate St Thomas' lessons. It is then that we realize that, when Zurbarán takes the trouble, he can paint a "brilliant" altar-piece quite as well as any international Baroque artist from Bologna or Naples, and much better than provincial artists like Roelas, Pacheco, Nardi or Carducho; but we also realize that it is then that we like him least. One is reminded of Camón Aznar's sapient phrase: "Zurbarán succeeded in making a grace of his clumsiness". And, vice versa, when he ceases to be clumsy he comes very near to losing his grace.

To his paintings for the Dominicans in San Pablo el Real and the College of St Thomas we must add the works done for the monastery of San Pablo in Córdoba, which were seen there by Cean Bermúdez, for the

monastery of Atocha in Madrid, according to Palomino, and for that of Porta Coeli in Seville, which include two of Zurbarán's noblest figures, *St Luis Beltrán* (Fig. 278), a hooded figure bearing the poisoned bowl he has been given by the pagans whose conversion forms the subject of the episodes in the background, and *Blessed Henry Suso* (Figs. 276 & 277), a wonderful mystical figure who is shown cutting the anagram of Christ on his chest with a stylus. These two works for the Dominicans are dated to 1638 by Soria and rather later by Guinard.

In the pictures painted for the Carthusians the interpretation of the themes is not very easy either. Zurbarán worked for the Order of St Bruno (a saint canonized in the painter's lifetime) on two occasions: in Seville, for the Charterhouse of the Caves of Triana, at a period that is much disputed (the dates given varying from 1624 to 1655), and in Jerez, for the Charterhouse of La Defensión, in 1637-39. In the Seville paintings a certain monotony of the whites, and even the confor-mation of the characters themselves and of the composi-tion, seem to argue the influence of Sánchez Cotán, whose Carthusian themes at Granada were probably known to Zurbarán. But I would almost be prepared to say that Cotán is more modern and rhetorical than his lay follower. Paradoxically enough, as Professor Caturla points out, Zurbarán here was trying to be up to date, for it was from a very recent print, *St Augustine Protecting his Community* (published by Schelte a Bolswert, in Antwerp, in 1624), that he took the idea for *Our Lady of the Caves* (Figs. 289 & 290), patroness of that particular Charterhouse. Besides, this was the iconographical type of Our Lady of Mercies, which had been very well known in Spain since the fifteenth century (see my *Pintura Española,* pp. 32-33), showing the central figure covering the faithful with her mantle, and Alejo Fernández' *Our Lady of the Navigators,* which Zurbarán had undoubtedly seen in Seville, was quite a late version.

We have already seen the difficulty Zurbarán experienced in "telling" with a little more story to it than usual, as in the case of *Pope Urban II and St Bruno, His Confessor.* And the third picture still extant from the series painted for the Carthusians of Seville is possibly the artist's least explicit work: *St Hugo in the Refectory* (Figs. 291-293). I have pointed out elsewhere that this rustic painter uses a subtlety very typical of his time (one much favoured by Velázquez) in explaining his theme by means of a picture within a picture. In this case the "containing" canvas represents the refectory of the

Carthusians, on the white wall of which hangs a landscape that includes both the Virgin and Child during the Flight into Egypt and St John the Baptist in the wilderness: an anchronism that may be excused by the doctrinal intention of the fasting which Mary and her nephew accepted in the service of God. For there can be no doubt that this picture has some connection with fasting and abstinence, though the nature of the connection is not clearly explained. At an L-shaped table we see a group of Carthusians, all with an abstracted, meditative air, and in front of them — but looking like a figure from another picture placed here as a collage — the bent form of an aged prelate, leaning on his stick and apparently chiding a much smaller character (but one who looks neither like a boy nor like a dwarf, since his head is in proportion to his body) dressed in a seventeenth-century mode and more or less in the fashion of the day (many of the arguments regarding the date of the picture have been based on the fashion of this little person's attire). On the table there are plates of meat, small loaves, pitchers and an oddly-shaped cup or bowl. The different explanations proposed all agree that the prelate is St Hugo, Bishop of Grenoble, in whose diocese St Bruno founded the first Charterhouse, and that the little character in seventeenth-century dress is the friars' cook, though it has later been suggested that the latter might be the Bishop's page. It is revealing that in a free copy of this picture drawn in pencil by the Sevillian Romantic painter Valeriano Domínguez Bec-quer (brother of the poet Gustavo-Adolfo) the size of this little man has been increased, evidently because his disproportionate smallness did not please the copyist's sense of balance. An early explanation held that the picture represented St Hugo arriving in the refectory and berating the friars for their gastronomic laxness; but it was later suggested that he had come to investigate the profound sleep that had overcome them. The most correct explanation would seem to be the latest, given by José María Carrascal in his recent book on the painter (*Zurbarán,* Madrid, 1973, pp. 38-39): "Hugo, Bishop of Grenoble and protector of the monastery at Chartreuse, had sent the friars a present of some meat. It was Quinquagesima Sunday. When they were already at table in the refectory and about to eat it, some of the monks raised the question of whether it was permitted for them to eat meat that day. Hour after hour was spent arguing the point, until at length they were all overcome by a profound sleep. On Ash Wednesday, when the

penitential season of Lent began, the Bishop sent one of his servants... As he found them fast asleep, the servant went back to tell his master. Then St Hugo came to see the phenomenon for himself, and at the very moment that he entered the refectory, the friars awoke. When Bruno was asked what day it was, he replied that it was Quinquagesima Sunday. But in fact three days had elapsed and the meat, still smoking, had been turned to ashes. Thus the argument was settled. The friars had slept until the moment when their Lenten rules forbade them to taste meat. In this way the miracle supported the early custom of continual abstinence." This ingenious explanation (which also identifies the seven friars at table as St Bruno and his six historical companions) covers everything except the fact that "the Bishop and his servant question each other in joyous astonishment". Despite all efforts this picture cannot be said to tell its story clearly; but no doubt the Carthusians of Seville were familiar with it.

At the height of his most prolific period (1638-39) Zurbarán was to paint for the Carthusians again, this time for the monastery of La Defensión, near Jerez, built to commemorate the battle of El Sotillo against the infidels in 1370. The iconography the painter was required to illustrate (Figs. 127-155) was partly of a general Christian type (Annunciation, Adoration of the Shepherds, Adoration of the Magi, Circumcision, the four Evangelists, St John the Baptist and St Lawrence), and partly more specifically Carthusian (St Bruno and other figures of the Order). Apparently the whole series, now split up between museums in Grenoble, New York and Cadiz, formed the ensemble of the high altar. From the altar a passage led to the sanctuary behind it, an architectural form frequently found in the Baroque period (seventeenth and eighteenth centuries), both in Andalusia and, specifically, in the Carthusian Order— two examples that come to mind at once are the sanctuaries in the charterhouses of Granada and El Paular. To decorate this passage, Zurbarán painted ten little pictures (about 120 cm high by 60 cm wide) depicting two incense-bearing angels — charming figures of a processional type — and eight prominent Carthusians. The latter, despite their size, are among his most majestic and architectonically conceived full-length figures. We know that isolated figures, motionless or walking, did not entail such difficulties for the painter as narrative episodes. In these works, however, and especially in the *Battle of El Sotillo* (Fig. 134), which

according to César Pemán would have been the main point of the ensemble, at the lowest level in the centre, Zurbarán came up against his usual difficulties of explanation: in an abruptly delimited foreground one soldier in full length and another in half length are attempting to explain the singularly unconvincing and manneristically painted battle scene taking place behind them, a scene being watched by the defending Virgin from the clouds, almost as though she were in a box at the theatre and without much appearance of intervening. We need only consider for a moment how Pietro da Cortona represents the Virgin supporting and defending the church of San Filippo Neri in Rome, to realize how very bad at narrative our painter was. The other point, which would have been above the battle scene, is the *St Bruno in Ecstasy* (Figs. 135 & 136), which is simply a representation of a simple figure, with a *gloria* of cherubs and flowers incorporated into the upper part. At a later stage in this book I will be examining the iconographical sources of the pictures of the four evangelists (Figs. 137-140); for the moment it is enough to say that they depict episodes so well known that it would be impossible to misinterpret them. But there are some very lovingly painted details in the series as a whole — such as the work-basket in the *Annunciation* (Figs. 127 & 128), or the basket of eggs and the lamb in the *Adoration of the Shepherds* (Figs. 129 & 130) — that are of particular significance, as we shall see.

Zurbarán worked for the Calced Mercedarians in 1628-34 and for their Discalced brethren rather later (1636?). The paintings done for the monastery of the Calced Mercedarians provide an excellent example of an articulated series in which the coherence of the whole depends on the pictures being hung in their proper order. "For it is true that these monastic ensembles are presided over by a programmatic, didactic and even rhetorical idea, which decides the selection and ordering of the themes," as I have written elsewhere (*Visión y Símbolo...*, op. cit., pp. 192-93). The twenty-two episodes in the life of *St Peter Nolasco* (a series in which few of those extant are universally accepted) were for the cloister; the (imaginary) portraits of doctors of the Order, for the library; the no less learned but even more saintly protectors of the Order, for the print room; and, finally, the martyrs were placed in the *De Profundis* chamber, where the bodies of dead monks spent the vigil of their burial, presided over by Christ on the Cross. This arrangement was the result of a typically monastic

programme, decided by the friars rather than by the painter, who confined himself to carrying it out, with all the usual difficulties he experienced in painting narrative episodes. The *Departure of St Peter Nolasco* in the Academy of San Carlos in Mexico (Fig. 20), often known as the *Picture of the Spaniel Bitch,* because there is one sitting in the foreground, in front of the elegant young man with his three rather less stylish companions, represents the saint's departure from his native city, then in the hands of the Albigensians.

In the single figures of this series Zurbarán did some of the best work of his career. The doctors, apart from their air of gravity, are distinguished by their books, pens and birettas. The painter's reluctance to explain anything reaches admirable heights of reserve in one case: in the *St Serapion* now in Hartford (Fig 13), one of Zurbarán's finest works, the painter uses the scapular of the corpse tied to posts to conceal the horrible wounds in the belly caused by the martyr's disembowelling. But he did not hide this evidence of torture in the smaller version of the same theme (Fig. 220), painted together with other little pictures in 1636 for the Discalced Mercedarians; indeed, it was probably these scenes of martyrdom, then housed in Louis-Philippe's collection in Paris, that inflamed the imagination of the Romantics and gave rise to the idea of Zurbarán as a violent, brutal painter, *très espagnol* in his cruelty. For the same monastery (i.e. of the Discalced Mercedarians) he probably painted the majestic *God the Father* (Fig. 251), the top painting in a retable which would also have included the pictures of *St Lawrence* (Fig. 124), *St Anthony Abbot, St Lucy* (Fig. 254) and *St Apollonia* (Fig. 255), now in the Hermitage, the Valdés Collection in Bilbao, the Museum of Chartres and the Louvre, respectively; perhaps, too, the *Burial of St Catherine on Mount Sinai* in the Château de Courçon in France (Fig. 275), a picture literally copied from a print by Cornelius Cort, but painted with great care. The picture representing *Our Lady of Ransom* in the Marqués de Valdeterrazo Collection in Madrid (Fig. 310) is a traditional altar-piece image, arranged like the embroidery on a handkerchief, with the Virgin in the centre and the four corners occupied by two cherubs and two Mercedarian friars. Zurbarán is a little more inventive in the rather similar *Our Lady of the Carthusians* (Fig. 145), now in Warsaw.

For the Franciscans he painted one of his first series, that of the life of *St Bonaventura* (Figs. 25-29), which was done for the church named after the Seraphic Doctor,

who had been canonized in 1582. This series, begun by Herrera the Elder, was continued (the precise reason is not known) by Zurbarán from 1629. It was a great honour for the young man from Extremadura to measure his powers against those of the "father of Andalusian painting".

It seems that there were originally eight canvases, hung on both sides of the nave, and it was traditionally held that four were by Herrera and four by Zurbarán. The mural decoration and that of the vault were, apparently, by Herrera. This series was dispersed during the Peninsular War and Marshal Soult, that most dangerous and predatory connoisseur of Andalusian painting, carried off four pictures. These are believed to have been the two Zurbaráns now in the Louvre, *St Bonaventura at the Council of Lyons* (Fig. 27) and the *Death of St Bonaventura* (Figs. 28 & 29), which are rather uneven but immensely powerful works, the admirably balanced composition of the *Prayer of St Bonaventura* in the Gemäldegalerie in Dresden (Fig. 26), which shows the saint imploring divine guidance at the election of a Pope, and the *Visit of St Thomas Aquinas to St Bonaventura* that hung in the Kaiser Friedrich Museum in Berlin until it was destroyed in an air raid in 1945 (Fig. 25), with Bonaventura showing his visitor the crucifix from which he drew inspiration for his writings, one of the rare occasions on which Zurbarán tells something clearly, without thereby losing the admirable physical presence of his objects and characters, in a perfect composition. In the Palazzo Bianco in Genoa there is a picture representing the viaticum being brought to a young man (Fig. 65), which may also have belonged to this series, but not all authorities recognize it as an authentic Zurbarán; it is, at all events, a very impressive painting. In this series the young painter clearly took great pains to make his pictures intelligible to the viewer, which was more necessary in a church open to the public at large than in a cloister, on principle reserved for initiates.

The figure of St Francis was frequently depicted by Zurbarán, either for the friars themselves or (more probably) for devout families, like those in Toledo who bought the ones painted by El Greco in even greater abundance. The St Francis represented, identical in the two painters, was the sad, wasted, ascetic figure of the penitent *Poverello;* and it is by no means impossible that Zurbarán drew inspiration from the great Cretan for his versions, which usually showed the saint with his

stigmata or in meditation with a skull. The finest of these (and one of Zurbarán's best works) is the *St Francis in Meditation* in the Alte Pinakothek in Munich (Fig. 471), a painting worthy of Murillo in the beauty of its impasto and colour, but without thereby losing the grave austerity peculiar to our artist. Zurbarán was also the creator of an iconographical type hitherto unknown in Spain: that of St Francis dead but standing, his eyes raised to Heaven and his hands in the sleeves of his habit, as his mummy appeared to the eyes of Pope Nicholas V when he entered the saint's tomb in 1449. Zurbarán did not invent this theme, which had been in use in Europe since the beginning of the century, but he did appropriate it enthusiastically and he used it in some of his most impressive pictures — such as the ones in Boston, Lyons (Fig. 244) and Barcelona (Fig. 245), from which Pedro de Mena probably took the inspiration for his famous little statue in the Cathedral of Toledo. Another Franciscan theme that Zurbarán painted several times was that of the *Portiuncula*, with Christ and his Mother appearing to St Francis in his church. The version in Cadiz (Fig. 229), painted around 1630, was so successful that it undoubtedly inspired Murillo to paint the same theme. Among the other figures of this Order painted by Zurbarán are *Blessed Pedro of Alcántara* (Fig. 265), who was canonized in 1669, and —with more felicitous results — *St Diego of Alcalá* (Fig. 266), canonized in 1588 and usually represented as a simple, manly figure, at the very moment when the alms he is carrying against his Superior's wishes are turned into flowers. This theme was admirably treated in sculpture by Cano and Mesa, among others, and Zurbarán's versions in the Museo Lázaro (Fig. 266) and the Prado (Fig. 477) are themselves almost like carvings on a smooth background. Zurbarán also painted some single-figure representations of St Anthony of Padua, with his usual mastery but without the flowing quality that makes Murillo such an ideal painter for the Franciscan mentality. In his last years our artist was to paint, for a chapel in Alcalá de Henares, the largest of his Franciscan figures, the *St James of the March* now in the Prado (Figs. 465 & 466), which shows the saint in the middle of a composition of strict perspective that is almost irritating in its use of the principles of convergence advocated by Alberti. He is holding up a crystal chalice full of the shining wine turned into the blood of the Lord, while in one of the lateral backgrounds then in fashion (cf. Velázquez' *Spinners,* or certain Velázquez-inspired portraits by

Mazo or Carreño) we see the miracle-worker bringing a dead child to life. An admirable picture, but one in which we miss — as in nearly all those he did for the Franciscans — the Zurbaranesque enchantment of the white habits, which the painter has nevertheless cunningly introduced into the *Portiuncula*, the *Death of St Bonaventura* and the *Visit of St Thomas Aquinas*.

Only once did Zurbarán work for the Hieronymites, but on that occasion he produced his greatest masterpieces, in his paintings for the sacristy of the monastery of Guadalupe in Extremadura, a place in which he possibly never set foot in his life. If this is so, then it can only be by some miracle that these scenes from the works of Father Sigüenza are so wonderfully suited to the solemn atmosphere of austere luxury that pervades the quiet, sleepy light of this space. At one end there is a chapel (with a statue of St Jerome), and for this Zurbarán painted an *Apotheosis of St Jerome* (Fig. 177), rather exaggeratedly known as "the pearl of Zurbarán", and two extremely interesting scenes from the saint's life which are among the best things to come from his palette: the *Scourging of St Jerome* (Figs. 170-172), in which we see the saint as a young man being scourged by the angels to moderate his excessive addiction to the reading of Cicero, a kind of Morality play of singular brilliance; and, in front of this, the tenebrist *Temptation of St Jerome* (Figs. 173-175), which shows a bony old man busily shooing away, so to speak, a group of very chaste-looking she-devils who want to entertain him with a little music. It is amusing to compare these two paintings with the versions of the same theme that Valdés Leal was to paint later for the Hieronymites of Seville, in a dynamic, impetuous, expressive style — a complete contrast to Zurbarán's works, which are at once more beautiful and more enigmatic, only to be understood by those already familiar with their subjects.

The same is true of the eight large canvases decorating the sacristy: even with the inscriptions on their magnificent frames, if we are not familiar with the writings of Father Sigüenza how are we to know that the *Vision of Fray Pedro de Salamanca* (Figs. 167 & 169), with nothing more portentous than a wonderfully reddened sky, is announcing the civil wars at the end of the reign of Henry IV of Castile? Who will tell us that in *Jesus Appearing to Father Andrés de Salmerón* (Figs. 160 & 161), one of the most elevated of all Spanish mystical paintings, the monk owes the apparition of Christ to his humble vow to walk on his knees? Would we guess that

the friar praying among his companions represents *Father Juan de Carrión Taking Leave of his Friends* (Fig. 166), after having his imminent death revealed to him? In that court scene reminiscent of Velázquez (Figs. 162 & 163), with a king that reminds us of Philip IV placing a cap on the head of a kneeling friar, would we know that the scene is entitled *Enrique III Conferring the Archbishop's Biretta on Father Yáñez,* and that the cleric is Prior of the Order and Archbishop of Toledo by the will of the King? (1) When we see the Host floating above the paten before the astonished, devout eyes of a priest celebrating Mass (in a pink chasuble, a colour so unusual in the liturgy that it is worn only once a year) and make out the words that seem to descend upon his head from Heaven, *Tace quod vides et inceptum perfice* (Fig. 157), we may well assume that this is the picture of a meticulous celebrant, but we may not realize that this is the *Mass of Father Cabañuelas,* held up for a moment by a doubt concerning the Real Presence, which has been thus resolved from Heaven. It is easy enough to understand that the darkest painting — the "poor relation" of the series in Guinard's opinion — which shows a friar struggling with something or somebody (it is almost impossible to know if his adversary is a beautiful woman, a lion or even a bear) represents the *Temptation of Fray Diego de Orgaz* (Fig. 168) and that he is supported in his virtue by the Virgin, to whom he can be seen praying in the enchanting picture within a picture in the background. Nor can there be much doubt about that other sturdy friar, standing in a doorway and handing out crisp loaves to some beggars (Figs. 164 & 165): this is evidently *Fray Martín Vizcaíno Distributing Alms,* for Father Sigüenza tells us that this friar was in fact a kindly porter of the Hieronymite monastery. And the most richly coloured and impressive picture of the whole series (Figs. 158 & 159) clearly represents that famed churchman and writer *Fray Gonzalo de Illescas, Bishop of Córdoba,* sitting before a "vanitas" that reminds him of how fleeting all intelligence is unless it is based on charity, as practised by himself in the background scene. Here Zurbarán was confronted with an unusual and imposed subject-matter, and he acquitted himself with enormous talent. The Hieronymites cannot boast of any saints in their order except the remote

Founder who gave them his name. These gravely devotional pictures, which are not meant for praying in front of, are half-way between history and piety.

The pictures at Guadalupe, which were begun around 1638, form the most homogeneous series in the whole of seventeenth-century Spanish monastic painting. It is really difficult to imagine how the same man who could create works breathing a transcendent reality of such severe gravity was also responsible for a feeble, nerveless picture like the *St Jerome with St Paula and St Eustacia* in Washington (Fig. 314), which Soria supposes to have been painted for the Hieronymite nuns of Santa Paula in Seville. If this is correct, it would be the only work Zurbarán ever painted for nuns, and not much of a compliment to them, for it is as false in its unctuousness as in its prim style. But this "workshop master", after all, was capable of things just as bad and even worse.

For the Carmelites of San Alberto, between 1630 and 1633, Zurbarán painted a number of pictures, most of them fairly small, which hung in that church in competition with works commissioned from Pacheco, Juan del Castillo and Alonso Cano. The exquisite quality of these single figures easily makes up for their small size. The white cloaks of *St Peter Tomás* (Fig. 237) and the wise young *St Cyril of Constantinople,* with his exotic coiffure (Fig. 238), both in the Boston Museum, make them visible and admirable from quite a distance. I have never heard of our artist painting a Trinitarian, with that black and white habit, broken by a two-coloured cross, which El Greco immortalized in his *Fray Hortensio Paravicino,* but in 1629 Zurbarán began work on a retable for the Calced Trinitarians of Seville (Figs. 30-37) which represented the lives of the Virgin and St Joseph (and thus was not exclusively Trinitarian in its iconography). It included seven canvases now in different collections and a charming *Child Jesus* (according to the eighteenth-century writer Ponz, who saw it in the tabernacle of the altar) which may be the *Jesus Giving His Blessing* (Fig. 36) in the Pushkin Museum in Moscow. And so, when we have recalled the wonderful *Vision of Blessed Alonso Rodríguez* in the Academy of San Fernando (Figs. 39, 41 & 508), with its central figure receiving on his breast the imprint of the sacred hearts of Jesus and Mary, one or two figures of saints, like the *St Nicholas of Tolentino* of the Order of St Augustine, and the varied series of Founder Saints, we can bring to a close this brief resumé of Zurbarán's activities as a painter of friars.

(1) I find it revealing that in Zurbarán's treatment of the stories of both *Father Salmerón* and *Father Yáñez* the first idea for the composition does not derive from the theme but from something which had remained in the painter's visual memory since 1623; Velázquez' *Descent of the Virgin,* which he would have seen in the church of St Anthony in Seville.

But this does not mean that we have mentioned all the commissions he received for works on sacred themes. To prove the contrary, we need only recall the *Retable of St Peter,* the date of which has caused so much argument, in the Cathedral of Seville (Figs. 68-73); the pictures commissioned for the altars of the churches of San Esteban, in about 1635 (Figs. 317 & 318), and San Román, in 1638 (Fig. 125); and the various images of the *Immaculate Conception,* an object of fervent devotion in Seville long before it was sanctioned by dogma and despite all the scruples of the Thomists. Of these images the Town Hall of Seville commissioned one, possibly the one now in Jadraque (Figs. 38 & 40); an unknown school ordered another, featuring two schoolboys, now in the Art Museum of Catalonia (Figs. 83, 84 & 507); and there are more in the Prado, the Museo Cerralbo, etc. Iconographically, they may be said to tend towards the sculptural. But they are given a very pictorial air by the Marian emblems that appear amid the clouds or forming beautiful landscapes at their feet.

Other such pious commissions came to him from various towns and villages — for instance, the retable for the church of Our Lady of the Pomegranate, in Llerena (Figs. 187, 190 & 191), and the pictures for the sacristy in the church of San Juan, in Marchena (Figs. 114-122) —and even from Madrid (for the churches of San José and San Miguel) and from the American colonies. For America he produced large collections of Virgins-and-Martyrs or Apostles or Founder Saints, in which most of the work was done by his assistants. Particularly notable among his characters are the sumptuously dressed female saints, like the ones commissioned for the old Hospital of the Precious Blood and now in the Museum of Seville (Figs. 388-396), which constitute, as we shall see, one of Zurbarán's most important contributions to iconography, whether they are entirely by his hand or not.

Who commissioned these works of reflective devotion and tender meditation, showing the Virgin as a child, sewing and praying or sleepily smiling, or the Child Jesus pricking his finger on a premonitory thorn, or the lamb with hobbled feet, as patient an offering as Christ himself, or the half-folded cloth of Veronica with the imprint of the face of the Saviour? For whom did he paint those Holy Families of his last years, sentimental, evanescent and full of an emotional quality akin to Murillo's? For towards the end of his life this painter of tremendous, almost frightening Crucifixions became capable of the most swooningly tender pinks and whites,

effects that look like the work of a talented nun. He never cared for the usual evangelical themes, nor was he attracted by the Acts of the Apostles; and still less by episodes from the Old Testament, in which he was no different from other Spanish painters, for they were all rather wary of anything Judaic. He liked everything silent, motionless, meditative, serenely severe. Is this a sign, as Soria suspected, of his possible sympathy with the Illuminati? Although, as Guinard reminds us, the scandal of the heretics had passed its peak fifty years before, we know that the movement was not so easy to stamp out. In 1623, indeed, the Inquisitor Andrés Pacheco outlawed certain religious confraternities in Seville and Cadiz which were still suspected of being nests of Illuminati. Perhaps there was, in fact, something of laxity in Zurbarán or in his melancholy patrons, as there may have been in his near-contemporary Georges de la Tour, when some of the heretics fled from their country to France, thus helping to spread the quietism of the Aragonese Miguel de Molinos. Zurbarán is undoubtedly a quiet painter. But it is difficult to imagine such a long career of commissions from the clergy for a painter suspected of heretical ideas (though there seem to have been some Hieronymites who "Judaized" in their own monastery).

Apart from the Ancestors of the house of Lara and the Roman emperors on horseback, which are of no great interest, the most notable of Zurbarán's commissions to paint secular subjects are those that came from or for the King: the boat presented to Philip IV for his lake at the Buen Retiro, by the Town Hall of Seville, and the *Labours of Hercules* (Figs. 103-112) and various historical scenes, painted in 1634 for the Grand Salon (or Salon of the Kingdoms) in the same palace. Like everything that had to do with the King, the Palace of the Buen Retiro had a quasi-divine significance; and Calderón de la Barca, the more or less official poet laureate and provider of texts for the operas and operettas presented there and in other royal residences with the most elaborate mechanical effects, went so far as to speak of this building as the New Law — as against the Synagogue, represented by the Alcázar. Indeed, since this building served the august person of His Majesty as both refuge and show-case (or "monstrance"), Calderón did not hesitate to compare the Buen Retiro with a ciborium in which the Eucharist could be venerated. (See my essay, "El Madrid de los Austrias; un urbanismo de teatro", in *Revista de Occidente,* No. 73, Madrid, 1969.)

In this semi-historical, semi-allegorical setting, the Grand Salon —later called the Salon of the Kingdoms, because its ceiling was decorated with the coats of arms of the different kingdoms and provinces of Spain— was the room in which the supreme greatness of the Monarchy revealed itself. It was therefore decided to give it a decoration based on symbols (for further details, see *Visión y Símbolo...*, op. cit., pp. 193 ff.), which may have been suggested by Velázquez, who was probably appointed director or supervisor of this work. Since the Spanish painters of the time did not do much work in fresco (not, at least, until the second half of the century), it was decided to have an articulated series of oil-paintings, like the ones I have mentioned in the church of the Discalced Carmelites in Seville. Velázquez undertook himself to paint the portraits, on horseback, of members of the reigning dynasty (today in the Prado), as well as one of the scenes from contemporary history relating that dynasty's triumphs all over the world; Velázquez' contribution was *The Surrender of Breda*. The other battle scenes were entrusted to the foremost painters in that genre: Vicente Carducho, Eugenio Caxés, Juan Bautista Mayno, Antonio de Pereda, Jusepe Leonardo... and Francisco de Zurbarán, possibly recommended by his old friend Velázquez, but perhaps remembered at Court for his decoration of the new pleasure boat, which was called *El santo Rey don Fernando* — with no capital letter for "santo", since Fernando III had not yet been canonized (though he was to be in 1671) — a boat of which all trace has since been lost. Palomino assures us that Zurbarán also worked in the palace known as the "Casa de Campo" (Country House), "and at other royal seats", but any such pictures, if they existed, have not survived. *The Defence of Cadiz against the English* (Figs. 101 & 102), of course, is still extant and hangs, with the other artists' works, in the Prado. The decoration of this vast room was completed by Zurbarán's ten paintings of the *Labours of Hercules,* which were to be hung on the upper part of the walls; these, too, are now in the Prado.

In these paintings an allusion is made to the Hispanic tradition of the demigod forcing Calpe and Abyla apart to make the Strait between those pillars where Charles V hung his proud motto of "Plus Ultra", slaying the monster Geryon and founding the monarchy of Spain. We have already seen how Calderón practically identified the King with Christ; now we see him identified with the Hércules Hispánico, father of Híspalo, the first king of Spain and thus the remote predeces-

sor of Philip IV, "the Great". Palomino says of these paintings that "while [Zurbarán] was painting them, on one of the several occasions that our gracious lord Philip Fourth came to see him at work, he arrived and, putting his hand on his shoulder, said: 'Painter of the King and King of Painters'." This royal admiration (which went just far enough to give him that title, but without any consequent emoluments) was not sufficient to persuade Zurbarán to remain in Madrid; and so, at the end of this 1634 journey and after being paid for his paintings, he simply went home to Seville.

At a later stage in this book we will be analysing the style of these ten paintings. I would like to point out now, however, that Zurbarán had realized that these compositions, which were not very large (just over a metre and a half in width by a little less in height), could not be understood unless they were simplified; so the painter treated them like the metopes of a classical temple, reducing them almost entirely to the figures of the hero and his adversaries against a very dark background. It is interesting to observe, however, that since these pictures were to be seen at close range before being hung (particularly if what Palomino tells us of the King's visits is true), Zurbarán took special pains with certain details of the backgrounds, which contain water in five of the canvases (and with what may well be the sea in another two). Water has almost a principal role in *Hercules Changing the Course of the River Alpheus* (Fig. 111), with its admirable painting of the foaming waves which sweep past the rock on which Hercules stands (in the rather swaggering pose of a "bravo") and seem to hurl themselves at the viewer.

In these nude figures Zurbarán, though in his general composition he may have followed the influences we shall be studying later (and it is curious to see how he in turn influenced Murillo, whose *Repentant Prodigal* is given a posture similar to that in *Hercules killed by the Poisoned Shirt of Nessus*), evidently chose his model —probably the same man throughout — for his similarity of type to the ones recently used by Velázquez in Rome. Zurbarán clearly wanted to be up to date and so he imitated, in particular, the pair of pictures his friend had brought back from Italy: *The Forge of Vulcan* and *Joseph's Coat*. The similarity to the second of these is in the type and even in the priming, while from the first he appears to have caught a certain very Sevillian irony in the treatment of mythological characters. Zurbarán's Hercules, symbol of the King of Spain, has all the

bragging air and somewhat grotesque arrogance of a bully-boy, like one of those swaggering soldiers crowding most of the canvases in the historical scenes painted for the Grand Salon. In this the painter was merely following a demythifying tendency that was a constant in the poetry and painting of the Spanish golden age (see *Visión y Símbolo...* pp. 64 ff., in connection with J.M. Cossío's *Fábulas mitológicas de España,* Madrid, 1954, especially pp. 517 ff., 679 ff. and 787 ff.).

The *Defence of Cadiz* by its gout-stricken governor, Don Fernando Girón, who is shown in a carrying chair in the left foreground, is as theatrical as all its companion pieces, a point to which we shall return in due course. It was Longhi who first attributed it to Zurbarán rather than Eugenio Caxés, an attribution later confirmed with documentary proof by Professor Caturla. Apparently, Philip IV commissioned Zurbarán to paint another battle scene, which has since been lost. And the one that remains is by no means the peak of the collection (it comes nowhere near *The Surrender of Breda,* for one), nor even as good as some of the others — those by Mayno and Jusepe Leonardo, for instance, in my opinion. Once again Zurbarán shows how difficult he found it to tell a story on canvas; without hearing whatever his actors are saying to accompany their affectedly martial gestures, it is almost impossible to make out what they can be doing. The *Labours of Hercules,* on the contrary, hardly deserve the contempt with which they have at times been dismissed. In episodes like *Hercules Struggling with the Lernean Hydra* (Fig. 103), for instance, we realize that Zurbarán could have been a great secular painter if fate had not decreed otherwise.

I am not going to speak here about the still lifes, only one of which — the one known as the Contini-Bonacossi *Still Life,* now in the Norton Simon Foundation (Figs. 85, 87 & 88), which I ventured to see some years ago as a possible symbolic homage to the Virgin (see *Pintura española,* Barcelona, 1963, p. 102) —is beyond all doubt by Zurbarán himself. Others are by his son, as César Pemán has shown. But I do not wish to pass by certain other sources of commissions for paintings by Zurbarán, whether sacred or profane: the commissions that came to him from the New World— spontaneously in some cases, sought out by the artist himself in others. For these commissions made it possible for Zurbarán's paintings, when they had gone out of fashion in Spain, to achieve fresh success, and even to create a "school", in Spanish America.

With no very rigidly defined iconography, without any attempt at meticulous detailing of their "message", and even without pictorial quality in many instances, these assembly-line series nevertheless possess great charm and freedom. And these throngs of Founder Saints and Virgin-Martyrs were to trail their habits and their bizarre garments all over the Americas for the benefit of viewers who imagined them to be truly Spanish.

III

LARGE COMPOSITIONS

Zurbarán's clumsiness of composition in his large-scale scenes is a defect so frequently urged against him that we might do well to reflect for a moment before accepting it unexamined. César Pemán, one of the most reliable students of his work, writes that "his lack of imagination makes him a poor creator of allegories, a bad interpreter of figures and animals in motion, an utterly uninspired inventor of compositions. Often, indeed, his compositions are literally copied from engravings; at other times he takes single figures from such prints and combines them most infelicitously... In perspective his lack of skill is evident wherever we look, even in such important pictures as those of *Father Cabañuelas* and *Fray Gonzalo de Illescas* in Guadalupe." Thus Pemán, in the catalogue of the 1964 Zurbarán exhibition in Madrid, page 88. As for Alfonso E. Pérez Sanchez, he remarks: "He never... succeeds in giving verisimilitude to the settings of his action, in making the proportions harmonious, the foreshortenings convincing or the far-off background really distant and yet at the same time a frame for the rest. His landscapes... are simply so many beautiful pictures, detached and remote, his architecture consists of stage sets, sometimes of disproportionate size but always revealing the stage machinery; the bodies of his characters are lifeless lay figures, repeating with ramrod stiffness the gestures that have been "programmed" into them, theatrical conventionalities with an inevitable air of *déjà vu*" (*Goya,* No. 64-65, Madrid, 1965, p. 195, p. 267).

All of this is undoubtedly true, but it only makes still more baffling the question of the talent of this man who — despite all these defects, or possibly thanks to them — created some truly memorable compositions. In them he obviously adopts a position radically opposed to the general concept of modern painting in his time, with its expression of movement, emotion, atmosphere and changing light; but this provincially archaic attitude would not be enough to bring about such a remarkable revival of interest in his work at the beginning of our century. Hundreds of rustic or monkish painters (descriptions that can be applied even to some famous ones, like Pacheco or Céspedes) have dropped out of sight, or at least out of favour with art-lovers, just because of such an attitude. We might then ask ourselves whether this clumsiness of Zurbarán is not to some extent intentional, at least in some of his larger pictures. On the subject of the paintings in the Charterhouse of the Caves (which she dates in the early days of the painter's career, somewhere between 1623 and 1626), María Luisa Caturla remarks, with penetrating shrewdness: "In them we find, together with an evident lack of experience and many undeniable shortcomings, an intention of coldness. This work is deliberately austere, like the age to which it still belongs. The painting of Francisco de Zurbarán is the spiritual child of the 'Herreran' style" (Zurbarán exhibition catalogue, Madrid, 1964, p. 19). I myself would go so far as to say that it must then be related to what in architecture might be called the "Lerma style", which amounts to a stylization of the architecture of the Escorial. (1) At one time I believed that Zurbarán would have been a more suitable painter for the Escorial than El Greco, but I am no longer of that opinion. Herrera's Mannerism is too robust, too clearly in the Michelangelo style, too balanced in its bareness, even if it represents the desire for an effect of showy poverty in comparison with the work of the man who began the monastery, Juan Bautista de Toledo; but Zurbarán belongs, in painting, to the third generation. Consider an ensemble like the chapel of the Virgin of the Sanctuary in the Cathedral of Toledo; or, better still, that of the Immaculate Conception in the retrochoir of the Cathedral of Murcia, attributed to the Trinitarian monk Fray Tomás de

(1) Lerma was rebuilt (1604-14) as a ring of monasteries linked to a new palace on an irregular plan and in a severely simple style.

Segura, who would have been working on it in the third decade of the century, when Zurbarán (if Professor Caturla is right) was planning the Charterhouse paintings. We find the same propensity to the separation of traditional elements and the creation of flattened, empty spaces, to fullness of form and the juxtaposition —an arbitrary one? — of elements; coats of arms, frames, reliquaries, carvings and paintings, the whole emphasized by the use of black and white marble. This deliberate restraint (which invites comparison with that of the French Neo-Classical architecture and painting of the early nineteenth century) is due rather to an attempt to create a style than to any inability to find a more vigorous solution.

There may have been another reason, more or less consciously felt by the painter, for maintaining this archaizing style. That mysterious period of his early training in Extremadura, within the sphere of influence of the great Morales, may have left him with a taste for Mannerist composition — expressed through the bodies of the characters or with the furniture and accessories placed on the slant in spaces that are never definitely delimited or entirely open — that led him to reject the unitary vanishing point so dear to all the theorists from Alberti and Leonardo onwards and respected by the most advanced of the Baroque artists, however much they tried to revivify it with their showy displays "di sotto in su". Though without wishing to compare a provincial painter like Zurbarán, who seems never to have attempted anything new, with Picasso, whose whole career was one of innovation, I cannot help seeing in the awkwardly contrived spaces that Zurbarán presents in works like *St Bonaventura at the Council of Lyons* (Fig. 27), *Pope Urban II and St Bruno, His Confessor* (Fig. 294), *The Circumcision* (Fig. 131) or *Fray Gonzalo de Illescas* (Figs. 158 & 159) a desire akin to that which leads Picasso, in his first Cubist pictures (*The Factory of Horta de Ebro* or *The Reservoir*), to reject rules of perspective he had known since childhood in search of a fresher expression of volume, which took him back to such pre-Renaissance artists as Giotto and Duccio, with their tiny buildings and their cities with "illogical" plans. To my mind, at least, this clumsiness of Zurbarán is more expressive than the monotonous perspective of the vast majority of the learned painters of the seventeenth century. With this conflict, Zurbarán opens our eyes to the corporeality of each and every object, isolating them all in their closed spaces just as they are isolated by our roving gaze. Zurbarán's large-scale compositions seem to have been built up piece by piece, in a series of glimpses. But is this not equally true of the best works by the portrait-painters of the House of Austria, who paint their royal sitters in two such glimpses, going downwards in the lower part and upwards in the rest of the canvas? And is it not thanks to this method that there is more life in the real people portrayed by Sánchez Coello or Villandrando than in their imaginary characters set in a perfect perspective in the Italian mode? The stage-effects of the *Vision of Blessed Alonso Rodríguez* (Figs. 39, 41 & 508) or the *Portiuncula* (Figs. 459 & 516), with their heavenly and earthly areas arranged as if they were shelves, give originality and strength to works that are full of conventions (for instance, that of putting the Blessed Alonso in the foreground and facing the viewer, as he contemplates a vision that is behind him). The most irritating aspect of the *Apotheosis of St Thomas Aquinas* (Figs. 79 & 80) is not the solid bank of clouds on which the well-nourished Doctor is standing, rather fortuitously supported by a column, nor yet the architectural back-drop in the lower part, but the display of learning in the composition of the upper area, with its amphitheatre of heavenly beings in the style of Raphael's *Disputa,* though this was probably the main reason for the picture's success.

This brings us to the question of the sources for Zurbarán's compositions, a question already dealt with by such well-qualified writers as Soria, Pita, Kehrer, Martín González, etc. We must distinguish between sources in actual pictures and those found in engravings, which are so important that, as Pérez so rightly says, "It is not surprising that Zurbarán frequently resorted to a practice in such general vogue among his contemporaries, whatever their abilities. When we see that one item in the inventory of his few poor belongings after his death mentions a collection of fifty engravings, we cannot help feeling a twinge of compassion at the thought of this final, almost desperate presence of his most treasured repertory, his familiar working tools, doubtless bearing the signs of constant thumbing on receiving each new commission. The recourse of the poor provincial..." (op. cit., page 268).

There is no evidence to show that Zurbarán made any more considerable journeys than those to Seville and Madrid. His knowledge of Italian painting, therefore, must have been gained from the few imported pictures he would have seen and, above all, from engravings. As a

painter, his training was totally Spanish, not to say Andalusian. When he made use of the imagination of other artists to supply his own deficiencies in composition, he usually resorted to prints. One of the most spectacular cases is that of *Our Lady of the Caves* (Figs. 289 & 290) sheltering the Carthusians under her mantle, which follows an iconographical formula used extensively in the late Middle Ages, that of *Our Lady of Mercy.* J.M. Pita Andrade has pointed out, quite rightly, that the initial idea for this theme is found in a print by Dürer, the *Virgin with St John and St Bruno Sheltering a Community of Carthusians,* though it probably reached Zurbarán indirectly, through Sánchez Cotán's *Apparition of the Virgin of the Rosary* (now in the Museum of Granada), regarding which Emilio Orozco has noticed the "undeniable formal resemblance" to Zurbarán's picture. This leads Orozco to consider it very probable that "Zurbarán made the short journey from Seville to Granada before starting work on the paintings for the Charterhouse of the Caves", in order to see how Cotán, himself a Carthusian, had dealt with his Order's history in the Granada monastery (see Pita Andrade, in *Goya,* No. 64-65, p. 245, referring to E. Orozco Díaz in the catalogue of the Zurbarán exhibition, Granada, 1954, p. 61). Though this is true, the model Zurbarán had in mind (or before him) when composing this picture was a print by Schelte a Bolswert (1617) representing *St Augustine Sheltering the Augustinians under his Cloak,* from which he copied quite literally not only the general elements but details like the two cherubs holding up the mantle and even the draping and the folds of the robe worn by the central figure. This is not the only time St Augustine takes the place of Our Lady of Mercy (consider, for instance, the door of the cloister of Santo Stefano in Venice) and it is perhaps only fair that Zurbarán should return this Marian iconography to its original form. But this approximate application of the irreverent popular saying, "If it has a beard, it's St Anthony; if not, it's the Immaculate Conception", much used of bad painters, enables us to imagine Zurbarán's method of working (or inventing), which was at the opposite pole to that of the mystic enamoured of his subjects: it was an absolutely formal system, in which one figure could always be replaced by another. As we shall see later on, for Zurbarán a richly dressed woman may represent either a saint or a demon. With a similar indifference to the meaning of a composition, he sometimes introduces marginal characters who have nothing to do with his theme.

It was Kehrer who first pointed out the similarity between this picture and the Bolswert print. In search of other such analogies, Martín S. Soria (*Archivo Español de Arte,* XXVIII, No. 112, Madrid, 1955, pp. 339-340), César Pemán (ibid., XXIX, No. 116, pp. 298-301) and Diego Angulo (*Archivo Español de Arte y Arqueología,* No. 19, 1931, p. 65) all speak of the exact resemblance of Zurbarán's *Burial of St Catherine on Mount Sinai* (Fig. 275), probably painted for the Discalced Mercedarians, to a picture by Marten de Vos, through a print by Cornelius Cort; as Professor Caturla remarks, however, "this does not mean that what Zurbarán achieved with the help of an imported print is not beautiful and even moving" (catalogue of the Granada exhibition, p. 39). Pérez Sánchez describes as "literal copies of prints, without any substantial modification of the composition", some of the pictures in the sacristy of the church of San Juan Bautista in Marchena — like the *St James* (Fig. 119), which repeats the Rubens in the Prado, or the *St Andrew* (Fig. 120), which, as Milicua had already remarked, came from a print by J. de Gheyn after a drawing by Van Mander. In the *Vision of St Peter* painted for the retable in the church of San Esteban in Seville (and still in the same church, but now hung on a wall), the figure of the saint, as Professor Caturla has shown, comes from an engraving by Jusepe de Ribera representing *St Jerome in Penitence.* Some of the scenes in the *St Bonaventura* series painted for the church of that saint in Seville in 1629 (Figs. 27-29) may derive from engravings by Th. Galle illustrating Van der Sterra's *Life of St Norbert,* published in 1605. As César Pemán has shown, Zurbarán's series of the *Twelve Caesars on Horseback* copies the prints on the same theme by Antonio Tempesta. He also borrowed frequently from prints by Albrecht Dürer, such as the latter's *St Philip, St Paul, Virgin with a Monkey,* etc., which were the sources for various works, as has been noted by Soria, Angulo and Pita. Benesch noticed, too, that it was Dürer's *Nativity of the Virgin* that inspired Zurbarán's version painted in 1629, possibly for the Discalced Trinitarians (Fig. 44). And there is evidence of identical themes by Dürer in the 1659 *Holy Family* (Fig. 457), the *Adoration of the Magi* painted for the Charterhouse of Jerez (Figs. 132 & 133), etc. As Pita Andrade remarks, while commenting on the influence of Dürer's *Melancholy* on the figure of the Virgin in *The Holy House of Nazareth* (Figs. 257 & 259), or of the figure of the Virgin in the print of the *Adoration of the Shepherds* or that of the

Angel Gabriel in the Jerez *Annunciation* (Figs. 127-128), "it would be quite easy to extend the list of such derivations" (op. cit., *Goya,* p. 246). Martín Soria, for instance, lists seventeen artists as sources for Zurbarán's compositions.

But even with this the account of Zurbarán's indebtedness to other painters and engravers will never be complete. Among the most interesting cases is that of his *Labours of Hercules,* painted in 1634 for the Grand Salon of the Palace of the Buen Retiro (Figs. 103-112), which are derived from prints by Gabriel Salomón and H. Cook after compositions by Frans Floris, as we are told by Pérez Sánchez, who also indicates the similarity of pose between the last of these scenes, the *Hercules Killed by the Poisoned Shirt of Nessus* (Fig. 112), and Leonardo da Vinci's celebrated, and unfinished, *St Jerome* in the Vatican: "this is a really interesting case, for since the early history of Leonardo's painting is unknown, and there were no prints of it, we are led to suppose either that Zurbarán knew the picture at first hand or, more probably, that there was an earlier source common to both works..." (op. cit., *Goya,* p. 272); the almost invisible form of the fleeing centaur in the background comes from an engraving by H. Sebald Beham. Marten van Heemskerck (the artist who probably provided Velázquez with the composition of *Jesus in the House of Martha and Mary)* may have been Zurbarán's source, through a print by Philip Galle, for several works, such as the *Jacob and his Sons* (Figs. 428-440), not unanimously accepted as Zurbarán's own work, and the *Retable of St Peter* (Figs. 68-73) in the Cathedral of Seville.

If we are to continue like this, however, it would be difficult not to find precedents for everything. An important part of a painter's equipment is his visual memory, which often offers him the form he wants without his having to consult any prints, and convinces him at the same time that it is his own invention. Innumerable instances of such false inspirations occur in the history of art, and even in museums. It is very difficult, after all, to invent an absolutely original pattern. The fact that Zurbarán is such a personal painter despite all his borrowings is still more surprising; but it is a surprise in which, as Ortega y Gasset maliciously remarked on reading of the numerous borrowings detected in Velázquez' *Surrender of Breda,* the veracity and originality are greater still. It should be borne in mind, as I have pointed out already, that Zurbarán's system of combining and composing was far from being a shameful recourse employed by him alone. In the seventeenth century there was nothing shameful about plagiarism (above all, as the French saying has it, and as is the case with Zurbarán, if "il est suivi de l'assassinat" of the victim), and not even the greatest and most innovative artists hesitated to resort to it.

I think I should mention here a possible reaction of the younger generation of seventeenth-century artists (that of Velázquez, Cano and Zurbarán, who were constantly borrowing compositions and single figures) against the inflated pretensions of the earlier school, the school of the Mannerists and semi-Mannerists. Just as some younger artists of today see nothing wrong in taking inspiration from photography for their "Hyper-Realist" creation, so the painters born around 1600 thought "Raphaelizing" a waste of time, when before them lay such absorbing fields of study as volume, the texture of objects and light or atmosphere. There was also, possibly, a sense of humour involved in the use (or abuse, one might say) of a composition or figure for a context quite different from that of the original. When Velázquez turns Michelangelo's Ignudi into spinners, his Jeremiah into a jester, or when he surrounds the clownish *Pablo de Valladolid* with the luminous glow of celestial visions (see *Visión y Símbolo.. .* Part II, Ch. III), from the artistic point of view it is blasphemy against the originals. And though Zurbarán is usually supposed (on no particular grounds) to have been a rather less sophisticated person, he may well have been amusing himself in using a print by Bloemaert for the picture hanging on the wall in *St Hugo in the Refectory* (Figs. 291-293), giving it a symbolic feeling of curious incongruity. In many other cases his line-for-line copies of certain elements — such as the angel-musicians in his first picture, the *Virgin as a Child* (Figs. 1, 2 & 504), or those in the Jerez *Adoration of the Shepherds* (Figs. 129 & 130), taken from Guido Reni — may be the result of necessity, facility, a wish to be up to date or even barefaced laziness. As I pointed out in the introduction, it is illogical to attribute to Zurbarán the virtues of his characters, and it must be supposed that in his wholesale picture-factory (though this holds good for many painters in every age) they were convinced that nobody would be sharp-eyed or learned enough to detect the imposture or the imitation.

The lyricism derived from Guido Reni, which Pérez Sánchez rightly refers to as paradoxically existent in the

severe, prosaic Zurbarán (and extending to the full-grown angels mingling with the shepherds in the Jerez *Adoration* and possibly playing the same airs as those of Reni in his loggia of San Gregorio al Celio in Rome), though not confined to him since "many artists of the pious, domestic Tenebrist school of Spain and elsewhere turned their eyes to the master of Bologna", quite as much as to Caravaggio or even more so (see Pérez Sánchez, *Goya*, cit., pp. 273-74 ff.), was combined with the influence of Caravaggio — the "Antichrist of painting" according to Carducho, or, in a more enlightened view, its renewer. In his youth in Seville, Francisco was to combine the teaching of Díaz de Villanueva and the memory of his Morales-influenced early training in Extremadura with his respect for the great Romanists of the Cathedral of Seville, Sturmio, Frutet, Vargas or Kempeneer (of whose hardness of outline, insistence on making the figures in the background stand out boldly and total ignorance of atmospheric values we still find so many traces in Zurbarán's later works) and with an almost scandalized admiration for Caravaggio. For the modernity of Caravaggio, who was much more conventional and "Raphaelesque" than is usually believed (see my study of him in Volume VIII of the *Grande Histoire de la Peinture*, Geneva, 1973), is not based on the ugliness of his models (Roman boys and youths of undeniable and even delicately soft charms), but on the modernization of his sacred scenes, which are presented as if they were taking place in the artist's own time, and on that basement-laboratory lighting which enables him to isolate bodies and objects at will and give the most ordinary scene a mysterious, melodramatic tone. The influence (direct or indirect) of Caravaggio in many of Zurbarán's pictures seems unquestionable. Works like *St Bonaventura in Prayer* (Fig. 26), the *Apparition of St Peter the Apostle to St Peter Nolasco* (Figs. 16, 19 & 506), *The Holy House of Nazareth* (Figs. 257 & 259) and the *Vision of Fray Pedro de Salamanca*, as well as many single figures, such as his several versions of *St Francis in Penitence* and *St Francis after Death,* are practically unthinkable without the precedent of Caravaggio. Even the insistent, almost obsessive focussing on a particular object — the symbolic accessories in the *Virgin as a Child, Praying* (Fig. 230), for instance — seem to come from the admirable painter of the *Basket of Fruit* in the Ambrogiana in Milan. Against backgrounds in semi-darkness, arranged like black back-drops, Zurbarán — like Caravaggio — presents his theatrical

pageants or pageant-figures, though he freezes the movement since this is never to his taste. His contempt for action, and the contemplative content of his work (hence the theories regarding his relations with the Illuminati, a sect I have myself spoken of as possibly influencing another "motionless" Tenebrist, Georges de la Tour — see *Goya*, Nos. 109 and 112, Madrid, 1972-73) are what most differentiate him from the great Italian painter and even from the latter's Spanish imitators, Ribalta and Ribera. Possibly on account of his invincible provincialism, Zurbarán sometimes seems nearer to Ribalta — consider such works as the *St Peter* in the Lisbon Apostle series (Fig. 89) or the *St Luke before the Crucified Christ* in the Prado (Fig. 269), so similar to Ribalta's style — than to Ribera; for Ribera was a true virtuoso, and that is something Zurbarán never was, despite which some writers have spoken of the influence of Ribera on his work, in the retable of the Charterhouse of Jerez, for instance.

Zurbarán's situation is to some extent similar to that of the Carthusian painter Fray Juan Sánchez Cotán. Emilio Orozco Díaz has made the most penetrating analysis (see *Goya*, No. 64-65, 1965, pp. 224 ff.) of this influence and affinity as the result of the visit the younger painter almost certainly paid to the Charterhouse of Granada, decorated by Cotán with his great compositions of monks whose habits do not prevent the artist from expressing the individuality of their faces; faces which are ecstatic and tender in this friar-painter's work, though in that of Zurbarán they were to be reserved and introverted. Paul Guinard is right to include Zurbarán in the cycle of Spanish monastic painting with Cotán as his herald. Rather than literal similarity or slavish imitation, Orozco sees something deeper as common to both: "A similar sense of space to be found, for instance, in their fondness for well-lit openings in the backgrounds, giving on to architectural perspectives with figures....", or "the division of the canvas into the heavenly and earthly planes, though these are in close proximity", and even "the same marked taste for dealing with their subject at close range", without neglecting "the conception of ample, serene forms, above all in the treatment of cloth, especially that of the white habits".

It is indeed true that in Cotán we can already see those dazzling symphonies, those snowy ranges of the habits of his fellow-monks in Granada, that were to be Zurbarán's greatest chromatic triumph, with an in-

fluence that has come down as far as our own century, notably in the post-Cubist work of Vázquez-Díaz. The quality of such a Zurbaranesque painting as *Our Lady of the Caves* is the result of the combination of prints by Dürer and Bolswert with Cotán's *Our Lady of the Rosary,* within the *minerva oscura* — the dark wisdom— of the mind of the young painter from Extremadura, who may have been clumsy but could never have been uncultured or uninformed. Even his popular, vernacular feeling, so much appreciated centuries later, is the result of cultured influences and studies, particularly of the works of Cotán. A charming little picture by Cotán in the Museum of Granada, *The Virgin of the Candle,* which is almost identical with a print by Jacques Callot and very close to the silent illumination of Georges de la Tour, heralds the humble, popular Spanish feeling of certain paintings by Zurbarán. Similarly, the lamb with hobbled feet, that patient victim and image of Christ, which we shall be examining later among Zurbarán's symbolic objects (and which was in turn adopted by one of his imitators, the Portuguese woman painter Josepa de Obidos), already existed in the *Adoration of the Shepherds* by Cotán which now hangs in the Museum of Cadiz. In this respect I might add that "the popular" as a subject for artists has not always existed, and that only cultured artists, like Lope de Vega or Luis de Góngora, are capable of stylizing it properly. Poems like *Oh, que bien que baila Gil* or *Hermana Marica* could only be written by poets who knew how to extract the permanent from the ephemeral, as did Cotán and, after him, Zurbarán.

I have already mentioned Herrera the Elder, Céspedes, Pacheco and Roelas as masters who influenced Zurbarán's early career. But now I would like to speak of that of a slightly younger contemporary of his own, Diego Velázquez, both in such pictures as *Enrique III Conferring the Archbishop's Biretta on Father Yáñez* (Figs. 162 & 163) or *Jesus Appearing to Father Andrés de Salmerón* (Figs. 160 & 161), inspired by Velázquez' *St Ildefonso Receiving the Chasuble* (as can be seen in their triangular composition and even in certain details like the Virgin's hands) and, from a broader stylistic point of view, in portraits like the *Doctor of Law* (Fig. 472) or the little boy *Alonso Verdugo de Albornoz* (Fig. 113), in which there are traces of Velázquez' stately, royal portrait manner, softened by the colour and the psychological refinement. We may also detect the influence of Velázquez in certain details of the *Labours of*

Hercules (Figs. 103-112), which Zurbarán painted in Madrid in 1634, probably on the recommendation, and under the authority, of Philip IV's great painter. The "bully-boy" look of some of the characters in these "metopes" is not without a certain Velázquez-like irony and some of the heads are rather like those of the other painter.

I do not wish to make too much of the influence of the fashionable young painter Murillo on the ageing and rather old-fashioned Zurbarán. But it is obvious that his last sacred compositions are filled with a tender, flowing quality that was not there before, and that he used a system of spatial interpenetration in the heavenly apparitions very different from the floor-by-floor staging, in Cotán's style, of his earlier works. The *Portiuncula* in New York (Figs. 459 & 516), which is signed and dated in 1661, may or may not be authentic, but if it is then it is absolutely in the style of Murillo. In the last images of the *Virgin as a Child, Praying* (Fig. 302) and the *Virgin of the Milk* (Fig. 452), or in the delightful *Virgin with the Child Jesus and St John* (Fig. 461), which is the painter's last known work, we can see something of the Sevillian charm of Murillo, though attenuated by that kind of melancholy stillness referred to by Professor Caturla. Personally, I find the penetration of Murillo's style into the work of Zurbarán almost inexplicable in the portentous bust-length *St Francis of Assisi* in Munich (Fig. 471), painted between 1658 and 1660, in which the painter has assimilated not only Murillo's way of treating the subject and his amiable devoutness, but also his colour and a Baroque execution of which Zurbarán hardly seemed capable.

In Zurbarán we also find some triangular compositions, like the two mentioned in Guadalupe or the two pictures of *St Peter Nolasco* in the Prado (Figs. 15 & 16), the first origins of which must be sought in El Greco, after seeing whose works, on his first journey to Madrid, Velázquez painted his *Descent*. There are several pictures with superimposed levels, such as the *Vision of Blessed Alonso Rodriguez* (Figs. 39, 41 & 508), or the *Apotheosis of St Thomas Aquinas* (Figs. 79 & 80), and the *Adoration of the Shepherds* (Figs. 129, 130 & 512) and the *Battle of El Sotillo* (Fig. 134), both painted for the Charterhouse of Jerez, and the Warsaw *Our Lady of the Carthusians.* There are also some in sequences of horizontal compartments: *Pope Urban II and St Bruno, His Confessor* (Fig. 294), the *Mass of Father Cabañuelas* (Fig. 157), the *Annunciations* in Grenoble and Philadelphia (Figs. 127 &

467), and the *St James of the March* in the Prado (Figs. 465 & 466). I would also be tempted to include in this group the *St Bonaventura* in the church of San Francisco el Grande in Madrid (Fig. 464), whose authenticity is upheld by A.E. Pérez Sánchez (see *The Golden Age of Spanish Painting*, no. 36, London, 1976) and the *Temptation of St Jerome* in Guadalupe, with its double setting of cave and open air (Figs. 173-175).

In other cases the introduction of a heavenly universe into the earthly world is effected by means of juxtaposition. The Heavenly Jerusalem in the *Vision of St Peter Nolasco* (Fig. 15) is simply hung in the background, like a picture with a frame of clouds. The angel in *St Bonaventura in Prayer* (Fig. 26) leans down from Heaven as though through a window. Seldom before his last years did Zurbarán decide to employ the imprecise contours, the clear tones, the hazy quality that Murillo used so skilfully to help the viewer to distinguish heavenly from earthly characters. The Christ with the pink mantle in the *Jesus Appearing to Father Andrés de Salmerón* (Figs. 160 & 161) and the one watching the Scourging of St Jerome (Figs. 170-172), both of which are in Guadalupe, are among these exceptions. In other cases Zurbarán's empyrean characters are too heavy and seem to find difficulty in flying, like the cherub bearing the martyr's crown in the *Martyrdom of St James* in the Plandiura Collection in Barcelona (Fig. 315); it seems to be a mere object hanging from the frame, lacking only the cord which should hold it up. Who would think at first sight that the solid figures of Christ and St Joseph in the *Coronation of St Joseph* in the Museum of Seville (Figs. 252 & 253) are standing on clouds?

It may be on account of these difficulties that Zurbarán's favourite system for inserting an ideal space within that of the picture he is painting is the metaphorical, indirect method of the picture within a picture, which he uses in masterly fashion in *St Hugo in the Refectory* (Figs. 291-293) or in *Fray Gonzalo de Illescas* (Figs. 158, 159 & 511). This painter of the mystique of a visionary Spain is too firmly attached to earthly reality to lose himself in imaginings. His figures are simply too heavy to launch themselves into the air.

SINGLE FIGURES

I have already referred to the independence of Zurbarán's different characters even in his large-scale compositions. This introversion is surprising in pictures in which some degree of intercommunication would seem to be demanded by the subject.

Serenity and self-absorption are the almost constant qualities of these characters. This gives a curiously waxwork effect to pictures like those from the Charterhouse of the Caves in the Museum of Seville, the *Defence of Cadiz against the English* (Figs. 101 & 102), in which the falsest note is struck by the explanatory gestures of the gentlemen on the right, the *Surrender of Seville* (Fig. 24), which is a mere pageant, like the set-pieces contrived for the entertainment of monarchs when they made state entrances into cities, or the superb *Death of St Bonaventura* (Figs. 28 & 29), with its air of photomontage, in which separate couples talking to each other are the maximum concession. Even in the magnificent *Apotheosis of St Thomas Aquinas* (Figs. 79 & 80), though the figures in Heaven may be engaging in rather sketchy conversations, on earth not only are the characters separated into two compact groups, but in these groups each of their four members is absorbed in his own thoughts. There are exceptions to this rule in the retable of the Charterhouse of Jerez and in the sacristy of Guadalupe. But if the *Scourging of St Jerome* (Figs. 170-172) may seem one of the master's most extrovert and narrative compositions (despite the abstraction of the mediating angel on the left), its companion piece, the *Temptation of St Jerome* (Figs. 173-175), depicts an old man fending off, with puppetlike gestures, a vision which he does not even see and a group of virtuous-seeming temptresses who, instead of playing as an ensemble, appear to be absorbed in their individual performances. This difficulty of intercommunication is admirably suited to scenes in which the only mobility is in the thoughts of the characters, as in the *Holy Family* in the Campo Real Collection (Fig. 63) or *The Holy House of Nazareth* in the Cleveland Museum (Figs. 257 & 259).

In many of Zurbarán's compositions we find a marginal figure, an intruder, as it were, who seems quite uninterested in what is taking place around him. This occurs for the first time in the paintings done for the monastery of San Pablo el Real. The two saintly female figures on the left in the *Miraculous Cure of Blessed Reginald of Orleans* (Figs. 5, 7 & 86), who are the first in a mysterious procession in which they are to be followed by dozens of Virgins-and-Martyrs, do not show the slightest interest in the sick friar. Even more detached is the attitude of the elegant Mary Magdalen in the picture hanging beside it, the *Apparition of the Virgin to the Monks of Soriano* (Figs. 4 & 6), for she seems to be accompanying the Virgin out of a sense of mere social obligation and is in fact looking straight at the viewer, who can thus perceive not only the spatial development represented by her attitude (establishing communication between her position in the picture and the place where the viewer is standing), but also her regal presence, rather than the friar kneeling before the image of St Dominic.

Stranger still is the handsome visitor with a basket of eggs in the *Nativity of the Blessed Virgin* (Fig. 44), who fixes her big black eyes on us, quite oblivious of whatever she was supposed to be doing in this Dürer-like scene. The presence of this feminine interest in the form of women both beautiful and arrogant (by the standards of the day) was to be a constant in the painting of this pseudo-friar, twice married to older women but always with an eye (however Platonic) for a pretty girl. We find proof of this in his delightful "walking saints", as they are called, which his workshop turned out by the dozen and which do so much to mitigate the freezing austerity of many a church and cloister. From the exquisite *St*

Agatha (Fig. 240), possibly painted for the church of San Alberto in Seville between 1630 and 1633, to the *St Marina* in the Museum of Seville (Fig. 388), who is almost like one of Goya's *majas*, there is a whole gallery of women who seem to be either in a procession or on a stage, not painted for praying to but for solacing our hearts with their wayward strolling. As I have said elsewhere (*Visión y símbolo...*, p. 296), "although painted to be hung together on the walls of a gallery, a church or a cloister, they are as unacquainted with one another as with the viewer. Thus they are not saints-for-praying-to, but figures we look at as if they were in a procession, and indeed these lines of single-figure canvases form a heavenly 'parade' that is the last expression of the procession that lined the walls of the Early Christian or Byzantine basilicas." In the same book (pp. 253-254) I pointed out that, though we may be intended to see in the elegant attire of saints a symbol of their spiritual beauty, their heavenly or human rank, in the case of Zurbarán there is also a brimstone whiff of the unholy world of the stage. Both this *St Marina* and the enchanting *St Margaret* in the National Gallery in London (Figs. 199 & 200) are dressed as stage peasants, with their broad-brimmed hats, their pannier bags and their long staffs. *St Casilda,* whether in the Plandiura Collection version (Fig. 261) or in the picture in the Prado (Fig. 301), the former being perhaps the better of the two, is dressed for the role of a princess, as is the beautiful *St Dorothy* in the Museum of Seville (Fig. 393), with her pink satin dress and her black-and-yellow striped shawl.

I am not going to enter into the polemics of the experts as to whether these assembly-line figures were painted by Zurbarán himself or not. Hernández Díaz, in the catalogue of the Museum of Fine Arts of Seville, tends to deny the possibility in many cases. But they certainly came from his workshop and are among its most felicitous achievements. We may prefer one or another to the rest — the grave stateliness of the *St Apollonia* in the Louvre (Fig. 255), the popular, almost Murillo-like charm of the *St Justa* in Dublin (Fig. 404), with the earthen pitchers dangling from her hand, the self-communion of the *St Agnes* in Seville (Fig. 391), the regal splendour of the *St Elizabeth of Portugal* in Montreal (Fig. 409) — but we find them all enchanting, nor are we bothered by such scruples as St Jerome felt before his chaste, musical temptresses. As I have said before, those pretty she-devils in the *Temptation of St Jerome* are no different, except in their reluctance to be grouped together, from Zurbarán's "walking saints". It is odd that people should continue to regard as a mystic this painter who has created such seductive versions of the most circumspect and widely venerated women.

With regard to their attire, A.E. Pérez Sánchez (op. cit., p. 273) tells us that their dresses "are not those of the artist's own day, even though the faces may be portraits", and that they are said to derive from prints by Pieter de Baillis after drawings by Teniers the Elder. María-José Sáez Piñuela (*Goya*, No. 64-65, pp. 284 ff.), on the other hand, regards them as indicative of women's fashions in the seventeenth century: "Zurbarán confines himself to portraying young ladies of Seville in elaborate dresses, with vivid colours, sumptuous stuffs and expensive trimmings...". In my opinion, they are usually dresses for processions or the theatre (which amount to the same thing), like those of the Magi, dressed as Moors or some such exotic pagans, in the *Adoration of the Magi* in Grenoble (Figs. 132 & 133) or in the *Martyrdom of St James* in the Plandiura Collection (Fig. 315). Thus these "holy" portraits of ladies who probably bore the same names as the saints they embodied are on the borderline of the spectacular and the worldly, and certainly far from any suggestion of mysticism. And I would point out that this "painter of friars", as I have written elsewhere (*Goya*, No. 64-65, p. 301), "had a fashion artist's fondness for depicting stage clothes". Proof of this is to be found in the two incense-bearing angels in the Museum of Cadiz (Figs. 143 & 144) or in the Angel Gabriel in the Philadelphia *Annunciation* (Figs. 467-469), with their scalloped tunics. It is a great pity that no clearer examples of Zurbarán's talents in this line have survived — for instance, in the decoration of the boat *El santo Rey don Fernando*, which the city of Seville presented to Philip IV for his lake in the grounds of the Buen Retiro, and which Zurbarán decorated in 1638. Nor should we forget that one of his first commissions (in 1622) was for the decoration of a processional image belonging to the Confraternity of the Mother of God in Fuente de Cantos. Many of Zurbarán's characters, after all, are really of the type known as "candlestick-maker's statues" or lay-figures for dressing up, in which the most important element is the dress, on to which any kind of head and hands can be stuck.

Among his examples of male "walking saints", I might mention the delicate *Angel Gabriel* in Montpellier (Fig. 239), as well as some figures of Apostles, Founder Saints and Carthusians. None better than the "Man of

Sorrows", as represented by Zurbarán: dressed in the *Christ Carrying the Cross* in the Cathedral of Orleans (Fig. 288), which Guinard considers to be a fundamental piece in the artist's last style, and naked in *Christ after the Scourging* (Fig. 460), in the parish church of Jadraque, dated in 1661 and one of his most deeply felt works.

These walking characters constitute whole series, rather like packs of cards, which may be arranged according to varying necessities. Some are shown walking towards the left, others towards the right; and by taking this into account they can be quite flexibly grouped. The spaces in which they walk are abstract, so that they can be identified with the wall of the place where they are hung. In a country as indifferent to the art of fresco as seventeenth-century Spain, interchangeable decorative pictures would be regarded as ideal substitutes for, and improvements on, fixed decorations. Their mobility, too, made them suitable for export; indeed, it was religious communities of Lima, Buenos Aires or Mexico which ordered them in greatest profusion, eager to keep their colonial monasteries in line with the latest fashion in the mother country. They did not realize for some time that that particular latest fashion was considered a little antiquated by the middle of the century, and that Murillo and Valdés Leal had imposed new modes in Seville. Thanks to this the art of Zurbarán still awoke echoes in Latin America and the Indies when those echoes had died down in Spain.

In Zurbarán we frequently find compositions of two or three characters, each wrapped in his own meditations or daydreams. It is difficult to divine what they are thinking, or if they are thinking at all, but their "still life" immobility induces us to give them credit for some sort of mental activity. Zurbarán's feeling for the foreground, for intimacy and for objectivity, enables him to compose with equal monumentality a still life of three earthen pots or a scene with three characters. Works like the *Virgin as a Child with St Joachim and St Anne* (Fig. 198), formerly in the Contini-Bonacossi Collection, and the *Return of the Holy Family from Egypt to Jerusalem* (sometimes known as *The Double Trinity*) in the retable of the church of Santa María in Zafra, for which it was painted in 1643-44, are not only valid proofs of this contention, but also examples of how Zurbarán could succeed with an ancient formula like that of the principal image between two orants or devout figures. Other specimens of this triangular system are the beautiful *Immaculate Conception* in the Art Museum of

Catalonia (Figs. 83, 84 & 507), shown between two schoolboys who are reciting fragments of the hymn Ave Maris Stella, the written words coming out of their mouths in the medieval manner; *Our Lady of Ransom*, between two Discalced Mercedarians — for whose order Zurbarán was painting around 1636 — in the Marqués de Valdeterrazo Collection (Fig. 310); *Our Lady of the Carthusians*, between two monks of that order, which is now in Warsaw (Fig. 145) and is similar to the preceding picture but with more cherubs and secondary friars, who do not spoil the triangular rhythm; and the *Virgin with St Joachim and St Anne* from the same Charterhouse, now in the National Gallery of Scotland (Figs. 153 & 154). The theme of *Christ at Emmaus* is undoubtedly one of the most classical of these three-figure compositions, and Zurbarán treated it with talent, as we can see in the version in the Academy of San Carlos in Mexico (Fig. 188).

The composition with a pair of figures is very frequent, not only in Zurbarán but in all Spanish seventeenth-century painting, and some of the artist's finest works are of this kind. The dialogue is not usually very lively, even when the situation might seem to demand it. The admirable *St Bonaventura in Prayer* in Dresden (Fig. 26) receives the advice of the angel leaning out at his cloud-window without changing an attitude that suggests he already has a close, individual relationship with the next world without any need for go-betweens; to such a degree that Zurbarán was able to repeat both attitude and expression in his *St Francis Receiving the Stigmata,* in the mute and blind company of a cowled lay brother, now in the Alvaro Gil Collection (Fig. 260), possibly painted a good ten years later. And *St Diego de Alcalá*, whether before his prior, as in the Prado version (Fig. 477), or alone, as in the one in the Museo Lázaro Galdiano, changes neither his attitude nor his absorbed expression. In dealing with the *Annunciation*, Zurbarán shows a certain concern with externalizing the message (Figs. 127 & 128, Grenoble; Figs. 467 & 482, Philadelphia), but it is curious to see that it is Mary who offers obedience, with the well-known gesture of her open hand on her breast (see *Visión y Símbolo...*, p. 298), while Gabriel has his hands crossed, absorbed in adoration.

When the scene the painter has to depict can be reduced to two characters, Zurbarán comes into his own. This is the case in the two pictures of *St Peter Nolasco* in the Prado, especially the one in which the apostle appears to the saint (Figs. 16, 19 & 506), so very superior

to its companion piece, the *Vision of St Peter Nolasco* (Fig. 15), that one can hardly believe they are by the same artist in the same period. Another such painting is the equally admirable *Jesus Appearing to Father Andrés de Salmerón* (Figs. 160 & 161), in which Christ appears to the monk as a reward for his vow to walk on his knees all his life; a picture that may be counted, along with the *Apparition of St Peter the Apostle to St Peter Nolasco* (Figs. 16 & 19), as among the greatest achievements of Spanish mystical painting, and very close to Ribalta's *Vision of St Bernard* in the Prado, in its emotional intensity within a dignified gravity, the mute communion between the two figures and the use of the whites of the habits, in snowy, sculptured folds, as an emblem of the radiant light of grace. The *Vision of Fray Pedro de Salamanca* in Guadalupe (Figs. 167 & 169) would not be nearly so dramatic if it were not witnessed, in astonishment, by another friar; similarly, the *Mass of Father Cabañuelas* in the same monastery (Fig. 157) would not express its inner meaning of the miraculous dialogue between the doubter and God were it not for the presence of a lay brother, who attends the Mass without perceiving the miracle that is taking place. But among all the pictures with two figures, perhaps none is so beautiful, so full of deep, contained emotion, as *The Holy House of Nazareth* in the Cleveland Art Museum (Figs. 257 & 259), in which the composition all on the front plane, with its isolated elements (Jesus, Mary, the table, the flowers, the work-basket, the bowl, the doves), contributes to the silent tension between the Mother, who sees Jesus pricking his finger on a thorn and whose mind goes forward to the bitterness of his Passion, and the Son, who contemplates the same vision with infinite meekness. But in the *Coronation of St Joseph* in the Museum of Seville (Figs. 252 & 253), the greater conventional expressiveness has destroyed that tension, leaving nothing but a large "banner" for a confraternity.

When Zurbarán's characters are painted in isolation, their introversion and abstraction, their immobility and apparent silence, make them look like carvings, and in certain cases they are, in fact, substitutes for carved figures. It is evident that when Zurbarán painted a Crucified Christ for some dark chapel in a Dominican or Capuchin monastery, he was providing a *trompe-l'œil* replacement for a figure by Montañés or Mena. But the average devout visitor, who usually prefers to conduct his communications with the next world through images in relief (see my *Pintura española,* p. 43), would have to get within very short range to perceive that Zurbarán's Christ is not a statue. Thanks to this sculptural quality, Zurbarán was the most eminent supplier of those images of devotion that I have described elsewhere (*Visión y Símbolo...,* pp. 293-295) as "statue-saints", a type derived from the painting of those medieval altar-pieces which made a deliberate attempt to pass off a flat image as a figure in relief by isolating it at the centre of the altar thanks to a gilded or neutral background. Zurbarán's compact volumes and projections are very close to polychrome carving (so highly developed in Seville during Zurbarán's apprenticeship among mediocre painters and undoubtedly influential on his manner and even on his iconography). His isolated figures of saints "are authentic objects, almost still lifes, which is what gives them their mysterious majesty". We may well remember these words when we think of one of Zurbarán's finest works, the *St Serapion* now in Hartford (Fig. 13). The Immaculate Conceptions are sometimes like carvings, too, with their plinths composed of cherubs' heads, and are thus similar to those painted by the young Velázquez and absolutely the opposite of those of Murillo in his later years, so floating and evanescent. And even with backgrounds of conventional landscapes, the *St Luis Beltrán* (Fig. 278) and *Blessed Henry Suso* (Figs. 276 & 277) in the Museum of Seville are just as much statue-saints as the *St Peter as Pope* in the Cathedral of Seville or the delicate little *St Cyril of Constantinople* in the Boston Museum (Fig. 238), standing in a niche which accentuates the rounded darkness of his hair. But there is no image better suited to this typology of saints in imitation-carving than that of *St Francis in Penitence* or, better still, *St Francis after Death,* standing up with his glassy eyes raised to Heaven, his hands sunk in the sleeves of his habit, just as he was discovered by Nicholas V in the crypt of the church Gregory IX had consecrated to the saint of Assisi. Eugenio Caxés (in a drawing now in the Albertina in Vienna) and Laurent de la Hire (in a picture in the Louvre) both represented the melodramatic scene of this discovery. Zurbarán preferred to paint the mummified saint alone in his niche, harshly illuminated by a light that comes obliquely from above (Figs. 244 & 245). This theme had such a success that it was frequently repeated and copied and soon came to the notice of the sculptors, since it practically belonged to their art as it was. Cano and Mena, for instance, interpreted it perfectly, but neither of them any more sculpturally than Zurbarán.

We have already seen something of the influence on Zurbarán's painting not only of polychrome carving in wood but also of "candlestick-maker's statues", a popular expression for statues or lay figures (sometimes with only the head and hands finished) for dressing. The *Child Jesus Blessing* painted around 1629 for the door to the sanctuary in the church of the Calced Trinitarians in Seville, which is possibly the one in the Pushkin Museum in Moscow (Fig. 36), is as much a "lay-figure for dressing" as any Montañés ever made. In some of these curtains are used to emphasize the impression of an image in its shrine. The exquisite *Virgin as a Child, Praying* in the Metropolitan Museum in New York (Fig. 230) is presented to the veneration of the faithful between the two little curtains which have just been drawn up and which, apart from this theatrical role, perform their usual function as the royal bed-hangings that belong by right to the Mother of God from her tenderest years.

As we have seen, too, the sculptural quality of the holy personage does not vary essentially for Zurbarán when he takes it from the niche or the abstract space of carvings and places it in the strong, luminous space of apotheoses. In this he is merely following (with an obstinacy that might be described as an excess of zeal if we did not know it to be the result of technical awkwardness) the advice of St Ignatius of Loyola in his Spiritual Exercises: to imagine what we cannot see with as much detail as what we can see. The images of the *Immaculate Conception* of Jadraque (Figs. 38 & 40) and Barcelona (Fig. 84) seem to be in levitation above a luminous space instead of on a pedestal, without any change in their solidity and without losing their jewels. Only in his last period, under the influence of Murillo, did Zurbarán let any of the glory that surrounds the image enter into the image itself: the charming *Inmaculate Conception* in Budapest (Fig. 462), which Guinard describes as the painter's swan song, is the best example of this transformation. Until this late stage in his career, the area of eternal glory had meant no more to Zurbarán than just another part of the canvas, to be covered with brushwork of rather murky ochre, on the levels of which he perched his saints and angels, as we may see in the *Vision of Blessed Alonso Rodríguez* (Figs. 39, 41 & 508).

For Théophile Gautier and the other Romantics who visited Louis-Philippe's Spanish gallery in the Louvre, Zurbarán was the painter of friars tortured by remorse. It is a curious fact that, objectively speaking, the theme of *St Francis in Penitence* is the only one to come anywhere near this concept, as gratuitous as are most of those which gain greatest acceptance. Consider, for instance, the fact that Rubens' sister-in-law, in the portrait in the National Gallery in London universally known as *Le chapeau de paille,* is in fact wearing a felt hat; that Procaccini's celebrated *Judith,* in the Galleria Sabauda in Turin, being a winged figure carrying a pair of scales, is just as likely to be a figure of the Archangel Michael, etc. Or that a joke made by a mediocre writer has made the phrase "a Watteau shepherdess" a commonplace, though it was Boucher who was the really prolific producer of pastoral scenes. Anyway, apart from St Francis, spectacularly painted by Zurbarán in the semi-darkness of repentance, with a cowl or without, with a skull — what is known, no less gratuitously, as the "Hamlet" *St Francis,* and of which a good example is the Murillo-like half-length figure in Munich (Fig. 471) — or without, standing or kneeling, etc., it is difficult to find in his work any penitents other than the *St Peter* in Seville (Fig. 69), the *St Jerome* in Córdoba (Fig. 344), the dubious *Mary Magdalen* in Mexico (Fig. 263) and perhaps the *St Bruno* in Cádiz (Fig. 146). Any Spanish Painter of the time (except Velázquez) would offer us as many. But none would achieve whit the raised cowl of St Francis an effect so picturesque and dramatic, almost as hallucinating as the hood of a dangling gibbet figure or the head of a ghost. In this theme Zurbarán shows off all his powers of combination, repeats his patched habits, his drooping cowls, his gloomy lighting, to incomparably felicitous effect.

We must not, of course, confuse the penitent with the just man fled into the wilderness, like the young *St John the Baptist* so often painted by Zurbarán — for instance, in the Cathedral of Seville (Fig. 243), the Museum of Cadiz (Fig. 141) and the Rifà de Moles Collection in Barcelona (Figs. 241 & 242) — who likes to decorate the images of quite unrustic saints with little trees — the *Evangelists* in the Museum of Cadiz (Figs. 137-140), or the images of *St Lawrence* in Leningrad (Fig. 124) and Cadiz (Fig. 142), etc. — as we shall see when we discuss the painter's backgrounds. Nor can we describe as a penitent *Fray Gonzalo de Illescas* in Guadalupe (Figs. 158, 159 & 511), one of Zurbarán's masterpieces, which we must include in the typology of "writer-prelates". (Regarding the table as an object in the composition used to symbolize sovereign authority, see *Visión y Símbolo...,* pp. 260 ff.). Writing tables are found in the *Vision of St Peter Nolasco* (Fig. 15) — which shows a very simple, monkish table — in the *Visit of St*

Thomas Aquinas to St Bonaventura (Fig. 25), in *Pope Urban II and St Bruno, His Confessor* (Fig. 294) and in *St Bruno in Ecstasy* (Figs. 135 & 136), but none has such authority as that of Fray Gonzalo in the sacristy of Guadalupe. Though the influence of the pontifical portraits of Raphael and Titian may not have filtered through to Seville, we probably cannot say the same of El Greco and his celebrated *St Ildefonso* in the Hospital of Illescas. Zurbarán has combined in this picture several of his favourite subjects: the friar and the prelate, the table with its still life or "vanitas", the curtain, canopy and draperies all in one, the column on its plinth, the architectural background. He arranges them admirably, in reds and blues, as carefully as any priest preparing his sermon: the background townscape —a picture within a picture— where we see Fray Gonzalo himself distributing alms, is the justification of authority, knowledge and faith, the mortification of the figure in the foreground. Between the two areas we have the apple of original sin (or of knowledge), rescued by charity, without which all is as a tinkling bell, empty and vain.

Among the sacred themes, which means the majority of those painted by Zurbarán, pride of place must be given to those depicting Christ and the Virgin as isolated figures. I have already referred to some of these. They may be classified in two main groups: the Holy Childhoods and the variations on the "Man of Sorrows".

Holy Childhoods, particularly those of Jesus, Mary and St John, were enormously popular throughout Spain in the Baroque age, and more than anywhere else in Andalusia. One of the most characteristic, that of the Child Jesus with the attributes of the Passion, was an object of special devotion, to which the image-makers, such as Alonso Cano or José Risueño, devoted their best efforts. The fact that we may find these subjects in doubtful taste today does not in the least mean that they were so regarded in the seventeenth century, since from the day Father Sigüenza used the term "good taste" right down to our own age what was good for one period was bad for another. Zurbarán, at least in those works of his that we know, very much disliked those bloodstained themes that did not go with his impassive style. The episodes of Christ's Passion (the Scourging at the Pillar, the Crowning with Thorns, etc.) do not seem to have inspired him as they did many of his colleagues. He preferred to deal with that Passion through premonitions, in a manner that was half-apocryphal, half-devout. In both *The Holy House of Nazareth* in Cleveland (Figs.

257 & 259) and the *Child Jesus with a Thorn* in the Sánchez Ramos Collection in Seville (Fig. 64), we see a boy of about twelve, with a pensive face and wearing a tunic with ample folds, looking thoughtfully at a finger he has pricked while weaving (we do not know for what) a crown of thorns; this popular-sententious tone seems fairly similar to that of unwritten Andalusian poetry and it would hardly suprise me to hear a folk ballad celebrating the event. We should remember that this is not a real scene, with symbolic repercussions (like that in the beautiful *Carpenter's Shop* in the Museo Lázaro Galdiano, which is considered to be an anonymous Toledan painting of the early seventeenth century, but which has many characteristics in common with Zurbarán's early work, such as the linen sticking out of the work-basket, so often repeated by the painter) with the child playing in St Joseph's workshop or hurting himself (as in J.E. Millais' fine picture in the Tate Gallery, London) as he tries to help with the work. In this picture Jesus is engaged in the mysterious activity of weaving a crown that prefigures the one the soldiers will press down on his head some twenty years later. The Holy Families of Zurbarán's later years have lost a lot of this poetry, however much the painter attempts to linger over the folds of cloth and soften the tones. This only brings him nearer to more conventional painters, even though the works themselves may be beautiful — the *Virgin with the Child Jesus and St John,* in the San Diego Gallery (Figs. 450 & 515), is a case in point.

More charming are the images of the Virgin as a Child, sewing or embroidering without forgetting her prayers, an example to be presented to the little girls of Seville, who should be taught to combine the diligence of Martha with the contemplativeness of Mary. In the picture on this theme in the Metropolitan Museum in New York (Fig. 230), we see the Virgin, as I have written elsewhere (*Goya*, No. 64-65. p. 298), "absorbed in her prayer at the moment when she was embroidering. Her face has the precocious, almost tearful, gravity of the painter's younger Immaculate Conceptions; her joined hands, with the thumbs crossed, are seen from straight in front, as is usual in that iconography. Some curtains drawn up on either side of the child indicate that the scene takes place in an interior, an interior which is (or deserves to be) a canopied throne; the curtains at the same time hollow out the space by the simple process of placing two foregrounds right against the frame, so that they seem to belong to it, like the curtains in a puppet

booth. This canvas ... belongs at once to the Holy Childhood series (in which the childhood of Mary, already free from sin since her birth, is like a parallel to the childhood of her Son and that of her nephew, St John) and to the series of works exalting the Christian family, with details of virtuous domestic well-being, like the little pitcher of water (purity and fecundity at once), the vase of (Madonna) lilies and roses (virginity and love), the work-basket with linen (diligence and cleanliness) — a detail, incidentally, which did not escape Dalí — the little table on which the book and the scissors show a combination of study and manual labour; and, finally, the flowers strewn on the floor, in due homage to this sublime child sitting on the dais on which women usually did sit in Zurbarán's time, which combines two separate iconographies: the throne of the Virgin Queen of Heaven and the floor of the Virgin of Humility. An aureole of dimly seen angels emphasizes the heavenly character of this youthful figure." In the same article I went on to speak of the beauty and originality of the colouring in this little picture: "The curtains, which are of a very beautiful pink colour, form two large patches in the upper area which contrast admirably with the turquoise and white of Mary's bodice and her black-embroidered blouse, as also with the vibrant red of her skirt." This picture of the Virgin as a child is not exceptional in Zurbarán's work, except in its quality. She also appears, asleep, in a picture in the Colegiata of Jerez (Fig. 42), with her parents in a collection in Florence (Fig. 198), and with incomparable simplicity in the *Virgin as a Child, Praying* in the Hermitage in Leningrad (Fig. 302), a work with a charm almost equal to Murillo's. Zurbarán also represented the *Immaculate Conception* in the form of a young girl on several occasions, beginning with his first work (Figs. 1, 2 & 504) and finishing with one of his last, in Budapest (Fig. 462). Though the great *Immaculate Conception* in the Museo Cerralbo in Madrid (Fig. 303), which shows an older girl, is one of the stateliest versions of this theme, it cannot hope to rival the ingenuous charm of the child "Purísimas" in Jadraque, Barcelona or the Prado.

The most delightful image of St John in childhood is that in a *Holy Family* in the Campo Real Collection in Madrid (Fig. 63), which shows him as an engaging little rascal kneeling to offer his aunt and cousin a plate of fruit and flowers; Mary, with a pensive air, chooses the apple of Adam, which she is to make up for as Co-Redeemer, while Jesus presses against his mother's breast an orange blossom, virginal but in the shape of a cross. A child saint not often painted is the *St Barulas* who appears, in an attitude of absorbed prayer rather like that of the child Mary, standing beside the sumptuous cope embroidered with representations of prophets — a real set of pictures within a picture — worn by *St Romanus* in the picture Zurbarán painted in 1638 (Fig. 125) for the church dedicated to the latter saint in Seville (now in the Art Institute, Chicago).

Similarly serious and absorbed in prayer are the two schoolboys on either side of the *Immaculate Conception* in the picture in the Art Museum of Catalonia (Figs. 83, 84 & 507).

In all this part of Zurbarán's work there is an air of sweet domesticity, one that is also present in the different kinds of still life we shall be examining in the next chapter. And this tone does not disappear even in his Crucifixions, which are truly impressive, tragic and grim, but which are given an unexpectedly natural air by the shirt hastily converted into a loincloth without losing its folds. I do not remember any other painter who has had this idea, logical enough, of thinking that the cloth used to cover Christ's nakedness might well be part of his own linen, sewn by the hands of the Virgin herself. And thus we see it in the *Crucified Christ* in the Art Institute of Chicago (Fig. 12), in the Wildenstein Collection in New York (Fig. 57), in the one in the Museum of Seville (Fig. 56), etc. And it is worth noticing that the shirt of the Crucified Christ is very similar to the one the chastising angels have rolled down to the saint's waist in the *Scourging of St Jerome* (Figs. 170-172). Carvings, perhaps, but for dressing: humanized, like the carved figures in processions, by the humble toil of sempstresses, washerwomen and ironing women.

The humble work of the carpenter can be seen in some of the crosses Christ bears in his hand in certain devout pictures, like the *Coronation of St Joseph* in the Museum of Seville (Figs. 252 & 253), the *Christ Blessing* which may have been painted for the church of Our Lady of the Pomegranate in Llerena and is now in the Museum of Badajoz (Fig. 187), the half-length figure, dated in 1638, in the Millet Collection in Barcelona (Figs. 126 & 510), entitled *Salvator Mundi,* etc. This cross, carefully planed and jointed, is of a processional type different from the true crosses with the effigy of Christ: similar in its brilliant *trompe-l'œil* to the one Zurbarán may have seen on the end wall of the Carthusian refectory in Granada, possibly painted by Sánchez Cotán.

V

STILL LIFES

If their isolation, or their juxtaposition in a space devoid of atmosphere — one might almost call it airtight, as is evident in pictures like the *Vision of Blessed Alonso Rodríguez* (Figs. 39, 41 & 508) and implicit in other works, such as *Pope Urban II and St Bruno, His Confessor* (Fig. 294)—gives Zurbarán's figures their rounded, statue-like presence, it must be admitted that this treatment is wonderfully suited to the representation of inanimate objects. Zurbarán's fame as a painter of still lifes is too well established to need any introduction from me. But if we look into the reasons for this fame, we will find to our surprise that there seem to be as few clearly-defined grounds for it as for the reputation Zurbarán enjoyed, thanks to Gautier and the other Romantics, as a painter of tormented friars. For only one still life (formerly in the Contini-Bonacossi Collection in Florence and recently acquired by the Norton Simon Foundation of Los Angeles, in spite of the vehement protests of many Italian art-lovers) is signed and dated: "FRANCO DE ZURBARÁN FACIE. 1633" (Fig. 85). All the others attributed to him — not that there are many, anyway — are disputable. And surely it seems excessive to speak of a painter as excelling in a genre in which we have only one work unquestionably from his hand.

It is true that this work is an exceptional one. I believe I was the first to point out that it did not represent, as was commonly thought, a plate of lemons, a basket of oranges with orange blossom and a cup of chocolate with a rose on the smaller plate: in my opinion, as I wrote at the time (*La Peinture Espagnole,* Paris, 1962, pp. 121-22), the lemons are in fact citrons (as has more recently been accepted by Tiziana Frati, in *Zurbarán,* Rizzoli, Milan, 1973, p. 101) and the cup is a cup of water. Following this idea, I have taken the liberty of suggesting a symbolic significance for this compo-

sition, which may have been painted in homage to the Virgin: the citrons are a paschal fruit (still used in Italy in the paraliturgical observances); the oranges and orange blossom, the fruit and flower of chastity; the rose, love; the water, fruitful purity. Some of these attributes also appear in the *Virgin as a Child, Praying* in New York (Fig. 230). In his introduction to the catalogue of an exhibition entitled *Flower Pieces and Still Lifes in Spanish Painting* (Madrid, 1940), Julio Cavestany spoke of the quasi-religious aspect of certain vases of flowers placed symmetrically on either side of a holy image, or of fruits that seem to be votive offerings. In an article on the still life under discussion (*Burlington Magazine,* 1924), A.L. Mayer wrote that the objects are presented like flowers on an altar, linked to one another in a kind of litany. We know that when Sánchez Cotán entered the Carthusian Order in 1604, he drew up an inventory of his pictures, and that among them there were several flower pieces which were entered, literally, as offerings to the Virgin. Thus the hypothesis I formed regarding the Contini still life does not seem so very extravagant.

The interpretation of Zurbarán's flowers and fruits as symbols also seems convincing when they are used as the attributes of a saint — the flowers into which the alms carried by *St Casilda* (Figs. 261 & 301) and *St Diego de Alcalá* (Figs. 228, 266 & 477) are miraculously transformed to escape reproof; the apples and roses of the Garden of Eden carried by *St Dorothy* (Fig. 393); the Madonna lilies so often found in images of the Virgin or St Anthony of Padua; the flowers the painter strews on the floor in some pictures, as was the custom in monasteries on the steps of the altar, etc., etc. We will return to these when we come to deal with the types of object painted by Zurbarán. At all events, this strengthens the idea that flower pieces and still lifes may also be allowed to have a symbolic significance.

As I have said, Zurbarán's still lifes are few in number, even if we include as authentic certain works which are merely attributed to him. Pantorba (*Zurbarán*, Barcelona, 1953, p. 28) regrets the absence of works of this kind from the painter's early years; as to those of his maturity, he refers to four, one of which is the one already mentioned, another the celebrated *Still Life of the Pots* in the Prado (Fig. 484), of which he says that "it is impossible to do more with such limited means. Here we have more than sufficient demostration of how the hand of any great painter leaves its unmistakable mark on everything it touches..." Nevertheless, this little master-piece is not universally accepted. César Pemán attributed it to Juan de Zurbarán, basing his view on a comparison with a work signed by Juan in the Museum of Kiev (*Archivo Español de Arte,* 1968), while Paul Guinard thinks it may have been the result of collaboration between father and son. The still life in the Lung Collection in Bordeaux seems to be signed by Juan — at that time nineteen years old, which makes the collaboration of his father probable (see César Pemán, in the catalogue of the 1964 Zurbarán exhibition in Madrid, p. 85). Juan died in Seville in 1649, and seems to have been estranged from his father at the time, for his burial certificate records him as the "son-in-law of Jorge de Quadros", not as the son of Francisco; he was then twenty-nine. We must not forget the shortness of his life when we think of attributing works to him (see María Luisa Caturla, ibid., pp. 48-49). Tiziana Frati (op. cit.), rightly or wrongly, attributes six still lifes to the elder Zurbarán: the ones in Los Angeles and Madrid already mentioned; one she calls *Apples on a Pewter Plate* (No. 99 in her catalogue), which is in the Art Museum of Catalonia (Fig. 485) and which to my mind represents quinces rather than apples (and perhaps some preserved citrons); a *Basket of Apples* now in a private collection in Madrid (Fig. 489), which was included in the catalogue of the 1964 exhibition in Madrid as No. 27; a *Plate of Apples with a Spray of Orange Blossom,* published by Guinard; and another with a *Cake, Glasses and a Napkin* in the Serra Collection in Madrid (Fig. 490), which Pemán considers doubtful and Soria connects with the still lifes of Van der Hamen. Even if we also include the *Madonna Lilies* (with carnations and a rose) in the Prado (Fig. 486), the list is still a short one.

Despite this shortness and these doubts, there is a style in these few works which can truly be described as Zurbaranesque, and which differentiates them from the naïvetés of Labrador or from the confectioner's trifles of Van der Hamen or Josepa de Ayala. Only Sánchez Cotán (consider the *Still Life with Thistle* in the Museum of Granada, so clearly heralding Zurbarán's style) or the mysterious Madrid artist Ramírez (who painted the other *Still Life with Thistle*, in the Prado) come anywhere near this sober, monumental style that was to enchant the art-lovers of our time, who had been taught to see by Cézanne and the Cubists. These objects, so carefully and austerely depicted, have the presence of living characters, even if it may be argued that Zurbarán's characters have the presence of earthen pots. Their isolation, their lack of atmosphere and the almost obsessive swelling of their convex curves give them a wholly modern appeal, the appeal of Surrealist, magic-realist and Hyper-realist objects, divorced from their context in a deliberate abnormality which is, as we know, one of the ways in which the Surrealists attempt to surprise a new reality. The "implacable objectivity of Zurbarán's objects", however tautologous as a phrase, reflects a rare quality: it is only when we see one of these still lifes that we realize that being a fruit, a cup, a napkin, a plate or an earthen pot is something almost as essential as being a man.

There are many clear examples in Spanish painting of what Emilio Orozco has penetratingly described as "still lifes on divine themes", which may be either compositions with inanimate objects, or animal or "kitchen" pictures with characters, of the kind Veláz-quez painted so splendidly in his youth in Seville. The theme of this kind most typical of Zurbarán is that of the lamb, which as Orozco has also pointed out (*Goya*, No. 64-65, pp. 222 ff.), already existed in Sánchez Cotán's work: "We should remember how near to Zurbarán's canvases representing the Lamb or God, or to his *Adoration of the Shepherds* in Grenoble, is the sheep with feet tied together that stands out in the foreground of Cotán's picture on the same subject painted for the Charterhouse of Granada". It is usual in this connection to speak of "lambs", identifying them with the Agnus Dei, i.e. with Christ, the victim who takes away the sins of the world. But the horns on the heads of the two best-known examples — the one in the Plandiura Collection in Barcelona, dated 1632, and the one in the Marquesa del Socorro Collection in Madrid, which figured as a "lamb" in the 1964 Zurbarán exhibition in Madrid (Fig. 81) — indicate that the animal in question is a ram, probably the one sacrificed by Abraham instead of the innocent Isaac and thus intended to be an emblem of the

latter (and, consequently, of Christ). On the other hand, in the Fine Arts Gallery of San Diego there is a lamb (Fig. 283) with a halo and the inscription TAMQUAM AGNUS, which established its symbolism beyond all possible doubt, and this animal is exactly repeated in the *Adoration of the Shepherds* in Grenoble. The theory of the sacred significance of this representation is given further support by the fact that the woman painter Josepa de Ayala (or de Obidos), a Portuguese imitator of Zurbarán, shows the lamb with a halo and surrounded by offerings of flowers, like a holy image (see Hernández Díaz: *Josefa de Ayala,* Seville, 1968). Evidently the lamb in the Grenoble *Adoration of the Shepherds* has a double function: that of a symbol and that of a real offering by the shepherds, which is in accordance with a system of deliberate ambiguity or double meaning that I have endeavoured to analyse elsewhere (see *Visión y Símbolo...,* particularly Part 2).

I would venture to describe as a "still life on a divine theme" another subject treated by Zurbarán with incomparable mastery: that of the *Veil of St Veronica,* or *Holy Face,* of which there are some beautiful examples extant (Figs. 495-499). María Luisa Caturla, with her usual penetration, has described these works as *trompe-l'œil* on a divine theme (*Goya,* No. 64-65, pp. 202 ff.). And how does Zurbarán bring off this sleight of hand? "Against the dark red or black background, the tactile values of a white (bluish or ivory) cloth stand out boldly, the cloth being caught up in complicated folds, as if to frame the Divine Face. The folds are held in place by old-fashioned pins, with the gilt heads made separately. These pins are stuck... into the outer world... i.e. into the background, as though this were made of real material that could be pierced by their points. Little cords come down diagonally from the two upper corners of the picture and hold the cloth at two points. Zurbarán's *Veil of St Veronica* is hung from these fine cords, tied to something we cannot see, since it is outside the picture: nails, no doubt, from which the cords descend to secure the bunched cloth... In a later, more classical version he eliminates this bunching at the top of the cloth and the big pin that pulled the lower part up at the middle..." In its meticulous simplicity, this is surely the most telling description of these pictures, one of which is in Professor Caturla's own collection. Thus the veil of St Veronica conceived as *trompe-l'œil* is an object: a napkin or towel, washed and ironed with nun-like care (once more I must confess my surprise at the fact that Zurbarán should

have painted for friars but not for nuns), and at the same time the effigy of Christ: truly a "still life on a divine theme".

But let us go a little further in this direction and return to the admirable *St Serapion* in Hartford (Fig. 13), the white-robed Mercedarian martyr, hanging by his hands from some posts or nails; his loosely-hanging scapular conceals the horrible signs of his martyrdom by disembowelling —though they are not so hidden in Zurbarán's other little picture on this subject, in the Lifschitz Collection in New York (Fig. 220). In my opinion there is an undeniable similarity of composition between the Hartford *St Serapion* and the *Veil of St Veronica.* I would therefore venture, in all reverence, to call this picture a still life on a divine theme too.

There is one more comment I would like to add on this subject. As I written elsewhere (*Visión y Símbolo...,* p. 294), "Zurbarán's saints are true objects, almost still lifes, very real and quite petrified at the same time, which is what gives them their mysterious majesty". Thus not only the *St Serapion* but also other pictures by our painter might be included, on this score, in the category of still lifes on divine themes. Take, for instance, a picture we have already mentioned more than once, the *Virgin as a Child, Praying* (Fig. 230) in New York: the table-stool, with book, scissors and flowers, the little pitcher of water, the daisies on the floor, the embroidery pillow and piece of embroidery, the gilded vase decorated with angels and holding a bouquet of roses and Madonna lilies, and the almost inevitable work-basket, combine to form a genre picture, in which the clothed figure of Mary is inserted.

Nor should we forget the curtains. I have already alluded to their wide-ranging role; indeed, I would almost be tempted to say that they are sometimes the most important elements in a picture. Little curtains like the one St Bonaventura is drawing back in the *Visit of St Thomas Aquinas* (Fig. 25), the opulent curves of the one in the *Child Jesus with a Thorn* in the Sánchez Ramos Collection (Fig. 64) or the one hanging over *Fray Gonzalo de Illescas* (Figs. 158 & 159), cannot be described as mere accessories, for they are an essential, almost a central, element in the composition of the picture. In the first two the double-falling rhythm is like that of the upper part of the cloth in the *Veil of St Veronica,* a rhythm that is maintained by Josepa de Ayala in her version of the same theme in the church of the Misericordia in Peniche.

It is this same triumphal rhythm of the raised curtain that so brilliantly composes a picture in other respects so clumsy as *Our Lady of the Caves,* with her raised mantle, in the Museum of Seville (Figs. 289 & 290). The curtains are also very important in *Pope Urban II and St Bruno, His Confessor* (Fig. 294) and in the *Our Lady of the Carthusians* in Warsaw (Fig. 145). The one hanging over the Virgin in the Philadelphia *Annunciation* looks as if it has just been raised (Fig. 467), as do those in the *Virgin with the Child Jesus and St John* in San Diego (Figs. 450 & 515) and in the *St James of the March* in the Prado (Figs. 465 & 466). Even in these pictures of his maturity Zurbarán retains this little trick of the puppet booth, the sacrarium, the shrine. Not only because of its value as a symbol of a canopy or ceiling, nor yet simply for its illusionist function of separating external space from the space within the picture, but also on account of its abstract beauty as an enclosed area in which shadows and lights are caught, as the object of a representation in which the strange modernity seems to lie in the fact that the painter appears to bestow as much or more consideration, as much or more care, on things as on people: with this thought we may go on to a brief inventory of the objects Zurbarán paints.

VI

TYPOLOGY OF ZURBARAN'S OBJECTS

Since Zurbarán is an artist of such uneven quality of execution that in one and the same canvas we can find areas that are excellently painted and others of appallingly poor craftsmanship, any stylistic study of his work must be based on objective data, and in estimating these we must be quite sure that the intention of the workshop master is clear. It does not seem irrelevant, therefore, to make a brief typological examination of the objects painted by Zurbarán, considered in themselves, as elements combined in the composition of a picture.

We have already seen how important textiles are in Zurbarán's work. All those who have written about the painter are at one in acclaiming the incomparably tactile quality of his cloths. Indeed, there are works by him which seem to be so essentially composed of woven materials as to warrant description as "textile" pictures. One of these is the *Nativity of the Virgin* in the Norton Simon Foundation of Los Angeles (Fig. 44). This picture might well be compared to a collage of stuffs: the hangings and counterpane of the bed, in varying tones of red; the different-coloured clothes of the women attending at the birth (particularly the yellow skirt of the woman on the right, of whom I have spoken in Chapter IV, not really part of the scene although she is carrying the eggs of fecundity and birth, for she is a character whose purpose on the one hand is to bring the viewer into this sacred mystery and on the other to alienate him from it, in the manner aimed at by the off-stage characters in some of Berthold Brecht's plays, who prevent the public from identifying with the action); and a delicate symphony of white cloths composed by the sheet, the nightgown, the head-dresses and the linen in the basket in the foreground. The faces, for the most part, are hardly more than masks peeping through all these materials; to such a degree that, as in the case of processional statues, it would be difficult to imagine the bodies of some of these characters that the cloth of their dresses is supposed to cover.

Even in some pictures with only one figure the meaningful effect of the materials is greater than that of the character clothed in them. This is very evident, I think, in the *St Casilda* in the Prado (Fig. 301), of which we remember the rich stuffs of the multicoloured dress long after we have forgotten the flat, conventional hand or the face, which at any rate has no place in the concept of feminine beauty in our time. Even in such a delightful and well-balanced picture as the *St Agatha* in the Musée Fabre in Montpellier (Fig. 240), we can see that the painter has draped his model in sumptuous materials in much the same way as the window-dresser of a fashionable boutique, for whom the dress displayed is more important than the figure displaying it. From this point of view, we may say that in Zurbarán, contrary to the popular Spanish saying, the habit does make the monk, and what differentiates one person from another in many of his monastic paintings is in fact the habit worn by each. To such an extent that, with only a little exaggeration, an emotional and almost tragic painting like the cowled figure of *St Francis Kneeling,* in the National Gallery in London (Fig. 268) —formerly in Louis-Philippe's Spanish gallery in the Louvre, where it was one of those that did most to give the Romantics their idea of the tormented Zurbarán— might be compared with that *capricho* of Goya's entitled *What a tailor can do...*

Zurbarán's monastic pictures, indeed, constitute an astonishing collection of different cloths. From the patched wool and sackcloth of St Francis to the soft creases in the cloak of *St Peter Nolasco* as he kneels before his apostolic namesake (Figs. 16 & 19), the ample folds worn by the same saint in his *Vision* (Fig. 15) or the silky tunic of the angel explaining it to him, who looks

almost like a village lad in a procession, with his very false-seeming wings; from the snowy goffering of the *St Gregory* (Fig. 9) and *St Jerome* (Fig. 8) in the Museum of Seville to the heavy, embroidered cope of the former and the cardinal's purple of the latter, Zurbarán presents and, one might almost say, permits us to touch all kinds of cloth with the easy familiarity of one who knows them well, perhaps because he was a haberdasher's son and accustomed from childhood to hearing talk about clothes. Can anyone that has once seen it ever forget the brocade cape of the *St Ambrose* in the Museum of Seville (Figs. 10 & 11) which, with its stiff, conical fall, looks as if it were on a hanger in some museum of liturgical objects? Or the white folds that make the *St Serapion* in Hartford (Fig. 13) the equivalent of a "still life on a divine theme"? I would again remind the reader, in passing, that these whites, which seem to be the most characteristic element in Zurbarán's monkish habits, are rarely true whites. The texture and thickness of the material modify the tones; St Serapion's Mercedarian habit, for instance, is a sophisticated combination of greys, clear ochres, bluish mauves and pale reds. Even one and the same figure, like the *Archangel Gabriel* in the Musée Fabre in Montpellier (Fig. 239), may wear a tunic of two different whites. As I have said elsewhere, "there is no one white, no given number of whites, no white habits, in Zurbarán; there is the whole range of daylight with all its lights and reflections" (*Goya*, No. 64-65, p. 304). With this profusion of habits — Carthusian, Mercedarian, Hieronymite or Dominican — Zurbarán creates great symphonies in white of astonishing visual and even spiritual power. Exquisite, too, are the robes of his Immaculate Conceptions, which, as Angulo Iñíguez remarked in the catalogue of the 1964 exhibition in Madrid (p. 78), go all the way from white to red and back again; tunics of the finest linen, framed in the thick blue silk of the mantles.

In commissioned works, like the retable for the Charterhouse of Jerez, Zurbarán's skill in the rendering of textiles reaches its highest point: in the four great paintings from this Charterhouse which now hang in Grenoble he passes from the fine, delicate cloths of the *Annunciation* (Figs. 127 & 128) to the thick, coarse wool of the *Adoration of the Shepherds* (Figs. 129 & 130) and the extraordinary sumptuousness of the *Adoration of the Magi* (Figs. 132 & 133) or the *Circumcision* (Fig. 131), with a display of priests and acolytes surely well deserved by an Infant who endures the operation without a

murmur of protest, his eyes raised to Heaven and his hand open in a gesture of offering. Folds and qualities like the ones in Melchior's magnificent cloth-of-gold cape can only be the result of observation from life. There can be no doubt that Zurbarán — probably using a lay figure, which would account for the exaggerated bulkiness of the puffed-out cloth — experimented with the effects of these rich materials, of the kind used by the tailors and embroiderers of ecclesiastical vestments. But we can hardly be so sure of this in the case of Melchior's conventional cape, with its pasteboard stiffness. The pale pink cloak worn by Balthazar, however, has all the delicious texture of the Virgin's tunics I mentioned above. If Zurbarán can be so different in one and the same picture, as in this *Adoration of the Magi,* what can we expect from those almost mass-produced pictures churned out by his workshop for the colonial market? In the Introduction to this book I have already quoted César Pemán's shrewd comments on the use of stencilling and slight glazing or scumbling in what were thought to be less important works (catalogue of the 1964 exhibition in Madrid, p. 89).

Apart from such cases, it is evident that Zurbarán regards woven materials as so basic an element in his figures that he hardly knows how to strip them. We have already seen, in his images of the crucified Christ, the great attention he pays to the loincloth, sometimes simply the shirt of the "Man of Sorrows" tied round his waist. How carefully Christ picks up his garments after the scourging, in the beautiful picture in Jadraque (Fig. 460)! What snowy-shining folds gird his hips in the *Christ after the Scourging* in Poznan (Fig. 272), which Soria and Guinard both consider contemporary with the Jadraque painting. And with just the same care Zurbarán paints the shirt and cloak that cover the flanks of *St Jerome* as he is scourged by angels (Figs. 170-172) and as he resists his temptresses (Figs. 173-175), in the great paintings in Guadalupe. Perhaps the weakest point in his *Labours of Hercules* (Figs. 103-112) is the nude without any clothes to help it; it is curious, to say the least, that two of the best pictures in this series are those in which the demigod is more or less clothed: in his struggle with the Hydra (Fig. 103), wearing a well-conceived and lighted skin, and in his death scene (Fig. 112), with the lethal shirt of Nessus turning to flames on his body. Consider, on the other hand, how much a rather conventional set-piece like the *Apotheosis of St Thomas Aquinas* in the Museum of Seville (Figs. 79-80) is enhanced by the look it has of a

shop-window full of stuffs and embroideries in the richest of qualities.

Carpets are not very frequent in Zurbarán's work, but are extremely rich and very carefully painted when they do occur. As examples of this I might mention those in the *Mass of Father Cabañuelas* (Fig. 157), *Our Lady of the Carthusians* (Fig. 145), *Pope Urban II and St Bruno, His Confessor* (Fig. 294) and *St Bonaventura at the Council of Lyons* (Fig. 27). In all of them the design on the carpet is so painstakingly copied that it gives an impression of absolute reality.

I will not linger over the question of curtains, since we have already dealt with this in Chapter V. We now come to the pieces of wooden furniture, which the painter uses in many cases to create spaces, by placing them obliquely, rather in the Mannerist style of Morales. Such furniture, in most cases, seems as close an imitation of the model as do the painter's textiles. The unusual way in which they are placed makes them appear to some extent independent of the general perspective of the scene and gives them a very characteristic importance.

Zurbarán likes to represent his pieces of furniture in some isolation, separated from one another —sometimes exaggeratedly so, as in *The Holy House of Nazareth* in Cleveland (Figs. 257 & 259) — by accentuating the empty spaces around them, a system of composition similar to that used in the still lifes with three or four objects. Apart from beds, which in his paintings are mere platforms or stretchers placed aslant — compare the *Miraculous Cure of Blessed Reginald of Orleans* (Figs. 5, 7 & 86) with the *Death of St Bonaventura* (Figs. 28 & 29) or the *Nativity of the Virgin* (Fig. 44) — Zurbarán represents three types of table and three types of chair.

The most interesting table is one that appears in one of the master's first works, the *Miraculous Cure of Blessed Reginald of Orleans* that I have just mentioned (painted in 1626-27), and is repeated for a time — the *Virgin as a Child with St Joachim and St Anne* (Fig. 198), painted in 1629, the *Child Jesus with a Thorn* (Fig. 64), done in 1629, *The Holy House of Nazareth,* which has the best version of the table and was painted around 1630, and the contemporary *Virgin as a Child, Praying* in the Metropolitan Museum in New York (Fig. 230) — after which it was abandoned. In the later versions of the Holy Family there is a table holding fruit, but it is not clearly defined and is evidently a mere accessory. We may suppose, therefore, that this table that stands out as boldly as a principal character — centering the whole

composition of *The Holy House of Nazareth,* for instance, with its turned legs, its half-open drawer and the different objects on its top — was a piece of furniture that Zurbarán owned between 1627 and 1630, probably brought from Llerena to Seville when he moved to the latter city. Zurbarán usually shows it from behind and paints it with such meticulous objectivity that a carpenter of today could easily make a copy of it.

The tables of authority and justice sometimes coincide with those merely used for writing (see *Visión y Símbolo...*, p. 261), but not always. The one in the *Vision of St Peter Nolasco* (Fig. 15) is a simple work-table, with the book the saint has forgotten in his vision on the point of sliding off it; the Pope's table in *Pope Urban II and St Bruno, His Confessor* (Fig. 294) is definitely a table of authority, the equivalent of the French *lit-de-justice*. While the table in the *Visit of St Thomas Aquinas to St Bonaventura* (Fig. 25) is of the same kind as St Peter Nolasco's, the mere fact of its being covered with a cloth in *St Bonaventura in Prayer* (Fig. 26) makes it a worthy support for the papal tiara. For the table of authority is always covered, and thus appears as an accessory in the portraits of learned Mercedarians, to support their scholar's birettas (Figs. 204-206). The table at which *Fray Gonzalo de Illescas* (Figs. 158 & 159) is writing is at once a work-table and a table of justice, as is proper in any portrait of this great Prior of the Order of St Jerome. In the centre of the lower part of the *Apotheosis of St Thomas Aquinas* (Figs. 79 & 80) there is a table of authority covered with velvet, on which we can see the certificate of the foundation of the Dominican school and the Founder's biretta; but the table in the portrait of *Fray Diego de Deza* (Fig. 55) is at once a table of authority, for Fray Diego was Archbishop of Seville, and a work-table holding the learned cleric's books.

A curious sub-species of the work-table is what might be called the "penitent's table", which is shown covered in the *Mary Magdalen* in Mexico (Fig. 263), but which in other pictures is no more than a rock, though usually flat and squared and even not too uncomfortable to lean on, as in the bareheaded version of *St Francis Kneeling* in the National Gallery in London (Fig. 193). Another secondary kind of table is the *prie-dieu* type used in the *Annunciation* in Philadelphia (Figs. 467 & 482) and the one in Grenoble (Figs. 127 & 128), or in the portrait, traditionally ascribed to Zurbarán, of the Sevillian canon *Maese Rodrigo Fernández de Santaella* (Fig. 50). Zurbarán's table of "respect" or authority is no

different, in essentials, from those of other painters—Velázquez, for instance, in his portraits of important dignitaries — and is merely an accessory symbolizing the social rank of the sitter and not calling for any particular attention from the painter.

The seats painted by Zurbarán are usually armchairs, and generally of the type known as "friar's" armchairs at that, with an occasional folding chair and domestic chairs and stools of modest dimensions. The painter very clearly differentiates the armchair of authority — that of *Pope Urban II* (Fig. 294) or that of Mary Queen of Heaven in the Philadelphia *Annunciation* (Fig. 467) — from the humble straw chair of the *Virgin as a Child, Praying* in the Hermitage (Fig. 302), or the *Virgin as a Child, Sleeping* in Jerez (Fig. 42). We find a very carefully observed folding chair in the *Vision of St Peter Nolasco* (Fig. 15), and the same painstaking work can be seen in the stool in the *Child Jesus with a Thorn* in the Sánchez Ramos Collection (Fig. 64) and in the identically similar one in the *Holy House of Nazareth* (Figs. 257 & 259). Zurbarán would appear to have studied furniture with greater attention and concern for accuracy in his younger days, as we can see in the armchair in the *Visit of St Thomas Aquinas to St Bonaventura* (Fig. 25), a picture in which the furniture in general seems to have interested him. The almost royal impression given by Pope Urban's chair is shown by comparing it with the very similar one on which *St Ferdinand* is sitting in the picture of him in the Mont Collection in New York (a picture Soria accepts as having been painted by Zurbarán himself, with some of the work done by pupils). Chairs of much the same kind are occupied by Fray Diego de Deza and Fray Gonzalo de Illescas in their portraits. A very interesting piece is the carrying chair in which Don Fernando Girón is sitting as he directs operations in the *Defence of Cadiz against the English* (Figs. 101 & 102), since it is fitted with a special step on account of its occupant's gout.

On tables or on floors Zurbarán arranges working tools and household utensils. Sometimes with these alone he creates astonishing still lifes. We can see this, for instance, in the frugally laid table in *St Hugo in the Refectory* (Figs. 291-293), defined only by its white cloth and the loaves and crockery set out on it (the crockery, incidentally, with the shield of the Charterhouse, which is still the trade-mark of the wares produced there). Another example is the table in *Fray Gonzalo de Illescas* (Figs. 158 & 159), a true "vanitas" with its books, papers

and writing materials confronting the skull and the hour-glass, symbols of the transience of this life, the whole seen under the apple of pride and sin, but saved by the charity shown as an example in the background.

It should be noted, too, that Zurbarán is as admirable a painter of papers and parchments, ceramics and glass, as he is of cloth. There is great charm in the sewing and embroidering materials represented in pictures of the Virgin's childhood. The work-basket with its dazzling white linen is used repeatedly as an emblem of Mary's diligence, beginning with the *Nativity* (Fig. 44) and continuing in *The Holy House of Nazareth* (Figs. 257 & 259), the *Virgin as a Child, Praying* in New York (Fig. 230) and the *Annunciation* in Grenoble (Figs. 127 & 128). The basket of eggs, symbol of birth and resurrection, is in the above-mentioned *Nativity* and also in the *Adoration of the Shepherds* in Grenoble (Figs. 129 & 130) — in which, incidentally, it is held by an almost comic popular character who is looking out at us and pointing to the newborn Child, in an ambiguous position in his space and ours, a position which (like that of an actor speaking to the public in an aside) at once brings us into the scene and hints that it is only a painted one. The pretty little cup with a rose on the plate in the *Still Life* now in the Norton Simon Foundation (Figs. 85, 87 & 88) had already been used in the *Miraculous Cure of Blessed Reginald of Orleans* (Figs. 5, 7 & 86) and in the *Virgin with St Joachim and St Anne* (Fig. 198), as a symbol of purity and love. There are many pewter plates with fruit, and indeed they become inevitable accessories in Zurbarán's later Holy Families, doubtless because they had proved so popular. No less delightful is Zurbarán's painting of loaves and rolls, whether those in *St Hugo in the Refectory* (Figs. 291-293) or the ones *Fray Martín Vizcaíno* is distributing among the poor (Figs. 164 & 165), taking them out of a splendid basket which seems still redolent of the bakery. Although we cannot say that Zurbarán invented these accessories (the scissors and work-basket appear in El Greco's Annunciations, and the work-basket by itself, as we have seen, is found in very Zurbaranesque form in an anonymous picture in the Museo Lázaro Galdiano), he gave them extraordinary strength and appeal. For the first time we seem to be seeing books, fruit, loaves and baskets that are real and not painted, thanks to the attention Zurbarán concentrated on each in turn, isolating it from its companions.

As a painter of flowers, Zurbarán sometimes scatters them as if on an altar or in a sanctuary — the

Portiuncula in Cadiz and New York (Figs. 229, 459 & 516), *Our Lady of the Caves* (Figs. 289 & 290) and the *Child Jesus with a Thorn* (Fig. 64), both in Seville, the *Virgin as a Child, Praying* in New York (Fig. 230) and *Our Lady of the Carthusians* in Warsaw (Fig. 145); sometimes leaves the scattering to some very conventional cherubs — *Our Lady of Ransom* in the Valdeterrazo Collection (Fig. 310); and sometimes places them delicately in a rather ornate vase, as on the right of the *Virgin as a Child, Praying,* or in a fine crystal one, as in the *Child Jesus with a Thorn.* The roses of love and the Madonna lilies of virginity are the most frequent of these flowers, drawn with such meticulous naïveté that they look as if they were made of cloth or paper, like the ones on monastery altars, just as his fruit at times seems to be preserved or even waxen.

Although important, the small amount of work in precious metals represented by Zurbarán — see, for instance, the vase in the New York *Virgin as a Child, Praying* or the ewer and basin in the *Circumcision* in Grenoble (Fig. 131) — rather gives the effect of stage props. Much more authentic in appearance are his ceramics, whether unglazed, as in the *St Justa* in Dublin (Fig. 404), or glazed, in the *Nativity of the Virgin* (Fig. 44) and in *St Hugo in the Refectory* (Figs. 291-293). But the pewter or tin plates are the metal objects best depicted by this simple, domestic painter —as we can see very clearly in the *Still Life* presented by Cambó to the Prado (Fig. 484)— and the only ones comparable to his pottery or his woven stuffs.

I will conclude this chapter with a brief reference to the attributes of Zurbarán's characters. The beguiling harp of one of the gadding she-devils in the *Temptation of St Jerome* (Figs. 173-175) is very similar to the one being strummed by an angel in the Grenoble *Adoration of the Shepherds* (Figs. 129 & 130); nor is there much difference between the lutes, angelical or infernal, in the two pictures. Saints in penitence are shown contemplating a skull or carrying a little wooden cross, as in the two

images of *St Bruno* in the Museum of Cadiz (Figs. 135, 136 & 146); as I have said before, the Risen Christ usually has a larger cross, like the ones used in processions, as we see in the *Coronation of St Joseph* in Seville (Figs. 252 & 253). As regards more personal attributes, Zurbarán always paints these very carefully; the eyes of *St Lucy* on their silver tray (Fig. 254), the breasts of *St Agatha* (Fig. 240), the earthen pots of *St Justa* (Fig. 404), the dragon, pannier bags and staff of *St Margaret* (Figs. 199 & 200), *St Apollonia's* tongs with the tooth, the lambs of *St John the Baptist* or *St Agnes,* etc. In Zurbarán 's workshop the palms of martyrs, the roses of their miracles or the swords of their tortures were carried out with all the care demanded by a sign (or signboard) for illiterates, one which everyone could read easily in order to identify the character. This great producer of holy pictures, though sometimes careless or in a hurry, never begrudged extra work on these symbolic objects, to which he gave an innocent freshness that is their greatest charm. Among other examples I might mention the rosary and porter's key worn by *Blessed Alonso Rodríguez* (Fig. 39), or the rich brooches of the *Immaculate Conception* in Jadraque (Fig. 38) and Barcelona (Fig. 84), like those St Teresa saw, together with all the attribute-objects surrounding them — the door, the looking-glass, the steps, the star — and the ones that make up the landscapes above which they float. Not the most demanding friar in any of those monasteries — and they were by no means easy to please, as we are told by Jusepe Martínez — could find the slightest fault. Of these saints, bearing attributes as real as those carried by walkers in processions, nobody could say (like Alcalá Yáñez's character in *El donado hablador*) that "if it were not by a miracle, they could not exist". Zurbarán and his saints know their roles by heart. Even the grill grasped firmly in his left hand by the *St Lawrence* in the Hermitage (Fig. 124; painted in 1636), while with his right hand on his breast and his eyes uplifted he offers his martyrdom to Heaven, certainly seems big enough to have been the instrument of that martyrdom.

VII

INTERIORS AND EXTERIORS

I hope that this method of approaching Zurbarán's work through its structural elements will not seem excessively materialistic — almost, indeed, bordering on the irreverent. But nobody can deny that, before being anything else (in the case of Zurbarán, an apparition, a miracle or some other pious scene), a picture is primarily, as Maurice Denis has said, "a surface covered with colours arranged in a certain way". We need not, of course, neglect to consider the iconographical or devotional aspects as motivations for the commissioning and execution of a picture. But it would seem advisable —above all when dealing with an artist whose work betrays such evident unevenness of execution and such insoluble questions of authenticity— to study him in those aspects which are, almost certainly, his: the composition, presentation and structuring of his work, everything that (despite influences from other men's work, particularly through prints) gives a picture, good or bad, that stamp we call Zurbaranesque. After our brief examination of the works in relation to their groups of characters or their single figures, with their objects treated separately or as accessories to a human theme, I now propose to study the setting of the works, after which we can consider the questions of space, light and colour.

A figurative picture is always an interior, an exterior or a combination of the two. As I wrote some time ago (see *Visión y Símbolo...*, pp. 281 ff.), "the most usual form of presentation ... is the picture of an interior, for a great many of the scenes in the Gospels, in the history of the religious orders and in the lives of saints take place within the walls of a building or in a cave. The sight that meets our eyes in these cases through a door or a window is quite simply a figurative element, an object that the painter makes use of to indicate the interior-exterior ambivalence of the scene, combining it with the other objects of his paintings according to the possibilities of the proposed theme and those he is offered by his own imagination" (the reader interested in pursuing this further would do well to consult Pierre Francastel's *Peinture et Société,* particularly pages 65 and 89). In the seventeenth century we frequently find, as a result of the growing influence of the Tenebrists, painted scenes with backgrounds so dark that it is sometimes difficult to distinguish whether the scene is taking place indoors or in the open air; but a closer examination of the picture and its theme will usually dissipate our uncertainty, an uncertainty sometimes deliberate on the painter's part (as may be the case, for instance, of Velázquez' *Adoration of the Magi* in the Prado, which might well be taking place in the cavern suggested by St Ignatius, if it were not for the dimly-seen shaft of a column in the background, showing the scene to be at least half-sheltered by some building). In the case of many of Zurbarán's Crucifixions, the blackness of the background, which may be meant to evoke the starless night into which the world was plunged by the death of Christ, is a wonderful foil for the white silhouette of the crucified figure on the walls of a dimly-lit chapel, accentuating the sculptural appearance aimed at by the artist and his patrons. In other cases we immediately identify this impenetrable darkness with the wall of a closed interior, not because of any other clues provided by the painter but because we know beforehand the logical place where the principal figure is set. When the picture is a still life, we are accustomed to associating these harvested fruits, these pots and plates, with a kitchen or larder rather than an exterior by night. In the case of one of those figures I have described as "statue-saints", the dark background is still a kind of niche or alcove in which the figure is displayed, and sometimes the shadow cast by the figure itself — as in the *St Cyril of Constantinople* in Boston

(Fig. 238) or the *St Francis* in Barcelona (Fig. 426) — confirms this idea. With a saint-in-penitence — like the cowled figure of *St Francis Kneeling* in the National Gallery in London (Fig. 268) — we interpret this darkness as a "cave of expiation", and frequently the insertion of a view, as in the National Gallery's other *St Francis* (Fig. 193), shows that this is the right explanation. In the case of the "walking saints", we have already seen that this lack of definition (or darkness) permits greater flexibility in the order in which such paintings are hung. A Tenebrist painter uses light only to set off whatever feature interests him most, without worrying about the rest of the picture. The system is rather like that of an electric torch or reflector illuminating only what it chooses. I might say, in passing, that this procedure of Caravaggio and his followers, often regarded as a miracle of realism, is as conventional as any other. Its impression of reality is in fact gained by preventing the viewer's attention from wandering. The mysterious *Mary Magdalen,* for instance, in the Academy of San Carlos in Mexico (Fig. 263), whether an authentic Zurbarán or not, reveals only the saint's face and a table with the normal penitent's equipment of a skull, an hour-glass and a candlestick. As we have seen, too, the dark background in the several versions of the *Holy Face* (Figs. 495-499) accentuates the *trompe-l'œil* quality pointed out by Professor Caturla. The Hartford *St Serapion* (Fig. 13), whose similarity of treatment to those still lifes on a divine theme we have already dealt with, is tied to some posts or tree-trunks, but these stand out so faintly against the dark background that we can hardly see them, and the paper with the martyr's name, fastened to one of them with a pin of the same kind as those used in the *Holy Face,* might just as well be pinned to the wall.

Curtains are elements that have been used to suggest interiors ever since the illuminated manuscripts of the later Middle Ages, and in Zurbarán — apart from what we have seen of their use as symbolic representations of canopies, beds and thrones — they are regarded as sufficient indication of this. We know that the *Virgin as a Child, Praying* in the Metropolitan Museum in New York (Fig. 230) is an interior scene, not because of the dais on which Mary is sitting or the furniture around her, but because the fact is underlined by the curtain. On the other hand, paradoxically enough, the draperies framing *Our Lady of the Carthusians* (Fig. 145) are like a door opening on to a vision of Heaven, though our surprise is

lessened when we realize that this "Heaven" at the top of some altar steps is no more than a typical Andalusian shrine.

In other cases the "indoor" character of the scene is indicated by a tiled or smooth floor, as we see in the two images of *St Peter Nolasco* in the Prado (Figs. 15, 16, 19 & 506), with rather ill-defined cells in which the celestial vision appears. In the portraits of learned Mercedarians or Carthusians, the covered table with a biretta certainly suggests an interior — in those in the Academy of San Fernando (Figs. 201-206), for instance, except for the one supposed to represent *Fray Alonso de Sotomayor,* which differs from the others not only in the absence of this accessory but, above all, in the pictorial quality of the cloth of his habit.

Generally speaking, the feeling of an interior that Zurbarán produces is not so much due to a clear definition of the space depicted (the "Impressionistic" Velázquez, for instance, gives us sufficient data on his space in *The Maids of Honour* or *The Spinners* to enable us to draw plans of the rooms, which would be impossible with any picture by Zurbarán) as to the use of elements which define it, as in a theatre. G.R. Kernodle (*From Art to Theater,* Chicago, 1944) has described the appearance of a Spanish stage setting in Zurbarán's time: a platform with a background of curtains which are left half-drawn to reveal details of a façade or of pictures arranged in front of one; in this space there are three-dimensional elements such as furniture or imitative objects (trees, flags, sails)... which, together with the actors' costumes, give the desired local colour and can be easily read by the audience as gardens, interiors, battlefields, seascapes, etc. A gallery above the stage is used for representing celestial scenes: a *mise-en-scène,* in fact, that is very similar to those used by many modern theatrical directors since Gordon Craig's time and the very one Lope de Vega had in mind when writing his popular comedies. But besides this simple kind of setting there was the complex machinery of the Court productions, with earthquakes, storms at sea, apparitions and transformations, the staging of the "splendiferous" musical spectacles organized by Calderón de la Barca at the Buen Retiro, which were what led the cultivated people of the time to gravitate towards such painters as Valdés Leal or Herrera the Younger. Needless to say, the provincial Zurbarán preferred the simpler settings of Lope de Vega, which offered the audience the indoor or outdoor scene required with a few uncomplicated

backcloths and a repertory of solid objects, fixed or movable, such as we have seen in Chapter VI.

In *The Holy House of Nazareth* in Cleveland (Figs. 257 & 259) the two characters and a few pieces of furniture and other accessories (among them the column with a pedestal to which I will refer later) are enough to define an interior. The same may be said of several other pictures, among them the *Miraculous Cure of Blessed Reginald of Orleans* (Figs. 5, 7 & 86), the *Virgin as a Child with St Joachim and St Anne* (Fig. 198), the *Virgin as a Child, Sleeping* (Fig. 42), the *Child Jesus with a Thorn* (Fig. 64) —this last with a classicist backcloth— and, yet again, the *Virgin as a Child, Praying* in New York (Fig. 230), in which the curtains heighten the illusion of a play just beginning. In all these pictures, the little table with the half-open drawer, placed obliquely in the centre of the scene rather than in a more normal position against a wall, is a definitely theatrical element which fulfils the purpose of creating a feeling of space and interior simultaneously.

On very few occasions does Zurbarán present us with a complete interior that could be reconstructed in real space. And, even when he does, his fragmentary way of viewing perspectives introduces sometimes rather amusing incongruities in such details as the lintels of doors or the vanishing points of floors or walls. It is significant that he does not like painting ceilings — and the very few he does paint, such as the ones in the *Mass of Father Cabañuelas* (Fig. 157) or in *Enrique III Conferring the Archbishop's Biretta on Father Yañez* (Figs. 162 & 163), both in Guadalupe, are no more than parts of the background scenery — which are the very elements not represented on a stage. His most clearly defined interiors are those in the *Visit of St Thomas Aquinas to St Bonaventura* (Fig. 25), representing a monk's cell almost entirely delimited by its furniture, *St Hugo in the Refectory* (Figs. 291-293), which is fixed only by the angle of the table in front of the background wall, with an opening providing a forced perspective, and the picture of Enrique III and Father Yáñez; and all of these are extremely summary. He generally places his individual elements and backcloths as best he can, in very strange but not unpleasing perspectives, as in *Pope Urban II and St Bruno, His Confessor* (Fig. 294) or *St James of the March* (Figs. 465-466), which no architect could ever interpret. In other cases we can see that the painter has confined himself to arranging two or three

back-drops in succession, as in the *Annunciation* (Figs. 127 & 128) and *Circumcision* (Fig. 131) in Grenoble, or in two of the Guadalupe paintings, the *Fray Gonzalo de Illescas* (Figs. 158 & 159) and the *Fray Martín Vizcaíno* (Figs. 164 & 165). An element much used by Zurbarán in defining an architectural interior linked with an exterior is the cylindrical column with a pedestal; sometimes, as pointed out by Pita Andrade (*Goya,* No. 64-65, p. 248), in an illogical way, "in rooms so small that they do not need it or would even be better without it". We can see this in *The Holy House of Nazareth* (Figs. 257 & 259), in the *St Anthony of Padua* in São Paulo (Fig. 51), in the *St Ferdinand* in New York and in the *Virgin with the Child Jesus and St John* in San Diego (Fig. 450). There is rather more excuse for the use of columns as points of connection between indoors and outdoors, in works like the *Apotheosis of St Thomas Aquinas* (Figs. 79 & 80), the *Fray Gonzalo de Illescas* and *Vision of Fray Pedro de Salamanca* (Figs. 167 & 169) in Guadalupe, the *Annunciation, Circumcision* and *Adoration of the Shepherds* in Grenoble, the *Martyrdom of St James* in the Plandiura Collection in Barcelona (Fig. 315), the *St Bruno in Ecstasy* in the Museum of Cadiz (Fig. 135), the *Annunciation* in Philadelphia (Fig. 467), the *Portiuncula* in New York (Fig. 459), *Pope Urban II and St Bruno,* the *Vision of Blessed Alonso Rodríguez* (Fig. 39) and the *St. Bonaventura at the Council of Lyons* (Fig. 26).

Pita Andrade (*Goya,* No. 64-65, p. 248) also comments on the interest of "works which show the contrast between the interior and what can be seen through random openings. Works like the *Vision of Blessed Alonso Rodríguez* and the *Apotheosis of St Thomas Aquinas* (dated 1630 and 1631 respectively) bring us one step further in a process which was to reach its full development after the journey to Madrid in the series painted for the Charterhouse of Jerez and, above all, at Guadalupe. . . The spatial effects achieved with the light from the backgrounds and the foreshortened buildings seem much more successful by 1638; this may be due to the influence of whatever paintings he had seen in Madrid..." We might also mention the influence of the Madrid theatre, much more splendid in settings, lights and transformations, and even in the actors' costumes, than anything Zurbarán could have seen in Seville. Giulio-Cesare Fontana (from 1621) and Cosimo Lotti (from 1628) were producing stage décor at Aranjuez, at the Zarzuela and later at the Buen Retiro which was the first in Europe. As Martín González tells us (in *Goya,*

No. 64-65, pp. 264-265), "Zurbarán merely transposes a theatrical setting, as Guinard himself admits", adding that since we know (through Pacheco) of the use of dressed clay and wax figures for the study of relief, and of candles for chiaroscuro effects, "it is not at all surprising that Zurbarán should have used stage settings, too, in order to enliven the background, and that these should gradually have been included in his canvases".

Soria praises the perspective in the *Vision of Blessed Alonso Rodríguez* (a background which, according to Professor Caturla, is meant to be the School in Palma where Blessed Alonso was the porter) as one of Zurbarán's most successful in the illusion of space accentuated by the converging lines of the floor tiles. I should add that even the painter's signature, in this case as in that of the *Apparition of St Peter the Apostle to St Peter Nolasco* (Figs. 16 & 19), helps to produce this effect of distance.

What kind of architecture did Zurbarán prefer? Even taking into account the influence of his repertory of prints, probably the cause of certain perspective discordances due to their not fitting properly into the composition, or the memories of stage settings or even the settings themselves that he may have used, Zurbarán undoubtedly had his preferences in architecture. And the architecture he liked was of an austere kind, as we see in the backgrounds of *St Bonaventura in Prayer* and *St Bonaventura at the Council of Lyons, St Peter Healing the Man Sick of the Palsy* (Fig. 71), in the splendid gallery in the *Circumcision* in Grenoble (Fig. 131), in the porticoes and arches of the *Mass of Father Cabañuelas* (Fig. 157) and in the Florentine elegance of eaves and galleries in the *Vision of Fray Pedro de Salamanca* (Figs. 167 & 169). On the other hand, the walled, medieval character of the view in *Fray Gonzalo de Illescas* (Figs. 158 & 159), like the little Italianate church in the background of the *St Anthony of Padua* in the Prado (Fig. 425), may express a desire for exactitude of representation. The Palladian Teatro Olimpico effect of the architectural perspective in the *Apotheosis of St Thomas Aquinas* (Figs. 79 & 80) is certainly picturesque, but has little relation to the school whose foundation the canvas is intended to commemorate; a setting underneath the stage on which, as if they were real portraits, the figures of the saints are placed.

In this case the vision of Heaven is produced as it would have been in a simple open-air theatre or a Corpus Christi processional float. This elementary theatrical system is evident in other works by Zurbarán which attempt to place in juxtaposition two different and almost antagonistic spaces, the earthly and the heavenly; the *Vision of Blessed Alonso Rodríguez* (Fig. 39), for instance, with its opera boxes: one for Christ and his Mother, who send their hearts to the Blessed Alonso in the form of rays, the other for the choir of angel-musicians. A similar arrangement is used in the *Portiuncula* in Cadiz (Fig. 229), where Jesus and Mary occupy what we might call the "first floor", while the lower space is defined by steps in perspective, strewn with roses. And the same theatrical superimposition may be seen in the Grenoble *Adoration of the Shepherds* (Figs. 129 & 130) and in the *Battle of El Sotillo* (Fig. 134); in this last, which is enormous, Zurbarán has been unable to avoid the incoherence caused by a very narrow foreground, with a commentator and his companion, and the action in the background, with the Virgin in her balcony of clouds gazing down on the battle below. What is really surprising is that when Zurbarán does not use this artificial, theatrical system of tiers or layers, his compositions seem falser and more mannered; examples of this are the *St Bruno in Ecstasy* (Fig. 135) and the *Annunciation* in Grenoble with its open clouds (Figs. 127 & 128), both from the series painted for the Charterhouse of Jerez.

A classic example of Zurbarán's theatrical scenes is the *Defence of Cadiz against the English* (Figs. 101 & 102) in the Prado. Carl Justi has written with great insight (*Velázquez y su tiempo*, Madrid, 1953, p. 334) of the plays being presented in Madrid while Velázquez, Mayno, Pereda, etc. were decorating the Grand Salon of the Palace of the Buen Retiro with scenes of contemporary Spanish battles and triumphs. As has been pointed out by Angel Valbuena Prat (*Varia Velazqueña*, Madrid, 1960, I, pp. 175 ff.), Mayno's *Recapture of Bahía* in the Prado corresponds exactly to a scene in Lope de Vega's "El Brasil restituído". And the theatrical origin of Zurbarán's contribution to the decoration of the Grand Salon is undeniable. As usual, he has focused on one part of the stage: a platform with a few stones on it to give the idea of a projecting rock floor, a battlemented wall and a back-drop representing the naval battle, a vast, rather unskilfully drawn seascape with innumerable ships and a treatment of waves that is quite well done, unusually so for a Spanish painting. Between this back-drop and the "actors' platform" in the foreground, a frieze of soldiers in half-length unsuccessfully attempts to give some spatial logic to the scene.

Of interest in this scene is the placing of the legs in these foreground characters. With the feet in counter-position, as if about to begin a contredance, Zurbarán achieves all the sensation of space he wants, as with scenic elements like tables and chairs in other pictures. We see a similar impression of balletic poses in the *Labours of Hercules* (Figs. 103-112) — works also painted at a time when Zurbarán was in touch with the artistic and theatrical worlds of Madrid. The apparently exaggerated positions of Hercules' legs create the suggestion of space by a process originally used by the Mannerists but given a fresh approach by Zurbarán. In this aspect, as in others, we may detect the influence of Velázquez' *The Forge of Vulcan* and (even more so) *Joseph's Coat,* two stage-pictures painted in Italy not long before, as also that of the *Surrender of Breda,* a stage-picture which took its inspiration from a play by Calderón de la Barca. But Velázquez succeeds in blending the setting and the other scenic elements into a third dimension of subtle atmospheric gradations; and atmosphere was the very thing for which Zurbarán showed least concern — and least ability. And in an earlier picture, the *Legend of the Bell* in the Museum of Cincinnati (Figs. 22 & 23), painted in 1630, we see a stage scene in which the space is determined by the feet of the characters.

His exteriors are summarily characterized by one or two backgrounds, usually some kind of greenery. He was not greatly interested in, or skilful at, those atmospheric values which are of the first importance in the work of the great landscape artists of the time, men such as Claude Lorrain, Nicolas Poussin, Gaspard Dughet, the Dutch painters and, in Spain, Collantes or Velázquez. Velázquez produces a *plein-air* effect by a process that combines landscape and figure: his horsemen and hunters seem to be bathed in the fine, dry air of the Guadarrama mountains, though they were painted in his studio in the Alcázar. Zurbarán neither achieves this impression nor even seems to seek it. For him, as we have seen, the elements that made up an interior were stage accessories set in front of stage scenery. He used a similar method in his exteriors, of which we have already studied some examples, and so his landscapes are rarely more than fragmentary.

The eminent Zurbarán authority Paul Guinard has written a study of the painter as a landscape artist (*Goya,* No. 64-65, pp. 206 ff.). Though he affirms that Zurbarán is not a landscape artist in the strict sense of the term, for there is no example of a landscape painted by him as an autonomous genre, Guinard does go on to speak of the importance of landscape backgrounds in his paintings. "The landscape element in a work sets us an interesting double problem, at once historical and aesthetic. When did the landscape first appear in his work and how did it develop throughout his career? What, moreover, is its spiritual significance? Is it a question of practice based on previous models, or does it reflect a direct experience of the countryside, expressing the painter's personal sensitivity to nature?" Though Guinard modestly tells us that he cannot give categorical answers to these questions, he points out that, while the painter's career had begun under the sign of Tenebrism and sculptural reliefs, "it was after his visit to Madrid in 1634, and possibly under Velázquez' influence, that atmosphere and landscape first entered Zurbarán's pictures". This, at least, was the idea suggested by the chronology of his works as it was outlined in the eighteenth century, passing from darkness to light. Today we see that landscape is by no means absent in his early work, or, rather, in what we know of it. Zurbarán painted landscape background in his two pictures within a picture: in the *Apparition of the Virgin to the Monks of Soriano* (Fig. 4) and *St Hugo in the Refectory* (Figs. 291-293), which Guinard considers to have been painted in his youth. After the visit to Madrid, however, the landscape background became more frequent. "The novelty does not consist in the presence of the landscape, but in its frequency, its diffuseness and, above all, the greater softness of the light in which it is bathed". Guinard points out that later on two new enrichments of his range were to come: the discovery of the twilight — for instance, in the *Christ Carrying the Cross* in the Cathedral of Orleans (Fig. 288) — and the introduction of landscapes into pictorial themes from which Zurbarán had hitherto excluded them, as in the San Diego *Virgin with the Child Jesus and St John* (Fig. 450), or the Philadelphia *Annunciation* (Fig. 467).

As to the second question, that of the possible influence of natural landscape, Guinard admits that "some of the more picturesque landscapes, with their hermitages perched on steep cliffs among crags, are almost identical with the series of *Hermitages* by Marten de Vos, engraved by Sadeler, which were so successful in the early seventeenth century. Though it is difficult to be more specific, it is very probable that Zurbarán took much of his inspiration, though with a certain freedom,

from engravings and, possibly, from earlier painters, like Carducho, in the backgrounds of his famous series of Carthusians painted for the Charterhouse of El Paular between 1625 and 1630. This, however, does not exclude the possible reflection of landscapes familiar to the painter, which would remain in his visual memory without having to be copied. The broadest and most luminous of his landscapes, in the *Apotheosis of St Jerome* (Fig. 177), is also the most reminiscent of the broad, open horizons and flattened forms of his native Extremadura." And Guinard ends with this sage conclusion: "Like Poussin and Claude, Zurbarán practised a form of composite landscape, combining elements taken from different sources, and did not attempt to reflect any real countryside. But to our eyes, so accustomed to nineteenth-century landscapes, he seems in some ways a forerunner."

It is quite evident that Zurbarán did not paint his landscapes from life any more than the other painters of his time, except (and even this is disputed) the Dutch. Salvator Rosa's fame as a painter from life collapses at once when we look at his pictures. The landscapes of Claude and the two Poussins are "cosa mentale": "Il signor Poussin labora di là", Bernini is supposed to have said, touching his forehead. Even the most astonishing landscape artist of the day, Peter Paul Rubens, cannot avoid composing his landscapes, which were painted in his studio anyway, despite their freshness and close observation. The unusual aspect of Velázquez' two little views of the *Garden of the Villa Medici* — probably painted around 1650 — is that they seem to have been done in the open air, from a position in front of the gardens. The most normal procedure was for the painter to take notes and use them in composing his pictures, if he was one of the more modern, innovative artists; and if he had no pretensions to modernity, like Zurbarán, he confined himself to copying from others.

I believe that the fact of having been born in the country would tend to militate against any fondness for landscape rather than favour it. Landscape and nature may interest city folk — especially from the eighteenth century onwards — but they rarely inspire peasants and labourers, accustomed to interpreting the beauty of the countryside in direct proportion to its productivity. Besides, a feeling for landscape is not an innate quality but an acquired taste, generally acquired through the works of our predecessors. Only an artist of genius like Velázquez can offer us new data that will help us to see the landscape. When we see any landscape after this sort of visual apprenticeship, we may say that it looks like a Velázquez, or a Ruysdael, or a Corot, or a Turner, a Monet, a Marquet; we will never say that it looks like a Zurbarán, whereas the sight of certain household utensils may immediately bring this artist to mind. The landscape of Tierra de Barros has nothing to inspire an image-painter. We can hardly imagine anything further removed from Giorgione than Zurbarán's landscapes, separated by a respectful distance from his characters. Such landscapes are never any more than a conventional background for his open-air theatrical scenes. Even in the figures most beautifully surrounded by foliage, like the *St Lawrence* in Leningrad (Fig. 24) or the *St Anthony Abbot* in the Valdés Collection in Bilbao, both painted in 1636, the landscape is a background and no more. And this is so even when, as in the splendidly emotional *Blessed Henry Suso* in the Museum of Seville (Figs. 276-277) or that other apostle to the Indians, *St Luis Beltrán* (Fig. 278), painted around 1640, the landscape is used, in a very medieval way, to narrate certain episodes of the legend or life of the character depicted. Velázquez makes a similar use of landscape in his *Holy Hermits* in the Prado, with the successive episodes of St Anthony's visit to St Paul; but by wrapping the whole in a prodigious bluish atmosphere and diminishing the size of the characters, he creates a landscape with figures just like those which were becoming fashionable at the time in Italy, or the ones painted in Spain by Collantes. Zurbarán's saints draw themselves up before that background like carved images in front of a tapestry.

Even in scenes in which nature, in the form of the wilderness of penitence, has a fundamental role to play, Zurbarán reduces its importance, as we may see in the several versions of *St Francis in Penitence* or in the background of the *Temptations of Fray Diego de Orgaz* (Fig. 168).

In the *Temptation of St Jerome* (Figs. 173-175), the landscape is limited to one stage rock. The theme of the rock as a theatrical accessory was already used, as Pierre Francastel has pointed out, in early Renaissance painting. A clear example of the use of this accessory is to be found in the beautiful *St John the Baptist in the Wilderness* (Figs. 241-243), painted around 1630. The composition of this picture is divided into two halves, which is rare in Zurbarán (though habitual in Murillo), the left-hand side showing the saint, in a declamatory attitude, in front of what looks like a cardboard rock,

while on the right there is a river landscape between lofty headlands of a sort the painter never saw in his native region; the two sides hinge, as it were, on a tree, the same tree which provides the only landscape element in other pictures of his —for instance, the *St Mark* and *St Luke* in the Museum of Cadiz (Figs. 138 & 140). Speaking of this surging river, however, I must call attention to Zurbarán's not inconsiderable talent for representing water by means of tiny flecks of white paint. I have already mentioned this in dealing with the *Defence of Cadiz against the English* (Figs. 101 & 102) and *Hercules Changing the Course of the River Alpheus* (Fig. 111), both pictures painted during that stay in Madrid that meant, for the still young painter, such a treasure of new impressions before going back to his usual routine in Seville. The *Labours of Hercules,* which were indeed labours for their painter, pose so many new questions regarding the representation of scenes, the articulation of spaces and backgrounds, that it is not surprising Zurbarán did not achieve a very brilliant result; but this does not mean that, if properly examined, they do not represent a milestone in the painter's career, especially in that sturdy giant standing before the turbulent waters he has just let loose.

The background landscape is sometimes intended to be the key to the principal scene. The most typical case of this concept of the picture within a picture is that of *St Hugo in the Refectory* (Figs. 291-293), in which the foreground presents the saintly Archbishop of Grenoble standing before the table at which the monks sit in their mysterious sleep. The background landscape is like a biblical illustration of fasting: in a conventional land-scape setting we see the Virgin and Child apparently during the Flight into Egypt — another version of the wanderings of Hagar and Ishmael — on the left, and on the right St John the Baptist, obviously years later, for if he were a contemporary of the Virgin on the other side of the picture he would have been a child hardly older than Jesus. What unites these characters, however, and makes them examples for the monks to follow, is their practice of the virtues of fasting and abstinence in a wilderness compared with which the Charterhouse table would seem luxuriously well provided. The background picture, therefore, is simply the representation of the real theme of the picture as a whole. For both scenes Zurbarán has evidently made use of prints. According to Soria, this composition derives from an engraving by Bernardino Passeri in a life of St Benedict published in 1579.

Another example of important landscapes is that to be found in the images of the *Immaculate Conception* by Andalusian painters (and those of other parts of Spain too). These landscapes are composed of emblems of the Virgin: palm trees, cypresses, cedars, olive trees, closed orchards, fountains, oceans, ships, doors, towers... And the painter will be all the more praised for his ingenuity if the tower is the Giralda of Seville, as in the very beautiful *Immaculate Conception* in Jadraque (Figs. 38 & 40): the *turris davidica* or *turris eburnea* of this Jerusalem on the banks of the Guadalquivir. This landscape, half real and half imagined, with other Marian emblems showing between the clouds (the evening star, the mirror of wisdom, the gate of Heaven, the stairway to God) is, despite the early date it is usually given (around 1630, possibly commissioned by the Town Hall of Seville on 8 June that year), the most beautiful Zurbarán ever painted.

VIII

STYLE IN ZURBARAN: COLOUR AND MATERIAL

The personality of a painter is not always seen in what he represents, which may be dictated by commissions, by facility or by fashion, but it usually can be seen in his way of representing. Hitherto we have been endeavouring to analyse Zurbarán's style of composition, his way of arranging the layout of a picture and using the objects or characters in it. But I have left for last the very essential question of his style in the pictorial sense. *"Le style c'est l'homme même,"* wrote Buffon. And what kind of man was Zurbarán? His personality and the authenticity of the pictures attributed to him confront us with problems to which I have already referred, in the Introduction, and which it would be out of place to attempt too insistently to solve in a work like this. We must learn to know Zurbarán's style through a few works whose beauty guarantees them as being from the hand of a great master.

Many scholars, indeed, and some of them writers of eminent authority, have attempted to answer the question of Zurbarán's material participation in the works produced in his workshop. Sometimes only a true specialist can really confirm the authenticity of a Zurbaranesque canvas. Particularly with regard to the works of the fourth decade of the seventeenth century, when Zurbarán's workshop turned out pictures by the dozen for the American colonies, we should remember Professor Caturla's theory of the concentric circles: (a) original works, (b) works produced in the workshop in which the master took an active part, (c) pictures from the workshop in which he took no part, (d) works by his pupils, and (e) works by his imitators. I myself would shrink from the task of placing in their correct circle (and I do not know if they are circles of Paradiso or Inferno) certain pictures attributed to Zurbarán, such as the *St Jerome, St Paula and St Eustacia* in Washington or the *Mystical Marriage of St Catherine* at Keir. But I will be bold enough to state my opinion that the *Crucified Christ* in Chicago (Fig. 12), the Hartford *St Serapion* (Fig. 13), the *Vision of Blessed Alonso Rodríguez* in Madrid (Fig. 39), the *Immaculate Conception* in Jadraque, the *Adoration of the Shepherds* in Grenoble (Figs. 129 & 130), the *Fray Gonzalo de Illescas* in Guadalupe and quite a few more are undeniably the work of a great master, with a style of his own in material and colour.

I have already written elsewhere of colour in Zurbarán (*Goya,* No. 64-65, pp. 296 ff.) and I do not wish to repeat myself too much; nor, however, do I wish to avoid the subject entirely. It would be unjust to think that Zurbarán is not a colourist with as much right to be so described as Velázquez, Murillo or Valdés Leal. In speaking of Zurbarán it is very easy to think of monks in white habits against a dark or black background, but it is anything but fair. The colourist in Zurbarán, as in Velázquez, can be seen even when he dispenses with bright colours, even when he uses only whites (which are never simply white) against blacks (which are never wholly black either). If we hang even the roughest and most dubious Zurbarán next to a work by a second-rate painter of his time, or even next to a work by a distinguished pupil, we shall see how it sparkles like a true diamond. When we see authentic works by Zurbarán in a gallery (in Seville, in the Academy of San Fernando, in Cadiz, in Barcelona...) we are astonished not only by his sculptural and almost architectural strength, the graceful severity, the objectivity full of mystery, the austere, virile tenderness, the feeling of peace and silence, cleanliness and truth that they inspire, by the tactile quality of his stuffs and furniture, his serene, unafraid, unexcited devoutness; we marvel also at his colouring.

Consider those dazzling white symphonies composed on his great canvases by the habits of Carthusians,

Mercedarians or Hieronymites. What a difference there is between the refinement of those snowy white or ivory cloths and the monotonous white lead of his imitators! In one and the same picture, the *Vision of Blessed Alonso Rodríguez,* the white of the Virgin's robe seems tinged with pink, while that of the angel-musician borders on blue. In one and the same series, that of the passage behind the altar in the Charterhouse of Jerez, the creamy white of *St John Houghton* (Fig. 152) is quite a different colour from the ivory of *St Anselm* (Fig. 147) or the icing-sugar tones of *St Bruno* (Fig. 146), and all three are wonderful. If the reader has ever visited a monastery where the friars or monks wear white habits, he will have noticed the variety of shades and even of forms to be seen in those habits, which the monastic rule decrees must be identical. Zurbarán certainly noticed these differences and transposed them delicately on to his canvas. For he is able to discern in a single white cloth the reflections and shadows of everything around it. I have already spoken of the habit of the martyred *St Serapion* (Fig. 13): pale grey, clear ochre, faded red, bluish mauve. Consider, too, the best portraits of Mercedarians in the Academy of San Fernando, with the simultaneously light and pastose treatment given to the bone-white capes, painted in a material that is "smooth and flat, like good paint", as Matisse said. In Zurbarán's time there was only one other painter capable of painting those white habits so softly shaded by the light: the man who painted the votive offering in the Louvre in gratitude for the miraculous cure of his daughter, a nun of Port-Royal, thanks to the intercession of the mother superior, Mère Angelique Arnauld. But Philippe de Champaigne, though more civilized, more European, in his other works (even in the superb portrait of Richelieu in his cardinal's purple), lacks the moving simplicity of Zurbarán and does not surpass him in impasto and colour.

Consider, again, how the colour makes up for a certain poverty of material in pictures with an unsure technique (possibly workshop paintings) like the ones in the Charterhouse of the Caves; and how *Our Lady of the Caves* (Fig. 289 & 290) remains in our memory thanks to the brilliant orange colouring of her robe and the enchanting blue of the mantle spread over the white habits of the Carthusians. The *St Hugo in the Refectory* (Figs. 291-293), which is more opaque, is enlivened by the contrast between the sienna suit and blue sleeves of the layman in the foreground — variously identified as a page or a cook — and the leaden grey of St Hugo's mozzetta and cassock. In that severe atmosphere the symbolic picture on the wall is like an orgy of colour and attracts our attention immediately, like the warm red and gold of the meat and loaves and the bluish white of the crockery. In *Pope Urban II and St Bruno* (Fig. 294), the glimmer of silken canopies and carpets alternates with the modest habit worn by the saintly monk, a humble black and white swallow amid the luxurious decoration of the Vatican.

There are some pictures by Zurbarán in which the colouring is their principal *raison d'être*. In the *St Agatha* in the Musée Fabre in Montpellier (Fig. 240), for instance, the blue, yellow, maroon and scarlet of the dress are arranged like a collection of silks in a shop window, creating a tremendous explosion of colour. Zurbarán likes vivid, well-defined tones, complementary or contrasting. Consider the delightful yellow and blue *Angel with a Thurible* from the Charterhouse of Jerez (Fig. 143), with his splendidly blue-tinged wings; or the brilliant *St Casilda* in the Prado (Fig. 301), the areas of colour as clearly delimited as in a piece of *cloisonné*, peacock blue, greenish grey, yellow, vermilion and soft pink, more flower-like than her own flowers; or the other *St Casilda*, in the Plandiura Collection (Fig. 261), a better picture in pictorial quality and emotion, if not so showy, with her enormous gold-embroidered red skirt, her dazzling white, lace-trimmed blouse and her olive-green shawl; or the magnificent *St Dorothy* (Fig. 393), another picture of very uneven quality but with its deficiencies compensated for by the pink and yellow of the dress; or, finally, the excellent *St Margaret* in London (Figs. 199 & 200), a village belle in dark blue and fiery red. From these pictures we can see that Zurbarán has a sense of colour like that of the potters of Triana, Manises or Talavera, or that of the embroiderers of Lagartera or the hand-weavers of the Alpujarras: vivid colours in juxtaposition, bordered by broad areas of black or white.

As I wrote in my article in *Goya,* "the luminosity, which is of the morning in the *Immaculate Conception* in Jadraque and Barcelona, but of the evening in the *Apparition of St Peter the Apostle to St Peter Nolasco* or in the *St Serapion* in Hartford, contrasts with the compact, homogeneous luminosity of these characteristic colours of Zurbarán, isolated from the rest and, though harmonizing, never blending with them: pink, red, violet, mauve, blue, green, yellow, vermilion,

orange, brown and sienna. Placed next to one another, but each with its own shade different from those beside it, they are true islands of colour which separate Zurbarán from the main trends of the seventeenth century — from the scattered brushstrokes of Velázquez and Cano or the flowing impasto of Rubens, van Dyck or Murillo — and unexpectedly bring us closer, on the one hand, to the cold, jewel-like gleam of the Mannerists and, on the other, but through a different superimposed area, to the luminous, independent tones of Vermeer of Delft."

Zurbarán remained aloof from those post-Venetian fashions, having little taste for the newly prevailing reddish tone that others obtained from the use of bolus grounds (particularly Seville red earth) for the priming of their canvases. He wanted clean colours and well-differentiated, isolated objects. And so he preferred not to use loose brushwork, quivering air, atmosphere. He also shunned any kind of bravura or excessive liberty with the brush. He knew he could not, like Velázquez, paint in a series of bold, unerring single strokes: he needed many strokes, small and closely bound together. What is surprising is that they do not look prim or fussy, except in pictures clearly done by his assistants or done by himself but carelessly. We can imagine a Velázquez reproduced in black and white, thanks to the exquisite grading of the colour values. But a Zurbarán in black and white is nothing but contrasts; the real picture disappears. We could never imagine the accord between the reddish curtain and the blue mozzetta in the *Fray Gonzalo de Illescas,* or the delicate pink chasuble of the doubting *Father Cabañuelas* harmonizing with the whites of his alb and the bluish greys of the background. Nor could we ever invent the colouring of the *Virgin as a Child, Praying* in the Metropolitan Museum in New York, a work in which the reds, whites, blues and pinks are encrusted on to a background of shadows. Or the reds, whites and bluish blacks of the *Nativity of the Virgin,* framed in the foreground by the yellow and pale green of the woman on the right and by the thick brown wool of the woman on the left. And it would be impossible for us to realize that the sensitive but severe browns of the *Holy Family* in the Campo Real Collection (Fig. 63) made such a splendid foil, not only for the almost Caravaggio-like fiery red of the little St John's cloak, but also for the pale pink of Mary's robe, a pink that we would never find in Caravaggio.

Thanks to these opposing tones, these bold con-trasts of colours, in his best works Zurbarán achieves what was the objective of all the painters of the seventeenth century: the expression of light. But since it is embodied in such clear, unmixed tones, this light takes on an air of high, snowcapped mountains and glaciers, with nothing of the heavy, aromatic atmospheres of the plain. And this despite the fact that Zurbarán did not scorn the greens of foliage, for he made almost conventional use of them in his backgrounds, as we have seen.

Zurbarán is a strict, careful painter, not the man to let himself be carried away. Only in some of his later paintings does his brushwork recall the impetuosity of Ribalta and Ribera or the luscious softness of Murillo. The almost medieval look of his objects and stuffs, always broken into colliding light and shade, is increased by this brushwork that never tries to dominate the picture, unlike that of Velázquez, Ribera or Valdés Leal. Sometimes his flesh tints are a little hard and then his characters really look like lay-figures for dressing. Their complexions do not react, like those of Murillo's virgins, to the light and air; anyway, Zurbarán's light hardly ever gives much idea of what time of day it is. It would be tempting to take this further and say that it is the light of eternity, but eternity and immobility are not the same thing. Zurbarán is one of those careful painters who either finish a picture to their satisfaction or destroy it: painters who leave behind them no sketches, like Velázquez, Valdés Leal, Murillo or Goya, but absolutely finshed works... or nothing. He is the same kind of artist as Juan de Juanes (remember the beautifully finished chalices and hosts in his renderings of the *Salvator Mundi*), like the great Morales in his best moments, like Sánchez Cotán: with a tense, silent, sensitive character, the sort that is easily overshadowed by the more vehement "Spanish fury", which is the character of the Herreras, father and son, of Valdés Leal, of Goya. When we compare a sewing-basket or a loaf painted by Zurbarán with the imitations (ingenious enough in their way) by Salvador Dalí, we at once realize the great pictorial quality of the painter of *Fray Martín Vizcaíno* (Figs. 164 & 165).

With Zurbarán this insistence on well-finished work extended even to his signature. I have already spoken of certain signatures of his, like the one in the *Vision of Blessed Alonso Rodríguez* (Fig. 508) or the one in the *Apparition of St Peter the Apostle to St Peter Nolasco* (Fig. 506), which are made to appear cut into the floor

tiles and following the line of the perspective. There are others still more interesting, written on little scrolls of paper — an idea, of course, well known in other painters and used by many (El Greco and Velázquez, to name only two), but one which acquired a special charm in Zurbarán thanks to the care he took with this little piece of paper. We can see this in the beautiful way it is pinned to the post from which the *St Serapion* in Hartford is hanging (Fig. 13), or nailed to the foot of the Cross in the *Christ Crucified* (Fig. 12) in Chicago, like an echo of the "INRI" painted on a board at the top. Zurbarán's signature appears on one of the many papers on the desk in *Fray Gonzalo de Illescas* (Fig. 511), and on a half-torn scrap of paper in the *Mass of Father Cabañuelas* (Fig. 157), while in the *Adoration of the Shepherds* in Grenoble it is like an apothecary's label (Fig. 512), stuck on the canvas and just beginning to peel off. In the *Still Life* (Fig. 85) in the Norton Simon Foundation, on the other hand, the only one signed by the artist, the signature is written in fine yellow characters on the front of the piece of furniture on which stand the citrons, the oranges and the cup. I would like to mention, in passing, that this piece of furniture, also used in other still lifes attributed to Zurbarán (such as the *Still Life of the Pots* (Fig. 484) in the Prado) and in one of the *Lambs* (in the Marqués del Socorro Collection), is like those parapets over which the Quattrocento artists used to view their sitters and on which Bellini or Crivelli sometimes placed the Child Jesus, held up by the Virgin, as if on the sill of a window between real space and the fictitious space of the picture.

We can see that Zurbarán signed his most important pictures, as if to give them legal authenticity. Unfortunately, he also signed lesser works; in any case, nothing is easier to forge than a signature. Frequently, however, it is a double-edged sword, for we all know that a false Dürer or Greco will not be saved by being properly signed. I have no wish to go into these problems of authenticity here, for this kind of problem, always full of pitfalls, is particularly so in the case of Zurbarán, bearing in mind the way he ran his workshop and those circles of Professor Caturla which I mentioned earlier in this chapter.

I will therefore make only a passing reference to the assistants in Zurbarán's workshop, who have been studied by various Zurbarán specialists. From the few documents still extant concerning Zurbarán, we know that as early as 1628 he had a team of men working with him, since on 29 August that year he contracted to paint, in the space of one year, twenty-two pictures of the life of St Peter Nolasco for the Calced Mercedarians of Seville, it being stipulated that he, his assistants, "and other persons connected with the work" should receive "food, drink and lodging, with beds and everything necessary for painting, such as canvases, oils and other things, for I alone will set my hand to this work". Which tells us that an organized workshop existed and that despite its existence the master undertook to paint this whole series personally, thus meeting any possible suspicion before it could be expressed. And it is curious that of the four canvases which are all that remain of this large series (for fate seems to have done very badly by Zurbarán, making the task of those studying his work still more difficult) one of them, the one with the two St Peters (Figs. 16 & 19), signed and dated in 1629, is so splendid in conception and execution that we can say the painter has already attained the highest point in his development, which makes this picture not only one of the best he ever painted but far superior, in pictorial quality, to the series painted for the Charterhouse of the Caves or for the Cathedral of Seville, though for that very reason these paintings had always been considered earlier works, as Professor Caturla and others believe. The *Vision of St Peter Nolasco* (Fig. 15) is not only inferior but is remarkable for the fact that the saint represented in it seems quite a different person from the one to whom the Apostle appears. In the rather puzzling *Departure of St Peter Nolasco* (Fig. 20), also known as the "Picture of the Spaniel Bitch", Soria thinks the three secondary characters are by another hand and Guinard admits the possibility of collaboration. The fourth picture, the *Legend of the Bell* (Figs. 22 & 23), is signed and dated 1630 and tradition has it that the boy looking at the viewer from behind the saint's beautifully painted cloak is the painter's son, Juan de Zurbarán. This is not at all a bad picture, but rather conventionally theatrical. I have already mentioned the differences in quality in the other canvases done for the Calced Mercedarians (such as the one supposed to represent Fray Alonso de Sotomayor), which María Luisa Caturla attempts to explain (catalogue of the 1964 exhibition in Madrid, p. 28) by supposing that this work continued for four years.

It might also be explained by restorations, repaintings or collaborations. Francisco Reina is mentioned among the assistants employed by Zurbarán at that time, and according to tradition he painted four pictures of Mercedarians in the Cathedral of Seville, which some

writers believe to belong to the series ordered from Zurbarán (see Rogelio Buendía in *Goya,* No. 64-65, p. 279), and which are far from contemptible. "In them the white-robed monks are treated in a way that comes close to the painting done in this series by his great companion", Buendía tells us.

As I have said, one of these paintings is supposed to contain a portrait of Juan de Zurbarán, who was born in 1620 and died in 1649, probably a victim of the plague that ravaged Seville that year. In this short life it is hardly likely that he did much work for his father. César Pemán reconstructed his brief ten years as a painter, starting with a signed still life in the Museum of Kiev and going on to one in the Lung Collection in Bordeaux, dated and signed (with a signature which seems to be "Juan" and not "Fran.", as was formerly supposed) at the age of nineteen "under his father's very close supervision, and perhaps even with an occasional brushstroke put in by him" (Madrid exhibition catalogue, 1964, p. 85). Some writers now attribute the *Still Life of the Four Pots* (Fig. 484) in the Prado to Juan rather than to Francisco, but I prefer to believe that it is by the father and that the son's version is the one in Barcelona. Juan is known to have been commissioned to paint some saints for a confraternity in Carmona, but these works have not survived. Juan de Zurbarán, therefore, is simply an hypothesis in the shadow of his father, though at the moment of his death he had very probably abandoned his father's establishment.

César Pemán, Ramón Torres Martín, Gómez Castillo, J.A. Gaya Nuño, Rogelio Buendía and other Zurbarán specialists have all dealt with these problems of Zurbarán's pupils, assistants and imitators, and I would recommend their works to the reader particularly interested in such matters, which are of minor interest only in a study like this one. Prominent among the imitators are the Polanco brothers, Miguel and Francisco, who are credited with pictures in the Carmelite Monastery of the Angel in Seville, including a version of Our Lady of Mercy (in the style of Zurbarán's *Our Lady of the Caves*) protecting the Carmelites. After studying these pictures, César Pemán (catalogue of the 1964 exhibition, p. 86) suggested that Miguel Polanco may have painted the *Santa Engracia* in the series for the Hospital of the Precious Blood, now in the Museum of Seville, which seems to me to derive from the earlier *St Euphemia* in Madrid. We should remember that José Hernández Díaz doubts the authenticity of this series of

saints, though he does say that some of them (such as St Agnes, St Dorothy and the charming St Marina) are "very worthy to be considered works done personally by the master". Ponz attributes to Polanco part of the retable in San Esteban. According to Buendía, "the central compositions are undoubtedly by him and as weak and crude as the incomplete series of Apostles, published by Soria, which was formerly in England and is now in Mexico". Buendía goes on to say that the *St Matthew* bears the only known signature of Francisco Polanco and declares that the series of Apostles in the Museum of Seville, much stronger and more in Zurbarán's style, cannot be by either of the brothers.

Another painter, Bernabé de Ayala, has been particularly studied by J.A. Gaya Nuño (*Goya,* No. 64-65, pp. 218 ff.), who supposes him to have been born around 1600 and to have been one of the founders, in 1660, of the Academy of Painting in Seville, where he died in 1672. His only signed and dated work is *Our Lady of the Kings* (Lima, 1662), a work "as impersonal as any devotional image copied faithfully from the original". Antonio Gómez Castillo (*Bernabé de Ayala, discípulo de Zurbarán,* Seville, 1950) attributes to this painter four *Sibyls* (now in a private collection in Seville) of a processional type, showier and less substantial than that of Zurbarán's female saints; Guinard and César Pemán both incline to doubt this attribution, as also that of the pictures in the Monastery of the Angel, which Gómez Castillo attributed to Ayala and which may be by the Polancos. Gaya Nuño considers these *Sibyls* to be Ayala's best work and quotes Guinard as having said that while the Polancos accentuate Zurbarán's harshness, Ayala for his part softens it.

One of Zurbarán's most interesting followers is the Spanish-Portuguese woman painter Josepa de Ayala (also known as Josepa de Obidos, from the pretty Portuguese village where she worked). Luis Reis Santos, José Hernández Díaz and J.A. Gaya Nuño have all studied the personality of this artist, a minor one but very interesting, possibly a niece of Bernabé de Ayala, who was born in Seville around 1630, the daughter of Doña Catalina de Ayala (Bernabé's sister or cousin?) and the Portuguese painter Baltasar Gómez Figueira. At the age of six she went with her family to Obidos, where she died in 1684. Her dated pictures were painted between 1646 and 1657. Whether because of her visits to Seville, or thanks to the presence of works by Zurbarán in Portugal, or even through the influence of her possible

kinsman Bernabé, Josepa painted in oils in a style noticeably similar to that of Zurbarán, finer and more faithful than that of Bernabé. Her compositions with figures are very thin and bloodless, but she came into her own with still lifes; her pictures in this genre are really charming, the most famous being the *Lamb of God* with feet tied together, a copy of the one Zurbarán placed in the *Adoration of the Shepherds,* or even more probably of the *Lamb* in the Marqués del Socorro Collection, but without horns. Josepa accentuates the sacred character of this symbolic animal with a halo, an offering of flowers and petals strewn over the typical Zurbarán parapet or table-top on which the victim lies, and even with a sign reading "occisus a[gnus] origine mundi" in the foreground. A very typical example of the picture within a picture, this little lamb has a *trompe-l'œil* frame with tassels and delicate, rather naïve garlands of fruit and flowers.

Josepa also shows her fondness for the Zurbarán type of still life on a divine theme in her *Holy Face* in the church of the Misericordia in Peniche, with the same effect of a curtain with a double fall that was a feature of Zurbarán's own versions. In view of the remarkable fidelity of this imitator, Gaya Nuño has suggested that it might be possible that Zurbarán was in Portugal between 1654 and 1658, since nothing is known of his life during these four years.

Guinard considers Josepa de Ayala to have been Zurbarán's most faithful follower. I do not wish to weary the reader further with the names of other painters more or less influenced by him, such as Alonso Cano, Sebastián de Llanos (see Diego Angulo Iñíguez, *Archivo Español de Arte,* 1946; J. Guerrero Lovillo, id., 1947) and the two brothers from Córdoba, Antonio del Castillo and José de Sarabia, who were at one time in Zurbarán's workshop, according to Pacheco, and the second of whom painted an *Adoration of the Shepherds* now in the Museum of Córdoba, signed and dated in 1630, which is undeniably reminiscent of the same theme painted by Zurbarán for the Charterhouse of Jerez eight years later; and this means, supposing that there is no error as to these dates, that the pupil went ahead of his master and the latter was able to make use of his pupil's work. In connection with these works, I should like to mention the splendid *Adoration of the Shepherds* (or, as I suspect, *of the Indians*) in the National Gallery in London, which is well worthy of the master. Other names mentioned as assistants or imitators of Zurbarán are Francisco Cubrián, Francisco Legot, Ignacio de Ries, Varela, etc., but their works never attained the coherence of the indisputable paintings of a great master.

As César Pemán so rightly says in dealing with these questions (ibid., 87), "it is clear that Zurbarán's mastery shone brilliantly in a single, well-defined field: he is an excellent master when he paints from life, whether a living model or a still life, and this excellence is revealed throughout the whole process of the work, in the monumental quality of the drawing, the sobriety and distinction of the colour, his knowledge of chiaroscuro, the plasticity of the volumes and quality of the clothing, the profundity of his expression and spiritual depths. In all of this he excels, but it is a very small field. And the moment he steps outside it Zurbarán makes one mistake after another." It is natural that with such a handicap he should have sought help and collaboration. But all this help and collaboration put together is as nothing beside a single table, a curtain, a scapular, a jug or a flower in a cup painted, as though by some angel of the house, by a man who, to quote J. Camón Aznar's penetrating remark, was able to make a grace out of his clumsiness.

CATALOGUE

Abbreviations used in the catalogue

GA. GAYA NUÑO, J.A.: *Zurbarán*. Ediciones Aedos, Barcelona, 1948
GUI. GUINARD, P.: *Zurbarán et les peintres espagnoles de la vie monastique*. Les Éditions du Temps, Paris, 1960
S. SORIA, M.S.: *The Paintings of Zurbarán*. Phaidon Press Ltd., London, (2nd edition) 1955
T.M. TORRES MARTIN, R.: *Zurbarán, el pintor gótico del S. XVII*. Gráficas del Sur. Seville, 1963

A.E. *Arte Español*
A.E.A. *Archivo Español de Arte*
B.M. *Burlington Magazine*
B.S.E.A.A. *Boletín del Seminario de Estudios de Arte y Arqueología* (University of Valladolid)
B.S.E.E. *Boletín de la Sociedad Española de Excursiones*
G.d.B.A. *Gazette des Beaux-Arts*
Z.f.b.K. *Zeitschrift für bildende Kunst*

Unless otherwise stated, all the paintings included in this catalogue are in oil on canvas.

1. THE VIRGIN AS A CHILD WITH A CHOIR OF ANGELS
Inscribed: "Fran[co] DeZurbaran fac/1616".
Figs. 1, 2 & 504.
1.93 × 1.56 m.
Seville: Manuel López Cepero sale, No. 66 (1860).
Madrid: Fernando Labrada.
Bilbao: Félix Valdés.
GA. 1 S. 1 GUI. 3 T.M. 1
Kehrer: pp. 32-33
Tormo y Monzó: "Cómo se estrenó Zurbarán y cómo hicieron estreno y principio otros artistas de su tiempo". *La Epoca,* 31 March 1905.
Mayer: *Die Sevillaner Malerschule* (pp. 147, 150 & 151). Leipzig, 1911.
Cascales Muñoz: *Francisco de Zurbarán* (Pl. X). Madrid, 1911.

2. THE CHILD JESUS BLESSING
Inscribed, in gold: "FRAN[CO] DEZVRBARAN FACIEBAT/1624", "... LLERE-NA".
Figs. 3 & 505.
Oil on copper, 0.19 × 0.17 m.
Barcelona: private collection.
A doubtful work, the inscription being contemporary with the picture itself. It is published as a possible example of what may have been produced in Zurbarán's studio in Llerena (1617-28).

3-8. PAINTINGS FROM THE DOMINICAN MONASTERY OF SAN PABLO EL REAL, SEVILLE (1626-27)
On 17 January 1626, Zurbarán — "a citizen of the town of Llerena at present residing in this city of Seville" — signed a contract with the prior of the Monastery of San Pablo el Real, by the terms of which he undertook to paint 21 pictures (14 scenes from the life of St Dominic, 4 Doctors of the Church, 1 St Bonaventura, 1 St Thomas and 1 St Dominic) in the space of eight months, being paid 4000 reales for the whole commission. Should any of the pictures not be to the prior's liking, Zurbarán undertook to paint it again. *Documentos para la Historia del Arte en Andalucía* II (p. 182).

3. APPARITION OF THE VIRGIN TO THE MONKS OF SORIANO
Figs. 4 & 6.
1.90 & 2.30 m.

Seville: Church of the Magdalen.
GA. 16 S. 5 GUI. 305 T.M. 3.

4. THE MIRACULOUS CURE OF BLESSED REGINALD OF ORLEANS
Figs. 5, 7 & 86.
1.90 × 2.30 m.
Seville: Church of the Magdalen.
GA. 15 S. 4 GUI. 304 T.M. 2.

5. ST JEROME
Fig. 8.
1.98 × 1.25 m.
Seville: Provincial Museum of Fine Arts, No. 193.
GA. 35 S. 16 GUI. 475 T.M.27.

6. ST GREGORY
Inscribed: "S. GREGO[VS]"
Fig. 9.
1.98 × 1.25 m.
Seville: Provincial Museum of Fine Arts, No. 191.
GA. 72 S. 14 GUI. 220 T.M. 25.

7. ST AMBROSE
Figs. 10 & 11.
2.05 × 0.98 m.
Seville: Provincial Museum of Fine Arts, No. 192.
GA. 37 S. 15 GUI. 210 T.M. 26.

8. CHRIST CRUCIFIED
Inscribed: "Fran[co] de Zurb.../fat 1627".
Fig. 12.
2.90 × 1.68 m.
In a memorial dated 27 June 1629, Councillor Rodrigo Suárez proposes that the Town Hall of Seville should take steps to ensure Zurbarán's continued residence in the city and, in support of his proposal, mentions the excellent quality of this canvas, which hung in the sacristy of San Pablo el Real. Gestoso y Pérez: *Ensayo de un diccionario de los artífices que florecieron en Sevilla,* II (pp. 124-125), Seville, 1900.
Seville: Monastery of San Pablo el Real. Oratory of the sacristy. On deposit in the Alcázar, Room 7, No. 224 (1810).
Canterbury: Jesuit College (given by the Duke of Alba around 1880).
Jersey: Jesuit College.

Chantilly: Jesuit College.
Basel: A. Frankhauser (1952).
Chicago: The Art Institute of Chicago (1954).
S. (2nd edition) 225 GUI. 90 T.M. 28.
Palomino: CVIII.
Ponz: IX-3/24.
Ceán Bermúdez: VI, pp. 47, 50.
Kehrer: pp. 62-63.
Guinard: "Los conjuntos..." II. *A.E.A.*, 1947 (pp. 161-201).
Zurbarán, introduction Cat. II (p. 186).
Milicua: "El crucifijo de San Pablo, de Zurbarán". *A.E.A.*, 1953 (pp. 177-186).
Soria: "Zurbarán's Crucifixion". *The Art Institute of Chicago Quarterly*, 1955 (pp. 46-48).

9-15. PAINTINGS FROM THE PRINCIPAL MONASTERY OF THE CALCED MERCEDARIANS, SEVILLE (1628-34)

On 29 August 1628, Zurbarán — "a citizen of the town of Llerena residing in this city of Seville" — signed a contract with the prior of the monastery of Our Lady of Ransom (The Mercedarian Order), according to which he undertook to finish before the end of August 1629, with the collaboration of as many assistants as he needed, 22 pictures for the refectory cloister, measuring two *varas* in height by two and a half in width (1 *vara* = about 2.8 ft), representing scenes from the life of St Peter Nolasco and following the prior's instructions as to what should figure in each of the canvases. The monastery, in turn, was to furnish the artist and his assistants with all the materials, besides providing them with board and lodging until the work was finished. Zurbarán was to be paid 1500 ducats for "working with his own hands" on the pictures. López Martínez: *Desde Martínez Montañés hasta Pedro Roldán* (pp. 221-222).

9. ST SERAPION
Inscribed: "Franco de Zurbarán fabt 1628" "B. Serapius".
Fig. 13.
1.205 × 1.035 m.
Seville: Monastery of the Calced Mercedarians. The "De Profundis" Room.
 On deposit in the Alcázar, No. 227 (1810).
 Julian Williams.
London: Richard Ford (1832).
Grantham: Sir Montague John Cholmeley (1836).
New York: David Koetser (1947).
Hartford (Connecticut): The Wadsworth Atheneum.
S. 28 GUI. 411 T.M. 28a.
This canvas may have been given by Zurbarán to the Mercedarian community, as an example of the quality of his work, when signing the above-mentioned contract.

10. BIRTH OF ST PETER NOLASCO
Figs. 14 & 18.
1.66 × 2.12 m.
Château de Courçon (France): private collection.
Bordeaux: Musée des Beaux-Arts.

11. VISION OF ST PETER NOLASCO
Inscribed: "FRANCO DE Z.F."

Fig. 15.
1.79 × 2.23 m.
Seville: Manuel López Cepero.
Madrid: Royal Collections (1821).
 Prado Museum, No. 1,236.
GA. 24 S. 30 GUI. 398 T.M. 29.

12. APPARITION OF ST PETER THE APOSTLE TO ST PETER NOLASCO
Inscribed: "FRANCISCVS DEZVRBARAN/FACIEBAT 1629".
Figs. 16, 19 & 506.
1.79 × 2.23 m.
Seville: Manuel López Cepero.
Madrid: Royal Collections (1821).
 Prado Museum, No. 1,237.
GA. 23 S. 31 GUI. 399 T.M. 30.

13. DEPARTURE OF ST PETER NOLASCO
Fig. 20.
1.71 × 2.12 m.
Paris: Louvre, Louis-Philippe's "Galerie Espagnole", No. 397 (acquired directly from the monastery of the Mercedarians in 1838).
London: Louis-Philippe sale, No. 415 (Christie's, 1853).
 J.W.C. Sawbridge-Erle-Drax sale, No. 153 (Christie's, 1935).
 A. Seligman.
United States: Randolph W. Hearst.
Dallas (Texas): Harry E. Stewart.
Mexico City: Franz Mayer (1959).
 Museum of the Academy of San Carlos.
S. 33 GUI. 400 T.M. 43.

14. THE LEGEND OF THE BELL
Inscribed: "FRANCO DEZURB... FATI/1630".
Figs. 22 & 23.
1.64 × 2.08 m.
Paris: Louvre, Louis-Philippe's "Galerie Espagnole", No. 398 (acquired directly from the monastery of the Mercedarians in 1838).
London: Louis-Philippe sale, No. 416 (Christie's, 1853).
 Pearce sale, No. 500 (Phillips, 1872).
 Charles T.D. Crews sale (Christie's, 1915).
 Sulley & Co.
Cincinnati (U.S.A.): The Cincinnati Art Museum, No. 1917-58.
GA. 25 S. 32 GUI. 401 T.M. 42.
Robinson, Fr. W.: *Cincinnati Art Museum Bulletin*, 1936, VII (pp. 17-27).

15. THE SURRENDER OF SEVILLE
Inscribed: "FRANCO DE ZVRBARAN 1634".
Fig. 24
1.60 × 2.08 m.
Eccleston, England: Duke of Westminster.
López Rey: "An Unpublished Zurbarán: the Surrender of Seville", *Apollo*, 1965. "Classici dell'Arte", No. 69. *Zurbarán* (Cat. No. 148). Rizzoli Editore.
Zurbarán did not paint the whole of the series envisaged. Figs. 518-521 reproduce the four compositions belonging to the series which are attributed to Francisco Reina.

Ramón, Fr. Alonso: *Discursos elógicos y apologéticos empresas y divisas sobre las triunfantes vida y muerte del glorioso patriarca San Pedro Nolasco*. Madrid, 1627.

Memoria de las admirables pinturas que tiene este Convento, Casa grande de N.ª Sr.ª de la Merced, redemptora de cautivos de la Ciudad de Sevilla. Seville: Biblioteca Colombiana (copy made in 1789 of a manuscript dated 1732).

Palomino: CVIII.

Carriazo: "Correspondencia Ponz-Aguila". *A.E.A.*, 1929 (p. 160).

Ponz: IX-3/47.

Ceán Bermúdez: VI, p. 49.

Notice des tableaux de la Galerie Espagnole. Paris, 1838.

Madrazo: *Catálogo descriptivo e histórico del Museo del Prado*. 1872.

Kehrer: pp. 42-43.

Sánchez Cantón: "La vida de San Pedro Nolasco: pinturas del refectorio de la Merced Calzada de Sevilla". *La Merced*, 24 January 1922.

Soria: "Francisco de Zurbarán: A Study of his Style". *G.d.B.A.*, January-March 1944 (pp. 161-175).

Guinard: "Los conjuntos..." II. *A.E.A.*, 1947 (pp. 161-175).

Zurbarán, introduction Cat. III (p. 187).

Sebastián, Santiago: "Zurbarán se inspiró en los grabados del aragonés Jusepe Martínez". *Goya*, No. 128, September-October 1975 (p. 82).

16-19. PAINTINGS FROM THE FRANCISCAN SCHOOL OF ST BONAVENTURA, SEVILLE

On 30 December 1627, Francisco de Herrera (The Elder) signed a contract with the Procurator of the Franciscan School of St Bonaventura by the terms of which he undertook to paint, on six canvases which were already mounted on stretchers at the School, six scenes from the life of St Bonaventura, the School's patron saint. According to this contract, Herrera would begin painting on 1 January 1628 and was to deliver one picture every six weeks, being paid 900 reales for the "manufacture and cost" of each of the finished canvases. If the painter failed to effect these deliveries on time, the Procurator was at liberty to transfer the commission to another artist. Four of the canvases painted by Herrera in accordance with this contract are still extant. López Martínez: *Arquitectos, escultores y pintores vecinos de Sevilla* (p. 63).

From 1629 onwards, the series devoted to St Bonaventura was continued by Zurbarán. According to Ceán Bermúdez, Zurbarán was responsible for "the pictures that are in the body of the church of the School of St Bonaventura on the Epistle side, for the ones on the Gospel side are by Herrera the Elder, and they all represent passages from the life of the titular saint". Ceán Bermúdez: VI, p. 48.

16. VISIT OF ST THOMAS AQUINAS TO ST BONAVENTURA

Inscribed: "Fᶜᴼ DE ZURBARAN/FAT 1629".

Fig. 25.

2.26 × 2.56 m.

Seville: on deposit in the Alcázar, No. 65 (1810).

Paris: Soult sale, No. 23 (1852).

Berlin: Kaiser Friedrich Museum, No. 404 A (1852); destroyed in April 1945.

GA. 17 S. 25 GUI. 378 T.M. 32.

17. PRAYER OF ST BONAVENTURA

Fig. 26.

2.39 × 2.22 m.

Seville: on deposit in the Alcázar, No. 70 (1810); returned to the School of St Bonaventura in 1814.

Paris: Louvre, Louis-Philippe's "Galerie Espagnole", No. 348 (acquired through Baron Taylor in 1836).

London: Louis-Philippe sale, No. 206 (Christie's, 1853).

Dresden: Gemäldegalerie, No. 696 (1952).

GA. 19 S. 24 GUI. 379 T.M. 33.

18. ST BONAVENTURA AT THE COUNCIL OF LYONS

Fig. 27.

2.50 × 2.25 m.

Seville: on deposit in the Alcázar, No. 69 (1810).

Paris: Soult sale, No. 22 (1852); acquired by the French State. Louvre, No. 1,738 (1858).

GA. 18 S. 26 GUI. 380 T.M. 34.

19. DEATH OF ST BONAVENTURA

Figs. 28 & 29.

2.50 × 2.25 m.

Seville: on deposit in the Alcázar, No. 64 (1810).

Paris: Soult sale, No. 24 (1852); acquired by the French State. Louvre, No. 1,739 (1858).

S. 27 GUI. 382 T.M. 35.

Palomino: CVIII.

Carriazo: "Correspondencia Ponz-Aguila". *A.E.A.*, 1929 (pp. 159, 160, 165, 166).

Ponz: IX-3/42.

Justi, Karl: "Das Leben des heiligen Buenaventura gemalt von Herrera dem Älteren und Zurbarán". *Jahrbuch der preussischen Kunstsammlungen*, 1883, IV (pp. 152-162).

Kehrer: pp. 47-52.

Kleinschmidt, R.P. Beda: "Das Leben des hl. Buenaventura in einem Gemäldezyklus von Francisco Herrera dem Älteren und Francisco Zurbarán". *Archivium historicum franciscanum*, 1926, XIX.

Guinard: "Los conjuntos..." I. *A.E.A.*, 1946 (pp. 266-270).

Soria: "Some Flemish Sources of Baroque Painting in Spain". *The Art Bulletin*, December 1948 (pp. 249-259).

Guinard: *Zurbarán*, introduction Cat. IV (p. 188).

20-27 PAINTINGS FOR THE RETABLE OF ST JOSEPH IN THE MONASTERY OF THE HOLY TRINITY, OUTSIDE SEVILLE (c. 1629)

On 26 September 1629, Pedro Calderón signed a contract with the treasurer in charge of certain property administered by the monastery of the Holy Trinity, by the terms of which he undertook to provide the painting, gilding and burnishing, in two months, of a retable (tabernacle included) which was already in position at one side of the chapel behind the high altar of the church. The price agreed upon was 490 ducats, of which he was to deliver "... one hundred and thirty of them to francisco de ÇURBARAN , master painter of this city, which is the price on which they have agreed for the painting of the panels of the said retable of St Joseph, and sixty ducats to give and deliver to baltasar quintero, master gilder and burnisher, for the burnishing and

flesh-tints of the Child Jesus and St Joseph in sculpture...". López Martínez, Celestino: *Retablos y esculturas de traza sevillana* (pp. 6-8). Antonio Ponz, in a reference to the retables to the side of the high altar chapel of the monastery, says that "Those on the Epistle side, by Zurbarán, represented the life of St Joseph and the Virgin, while on the little door to the sanctuary there is a Child Jesus, also by Zurbarán". Ponz: IX-5/6.

Ceán Bermúdez, for his part, tells us that in this monastery the works by Zurbarán are "The paintings of the side altar-piece on the Epistle side and a charming Child Jesus on the door of *its* sacrarium". Ceán Bermúdez: VI, p. 50.

Félix González de León, in a book entitled *Noticia artística, histórica y curiosa de todos los edificios públicos sagrados y profanos de esta ciudad de Sevilla*, published in 1844, says that there are eight canvases in the retable in question (p. 144).

20. ST JOSEPH AND THE CHILD JESUS
Fig. 30.
2.38 × 1.72 m.
Paris: Church of Saint-Médard.
T.M. 132.

21. ADORATION OF ST JOSEPH
Fig. 31.
1.24 × 1.045 m.
Paris: Louis-Philippe.
 Chevalier A.A. de Cosson.
Geneva: private collection.

22. ADORATION OF THE MAGI
Fig. 32.
1.24 × 1.045 m.
London: Rt. Rev. Mandell Creighton, Bishop of London.
Barcelona: private collection.

23. PRESENTATION IN THE TEMPLE
Fig. 34.
1.25 × 1.05 m.
London: F.A. Drey (1937).

24. THE FLIGHT INTO EGYPT
Fig. 37.
1.25 × 1.05 m.
France: Jean Gigoux.
Besançon: Musée des Beaux-Arts (1896).
GUI. 44 T.M. 206.
Angulo: "Algunos cuadros españoles en museos franceses". *A.E.A.*, 1954 (pp. 316-317).

25. JESUS AMONG THE DOCTORS
Fig. 35.
1.24 × 1.04 m.
Cádiz: Joaquín Giráldez.
GUI. 71 T.M. 156.
Pemán: "La serie de los Hijos de Jacob y otras pinturas zurbaranescas". *A.E.A.*, 1948 (pp. 153-155).

26. PRESENTATION OF THE VIRGIN
Fig. 33.
1.25 × 1.05 m.
Monastery of the Escorial.
Lozoya & Pérez Sánchez: "Los nuevos Museos en el Palacio Real de Madrid". *A.E.A.*, 1963 (p. 97, plate II).

27. CHILD JESUS GIVING HIS BLESSING
Fig. 36.
Oil on wooden panel, the back gilded, 0.42 × 0,27 m.
Seville: on deposit in the Alcázar, No. 280 (1810).
St Petersburg: Countess Schuwaloff (19th century).
Leningrad: Hermitage.
Moscow: Pushkin State Museum of Fine Arts.
S. 13 GUI. 58 T.M. 5.
Malitzkaya, K.: "Zurbarán in the Moscow Museum of Fine Arts". *B.M.*, July 1930 (pp. 16-20). "Zurbarán en los Museos Rusos". *A.E.A.*, 1964 (p. 109).
Guinard: "Los conjuntos..." II. *A.E.A.*, 1947 (pp. 189-191).
Zurbarán, introduction Cat. V (p. 190).

28. IMMACULATE CONCEPTION
Figs. 38 & 40.
1.74 × 1.38 m.
Seville: it seems very probable that this is the Immaculate Conception that Zurbarán painted for the Town Hall of Seville after the decision taken at a meeting of the Town Council on 8 June 1630.
Madrid: Melchor Gaspar de Jovellanos (1744-1811).
 Juan Arias de Saavedra (bequeathed by Jovellanos).
Jadraque (Guadalajara): Parochial School of Nuestra Señora del Carmen (bequeathed to the School by María Cristina Perlado y Verdugo, great-granddaughter of Juan Arias de Saavedra, in 1952).
Guinard: "Los conjuntos..." III. *A.E.A.*, 1949 (p.9).
Sanz-Pastor: *Catálogo de la Exposición Zurbarán en el III centenario de su muerte.* Madrid, 1964 (No. 4, pp. 98-100).
Gudiol: "Francisco de Zurbarán in Madrid". *B.M.*, 1965 (pp. 148-151).

29. VISION OF BLESSED ALONSO RODRIGUEZ
Inscribed: "F[CO] DE ZVRBARAN FA/1630".
Figs. 39, 41 & 508.
2.66 × 1.67 m.
Seville: Professed House of the Society of Jesus.
Madrid: Academy of San Fernando.
GA. 58 S. 39 GUI. 543.
This work comes from the Professed House of the Society of Jesus in Seville, as we are told in a text on Sevillian painters and sculptors written by Francisco de Bruna and the Conde del Aguila around the year 1780. Carriazo: "Correspondencia Ponz-Aguila". *A.E.A.*, 1929 (p. 176).
Kehrer: pp. 57-58.
Sanz-Pastor: *Catálogo de la Exposición Zurbarán en el III centenario de su muerte.* Madrid, 1964 (No. 6, p. 103).

30. THE VIRGIN AS A CHILD, SLEEPING
Fig. 42.
1.09 × 0.90 m.
Jerez: Collegiate Church.
GA. 166 S. 18 GUI. 27 T.M. 16a.
Mayer: "Some Unknown Works by Zurbarán". *Apollo*, 1928 (p. 181).
Romero de Torres: *Catálogo Monumental de la Provincia de Cádiz*, I (p. 405).
Gudiol: "Francisco de Zurbarán in Madrid". *B.M.*, 1965 (p. 151).

31. ADORATION OF THE SHEPHERDS
Fig. 43.
1.005 × 1.21 m.
London: Spanish Gallery (1936).
Seville: private collection.
Barcelona: private collection.

32. BIRTH OF THE VIRGIN
Fig. 44.
1.41 × 1.09 m.
Paris: Theodore von Berckheim (1925).
Florence: Conte Contini-Bonacossi.
Los Angeles: The Norton Simon Foundation (on deposit in Princeton University).
GA. 38 S. 10 GUI. 20 T.M. 7.
Longhi & Mayer: *The Old Spanish Masters from the Contini-Bonacossi Collection*. Rome, 1930.
Guinard: "Los conjuntos..." II. *A.E.A.*, 1947 (p. 191). *Zurbarán*, introduction Cat. V (p. 190).

33. ST NICHOLAS OF TOLENTINO
Fig. 45.
0.73 × 0.47 m.
Seville: private collection (1880).
Jerez: private collection.
Cadiz: Emile Huart.
GA. 56 S. 6 GUI. 517 T.M. 10.

34. ST ANTHONY OF PADUA
Fig. 46.
0.73 × 0.47 m.
Seville: private collection.
Jerez: private collection.
Cadiz: Emile Huart.
GA. 57 S. 7 GUI. 388 T.M. 11.
Angulo: "Cinco nuevos cuadros de Zurbarán". *A.E.A.*, 1944 (pp. 6-7).

35. ST JUSTA
Inscribed: "S. JVSA".
Fig. 47.
Oil on panel.
London: anonymous sale (Sotheby's, 1971). Private collection.

36. ST RUFINA
Oil on panel.
London: anonymous sale (Sotheby's, 1971). Private collection.
A.E.A., 1964. "Bibliografía", No. 179 (p. 253, plate I).

37. ST LAWRENCE
Fig. 48.
Madrid: private collection.

38. ST STEPHEN
Fig. 49.
Madrid: private collection.

39. MAESE RODRIGO FERNANDEZ DE SANTAELLA
Fig. 50
2.08 × 1.58 m.
Seville: School of Maese Rodrigo.
 Seminary of San Telmo.
S. 17 GUI. 575 T.M. 13.
Ceán Bermúdez: VI, p. 50.
Guinard: "Los conjuntos..." II. *A.E.A.*, 1947 (pp. 200-201).

40. ST. ANTHONY OF PADUA
Fig. 51.
1.60 × 1.04 m.
Milan: private collection.
São Paulo, Brazil: Museu de Arte (1950).
S. 17a GUI. 384 T.M. 36a.

41. DOMINICAN FRIAR READING
Fig. 52.
0.63 × 0.49 m.
Stockholm: Sven Boström.
Barcelona: Arteuropa.
GUI. 326.

42. ST DOMINIC
Fig. 53.

0.56 × 0.43 m.
London: in trade.
Barcelona: Arteuropa.

43. ST AUGUSTINE
Inscribed on the back: "The Glorious Great Doctor and light of the Church, St Augustine, Bishop of the city of Hipona in Africa. It is by the hand of the Admirable painter francisco de zurbaran. for Don Agustín Bejarano de Chaues".
Fig. 54.
Oil on panel, 0.425 × 0.295 m.
Barcelona: Bulbena Collection.
 Private collection.

44. FRAY DIEGO DEZA, ARCHBISHOP OF SEVILLE
Inscribed: "Donus Didacus Deca Archiep/Hisp elect Toletan inquisit/gen nr illustrissimus fundator".
Fig. 55.
1.74 × 1.43 m.
Seville: School of Santo Tomás de Aquino.
Madrid: Pérez de Acebo.
New York: Knoedler & Co.
Los Angeles: The Norton Simon Foundation.
S. 19 GUI. 328 T.M. 31.
Ponz: IX-3/25.
Ceán Bermúdez: VI, p. 48.
Guinard: *Zurbarán,* introduction Cat. VI (p. 190).

45. FRAY DIEGO DEZA
2.11 × 1.61 m.
Seville: School of Santo Tomás de Aquino.
Utrera: Marqués de San Marcial.
Seville: Fernando Serra y Pickman.
Barcelona: Galería Maragall.
Madrid: Prado Museum, unnumbered (1958).
GUI. 329 T.M. 31(I).
Guinard: "Los conjuntos..." I. *A.E.A.,* 1946 (p. 265). *Zurbarán,* introduction Cat. VI (p. 190).

46. CHRIST CRUCIFIED
Fig. 56.
1.24 × 0.80 m.
Seville: Provincial Museum of Fine Arts, No. 211.
GA. 68 S. 8 GUI. 93.
Gestoso: No. 211.

47. CHRIST CRUCIFIED
1.36 × 0.73 m.

Seville: Provincial Museum of Fine Arts.
GUI. 94.
Gestoso: No. 210.

48. CHRIST CRUCIFIED
Fig. 57.
1.68 × 1.19 m.
Madrid: Manuel Longorio.
 Condesa de Liniers.
New York: private collection.
GA. 69 S. 23 GUI. 92 T.M. 67.
Kehrer: p. 37.

49. CHRIST CRUCIFIED
Seville: Church of the Confraternity of Holy Charity.
Benjumea, José María: "Descubrimiento en Sevilla de un Zurbarán, un Herrera y un Murillo". *Bellas Artes,* No. 16, July-August 1972 (p. 57).

50. CHRIST DEAD ON THE CROSS
1.67 × 1.08 m.
Barcelona: Juan Guitart.
Oviedo: Massaveu Collection.
S. 22 GUI. 108.

51. ST LUCY
Inscribed: "S. LUCIA".
Fig. 58.
1.05 × 0.77 m.
Smyrna (Turkey): Paul Somazzi.
New York: Ehrich Galleries (1939).
 Chester Dale.
Washington: National Gallery of Art (1943).
S. 2 GUI. 272 T.M. 4
Mayer: "Unbekannte Werke Zurbarans". *Z.f.b.K.,* 1927-28 (p. 291).
Soria: "Two early Paintings of Zurbarán". *The Art Quarterly,* Autumn 1951 (pp. 256-260).

52. ST PETER'S DENIAL
Fig. 59.
Oil on paper laid on panel, 0.26 × 0.25 m.
Barcelona: private collection.

53. REGINA ANGELORUM
Fig. 60.
1.04 × 0.81 m.
Duxbury Hall, England: Frank Hall Standish.

Paris: Louvre, Louis-Philippe's "Galerie Espagnole".
London: Louis-Philippe sale (Christie's, 1853).
Keir, Scotland: William Stirling of Keir.
London: Stirling sale (Sotheby's, 1963).
 Sir Robert Adeane (Adeane sale: Christie's, 1968).
New York: private collection.
A.E.A., 1968 "Bibliografía", No. 210 (p. 202).

54. FRANCISCAN FRIAR
Fig. 61.
0.425 × 0.28 m.
Barcelona: J.M. Garrut.

55. CHRIST CRUCIFIED
Fig. 62.
2.52 × 1.72 m.
Seville : Church of the Capuchins.
 Provincial Museum of Fine Arts, No. 206.
GA. 67 S. 21 GUI. 95 T.M. 66.
Ponz: IX - 5/9.
Ceán Bermúdez: VI, p. 50.
Gestoso: No. 206.
Kehrer: p. 37.
Guinard: "Los conjuntos..." II. A.E.A., 1947 (p. 192).

56. THE HOLY FAMILY, ST ANNE, ST JOACHIM AND ST JOHN THE BAPTIST
Fig. 63.
1.36 × 1.28 m.
Madrid: Alberto Berges Gastiarena.
 Marquesa de Perinat.
 Marquesa de Campo Real.
GA. 97 S. 12 GUI. 53 T.M. 9.
Caturla: Catalogue of the Zurbarán Exhibition (No. 10), Granada, 1953.
Guinard: Zurbarán, introduction Cat. X (p. 194).

57. THE CHILD JESUS WITH A THORN
Fig. 64.
1.28 × 0.85 m.
Seville: according to tradition, in the Charterhouse of the Caves.
 Cayetano Sánchez Pineda.
 Manuel Sánchez Ramos.
GA. 40 S. 20 GUI. 61 T.M. 59.
Kehrer: p. 63.
Guinard: "Los conjuntos..." III. A.E.A., 1949 (pp. 5-6).

58. THE CHILD JESUS WITH A THORN
1.23 × 0.83 m.

Jerez: private collection.
Madrid: Joaquín Payá.
GUI. 62 T.M. 155.
Caturla: Catalogue of the Zurbarán Exhibition, Granada, 1953 (p. 49, fig. 3).

59. THE CHILD JESUS WITH A THORN
0.70 × 0.42 m.
Seville: possibly in the Charterhouse of the Caves.
 Provincial Museum of Fine Arts.
GA. 41 GUI. 64 T.M. 60.
Gestoso: No. 209.
Kehrer: p. 63.

60. VIATICUM
Fig. 65.
2.89 × 3.08 m.
Paris: Soult sale, No. 25 (1852).
Genoa: Palazzo Bianco (bequeathed by the Duchess of Galliera).
GA. 21 GUI. 381.
Kehrer: p. 51.
Justi: "Zurbarán und sein Ende". Z.f.b.K., 1911 (p. 25).
Soria: "Some Flemish Sources of Baroque Painting in Spain". The Art Bulletin, December 1948 (pp. 249-259).
Guinard: Los conjuntos... I. A.E.A., 1946 (pp. 269-270). Zurbarán, introduction Cat. IV (p. 188).
Herzog & Schlegel: "Beiträge zur F. de Zurbarán". Pantheon, 1960 (pp. 91-100).

61. ANGEL WEEPING
Fig. 66.
London: Koetser.
Santander: Emilio Botín.
T.M. 188.

62. ANGEL PRAYING
Fig. 67.
London: Koetser.
Santander: Emilio Botín.
T.M. 187.
Torres Martín: "La pintura de Zurbarán en los Museos y colecciones de la Gran Bretaña". Goya, No. 64-65, 1965 (p. 294).

63-70. PAINTINGS FOR THE RETABLE OF ST PETER IN THE CATHEDRAL OF SEVILLE
On 14 May 1620, Pedro Alvarez, acting on behalf of Doña Guiomar Pardo, Marquesa de Malagón, commissioned Diego López Bueno, "architectural carver and principal master-builder of buildings of this city of Seville and its archbishopric", to execute a retable "of wood,

paint, gilding and plaster", intended for the chapel of St Peter in the Cathedral of Seville. According to the contract, it was to contain seven canvases: St Peter, the Incarnation and the Eternal Father in the central part, St John the Evangelist and St Justa on the Gospel side, and St Anthony of Padua and St Rufina on the Epistle side. The work was to be completed in a year and the total price was to be 2250 ducats. López Martínez: *Desde Martínez Montañés hasta Pedro Roldán* (p. 71).

Three months later, on 11 August 1620, Diego López Bueno contracted Baltasar Quintero and Vicente Perea, "painters of religious images", to gild the retable in six months for 700 ducats. López Martínez: *Desde Martínez Montañés hasta Pedro Roldán* (p. 71).

After a further period of five years, on 8 August 1625, the retable was valued by the sculptor Juan Martínez Montañés and the painter Antonio Pérez. Their report gives a very detailed description of all its parts, including the stretchers and the panels for holding the canvases, but says nothing of the paintings themselves. López Martínez: *Retablos y esculturas de traza sevillana* (pp. 30-31).

Likewise, in the minutes of the chapter meeting held with reference to this chapel of St Peter on 3 October 1625, instructions are given for the retable to be set up in the place assigned to it and "then covering with boards the gaps where there are to be paintings, and let the secretary write to the Marqués de Malagón and to Don Duarte de Portugal, asking them to have the work completed in accordance with their obligation and the intention with which it was begun". *Documentos para la Historia del Arte en Andalucía*, Vol. I (p. 46).

63. VISION OF ST PETER
Fig. 68.
2.70 × 1.24 m.
GA. 7 S. 86 GUI. 144 T.M. 17.

64. REPENTANCE OF ST PETER
Fig. 69.
2.70 × 1.24 m.
GA. 8 S. 87 GUI. 146 T.M. 18.

65. JESUS GIVING THE KEYS TO ST PETER
Fig. 70.
0.76 × 1.30 m.
GA. 12 GUI. 139 T.M. 22.

66. ST PETER HEALING THE MAN SICK OF THE PALSY
Fig. 71.
0.76 × 1.30 m.
GA. 14 S. 89 GUI. 140 T.M. 23a.

67. CHRIST AND ST PETER WALKING ON THE WATER
Fig. 72.
0.76 × 1.30 m.
GA. 13 GUI. 138 T.M. 23.

68. IMMACULATE CONCEPTION
Fig. 73.
3.23 × 1.90 m.
GA. 9 S. 88 GUI. 4 T.M. 21.

69. ST PETER AND THE ANGEL
2.35 × 1.24 m.
GA. 10 S. 90 GUI. 142 T.M. 19.

70. CHRIST STOPPING ST PETER ON HIS FLIGHT FROM ROME
2.35 × 1.24 m.
GA. 11 GUI. 141 T.M. 20.
Palomino: CVIII.
Ponz: IX - 1/57.
Ceán Bermúdez: VI, pp. 45, 47, 48.
Kehrer: pp. 34-35.
Guinard: "*Los conjuntos...*" I. *A.E.A.,* 1946 (pp. 254-257). "*Los conjuntos...*" III. *A.E.A.,* 1949 (p. 35).
Soria: "Zurbarán's Altar of St Peter", *The Art Bulletin*, 1951 (pp. 165-173).
Guinard: *Zurbarán*, introduction Cat. VIII (p. 191).

71. IMMACULATE CONCEPTION
Fig. 74.
Seville: in trade.
Barcelona: private collection.

72. OUR LADY OF THE ROSARY
Fig. 75
Cadiz: Emile Huart.
GA. 206 GUI. 58 T.M. 254.
Angulo: "Cinco nuevos cuadros de Zurbarán". *A.E.A.,* 1944 (p. 7).

73. IMMACULATE CONCEPTION
Fig. 76.
1.39 × 1.04 m.
Seville: School of the Esclavas Concepcionistas del Divino Corazón.
Madrid: Prado Museum (1956).
S. (2nd edition) 226 GUI. 5 T.M. 226.
Sebastián y Bandarán: "Una Inmaculada de Francisco de Zurbarán". *Archivo Hispalense*, No. 64-65, 1955 (p. I).

74. IMMACULATE CONCEPTION
Fig. 77.
1.00 × 0.75 m.
London: in trade.
Private collection.
Young: "Una desconocida Inmaculada Concepción de Francisco de Zurbarán". *A.E.A.,* 1972 (p. 161).

75. DON ANDRES, CONDE DE RIBERA
Inscribed: "... ANTI BE/NEFECIJ..."

"/ANDRES/CONDE DE/RIBERA BENE/FACTOR INSIG/NE
DESTE HPL/MURIO A 29/DE DIZ DE/(1661)"
"...MEMORIAM TANTI BENEFICI..."
Fig. 78.
1.94 × 1.10 m.
Seville: Conde de Ribera.
 — On the death of the Conde de Ribera, this may have passed along with his other possessions into the possession of the Cuné family.
Provincial Museum of Fine Arts.
S. 35 GUI. 580 T.M. 63.
Hernández Díaz, José: "El retrato de D. Andrés, Conde de Ribera, del Museo Hispalense. Análisis de un cuadro". *Anales de la Universidad Hispalense,* Seville, 1960.

76. ST MICHAEL THE ARCHANGEL
1.64 × 1.10 m.
Cadiz: Bensusan Collection.
New York: Metropolitan Museum of Art, No. 89-15-17 (1888).
S.3.

77. ST MICHAEL THE ARCHANGEL
2.70 × 1.30 m. (approximately).
Madrid: Linares Collection.
Barcelona: Puig Palau.
GUI. 297 T.M. 127 (I).

1631-1640

78. APOTHEOSIS OF ST THOMAS AQUINAS
Inscribed: "Franco deZurbarán facb 1631".
Figs. 79 & 80.
4.73 × 3.75 m.
Seville: Church of the Dominican School of Santo Tomás (high altar).
On 21 January 1631, Francisco de Zurbarán signed a contract with the Rector of the Dominican School of Santo Tomás in Seville, undertaking to paint, by 24 June of the same year, a "large" picture, "of the size and shape agreed upon between us", intended for the chapel of the School's church. In the contract it was stipulated that the painter would be paid 400 ducats in copper coins. *Documentos para la Historia del Arte en Andalucía,* II (p. 183).
Seville: on deposit in the Alcázar, Room 2, No. 61 (1810).
Paris: between 1810 and 1814.
Madrid: between 1814 and 1818.
Seville: Dominican University College of Santo Tomás de Aquino (1819).
Provincial Museum of Fine Arts, No. 199 (1835).
GA. 70 S. 41 GUI. 317 T.M. 91.
Carriazo: "Correspondencia Ponz-Aguila". *A.E.A.,* 1929 (p. 169).
Ponz: IX — 4/25, 26.
Ceán Bermúdez: VI, pp. 45, 46, 48.
Gestoso: No. 199.
Kehrer: pp. 58-60.
Guinard: "Los conjuntos..." I. *A.E.A.,* 1946 (pp. 263-265). *Zurbarán,* introduction Cat. VI (p. 190).

79. SHEEP WITH FEET TIED TOGETHER
Inscribed: "Franco Dez.../. 1631".
Fig. 81.
1.20 × 0.90 m.
Madrid: private collection.

80. SHEEP WITH FEET TIED TOGETHER
Inscribed: "Franco de Zurbaran facie/1632".
0.65 × 0.79 m.
London: Frank Guymer.
Barcelona: Plandiura Collection.
S. 76 GUI. 591 T.M. 74.

81. ST FRANCIS
Inscribed: "Franco de Zurbaran fac/1632".
Fig. 82.
1.14 × 0.78 m.
Madrid: probably No. 414 in the 1814 catalogue of the collection in the Royal Palace.
Nice: Jones de Marcille.
Paris: Ivan Stchoukine sale, No. 71 (Hôtel Drouot, 1908).
Villandry: Dr Carvallo.
Buenos Aires: Alejandro E. Shaw (1934).
S. 61 GUI. 352 T.M. 105.

82. IMMACULATE CONCEPTION
Inscribed: "FRANCO DEZVRBARAN FACIE 1632".
Figs. 83, 84 & 507.
2.52 & 1.68 m.
Jerez: Pedro Aladro (c. 1900).
Señora de Almocadén Domecq.
Barcelona: Jaime Espona.
Art Museum of Catalonia (1958).
GA. 71 S. 59 GUI. 6 T.M. 78.
Kehrer: p. 61.
Mayer: "Some unknown works of Zurbarán". *Apollo,* VII, 1928 (p. 171).
Pemán: "La serie de los Hijos de Jacob y otras pinturas zurbaranescas". *A.E.A.,* 1948 (pp. 170-172).

83. STILL LIFE
Inscribed: "Franco DeZurbaran faciebt 1633".
Figs. 85, 87 & 88.
0.60 × 1.07 m.
Florence: Contini-Bonacossi.
Los Angeles: The Norton Simon Foundation.
S. 71 GUI. 594 T.M. 106.
Seckel: "Zurbarán as a painter of still life". *G.d.B.A.,* 1946 (pp. 283-286).
Sterling, Ch.: *La nature morte* (2nd edition), 1958.

84-95. THE APOSTLE SERIES OF THE MONASTERY OF SAO VICENTE DE FORA (LISBON)
Now in the National Museum of Ancient Art, Lisbon.

84. ST PETER
Inscribed: "Fran^co de Zurbaran faciebat 1633".
Fig. 89.
2.18 × 1.11 m.
Lisbon: Museu Nacional de Arte Antiga, No. 1379.
GA. 73 S. 78a GUI. 153 T.M. 79.

85. ST BARTHOLOMEW
Fig. 90.
2.18 × 1.11 m.
Lisbon: Museu Nacional de Arte Antiga, No. 1368.
GA. 78 S. 78k GUI. 184 T.M. 86.

86. ST PAUL
Fig. 91.
2.18 × 1.11 m.
Lisbon: Museu Nacional de Arte Antiga, No. 1377.
GA. 74 S. 78c GUI. 160 T.M. 80.

87. ST JOHN THE EVANGELIST
Fig. 92.
2.18 × 1.11 m.
Lisbon: Museu Nacional de Arte Antiga, No. 1381.
GA. 75 S. 78h GUI. 169 T.M. 87.

88. ST MATTHIAS
Fig. 93.
2.18 × 1.11 m.
Lisbon: Museu Nacional de Arte Antiga, No. 1369.
GA. 82 S. 78b GUI. 196 T.M. 82.

89. ST JAMES THE GREAT
Fig. 94.
2.18 × 1.11 m.
Lisbon: Museu Nacional de Arte Antiga, No. 1383.
GA. 77 S. 78f GUI. 189 T.M. 81.

90. ST ANDREW
Fig. 95.
2.18 × 1.11 m.
Lisbon: Museu Nacional de Arte Antiga, No. 1382.
GA. 76 S. 781 GUI. 179 T.M. 85.

91. ST THOMAS
Fig. 96.
2.18 × 1.11 m.
Lisbon: Museu Nacional de Arte Antiga, No. 1373.
GA. 84 S. 78j GUI. 205 T.M. 89.

92. ST SIMON
Fig. 97.
2.18 × 1.11 m.
Lisbon: Museu Nacional de Arte Antiga, No. 1370.
GA. 79 S. 78e GUI. 202 T.M. 84.

93. ST JAMES THE LESS
Fig. 98.

2.18 × 1.11 m.
Lisbon: Museu Nacional de Arte Antiga, No. 1380.
GA. 80 S. 78g GUI. 193 T.M. 88.

94. ST MATTHEW
Fig. 99.
2.18 × 1.11 m.
Lisbon: Museu Nacional de Arte Antiga, No. 1378.
GA. 83 S. 78i GUI. 175 T.M. 90.

95. ST PHILIP
Fig. 100.
2.18 × 1.11 m.
Lisbon: Museu Nacional de Arte Antiga, No. 1374.
GA. 81 S. 78d GUI. 199 T.M. 83.
O apostolado de Zurbarán. Museu Nacional de Arte Antiga, Lisbon, 1945.
dos Santos: "El apostolado de Zurbarán en Lisboa". *A.E.A.,* 1945 (pp. 189-192).
Angulo: "El apostolado de Zurbarán en el Museo de Lisboa". *A.E.A.,* 1945 (pp. 233-235).
Guinard: *Zurbarán,* introduction Cat. XXIV (p. 205).

92-106. CANVASES PAINTED IN MADRID AS PART OF THE DECORATION OF THE GRAND SALON (OR "SALON OF THE KINGDOMS") IN THE PALACE OF THE BUEN RETIRO (June-November 1634)
On 12 June 1634, Francisco de Zurbarán, "resident in Seville", signed a receipt in the "town of Madrid" for the two hundred ducats received "as an advance on what he is to receive for twelve pictures to be painted by him of the Labours of Hercules for the Salon of the Buen Retiro".
On 9 August, Zurbarán, "resident in this court" (of Madrid), signed a receipt for two hundred ducats which he was paid "as an advance on what he is to receive for the pictures he is now painting for the Salon of the Buen Retiro".
On 6 October, Zurbarán, "resident in this court", signed another receipt for two hundred ducats, "as an advance on what he is to receive for the pictures he is painting for the Salon of the Buen Retiro".
Caturla: "Cartas de pago de los doce cuadros de batallas para el Salón de Reinos del Buen Retiro". *A.E.A.,* 1960 (pp. 333-355).
On 13 November 1634, Francisco de Zurbarán, "resident in Seville and now in this court" (of Madrid), signed a receipt in which he declared that he had received five hundred ducats "which remained to complete the one thousand one hundred ducats which was the total price of the ten paintings representing the Efforts of Hercules and two large canvases he has painted of the Relief of Cadiz, the whole for the Grand Salon of the Buen Retiro". Caturla: "Zurbarán en el Salón de Reinos". *A.E.A.,* 1945 (pp. 292-300).
These pictures hang in the Prado Museum in Madrid, with the exception of one of the canvases of the "Relief of Cadiz" (possibly an episode in the arrival at Cadiz of the Indies Fleet, under the command of the Marqués de Cadereyta, after eluding the enemy blockade), which disappeared during the French occupation.

96. DEFENCE OF CADIZ AGAINST THE ENGLISH
Figs. 101 & 102.
3.02 × 3.23 m.
Madrid: Palace of Buenavista (Godoy) (1810).
Paris: 1810-1814.
Madrid: Prado Museum.
GA 100 S. 103 GUI. 571 T.M. 126.
Longhi: "Un San Tomaso di Velázquez e la congiuntura italo-spagnola tra il '500 e il '600". *Vita Artistica*, No. 2, 1927 (p. 8).

97. HERCULES SEPARATING CALPE AND ABYLA
Fig. 105.
1.36 × 1.67 m.
GA. 101 S. 99 GUI. 560 T.M. 116.

98. HERCULES DEFEATING GERYON
Fig. 106.
1.36 × 1.67 m.
GA. 102 S. 98 GUI. 561 T.M. 117.

99. HERCULES SLAYING THE NEMEAN LION
Fig. 107.
1.51 × 1.66 m.
GA. 103 S. 93 GUI. 562 T.M. 118.

100. HERCULES DESTROYING THE ERYMANTHIAN BOAR
Fig. 108.
1.32 × 1.53 m.
GA. 104 S. 95 GUI. 563 T.M. 119.

101. HERCULES AND THE CRETAN BULL
Fig. 104.
1.33 × 1.52 m.
GA. 105 S. 97 GUI. 564 T.M. 120.

102. HERCULES WRESTLING WITH ANTAEUS
Fig. 109
1.36 × 1.51 m.
GA. 106 S. 100 GUI. 565 T.M. 121.

103. HERCULES AND CERBERUS
Fig. 110.
1.32 × 1.51 m.
GA. 107 S. 101 GUI. 566 T.M. 122.

104. HERCULES CHANGING THE COURSE OF THE RIVER ALPHEUS
Fig. 111.
1.33 × 1.53 m.
GA. 108 S. 96 GUI. 567 T.M. 123.

105. HERCULES STRUGGLING WITH THE LERNEAN HYDRA
Fig. 103.
1.33 × 1.67 m.
GA. 109 S. 94 GUI. 568 T.M. 124.

106. HERCULES KILLED BY THE POISONED SHIRT OF THE CENTAUR NESSUS
Fig. 112.
1.36 × 1.67 m.
GA. 110 S. 102 GUI. 569 T.M. 125.
Palomino: CVIII.
Ponz: VI - 2/28.
Ceán Bermúdez: VI, p. 52.
Kehrer: pp. 77-80.
Soria: "Zurbarán: A Study of his Style". *G.d.B.A.*, 1944 (pp. 43-48).
Caturla: "Zurbarán en el Salón de Reinos". *A.E.A.*, 1945 (pp. 292-300).
Guinard: "Los conjuntos...." III. *A.E.A.*, 1949 (pp. 29-30). *Zurbarán*, introduction Cat. XI (p. 194).

107. ALONSO DE VERDUGO DE ALBORNOZ, LATER FIRST CONDE DE TORREPALMA (born 1623)
Inscribed: "Fran^{co} de Zurbarán f". "AETAS 12 A".
Painted in 1635.
Fig. 113.
1.85 × 1.03 m.
Paris: Oudry sale, No. 155 (Hôtel Drouot, 1869).
London: Napoleon III sale, No. 327 (Christie's, 1872).
 Holloway Collection.
 Alfred Morrison.
Berlin: Kaiser Friedrich Museum, No. 404 C (1906); destroyed in April 1945.
GA. 222 S. 104 GUI. 585 T.M. 157.
Kehrer: pp. 84-85.

108-116. PAINTINGS IN THE PARISH CHURCH OF SAN JUAN BAUTISTA. MARCHENA, PROVINCE OF SEVILLE (1635-37)
The official account of the 1633 canonical visit of inspection to the Parish Church of San Juan Bautista in Marchena (Seville) included instructions to the steward of the church to commission eight pictures "well painted and of the best kind possible", for the decoration of the recently reconstructed sacristy. After the 1635 visit these instructions were renewed, the number of pictures being increased to nine.
In the account of the 1637 canonical visit we read: "Following the instructions given by the said inspector on the last visit, the steward had nine pictures made in paint on canvas, a crucifixion, a conception and a saint john the baptist and six apostles, all of which was done in the city of Seville, and when the agreement was made for their execution the said inspector was present and incurred costs of ten ducats for each of them, and for all of them he delivered to Francisco Suberán, resident in Seville, the master who painted them, ninety ducats for which he extended receipt item 33,660". In the margin is written: "of a *vara* and a half high by five *cuartas* wide each." Four reales were also paid for the transport from Seville. Hernández Díaz: "Los Zurbaranes de Marchena". *A.E.A.*, 1953 (pp. 31-36).

108. CHRIST CRUCIFIED
Fig. 114.
1.815 × 1.07 m.
S. (2nd edition) 227 GUI. 113 T.M. 137.

109. ST JOHN THE EVANGELIST
Fig. 115.
1.83 × 1.065 m.
S. (2nd edition) 234 GUI. 170.

110. ST PETER
Fig. 116.
1.82 × 1.08 m.
S. (2nd edition) 227 GUI. 155

111. ST BARTHOLOMEW
Fig. 117.
1.78 × 1.07 m.
S. (2nd edition) 233 GUI. 185.

112. ST PAUL
Fig. 118.
1.815 × 1.07 m.
S. (2nd edition) 232 GUI. 162.

113. ST JAMES THE GREAT
Fig. 119.
1.80 × 1.07 m.
S. (2nd edition) 230 GUI. 190.

114. ST ANDREW
Fig. 120.
1.81 × 1.09 m.
S. (2nd edition) 235 GUI. 180.

115. ST JOHN THE BAPTIST
Fig. 121.
1.83 × 1.07 m.
S. (2nd edition) 229 GUI. 134.

116. IMMACULATE CONCEPTION
Fig. 122.
1.83 × 1.07 m.
S. (2nd edition) 228· GUI. 10 T.M. 136.
Guinard: *Zurbarán*, introduction Cat. XIV (p. 197).

117. IMMACULATE CONCEPTION
Inscribed: "... De Zurbaran facie/1636".
Figs. 123 & 509.
2.03 × 1.58 m.
New York: private collection.

118-119. CANVASES FROM THE CHURCH OF THE MONASTERY OF SAN JOSE (OF THE DISCALCED MERCEDARIANS) IN SEVILLE

118. ST LAWRENCE
Inscribed: "Fran^co de Zurbaran facie/1636".
Fig. 124.
2.92 × 2.26 m.

Seville: on deposit in the Alcázar, No. 219 (1810).
Paris: Soult sale, No. 27 (1852); bought by Tsar Nicholas I.
Leningrad: Hermitage, No. 349.
GA. 116 S. 117 GUI. 225 T.M. 148a.
Malitzkaya: "Zurbarán en los Museos Rusos". *A.E.A.*, 1964.

119. ST ANTHONY ABBOT
Inscribed: "Fran^co de Zurbaran fac^bat 1636".
2.82 × 2.21 m.
Seville: on deposit in the Alcázar, No. 220 (1810).
Paris: Soult sale, No. 26 (1852).
 Soult sale, No. 4 (1867).
 Comte de Clary.
 Baron de la Tournelle.
Bilbao: Félix Valdés (1953).
S. 118 GUI. 505.
Ponz: IX - 3/50.
Ceán Bermúdez: VI, pp. 47 & 49.
Guinard: "Los conjuntos..." II. *A.E.A.*, 1947 (pp. 180-182).
Zurbarán, introduction Cat. XII (p. 196).

120. ST ROMANUS AND ST BARULAS
Inscribed: "1638".
Fig. 125.
2.46 × 1.85 m.
Seville: Church of San Román (centre of the retable over the high
 altar).
 On deposit in the Alcázar, No. 11 (1810).
Paris: Soult sale, No. 28 (1852).
 Soult sale, No. 6 (1867).
 Ivan Stchoukine (c. 1910).
Villandry (France): Dr Carvallo.
Sitges (Barcelona): Charles Deering.
Chicago: Art Institute of Chicago (1947).
GA. 122 S. 148 GUI. 228 T.M. 18a.
Ceán Bermúdez: VI, p. 48.
Kehrer: p. 82.
Guinard: "Los conjuntos..." I. *A.E.A.*, 1946 (p. 263). *Zurbarán*,
introduction Cat. XVI (p. 198).
Justino Matute, in his *Adiciones y correcciones al tomo IX del "Viaje de España" de D. Antonio Ponz* (published by Gestoso y Pérez in *Archivo Hispalense*, 1886-88), points out that the canvas in question was the centre of a simple retable over the high altar of the church. Between the columns there were four other pictures in the same style: a *St Joachim and St Anne*, a *St John the Baptist*, a *St Joseph* and a *St Michael*.

121. SALVATOR MUNDI
Inscribed: "Fran^co dezurbaran-faciebat 1638".
Figs. 126 & 510.
1.00 × 0.73 m.
Madrid: Señora de Iturbe.
 Duchess of Parcent.
Barcelona: Félix Millet (1939).
GA. 123 S. 146 GUI. 121 T.M. 186.
Kehrer: p. 97.

122-142. PAINTINGS FROM THE HIGH ALTAR OF THE CHARTERHOUSE OF OUR LADY OF THE DEFENCE, OUTSIDE JEREZ DE LA FRONTERA (1637-39).

The only known document that refers to the construction of the retable for the high altar of the Charterhouse of Jerez is dated 7 November 1637. It says that Alonso Cano, Francisco de Zurbarán and Francisco Arche declare themselves guarantors of the sculptor José de Arce, who had signed a contract with the charterhouse undertaking to carve in two years, beginning on 31 October 1637, "all the sculptural work necessary for the retable". López Martínez: *Arquitectos, escultores y pintores vecinos de Sevilla* (p. 25).

Fr. Esteban Rallón Mercado (1608-89), in his manuscript *Historia de Xerez de la Frontera,* describes the retable as "still ungilded" and says that "in the openings or locations is arranged the life of Xst., and in the principal part the miracle of the Defence (Cat. 126), the whole very well painted and with an expert use of the brush". Rallón Mercado: *Historia de Xerez de la Frontera.* Jerez edition, 1926 (pp. 139 ff); see also Pemán: "La reconstrucción del retablo de la Cartuja de Jerez". *A.E.A., 1950.*

Antonio Ponz, referring to the high altar, writes: "The paintings (of the retable) are all by the celebrated Zurbarán: the figures, which are life-size, are in large pictures which represent the Incarnation (Cat. 122), Circumcision (Cat. 124), Nativity (Cat. 123) and Adoration of the Magi (Cat. 125). In other parts of the retable, painted by the same craftsman, are the four evangelists and other saints. On the side doors leading to the Sanctuary he painted two life-size angels with thuribles in their hands (Cat. 134 & 135) and in the passage leading to the very clean little room which constitutes the said Sanctuary there are paintings of some members of the order, also life-size (Cat. 136-142)." Later on in the text he says: "In the principal niche of this retable there is a new statuette of Our Lady... I doubt whether it is as good as the one that was there before; but, in any case, they are both in the monastery." Ponz: XVII - 6/16, 17.

This indicates the construction of a shrine for the Virgin, added after the construction of the retable itself and occupying the principal space. At all events, the picture known as the *Miracle of the Defence* (Cat. 126), mentioned by Rallón Mercado as being in the "principal opening", is stated by Ponz to have been in the Lay Brothers' Choir: "In two little retables in the lay brothers' choir there are two excellent paintings by the aforesaid Zurbarán and also by his hand are two large pictures hanging on the walls of this space; one represents the Blessed Virgin with the Child Jesus and different monks kneeling (Cat. 143); in the other we see Our Lady assisting the people of Jerez in a battle which they fought successfully against the Moors in this district... (Cat. 126)." Ponz: XVII - 6/20.

122-133. PAINTINGS FROM THE MAIN RETABLE

122. THE ANNUNCIATION
Figs. 127 & 128.
2.61 × 1.75 m.
Paris: Louvre, Louis-Philippe's "Galerie Espagnole", No. 325 (acquired through Baron Taylor in 1838).
London: Louis-Philippe sale, No. 157 (Christie's, 1853).
Paris: Duke of Montpensier (No. 186 in the 1866 catalogue). General de Beylie (1904).
Grenoble: Musée des Beaux-Arts, No. 559.
GA. 127 S. 137 GUI. 31 T.M. 194.

123. THE ADORATION OF THE SHEPHERDS
Inscribed: "Franc' de Zurbaran Philipi IIII Regis Pictor Faciebat/1638".
Figs. 129, 130 & 512.
2.61 × 1.75 m.
Paris: Louvre, Louis-Philippe's "Galerie Espagnole", No. 327 (acquired through Baron Taylor in 1838).
London: Louis-Philippe sale, No. 159 (Christie's, 1853).
Paris: Duke of Montpensier (No. 179 in the 1866 catalogue). General de Beylie (1904).
Grenoble: Musée des Beaux-Arts, No. 560.
GA. 126 S. 138 GUI. 38 T.M. 193.

124. THE CIRCUMCISION
Inscribed: "Franco de Zurbaran faci/1639".
Fig. 131.
2.61 × 1.75 m.
Paris: Louvre, Louis-Philippe's "Galerie Espagnole", No. 329 (acquired through Baron Taylor in 1838).
London: Louis-Philippe sale, No. 140 (Christie's, 1853).
Paris: Duke of Montpensier (No. 174 in the 1866 catalogue). General de Beylie (1904).
Grenoble: Musée des Beaux-Arts, No. 562.
GA. 129 S. 140 GUI. 42 T.M. 192.

125. THE ADORATION OF THE MAGI
Figs. 132 & 133.
2.61 × 1.75 m.
Paris: Louvre, Louis-Philippe's "Galerie Espagnole", No. 328 (acquired through Baron Taylor in 1838).
London: Louis-Philippe sale, No. 160 (Christie's, 1853).
Paris: Duke of Montpensier (No. 189 in the 1866 catalogue). General de Beylie (1904).
Grenoble: Musée des Beaux-Arts, No. 561.
GA. 128 S. 139 GUI. 40 T.M. 191.

126. THE BATTLE OF EL SOTILLO (Miracle of the Defence)
Fig. 134.
3.35 × 1.91 m.
Paris: Louvre, Louis-Philippe's "Galerie Espagnole", No. 355 (acquired through Baron Taylor in 1838).
London: Louis-Philippe sale, No. 405 (Christie's, 1853). Lord Taunton.
New York: Metropolitan Museum of Art, No. 1920-104 (1920).
GA. 148 S. 133 GUI. 570 T.M. 195.

127. ST BRUNO IN ECSTASY
Figs. 135 & 136.
3.41 × 1.95 m.
Cadiz: Provincial Museum of Fine Arts, No. 64.
GA. 146 S. 141 GUI. 447 T.M. 204.

128. ST MATTHEW
Fig. 137.

0.65 × 0.63 m.
Cadiz: Provincial Museum of Fine Arts (1835).
GA. 134 GUI. 174 T.M. 201 (I).

129. ST MARK
Fig. 138.
0.55 × 0.53 m.
Cadiz: Provincial Museum of Fine Arts (1835).
GA. 132 GUI. 166 T.M. 201 (II).

130. ST JOHN THE EVANGELIST
Fig. 139.
0.65 × 0.63 m.
Cadiz: Provincial Museum of Fine Arts (1835).
GA. 135 GUI. 167 T.M. 201 (III).

131. ST LUKE
Fig. 140.
0.55 × 0.53 m.
Cadiz: Provincial Museum of Fine Arts (1835).
GA. 133 GUI. 165 T.M. 201 (IV).

132. ST JOHN THE BAPTIST
Fig. 141.
0.61 × 0.81 m.
Cadiz: Provincial Museum of Fine Arts, No. 66 (1835).
GA. 131 S. 135 GUI. 135 T.M. 199.

133. ST LAWRENCE
Fig. 142.
0.61 × 0.81 m.
Cadiz: Provincial Museum of Fine Arts, No. 67 (1835).
GA. 130 S. 136 GUI. 226 T.M. 200.

134-142. PAINTINGS WHICH DECORATED THE DOORS AND THE PASSAGE TO THE SANCTUARY

134. ANGEL WITH THURIBLE, LOOKING RIGHT
Fig. 143.
Oil on panel, 1.22 × 0.66 m.
Cadiz: Provincial Museum of Fine Arts, No. 75 (1835).
GA. 136 S. 131 GUI. 299 T.M. 185.

135. ANGEL WITH THURIBLE, LOOKING LEFT
Fig. 144.
Oil on panel, 1.22 × 0.66 m.
Cadiz: Provincial Museum of Fine Arts, No. 76 (1835).
GA. 137 S. 132 GUI. 300 T.M. 185 (I).

136. ST BRUNO
Fig. 146.
Oil on panel, 1.22 × 0.66 m.
Cadiz: Provincial Museum of Fine Arts, No. 72 (1835).
GA. 138 S. 126 GUI. 448 T.M. 178.

137. ST ANSELM
Fig. 147.

Oil on panel, 1.20 × 0.64 m.
Cadiz: Provincial Museum of Fine Arts, No. 70 (1835).
GA. 142 S. 125 GUI. 460 T.M. 182.

138. ST ARTHOLD
Fig. 148.
Oil on panel, 1.20 × 0.64 m.
Cadiz: Provincial Museum of Fine Arts, No. 69 (1835).
GA. 144 S. 130 GUI. 463 T.M. 184.

139. ST HUGH OF GRENOBLE
Fig. 149.
Oil on panel, 1.20 × 0.64 m.
Cadiz: Provincial Museum of Fine Arts, No. 71 (1835).
GA. 140 S. 124 GUI. 459 T.M. 180.

140. CARDINAL NICCOLO ALBERGATI
Fig. 150.
Oil on panel, 1.20 × 0.64 m.
Cadiz: Provincial Museum of Fine Arts, No. 74 (1835).
GA. 139 S. 128 GUI. 468 T.M. 183.

141. ST HUGH OF LINCOLN
Fig. 151.
Oil on panel, 1.20 × 0.64 m.
Cadiz: Provincial Museum of Fine Arts, No. 68 (1835).
GA. 143 S. 129 GUI. 466 T.M. 181.

142. ST JOHN HOUGHTON
Fig. 152.
Oil on panel, 1.22 × 0.66 m.
Cadiz: Provincial Museum of Fine Arts, No. 73 (1835).
GA. 145 S. 127 GUI. 470 T.M. 179.

(UNNUMBERED). ST ARNOLD
Cadiz: Provincial Museum of Fine Arts (1835). Its present whereabouts being unknown, this painting is known to us only through a mid-19th century copy in a private collection in Cadiz.
Pemán: "Identificación de un Zurbarán perdido". *A.E.A.*, 1957 (pp. 321-329).
Ceán Bermúdez: VI, pp. 47, 51.
Kehrer: pp. 70-71, 75, 87-90.
Gutiérrez, Pedro: *La Cartuja de Jerez.* Jerez, 1924.
Guinard: "Los conjuntos...", III. *A.E.A.*, 1949 (pp. 14-20).
Pemán: "La reconstrucción del retablo de la Cartuja de Jerez de la Frontera". *A.E.A.*, 1950 (pp. 203-227).
Guinard: *Zurbarán*, introduction Cat. XVII (pp. 198-200).
Pemán: *Zurbarán en la hora actual.* Badajoz, 1961 (pp. 14-15).

143-146. PAINTINGS FROM THE CHARTERHOUSE OF JEREZ

143. OUR LADY OF THE CARTHUSIANS
Fig. 145.
3.25 × 1.90 m.
Paris: Louvre, Louis-Philippe's "Galerie Espagnole", No. 331 (acquired through Baron Taylor in 1838).

London: Louis-Philippe sale, No. 142 (Christie's, 1853).
Poznan: Count Raczynski.
　　　Muzeum Wielkopolskiego (Muzeum Narodowe w. Poznaniu).
Warsaw: on deposit in the Muzeum Narodowe.
GA. 147　S. 134　GUI. 474　T.M. 134.

144.　IMMACULATE CONCEPTION WITH ST JOACHIM AND ST ANNE
Figs. 153 & 154.
2.51 × 1.72 m.
Paris: Louvre, Louis-Philippe's "Galerie Espagnole", No. 332 (1838).
London: Louis-Philippe sale, No. 143 (Christie's, 1853).
　　　Hickman Collection.
　　　Lord Elcho and Wemyss (1857).
Edinburgh: National Gallery of Scotland, No. 340 (1859).
GA. 119　S. 143　GUI. 11　T.M. 196

145.　ST BRUNO
Fig. 185.
1.08 × 0.82 m.
Cadiz: Provincial Museum of Fine Arts, No. 17 (1835).
GA. 149　S. 142　GUI. 454.

146.　PENTECOST
Fig. 155.
1.60 × 1.16 m.
Cadiz: Provincial Museum of Fine Arts, No. 65 (c. 1835).
GA. 150　S. 123　GUI. 120　T.M. 203.
Ponz: XVII - 6/20, 22, 24.
Ceán Bermúdez: VI, p. 51.
Gutiérrez, Pedro: La Cartuja de Jerez. Jerez, 1924.
Guinard: "Los conjuntos..." III. A.E.A., 1949 (pp. 14-20).
Pemán: "La reconstrucción del retablo de la Cartuja de Jerez de la Frontera". A.E.A., 1950 (pp. 203-227). Catálogo del Museo de Bellas Artes de Cádiz. 1952.
Guinard: Zurbarán, introduction Cat. XVII (p. 198).
Pemán: Zurbarán en la hora actual. Badajoz, 1961.

147-165.　PAINTINGS IN THE SACRISTY OF THE MONASTERY OF SAN JERONIMO IN GUADALUPE
The building of the new sacristy in the monastery of San Jerónimo was begun on 5 August 1638 and the work was finished in 1647. Nothing is known of any document relating to the commission for the paintings which decorate the sacristy, but in the monastery account books there are the following records:
1640.　Payment to Francisco de Zurbarán, painter, resident in Seville, of 35,360 maravedís for the pictures he did for the Sacristy of Guadalupe.
1643.　Let payment be made to Francisco de Zurbarán, painter, for the rest of the paintings he did for the Sacristy of Guadalupe, of 15,266 maravedís.
Caturla: Catálogo de la exposición Zurbarán en el III centenario de su muerte (p. 62).

147.　THE MASS OF FATHER CABAÑUELAS
Inscribed: "Franco de Zurbaran/faciebat 1638"

Fig. 157.
2.90 × 2.22 m.
GA. 152　S. 157　GUI. 492　T.M. 213.

148.　FRAY GONZALO DE ILLESCAS, BISHOP OF CORDOBA
Inscribed: "Franco de Zurbaran f/1639".
Figs. 158, 159 & 511.
2.90 × 2.22 m.
GA. 157　S. 156　GUI. 491　T.M. 220.

149.　JESUS APPEARING TO FATHER ANDRES DE SALMERON
Inscribed: "Franco de Zurbaran faciet/1639".
Figs. 160 & 161.
2.90 × 2.22 m.
GA. 156　S. 155　GUI. 490　T.M. 219.

150.　ENRIQUE III CONFERRING THE ARCHBISHOP'S BIRETTA ON FATHER YAÑEZ
Inscribed: "Franco de Zurbaran fac/1639".
Figs. 162 & 163.
2.90 × 2.22 m.
GA. 158　S. 158　GUI. 493　T.M. 214.

151.　FRAY MARTIN VIZCAINO DISTRIBUTING ALMS
Inscribed: "Franco de Zurbaran facie/1639".
Figs. 164 & 165.
2.90 × 2.22 m.
GA. 154　S. 153　GUI. 495　T.M. 217.

152.　FATHER JUAN DE CARRION TAKING LEAVE OF HIS FRIENDS
Inscribed: "Franco de Zurbaran fac/1639".
Fig. 166.
2.90 × 2.22 m.
GA. 153　S. 152　GUI. 494　T.M. 216.

153.　VISION OF FRAY PEDRO DE SALAMANCA
Figs. 167 & 169.
2.90 × 2.22 m.
GA. 155　S. 151　GUI. 496　T.M. 215.

154.　TEMPTATION OF FRAY DIEGO DE ORGAZ
Fig. 168.
2.90 × 2.22 m.
GA. 151　S. 154　GUI. 489　T.M. 218.

155.　SCOURGING OF ST JEROME
Figs. 170, 171 & 172.
2.35 × 2.90 m.
GA. 161　S. 159　GUI. 486　T.M. 212.

156.　TEMPTATION OF ST JEROME
Figs. 173, 174 & 175.
2.35 × 2.90 m.
GA. 160　S. 160　GUI. 487　T.M. 211.

157-165. PAINTINGS FOR THE RETABLE IN THE CHAPEL OF THE SACRISTY

157. APOTHEOSIS OF ST JEROME
Fig. 177.
1.45 × 1.03 m.
GA. 159 S. 161 GUI. 488 T.M. 222.

158. HIERONYMITE FRIAR WITH A CROSS IN HIS HAND
Fig. 178.
Oil on panel, 0.34 × 0.16 m.
S. 162f GUI. 503 T.M. 221 (IV).

159. HIERONYMITE BISHOP READING
Fig. 179.
Oil on panel, 0.34 × 0.16 m.
S. 162b GUI. 498 T.M. 221 (I).

160. HIERONYMITE FRIAR WITH HIS EYES RAISED TO HEAVEN
Fig. 180.
Oil on panel, 0.34 × 0.16 m.
S. 162h GUI. 499 T.M. 221 (VI).

161. HIERONYMITE FRIAR STANDING
Fig. 181.
Oil on panel, 0.34 × 0.16 m.
S. 162c GUI. 502 T.M. 221 (III).

162. HIERONYMITE FRIAR SITTING
Fig. 182.
Oil on panel, 0.34 × 0.45 m.
S. 162d GUI. 501 T.M. 221 (VII).

163. HIERONYMITE FRIAR KNEELING
Fig. 183.
Oil on panel, 0.34 × 0.45 m.
S. 162e GUI. 500 T.M. 221 (VIII).

164. HIERONYMITE FRIAR READING
Fig. 184.
Oil on panel, 0.34 × 0.16 m.
S. 162a GUI. 497 T.M. 221 (II).

165. MARTYRED HIERONYMITE NUN
Fig. 186.
Oil on panel, 0.34 × 0.16 m.
S. 162g GUI. 504 T.M. 221 (V).
Ponz: VII - 4/18.
Ceán Bermúdez: VI, pp. 46, 51, 52.
Tormo: *El monasterio de Guadalupe y los cuadros de Zurbarán.* Madrid, 1905.
Kehrer: pp. 92-98.
Rubio y Acemel: *Historia de N.ª Sr.ª de Guadalupe.* Barcelona, 1926.
Guinard: "Los conjuntos..." III. *A.E.A.,* 1949 (pp. 21-22).
Gaya Nuño: *Zurbarán en Guadalupe.* 1951.
Pemán: "Zurbaranistas gaditanos en Guadalupe". *B.S.E.E.,* 1951 (pp. 155-186).
Guinard: *Zurbarán,* introduction Cat. XVIII (p. 200).

166-168. PAINTINGS PROBABLY FROM THE RETABLE OF THE CHURCH OF OUR LADY OF THE POMEGRANATE, LLERENA (1636-41).
In August 1636, Francisco de Zurbarán and the master-joiner Jerónimo Velázquez signed a contract in Llerena by the terms of which they undertook to execute in two and a half years, for the sum of 3150 ducats, a retable for the principal church of that town. In the contract it is specifically stated that Zurbarán, as a citizen of Llerena and because of his devotion to the town's patroness, Our Lady of the Pomegranate, had offered to do the work for no more than his expenses. Guinard: *Zurbarán* (p. 49).
On 4 May 1641, Francisco de Zurbarán empowered the master-joiner Jerónimo Velázquez to collect the 1575 ducats that were the latter's share of the 3150 ducats agreed upon in the contract for the architectural work and painting of the retable of the principal church of Llerena, "which is duly done and placed in it [the church], as appears from the written agreement drawn up in Llerena three years ago". López Martínez: *Desde Martínez Montañés hasta Pedro Roldán* (p. 223).

166. CHRIST BLESSING
Fig. 187.
Oil on panel, 0.51 × 0.26 m.
Llerena: Church of Nuestra Señora de la Granada.
Badajoz: Provincial Museum of Fine Arts.
S. 113 GUI. 122 T.M. 198.

167. THE VIRGIN IN THE CLOUDS
Fig. 190.
1.86 × 1.03 m.
Llerena: Church of Nuestra Señora de la Granada.
Badajoz: Provincial Museum of Fine Arts.
S. 112 GUI. 124 T.M. 197.

168. CHRIST DEAD ON THE CROSS
Fig. 191.
Oil on panel, approximately 1.50 × 0.75 m.
Llerena: Church of Nuestra Señora de la Granada.
S. 114 GUI. 114 T.M. 71.
Guinard: "Los conjuntos..." III. *A.E.A.,* 1949 (pp. 25-26). *Zurbarán,* introduction Cat. XIII (p. 197).

169. CHRIST AT EMMAUS
Inscribed: "Fran de /Zurbaran /1639".
Fig. 188.
2.28 × 1.54 m.
Mexico City: Monastery of San Agustín (possibly as early as the 17th century).
Academy of Fine Arts of San Carlos (1861).
GA. 167 S. 176 GUI. 118 T.M. 129.
Carrillo Gariel: *Las galerías de pintura de la Academia de San Carlos.* Mexico, 1944 (pp. 44 & 69).
Angulo: *Historia del Arte Hispanoamericano,* I, 1950 (p. 403).
Rudrauf: *Les disciples d'Emaüs, étude d'un thème plastique.* 1956 (p. 198).
Obregón: *Zurbarán en México.* Badajoz, 1964 (pp. 7-8).

170. ST FRANCIS KNEELING
Inscribed: "Fran^co de Zurbaran/faciebat/1639".
Fig. 193.
1.62 × 1.37 m.
Madrid: Estate of S.G. de la Huerta.
London: Sir Arthur Aston (c. 1840).
 Aston sale, No. 5 (1862).
 Sam Mendel sale, No. 348 (Christie's, 1875).
 Mrs Wood.
 National Gallery, No. 5655 (donated by Mrs Wood's heirs in 1946).
S. 167 GUI. 355 T.M. 224.

McLaren: *National Gallery Catalogues: The Spanish School.* 1952 (pp. 86-87).

171. CHRIST DEAD ON THE CROSS, WITH A DONOR
Inscribed: "Fran^co de Zur/baran faciebat/1640".
Fig. 189.
2.46 × 1.69 m.
Vitoria: Hueto and sons (1924).
Bilbao: Lezama Leguizamón.
S. 170 GUI. 116 T.M. 259.

WORKS PROBABLY PAINTED BETWEEN 1631 AND 1640

172. CHRIST AT EMMAUS
Fig. 192.
1.68 × 1.13 m.
Madrid: Dr Vega Díaz.
GUI. 119.

173. CHRIST CRUCIFIED
Figs. 194 & 195.
2.14 × 1.44 m.
Munich: Dr M.K. Rohe (1914).
Rome: private collection.
New York: Knoedler & Co.
Lugano-Castagnola: Château de Rohoncz Foundation (Baron Henry Thyssen-Bornemisza).
S. 50 GUI. 96 T.M. 112.
Kehrer: p. 36.

174. CHRIST CRUCIFIED
Fig. 196.
2.72 × 1.98 m.
Seville: Ibarburu (a canon of the chapter, born in Motrico).
Motrico (Guipúzcoa): Parish Church.
GA. 250 S. 51 GUI. 103 T.M. 70.
Tormo: "El Cristo de Motrico". *Cultura Española,* 1906.

175. CHRIST CRUCIFIED
Lima, Peru: private collection (acquired in Cuzco before 1930).
Stastny, Francisco: "Varia. Una Crucifixión de Zurbarán en Lima". *A.E.A.,* 1970 (pp. 83-86; plate I).

176. CHRIST CRUCIFIED
Cuzco (Peru): Church of Our Lady of Ransom (sacristy).
S. note to 51 GUI. 104.

177. CHRIST CRUCIFIED
Cuzco (Peru): Church of San Pedro.
S. note to 51 GUI. 105.

178. PORTRAIT OF A MERCEDARIAN FRIAR
Fig. 197.
0.69 × 0.56 m.
Madrid: Marqués de Casa Argudín (1905).
 Rumeu de Armas.
GA. 33 S. 29 GUI. 423.
Guinard: "Los conjuntos..." III. *A.E.A.,* 1949 (p. 37). *Zurbarán,* introduction Cat. III (p. 187).

179. THE VIRGIN AS A CHILD, WITH ST JOACHIM AND ST ANNE
Fig. 198.
Florence: Contini-Bonacossi.
GA. 85 S. 11 GUI. 22 T.M. 8.
Mayer: "The Education of the Virgin by Zurbarán". *B.M.,* 1924 (p. 212).
Longhi & Mayer: *The Old Spanish Masters from the Contini-Bonacossi Collection.* Rome, 1930.
Guinard: "Los conjuntos...." II. *A.E.A.,* 1947 (pp. 189-191). *Zurbarán,* introduction Cat. V (p. 190).

180. ST MARGARET
Figs. 199 & 200.
1.63 × 1.05 m.
London: possibly one of the three pictures given to the 2nd Lord
Ashburton (d. 1864) by the King of Spain around 1855.
Lady Ashburton (1871).
5th Marquess of Northampton.
National Gallery, No. 1930 (1903).
GA. 173 S. 56 GUI. 275 T.M. 53.
Kehrer: p. 106.
Soria: "Some Flemish Sources of Baroque Painting in Spain". *The*
Art Bulletin, December 1948 (pp. 249-259).
Guinard: "Los conjuntos..." III. *A.E.A.*, 1949 (pp. 30-31).
McLaren: *National Gallery Catalogues: The Spanish School* (2nd
edition), 1970 (p. 139).
Nothing is now known of the whereabouts of a replica of this canvas
which hung in the Royal Palace in Madrid towards the end of the
eighteenth century. Its existence is known thanks to an engraving of it
done in 1794 by Bartolomé Vázquez. It measured 1.56 × 0.91 m.
S. 57 GUI. 276 T.M. 54.
Ceán Bermúdez: VI, p. 52.
Catalogue of the Zurbarán Exhibition. Granada, 1953 (p. 44).

181-189. SERIES OF CANVASES WITH LIFE-SIZE
PORTRAITS OF PERSONALITIES OF THE MERCEDARIAN
ORDER, FROM THE PRINCIPAL MONASTERY OF THE
ORDER IN SEVILLE
Among the works by Zurbarán at the principal monastery of Our
Lady of Ransom (Calced Mercedarians), Ceán Bermúdez includes
"... the portraits of the Bishop of Teruel, Fray Gerónimo Carmelo,
and of the martyr Fray Fernando de Santiago in the print room;
eleven life-size standing figures of monks, and a crucifix with the
portrait of Fray Silvestre de Saavedra in the library". Ceán
Bermúdez: VI, p. 49.

181. MERCEDARIAN FRIAR
Figs. 201 & 203.
2.04 × 1.22 m.
Seville: principal monastery of Our Lady of Ransom (Library).
Madrid: Manuel Godoy (Palace of Buenavista).
Royal Academy of Fine Arts of San Fernando (1813).
GA. 26 S. 55 GUI. 415 T.M. 99.
An attempt has been made to identify this Mercedarian through the
portrait of Fray Alonso de Sotomayor signed by Valdés Leal in 1657,
which was published by the Marqués del Saltillo in "La heráldica en
el Arte". *A.E.*, 1931 (No. 34, p. 199).

182. FRAY JERONIMO PEREZ
Inscribed: "Mº F. GERONIMO PEREZ".
Figs. 202 & 204.
2.04 × 1.22 m.
Seville: principal monastery of Our Lady of Ransom (Library).
Madrid: Manuel Godoy (Palace of Buenavista).
Royal Academy of Fine Arts of San Fernando (1813).
GA. 28 S. 79 GUI. 416 T.M. 96.

183. FRAY PEDRO MACHADO
Inscribed: Mº F. PEDRO MACHADO".
Fig. 205.
2.04 × 1.22 m.
Seville: principal monastery of Our Lady of Ransom (Library).
Madrid: Manuel Godoy (Palace of Buenavista).
Royal Academy of Fine Arts of San Fernando (1813).
GA. 30 S. 80 GUI. 417 T.M. 95.

184. FRAY FRANCISCO ZUMEL
Inscribed: "Mº F. FRANCISCO ZUMEL".
Fig. 206.
2.04 × 1.22 m.
Seville: principal monastery of Our Lady of Ransom (Library).
Madrid: Manuel Godoy (Palace of Buenavista).
Royal Academy of Fine Arts of San Fernando (1813).
GA. 29 S. 81 GUI. 418 T.M. 98.

185. ST PETER PASCUAL, BISHOP OF JAEN
Inscribed: "SAN PASCUAL/OBISPO DE JAEN".
Fig. 207.
1.94 × 1.10 m.
Seville: principal monastery of Our Lady of Ransom (Print Room).
Provincial Museum of Fine Arts, No. 205 (1836).
GA. 36 S. 85 GUI. 412 T.M. 92.
Gestoso: No. 205.

186. ST CARMELUS, BISHOP OF TERUEL
Inscribed: "S. CARMELO/OBISPO DE TERVEL".
Fig. 208.
1.98 × 1.24 m.
Seville: principal monastery of Our Lady of Ransom (Library).
Madrid: Church of Santa Bárbara (Chapel).
GA. 29 S. 83 GUI. 413.
Tormo: *Las Iglesias del antiguo Madrid*: II, 1927 (p. 301).

187. FRAY FERNANDO DE SANTIAGO
Inscribed: "M FR FERNANDO/DE S.TIAGO PICO DE/ORO VERAEFIGIE".
Fig. 209.
2.04 × 1.22 m.
Seville: principal monastery of Our Lady of Ransom (Library).
Madrid: Manuel Godoy (Palace of Buenavista).
Royal Academy of Fine Arts of San Fernando (1813).
GA. 27 S. 82 GUI. 419 T.M. 97.

188. FRAY PEDRO DE OÑA, BISHOP OF GAETA
Inscribed: "D.F. PEDRO DE OÑA/OBISPO DE GAETA".
Fig. 210.
2.00 × 1.16 m.
Seville: principal monastery of Our Lady of Ransom (Library).
Convent of the Mercedarian Nuns (1836); discovered by the
Marqués de Lozoya.
Town Hall (1951); on deposit in the Provincial Museum of Fine
Arts.
S. 85a GUI. 420 T.M. 94.
"Un cuadro de Zurbarán descubierto en un convento sevillano".
ABC, Seville, 22 March 1950.
Angulo: "Crónica".,*A.E.A.*, 1950 (p. 269).

189. ST CARMELUS, BISHOP OF TERUEL

Inscribed: "S. CARMELO/OBISPO DE TE/RVEL".

1.94 × 1.10 m.

Seville: principal monastery of Our Lady of Ransom (Print Room).
Provincial Museum of Fine Arts, No. 196 (1836).

GA. 30 S. 84 GUI. 414 T.M. 93.

Gestoso: No. 196.

Memoria de las admirables pinturas que tiene este Convento, Casa grande de N.ª Srª de la Merced, redemptora de cautivos de la Ciudad de Sevilla. Seville, 1789 (copy of a 1732 manuscript).

Carriazo: "Correspondencia Ponz-Aguila". *A.E.A.*, 1929.

Ponz: IX - 3/48.

Colección de cuadros selectos de la Real Academia de San Fernando. Madrid, 1885.

Kehrer: pp. 57 & 145.

Mayer: "Anotaciones a cuadros de Velázquez, Zurbarán, Murillo y Goya en el Prado y en la Academia de San Fernando". *B.S.E.E.*, 1936 (p. 44).

Guinard: "Los conjuntos..." II. *A.E.A.*, 1947 (pp. 172-175).

Zurbarán, introduction Cat. III (p. 187).

Gudiol: "Francisco de Zurbarán in Madrid". *B.M.*, 1965 (pp. 148-151).

190-208. SERIES OF SMALL PICTURES OF MERCEDARIAN MARTYRS FROM THE DISCALCED MERCEDARIAN MONASTERY OF SAN JOSE, SEVILLE

Among the works by Zurbarán in the Discalced Mercedarian Monastery of San José, Ceán Bermúdez mentions "... many little pictures of martyred monks in the lower cloister, painted with the greatest skill and facility". Ceán Bermúdez: VI, p. 49.

In the inventory of the pictures assembled in the Alcázar of Seville in 1810, by order of Joseph Bonaparte, there are 38 "holy mercedarian martyrs" measuring 3/4 × 1/2 *varas*, lumped together under numbers 179, 337, 362 and 380. Gómez Imaz: *Inventario de los cuadros sustraídos por el Gobierno Intruso en Sevilla (año 1810).*

190. FRIAR FALLING ON A PYRE

Fig. 211.

0.61 × 0.41 m.

Madrid: Adanero Collection.

GA. 50 S. 163g GUI 429 T.M. 164.

191. FRIAR KNEELING

Fig. 212.

0.62 × 0.41 m.

Madrid: Vega-Inclán.
Toledo: "Casa del Greco".

GA. 53 S. 163j GUI. 433 T.M. 167.

192. MARTYR SITTING IN PRISON

Fig. 213.

0.62 × 0.42 m.

Seville: private collection.
Millán Delgado.
Madrid: private collection.

S. 163q GUI. 439 T.M. 170.

193. FRAY PEDRO DE SAN DIONISIO

Fig. 214.

0.61 × 0.41 m.

Madrid: Adanero Collection.

GA. 48 S. 163e GUI. 430 T.M. 162.

194. FRAY ARNALDO DE ARECHS

Fig. 215.

0.62 × 0.41 m.

Paris: Louvre, Louis-Philippe's "Galerie Espagnole" (1838).
London: Louis-Philippe sale (Christie's, 1853).
Asscher & Welker (1936).
Cambridge (Massachusetts): on deposit in the Fogg Art Museum.
Santander: Emilio Botín.

GA. 45 S. 163c GUI. 434 T.M. 159.

195. FRAY PEDRO DE ARMENGOL

Fig. 216.

0.61 × 0.41 m.

Paris: Louvre, Louis-Philippe's "Galerie Espagnole" (1838).
London: Louis-Philippe sale (Christie's, 1853).
Seville: Duke of Montpensier (1866 catalogue).
Madrid: Marqués de Valdeterrazo.

GA. 46 S. 163d GUI. 431 T.M. 160.

196. FRIAR BOUND TO THE STAKE

Fig. 217.

0.61 × 0.41 m.

Madrid: Adanero Collection.

GA. 49 S. 163f GUI. 428 T.M. 163.

197. FRIAR HANGED AND PIERCED WITH ARROWS

Fig. 218.

0.62 × 0.42 m.

Paris: Louvre, Louis-Philippe's "Galerie Espagnole" (1838).
London: Louis-Philippe sale (Christie's, 1853).
Hartford (Connecticut): on deposit in the Wadsworth Atheneum.

S. 163t GUI. 437 T.M. 172.

198. CRUCIFIED FRIAR

Fig. 219.

0.61 × 0.41 m.

Madrid: Señora de González Bilbao.

GA. 51 S. 163i GUI. 427 T.M. 166.

199. ST SERAPION

Fig. 220.

0.62 × 0.42 m.

Paris: Louvre, Louis-Philippe's "Galerie Espagnole" (1838).
London: Louis-Philippe sale (Christie's, 1853).
Asscher & Welker (1936).
New York: Jacques Lipschitz.
Amsterdam: in trade.

GA. 44 S. 163b GUI. 432 T.M. 158.

200. FRIAR EMBRACING A CROSS

Fig. 221.

0.62 × 0.42 m.
Paris: Louvre, Louis-Philippe's "Galerie Espagnole" (1838).
London: Louis-Philippe sale (Christie's, 1853).
Hartford (Connecticut): The Wadsworth Atheneum.
Amsterdam: in trade.
S. 163v GUI. 436 T.M. 175.

201. FRIAR STANDING
Fig. 222.
0.62 × 0.40 m.
Jerez: Pérez Asensio.
S. 163m GUI. 442.

202. FRIAR PIERCED WITH ARROWS
Fig. 223.
0.61 × 0.41 m.
Madrid: Ceballos Collection.
GA. 51 S. 163h GUI. 426 T.M. 165.

203. FRIAR KNEELING
Fig. 224.
0.61 × 0.41 m.
Jerez: Pérez Asensio.
S. 163n GUI. 443.

204. FRAY GUILLERMO DE SAGIANO
0.61 × 0.41 m.
Paris: Louvre, Louis-Philippe's "Galerie Espagnole" (1838).
London: Louis-Philippe sale (Christie's, 1853).
 Georges Durlacher sale (1938).
 Tomás Harris.
GA. 47 S. 163a GUI. 425.

205. MARTYR STANDING IN PRISON
0.62 × 0.42 m.
Seville: private collection.
 Millán Delgado.
S. 163r GUI. 440 T.M. 169.

206. FRIAR CARRYING THE MERCEDARIAN STANDARD
0.62 × 0.42 m.
Seville: private collection.
 Millán Delgado.
S. 163s GUI. 441 T.M. 168.

207. MARTYRED BISHOP
0.62 × 0.42 m.
Paris: Louvre, Louis-Philippe's "Galerie Espagnole" (1838).
London: Louis-Philippe sale (Christie's, 1853).
 W.E. Duits.

208. FRIAR KNEELING BEFORE A VISION OF GLORY
0.61 × 0.39 m. (enlarged to 0.63 × 0.42 m.).
Paris: Louvre, Louis-Philippe's "Galerie Espagnole" (1838).
London: Louis-Philippe sale (Christie's, 1853).
 Sir Charles Turner.
New York: Schaeffer Galleries.
S. 163w GUI. 435 T.M. 174.

(UNNUMBERED). FRIAR WITH NO HANDS
Paris: Louvre, Louis-Philippe's "Galerie Espagnole" (1838).
London: Louis-Philippe sale (Christie's, 1853).
Paris: Pereire sale, No. 65 (Hôtel Drouot, 1868); present whereabouts
 unknown.
S. 163k.

(UNNUMBERED). FRIAR WITH HIS TONGUE IN HIS HAND
Paris: Louvre, Louis-Philippe's "Galerie Espagnole" (1838).
London: Louis-Philippe sale (Christie's, 1853).
Paris: Pereire sale, No. 66 (Hôtel Drouot, 1868); present whereabouts
 unknown.
S. 163l.

(UNNUMBERED). MARTYR
Paris: Louvre, Louis-Philippe's "Galerie Espagnole" (1838).
London: Louis-Philippe sale (Christie's, 1853).
Paris: Laperlier sale, No. 198 (1879); present whereabouts unknown.
S. 163o.

(UNNUMBERED). MARTYR
Paris: Louis-Philippe's "Galerie Espagnole" (1838).
London: Louis-Philippe sale (Christie's, 1853).
Paris: Laperlier sale, No. 199 (1879); present whereabouts unknown.
S. 163p.
Palomino: CVIII.
Ponz: IX - 3/50.
Harris, E.: *From Greco to Goya*. London, 1938 (p. 44).
Angulo: "F. Zurbarán. Mártires mercedarios. San Carlos Borromeo". *A.E.A.*, 1941 (pp. 365-373). "Cinco nuevos cuadros de Zurbarán". *A.E.A.*, 1944 (pp. 1-9). "Tres nuevos mártires mercedarios". *A.E.A.*, 1947 (p. 146).
Guinard: "Los conjuntos..." II. *A.E.A.*, 1947 (pp. 185-187).
Pemán: "Nuevas pinturas de Zurbarán en Inglaterra". *A.E.A.*, 1949 (pp. 208-9).
Guinard: *Zurbarán*, introduction Cat. XII (p. 196).

209. ST ANTHONY ABBOT
Fig. 225.
1.62 × 1.20 m.
Paris: Yves Perdoux (1925).
Florence: Contini-Bonacossi.
 Galleria degli Uffizi (on deposit).
S. 173 GUI. 506 T.M. 258.
Longhi & Mayer: *The Old Spanish Masters from the Contini-Bonacossi Collection*. Rome, 1930.
Guinard: "Los conjuntos..." II. *A.E.A.*, 1947 (pp. 177-178).

210. PORTRAIT OF DR JUAN MARTINEZ SERRANO (1578-1653).
Fig. 226.
1.93 × 1.07 m.
New York: private collection.

211-212. TWO CANVASES IN THE CHURCH OF SANTOS JUSTO Y PASTOR, MADRID

211. ST FRANCIS
Fig. 227.
1.90 × 1.10 m.
S. 91 GUI. 368 T.M. 104.

212. ST DIEGO DE ALCALA
Fig. 228.
1.90 × 1.10 m.
S. 92 GUI. 389 T.M. 103.
Tormo: *Las Iglesias del antiguo Madrid*, II, 1927 (p. 287).

213. ST FRANCIS IN THE PORTIUNCULA
Fig. 229.
2.48 × 1.67 m.
Jerez: according to Ponz, in the choir of the Capuchin Church.
Cadiz: Provincial Museum of Fine Arts, No. 36 (1836).
GA. 22 S. 40 GUI. 331 T.M. 56.
Ponz: XVII - 5/70.
Ceán Bermúdez: VI, p. 51.
Kehrer: pp. 74-76.
Guinard: "Los conjuntos..." III. *A.E.A.*, 1949 (p. 21).
Pemán: *Catálogo del Museo de Bellas Artes de Cádiz*, 1952 (pp. 37-38).

214. THE VIRGIN AS A CHILD, PRAYING
Fig. 230.
1.17 × 0.94 m.
Madrid: Aureliano Beruete.
Darío de Regoyos.
New York: Metropolitan Museum of Art, No. 27-137.
GA. 43 S: 67 GUI. 23 T.M. 55.
Kehrer: p. 64.

215. PORTRAIT OF A FRANCISCAN
Fig. 233.
Olivares (Seville): private collection.
Seville: Millán Delgado.

216. VISION OF ST ANTHONY OF PADUA
Fig. 234.
1.805 × 1.13 m.
Wichita Falls (Texas): Midwestern University.

217. ST FERDINAND
Inscribed: "EL S.R.D.FERNANDO".

Fig. 231.
1.60 × 0.85 m.
Madrid: General Espeleta.
Gómez Moreno.
Granada: Rodríguez Acosta Foundation (Gómez Moreno Bequest).
GUI. 217.

218. ST FERDINAND SITTING
1.27 × 1.02 m.
London: Sotheby's, 3 July 1946.
New York: Frederick A. Mont.
Present whereabouts unknown.
S. 53 GUI. 218.

219. ST FERDINAND
Fig. 232.
1.29 × 0.61 m.
Leningrad: Hermitage.

220-227. PAINTINGS FROM THE CHURCH OF THE CARMELITE MONASTERY OF SAN ALBERTO, SEVILLE

(UNNUMBERED). ST FERDINAND
1.25 × 0.60 m.
Seville: on deposit in the Alcázar, Room 5, No. 231 (1810).
Paris: Soult sale, No. 39 (1852) (1.43 × 0.59 m.).
Jacques Reiset sale, No. 35 (1870).
Dollfus sale, No. 81 (1912).
Present whereabouts unknown.
S. note to 46 GUI. 216.

220. ST AGATHA
Fig. 240.
1.30 × 0.61 m.
Seville: on deposit in the Alcázar, Room 7, No. 232 (1810).
Paris: Soult sale, No. 34 (1852).
Montpellier: Musée Fabre, No. 34 (1852).
GA. 194 S. 46 GUI. 230 T.M. 50.

221. THE ARCHANGEL GABRIEL
Fig. 239.
1.46 × 0.60 m.
Seville: on deposit in the Alcázar, Room 2, No. 62 (1810).
Paris: Soult sale, No. 29 (1852).
Montpellier: Musée Fabre, No. 170 (1852).
GA. 125 S. 48 GUI. 298 T.M. 49.

222. ST ANDREW
Fig. 235.
1.46 × 0.60 m.
Seville: on deposit in the Alcázar, Room 2, No. 63 (1810).
Paris: Maréchal Soult.

London: *Duke of Sutherland (before 1836).*
 Sutherland sale, No. 144 (Christie's, 1913).
 Knoedler & Co.
Budapest: *Baron Hatvany.*
 Museum of Fine Arts, No. 25 (1949).
GA. 59 S. 47 GUI. 178 T.M. 44.
Waagen: II (1854), p. 67.
Kehrer: p. 110.

223. ST BLAISE
Inscribed: "S. BLAS".
0.92 × 0.31 m.
Seville: *on deposit in the Alcázar, Room 8, No. 268 (1810).*
Paris: *Soult sale, No. 37 (1852).*
Nice: *Bemberg Collection.*
Bucharest: *Royal Palace.*
Sinai (Romania): *Castle of Pelesh.*
S. 45 GUI. 212 T.M. 47.

224. ST PETER TOMAS
Inscribed: "S. P.º THOMAS".
Fig. 237.
0.91 × 0.32 m.
Seville: *on deposit in the Alcázar, Room 8, No. 269 (1810).*
Paris: *Maréchal Soult.*
London: *Duke of Sutherland (before 1836).*
 Sutherland sale, No. 145 (Christie's 1913).
New York: *Knoedler & Co.*
Boston: *Zoe Oliver Sherman.*
 Museum of Fine Arts (1922).
GA. 61 S. 42 GUI. 531 T.M. 46.
Waagen: II (1854), p. 67.
Kehrer: pp. 108, 145.

225. ST CYRIL OF CONSTANTINOPLE
Inscribed: "S. CIRILO".
Fig. 238.
0.91 × 0.32 m.
Seville: *on deposit in the Alcázar, Room 8, No. 270 (1810).*
 Paris: *Maréchal Soult.*
 London: *Duke of Sutherland (before 1836).*
 Sutherland sale, No. 145 (Christie's, 1913).
New York: *Knoedler & Co.*
Boston: *Zoe Oliver Sherman.*
 Museum of Fine Arts (1922).
GA. 60 S. 43 GUI. 530 T.M. 45.
Waagen: II (1854), p. 67.
Kehrer: p. 109.

226. ST FRANCIS
Fig. 236.
0.91 × 0.32 m.
Seville: *on deposit in the Alcázar, Room 8, No. 271 (1810).*
Paris: *Soult sale, No. 38 (1852).*
New York: *A. Seligman, Rey & Co.*
St. Louis (Missouri): *City Art Museum, No. 47-1941.*
S. 44 GUI. 339 T.M. 58.

227. VISION OF ST JOHN THE BAPTIST
Figs. 241 & 242.
1.19 × 1.96 m.
Paris: *Louvre, No. 172 in the 1842 catalogue of the Standish Collection.*
London: *Frank Hall Standish sale, No. 215 (Christie's, 1853).*
 J.S.W. Erle Drax sale, No. 132 (Christie's, 1910).
 Quinto Collection.
Barcelona: *José Rifà de Moles.*
GA. 4 S. 49 GUI. 132 T.M. 77.
Palomino: CVIII.
Carriazo: "Correspondencia Ponz-Aguila". *A.E.A.,* 1929 (p. 177).
Ponz: IX - 3/44.
Ceán Bermúdez: VI, p. 48.
Gómez Imaz: *Inventario de los cuadros sustraídos por el Gobierno Intruso en Sevilla (año 1810).* Seville, 1917.
Guinard: "Los conjuntos..." I. *A.E.A.,* 1946 (pp. 270-273). *Zurbarán,* introduction Cat. VII (p. 191).

228. ST FRANCIS
2.04 × 1.12 m.
Madrid: *Marqués de Leganés (18th century).*
Paris: *Marqués de Salamanca sale, No. 44 (1875).*
 Marqués de Salamanca sale, No. 51 (1876).
Mexico City: *Conde Felipe Suberville.*
Milwaukee (Wisconsin): *Milwaukee Art Center (1958).*
S. (2nd edition) 238 GUI. 340 T.M. 115.
Soria: "A life-size St Francis by Zurbarán in the Milwaukee Art Center". *The Art Quarterly,* 1959 (p. 148).

229. ST FRANCIS IN MEDITATION
0.56 × 0.33 m.
Madrid: *Prado Museum.*
Pontevedra: *Provincial Museum of Fine Arts (on deposit).*
S. note to 44 GUI. 341 T.M. 58 (I).

230. ST FRANCIS IN MEDITATION
0.54 × 0.36 m.
Paris: *Louvre, Louis-Philippe's "Galerie Espagnole", No. 358.*
London: *Louis-Philippe sale, No. 265 (Christie's, 1853).*
 Graves Collection.
 Th. Baring (d. 1873).
 Lord Northbrook sale (Christie's, 1940).
New York: *David Koetser.*
Princeton: *University Art Museum.*
S. note to 44 GUI. 342 T.M. 58 (II).
Waagen: IV (1857), p. 96.

231. ST FRANCIS IN MEDITATION
1.80 × 0.90 m., approximately.
Encinagorda (Zaragoza): *Parish Church.*
GUI. 343.

232. ST JOHN THE BAPTIST IN THE WILDERNESS
Fig. 243.
1.66 × 1.58 m.
Seville: Pedro Curiel.
Cathedral (Baptistery); sacristy of the Antigua (c. 1800).
GA. 120 S. 105 GUI. 133 T.M. 128.
Carriazo: "Correspondencia Ponz-Aguila". *A.E.A.,* 1929 (p. 174).
Ceán Bermúdez: VI, p. 48.
Soria: "Zurbarán: A Study of his Style". *G.d.B.A.,* 1944 (p. 158).
Guinard: "Los conjuntos..." I. *A.E.A.,* 1946 (pp. 258-259).

233. ST FRANCIS
Fig. 245.
1.81 × 1.11 m.
José Fernández Pintado.
Barcelona: Art Museum of Catalonia (1905).
GA. 244 S. 185 GUI. 375 T.M. 207.
Sanz-Pastor: *Catálogo de la Exposición Zurbarán en el III centenario de su muerte.* Madrid, 1964 (No. 104, p. 197).

234. ST FRANCIS
Fig. 244.
1.97 × 1.06 m.
Lyons: unidentified monastery suppressed in 1789, during the Revolution.
Public sale in the Place de St Pierre.
J.J. de Boisseau (1797).
Musée des Beaux-Arts (1807).
GA. 243 S. 183 GUI. 373 T.M. 208.
Kehrer: pp. 121-123.

235. ST FRANCIS
2.07 × 1.06 m.
Madrid: Lord Heytesbury, British Ambassador (1823).
Heytesbury (Wilts): Heytesbury sale, No. 1,358 (1926).
London: Tomás Harris (1931).
Lucerne: Böhler & Steinmeyer (1938).
Boston: Museum of Fine Arts, No. 1938-1617 (1938).
GA. 168 S. 184 GUI. 374 T.M. 209.
Waagen: IV (1857), p. 389.

236. PORTRAIT OF A YOUNG ECCLESIASTIC
Fig. 246.
0.59 × 0.46 m.
Seville: Aniceto Bravo.
London: Richard Ford (bought in Seville in 1832).
Ford sale, No. 32 (Rainey's, 1836); unsold.
Brinsley Ford.
S. 60 GUI. 578 T.M. 102.
Waagen: II (1854), p. 223.

237. ST AMBROSE OF SIENA
Inscribed: "S. Ambrosio de Sna".
Fig. 247.
1.08 × 0.80 m.
Córdoba: Monastery of San Pablo?
Provincial Museum of Fine Arts.
GA. 113 GUI. 319.
Kehrer: pp. 60-61.
Guinard: "Los conjuntos..." III. *A.E.A.,* 1949 (p. 13).

238. ST VINCENT FERRER
Fig. 248.
0.82 × 0.62 m.
Madrid: Guillermo Bernstein.
GUI. 321.

239. ST FRANCIS IN MEDITATION
Fig. 249.
0.95 × 0.70 m.
Santa Barbara (California): Santa Barbara Museum of Art, No. PT-1400-HLMP-54.
T.M. 76.
There are two other, rather larger, versions of this, one in the A. Domínguez Collection in Seville (1.19 × 0.89 m.; T.M. 39) and the other the property of Doña Concha Ibarra also in Seville (1.12 × 0.89 m.; T.M. 37).

240. ST FRANCIS IN MEDITATION, KNEELING
1.42 × 0.93 m.
Paris: Maréchal Soult.
Convent of Franciscan nuns of St Elizabeth (Rue de Turenne).
Lefébre Collection.
Adry et Tzanck.
Padienne Collection.
Zürich: Loschbichler.
GUI. 353.

241. ST FERDINAND
Fig. 250.
2.09 × 1.42 m.
Seville: Provincial Museum of Fine Arts.
GUI. 219.
Gestoso: No. 214.

242-246. CANVASES FROM THE CHURCH OF THE DISCALCED MERCEDARIAN MONASTERY OF SAN JOSE, SEVILLE

242. THE ETERNAL FATHER
Fig. 251.

2.40 × 2.77 m.

Seville: on deposit in the Alcázar, No. 73 (1810).

Provincial Museum of Fine Arts, No. 207 (before 1840).

GA. 5 S. 121 GUI. 1 T.M. 223.

Kehrer: pp. 33-34.

243. THE CORONATION OF ST JOSEPH

Figs. 252 & 253.

2.48 × 1.66 m.

Seville: on deposit in the Alcázar, No. 184 - attributed to Bernabé de
Ayala (1810).

Provincial Museum of Fine Arts, No. 198 (before 1840).

GA. 118 S. 120 GUI. 128 T.M. 152.

Kehrer: p. 150.

Gestoso: No. 207.

244. ST LUCY

Inscribed: "S. LVCIA".

Fig. 254.

1.16 × 0.68 m.

Seville: on deposit in the Alcázar, No. 321 (1810).

Paris: Soult sale, No. 31 (1852).

Marcille sale (1876).

Chartres: Musée de Chartres, No. 112 (1876).

GUI. 270 T.M. 141.

Kehrer: p. 106.

245. ST APOLLONIA

Inscribed: "S. POLO/NIA".

Fig. 255.

1.13 × 0.66 m.

Seville: on deposit in the Alcázar, No. 322 (1810).

Paris: Soult sale, No. 32 (1852).

Soult sale, No. 5 (1867).

Louvre Museum, No. 1740.

GA. 178 S. 119 GUI. 240 T.M. 142.

Kehrer: p. 148.

246. ST RAYMOND NONNATUS

Inscribed: "S. RAMON NONAº".

Fig. 256.

1.18 × 0.63 m.

Seville: on deposit in the Alcázar, No. 324.

Geneva: private collection.

(UNNUMBERED). ST PETER NOLASCO

1 1/4 × 3/4 *varas.*

Canvas mentioned, together with the preceding three, in the inventory
of the paintings assembled in the Alcázar of Seville in 1810, by order
of Joseph Bonaparte (No. 323). Present whereabouts unknown.

Ponz: IX - 3/50, 51.

Ceán Bermúdez: VI, p. 49.

Gómez Imaz: *Inventario de los cuadros sustraídos por el Gobierno*
Intruso en Sevilla (1810).

Guinard: "Los conjuntos..." II. *A.E.A.*, 1947 (pp. 177-179).

Soria: "Some Flemish Sources of Baroque Painting in Spain". *The*
Art Bulletin, December 1948 (pp. 249-259).

Guinard: *Zurbarán*, introduction Cat. XII (pp. 196-197).

247. THE HOLY HOUSE OF NAZARETH

Figs. 257 & 259.

1.65 × 2.30 m.

Paris: possibly No. 65 in the Walderstorff sale (1821).

Various private collections in France.

Cleveland (Ohio): The Cleveland Museum of Art (1960).

GUI. 67 T.M. 154a.

Francis, Henry S.: "Francisco de Zurbarán: The Holy House of
Nazareth". *The Bulletin of the Cleveland Museum of Art*, 1961 (pp. 46-
50).

248. JESUS AND THE CROWN OF THORNS

Fig. 258.

0.91 × 0.57 m.

South America: private collection.

Paris: private collection.

Barcelona: private collection.

GUI. 65.

249. ST FRANCIS RECEIVING THE STIGMATA

Fig. 260.

2.50 × 2.00 m., approximately.

Jerez: private collection.

Madrid: Linares Collection.

Barcelona: Luis Plandiura.

Madrid: Alvaro Gil.

GUI. 332.

Sanz-Pastor: *Catálogo de la Exposición Zurbarán en el III centenario*
de su muerte. Madrid, 1964 (No. 75, pp. 170-171).

250. ST CASILDA

Fig. 261.

1.70 × 1.08 m.

Granada: Archbishop's Palace.

Barcelona: Luis Plandiura (c. 1945).

Antonio Plandiura.

GA. 193 GUI. 243 T.M. 232.

Orozco Díaz, E.: "Un Zurbarán desconocido". *Cuadernos de Arte*,
Arts Faculty, Granada, 1937 (p. 34).

251. ST FRANCIS KNEELING

Fig. 262.

1.33 × 1.04 m.

Aachen: Weber van Houten (1886).

Sürmondt Museum (donated to the Museum by Frau van Houten
before 1914).

GA. 239 S. 168 GUI. 358 T.M. 225.

Kehrer: pp. 118 & 119.

252. ST FRANCIS KNEELING
Fig. 264.
1.64 × 1.23 m.
Madrid: Condesa de la Paz (?).
Paris: Otto Mündler.
Bonn: Wesendonck Collection.
Provincial Museum, No. 336.
Düsseldorf: Municipal Museum of Art, No. 773 (1935).
GA. 242 S. 169 GUI. 356 T.M. 210.
Kehrer: p. 124.

253. ST FRANCIS IN MEDITATION, KNEELING
1.37 × 0.47 m.
London: Arnol Collection.
Vienna: Kunsthistorisches Museum, No. 6,770 (Arnol Donation, 1931).
GUI. 357.

254. MARY MAGDALEN
Inscribed: "Fra... baran" (Doubtful).
Fig. 263.
1.46 × 1.11 m.
London: John Meade sale (1851).
Richard Ford.
Ford Sale, No. 25 (Christie's, 1929).
Tomás Harris.
Mexico City: Academy of Fine Arts of San Carlos (1934).
GA. 171 S. 174 GUI. 273 T.M. 237.
Waagen: II (1854), p. 223.

255. ST PETER OF ALCANTARA
Fig. 265.
0.67 × 0.54 m.
Seville: L. Koidl.
García de Blanes Claros.
S. 36 GUI. 395.

256. ST DIEGO DE ALCALA
Fig. 266.
1.10 × 0.84 m.
Madrid: Museo Lázaro.
GA. 229 S. 201 GUI. 391 T.M. 262.
Kehrer: p. 147.
Sánchez Cantón: "D. José Lázaro y su legado a España". *Albor*, XI-26 (pp. 215-231).
Soria: "Zurbarán: A Study of his Style". *G.d.B.A.*, 1944 (p. 169).

257. HIERONYMITE FRIAR READING
Fig. 267.
0.64 × 0.50 m.
Venice: private collection.
Barcelona: private collection.

258. ST FRANCIS KNEELING
Fig. 268.
1.52 × 0.99 m.
Paris: Louvre, Louis-Philippe's "Galerie Espagnole", No. 346 (1838).
London: Louis-Philippe sale, No. 50 (Christie's, 1853).
National Gallery, No. 230 (1853).
GA. 245 S. 166 GUI. 354 T.M. 151.
Kehrer: p. 119.
McLaren: *National Gallery Catalogues: The Spanish School.* London, 1952.

259. ST LUKE BEFORE THE CRUCIFIED CHRIST
Fig. 269.
1.05 × 0.84 m.
Madrid: possibly in one of the royal collections.
Pau: Prince Sebastián Gabriel (d. 1875, great-grandson of Carlos III).
Madrid: Cristóbal Colón, Duke of Veragua (married to an heir of Prince Sebastián Gabriel).
Prado Museum, No. 2,594 (1936).
GA. 252 S. 219 GUI. 107 T.M. 270.
Kehrer: pp. 24, 126.

260. CHRIST DEAD ON THE CROSS
Fig. 270.
1.55 × 1.05 m.
Seville: Misericordia Hospital.
Provincial Museum of Fine Arts.
GUI. 111 T.M. 48.
Angulo: "Algunos cuadros españoles en Museos franceses". *A.E.A.*, 1947 (pp. 317-318).

261. CHRIST DEAD ON THE CROSS
2.50 × 1.90 m., approximately.
Seville: Marqués de Villafuerte.
Bilbao: Félix Valdés.
S. 37 GUI. 109 T.M. 68.

262. CHRIST DEAD ON THE CROSS
Fig. 271.
2.53 × 1.93 m.

Seville: School of Maese Rodrigo.
Provincial Museum of Fine Arts, No. 202 (before 1840).
GA. 68 S. 62 GUI. 110 T.M. 69.
Ceán Bermúdez: VI, p. 50.
Gestoso: No. 202.
Kehrer: p. 137.
Guinard: "Los conjuntos..." III. *A.E.A.,* 1949 (p. 200).

263. CHRIST DEAD ON THE CROSS
2.88 × 1.87 m.
Seville: Monastery of San José, of the Discalced Mercedarians (Sacristy).
On deposit in the Alcázar, No. 10 (1810).
Paris: Louvre, Louis-Philippe's "Galerie Espagnole", No. 333.
London: Louis-Philippe sale, No. 145 (Christie's, 1853).
Sir Edward Hammer, Bart.
Giuseppe Bellesi (1936).
R. Langton Douglas.
New York: Carl W. Hamilton.
Mr Hann.
The Metropolitan Museum of Art, No. 65.220.2.
GUI. 112.
Ponz: IX - 3/50.
Céan Bermúdez: VI, p. 49.
Mayer: "Anotaciones a los cuadros de Velázquez, Zurbarán...".
B.S.E.E., 1936 (p. 43).
Guinard: "Los conjuntos..." II. *A.E.A.,* 1947 (pp. 183-184).

264. CHRIST AFTER THE SCOURGING
Fig. 272.
1.79 × 1.23 m.
Berlin: Royal Museum (1835).
Kaiser Friedrich Museum (until 1884).
Breslau: Schlesisches Museum der bildenden Künste, No. 119 (until 1906).
Poznan: Muzeum Narodowe W. Poznaniu.
GA. 255. S. 221 GUI. 77 T.M. 273a.
Kehrer: p. 141.

265. CHRIST BOUND TO THE COLUMN, WITH A DOMINICAN DONOR
Hamburg: Aehrens Collection.
Present whereabouts unknown.
GA. 2 GUI. 76.
Mayer: *Historia de la pintura española,* 1947 (p. 328, fig. 244).

266. THE CHILD JESUS IN THE DOMINICAN HABIT
Fig. 273.
Madrid: private collection.

267. THE ADORATION OF THE EUCHARIST
Fig. 274.
1.38 × 1.04 m.
Madrid: Estate of Isabel López (1905).
Villanueva de Segura (Murcia): The Hospice.
Murcia: Provincial Museum of Fine Arts.
GA. 65 GUI. 130.

268. BURIAL OF ST CATHERINE ON MOUNT SINAI
Fig. 275.
2.02 × 1.28 m.
Seville: Monastery of San José, of the Discalced Mercedarians (Chapel of St Catherine).
On deposit in the Alcázar, No. 71 (1810).
France: after 1810.
Château de Courçon: private collection.
GUI. 248.
Ponz: IX - 3/50.
Ceán Bermúdez: VI, p. 49.
Gómez Imaz: *Inventario de los cuadros sustraídos por el Gobierno Intruso en Sevilla (año 1810).*
Angulo: "Una estampa de Cornelius Cort en el taller de Zurbarán". *A.E.A.,* 1931 (pp. 65-67).
Exposition des Amis du Louvre. Le Cabinet de L'Amateur. Paris, 1956.
Guinard: "Los conjuntos..." II. *A.E.A.,* 1947 (pp. 183-184).
Zurbarán, introduction Cat. XII (pp. 196-197).
In the inventory of the paintings deposited in the Alcázar of Seville in 1810, published by Gómez Imaz, this picture is mentioned along with another original by Zurbarán, of identical size, representing the Martyrdom of St Catherine. Nothing is known of the present whereabouts of this work.

269. BURIAL OF ST CATHERINE
1.95 × 1.32 m.
New York: Frederick Mont.
Kansas City: The Nelson Gallery of Art.
GUI. 246.

270. BURIAL OF ST CATHERINE
Madrid: José Lázaro.
Present whereabouts unknown.
GUI. 245.

271. BURIAL OF ST CATHERINE
Seville: House of Lay Sisters of the Holy Trinity (19th century).
Dos Hermanas (Seville): Conde de Ibarra.
GUI. 247.
Sebastián y Bandarán: *Boletín de la Academia de Buenas Letras.* Seville, March 1921 (p. 19).

272. BURIAL OF ST CATHERINE
Ginés (Seville): Parish Church.
GUI. 249.
Hernández Díaz: *Catálogo Monumental de Sevilla,* IV (p. 208, fig. 369).

273-274. PAINTINGS FROM THE DOMINICAN MONAS-TERY OF SANTO DOMINGO DE PORTA COELI, SEVILLE

273. BLESSED HENRY SUSO
Inscribed: "ENRIQUE".
Figs. 276 & 277.
2.09 × 1.54 m.
Seville: on deposit in the Alcázar, No. 67 (1810).
 Provincial Museum of Fine Arts, No. 197 (1835).
GA. 232 S. 149 GUI. 322 T.M. 189.

274. ST LUIS BELTRAN
Fig. 278.
2.09 × 1.55 m.
Seville: on deposit in the Alcázar, No. 68 (1810).
 Provincial Museum of Fine Arts, No. 201 (1835).
GA. 233 S. 150 GUI. 323 T.M. 190.
Ponz: IX - 5/3.
Ceán Bermúdez: VI, p. 50.
Kehrer: p. 83.
Guinard: "Los conjuntos..." II. *A.E.A.,* 1947 (pp. 187-189).
Zurbarán, introduction Cat. XX (p. 204).

275. ST AUGUSTINE
Fig. 279.
2.02 × 1.05 m.
Seville: Monastery of St Augustine.
 León Barrau (1868).
 Adela Grande (Señora de Barrau).
Bilbao: Félix Valdés (1945).
GA. 204. S. 65 GUI. 509 T.M. 101.

276. ST SEBASTIAN
Fig. 280.
2.00 × 1.05 m.
Seville: Monastery of St Augustine.
 León Barrau (1868).
 Adela Grande (Señora de Barrau).
 Provincial Museum of Fine Arts (on loan from Adela Grande).
San Sebastián: private collection (1959).
S. 203 GUI. 229.

277-280. PAINTINGS OF THE LATERAL RETABLES IN THE CHOIR OF THE CHAPEL OF THE MONASTERY OF SAN JERONIMO, GUADALUPE
Ceán Bermúdez heads his list of works by Zurbarán in the monastery of San Jerónimo with "St Ildefonso and St Nicholas of Bari on two altars at the entrance to the choir". Ceán Bermúdez: VI, pp. 51-52.

277. ST NICHOLAS OF BARI
Fig. 281.
2.50 × 1.50 m.
GUI. 227.

278. THE MASS OF ST GREGORY
1.00 × 0.70 m.
GUI. 221.

279. ST ILDEFONSO RECEIVING THE CHASUBLE
Fig. 282.
2.50 × 1.50 m.
GUI. 224.

280. ST JEROME IN PENITENCE
1.10 × 0.60 m.
GUI. 476.
Ponz: VIII - 4/18.
Guinard: *Zurbarán,* introduction Cat. XVIII (pp. 200-202).

281. LAMB
Inscribed: "TANQUAM AGNUS".
Fig. 283.
0.35 × 0.52 m.
Paris: possibly No. 129 in the Alphonse Oudry sale (Hôtel Drouot, 1869).
Edinburgh: Arthur Kay.
London: A. Kay sale (Christie's, 1922).
 A. Kay sale (Christie's, 1943).
San Diego (California): Fine Arts Gallery.
S. 75 GUI. 129 T.M. 249.
Soria: "A Zurbarán for San Diego". *The Art Quarterly,* 1947 (p. 67).

282. SHEEP
0.38 × 0.62 m.
Madrid: Marquesa de Socorro (on the back this picture bears the seal "REX FERDINANDUS VII").
S. 77 GUI. 592 T.M. 250.
Palomino: CVIII.
Angulo, Diego: "Una variante del Agnus Dei del Museo de San Diego". *A.E.A.,* 1950.

283-285. ST. PETER SET FREE BY THE ANGELS (composition in three canvases)
Madrid: Molina Dazas.
Oviedo: Massaveu Collection.

283. ST PETER AND AN ANGEL
1.50 × 1.50 m.
GUI. 143a.

284. ORANT ANGEL
1.50 × 1.00 m.
GUI. 143b.

285. ORANT ANGEL
1.50 × 1.00 m.
GUI. 143c.

Zurita: "Tres magníficos cuadros de Zurbarán que son desconocidos". *ABC*, Madrid, 4 March 1928.
Cascales: *Francisco de Zurbarán* (2nd edition), 1931.

286-295. PAINTINGS FOR THE RETABLE OF ST ILDEFONSO IN THE PARISH CHURCH OF SANTA MARIA, ZAFRA (1643-44)

On 16 May 1643, Alonso de Salas Parra, who was Attorney, Syndic and Perpetual Councillor of Zafra, founded the chapel of Our Lady of Remedies in the Collegiate Church of Santa María in that town. In the statute of foundation it was specifically stated that the retable should include an *Assumption of the Virgin* in sculpture, a *St Ildefonso*, a *St Jerome*, a *St Barnabas* and a *St Nicholas of Tolentino*. Guinard: *Zurbarán*, introduction Cat. XIX (p. 202).

Beside the altar there is a tablet with the following inscription: "ESTA CAPILLA AI AL/TAR ES ONROSO SEPULCRO ADODE/YA-CEN ALONSO DE SALAS PARAL PRO/CURADOR G SINDI/CO I REGIDOR PER/PETUO DESTA VILLA DE CAFRA Y DA GEZO/NIMA DE AGUILAR GUEVARA SU MU/GI LOS Q SUCEDIE/REN POR SU TES/TAMENTO QUE MDARO HA-CER ESTE RE/TABLO AÑO DEL SR DE 1644", which may be translated: "THIS CHAPEL AT THE ALTAR IS THE HONOUR-ABLE SEPULCHRE IN WHICH ARE LAID ALONSO DE SALAS PARAL, ATTORNEY, SYNDIC AND PERPETUAL COUNCILLOR OF THIS TOWN OF ZAFRA AND DOÑA GERONIMA DE AGUILAR GUEVARA HIS WIFE, AND THOSE WHO SUCCEEDED THEM ACCORDING TO THEIR TESTAMENT, WHO CAUSED THIS RETABLE TO BE MADE IN THE YEAR OF OUR LORD 1644".

286. ST ILDEFONSO RECEIVING THE CHASUBLE
Fig. 284.
2.90 × 1.80 m., approximately,
S. 189 GUI. 223 T.M. 241.

287. THE DOUBLE TRINITY
1.25 × 1.35 m., approximately.
S. 190 GUI. 60 T.M. 242.

288. ST JOHN THE BAPTIST
2.00 × 0.80 m., approximately.
S. 191 GUI. 137 T.M. 243.

289. ST MICHAEL THE ARCHANGEL
2.00 × 1.00 m., approximately.
S. 192 GUI. 295 T.M. 245.

290. ST JEROME
2.00 × 0.80 m., approximately.
S. 193 GUI. 478 T.M. 244.

291. ST NICHOLAS OF TOLENTINO
2.00 × 1.00 m.
S. 194 GUI. 516 T.M. 246.

292. ALONSO DE SALAS PARRA
Fig. 285.
0.50 × 0.75 m., approximately.
S. 195 GUI. 583 T.M. 240.

293. ST ANDREW
0.50 × 0.23 m., approximately.
S. 196 GUI. 183 T.M. 247.

294. ST BARNABAS
0.50 × 0.23 m., approximately.
S. 197 GUI. 211 T.M. 248.

295. JERONIMA DE AGUILAR
0.50 × 0.75 m., approximately.
GUI. 584.
Caturla: "Conjunto de Zurbarán en Zafra". *ABC*, 20 April 1948.
"A Retable by Zurbarán". *B.M.*, 1952.
Guinard: *Zurbarán*, introduction Cat. XIX (p. 202).

296. ST JOHN CHRYSOSTOM AND FRAY LUIS DE GRA-NADA
Inscribed: "fran^co dezurbaran/faciebat 1651". "S. JVAN CHRISOSTOM...".
Figs. 286, 287 & 513.
1.62 × 2.34 m.
Lima: Gran Galería de Pinturas Antiguas (1873 catalogue).
 Private collection.

297. CHRIST CARRYING THE CROSS
Inscribed: "Fran^co de Zurbar(an)/1653".
Figs. 288 & 514.
1.95 × 1.08 m.
Paris: Lebrun sale (1813).
Orleans: Sacristy of the Cathedral (shortly after the Lebrun sale).
S. 204 GUI. 80 T.M. 262a.
Guinard: "Los conjuntos..." III. *A.E.A.*, 1949 (pp. 28-29).

298-300. PAINTINGS FROM THE SACRISTY OF THE CHARTERHOUSE OF OUR LADY OF THE CAVES IN TRIANA, SEVILLE

298. OUR LADY OF THE CAVES
Figs. 289 & 290.
2.67 × 3.20 m.
Seville: on deposit in the Alcázar, No. 222 (1810).
Provincial Museum of Fine Arts, No. 194 (1836).
GA. 86 S. 68 GUI. 473 T.M. 14.

299. ST HUGO IN THE REFECTORY
Figs. 291, 292 & 293.
2.62 × 3.07 m.
Seville: on deposit in the Alcázar, No. 221 (1810).
Provincial Museum of Fine Arts, No. 203 (1836).
GA. 87 S. 69 GUI. 458 T.M. 16.

300. POPE URBAN II AND ST BRUNO, HIS CONFESSOR
Fig. 294.
2.72 × 3.26 m.
Seville: on deposit in the Alcázar, No. 223 (1810).
Provincial Museum of Fine Arts, No. 204 (1836).
GA. 88 S. 70 GUI. 457 T.M. 15.
Ponz: VIII - 6/26.
Ceán Bermúdez: VI, p. 51.
Caturla: *Bodas y obras juveniles de Zurbarán.* Granada, 1948 (pp. 38-42).
Guinard: "Los conjuntos..." III. *A.E.A.,* 1949 (pp. 1-5).
Serra y Pickman: "Los cuadros del monasterio de Las Cuevas; fechas en que los pintó Zurbarán". *Archivo Hispalense,* 1950 (pp. 209-214).
Guinard: *Zurbarán,* introduction Cat. X (p. 194).
Bravo, Fr Luis & Pemán: "¿Cuándo pintó Zurbarán los cuadros de la Cartuja de Jerez de la Frontera?" (sic). *Revista de Estudios Extremeños,* 1963 (pp. 121-9).
Salas, X. de: "La fecha de las historias de la Cartuja y alguna minucia más sobre Zurbarán". *A.E.A.,* 1964 (pp. 129-138).
Gudiol: "Francisco de Zurbarán in Madrid". *B.M.,* 1965 (pp. 148-151).
Caturla: "El conjunto de las Cuevas", *Forma y Color,* No. 41. Granada, 1968.

301. CHRIST CRUCIFIED AND TWO CARTHUSIANS
Fig. 295.
1.65 × 1.05 m.
Ampudia (Palencia): Fontaneda Collection.
Martín González: "Un crucifijo con dos cartujos, de Zurbarán". *B.S.E.A.A.,* 1973 (pp. 465-469).

302. CHRIST CRUCIFIED
Fig. 300.

2.32 × 1.67 m.
Seville: according to Ponz and Ceán Bermúdez, the Capuchin Monastery.
Provincial Museum of Fine Arts, No. 195.
GA. 68 S. 38 GUI. 97.
Ponz: IX - 5/10.
Ceán Bermudez: VI, p. 50.
Guinard: "Los conjuntos..." II. *A.E.A.,* 1947 (p. 192).

303. CHRIST CRUCIFIED
Fig. 296.
Madrid: Suárez Inclán.
Barcelona: Montal Collection.
Art Museum of Catalonia.
GUI. 100 (102).

304. CHRIST CRUCIFIED
Fig. 298.
2.50 × 1.50 m., approximately.
Seville: Cathedral (Chapel of the Chalices).
GUI. 98 T.M. 62.
Santos, B.: *Guía de la Catedral de Sevilla.* 1930 (p. 24).
Dotor, A.: "La Catedral de Sevilla: Museo". *Arte en España,* No. 31.

305. CHRIST CRUCIFIED
2.50 × 1.50 m., approximately.
Seville: López Cepero.
Convent of the Immaculate Conception.
Cathedral (Chapel of Santa Ana).
GUI. 99.
Merchan, Maria Regla: *La colección pictórica del Deán López Cepero.* Seville, 1957 (unpublished thesis).

306. CHRIST CRUCIFIED
1.75 × 1.25 m.
Cadiz: Angel Picardo.
GUI. 101.
Mayer: "Some Unknown Works by Zurbarán". *Apollo,* 1928 (p. 181).
Pemán: "Zurbarán y el arte zurbaranesco en colecciones gaditanas". *A.E.A.,* 1946 (p. 163).

307. CHRIST CRUCIFIED
Castro Urdiales (Santander): Church of Santa María.
GUI. 106.
Perera: "Algunos cuadros poco conocidos". *B.S.E.E.,* 1949 (p. 214, fig. 3).

308. ST TERESA
Fig. 297.
3.00 × 1.80 m., approximately.
Seville: Cathedral (principal sacristy).
GUI. 533.

309. ST TERESA
1.05 × 0.78 m.
Lille (France): Leon Screpel (1870, bought from an antique dealer).
Emmanuel Motte (a relative of the preceding owner).
Toledo: Antonio María Aguirre (1952).
GUI. 534.
Caturla: Cat. Expo. Granada, 1953 (No. 43).

310. ST CASILDA
Fig. 301.
1.84 × 0.98 m.
Madrid: Royal Palace (1814).
Prado Museum, No. 1239.
GA. 172 S. 181 GUI. 242 T.M. 231.
Kehrer: p. 107.

311. THE VIRGIN AS A CHILD, PRAYING
Fig. 302.
0.75 × 0.54 m.
Amsterdam: W.G. Coesveldt.
St Petersburg: Nicholas I (1814).
Leningrad: Hermitage, No. 328.
GA. 235 S. 211 GUI. 28 T.M. 39a (I).
Kehrer: p. 124.
Bazin, G.: *Les grands maîtres de la peinture à L'Ermitage.* 1958 (p. 94).
Malitzkaya: "Zurbarán en los Museos Rusos". *A.E.A.*, 1964 (p. 109).

312. THE VIRGIN AS A CHILD, PRAYING
Fig. 299.
0.80 × 0.54 m.
Medina del Campo (Valladolid): unidentified monastery.
Madrid: Manuel Gómez-Moreno.
Granada: Rodríguez-Acosta Foundation (Gómez-Moreno Bequest).
GA. 234 S. 212 GUI. 29 T.M. 39a.
Sanz Pastor: *Catálogo de la Exposición Zurbarán en el III centenario de su muerte.* Madrid, 1964 (No. 101, p. 194).

313. IMMACULATE CONCEPTION
Fig. 303.
2.00 × 1.45 m.
Madrid: Marqués de Leganés (17th century).

Paris: Marqués de Salamanca sale, No. 49 (1867); unsold.
Marqués de Salamanca sale, No. 43 (1875).
Madrid: Museo Cerralbo.
GA. 203 S. 66 GUI. 13.

314. IMMACULATE CONCEPTION
Fig. 304.
1.98 × 1.20 m.
Seville: Nuestra Señora del Pópolo (suppressed in 1868).
Town Hall (Mayor's Office).
S. 200 GUI. 12 T.M. 253.
Guinard: "Los conjuntos..." III. *A.E.A.*, 1949 (p. 9).

315. IMMACULATE CONCEPTION
Fig. 305.
1.28 × 0.98 m.
London: F.A. White sale, No. 126 (Sotheby's, 1934).
E. Spielman.
Lisbon: private collection.
New York: Samuel H. Kress Foundation.
S. (2nd edition) 236 GUI. 14.

316. IMMACULATE CONCEPTION WITH TWO ALLEGORI-
CAL FIGURES
Fig. 306.
1.32 × 1.04 m.
London: Captain Larkyns sale (1872).
W. Graham sale (1886).
Dublin: National Gallery of Ireland, No. 273 (1886).
GA. 226 GUI. 17.
Mayer: *Historia de la pintura española.* 1947 (3rd edition) (pp. 344-345).

317. OUR LADY OF RANSOM
Fig. 307.
1.39 × 1.07 m.
Seville: López Cepero sale, No. 402 (1860); unsold.
Jacobo López Cepero.
U.S.A.: Isabella Stewart Gardner (1888).
Boston: The Isabella Stewart Gardner Museum.
GUI. 445 T.M. 135.
Amador de los Ríos: *Sevilla Pintoresca.* 1844 (p. 452).

318. OUR LADY OF RANSOM
Fig. 308.
1.00 × 0.78 m.
Paris: Louvre, Louis-Philippe's "Galerie Espagnole", No. 336.
London: Louis-Philippe sale, No. 61 (Christie's, 1853).
Drax Collection.
Sawbridge Erle Drax sale, No. 155 (Christie's, 1935).
Smith Collection.

Madrid: José Lázaro.
 Museo Lázaro.
GUI. 446 T.M. 133 (I).

319. OUR LADY OF THE ROSARY
Fig. 309.
1.50 × 1.00 m.
Seville: Cathedral (Chapel of the Chalices).
GUI. 57.

320. OUR LADY OF RANSOM AND TWO MERCEDARIANS
Fig. 310.
1.66 × 1.29 m.
Seville: Monastery of San José, of the Discalced Mercedarians (Sacristy).
Paris: Louvre, Louis-Philippe's "Galerie Espagnole", No. 337 (1838).
London: Louis-Philippe sale, No. 62 (Christie's, 1853).
 Colnaghi & Co.
Seville: Duke of Montpensier (Palace of San Telmo, 1866).
Château de Randan (Auvergne): Madame la Comtesse de Paris.
Madrid: Duke of Montpensier.
 Marqués de Valdeterrazo.
S. 122 GUI. 444.
Ceán Bermúdez: VI, p. 49.
Guinard: "Los conjuntos..." II. A.E.A., 1947 (pp. 184-185).
Zurbarán, introduction Cat. XII (p. 196).

321. VIRGIN AND CHILD IN THE CLOUDS
Fig. 311.
Espejo (Córdoba): Duchess of Osuna.
Madrid: Duchess of Osuna.
GA. 112 GUI. 55.
Catálogo del Palacio de Bellas Artes. Arte Antiguo. Seville, 1930 (p. 36, plate 22).

322. RETURN OF THE HOLY FAMILY FROM EGYPT TO JERUSALEM
Fig. 312.
1.92 × 2.49 m.
Madrid: George Villiers (British Ambassador to Madrid from 1833 to 1839).
U.S.A.: Edward Drummond Libbey.
Toledo (Ohio): Museum of Fine Arts (1923).
GUI. 45 T.M. 239.
Waagen: II (1854), p. 458.
Blakemore, Godwin: "A Zurbarán presented". The Toledo Museum News, May 1924.

323. RETURN OF THE HOLY FAMILY FROM EGYPT TO JERUSALEM
Fig. 313.
0.83 × 1.13 m. (fragment).
Heytesbury (Wilts.): Lord Heytesbury (British Ambassador to Madrid in 1823).

Heytesbury sale (1926).
London: Colnaghi & Co.
Sarasota (Florida): The John and Mable Ringling Museum, No. 340.
GUI. 46.
Waagen: II (1854), p. 458.

324. ST JEROME, ST PAULA AND ST EUSTACIA
Fig. 314.
2.47 × 1.74 m.
Seville: Convent of Santa Paula (?).
Paris: Louvre, Standish Collection, No. 161 (1842).
London: F.H. Standish sale, No. 105 (Christie's, 1853).
Paris: Alphonse Oudry sale, No. 157 (Hôtel Drouot, 1869).
 Alphonse Oudry sale, No. 60 (Hôtel Drouot, 1875).
New York: Knoedler & Co. (1951).
 Samuel H. Kress Foundation.
Washington: National Gallery (1956).
S. 198 GUI. 485 T.M. 252.

325. MARTYRDOM OF ST JAMES
Fig. 315.
2.52 × 1.86 m.
London: Louis-Philippe sale, No. 68 (Christie's, 1853).
Madrid: Julia Martínez Ibáñez.
Barcelona: Plandiura (after 1939).
GA. 219 GUI. 188.
Blanc, Ch.: Histoire des peintres. École espagnole. Zurbarán. (p. 8).
López Martínez: Desde Martínez Montañés hasta Pedro Roldán. (p. 223).
Guinard: "Los conjuntos..." III. A.E.A., 1949 (pp. 1-38).

326. ST JEROME
Fig. 316
1.85 × 1.03 m.
Madrid: Lord Heytesbury (British Ambassador to Madrid in 1823).
Heytesbury (Wilts.): Heytesbury sale, No. 1,357 (1926).
Lucerne: Böhler & Steinmeyer.
New York: Kleinberger & Co.
San Diego (California): Fine Arts Gallery (1940).
GA. 216 S. 188 GUI. 479.

327. ST BENEDICT
Fig. 323.
1.85 × 1.00 m.
Madrid: Lord Heytesbury (British Ambassador to Madrid in 1823).
Heytesbury (Wilts.): Heytesbury sale, No. 1,329 (1926).
Lucerne: Julius Böhler.
New York: Kleinberger & Co.
S. 187 GUI. 521 T.M. 235.
Waagen: IV (1857), p. 388.
Mayer: "Unbekannte Werke von Zurbarán". Z.f.b.K., 1927-28 (p. 286).
Guinard: "Los conjuntos..." III. A.E.A., 1949 (pp. 33-35).

328-337. RETABLE OF THE HIGH ALTAR IN THE CHURCH
OF SAN ESTEBAN, SEVILLE

328. MARTYRDOM OF ST STEPHEN
2.50 × 1.50 m.
GUI. 214.

329. ST PETER
1.80 × 1.10 m.
GUI. 154 T.M. 40.

330. ST PAUL
1.80 × 1.10 m.
GUI. 161 T.M. 41.

331. THE ADORATION OF THE SHEPHERDS
1.80 × 1.80 m.
GUI. 39.

332. ST HERMENEGILDUS
Fig. 317.
1.80 × 1.05 m.
GUI. 222.

333. ST FERDINAND
Fig. 318.
1.80 × 1.05 m.
GUI. 215.

334. CHRIST CRUCIFIED, THE VIRGIN AND ST JOHN
1.50 × 1.10 m. (in three canvases).
GUI. 117abc.

335. THE SOULS IN PURGATORY
0.40 × 0.60 m.
GUI. 303.

336. THE VISION OF ST PETER
0.50 × 0.80 m.
GUI. 145 T.M. 24.

337. THE CONVERSION OF ST PAUL
0.50 × 0.80 m.
GUI. 159.
Ponz: IX - 3/8.
Ceán Bermúdez: VI, p. 48.
Caturla: "Ternura y primor de Zurbarán". *Goya*, 1959 (p. 342).
Guinard: "Los conjuntos..." I. *A.E.A.*, 1946 (pp. 260-262). *Zurbarán*,
introduction Cat. IX (p. 192).

338-341. PAINTINGS IN THE GRAND SALON OF THE
ARCHBISHOP'S PALACE, SEVILLE

338. ST BRUNO
Inscribed: "S. BRVNO".

Fig. 319.
1.80 × 1.10 m., approximately.
S. 106 GUI. 449 T.M. 150 (II).

339. ST PETER MARTYR
Fig. 320.
1.80 × 1.10 m., approximately.
S. 109 GUI. 320 T.M. 150 (IV).

340. ST DOMINIC
Inscribed: "... DOMINGO".
Fig. 321.
1.80 × 1.10 m., approximately.
S. 107 GUI. 309 T.M. 150 (I).

341. ST FRANCIS
Fig. 322.
1.80 × 1.10 m., approximately.
S. 108 GUI. 344 T.M. 150 (III).

342-351. APOSTLE SERIES IN THE MONASTERY OF
SANTO DOMINGO, GUATEMALA CITY
Moved to this monastery after the destruction of the monastery of
Santo Domingo in Antigua during the earthquake of 29 July 1773.

342. ST MATTHIAS
Inscribed: "S. MATIAS XII".
Fig. 324.
1.77 × 1.05 m.
S. 145b GUI. 208 T.M. 229 (III).

343. ST THOMAS
Inscribed: "S. TOMAS VII".
Fig. 325.
1.77 × 1.05 m.
S. 145c GUI. 206 T.M. 229 (X).

344. ST PHILIP
Inscribed: "S. FELIPE V".
Fig. 326.
1.77 × 1.05 m.
S. 145a GUI. 200 T.M. 229 (IX).

345. ST PETER
Inscribed: "S. PEDRO I".
Fig. 327.
1.77 × 1.05 m.
S. 145e GUI. 156 T.M. 229 (I).

346. ST SIMON
Inscribed: "S. SIMON XI".
Fig. 328.
1.77 × 1.05 m.
S. 145d GUI. 203 T.M. 229 (XI).
Inscribed on the back (in translation): "This Apostle Series, excepting
the St Andrew, which is by Master Merlo in Guatemala, and St

Bartholomew, the Saviour and the Virgin, by Rosales, are all the rest by the renowned Don Francisco Zurbaran in Seville, who died in Madrid in the year 1662. At the request of the R.P. Fray Luis de la Puente, they were repaired by Rosales in the year 1804, in the New Guatemala on 1 March."

347. ST JOHN THE EVANGELIST
Inscribed: "S. JUAN EVANGELISTA IV".
Fig. 329.
1.77 × 1.05 m.
S. 145f GUI. 171 T.M. 229 (XIII).

348. ST MATTHEW
Inscribed: "S. MATEO VIII".
Fig. 330.
1.77 × 1.05 m.
S. 145h GUI. 176 T.M. 229 (VIII).

349. ST JUDE THADDEUS
Inscribed: "S. JUD. TAD.".
Fig. 331.
1.77 × 1.05 m.
S. 1451 GUI. 197 T.M. 229 (XII).

350. ST JAMES THE LESS
Inscribed: "SANTIAGO EL MEN.".
Fig. 332.
1.77 × 1.05 m.
S. 145k GUI. 194 T.M. 229 (VI).

351. ST PAUL
Inscribed: "S. PABLO".
Fig. 333.
1.77 × 1.05 m.
S. 145i GUI. 163 T.M. 229 (II).
Angulo: "El apostolado zurbaranesco de Guatemala". *A.E.A.*, 1949.
Guinard: *Zurbarán*, introduction Cat. XXV (p. 205).

352-361. SERIES OF FOUNDERS OF RELIGIOUS ORDERS NOW IN THE CONVENT OF THE CAPUCHIN NUNS IN CASTELLON DE LA PLANA
Bequest of the Condesa de Campo Alange.

352. ST PETER NOLASCO
Fig. 334.
1.90 × 1.10 m.
GUI. 407 T.M. 205 (VI).

353. ST BRUNO
Fig. 335.
1.90 × 1.10 m.
GUI. 450 T.M. 205 (I).

354. ST FRANCIS OF ASSISI
Fig. 336.
1.90 × 1.10 m.
GUI. 345 T.M. 205 (IV).

355. ST JEROME
Fig. 337.
1.90 × 1.10 m.
GUI. 480 T.M. 205 (VII).

356. ST DOMINIC
Fig. 338.
1.90 × 1.10 m.
GUI. 310 T.M. 205 (II).

357. ST BASIL
Fig. 339.
1.90 × 1.10 m.
GUI. 519.

358. ST IGNATIUS LOYOLA
Fig. 340.
1.90 × 1.10 m.
GUI. 538 T.M. 205 (V).

359. ST AUGUSTINE
Fig. 341.
1.90 × 1.10 m.
GUI. 512.

360. ST ELIAS
Fig. 342.
1.90 × 1.10 m.
GUI. 526 T.M. 205 (III).

361. ST BENEDICT
Fig. 343.
1.90 × 1.10 m.
GUI. 522 T.M. 205 (VIII).
Guinard: "Los conjuntos..." III. *A.E.A.*, 1949 (pp. 33-35). *Zurbarán*, introduction Cat. XXVIII (pp. 206-207).

362. ST JEROME IN PENITENCE
Fig. 344.
2.00 × 1.10 m., approximately.
Córdoba: Provincial Museum of Fine Arts.
GA. 115. GUI. 477.

363. ST ELIAS
Inscribed: "S. ELIAS".
Fig. 345.
2.00 × 1.10 m., approximately.
Córdoba: Provincial Museum of Fine Arts.
GUI. 527.

364. ST JOHN THE EVANGELIST
Fig. 346.
1.90 × 1.10 m.
Córdoba: Provincial Museum of Fine Arts.
GA. 114 GUI. 173.
Mayer: "Unbekannte Werke von Zurbarán". *Z.f.b.K.*, 1927-28 (p. 289).
Guinard: "Los conjuntos..." III. *A.E.A.*, 1949 (pp. 11-13).

365-379. APOSTLE SERIES IN THE MONASTERY OF ST FRANCIS OF JESUS, IN LIMA, PERU
First mentioned in 1785.

365. ST JUDE THADDEUS
Fig. 347.
1.81 × 0.94 m.
S. 144k GUI. 198 T.M. 228 (XIV).

366. ST JAMES THE LESS
Fig. 348.
1.81 × 0.94 m.
S. 144l GUI. 195 T.M. 228 (VIII).

367. ST THOMAS
Fig. 349.
1.81 × 0.94 m.
S. 144g GUI. 207 T.M. 228 (XII).

368. ST MATTHIAS
Fig. 350.
1.81 × 0.94 m.
GA. 212 S. 144i GUI. 209 T.M. 228 (V).

369. ST BARTHOLOMEW
Fig. 351.
1.81 × 0.94 m.
GA. 207 S. 144a GUI. 187 T.M. 228 (VI).

370. ST JOHN THE EVANGELIST
Fig. 352.
1.81 × 0.94 m.
S. 144n GUI. 172 T.M. 228 (XV).

371. ST PAUL
Fig. 353.
1.81 × 0.94 m.
S. 144h GUI. 164 T.M. 228 (IV).

372. ST SIMON
Fig. 354.
1.81 × 0.94 m.
GA. 210 S. 144j GUI. 204 T.M. 228 (XIII).

373. ST MATTHEW
Fig. 355.
1.81 × 0.94 m.
S. 144d GUI. 177 T.M. 228 (X).

374. ST PETER
Fig. 356.
1.81 × 0.94 m.
S. 144m GUI. 157 T.M. 228 (III).

375. ST PHILIP
Fig. 357.
1.81 × 0.94 m.
GA. 211 S. 144c GUI. 201 T.M. 228 (XI).

376. ST ANDREW
Fig. 358.
1.81 × 0.94 m.
S. 144c GUI. 182 T.M. 228 (IX).

377. ST JAMES THE GREAT
Fig. 359.
1.81 × 0.94 m.
GA. 208 S. 144b GUI. 192 T.M. 228 (VII).

378. THE VIRGIN
Fig. 360.
1.81 × 0.94 m.
S. 144o GUI. 125 T.M. 228 (II).

379. CHRIST BLESSING
Fig. 361.
1.84 × 0.94 m.
S. 144f GUI. 123 T.M. 228 (I).
Lozoya, Marqués de: "Zurbarán en el Perú". *A.E.A.*, 1943.
Angulo & Dorta: *Historia del Arte Hispano-Americano*, Vol. II, 1950.
Guinard: *Zurbarán,* introduction Cat. XXVI (p. 206).

380-392. SERIES OF FOUNDERS OF RELIGIOUS ORDERS IN THE MONASTERY OF ST CAMILLUS DE LELLIS (or OF THE HOLY DEATH) IN LIMA
Possibly donated to the Monastery by Gertrudis de Vargas, on 1 February 1769.
1.84 × 1.03 m.

380. ST ELIAS
Fig. 362.
S. 171f GUI. 528.

381. ST AUGUSTINE
Fig. 363.
S. 171b GUI. 513.

382. ST BASIL
Fig. 364.
S. 171l GUI. 520.

383. ST BERNARD OF CLAIRVAUX
Fig. 365.
S. 171a GUI. 524.

384. ST JEROME
Fig. 366.
S. 171g GUI. 482.

385. ST FRANCIS OF PAOLA
Fig. 367.
S. 171e GUI. 545.

386. ST JOHN OF GOD
Fig. 368.
S. 171j GUI. 537.

387. ST IGNATIUS LOYOLA
Fig. 369.
S. 171d GUI. 539.

388. ST ANTHONY ABBOT
Fig. 370.
S. 171m GUI. 508.

389. ST DOMINIC
Fig. 371.
S. 171i GUI. 311.

390. ST FRANCIS OF ASSISI
Fig. 372.
S. 171h GUI. 346.

391. ST BRUNO
Fig. 373.
S. 171c GUI. 451.

392. ST PETER NOLASCO
Fig. 374.
S. 171k GUI. 408.
Lozoya: "Zurbarán en el Perú". *A.E.A.*, 1943 (pp. 5-6). "Pintura española en el Perú". *B.S.E.E.*, 1943 (pp. 52-53).
Angulo & Dorta: *Historia del Arte Hispano-Americano*, Vol. II, 1950 (pp. 477-479).
Guinard: "Los conjuntos..." II. *A.E.A.*, 1947 (p. 181). "Los conjuntos..." III. *A.E.A.*, 1949 (pp. 33-34). *Zurbarán*, introduction Cat. XXIX (p. 207).

393-395. PAINTINGS FROM A SERIES OF FOUNDERS OF RELIGIOUS ORDERS, NOW IN BOLIVIA

393. ST DOMINIC
1.85 × 1.10 m., approximately.
Sucre: Casa de Jesús del Gran Poder.
GUI. 312.

394. ST FRANCIS OF ASSISI
Sucre: Casa de Jesús del Gran Poder
GUI. 347 T.M. 227 (IV).

395. ST PETER NOLASCO
1.80 × 1.10 m., approximately.
Sucre: Church of La Merced (Our Lady of Ransom).
GUI. 409.

Schenone: "Pinturas zurbaranescas y esculturas de escuela sevillana en Sucre". *Anales del Instituto de Arte Americano*, No. 4, 1951 (p. 63).

396. ST FRANCIS IN MEDITATION
1.90 × 1.08 m.
Villalba de Alcor (Huelva): Parish Church.

Destroyed during the Spanish Civil War (1936-39).
GUI. 348 T.M. 227 (I).
Guinard: "Los conjuntos..." III. *A.E.A.*, 1949 (reproduced).

397. ST FRANCIS IN MEDITATION
1.92 × 1.17 m.
Berlin: Muñoz de Ortiz sale, No. 65 (Lepke, 12 December 1911).
Florence: Volterra Collection (1936).
Milan: Foresti Collection.
Present whereabouts unknown.
GUI. 349 T.M. 227 (II).
Catalogue of the Muñoz de Ortiz sale (reproduced).

398. ST FRANCIS IN MEDITATION
1.01 × 0.81 m.
Seville: José Gestoso y Pérez.
Present whereabouts unknown.
GUI. 350 T.M. 227 (III).
Kehrer: p. 151 (reproduced).

399. ST JEROME
Fig. 375.
0.80 × 0.42 m.
Paris: Louis-Philippe.
London: Erle Drax.
 Tomás Harris (1937).

400. ST ANTHONY ABBOT
Fig. 376.
2.04 × 1.10 m.
Madrid: Marqués de Casa Torres.
GA. 117 S. 186 GUI. 507 T.M. 233.
Guinard: "Los conjuntos..." II. *A.E.A.*, 1947 (pp. 181-182).

401. ST FRANCIS XAVIER
Fig. 377.
1.90 × 1.33 m.
Seville: Conde del Aguila (18th century).
Madrid: Marqués de la Vega Inclán.
 Museo Romántico.
GA. 237 GUI. 542.
Kehrer: p. 73.

402. ST DOMINIC
Fig. 378.
1.50 × 1.00 m., approximately.
Seville: University (Rector's house).
GUI. 316.

Kehrer: p. 151.
Hernández Díaz: *La Universidad Hispalense y sus obras de arte.* 1943
(p. 42).

403-404. PICTURES OF SAINTS FROM THE CAPUCHIN MONASTERY IN MALAGA
Now in the Provincial Museum of Fine Arts, Malaga.

403. ST BENEDICT
Fig. 379.
1.90 × 1.12 m.
GA. 218 GUI. 523.

404. ST JEROME
Fig. 380.
1.90 × 1.10 m.
S. note to 188 GUI. 481.

405-408. PICTURES WHICH PROBABLY FORMED PART OF A SERIES OF FOUNDERS OF MONASTIC ORDERS, IN MEXICO

405. ST AUGUSTINE
Fig. 381.
2.04 × 1.08 m.
Mexico City: Academy of Fine Arts of San Carlos.
GA. 163 S. 164 GUI. 510.

406. ST JOHN OF GOD
Fig. 382.
2.02 × 1.07 m.
Mexico City: Academy of Fine Arts of San Carlos.
GA. 162 S. 165 GUI. 535.

407. ST JEROME
2.04 × 1.08 m.
Guadalajara (Jalisco): Museum.
S. note to 164 GUI. 483.

408. ST ELIAS
2.04 × 1.08 m.
Guadalajara (Jalisco): Museum.
S. note to 164 GUI. 529.
Angulo: *La Academia de Bellas Artes de Méjico y sus cuadros españoles.* Seville, 1935.

409-412. SERIES OF FOUNDERS OF RELIGIOUS ORDERS, IN THE FRANCISCAN MONASTERY OF TLANEPLANTLA, MEXICO

409. ST BRUNO
1.80 × 1.05 m., approximately.
GUI. 452.

410. ST AUGUSTINE
2.00 × 1.00 m., approximately.
GUI. 511.

411. ST BERNARD
2.00 × 1.00 m., approximately.
GUI. 525.

412. ST IGNATIUS LOYOLA
GUI. 540.
Angulo: *La Academia de Bellas Artes de Méjico y sus cuadros españoles.* Seville, 1935.

413. ST JOHN OF GOD
Fig. 383.
2.00 × 1.10 m., approximately.
Seville: Fernando Ibarra.
 Provincial Museum of Fine Arts.
GUI. 536 T.M. 255.

414. ST BRUNO
2.00 × 1.08 m.
Seville: Fernando Ibarra.
 Provincial Museum of Fine Arts.
GUI. 453.
Guinard: "Aportaciones críticas de obras zurbaranescas". *A.E.A.,* 1964 (pp. 126-127, plate VI).

415. ST FRANCIS OF ASSISI
Fig. 384.
1.85 × 1.10 m., approximately.
Tlaxcala: Franciscan Monastery.
GUI. 351.

416. ST DOMINIC
Fig. 385.
1.85 × 1.10 m., approximately.
Tlaxcala: Franciscan Monastery.
GUI. 313.

417. ST DOMINIC
Fig. 386.
Madrid: José Lázaro.
Barcelona: Ricardo Viñas.

418. ST FRANCIS IN MEDITATION
1.00 × 0.70 m., approximately.
Comacayas: Royal Mint (Chapel of the Counts).
Potosí (Bolivia): Yáñez Collection.
 Museum.
GUI. 361.
Angulo & Dorta: *Historia del Arte Hispano-Americano,* Vol. II, 1950
(p. 489).

419. ST LAWRENCE (?)
0.40 × 0.33 m.
Parma: Giuseppe Stuart (d. 1834).
Pinacoteca Stuart.

420. ST STEPHEN (?)
0.40 × 0.33 m.
Parma: Giuseppe Stuart (d. 1834).
Pinacoteca Stuart.
Pérez Sánchez: "Varia. Dos nuevos zurbaranes". *A.E.A.*, 1965 (pp. 261-263, plates I-II).

421. ST URSULA
Inscribed: "S. VRSVLA".
Fig. 387.
1.95 × 1.09 m.
Paris: private collection.

422-430. SERIES OF FEMALE SAINTS ORIGINALLY IN THE HOSPITAL OF THE PRECIOUS BLOOD, SEVILLE
In the Provincial Museum of Fine Arts since 1915.

422. ST MARINA
Inscribed: "S. MARINA".
Fig. 388.
1.70 × 1.01 m.
S. note to 57 GUI. 277 T.M. 149 (I).
There is a replica of this canvas in the Kunst-Museum in Gothenburg.
It was formerly in Louis-Philippe's "Galerie Espagnole" (No. 389) and measures 1.86 × 1.03 m.
S. note to 57 GUI. 278.

423. ST EULALIA
Inscribed: "S. EULALIA".
Fig. 389.
1.73 × 1.02 m.
GA. 186 GUI. 263 T.M. 149 (V).

424. ST BARBARA
Inscribed: "S. BARBARA".
Fig. 390.
1.73 × 1.03 m.
GA. 187 GUI. 241 T.M. 149 (VI).

425. ST AGNES
Inscribed: "S. INES".
Fig. 391.
1.72 × 1.01 m.
GUI. 234 T.M. 149 (VII).

426. ST ENGRACIA
Inscribed: "S. ENGRACIA".
Fig. 392.
1.73 × 1.02 m.
GA. 188 GUI. 261 T.M. 149 (IV).

427. ST DOROTHY
Inscribed: "S. DOROTEA".
Fig. 393.
GA. 191 GUI. 255 T.M. 149 (III).

428. OUR LADY OF THE ROSARY
Fig. 394.
1.81 × 1.02 m.
GA. 225 S. 199 GUI. 56 T.M. 260.

429. ST MATILDA
Inscribed: "S. MATILDA".
Fig. 395.
1.73 × 1.02 m.
GA. 190 GUI. 285 T.M. 149 (II).

430. ST CATHERINE
Inscribed: "S. CATALINA".
Fig. 396.
1.69 × 1.02 m.
GA. 189 GUI. 251 T.M. 149 (VIII).

González de León: *Noticia artística, histórica y curiosa de todos los edificios públicos sagrados y profanos de esta ciudad de Sevilla y de muchas casas particulares.* Seville, 1844 (p. 253).
Soria: "Some Flemish Sources of Baroque Painting in Spain". *The Art Bulletin*, December 1948 (pp. 249-259).
Merchan, María Regla: *La colección pictórica del Deán López Cepero.* Seville, 1957 (unpublished thesis).
Guinard: *Zurbarán*, introduction Cat. XXVII (p. 206).

431. ST MARINA
Fig. 418.
1.10 × 0.87 m.
Madrid: Duke of Osuna.
Duke of Tovar.
Estate of the Duke of Tovar.

432. ST URSULA
Inscribed: "S. VRSOLA".
Fig. 397.
1.72 × 1.05 m.
Paris: Soult sale, No. 33 (1852).
Duchess of Galliera.
Genoa: Palazzo Bianco (bequeathed in 1884).
GA. 176 S. 116 GUI. 291 T.M. 140.

433. ST EUPHEMIA
Fig. 398.
1.72 × 1.05 m.
Paris: Soult sale, No. 30 (1852).
Duchess of Galliera.
Genoa: Palazzo Bianco (bequeathed in 1884).

GA. 177 S. note to 115 GUI. 264 T.M. 139.
Kehrer: p. 106.
Grosso: *La Galleria d'Arte del Comune di Genova.* 1932 (pp. 132-133).
Soria: "Some Flemish Sources of Baroque Painting in Spain". *The Art
Bulletin,* December 1948 (pp. 249-259).

434. ST RUFINA
Inscribed: "S. RVFINA".
Fig. 399.
0.85 × 0.64 m.
London: Sir Charles Brinsley Marlay.
Cambridge: Fitzwilliam Museum, No. 83 (1912).
GUI. 288.

435. ST JUSTA
Fig. 400.
Paris: Kugel Collection.

436. ST EUPHEMIA
Fig. 401.
0.83 × 0.73 m.
Cadiz: Angel Picardo.
Madrid: Dr Jiménez Díaz (1945).
 Prado Museum.
S. 115 GUI. 265 T.M. 138.

437. ST LUCY
Fig. 402.
1.82 × 1.11 m.
*Paris: Louvre, Louis-Philippe's "Galerie Espagnole", No. 392 (acquired
 in Spain by Baron Taylor).*
London: Louis-Philippe sale, No. 299 (Christie's, 1853).
 Pearce Collection.
New York: Ehrich Galleries (1919).
 Jenö Boross.
 Hispanic Society of America, No. 94 (1921).
GA. 195 GUI. 271 T.M. 144.
Mayer: "Zurbarán in America". *Art & Decoration,* March 1916.
Kehrer: pp. 107-108.

438. ST RUFINA
Fig. 403.
1.72 × 1.05 m.
Paris: Soult sale, No. 36 (1852).
 Comte Duchatel.
New York: Ehrich Galleries (before 1913).
 Archer M. Huntington.
 *Hispanic Society of America, No. A1891 (donated by A.M.
 Huntington in 1925).*

GA. 175. S. 180 GUI. 287 T.M. 143.
Kehrer: p. 107.
Soria: "Some Flemish Sources of Baroque Painting in Spain.". *The
Art Bulletin,* December 1948 (pp. 249-259). "Zurbarán: A Study of his
Style". *G.d.B.A.,* 1944 (pp. 166-167).

439. ST JUSTA
Fig. 404.
1.83 × 1.09 m.
*Paris: Louvre, Louis-Philippe's "Galerie Espagnole", No. 393 (acquired
 in Spain by Baron Taylor).*
London: Louis-Philippe sale, No. 297 (Christie's, 1853).
 Graves Collection.
Newark-on-Trent: Denyson.
 Lady Eleanor Denyson.
London: Denyson sale, No. 61 (Christie's, 1853).
Dublin: National Gallery of Ireland.
GA. 183 GUI. 266.

440. ST JUSTA
1.00 × 0.75 m.
Smolensk, U.S.S.R.: Museum.
Malitzkaya: "Zurbarán en los Museos Rusos". *A.E.A.,* 1964 (p. 110,
plate II).

441. ST URSULA
Fig. 405.
1.80 × 1.09 m.
Paris: Louvre, Louis-Philippe's "Galerie Espagnole".
London: Louis-Philippe sale, No. 404 (Christie's, 1853).
 King Collection.
 Charles Butler.
Strasbourg: Musée des Beaux-Arts, No. 306 (1893).
GA. 170 GUI. 292.

442. ST CRISTINA
Fig. 406.
1.80 × 1.09 m.
Paris: Louvre, Louis-Philippe's "Galerie Espagnole".
London: Louis-Philippe sale, No. 391 (Christie's, 1853).
 King Collection.
 Charles Butler.
Strasbourg: Musée des Beaux-Arts, No. 305 (1893).
Kehrer: pp. 105-106.

**443-444. TWO FEMALE SAINTS IN THE CATHEDRAL OF
SEVILLE (CHAPEL OF ST HERMENEGILDUS)**

443. ST ENGRACIA
Inscribed: "S. ENGRACIA".
Fig. 407.
1.97 × 1.08 m.
GUI. 262 T.M. 149 (IX).

444. ST RUFINA
Inscribed: "S. RUFINA".
Fig. 408.
1.97 × 1.08 m.
GUI. 289 T.M. 149 (X).
Kehrer: p. 105.

445. ST ELIZABETH OF PORTUGAL
Fig. 409.
1.71 × 1.07 m.
Paris: Soult sale, No. 35 (1852).
 Comte Duchatel.
New York: Ehrich Galleries (before 1913).
Montreal: Sir William van Horne.
GA. 174 S. 179 GUI. 260 T.M. 230.
Kehrer: p. 107 (plate 66).
Mayer: *Historia de la Pintura Española* (p. 249).
Soria: "Francisco de Zurbarán: a Study of his Style". *G.d.B.A.,* 1944 (p. 167). "Zurbarán right and wrong". *Art in America,* 1944 (pp. 130-131). "Some Flemish Sources of Baroque Painting in Spain". *The Art Bulletin,* December 1948 (p. 256).
Brown, Jonathan: *Zurbarán.* 1973 (plate 40).

446. ST CASILDA (or ST ELIZABETH)
1.02 × 0.86 m.
Jerez: possibly in the Capuchin Monastery.
Cadiz: Town Hall (1871).
 Provincial Museum of Fine Arts (1875).
GUI. 244 T.M. 149 (XIII).

447. ST DOROTHY
1.02 × 0.86 m.
Jerez: possibly in the Capuchin Monastery.
Cadiz: Town Hall (1871).
 Provincial Museum of Fine Arts (1875).
GUI. 259 T.M. 149 (XIV).
Molina: "Dos cuadros de la sala de Zurbarán". *Boletín del Museo de Bellas Artes de Cádiz,* 1922, pp. 34-35.

448. ST AGATHA
Fig. 410.
1.08 × 0.80 m.
Seville: Conde de Villapineda.
 Luis Taviel de Andrade y Cavalleri.
Bilbao: Elosegui Collection.
GUI. 232.

449. ST DOROTHY
1.08 × 0.80 m.
Seville: Conde de Villapineda.
 Luis Taviel de Andrade y Cavalleri.
Bilbao: Elosegui Collection.
GUI. 258.

450. ST CATHERINE
Fig. 411.
1.24 × 1.00 m.
Bilbao: Provincial Council of Vizcaya.
 On deposit in the Provincial Museum of Fine Arts, No. 107.
GA. 165 S. 110 GUI. 253 T.M. 145.

451. ST ELIZABETH OF THURINGIA
Fig. 412.
1.24 × 1.00 m.
Bilbao: Provincial Council of Vizcaya.
 On deposit in the Provincial Museum of Fine Arts, No. 108.
GA. 164 S. 111 GUI. 293 T.M. 146.
Soria: "Some Flemish Sources of Baroque Painting in Spain". *The Art Bulletin,* December 1948 (pp. 249-259).

452. ST AGATHA
0.84 × 0.56 m.
Seville: private collection.
Madrid: Señora de Domínguez.
New York: Ehrich Galleries.
 Hispanic Society of America (Archer M. Huntington, 1921).
GUI. 231.
Kehrer: p. 105.

453. ST AGATHA
2.05 × 1.40 m.
Seville: private collection.
Madrid: Linares Collection.
 Manuel Arburúa.
GUI. 233.

454. ST JUSTA
0.92 × 0.59 m.
Seville: Salinas Collection.
T.M. 147.

455. ST RUFINA
0.92 × 0.59 m.
Seville: Pablo Benjumea.
T.M. 148.

456. ST CATHERINE
Zürich: Emil Bührle.

457. ST AGNES
1.46 × 1.08 m.
Madrid: Duke of Béjar.

Lugano: Baron H. Thyssen-Bornemisza (1958).
GA. 184 GUI. 237.
Kehrer: p. 146.

458. IMMACULATE CONCEPTION
1.60 × 0.98 m.
Seville: Professed House of the Jesuit Fathers.
University (Rector's house).
GUI. 7.
Carriazo: "Correspondencia Ponz-Aguila", *A.E.A.,* 1929.
Hernández Díaz: *La Universidad Hispalense y sus Obras de Arte.* 1942
(p. 42).
Guinard: "Los conjuntos..." III. *A.E.A.,* 1949 (pp. 6-7).

459. MYSTICAL MARRIAGE OF ST CATHERINE OF SIENA
Fig. 413.
1.09 × 1.00 m.
London: Sir John Brackenbury (1835).
Keir (Scotland): Sir John Stirling Maxwell (1850).
William Stirling of Keir.
Dallas (Texas): The Meadows Museum.
S. 9 GUI. 327 T.M. 6.
Wagen: IV (1857), pp. 449-450.

460-463. FOUR PAINTINGS IN THE PARISH CHURCH OF BOLULLOS DE LA MITACION, SEVILLE

460. ST LUCY
Fig. 414.
Inscribed: "S. LVC...".
Oil on panel, 0.71 × 0.40 m.

461. ST CATHERINE
Fig. 415.
Inscribed: "S. CATALINA".
Oil on panel, 0.71 × 0.40 m.

462. ST BLAISE
Fig. 416.
Inscribed: "S. BLAS".
Oil on panel, 0.71 × 0.40 m.

463. ST AGNES
Fig. 417.
Inscribed: "S. IGNES".
Oil on panel, 0.71 × 0.40 m.
Hernández Díaz: *Catálogo arqueológico de la Provincia de Sevilla.*
Seville, 1939 (Vol. I. p. 217).
Pérez Sánchez: *The Golden Age of Spanish Painting.* Catalogue Notes
33-34. Royal Academy of Arts, London, 1976 (pp. 55, 58).

464-466. THREE PAINTINGS FROM THE MONASTERY OF THE DISCALCED MERCEDARIANS, SEVILLE

Seville: on deposit in the Alcázar (1810); Nos. 328-330, attributed to
Bernabé de Ayala.
Paris: Maréchal Soult (not included in the catalogue of the Soult sale).
Saint-Amans-Soult (Tarn): Duke of Dalmatia (descendant of
Maréchal Soult).

464. CORONATION OF ST CATHERINE
Fig. 419.
1.10 × 0.85 m., approximately.
GUI. 250.

465. OUR LADY OF RANSOM BESTOWING THE HABIT OF THE MERCEDARIANS ON ST PETER NOLASCO
Fig. 420.
1.00 × 0.80 m., approximately.
GUI. 406.

466. MIRACULOUS COMMUNION OF ST PETER NOLASCO
Fig. 421.
1.00 × 0.80 m., approximately.
GUI. 410.
Guinard: "Aportaciones críticas de obras zurbaranescas". *A.E.A.,*
1964 (pp. 115-128).

467-468. TWO PAINTINGS OF ST DOMINIC

Seville: on deposit in the Alcázar (1810); Nos. 245 & 246, attributed to
Bernabé de Ayala.
Paris: Maréchal Soult (not included in the catalogue of the Soult sale).
Saint-Amans-Soult (Tarn): Duke of Dalmatia (descendant of
Maréchal Soult).

467. APPARITION OF THE VIRGIN TO ST DOMINIC
Fig. 422.
0.60 × 0.60 m., approximately.
GUI. 324.

468. DEATH OF ST DOMINIC
Fig. 423.
0.60 × 0.60 m., approximately.
GUI. 325.
Guinard: "Aportaciones críticas de obras zurbaranescas". *A.E.A.,*
1964 (pp. 115-128).

469. CHRIST CROWNING A FRIAR
1.00 × 0.50 m.
Lima: unidentified monastery (19th century).
Paris: Señora de Peña.

470. YOUNG GENTLEMAN KNEELING BEFORE TWO ELDERS
1.00 × 0.50 m.
Lima: unidentified monastery (19th century).
Paris: Señora de Peña.
Guinard: "Aportaciones de obras zurbaranescas". *A.E.A.*, 1964 (pp. 122-24, plate III).

471. A MOTHER IMPLORING A SAINT TO CURE HER SON
0.82 × 0.42 m.
London: Colnaghi & Co.
A.E.A., 1964, "Bibliografía", No. 107 (p. 352, plate III).
Burlington Magazine, 1964, "Current & Forthcoming Exhibitions" (p. 240).

472. ST FRANCIS KNEELING
Fig. 424.
1.18 × 0.90 m.
London: Trafalgar Galleries.
Los Angeles: The Norton Simon Foundation (1975).
Young: "An Unknown St Francis, by Francisco de Zurbarán". *B.M.*, 1973 (p. 247, figs. 1, 71).

473. ST ANTHONY OF PADUA
Fig. 425.
1.48 × 1.08 m.
Manzanilla (Seville): private collection (18th century).
Seville: Salvador Cumplido (1905).
 Alfonso Grosso.
Madrid: Prado Museum (1958).
S. 202 GUI. 385 T.M. 263.
Kehrer: p. 151.
Guinard: "Los conjuntos..." II. *A.E.A.*, 1947 (p. 201).

474. ST FRANCIS IN PRAYER
Fig. 426.
1.15 × 0.40 m., approximately.
Barcelona: Puig Palau.
GUI. 369.

475. ST FRANCIS RECEIVING THE STIGMATA
Fig. 427.
1.64 × 1.11 m.
Bogotá: Monastery of San Francisco (donated by Antonio de Verástegui in 1768).
S. 172 GUI. 336 T.M. 238.
Inscribed on the back (in translation): "The Donor, Don Antonio Verástegui, Judge of this Royal Tribunal of Santa Fe, on account of his special devotion to the Wounds of Our Penitent Saint Francis,

gave to this his Monastery this Painting, so that each year it may be placed on the High Altar on the days of the Devotions to the Five Wounds for the benefit of the faithful: year 1768".

476. ST FRANCIS RECEIVING THE STIGMATA
1.53 × 1.10 m.
Bilbao: private collection.
Madrid: Señora de Taramona.
Bilbao: Provincial Museum of Fine Arts, No. 252.
S. note to 172 GUI. 337 T.M. note to 238.

477-489. JACOB AND HIS SONS

477. BENJAMIN
Inscribed: "BENJAMIN XII".
Fig. 428.
London: Mendés (early in 1756).
Scotland: Lord Willoughby of Eresby.
Grimsthorpe Castle: Earl of Ancaster.
GUI. 558 T.M. 202 (XIII).

478. JACOB
Inscribed: "JACOB".
Fig. 429.
London: Mendés (early in 1756).
 Richard Trevor, Bishop of Durham (21 February 1756).
Bishop Auckland (summer residence of the Bishop of Durham).
GUI. 546 T.M. 202 (I).

479. LEVI
Inscribed: "LEVI III".
Fig. 430.
London: Mendés.
 Richard Trevor.
Bishop Auckland.
GUI. 549 T.M. 202 (V).

480. REUBEN
Inscribed: "RUBEN I".
Fig. 431.
London: Mendés.
 Richard Trevor.
Bishop Auckland.
GUI. 547 T.M. 202 (II).

481. SIMEON
Inscribed: "SIMEON II".
Fig. 432.
London: Mendés.
 Richard Trevor.
Bishop Auckland.
GUI. 548 T.M. 202 (III).

482. ZEBULUN
Inscribed: "ZABULON V".
Fig. 433.
London: Mendés.
 Richard Trevor.
Bishop Auckland
GUI. 551 T.M. 202 (VI).

483. ISSACHAR
Inscribed: "ISSACHAR VI".
Fig. 434.
London: Mendés.
 Richard Trevor.
 Bishop Auckland.
GUI. 552 T.M. 202 (VII).

484. JUDAH
Inscribed: "JUDA IV".
Fig. 435.
London: Mendés.
 Richard Trevor.
Bishop Auckland.
GUI. 550 T.M. 202 (IV).

485. DAN
Inscribed: "DAN VII".
Fig. 436.
London: Mendés.
 Richard Trevor.
Bishop Auckland.
GUI. 553 T.M. 202 (VIII).

486. ASHER
Inscribed: "ASER IX".
Fig. 437.
London: Mendés.
 Richard Trevor.
Bishop Auckland.
GUI. 555 T.M. 202 (X).

487. NAPHTALI
Inscribed: "NEPHTALI X".
Fig. 438.
London: Mendés.
 Richard Trevor.
Bishop Auckland.
GUI. 556 T.M. 202 (XI).

488. GAD
Inscribed: "GAD VIII".
Fig. 439.
London: Mendés.
 Richard Trevor.
Bishop Auckland.
GUI. 554 T.M. 202 (IX).

489. JOSEPH
Inscribed: "JOSEPH XI".

Fig. 440.
London: Mendés.
 Richard Trevor.
Bishop Auckland.
GUI. 557 T.M. 202 (XII).
Pemán: "La serie de los hijos de Jacob y otras pinturas zurbaranescas". *A.E.A.*, 1948 (pp. 153-172).
Soria: "Some Flemish Sources of Baroque Painting in Spain". *The Art Bulletin*, December 1948 (pp. 249-259).
Pemán: "Nuevas pinturas de Zurbarán en Inglaterra". *A.E.A.*, 1949 (p. 209).
Guinard: *Zurbarán*, introduction Cat. XXX (p. 207).

490. DAVID
Fig. 441.
London: Faustus Galleries.
Madrid: private collection.

491. ST WILLIAM OF AQUITAINE
Inscribed: "S. guillermo duq.ᵉ de Aquitania".
Fig. 442.
1.87 × 1.00 m.
Lavarde (France): Mlle Bonvoisin.
Paris: private collection.
Lozoya: "Varia. Más zurbaranes en el Perú". *A.E.A.*, 1967 (pp. 84-86).
Guinard: "Sobre el San Guillermo de Aquitania de Zurbarán". *A.E.A.*, 1969 (pp. 297-299, plates I-IV).

492. ST WILLIAM OF AQUITAINE
1.85 × 1.00 m., approximately.
Lima: Nicolás Salazar Orfila.
Lozoya: "Varia. Más zurbaranes en el Perú". *A.E.A.*, 1967 (pp. 84-86, plate II).

493-498. PAINTINGS FROM A SERIES OF THE INFANTES DE LARA, OF UNKNOWN PROVENANCE

493. DIEGO BUSTOS DE LARA
Inscribed: "DIEGO BVSTOS DE LARA".
Fig. 443.
2.00 × 1.04 m.
Seville: Arias de Saavedra (Juana Arias de Saavedra?).
 Marqués de Moscoso.
 Conde de Gómara (by inheritance from the preceding owner).
 Conde de Bustillo.
GUI. 572 T.M. 12 (II).
Sanz-Pastor: *Catálogo de la Exposición Zurbarán en el III centenario de su muerte.* Madrid, 1964 (No. 68, p. 164).

494. ALVAR BLASQUEZ DE LARA
Inscribed: "ALVAR BELASQVES DE LARA".
Fig. 444.
Castres (France): Musée Goya.

495. P. BUSTOS DE LARA
Inscribed: "P. BVSTOS DE LARA".
Fig. 445.
New York: Julius Weitzner.

496. NUÑO SALIDO
Inscribed: "NVÑO SALIDO".
Fig. 446.
Madrid: Clara de Gaztelo y Jácome.
Sanz-Pastor: *Catálogo de la Exposición Zurbarán en el III centenario de su muerte.* Madrid, 1964 (No. 70, p. 166).

497. ALMANZOR
Inscribed: "R. ALMANZOR".
Fig. 449.
2.00 × 1.04 m.
Seville: Marqués de Grañina.
Madrid: private collection.
GUI. 574 T.M. 12 (III).
Sanz-Pastor: *Catálogo de la Exposición Zurbarán en el III centenario de su muerte.* Madrid, 1964 (No. 69, p. 165).

498. GONZALO BUSTOS DE LARA
Inscribed: "GONZALO BVSTOS DE LARA".
2.00 × 1.04 m.
Seville: Joaquín Albarracín (son of Juana Arias de Saavedra).
GUI. 573 T.M. 12 (I).

499. INFANTE
Fig. 447.
Mexico City: Franz Mayer.

500. INFANTE
Fig. 448.
Mexico City: Franz Mayer.

501-512. SERIES OF TWELVE PAINTINGS REPRESENTING SIBYLS
1.80 × 1.05 m.
Seville: Antonio and Aniceto Bravo (1837).
France: private collection.

501. THE PERSIAN SIBYL
Bravo Catalogue No. 352.

502. THE ERYTHRAEAN SIBYL
Bravo Catalogue No. 325.

503. THE CUMAEAN SIBYL
Bravo Catalogue No. 333.

504. THE TIBURTINE SIBYL
Bravo Catalogue No. 328.

505. THE DELPHIC SIBYL
Bravo Catalogue No. 329.

506. THE HELLESPONTIC SIBYL
Bravo Catalogue No. 332.

507. THE AFRICAN SIBYL
Bravo Catalogue No. 349.

508. THE SAMIAN SIBYL
Bravo Catalogue No. 348.

509. THE LIBYAN SIBYL
Bravo Catalogue No. 344.

510. THE CUMAN SIBYL
Bravo Catalogue No. 345.

511. THE EUROPEAN SIBYL
Bravo Catalogue No. 338.

512. THE PHRYGIAN SIBYL
Bravo Catalogue No. 336.
Catalogue of the Antonio and Aniceto Bravo Collection, Seville, 1837.
Guinard: "España, Flandes y Francia en el S. XVII. Las Sibilas zurbaranescas y sus fuentes grabadas". *A.E.A.,* 1970 (p. 105).

513. THE VIRGIN AND CHILD WITH ST JOHN
Inscribed: "Fran^{co} de Zurbaran/1658".
Figs. 450 & 515.
1.37 × 1.04 m.
Madrid: Conde de Altamira.
London: Altamira sale, No. 55 (Christie's, 1827).
 Marquess of Stafford.
 Duke of Sutherland sale, No. 43 (1913).
Munich: Dr C. Gütter.
New York: Reinhard Galleries.
 Lilienfeld Galleries.
San Diego (California): Fine Arts Gallery (1935).
GA. 236 S. 206 GUI. 50 T.M. 265.
Waagen: I (1839), p. 67.
Kehrer: p. 23.

514. IMMACULATE CONCEPTION
Signed and dated 1658.
Fig. 451.
2.03 × 1.57 m.
London: Christie's, 28 March 1969.
A.E.A., 1970 "Bibliografía", No. 183 (p. 442).

515. THE VIRGIN SUCKLING THE CHILD JESUS ("THE VIRGIN OF THE MILK")
Inscribed: "Fran^{co} de Zurbaran 1658".
Fig. 452.
1.01 × 0.78 m.
Moscow: Pushkin State Museum of Fine Arts.
S. 207 GUI. 47 T.M. 257.
Malitzkaya: "Zurbarán in the Moscow Museum of Fine Arts". *B.M.,* July 1930 (pp. 16-20). *Spanish Painting of the XVI-XVII Centuries.* Moscow, 1947 (pp. 113-114). "Zurbarán en los Museos Rusos". *A.E.A.,* 1964 (p. 113).

516. VEIL OF ST VERONICA
Inscribed: "fran^{co} Dezurbaran/1658".
Figs. 453 & 454.
1.02 × 0.80 m.

Torrecilla de la Orden (Valladolid): Hermitage (top of the altar-piece).
Valladolid: National Museum of Sculpture (on deposit).
Martín González, J.J.: "La Santa Faz. A propósito de un inédito de Zurbarán". *Goya,* No. 97, 1970 (pp. 11-12).

517. THE REPENTANCE OF ST PETER
Inscribed: "Fran^{co} de Zurbaran fec/1659".
Fig. 455.
Mexico: Since the 17th or 18th century.
 José Pérez.
 José Luis Bello y González (c. 1864).
Puebla (Mexico): José Luis Bello y Zetina.
 Museo José Luis Bello.
S. 217 GUI. 152.
Obregón: *Zurbarán en México.* Badajoz, 1964 (p. 12).

518. VIRGIN WITH SLEEPING CHILD
Inscribed: "Fran^{co} de Zurbarán/1659".
Fig. 456.
1.20 × 0.98 m.
Madrid: Marqués de Unzá del Valle.
 Antonio Barnuevo.
GA. 248 S. 208 GUI. 48 T.M. 267.
Kehrer: pp. 125-126.
Angulo, Diego: "Cinco nuevos cuadros de Zurbarán". *A.E.A.,* 1944 (pp. 1-9).

519. THE HOLY FAMILY
Inscribed: "Fran^{co} de Zur/baran f./1659".
Fig. 457.
1.21 × 0.97 m.
London: Viscount Clifden sale, No. 32 (Christie's, 1893).
 Colnaghi & Co.
Paris: Porgès.
 Galerie Kleinberger.
Budapest: Museum of Fine Arts, No. 2536 (1904).
GA. 249 S. 209 GUI. 54 T.M. 264.
Kehrer: p. 125.
Guinard: "Los conjuntos..." III. *A.E.A.,* 1949 (p. 45).

520. ST FRANCIS KNEELING
Inscribed: "Fran^co de Zurbaran/1659".
Fig. 458.
1.27 × 0.97 m.
Madrid: Aureliano Beruete (1905).
Bilbao: Félix Valdés (c. 1945).
GA. 246 S. 216 GUI. 359 T.M. 268.
Kehrer: p. 124.

521. THE PORTIUNCULA
Inscribed: "Fran^co de Zurbarán/1661".
Figs. 459 & 516.
1.98 × 1.55 m.
Moreton-in-Marsh (Glos.): Lord Northwick (1864 catalogue).
E.G. Spencer-Churchill (d. 1964).
London: Spencer-Churchill sale, No. 70 (Christie's, 1965).
Greswell Collection.
New York: private collection.
S. (2nd edition) 237 GUI. 333 T.M. 272.

522. CHRIST AFTER THE SCOURGING
Inscribed: "Fran^co de Zurbaran 1661".
Fig. 460.
1.67 × 1.07 m.
Jadraque (Guadalajara): Parish Church.
GA. 254 S. 220 GUI. 79 T.M. 269.
Kehrer: pp. 126-127.
Sanz-Pastor: *Catálogo de la Exposición Zurbarán en el III centenario de su muerte.* Madrid, 1964 (No. 103, pp. 196-197).

523. IMMACULATE CONCEPTION
Inscribed: "Fran^co de Zurbaran facie/1661".

Fig. 462.
1.36 × 1.02 m.
Budapest: Inventory of the Estérhazy Collection (1820).
Museum of Fine Arts, No. 800 (1871, donated by Prince Nicolaus Estérhazy).
GA. 253 S. 222 GUI. 19 T.M. 276.
Kehrer: pp. 127-128.

524. IMMACULATE CONCEPTION
Inscribed: "Fran de Zurbaran f/1661".
Figs. 463 & 517.
1.40 × 1.03 m.
Langon (France): Parish Church.
Bordeaux: Musée des Beaux-Arts.

525. THE VIRGIN AND CHILD WITH ST JOHN
Inscribed: "Fran^co de Zurbaran/1662".
Fig. 461.
1.65 × 1.27 m.
Madrid: Condesa de Cabanillas.
José de Madrazo (1856).
Paris: Marqués de Salamanca sale, No. 50 (1867).
Madrid: Marqués de Camarines.
Marqués de Nerva.
Bilbao: Provincial Museum of Fine Arts, No. 441 (1936, donated by María Martín de Oliva).
GA. 256 S. 223 GUI. 52 T.M. 266 (I).
Madoz: *Diccionario geográfico, estadístico e histórico de España.* 1847, Vol. X (p. 861).
Mayer: "Some Unknown Works of Zurbarán". *Apollo*, 1928 (p. 181).
Angulo: "Cinco nuevos cuadros de Zurbarán". *A.E.A.*, 1944 (pp. 1-9).

WORKS PROBABLY PAINTED BETWEEN MAY 1658 AND AUGUST 1664

526-527. TWO PICTURES FROM THE FRANCISCAN MONASTERY OF SAN DIEGO, ALCALA DE HENARES

526. ST BONAVENTURA
Inscribed: "Fran^co de Zurbaran".
Fig. 464.
2.91 × 1.65 m.
Alcalá de Henares: Monastery of San Diego.
Madrid: Museo de la Trinidad (1835).
Church of San Francisco el Grande.

527. ST JAMES OF THE MARCH
Inscribed: "Fran^co de Zurbaran".

Figs. 465 & 466.
2.91 × 1.65 m.
Alcalá de Henares: Monastery of San Diego.
Madrid: Museo de la Trinidad.
Church of San Francisco el Grande.
Prado Museum, No. 2472.
GA. 199 S. 213 GUI. 393 T.M. 271.

Palomino: XCVIII, CLII.
Ponz: I - 7/18.
Ceán Bermúdez: I, p. 221; IV, pp. 245-246.
Cruzada Villaamil: *Catálogo Provisional del Museo Nacional de Pinturas.* Madrid, 1865 (p. 128).

Tormo: *Las Iglesias del Antiguo Madrid*, I. 1927 (p. 95).
Pérez Sánchez: *The Golden Age of Spanish Painting*. London, 1976 (p. 58, No. 36).

528. THE ANNUNCIATION
Inscribed: "Fran^{co} de Zurb(aran faci)ebat".
Figs. 467 & 482.
2.13 × 3.14 m.
Madrid: painting commissioned by Gaspar de Bracamonte (1658).
Peñaranda de Bracamonte (Salamanca): Parish Church (donated, on 4 July 1658, by Gaspar de Bracamonte, Conde de Peñaranda).
Madrid: Valentín Carderera (1824).
Paris: Marqués de Salamanca sale, No. 48 (1867).
London: Lord Dudley sale, No. 54 (Christie's, 1900).
 Colnaghi & Co.
Philadelphia: Philadelphia Museum of Art, No. 1900-1-16 (October 1900).
S. 210 GUI. 35 T.M. 275.
Palomino: CVIII.
Ceán Bermúdez: VI, p. 52.
Soria: "Sobre una Anunciación de Zurbarán". *B.S.E.E.*, 1948 (pp. 149-151).
Guinard: "Los conjuntos..." III. *A.E.A.*, 1949 (pp. 31-32).

529. THE ANNUNCIATION
Figs. 468 & 469.
2.15 × 3.08 m.
Seville: Manuel Delgado Brackenbury (before 1936).
Barcelona: Plandiura Collection.
Madrid: private collection.
GUI. 36.
Sanz-Pastor: *Catálogo de la Exposición Zurbarán en el III centenario de su muerte*. Madrid, 1964 (No. 100, pp. 193-194).

530. THE VIRGIN OF THE ANNUNCIATION
Figs. 470 & 483.
Palma de Mallorca: Juan March Foundation.
GUI. 37.

531. ST FRANCIS IN MEDITATION
Fig. 471.
0.64 × 0.53 m.
Mannheim: Gallery of the Elector Palatine (18th century).
Munich: Karl Theodor, Elector of Bavaria.
 Alte Pinakothek.
GA. 247 S. 215 GUI. 363 T.M. 273.
Kehrer: p. 120.

532. ST FRANCIS IN MEDITATION
Fig. 473.

0.75 × 0.58 m.
Madrid: Eduardo Martínez del Campo.
Barcelona: Aguilera Collection.
GA. 241 GUI. 364.
Kehrer: p. 151.

533. DOCTOR OF LAW OF THE UNIVERSITY OF SALA-MANCA
Fig. 472.
1.94 × 1.03 m.
Madrid: Marqués de Leganés (before 1700).
Paris: Marqués de Salamanca sale, No. 207 (1867).
 Ivan Stchoukine sale, No. 70 (Hôtel Drouot, 1908).
New York: Ehrich Galleries.
Boston: Isabella Stewart Gardner (1910).
 Isabella Stewart Gardner Museum.
GA. 227 S. 214 GUI. 577 T.M. 274.
Kehrer: p. 84.

534. THE REPENTANCE OF ST PETER
Fig. 474.
1.34 × 0.96 m.
Paris: Louvre, Louis-Philippe's "Galerie Espagnole", No. 340 (1838).
London: Louis-Philippe sale, No. 64 (Christie's, 1853).
 Bigge Collection.
Marseilles: Musée de Longchamp, No. 838 (1869).
S. 205 GUI. 151.

535-536. TWO PAINTINGS FROM THE CHURCH OF THE MAGDALENAS, ALCALA DE HENARES

535. ST AUGUSTINE
Fig. 475.
1.40 × 0.83 m.
Madrid: Chapaprieta Collection (1936).
 Juan de Córdoba y Mirón.
GUI. 515.

536. ST THOMAS OF VILLANUEVA GIVING ALMS TO A CRIPPLE
Fig. 476.
1.40 × 0.82 m.
Madrid: Chapaprieta Collection (1936).
 Juan de Córdoba y Mirón.
 Private collection (1970).
GUI. 518.
Guinard: "Aportaciones críticas de obras zurbaranescas". *A.E.A.*, 1964 (p. 126, plate VI).
Sanz-Pastor: *Catálogo de la Exposición Zurbarán en el III centenario de su muerte*. Madrid, 1964 (Nos. 93, 96).

537. ST DIEGO DE ALCALA
Fig. 477.
0.93 × 0.99 m.
Cadiz: José Luis de Sola (1905).
Madrid: Prado Museum, No. 2,442 (1932).
GA. 230 S. 54 GUI. 390 T.M. 65.
Soria: "Francisco de Zurbarán: A Study of his Style". *G.d.B.A.*, 1944 (p. 169).

538. COMMUNION OF ST MARY OF EGYPT
Fig. 478.
Madrid: Serrano Collection.
GUI. 274.

539. VIRGIN AND CHILD
Fig. 479.

1.42 × 1.09 m.
London: anonymous sale (Christie's, 14 July 1939).
New York: Koetser & Co.
 Oscar B. Cintas.
Present whereabouts unknown.
GA. 205 S. 182 GUI. 49.

540. THE VIRGIN AND CHILD WITH ST JOHN
Figs. 480 & 481.
1.30 × 1.00 m.
Madrid: private collection (1920).
New York: Paul O. Berliz.
Zürich: Bubenberg Erlenbach Collection.
S. 218 GUI. 51 T.M. 266.

WORKS OF UNCERTAIN DATE

541-542. TWO STILL LIFES FROM THE F. CAMBO COLLECTION

541. STILL LIFE
Fig. 484.
0.46 × 0.84 m.
Barcelona: Francisco Cambó.
Madrid: Prado Museum, No. 2,803 (1940).
GA. 93 S. 73 GUI. 609 T.M. 107.

542. STILL LIFE
Fig. 485.
0.46 × 0.84 m.
Barcelona: Francisco Cambó.
 Art Museum of Catalonia (1940).
S. 74 GUI. 610 T.M. 108.
Seckel: "F. de Zurbarán as a painter of still life". *G.d.B.A.*, 1946 (pp. 287-288).
Pemán: "Juan de Zurbarán". *A.E.A.*, 1958 (pp. 193-211).

543. FLOWER-PIECE
Fig. 486.
0.44 × 0.34 m.
Málaga: Antonio Pons.
 Provincial Museum of Fine Arts (on deposit).
Madrid: Prado Museum, No. 2,888 (1945).
GA. 95 GUI. 607.
Cavestany: *Catálogo de la Exposición Floreros y Bodegones en la pintura española.* Madrid, 1936 (p. 151).

544. STILL LIFE
Fig. 487.
Paris: private collection.
Madrid: private collection.

545. QUINCES ON A PLATE
Fig. 488.
0.35 × 0.40 m. (fragment).
Barcelona: Gil Collection.
 Art Museum of Catalonia (1944).
GUI. 599 T.M. 111.
Sanz-Pastor: *Catálogo de la Exposición Zurbarán en el III centenario de su muerte.* Madrid, 1964 (No. 37, p. 134).

546. STILL LIFE
Fig. 489.
0.45 × 0.54 m.
Seville: José Lafitte.
Dos Hermanas (Seville): Conde de Ibarra.
Madrid: private collection.
GA. 94 GUI. 598.
Sanz-Pastor: *Catálogo de la Exposición Zurbarán en el III centenario de su muerte.* Madrid, 1964 (No. 27).

547. STILL LIFE
Fig. 490.

0.60 × 0.79 m.
Barcelona: Ignacio Balanzó.
Buenos Aires: Javier Serra.
Madrid: Javier Serra.
S. 72 GUI. 608 T.M. 113.
Pemán: "Juan de Zurbarán". *A.E.A.*, 1958 (pp. 206-207).

548. ST DOMINIC
Fig. 491.
2.00 × 1.25 m.
Seville: Monastery of San Pablo.
 Provincial Museum of Fine Arts.
GA. 99 GUI. 314.
Kehrer: p. 150.
Gestoso: No. 208.
Guinard: *Zurbarán*, introduction Cat. II (p. 186).

549. ST DOMINIC
1.25 × 1.00 m., approximately.
Bordeaux: Dominican Novitiate.
GUI. 315.

550. ST DOMINIC
Fig. 492.
1.05 × 0.77 m.
Seville: private collection.
Madrid: Duke of Alba (1957).
GUI. 308.
Caturla: "Ternura y primor de Zurbarán". *Goya*, No. 30, 1959 (p. 345).

551. ST DOMINIC
2.03 × 1.35 m.
Seville: Francisco Romero Comavachuelo.
 Francisco Romero Brunet.
Bilbao: Félix Valdés.
 Zubillaga Collection.
GUI. 306 T.M. 36.
Caturla: "Ternura y primor de Zurbarán". *Goya*, No. 30, 1959 (p. 345).

552. ST FRANCIS RECEIVING THE STIGMATA
Signed: "Fran Zurbarán".
Fig. 493.
2.22 × 1.97 m.
Madrid: Franciscan Monastery.
Paris: Louvre, Louis-Philippe's "Galerie Espagnole", No. 345.

London: Louis-Philippe sale, No. 49 (Christie's, 1853).
 Gutten Collection.
 Charles Holden White.
 Giuseppe Bellesi (1935).
 Tomás Harris.
GUI. 334.
Mayer: "Anotaciones a cuadros de Velázquez, Zurbarán, Murillo y Goya en el Prado y en la Academia de San Fernando". *B.S.E.E.*, 1936 (p. 44).

553. ST FRANCIS
Fig. 494.
Abalos (Logroño): Palacio.
Pemán: "Miscelánea zurbaranesca. El San Francisco de Abalos". *A.E.A.*, 1964 (pp. 98-100).

554. VEIL OF ST VERONICA
Fig. 495.
1.04 × 0.84 m.
Madrid: Juan Pereira González.

555. VEIL OF ST VERONICA
1.04 × 0.84 m.
Valladolid: private collection.
London: Neil McLaren.
Madrid: private collection.
Pérez Sánchez: "Varia. Nuevas papeletas para el catálogo de Zurbarán". *A.E.A.*, 1964 (pp. 193-196, plate I).

556. VEIL OF ST VERONICA
Fig. 496.
1.00 × 0.85 m.
London: Trafalgar Galleries.

557. VEIL OF ST VERONICA
Fig. 497.
1.09 × 0.77 m.
Madrid: Angel Avilés.
GA. 63 S. 63 GUI. 82 T.M. 73.
Kehrer: p. 61.

558. VEIL OF ST VERONICA
Fig. 499.
0.70 × 0.515 m.
Paris: Louvre, Standish Collection, No. 183 (1842).
London: Frank Hall Standish sale, No. 120 (Christie's, 1853).
Keir (Scotland): Sir William Stirling-Maxwell.
Stockholm: National Museum (1957).

S. 64a GUI. 87 T.M. 72.
Sanz-Pastor: *Catálogo de la Exposición Zurbarán en el III centenario de su muerte.* Madrid, 1964 (No. 21).

559. VEIL OF ST VERONICA
Fig. 498.
1.00 × 1.00 m., approximately.
Jerez: Church of San Miguel.
GA. 64 GUI. 83.

560. VEIL OF ST VERONICA
1.07 × 0.75 m.
Ecija: private collection.
Madrid: Guillermo Bernstein.
GUI. 84.

561. VEIL OF ST VERONICA
Inscribed: "Fran^co Zurbarán fac 1631".
1.01 × 0.78 m.
Madrid: Estate of Mariano Pacheco.
Argentina: private collection.
GA. 62 S. 64 GUI. 81.
Kehrer: p. 61.
Sanz-Pastor: *Catálogo de la Exposición Zurbarán en el III centenario de su muerte.* Madrid, 1964 (note to No. 21).

562. VEIL OF ST VERONICA
1.00 × 1.00 m., approximately.
Seville: Church of San Pedro (chapel at the end of the right-hand aisle).
GUI. 85.

563. VEIL OF ST VERONICA
Arcos de la Frontera: Church of San Francisco.
GUI. 88.

564. PORTRAIT OF A FRANCISCAN FRIAR
Fig. 500.
Drawing in pencil on paper, 0.28 × 0.194 m.
Madrid: José de Madrazo.
London: John Malcolm of Poltalloch (1867).
 British Museum, No. 1895-9-15-873.
S. 34 GUI. 397.
Robinson: *Catalogue of the collection of John Malcolm of Poltalloch.* London, 1876 (No. 424).
Mayer: *Handzeichnungen Spanischer Meister* (p. 46).
Kehrer: p. 211.

565. FRANCISCAN FRIAR KNEELING
Fig. 501.
Drawing in ink and chalk on paper, 0.38 × 0.26 m.
Gijon: Instituto Jovellanos, No. 658.
Destroyed during the Spanish Civil War (1936-39).
GUI. 383.

566. ST CATHERINE
Fig. 502.
Drawing in pencil on paper.
Córdoba: Provincial Museum of Fine Arts.
GUI. 254.

567. ST CATHERINE
Fig. 503.
Drawing in pen and ink on paper.
Córdoba: Provincial Museum of Fine Arts.

ENGRAVINGS

1598. 7 November. Francisco de Zurbarán, son of the haberdasher Luis de Zurbarán and his wife, Isabel Márquez, is christened in the church of Our Lady of the Pomegranate in Fuente de Cantos, Province of Badajoz.

1613. 19 December. Luis de Zurbarán authorizes Pedro Delgueta Rebolledo, of Seville, to have Francisco de Zurbarán indentured as an apprentice to some painter, in Seville or elsewhere.

1614. 15 January. Pedro Delgueta Rebolledo places Francisco de Zurbarán as an apprentice to Pedro Díaz de Villanueva, a "painter of (religious) images" living and working in Seville. Zurbarán is to pay the sum of 16 ducats to Pedro Díaz and the latter undertakes to provide him with "food and drink and house and bed", and to teach him his craft within a period of three years. Zurbarán shall be free to work on his own account and for his own profit on Sundays and holy days.

1616. *The Virgin as a Child.* Canvas inscribed: "Fran co de Zurbarán fac/1616" (Cat. No. 1; Figs. 1, 2 & 504).

1617. Zurbarán moves to Llerena (province of Badajoz) and is married to María Páez, residing in the said town.

1618. 22 February. Christening, in the parish church of Llerena, of María, daughter of Francisco de Zurbarán and María Páez, "residents of this town".

1618. Zurbarán is paid six reales by the Town Hall of Llerena for his design of a fountain for the main square of the town, a fountain which in part still survives.

1619. 5 November. Zurbarán is paid 77 reales for a picture of the Virgin which was "placed" on the Villagarcía gate (the north gate) of Llerena. *(Lost work)*

1620. 19 July. Christening, in the parish church of Santiago, Llerena, of Juan, son of Francisco de Zurbarán and María Páez, "residents of this town".

1622. 25 February. Francisco de Zurbarán, "resident of Llerena", signs a contract in Fuente de Cantos for the decoration of some processional images.

1622. 28 August. After contracting for a retable with fifteen pictures of the mysteries of the Rosary for the parish church of Fuente de Cantos, Francisco de Zurbarán engages Fr González Morato, of Mérida, to do the sculptural work involved. *(Lost works)*

1623. 13 July. Christening, in the parish church of Santiago, Llerena, of Isabel-Paula, daughter of Francisco de Zurbarán and María Páez, "residents of this town".

1623-24. Death of María Páez.

1624. *The Child Jesus Blessing.* Painting on copper plate inscribed, in gold: "FRAN co DEZURVARAN FACIEBAT/1624" "... LLERENA" (Cat. No. 2; Figs. 3 & 505).

1625. Francisco de Zurbarán is married again, this time to Beatriz de Morales, a widow and the daughter of a rich family in Llerena.

1626. 17 January. Fco. de Zurbarán, resident of Llerena, signs a contract in Seville, with the prior of the monastery of San Pablo el Real in that city, by which he undertakes to paint twenty-one pictures in eight months, for 4000 reales (Cat. Nos. 3-7; Figs. 4-11 & 86).

1626. 26 June. Francisco de Zurbarán, "resident of Llerena at present in this city of Seville", delivers the residue of the property of García de Morales for the foundation of a perpetual chaplaincy.

1627. *Christ Crucified.* Canvas inscribed: "Fran co de Zurb.../fat. 1627" (Cat. No. 8; Fig. 12). Painted for the sacristy of the Sevillian monastery of San Pablo el Real.

1628. 29 August. Fco. de Zurbarán, "resident of Llerena at present in this city of Seville", signs a contract with the prelate of the principal monastery of Our Lady of Ransom (The Mercedarian Order), according to which he undertakes to paint, in one year and with as many assistants as he may need, twenty-two scenes from the life of St Peter Nolasco, measuring two *varas* in height by two and a half in width, for 1500 ducats. Both the painter and his assistants are to be lodged in the monastery. (Cat. Nos. 9-15; Figs. 13-24).

1628. *St Serapion.* Canvas inscribed: "Fran co de Zurbaran fabt 1628" "B. Serapius" (Cat. No. 9; Fig. 13). Originally in the "De Profundis" Room in the monastery of the Calced Mercedarians, Seville.

1629. *Apparition of St Peter the Apostle to St Peter Nolasco.* Canvas inscribed: "FRANCISCVS DEZVRBARAN/FACIEBAT 1629" (Cat. No. 12; Figs. 16, 19 & 506). This picture was one of the series painted for the principal monastery of Our Lady of Ransom in Seville.

1629. 21 June. Mentioning as witnesses to Zurbarán's skill the pictures "which he has finished" of the series for the Mercedarian monastery and the *Christ Crucified* in the monastery of San Pablo el Real, Councillor Rodrigo Suárez proposes that the Town Council of Seville should endeavour to keep Zurbarán in the city, his proposal being accepted by the Chief Magistrate, Don Diego de Mendoza.

1629. Fco. de Zurbarán, his wife, his three children, a woman relative, four male servants and four women (possibly maids) are mentioned in the census as residing at No. 27 in the Callejón de Alcázar, a street in the parish of the principal church of Seville.

1629. 26 September. Pedro Calderón signs a contract with the monastery of the Holy Trinity, outside Seville, for the painting, gilding and burnishing of a retable dedicated to St Joseph. The contract specifies that out of the total price of 490 ducats he must deliver 130 ducats to Zurbarán, the "master-painter of this city of Seville", commissioned to do the paintings. (Cat Nos. 20-27; Figs. 30-37).

1629. *Visit of St Thomas Aquinas to St Bonaventura*. Canvas inscribed: "F co DE ZURBARAN/FAT 1629" (Cat. No. 16; Fig. 25). This picture was one of the series painted by Herrera the Elder and Zurbarán for the Franciscan school of St Bonaventura in Seville.

1630. 24 May. Letter from Fco. de Zurbarán to the Town Council of Seville, protesting against the demands of the Sevillian painters that he should be obliged to take an examination. In this letter he mentions his works in the monasteries of San Pablo el Real and Our Lady of Ransom.

1630. 29 May. Letter from Zurbarán to the Vizconde de la Corzana, confirming that the painting commissioned for the sacristy of the monastery of San Pablo would be finished within the next twenty-two days, as had been stipulated. *(Lost work)*

1630. 8 June. The Town Council of Seville decides to commission an Immaculate Conception from Zurbarán, to be hung in the lower chamber. This may be the *Immaculate Conception* recorded in this book (Cat. No. 28; Figs. 38 & 40).

1630. *The Legend of the Bell*. Inscribed: "FRAN co DEZVRB... FATI/1630" (Cat. No. 14; Figs. 22 & 23). This picture was part of the scenes from the life of St Peter Nolasco painted for the principal monastery of Our Lady of Ransom in Seville.

1630. *Vision of Blessed Alonso Rodríguez*. Canvas inscribed: "F co DEZVRBARAN FA/1630" (Cat. No. 29; Figs. 39, 41 & 508). Painted for the Professed House of the Society of Jesus in Seville.

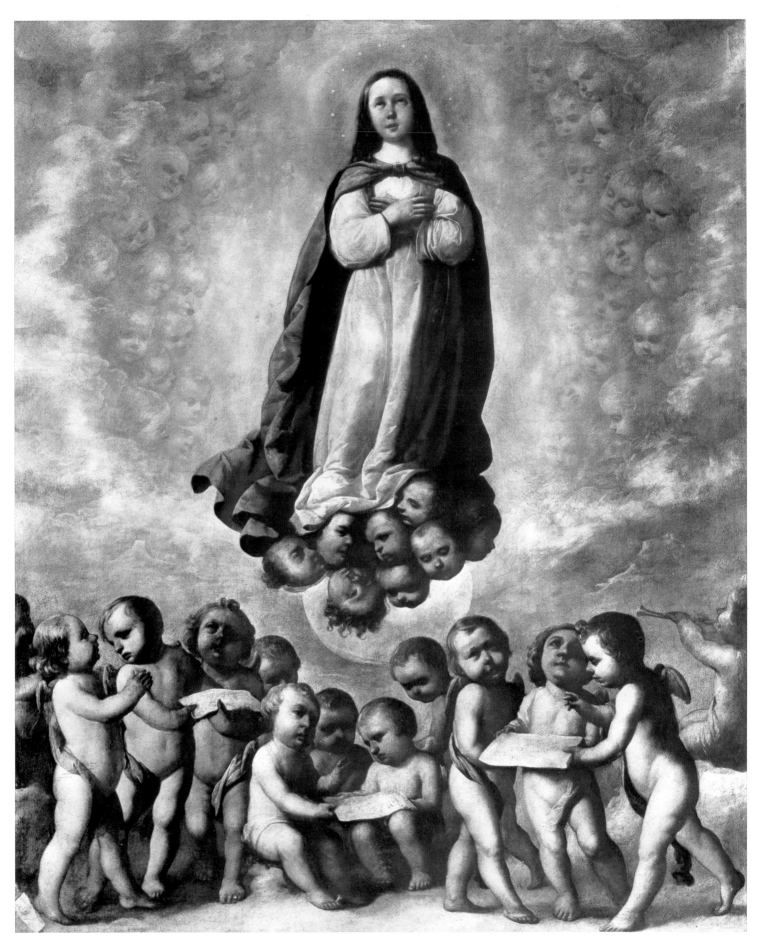

Fig. 1. THE VIRGIN AS A CHILD WITH A CHOIR OF ANGELS. 1616. Bilbao: Félix Valdés. Cat. No. 1.

Fig. 2. THE VIRGIN AS A CHILD WITH A CHOIR OF ANGELS. Detail of figure 1.
Fig. 3. THE CHILD JESUS BLESSING. 1624. Barcelona: Private collection. Cat. No. 2.
Fig. 4. APPARITION OF THE VIRGIN TO THE MONKS OF SORIANO. 1626-1627. Seville: Church of the Magdalen. Cat. No. 3.
Fig. 5. THE MIRACULOUS CURE OF BLESSED REGINALD OF ORLEANS. 1626-1627. Seville: Church of the Magdalen. Cat. No. 4.

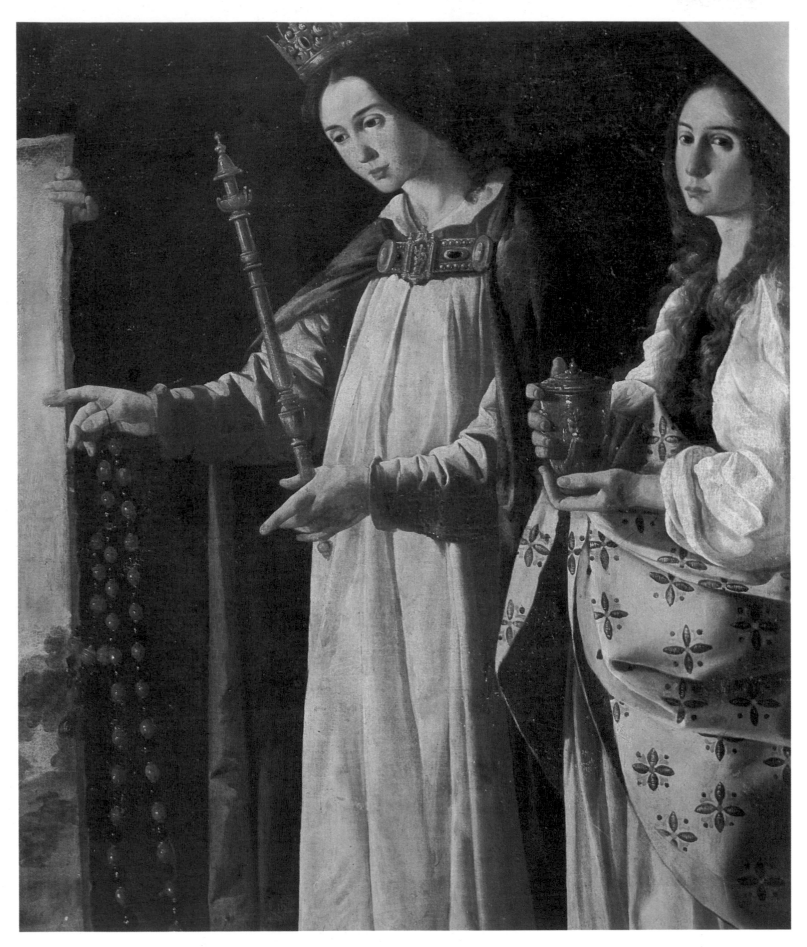

Fig. 6. **APPARITION OF THE VIRGIN TO THE MONKS OF SORIANO**. Detail of figure 4.
Fig. 7. **THE MIRACULOUS CURE OF BLESSED REGINALD OF ORLEANS**. Detail of figure 5.

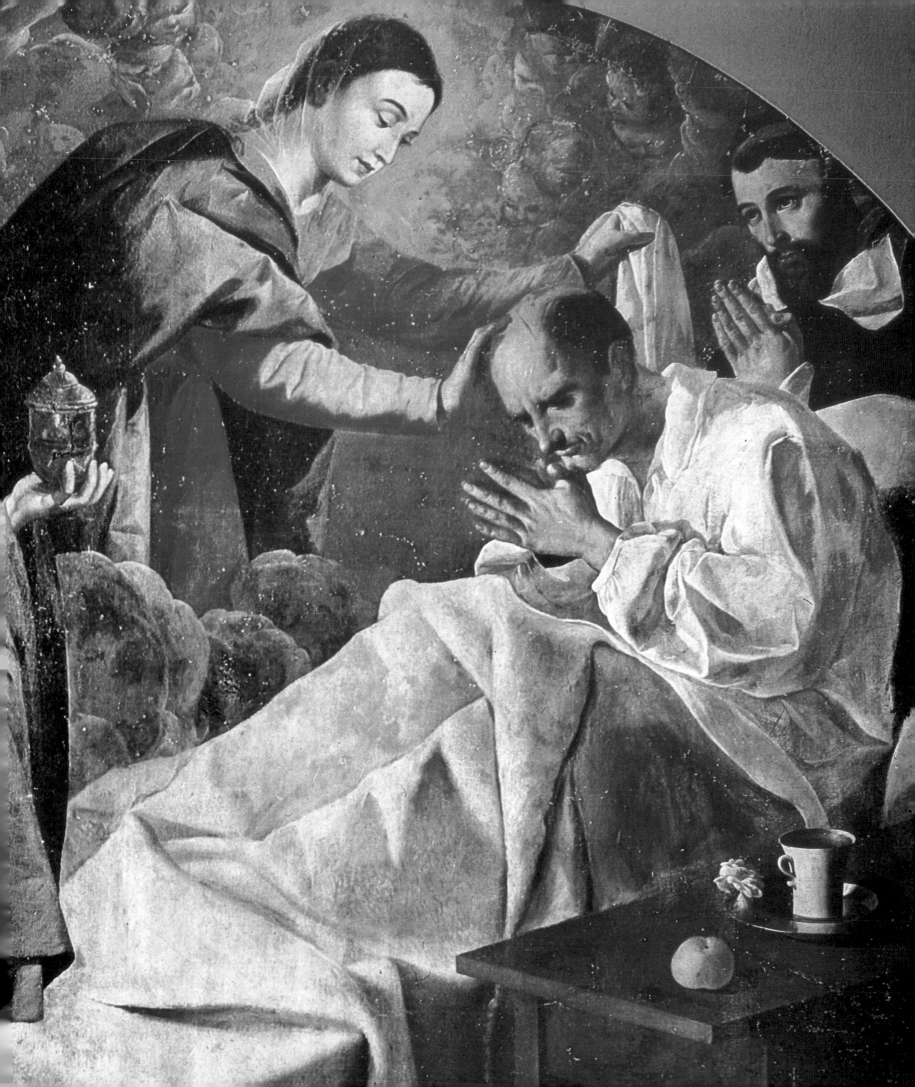

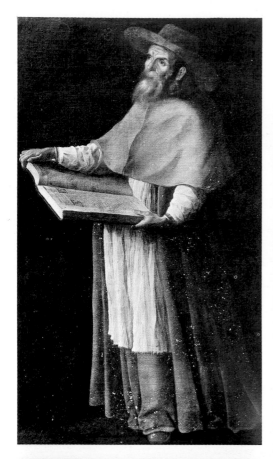

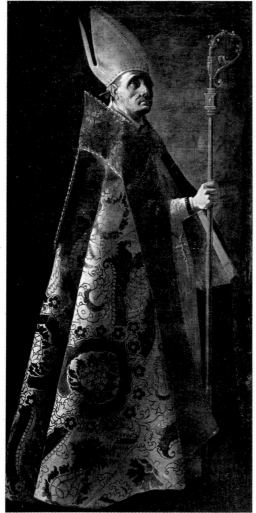

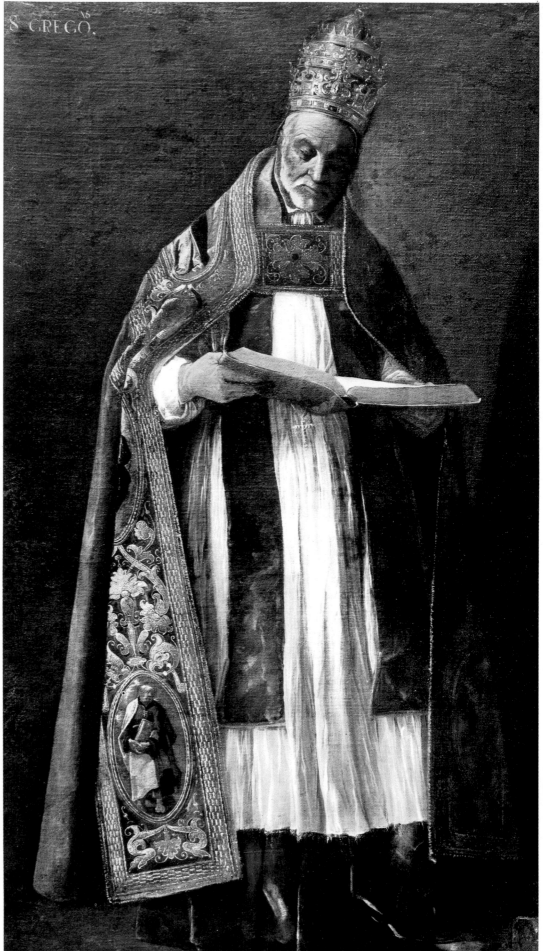

S GREGO.

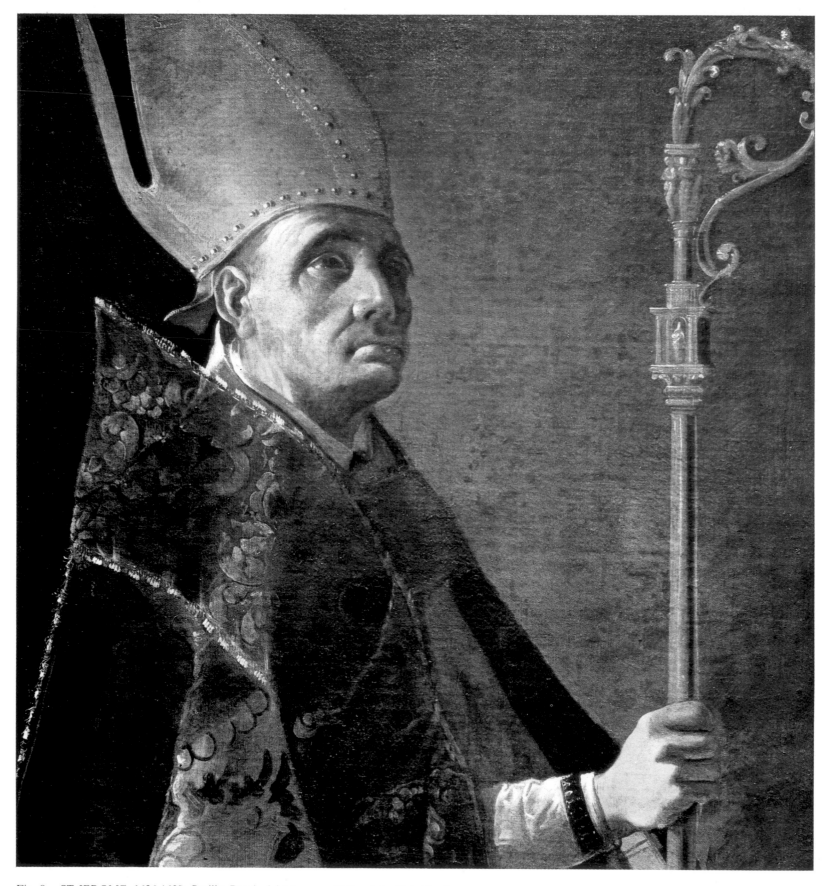

Fig. 8. ST JEROME. 1626-1627. Seville: Provincial Museum of Fine Arts. Cat. No. 5.
Fig. 9. ST GREGORY. 1626-1627. Seville: Provincial Museum of Fine Arts. Cat. No. 6.
Fig. 10 and 11. ST AMBROSE. 1626-1627. Seville: Provincial Museum of Fine Arts. Cat. No. 7.

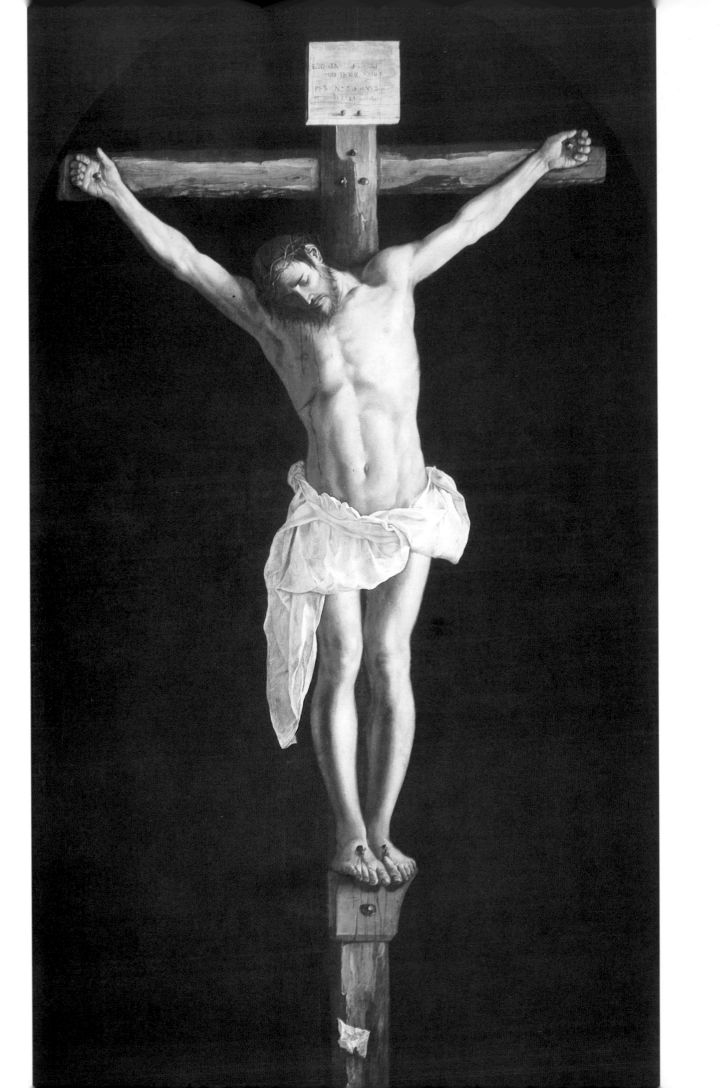

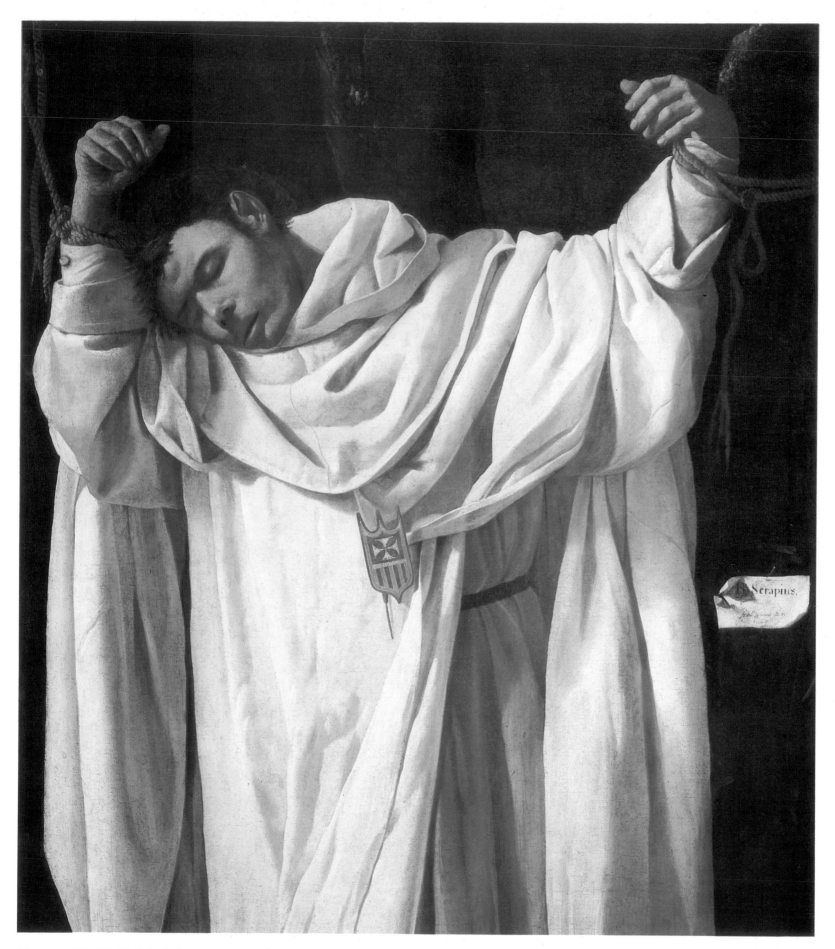

Fig. 12. CHRIST CRUCIFIED. 1627. Chicago: The Art Institute of Chicago. Cat. No. 8.
Fig. 13. ST SERAPION. 1628. The Wadsworth Atheneum, Hartford. Cat. No. 9.

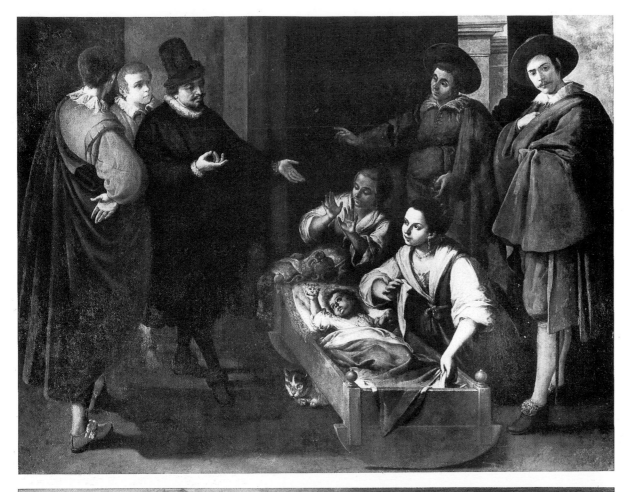

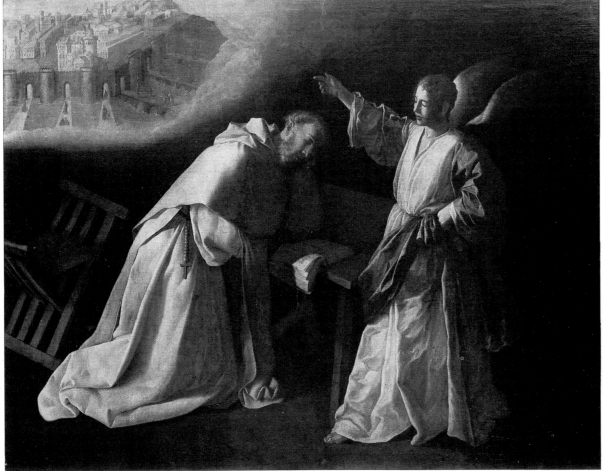

Fig. 14. BIRTH OF ST PETER NO-
LASCO. 1628-1634. Bordeaux: Musée des
Beaux-Arts. Cat. No. 10.
Fig. 15. VISION OF ST PETER NO-
LASCO. 1628-1634. Madrid: Prado Mu-
seum. Cat. No. 11.

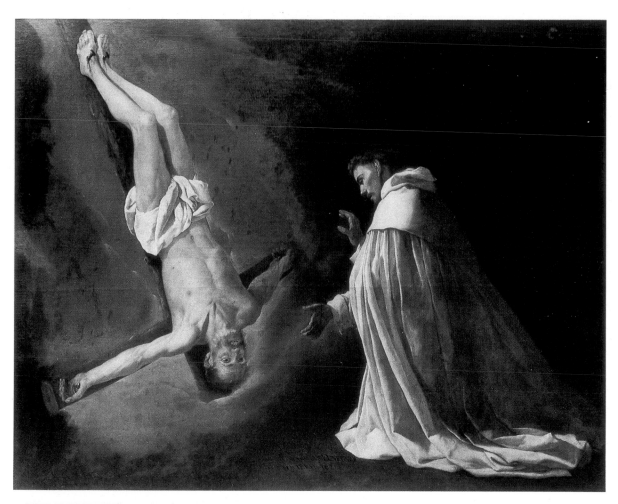

Fig. 16. APPARITION OF ST PETER THE APOSTLE TO ST PETER NOLASCO. 1629. Madrid: Prado Museum. Cat. No. 12.

Fig. 17. Jusepe Martínez. APPARITION OF ST PETER APOSTLE TO ST PETER NOLASCO. 1627. Madrid: Engraved. National Library.

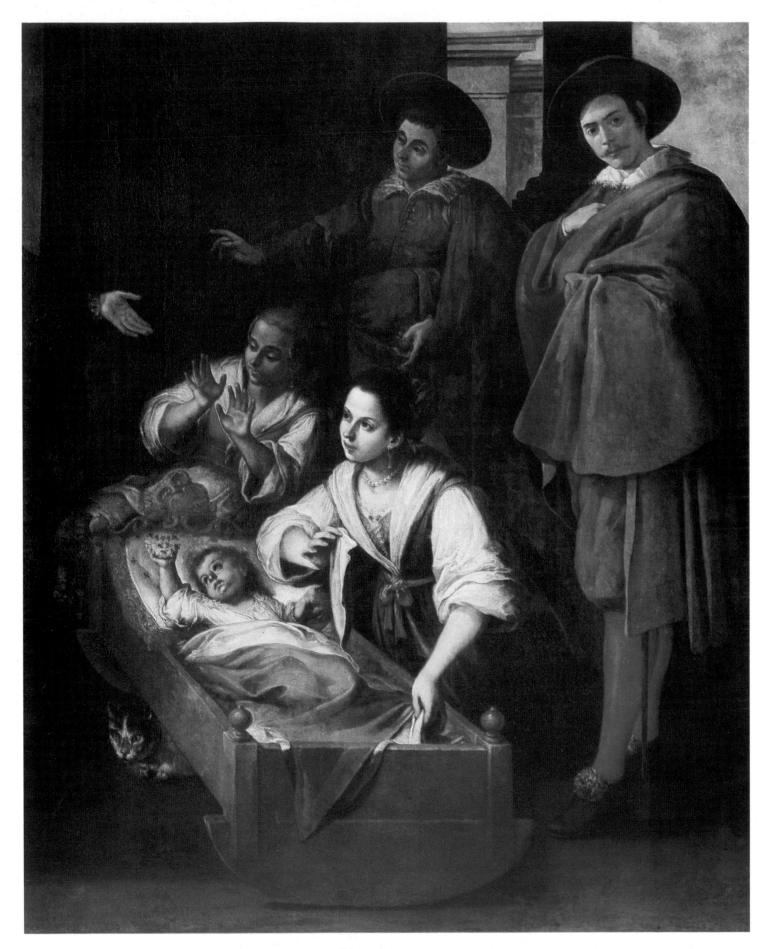

Fig. 18. BIRTH OF ST PETER NOLASCO. Detail of figure 14.
Fig. 19. APPARITION OF ST PETER THE APOSTLE TO ST PETER NOLASCO. Detail of figure 16.

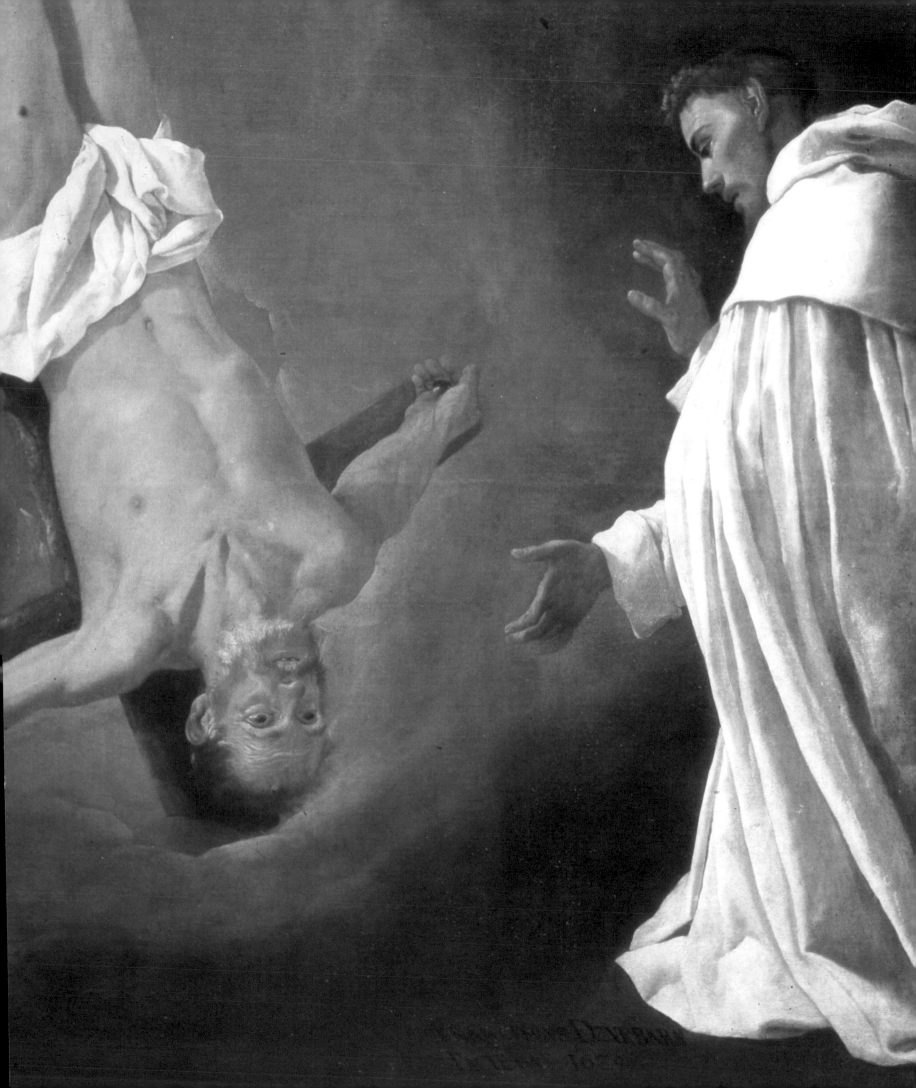

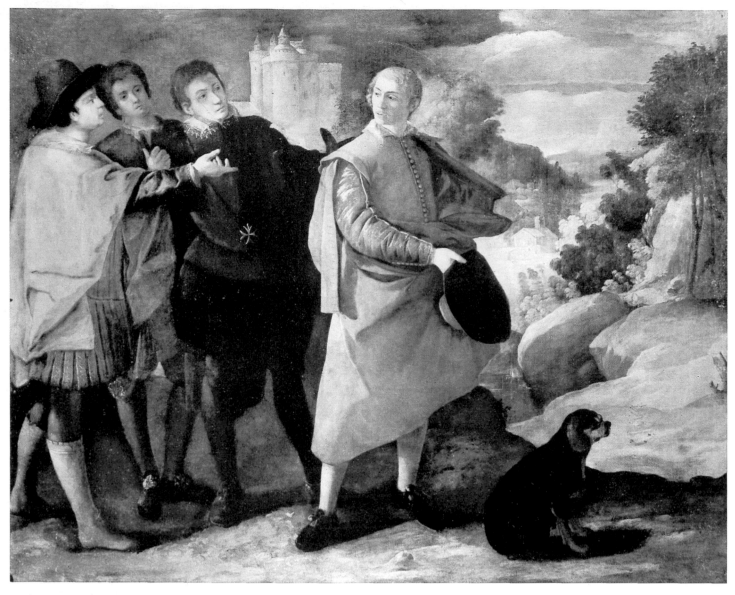

Fig. 20. DEPARTURE OF ST PETER NOLASCO. 1628-1634. Mexico, D.F.: Museum of the Academy of San Carlos. Cat. No. 13.
Fig. 21. Jusepe Martínez. DEPARTURE OF ST PETER NOLASCO. 1627. Madrid: Engraved. National Library.

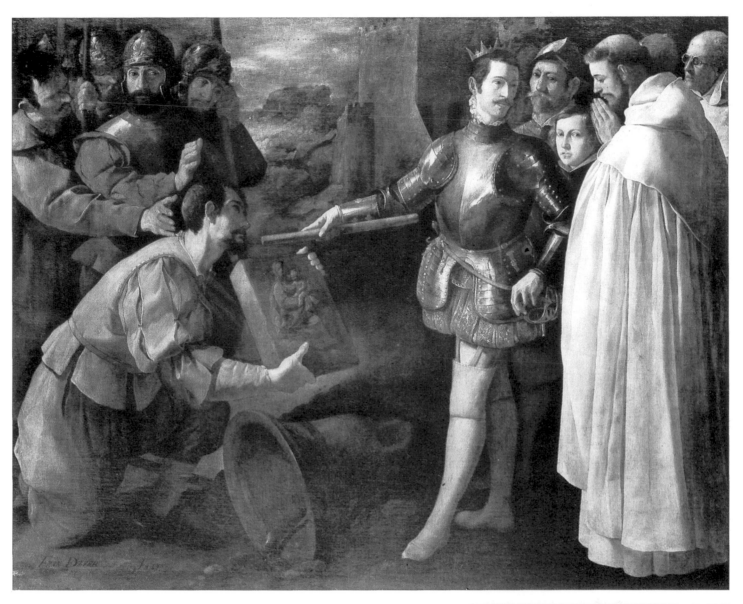

Figs. 22 and 23. THE LEGEND OF THE BELL. 1630. Cincinnati (U.S.A.):
The Cincinnati Art Museum. Cat. No. 14.

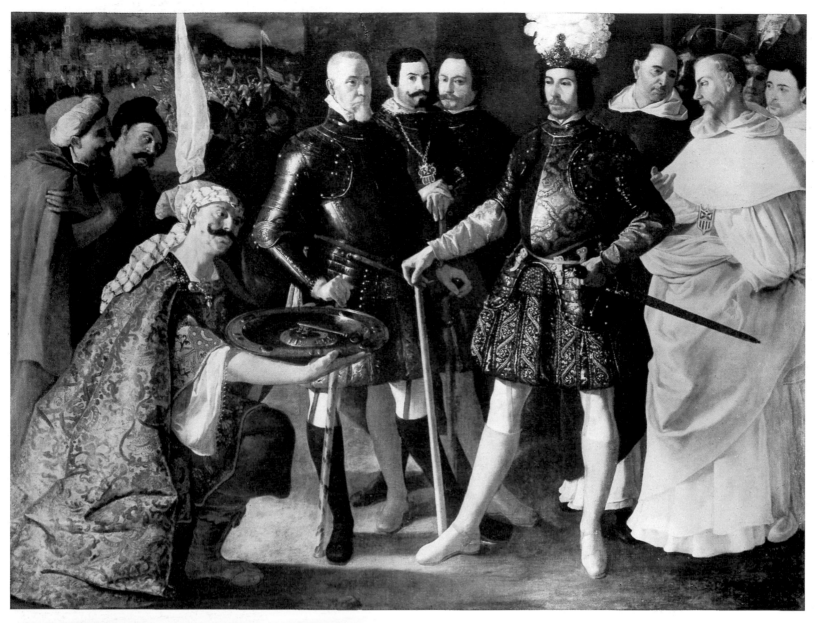

Fig. 24. THE SURRENDER OF SEVILLE. 1634. Duke of Westminster, Eccleston. Cat. No. 15.

Fig. 25. VISIT OF ST THOMAS AQUINAS TO ST BONAVENTURA. 1629. Destroyed in 1945. Cat. No. 16.

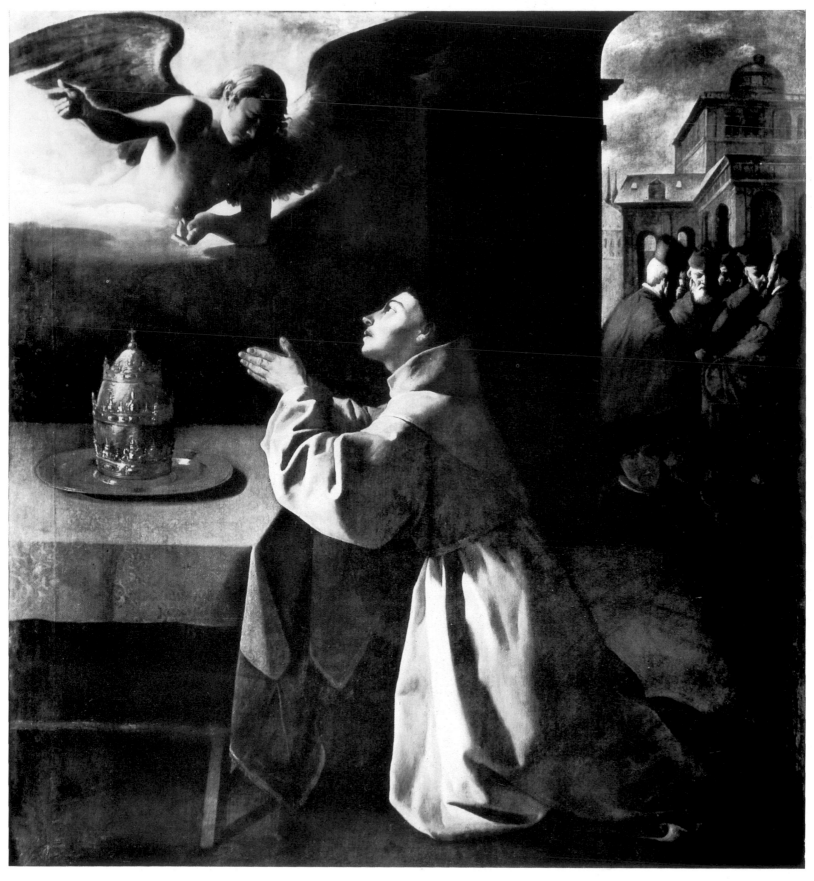

Fig. 26. PRAYER OF ST BONAVENTURA. 1629-1630. Dresden: Gemäldegalerie. Cat. No. 17.

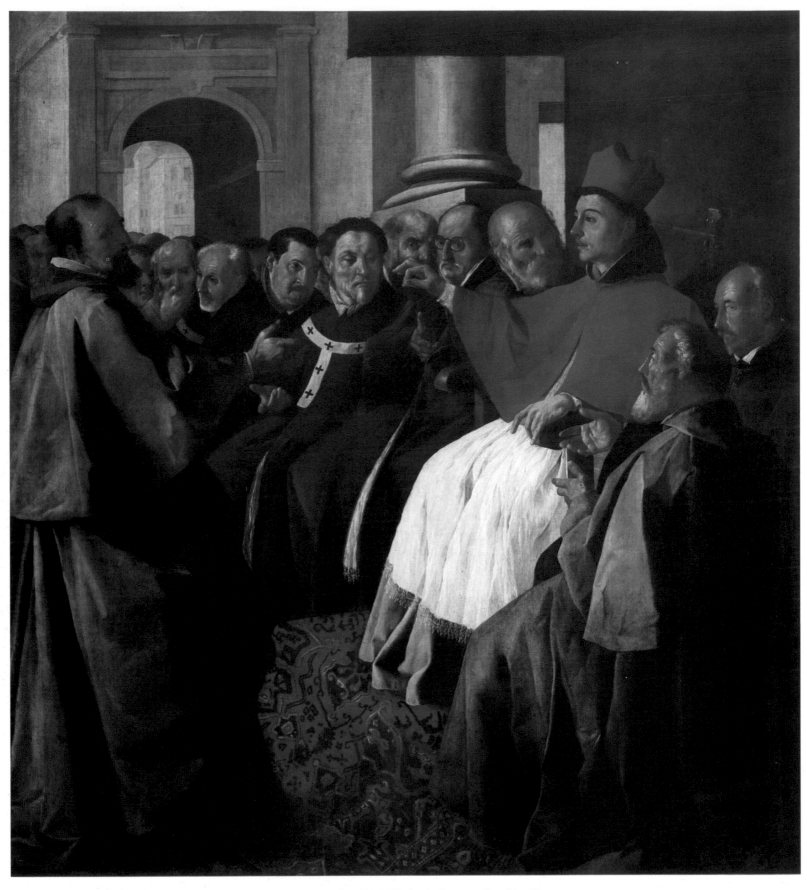

Fig. 27. ST BONAVENTURA AT THE COUNCIL OF LYONS. 1629-1630. Paris: Louvre. Cat. No. 18.

146

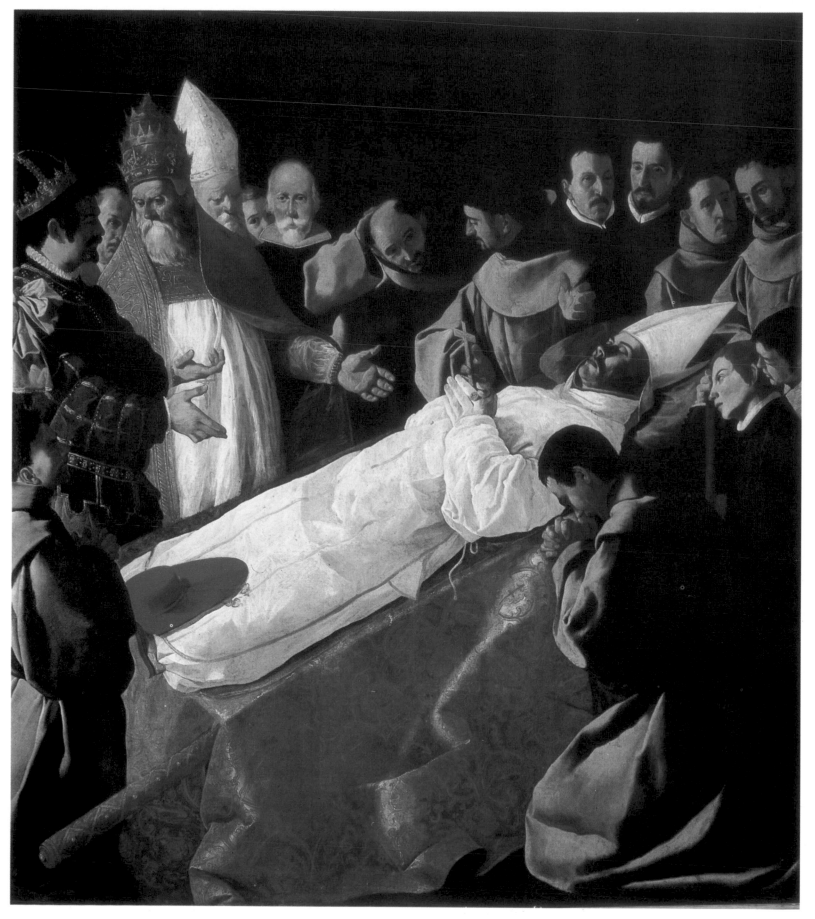

Fig. 28.　DEATH OF ST BONAVENTURA. 1629-1630. Paris: Louvre. Cat. No. 19.

Fig. 29. DEATH OF ST BONAVENTURA. Detail of figure 28.

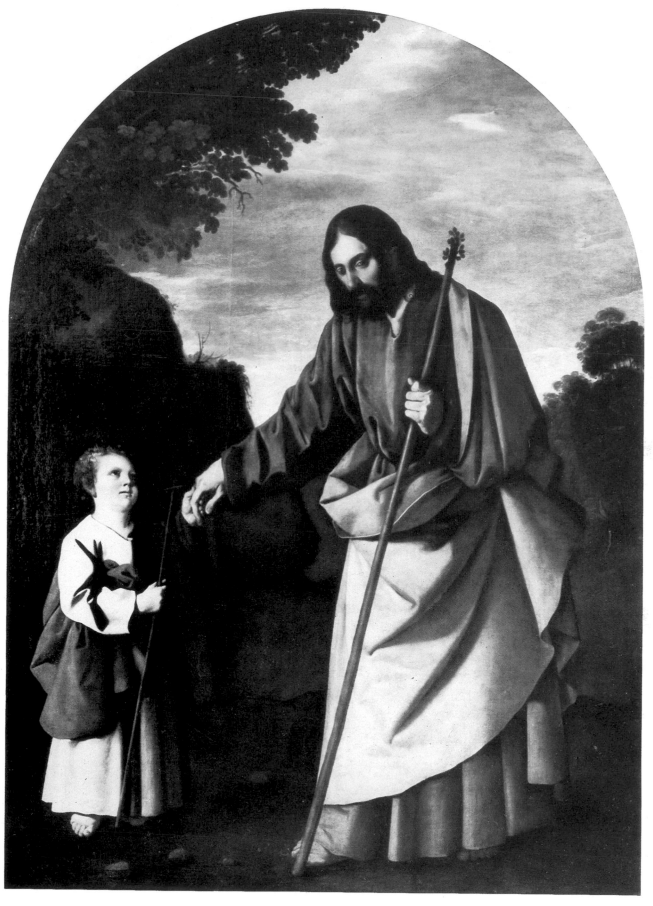

Fig. 30. **ST JOSEPH AND THE CHILD JESUS.** C. 1629. Paris: Church of Saint-Médard. Cat. No. 20.

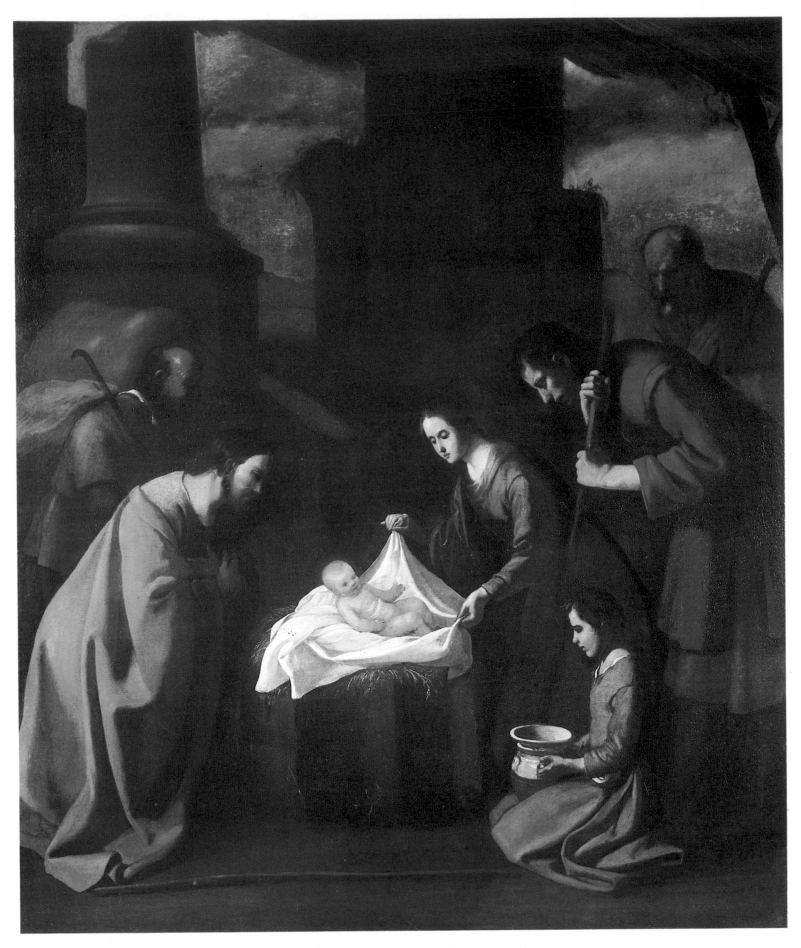

Fig. 31. ADORATION OF ST JOSEPH. C. 1629. Geneva: Private collection. Cat. No. 21.

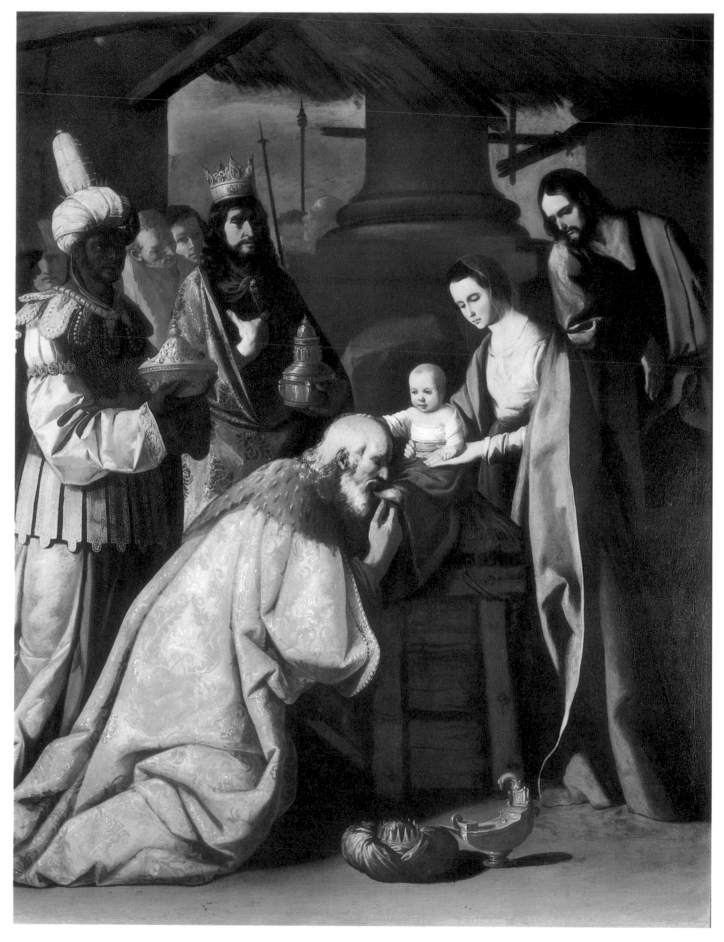

Fig. 32. ADORATION OF THE MAGI. C. 1629. Barcelona: Private collection. Cat. No. 22.

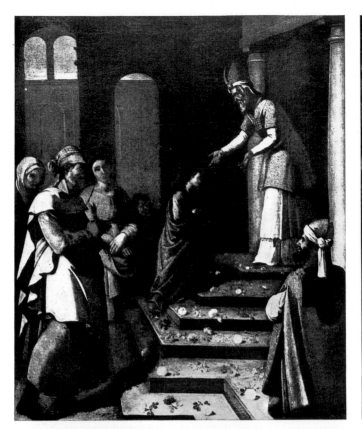

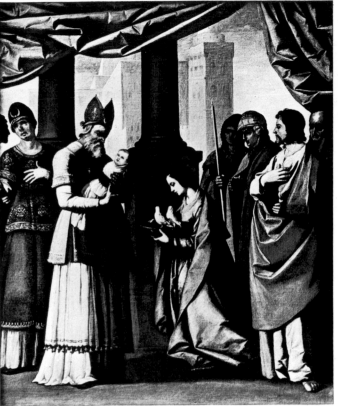

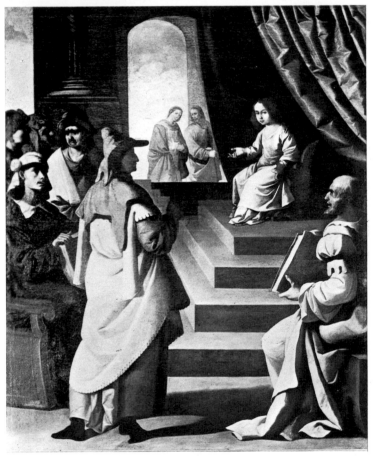

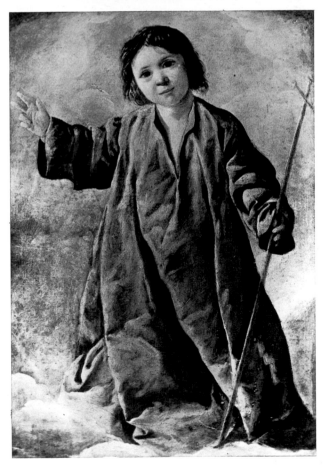

Fig. 33. PRESENTATION OF THE VIRGIN. C. 1629. Madrid: Monastery of the Escorial. Cat. No. 26.
Fig. 34. PRESENTATION IN THE TEMPLE. C. 1629. London: F.A. Drey. Cat. No. 23.
Fig. 35. JESUS AMONG THE DOCTORS. C. 1629. Cadiz: Joaquin Giráldez. Cat. No. 25.
Fig. 36. CHILD JESUS GIVING HIS BLESSING. C. 1629. Moscow: Pushkin State Museum of Fine Arts. Cat. No. 27.

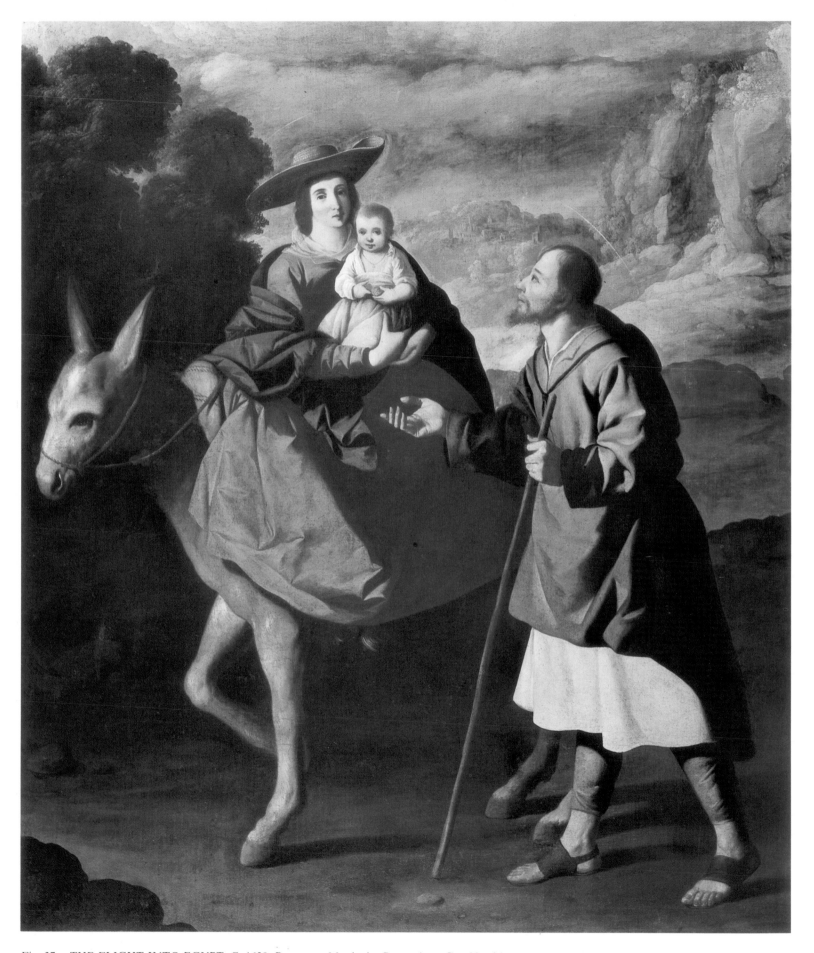

Fig. 37. THE FLIGHT INTO EGYPT. C. 1629. Besançon: Musée des Beaux-Arts. Cat. No. 24.

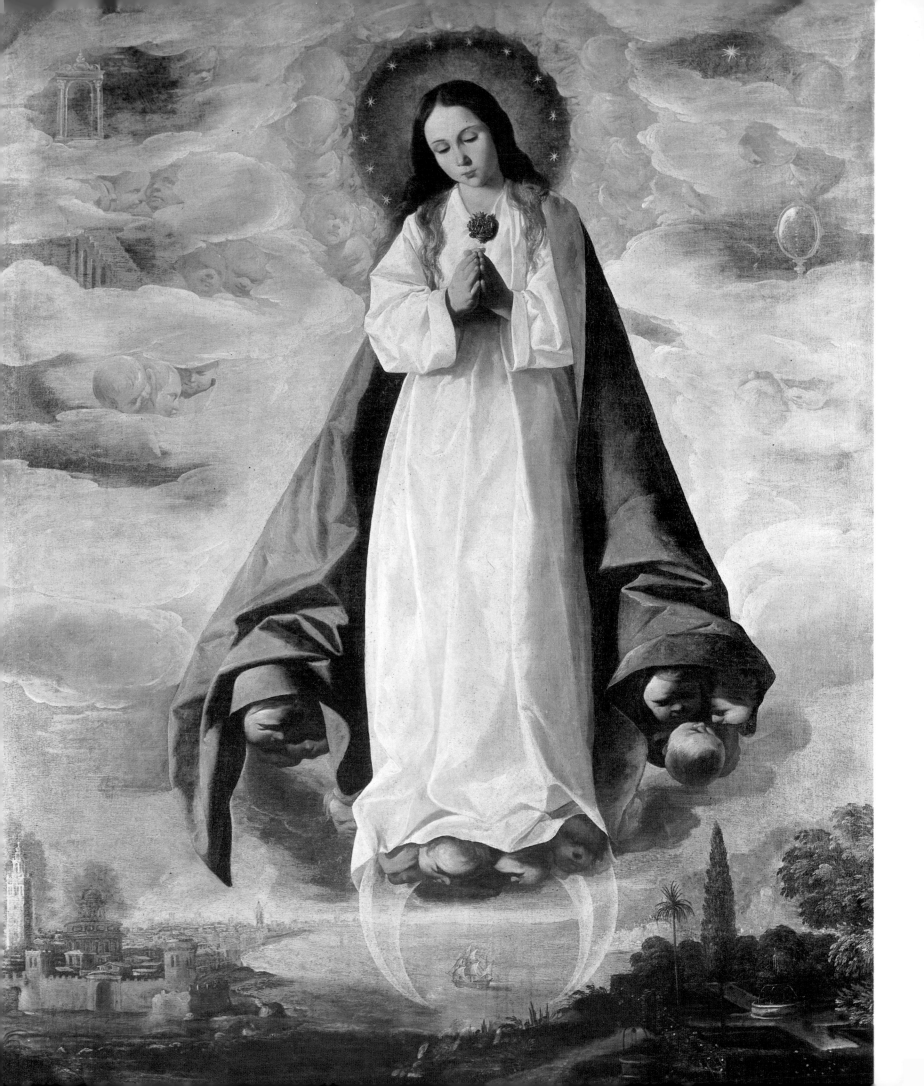

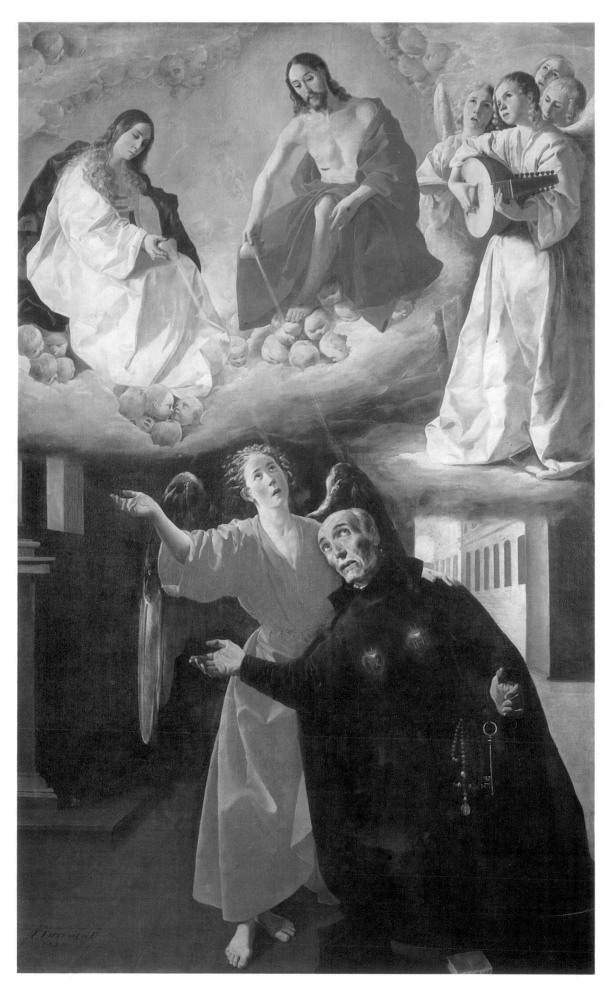

Fig. 38. IMMACULATE CONCEPTION.
1630. Jadraque: Parochial School of Nuestra
Señora del Carmen. Cat. No. 28.
Fig. 39. VISION OF BLESSED ALONSO
RODRIGUEZ. 1630. Madrid: Academy of
San Fernando. Cat. No. 29.

Fig. 40. IMMACULATE CONCEPTION. Detail of figure 38.
Fig. 41. VISION OF BLESSED ALONSO RODRIGUEZ. Detail of figure 39.
Fig. 42. THE VIRGIN AS A CHILD, SLEEPING. 1625-1630. Jerez de la Frontera: Collegiate Church. Cat. No. 30.

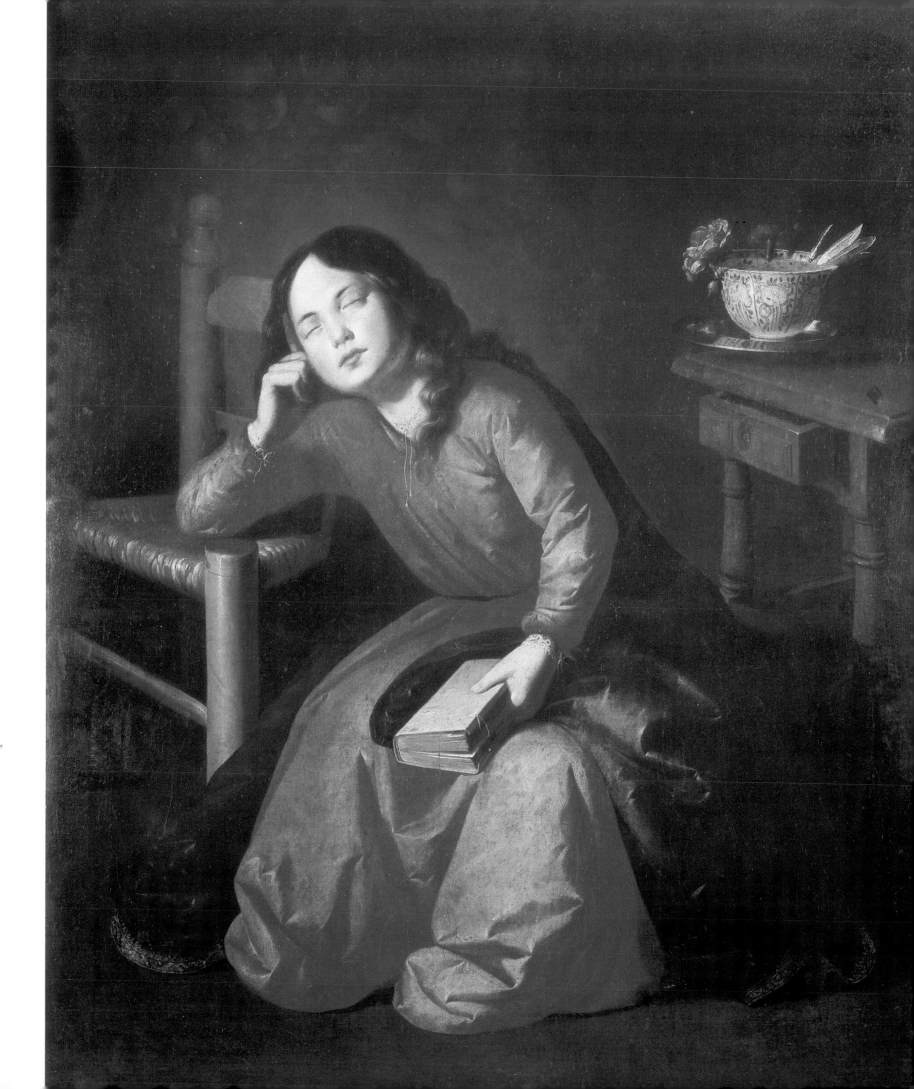

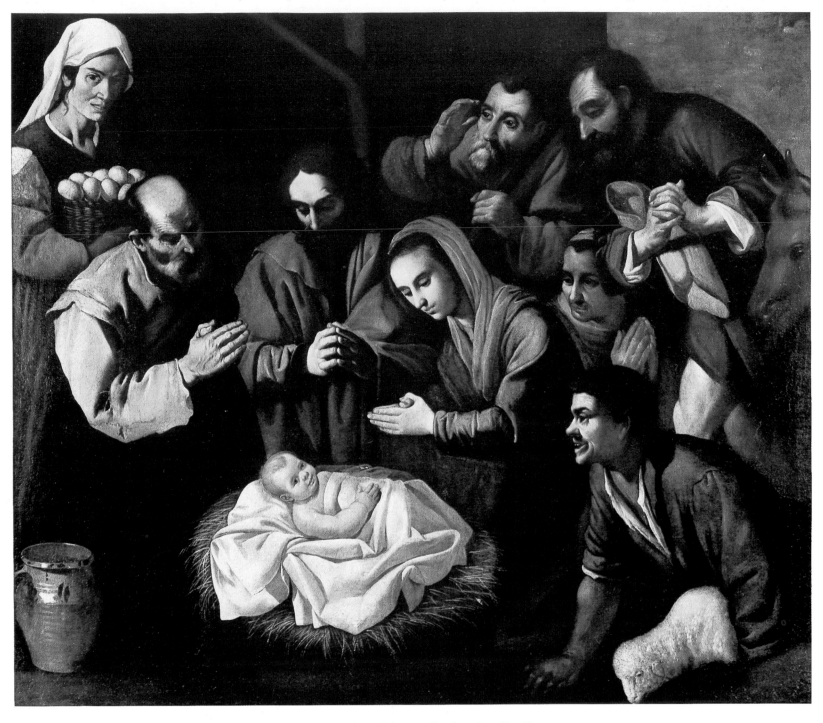

Fig. 43. ADORATION OF THE SHEPHERDS. 1625-1630. Barcelona: Private collection. Cat. No. 31.
Fig. 44. BIRTH OF THE VIRGIN. 1625-1630. Los Angeles: The Norton Simon Foundation. Cat. No. 32.

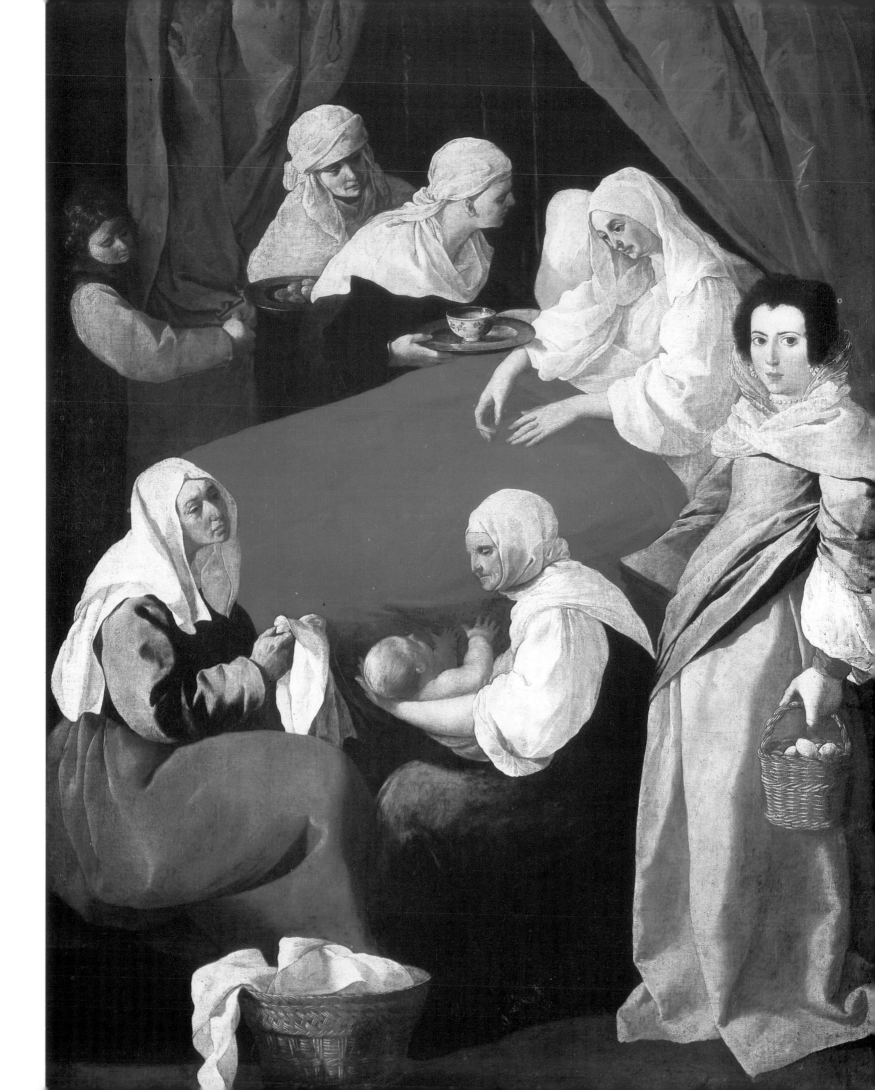

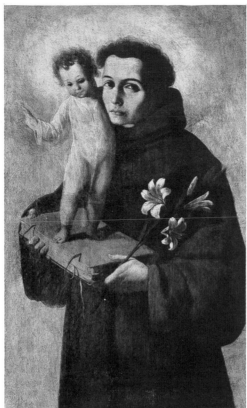
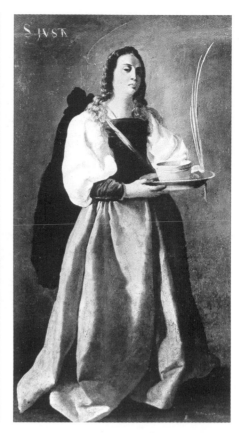
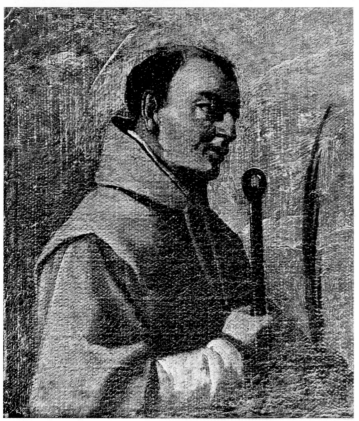
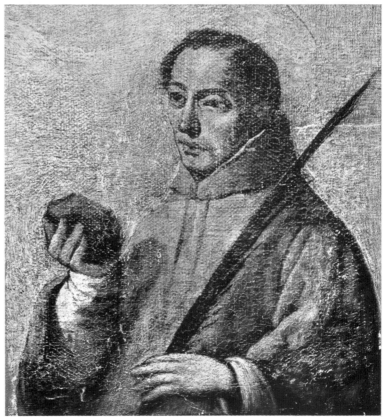

Fig. 45. ST NICHOLAS OF TOLENTINO. 1625-1630. Cadiz: Emile Huart. Cat. No. 33.

Fig. 46. ST ANTHONY OF PADUA. 1625-1630. Cadiz: Emile Huart. Cat. No. 34.

Fig. 47. ST JUSTA. 1625-1630. London: Private collection. Cat. No. 35.

Fig. 48. ST LAWRENCE. 1625-1630. Madrid: Private collection. Cat. No. 37.

Fig. 49. ST STEPHEN. 1625-1630. Madrid: Private collection. Cat. No. 38.

Fig. 50. MAESE RODRIGO FERNANDEZ DE SANTAELLA. 1625-1630. Seville: Seminary of San Telmo. Cat. No. 39.

Fig. 51. ST ANTHONY OF PADUA. 1625-1630. Sâo Paulo: Museu de Arte. Cat. No. 40.

Fig. 52. DOMINICAN FRIAR READING. 1625-1630. Barcelona: Arteuropa. Cat. No. 41.

Fig. 53. ST DOMINIC. 1625-1630. Barcelona: Arteuropa. Cat. No. 42.

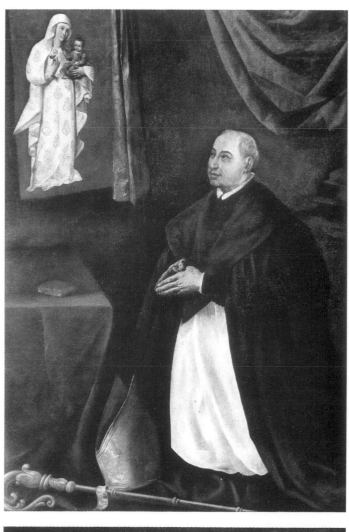

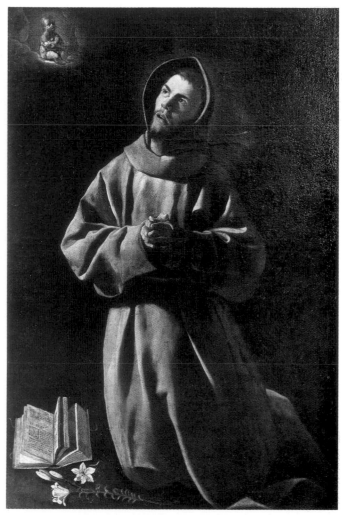

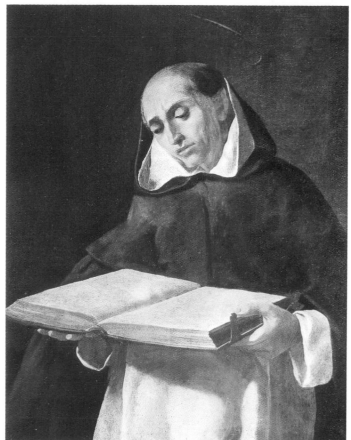

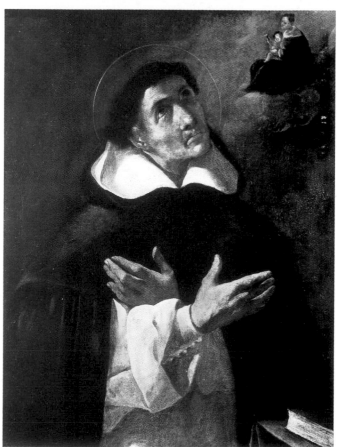

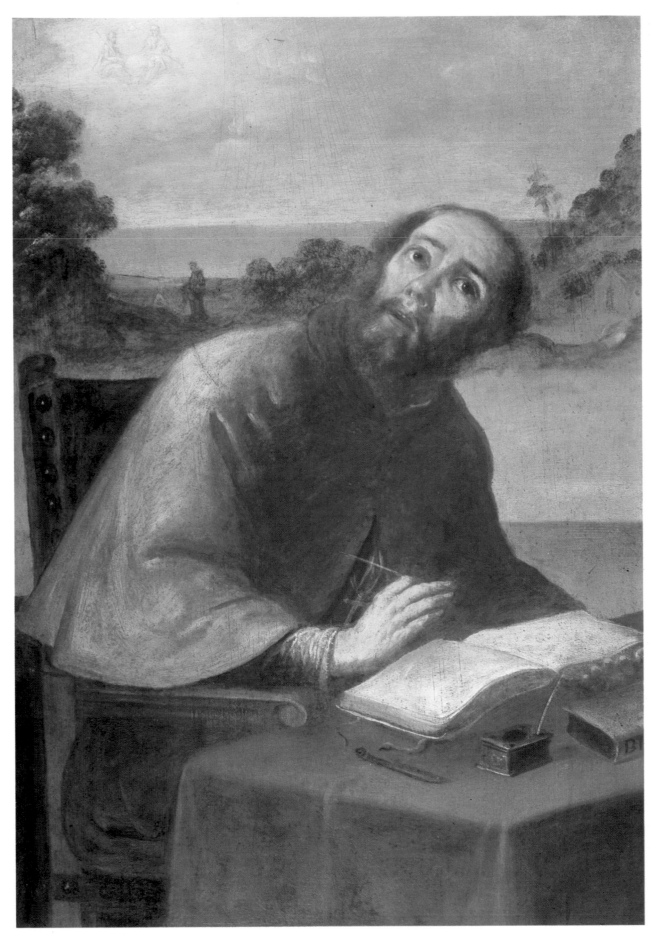

Fig. 54. ST AUGUSTINE. 1625-1630. Barcelona: Private collection. Cat. No. 43.

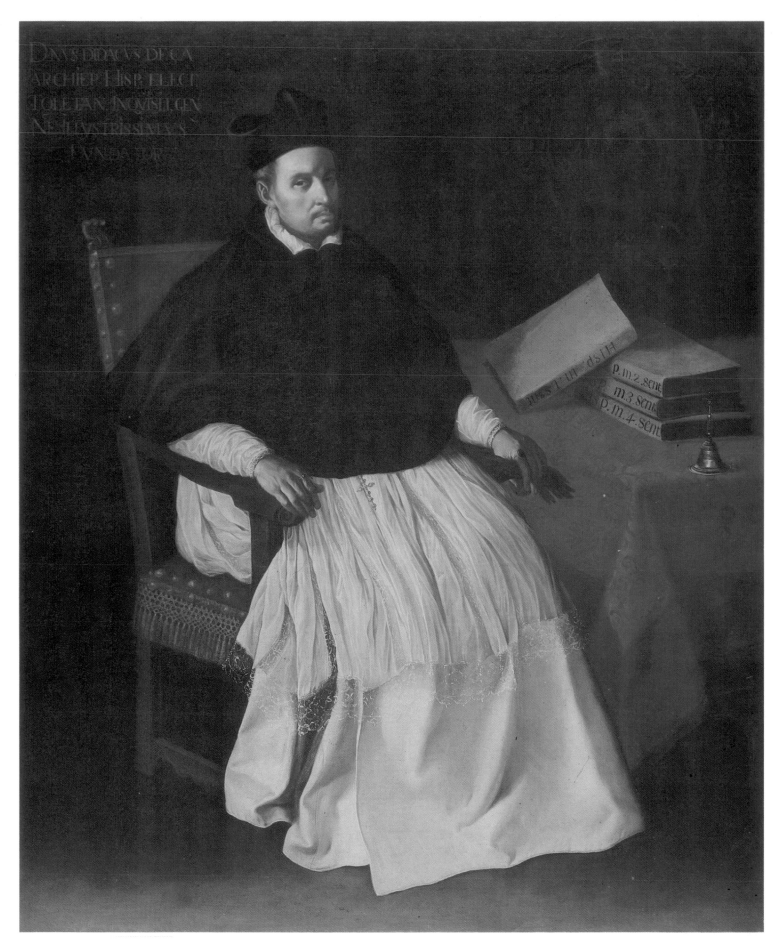

Fig. 55. FRAY DIEGO DEZA, ARCHBISHOP OF SEVILLE. 1625-1630. Los Angeles: The Norton Simon Foundation. Cat. No. 44.

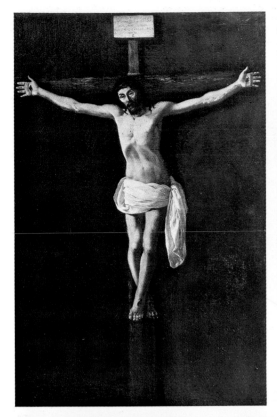
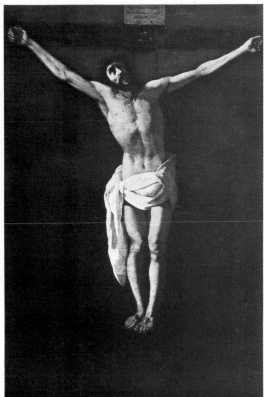
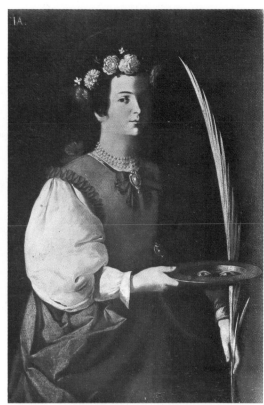
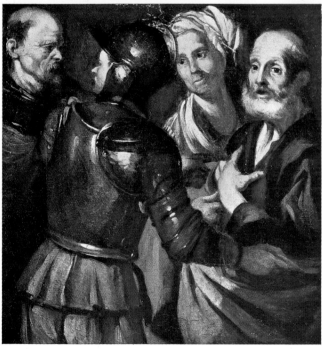
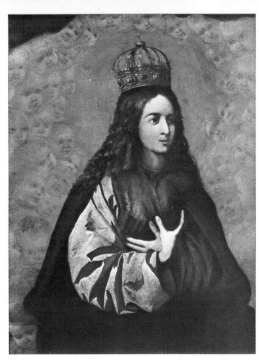
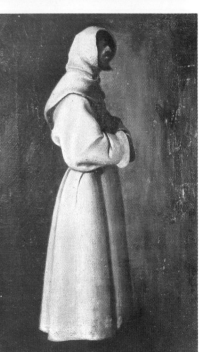

Fig. 56. CHRIST CRUCIFIED. 1625-1630. Seville: Provincial Museum of Fine Arts. Cat. No. 46.
Fig. 57. CHRIST CRUCIFIED. 1625-1630. New York: Private collection. Cat. No. 48.
Fig. 58. ST LUCY. 1625-1630. Washington: National Gallery of Art. Cat. No. 51.
Fig. 59. ST PETER'S DENIAL. 1625-1630. Barcelona: Private collection. Cat. No. 52.
Fig. 60. REGINA ANGELORUM. 1625-1630. New York: Private collection. Cat. No. 53.
Fig. 61. FRANCISCAN FRIAR. 1625-1630. Barcelona: Cat. No. 54.

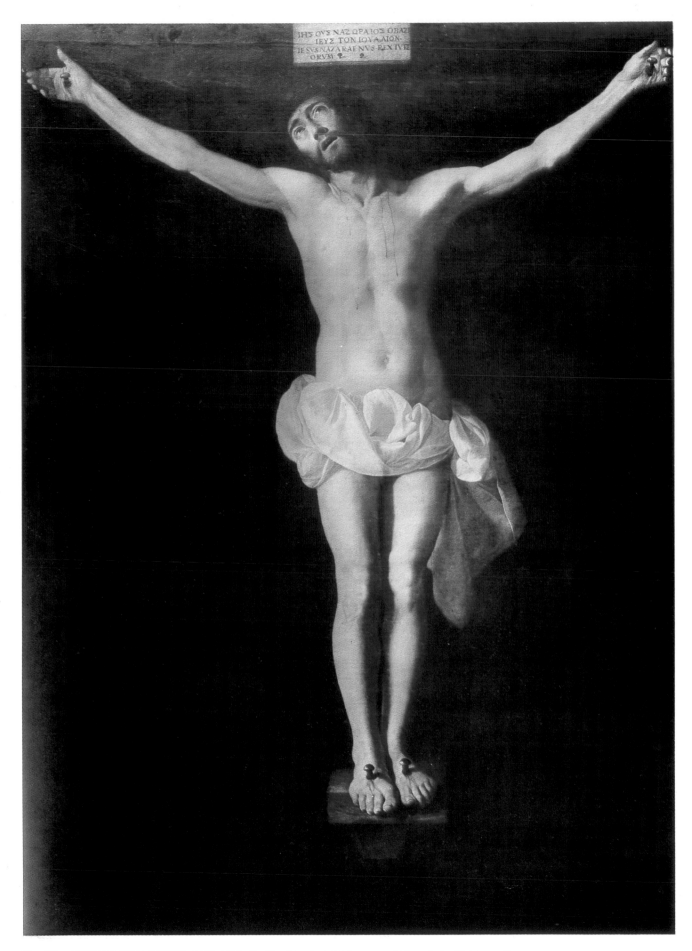

Fig. 62. CHRIST CRUCIFIED. 1625-1630. Seville: Provincial Museum of Fine Arts. Cat. No. 55.

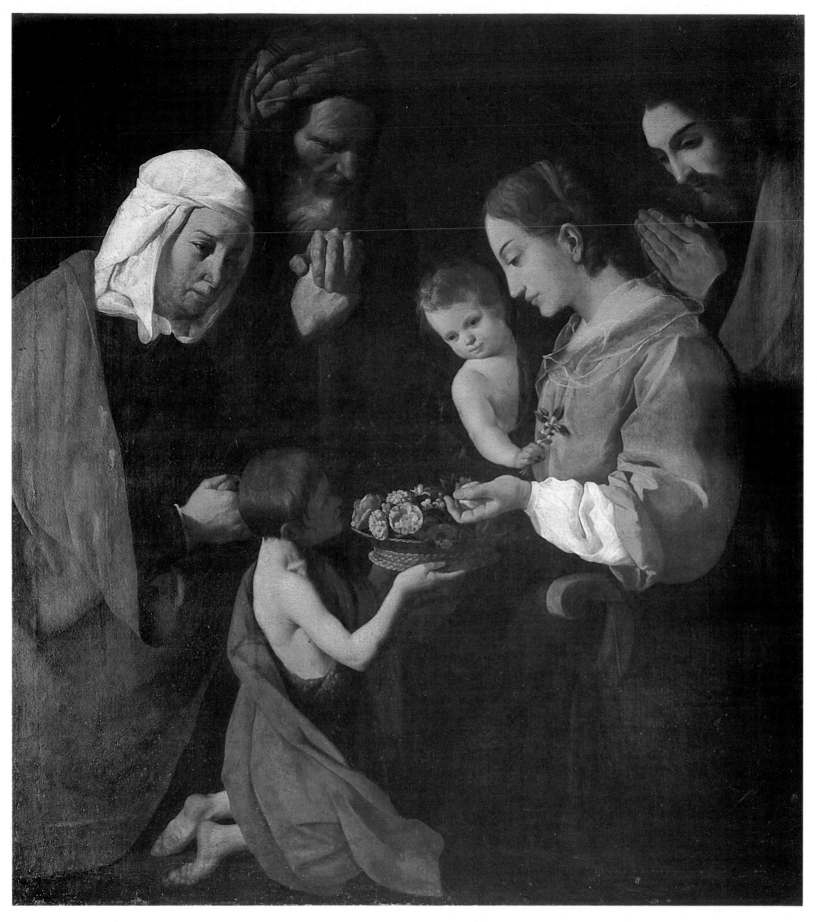

Fig. 63. THE HOLY FAMILY, ST ANNE, ST JOACHIM AND ST JOHN THE BAPTIST. 1625-1630. Madrid: Marquesa de Campo Real. Cat. No. 56.
Fig. 64. THE CHILD JESUS WITH A THORN. 1625-1630. Seville: Manuel Sánchez Ramos. Cat. No. 57.

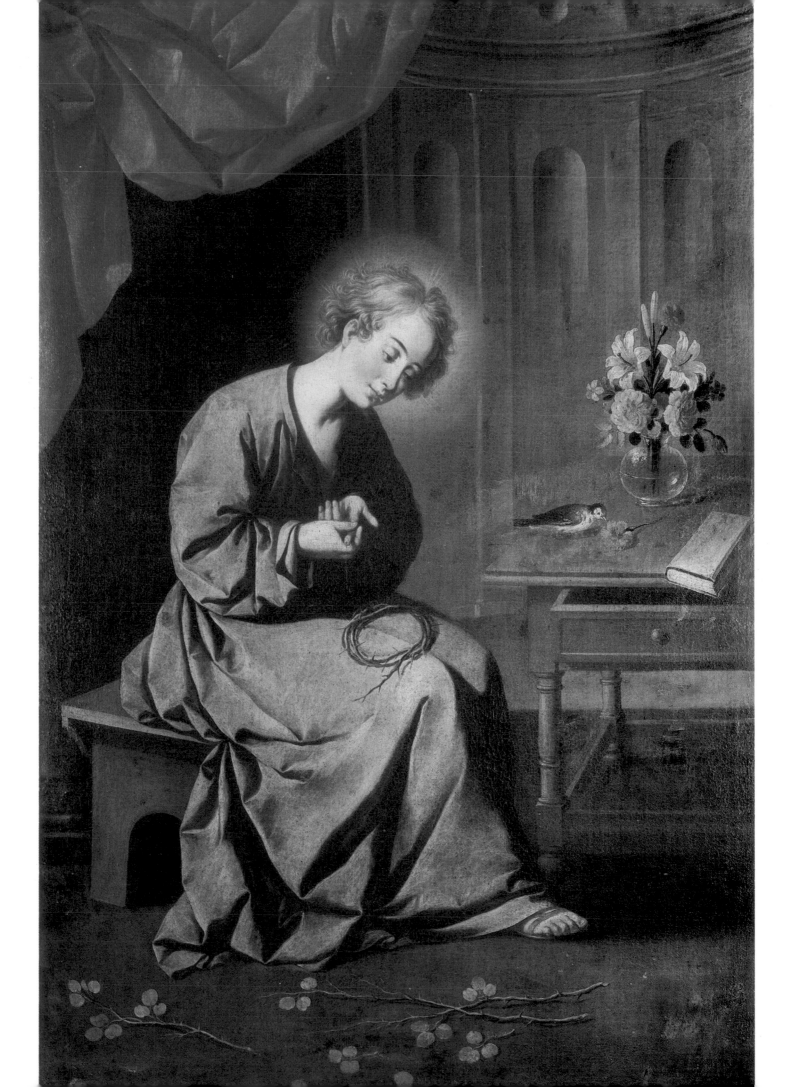

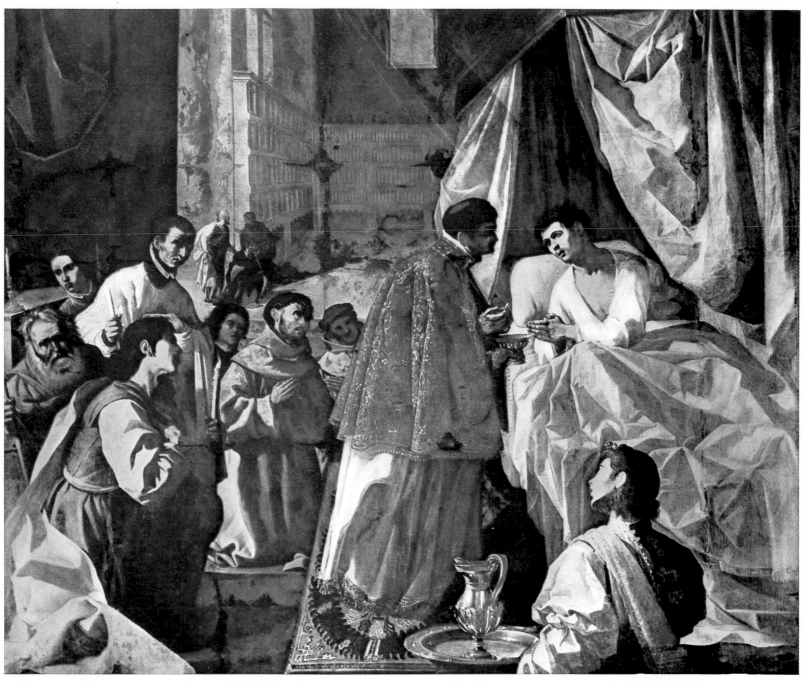

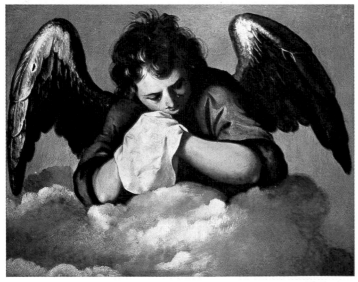

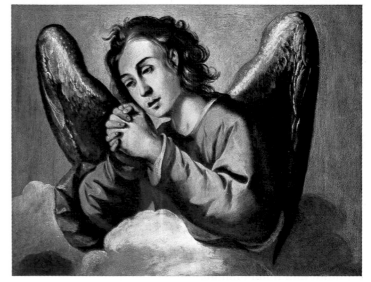

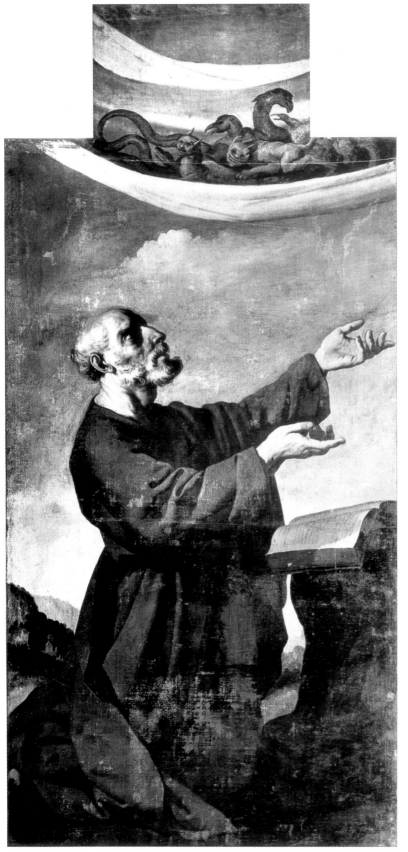
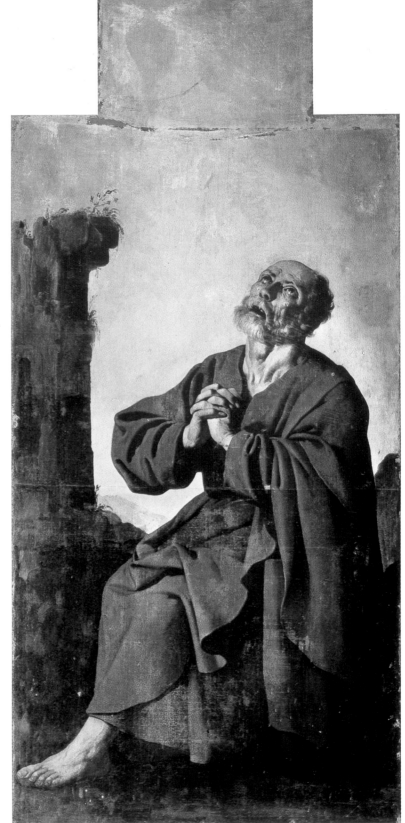

Fig. 65.　VIATICUM. 1625-1630. Genoa: Palazzo Bianco. Cat. No. 60.
Fig. 66.　ANGEL WEEPING. 1625-1630. Santander: Emilio Botín. Cat. No. 61.
Fig. 67.　ANGEL PRAYING. 1625-1630. Santander: Emilio Botín. Cat. No. 62.
Fig. 68.　VISION OF ST PETER. 1625-1630. Seville: Cathedral. Cat. No. 63.
Fig. 69.　REPENTANCE OF ST PETER. 1625-1630. Seville: Cathedral. Cat. No. 64.

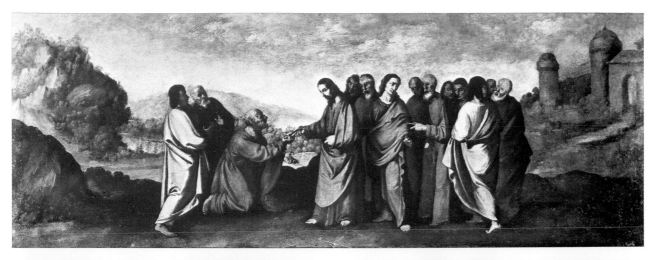

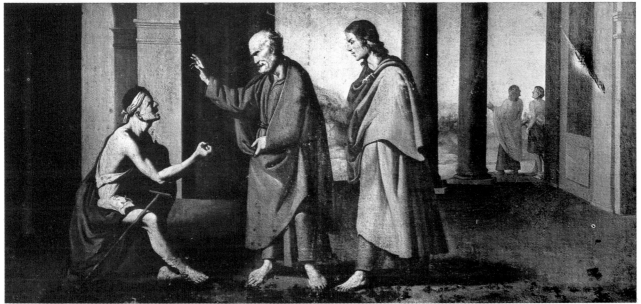

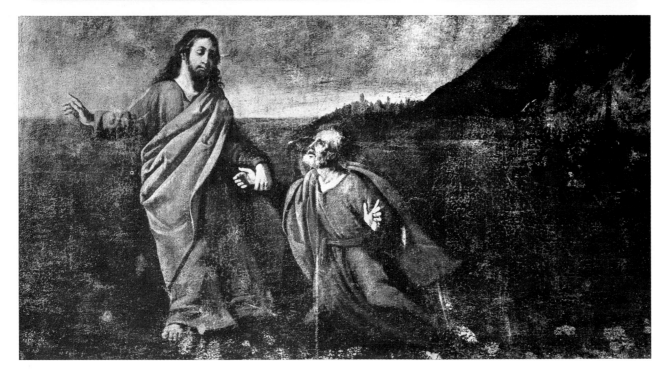

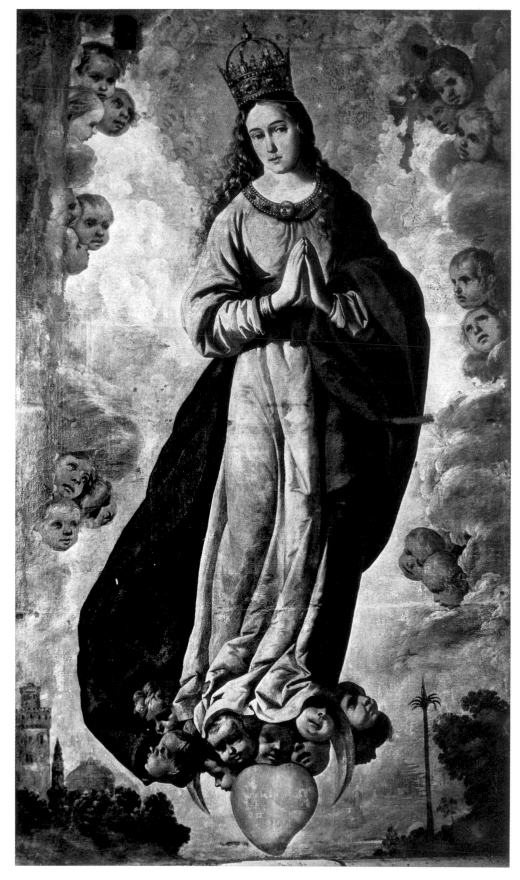

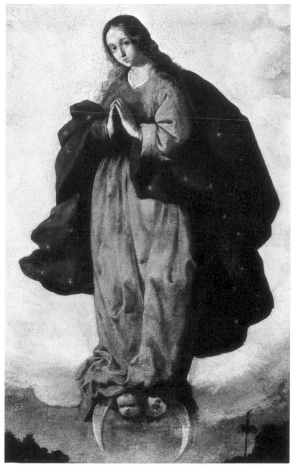

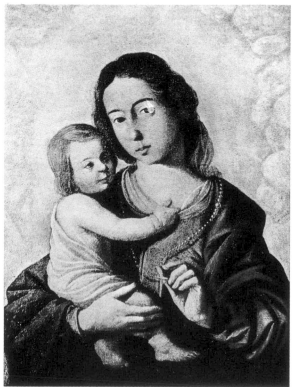

Fig. 70. JESUS GIVING THE KEYS TO ST PETER. 1625-1630. Seville: Cathedral. Cat. No. 65.
Fig. 71. ST PETER HEALING THE MAN SICK OF THE PALSY. 1625-1630. Seville: Cathedral. Cat. No. 66.
Fig. 72. CHRIST AND ST PETER WALKING ON THE WATER. 1625-1630. Seville: Cathedral. Cat. No. 67.
Fig. 73. IMMACULATE CONCEPTION. 1625-1630. Seville: Cathedral. Cat. No. 68.
Fig. 74. IMMACULATE CONCEPTION. 1625-1630. Barcelona: Private collection. Cat. No. 71.
Fig. 75. OUR LADY OF THE ROSARY. 1625-1630. Cadiz: Emile Huart. Cat. No. 72.

171

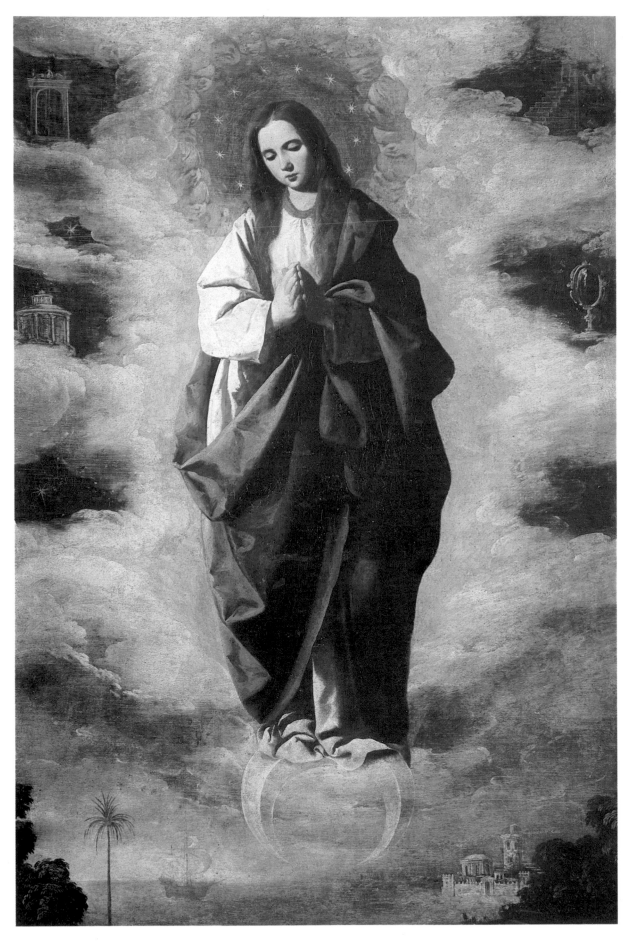

Fig. 76. IMMACULATE CONCEPTION. 1625-1630. Madrid: Prado Museum. Cat. No. 73.

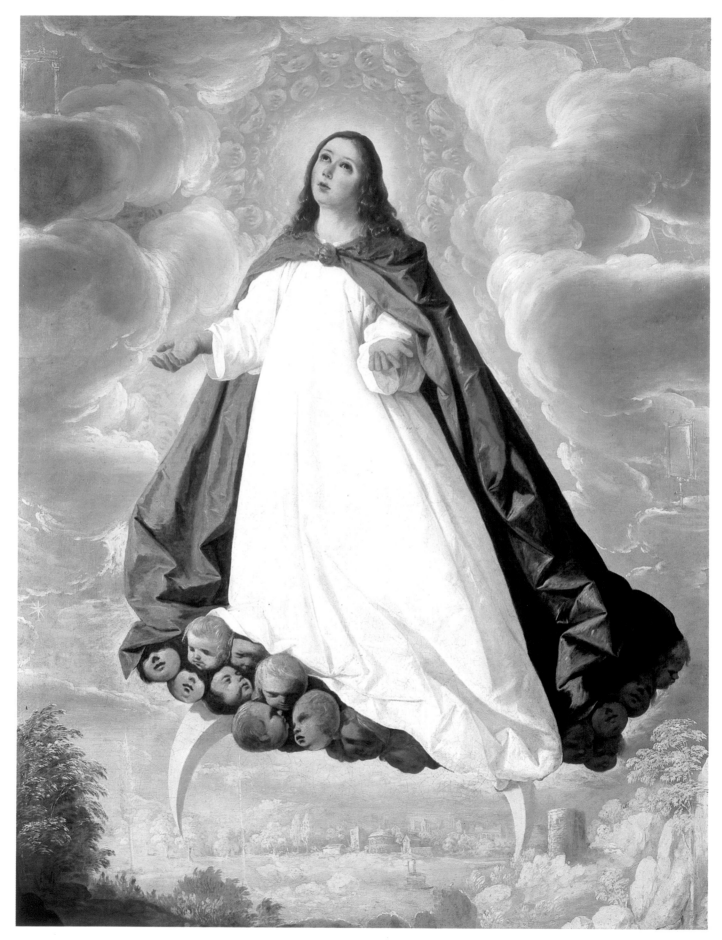

Fig. 77. IMMACULATE CONCEPTION. 1625-1630. London: Private collection. Cat. No. 74.

Fig. 78. DON ANDRES, CONDE DE RIBERA. 1625-1630. Seville: Provincial Museum of Fine Arts. Cat. No. 75.

1631. 21 January. By contract entered into with the rector of the Dominican School of Santo Tomás in Seville, Francisco de Zurbarán undertakes to paint, before 24 June and for 400 ducats, a picture for the chapel of the School's church (Cat. No. 78; Figs. 79 & 80).

1631. *Sheep with Feet Tied Together*. Canvas inscribed: "Fran co Dez.../1631" (Cat. No. 79; Fig. 81).

1632. *Sheep with Feet Tied Together*. Canvas inscribed: "Fran co de Zurbarán facie/1632" (Cat. No. 80).

1632. *St Francis*. Canvas inscribed: "Fran co de Zurbaran fac/1632" (Cat. No. 81; Fig. 82).

1632. *Immaculate Conception*. Canvas inscribed: "FRAN co DEZVRBARAN FACIE 1632" (Cat. No. 82; Figs. 83, 84 & 507).

1633. *Still Life*. Canvas inscribed: "Fran co de Zurbaran faciebat 1633" (Cat. No. 83; Figs. 85, 87 & 88).

1633. *St Peter*. Canvas inscribed: "Fran co de Zurbaran faciebat 1633". This picture belongs to the Apostle Series in the National Museum of Ancient Art in Lisbon (Cat. Nos. 84-95; Figs. 89-100).

1634. *The Surrender of Seville*. Canvas inscribed: "F co DE ZVRBARAN 1634" (Cat. No. 15; Fig. 24). This picture belonged to the series of scenes from the life of St Peter Nolasco painted for the principal monastery of Our Lady of Ransom in Seville.

1634. 11 March. Francisco de Zurbarán and his wife sign a power of attorney in Seville.

1634. 12 June. In the "town of Madrid", Francisco de Zurbarán, "resident in Seville", signs a receipt for 200 ducats received "as an advance on what he is to receive for twelve pictures to be painted by him of the Labours of Hercules for the Salon of the Buen Retiro" (Cat. Nos. 96-106; Figs. 101-112).

1634. 9 August. Francisco de Zurbarán, "resident in this court" (of Madrid), signs a receipt for 200 ducats paid "as an advance on what he is to receive for the pictures he is now painting for the Salon of the Buen Retiro".

1634. 6 October. Francisco de Zurbarán, "resident in this court" (of Madrid), signs a receipt for 200 ducats paid "as an advance on what he is to receive for the pictures he is painting for the Salon of the Kingdoms of the Buen Retiro".

1634. 13 November. Zurbarán signs, in the "Town of Madrid", a receipt in which he states that he has duly received the 500 ducats remaining of the 1000 ducats due to him for the ten pictures of the Labours of Hercules and the two of the Relief of Cadiz, painted for the Salon of the Kingdoms of the Palace of the Buen Retiro in Madrid.

1635. Portrait of *Alonso de Verdugo de Albornoz* (born in 1623). Canvas inscribed: "Fran co de Zurbarán f." "AETAS 12 A" (Cat. No. 107; Fig. 113).

1635. In the official account of the 1635 canonical visit of inspection to the parish church of San Juan Bautista in Marchena, the steward of the church is again instructed to commission the nine pictures for the sacristy (Cat. Nos. 108-116; Figs. 114-122).

1636. August. Francisco de Zurbarán and the master joiner Jerónimo Velázquez sign a contract in Llerena by the terms of which they undertake to carry out, in two and a half years and for 3150 ducats, a retable for the principal church of the town. The contract specifies that Zurbarán, as a citizen of Llerena and because of his devotion to Our Lady of the Pomegranate (the town's patroness), has offered to do all the painting work involved for no more fee than his expenses (Cat. Nos. 166-168; Figs. 187, 190 & 191).

1636. *Immaculate Conception*. Canvas inscribed: "... De Zurbaran facie/1636" (Cat. No. 117; Figs. 123 & 509).

1636. Zurbarán paints two pictures of saints for the Discalced Mercedarian church of San José in Seville:

St. Lawrence. Canvas inscribed: "Fran co de Zurbarán faciet/1636" (Cat. No. 118; Fig. 124).

St Anthony Abbot. Canvas inscribed: "Fran co de Zurbaran fac bat 1636" (Cat. No. 119).

1637. In the official account of the 1637 canonical visit of inspection to the parish church of San Juan Bautista in Marchena, an entry is made concerning the payment of 90 ducats to "Francisco Suberán", resident in Seville, for nine pictures placed in the sacristy (Cat. Nos. 108-116; Figs. 114-122).

1637. 4 March. Francisco de Zurbarán carries out an appraisal of the painting of two pulpits done by Lázaro de Pantoja for the parish church of San Lorenzo in Seville.

1637. 26 May. Francisco de Zurbarán, "painter to his majesty (and) resident in Seville, in the parish of Santa María", signs a contract for the painting and gilding of a retable intended for the high altar of the church of the nuns of the Incarnation in Arcos de la Frontera. The pictures are to be six in number; St John the Baptist (lower right), St John the Evangelist (lower left), St Francis (upper tier), St Clare (upper tier), the

175

Incarnation (centre of upper tier) and Christ Crucified (crowning the whole). The present whereabouts of all these canvases is unknown.

1637. 7 November. Francisco de Zurbarán, Alonso Cano and Francisco Arche agree to act as guarantors of the sculptor José de Arce, the latter having undertaken to carry out, in two years, all the sculptural work for the retable then being constructed for the high altar of the church of the Charterhouse of Jerez de la Frontera (Province of Cadiz).

1638. 16 January. "Marriage Contract" of María, Zurbarán's elder daughter. The dowry given her by her father consists of 900 ducats in furniture, clothing, etc., payable eight days after the wedding, an allowance of 600 ducats over a period of two years and 500 ducats payable at the end of December 1638 or whenever the galleons of the fleet should arrive.

1638. 5 March. Marriage of María de Zurbarán to José Gassó.

1638. 16 March. Francisco de Zurbarán signs an acknowledgement of his indebtedness to Doña Leonor de Porras, a resident of Utrera. It is specified that Doña Leonor granted the loan "for the purpose of performing a charitable action", thanks to the intervention of Father Juan Bautista Janel, of the Dominican monastery of San Pablo el Real in Seville.

1638. 10 April. Francisco de Zurbarán authorizes Antonio Velasco, a resident of Lima, to collect money owed to the painter.

1638. 27 August. Receipt confirming the completion of the retable for the church of the nuns of the Incarnation in Arcos de la Frontera, a contract undertaken by Zurbarán on 26 May 1637.

1638. *St Romanus and St Barulas*. Canvas inscribed: "1638" (Cat. No. 120; Fig. No. 125). The central painting in the retable placed over the high altar of the church of St Romanus in Seville.

1638. *Salvator Mundi*. Canvas inscribed: "Fran co dezurbaran /faciebat 1638" (Cat. No. 121; Figs. 126 & 510).

1638. *Adoration of the Shepherds*. Canvas inscribed: "Franc' de Zurbaran Philipi /IIII Regis Pictor faciebat /1638" (Cat. No. 123; Figs. 129, 130 & 512). This picture belonged to the retable over the high altar in the Charterhouse of Jerez.

1638. Francisco de Zurbarán, in co-operation with Alonso de Deza, does the paintings for the interior decoration of the pleasure boat *El santo Rey Don Fernando*, presented to Philip IV by the city of Seville. For his share of the work Zurbarán is paid 914 reales.

1639. 22 March. Francisco de Zurbarán authorizes the lawyer Baltasar Barrera to receive payment of a credit of 3950 reales when the galleons arrive. In this document a contract dated 31 December 1638 is mentioned several times.

1639. 28 May. Burial of Beatriz de Morales, Zurbarán's second wife, in the parish of La Magdalena.

1639. 8 October. Letter from Zurbarán to the Marqués de Torres, in Madrid, informing him that, in compliance with "Your Lordship's instructions" and "to gratify the Conde de Salvatierra", the eleven journeymen gilders that the Marqués has asked him to send to Madrid for gilding of the New Salon in the Alcázar have already set out.

1639. *The Circumcision*. Canvas inscribed: "Fran co de Zurbaran faci /1639" (Cat. No. 124; Fig. 131). This picture was part of the retable over the high altar in the Charterhouse of Jerez.

1638-39. Zurbarán paints a series of pictures for the monastery of San Jerónimo in Guadalupe (Province of Cáceres), several of which are signed and dated.

The Mass of Father Cabañuelas. Canvas inscribed: "Fran cus de Zurbaran /faciebat 1638" (Cat. No. 147; Fig. 157).
Fray Gonzalo de Illescas, Bishop of Córdoba. Canvas inscribed: "Fran co de Zurbarán f /1639" (Cat. No. 148; Figs. 158, 159 & 511).

Jesus Appearing to Father Andrés de Salmerón. Canvas inscribed: "Fran co de Zurbarán fat /1639" (Cat. No. 149; Figs. 160 & 161).
Enrique III Conferring the Archbishop's Biretta on Father Yáñez. Canvas inscribed: "Fran co de Zurbarán fat /1639" (Cat. No. 150; Figs. 162 & 163).
Fray Martín Vizcaíno Distributing Alms. Canvas inscribed: "Fran co de Zurbaran facie /1639" (Cat. No. 151; Figs. 164 & 165).
Father Juan de Carrión Taking Leave of His Friends. Canvas inscribed: "Fran co de Zurbarán fac /1639" (Cat. No. 152; Fig. 166).

1639. *Christ at Emmaus*. Canvas inscribed: "Fran de /Zurbarán /1639" (Cat. No. 169; Fig. 188).

1639. *St Francis Kneeling*. Canvas inscribed: "Fran co de Zurbaran /faciebat /1639" (Cat. No. 170; Fig. 193).

1640. 10 April. Francisco de Zurbarán gives a receipt to the naval captain Diego de Mirafuentes for "all the maravedís, ducats and reales resulting from the proceedings we have had in the Royal court of the trading house of the Indies".

1640. 24 November. Francisco de Zurbarán, "resident in Seville, in the parish of La Magdalena", authorizes Alonso García Hidalgo to collect 3400 reales, being the rest of the price of some "principal houses" the painter has sold in Llerena.

1640. *Christ Dead on the Cross, with a Donor*. Canvas inscribed: "Fran co de Zur /baran faciebat /1640" (Cat. No. 171; Fig. 189).

1640. Francisco de Zurbarán receives 35,360 maravedís as part payment for the pictures he is painting for the sacristy of the monastery of San Jerónimo in Guadalupe (Cat. Nos. 147-165; Figs. 157-186).

176

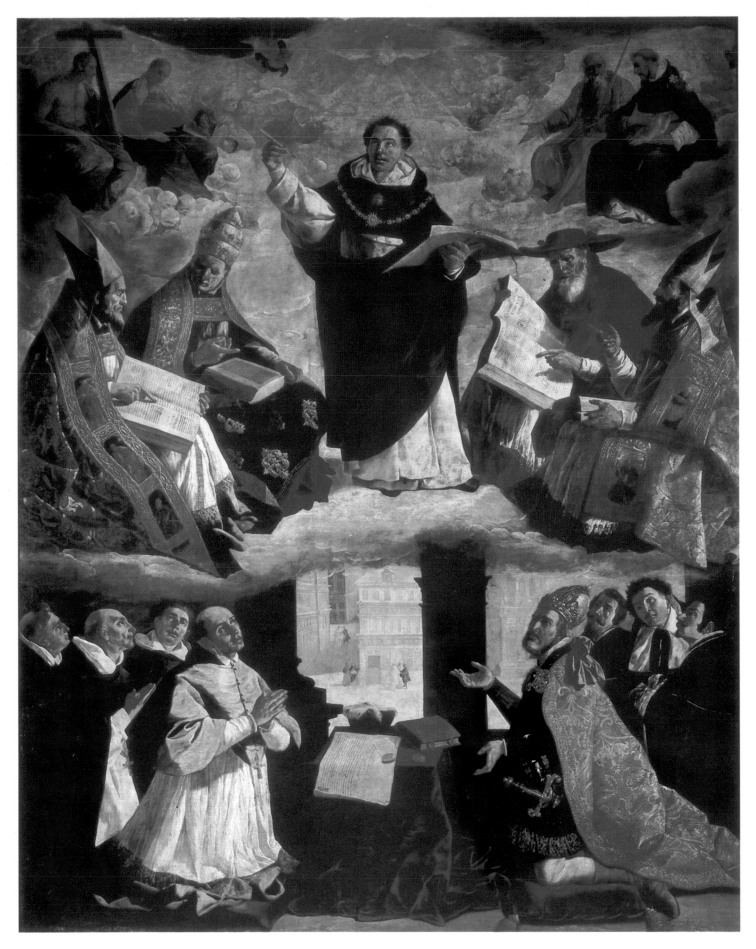

Fig. 79. APOTHEOSIS OF ST THOMAS AQUINAS. 1631. Seville: Provincial Museum of Fine Arts. Cat. No. 78.

Fig. 80. APOTHEOSIS OF ST THOMAS AQUINAS. Detail of figure 79.

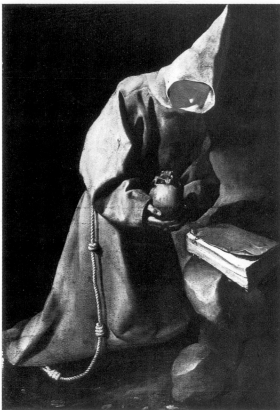

Fig. 81. SHEEP WITH FEET TIED TOGETHER. 1631. Madrid: Private collection. Cat. No. 79.
Fig. 82. ST FRANCIS. 1632. Buenos Aires: Alejandro E. Shaw. Cat. No. 81.
Fig. 83. IMMACULATE CONCEPTION. Detail of figure 84.

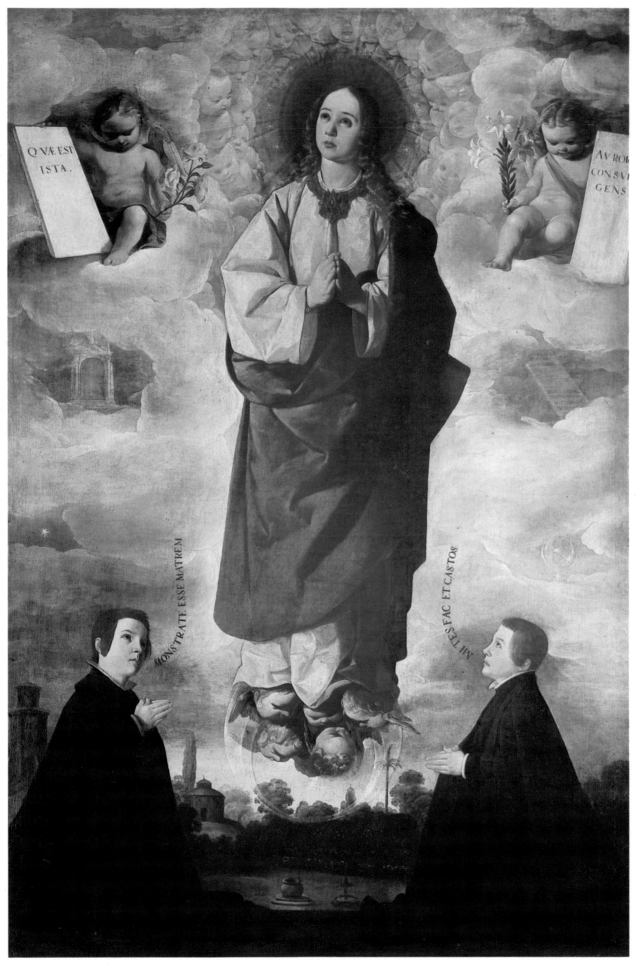

QVÆ EST
ISTA.

AVROR
CONSVR
GENS

MONSTRATE ESSE MATREM

NII NES FAC ET CASTOS

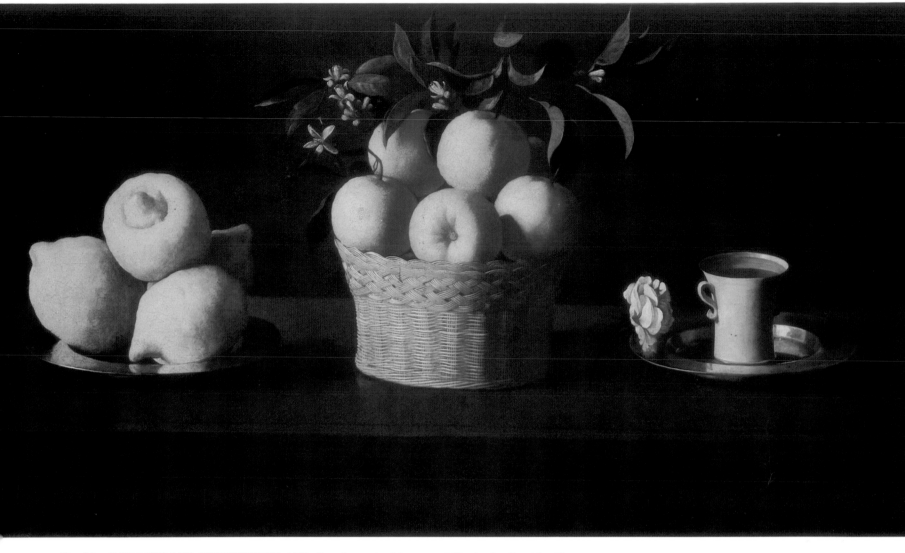

Fig. 84. IMMACULATE CONCEPTION. 1632. Barcelona: Art Museum of Catalonia. Cat. No. 82.
Fig. 85. STILL LIFE. 1633. Los Angeles: The Norton Simon Foundation. Cat. 83.

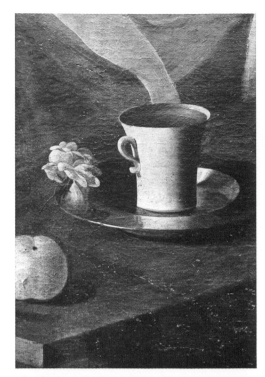

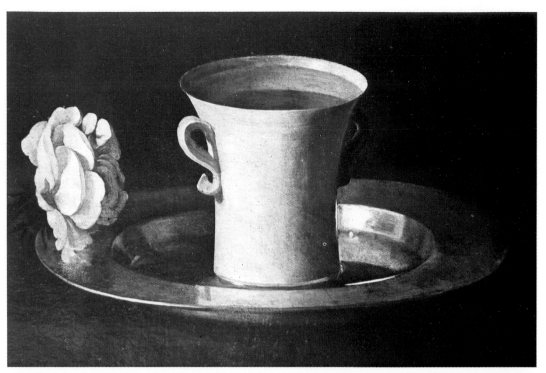

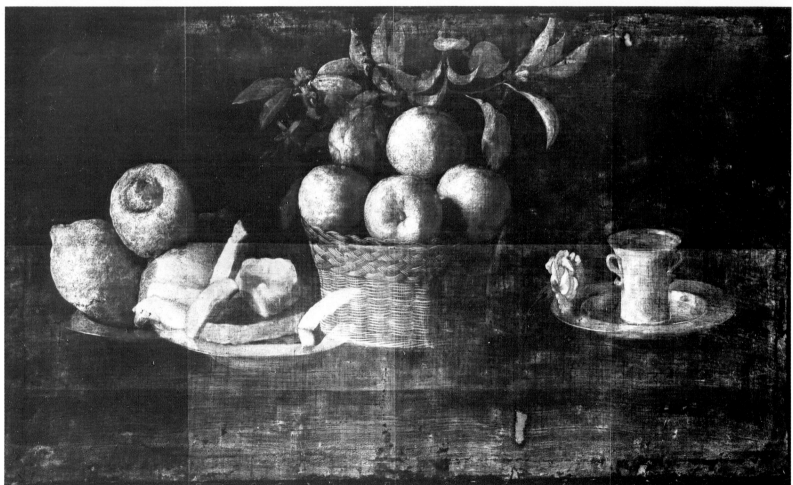

Fig. 86. THE MIRACULOUS CURE OF BLESSED REGINALD OF ORLEANS. 1626-1627. Detail of the figure 5. Cat. No. 4.
Fig. 87. STILL LIFE. Detail of figure 85.
Fig. 88. STILL LIFE. Radiography of figure 85.

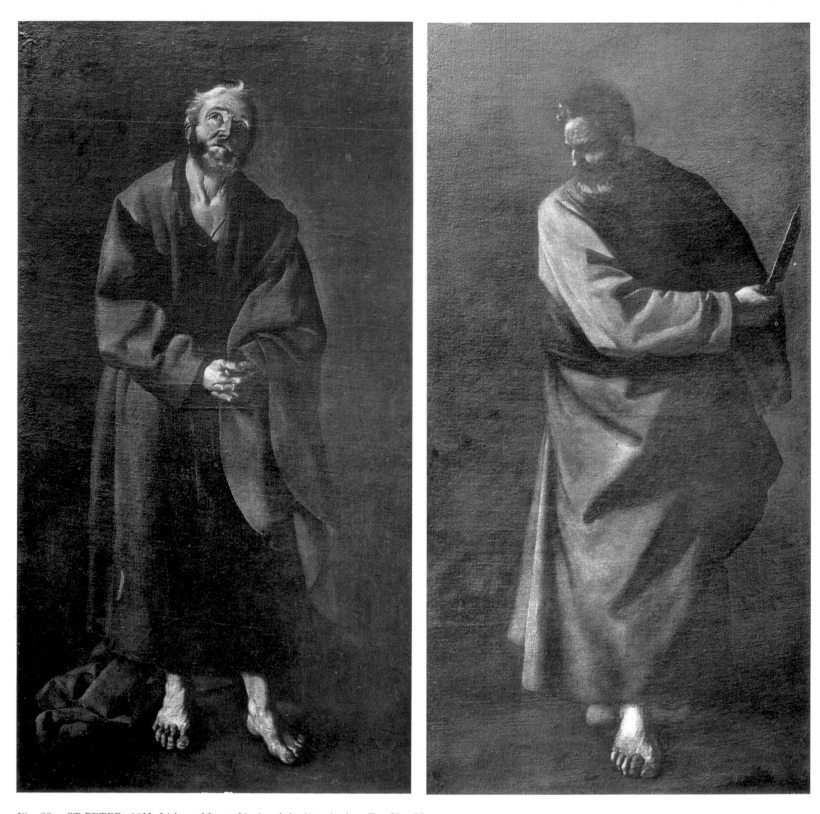

Fig. 89. ST PETER. 1633. Lisbon: Museu Nacional de Arte Antiga. Cat. No. 84.
Fig. 90. ST BARTHOLOMEW. 1633. Lisbon: Museu Nacional de Arte Antiga. Cat. No. 85.

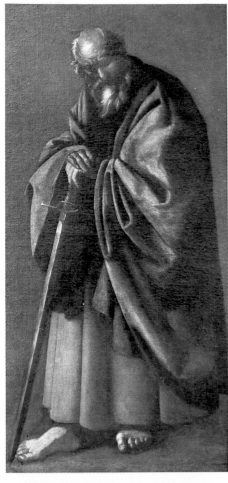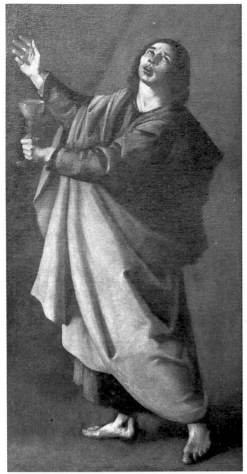

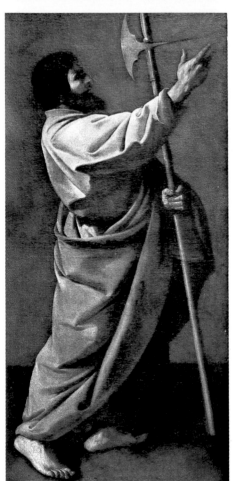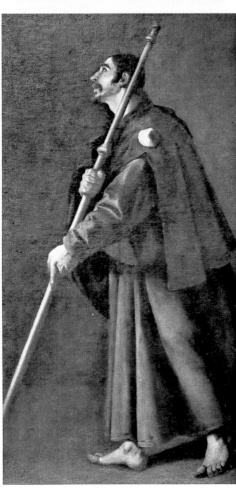

Fig. 91. ST PAUL. 1633. Lisbon: Museu Nacional de Arte Antiga. Cat. No. 86.

Fig. 92. ST JOHN THE EVANGELIST. Lisbon: Museu Nacional de Arte Antiga. Cat. No. 87.

Fig. 93. ST MATTHIAS. 1633. Lisbon: Museu Nacional de Arte Antiga. Cat. No. 88.

Fig. 94. ST JAMES THE GREAT. 1633. Lisbon: Museu Nacional de Arte Antiga. Cat. No. 89.

Fig. 95. ST ANDREW. 1633. Lisbon: Museu Nacional de Arte Antiga. Cat. No. 90.

Fig. 96. ST THOMAS. 1633. Lisbon: Museu Nacional de Arte Antiga. Cat. No. 91.

Fig. 97. ST SIMON. 1633. Lisbon: Museu Nacional de Arte Antiga. Cat. No. 92.

Fig. 98. ST JAMES THE LESS. 1633. Lisbon: Museu Nacional de Arte Antiga. Cat. No. 93.

Fig. 99. ST MATTHEW. 1633. Lisbon: Museu Nacional de Arte Antiga. Cat. No. 94.

Fig. 100. ST PHILIP. 1633. Lisbon: Museu Nacional de Arte Antiga. Cat. No. 95.

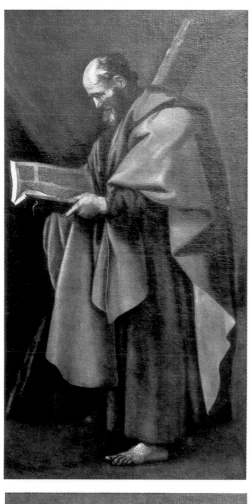

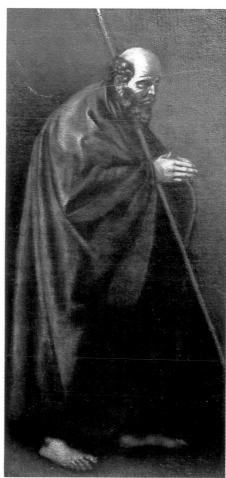

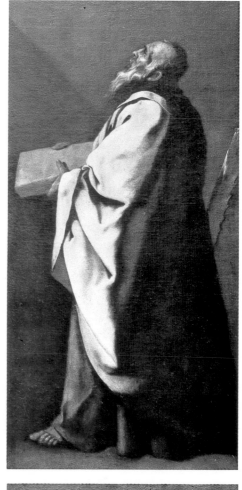

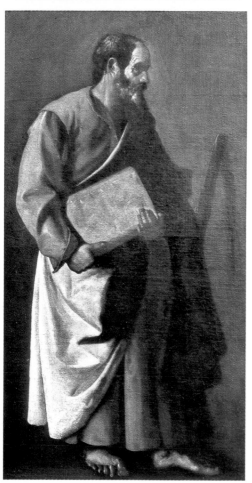

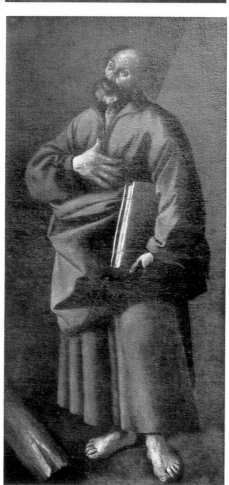

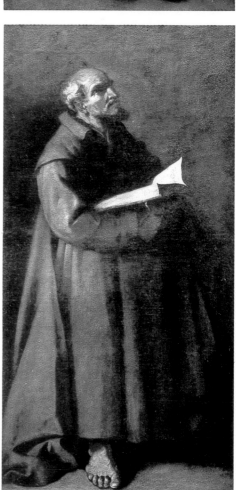

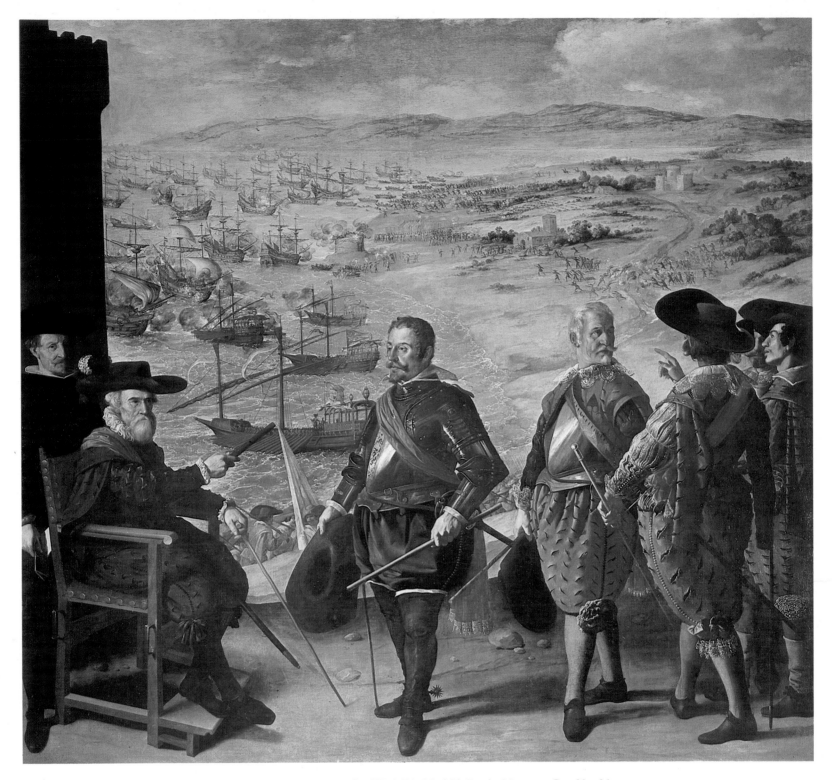

Figs. 101 and 102. DEFENSE OF CADIZ AGAINST THE ENGLISH. 1634. Madrid: Prado Museum. Cat. No. 96.

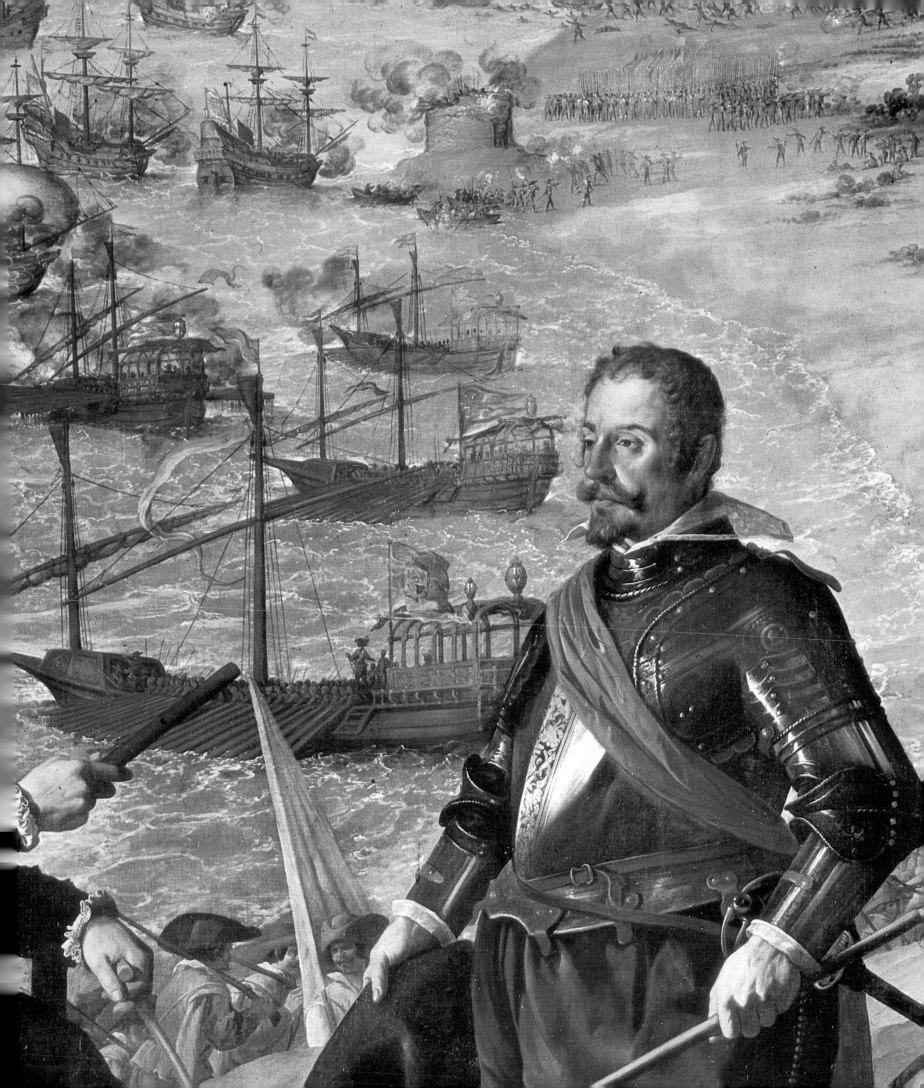

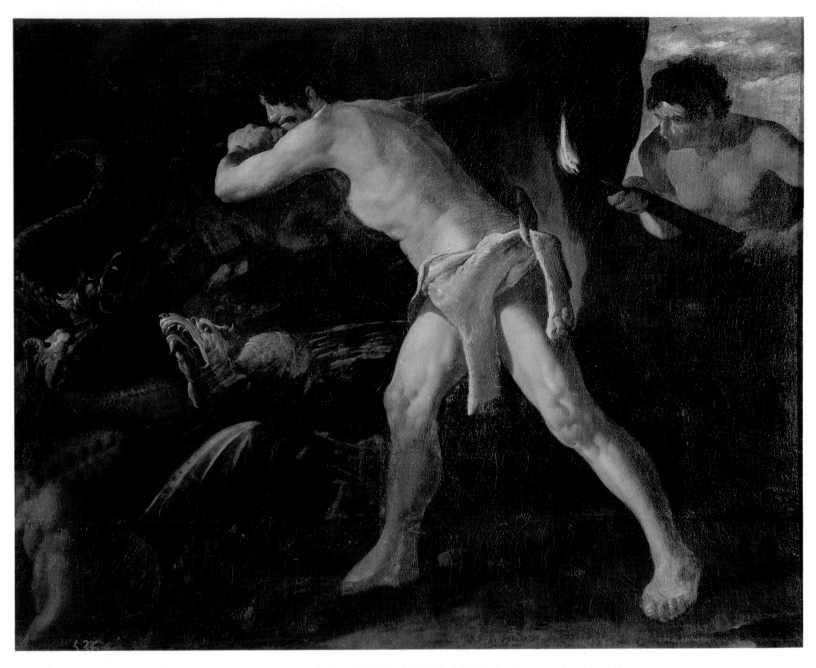

Fig. 103. HERCULES STRUGGLING WITH THE LERNEAN HYDRA. 1634. Madrid: Prado Museum. Cat. No. 105.

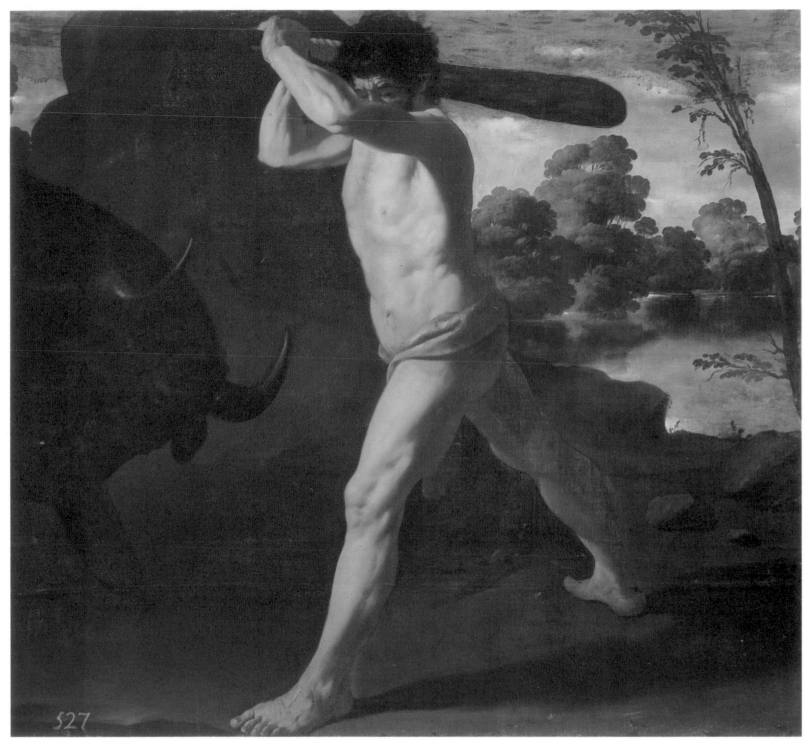

Fig. 104. HERCULES AND THE CRETAN BULL. 1634. Madrid: Prado Museum. Cat. No. 101.

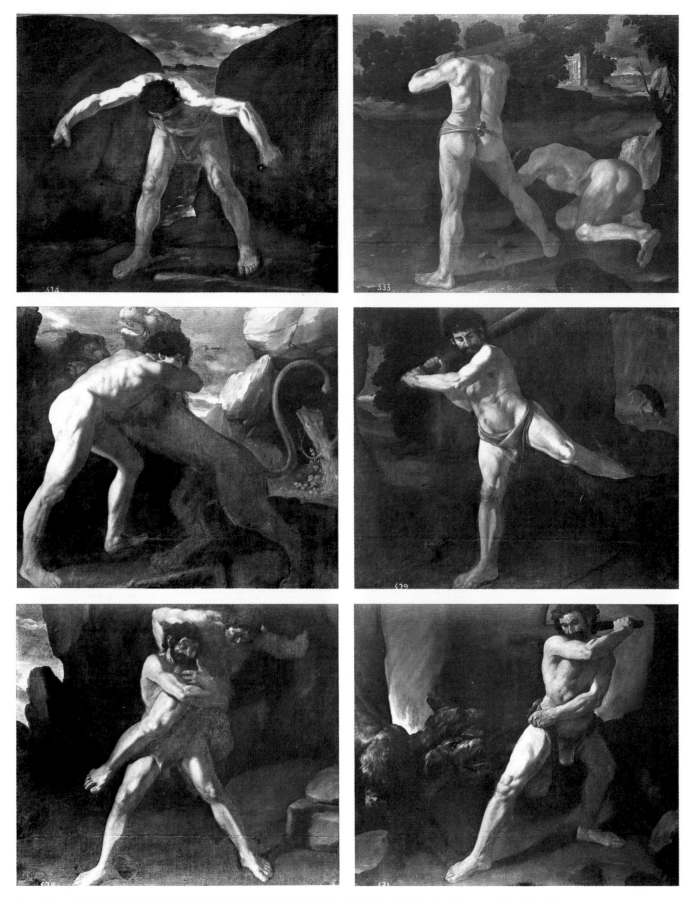

Fig. 105. HERCULES SEPARATING CALPE AND ABYLA. 1634. Madrid: Prado Museum. Cat. No. 97.
Fig. 106. HERCULES DEFEATING GERYON. 1634. Madrid: Prado Museum. Cat. No. 98.
Fig. 107. HERCULES SLAYING THE NEMEAN LION. 1634. Madrid: Prado Museum. Cat. No. 99.
Fig. 108. HERCULES DESTROYING THE ERYMANTHIAN BOAR. 1634. Madrid: Prado Museum. Cat. No. 100.
Fig. 109. HERCULES WRESTLING WITH ANTAEUS. 1634. Madrid: Prado Museum. Cat. No. 102.
Fig. 110. HERCULES AND CERBERUS. 1634. Madrid: Prado Museum. Cat. No. 103.

Fig. 111. HERCULES CHANGING THE COURSE OF THE RIVER ALPHEUS. 1634. Madrid: Prado Museum. Cat. No. 104
FIg. 112. HERCULES KILLED BY THE POISONED SHIRT OF THE CENTAUR NESSUS. 1634. Madrid: Prado Museum.
Cat. No. 106.
Fig. 113. ALONSO DE VERDUGO DE ALBORNOZ, LATER FIRST CONDE DE TORREPALMA. 1635. Destroyed in 1945.
Cat. No. 107.
Fig. 114. CHRIST CRUCIFIED. 1635-1637. Marchena: Church of San Juan Bautista. Cat. No. 108.

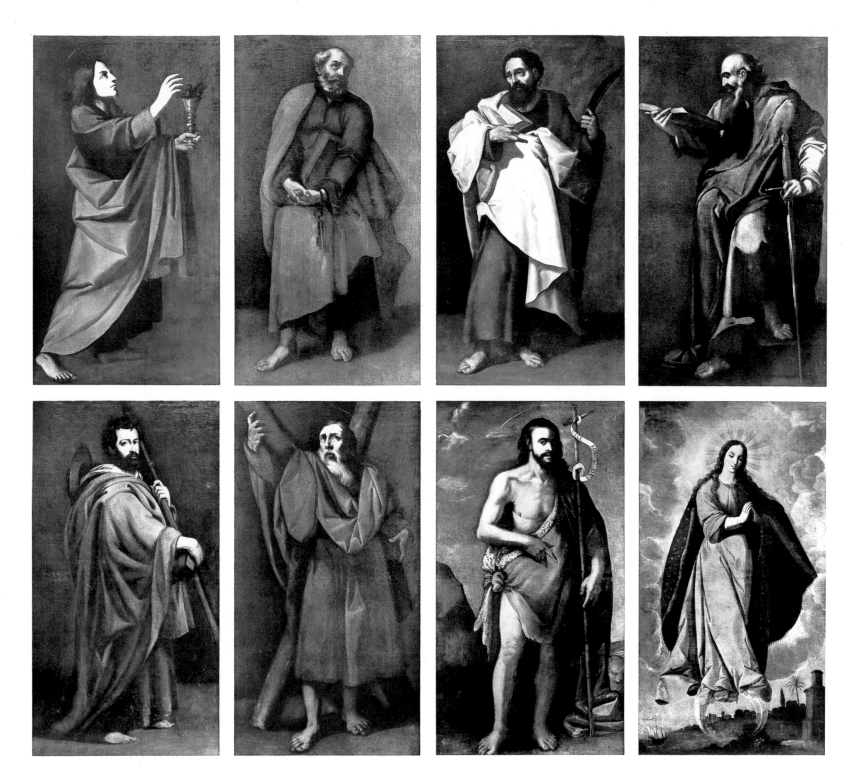

Fig. 115. ST JOHN EVANGELIST. 1635-1637. Marchena: Church of San Juan Bautista. Cat. No. 109.

Fig. 116. ST PETER. 1635-1637. Marchena: Church of San Juan Bautista. Cat. No. 110.

Fig. 117. ST BARTHOLOMEW. 1635-1637. Marchena: Church of San Juan Bautista. Cat. No. 111.

Fig. 118. ST PAUL. 1635-1637. Marchena: Church of San Juan Bautista. Cat. No. 112.

Fig. 119. ST JAMES THE GREAT. 1635-1637. Marchena: Church of San Juan Bautista. Cat. No. 113.

Fig. 120. ST ANDREW. 1635-1637. Marchena: Church of San Juan Bautista. Cat. No. 114.

Fig. 121. ST JOHN THE BAPTIST. 1635-1637. Marchena: Church of San Juan Bautista. Cat. No. 115.

Fig. 122. IMMACULATE CONCEPTION. 1635-1637. Church of San Juan Bautista. Cat. No. 116.

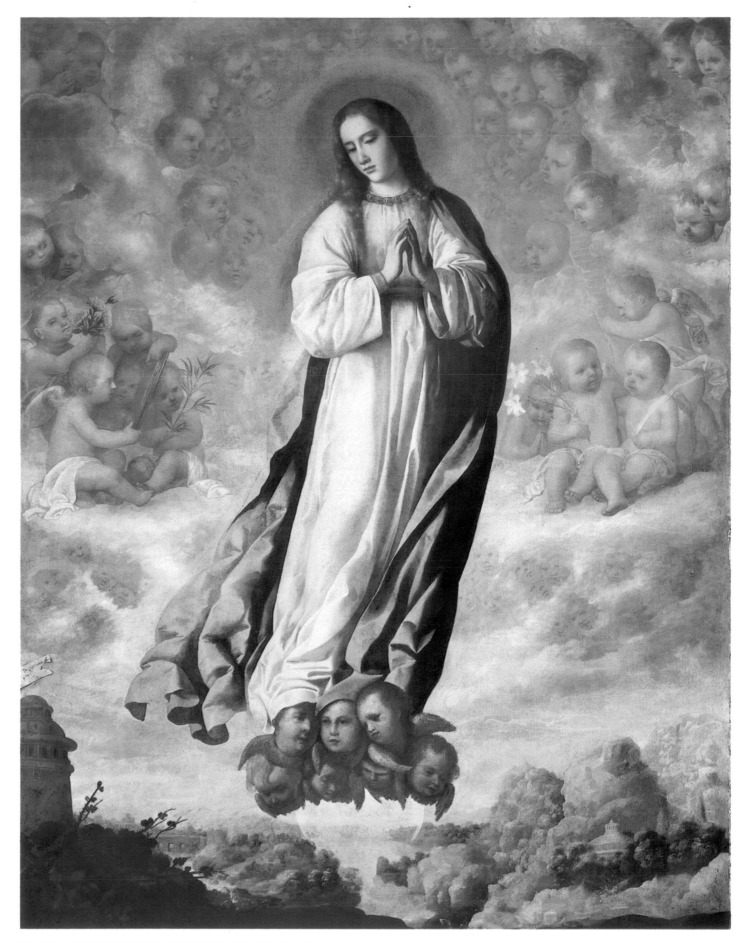

Fig. 123. IMMACULATE CONCEPTION. 1636. New York: Private collection. Cat. No. 117.

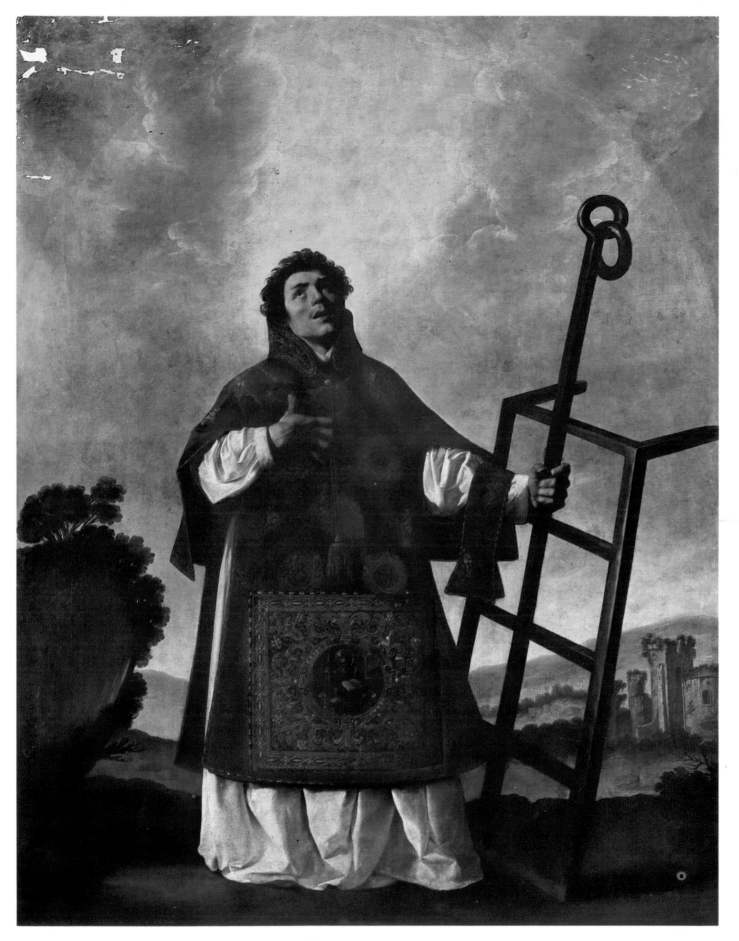

Fig. 124. **ST LAWRENCE**. 1636. Leningrad: Hermitage. Cat. No. 118.

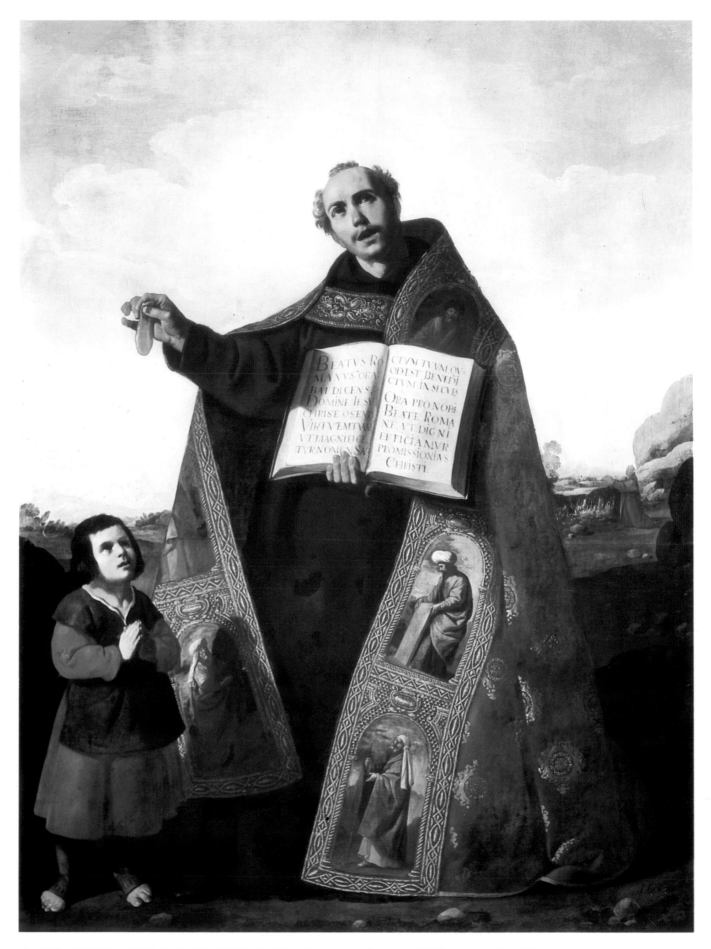

Fig. 125. ST ROMANUS AND ST BARULAS. 1638. Chicago: Art Institute of Chicago. Cat. No. 120.

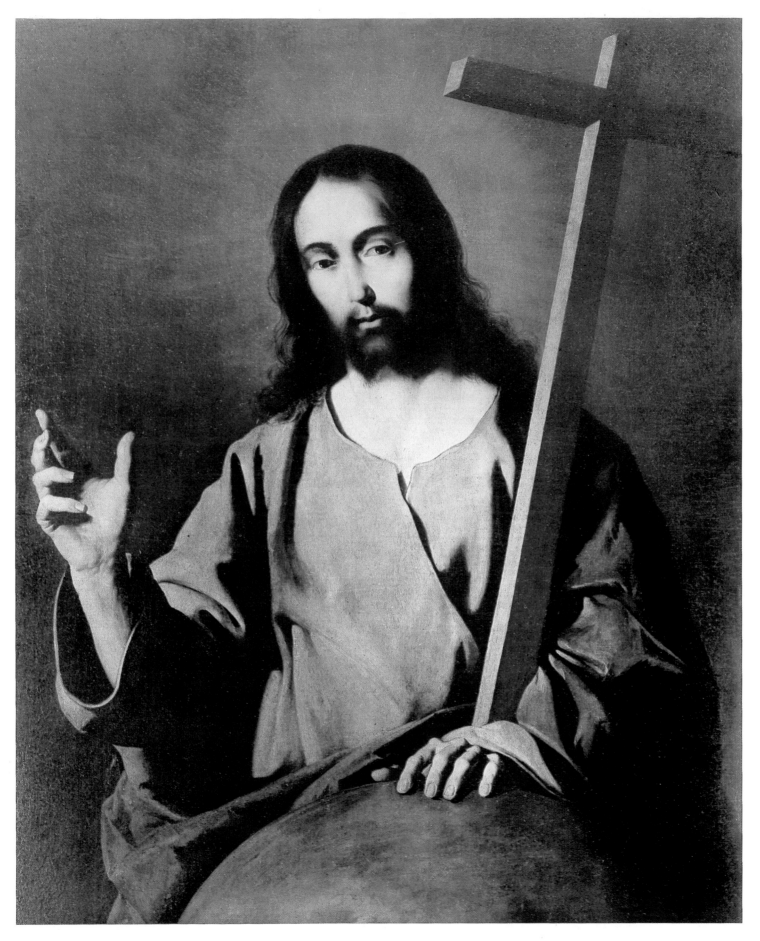

Fig. 126. SALVATOR MUNDI. 1638. Barcelona: Félix Millet. Cat. No. 121.

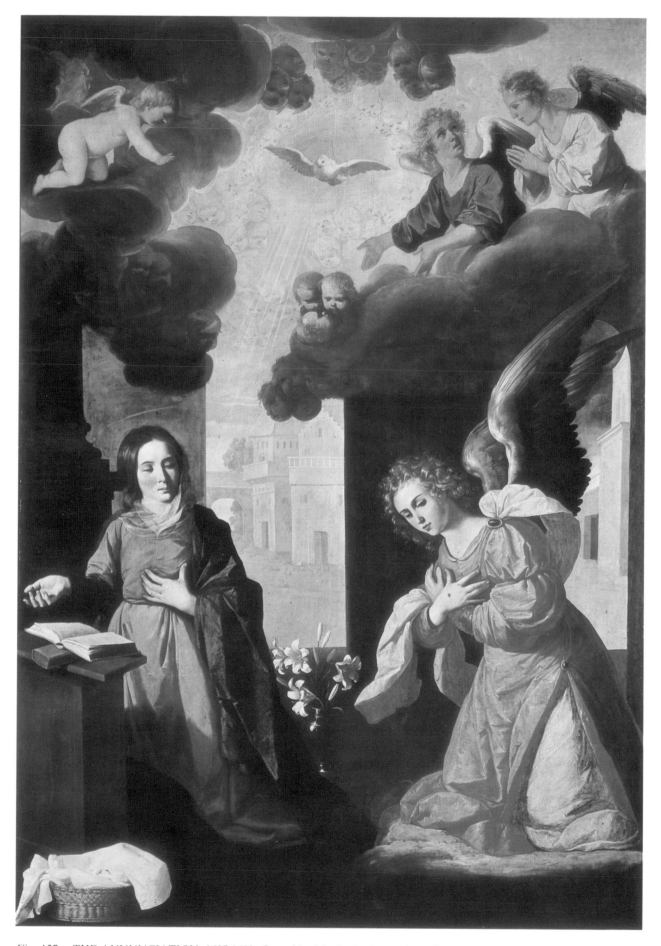

Fig. 127. THE ANNUNCIATION. 1637-1639. Grenoble: Musée des Beaux-Arts. Cat. No. 122.

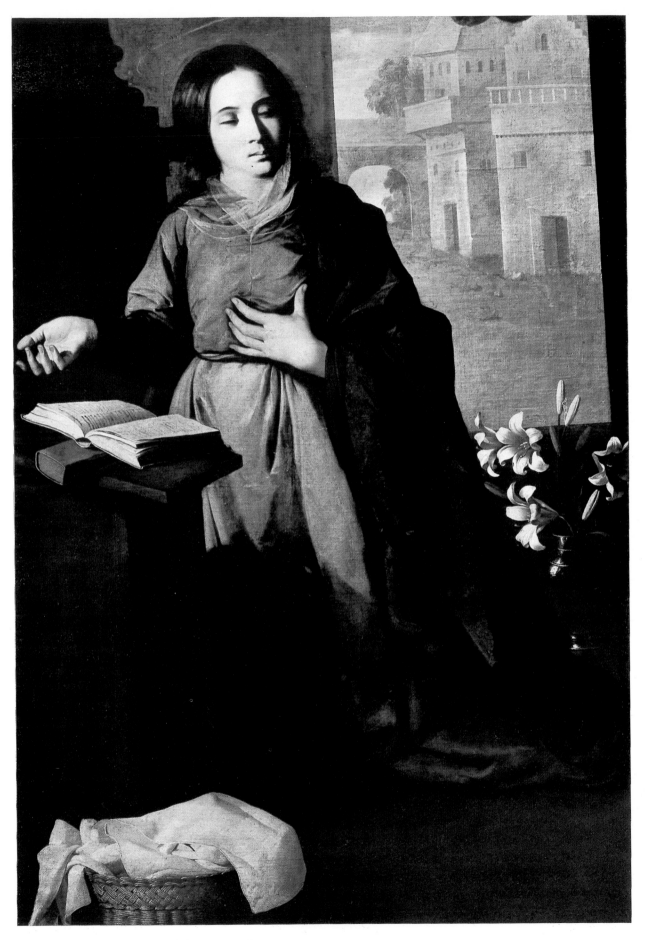

Fig. 128. THE ANNUNCIATION. Detail of figure 127.

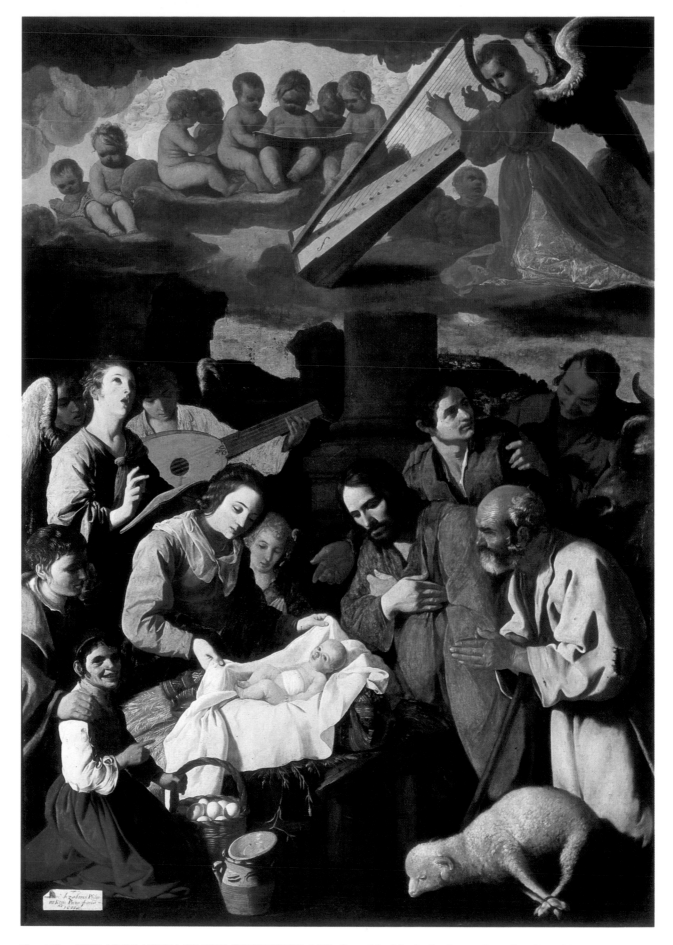

Fig. 129. THE ADORATION OF THE SHEPHERDS. 1638. Grenoble: Musée des Beaux-Arts. Cat. No. 123.

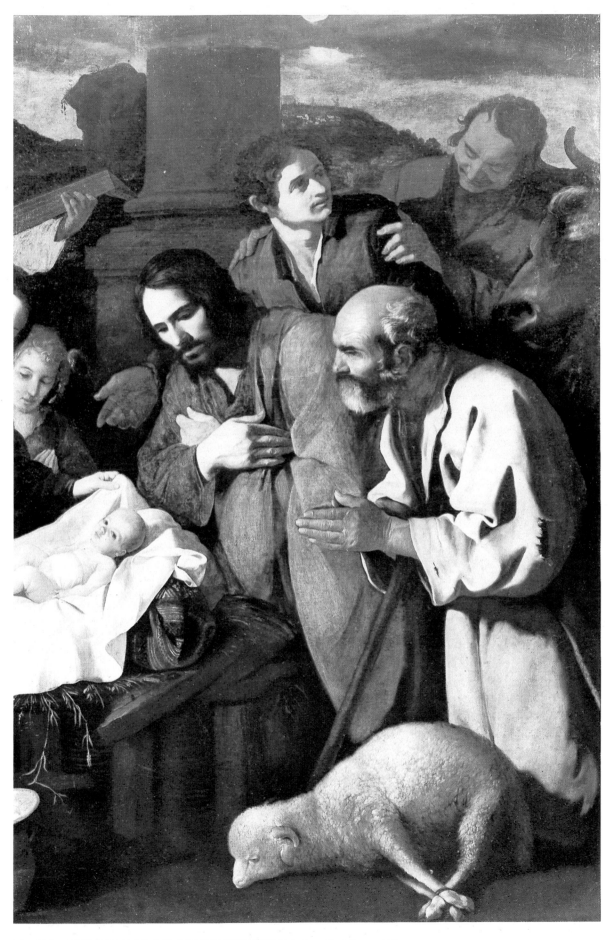

Fig. 130. THE ADORATION OF THE SHEPHERDS. Detail of figure 129.
Fig. 131. THE CIRCUMCISION. 1639. Grenoble: Musée des Beaux-Arts. Cat. No. 124.

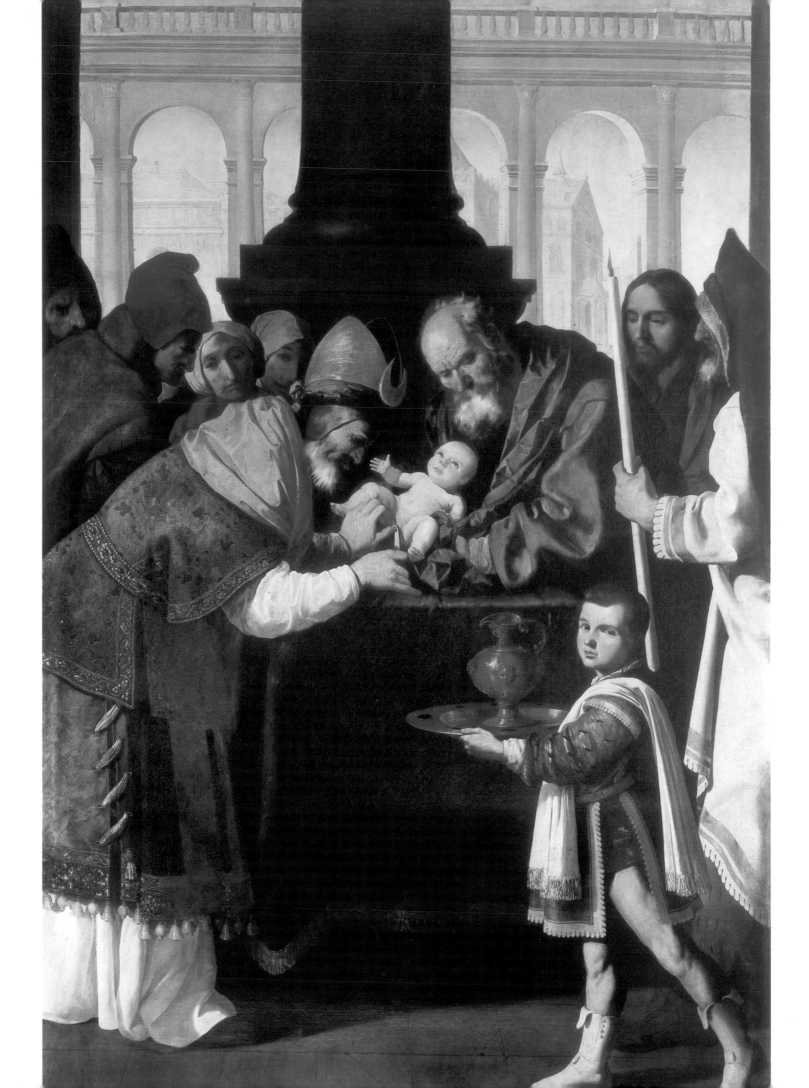

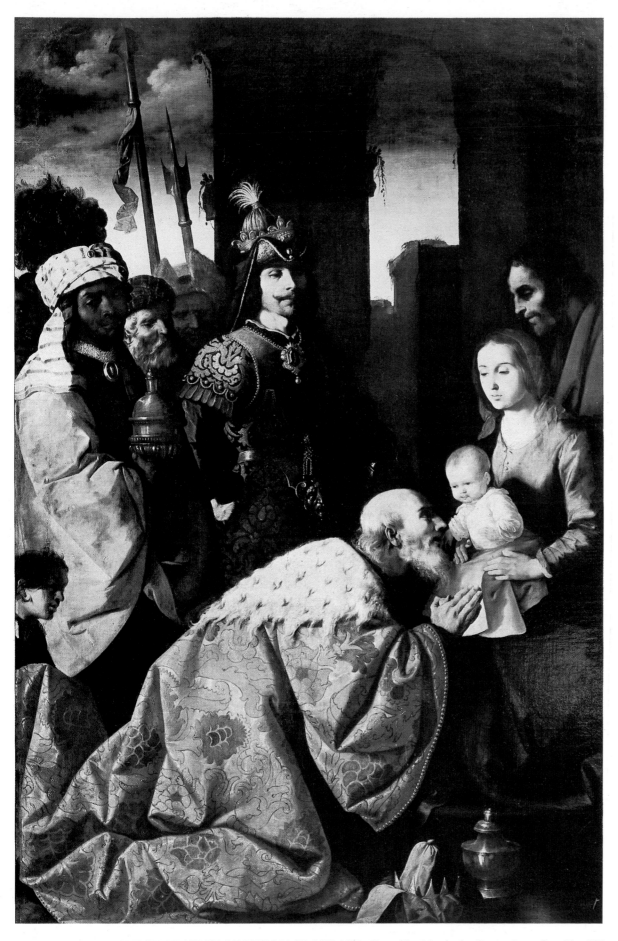

Figs. 132 and 133. **THE ADORATION OF THE MAGI.** 1637-1639. Grenoble: Musée des Beaux-Arts. Cat. No. 125.

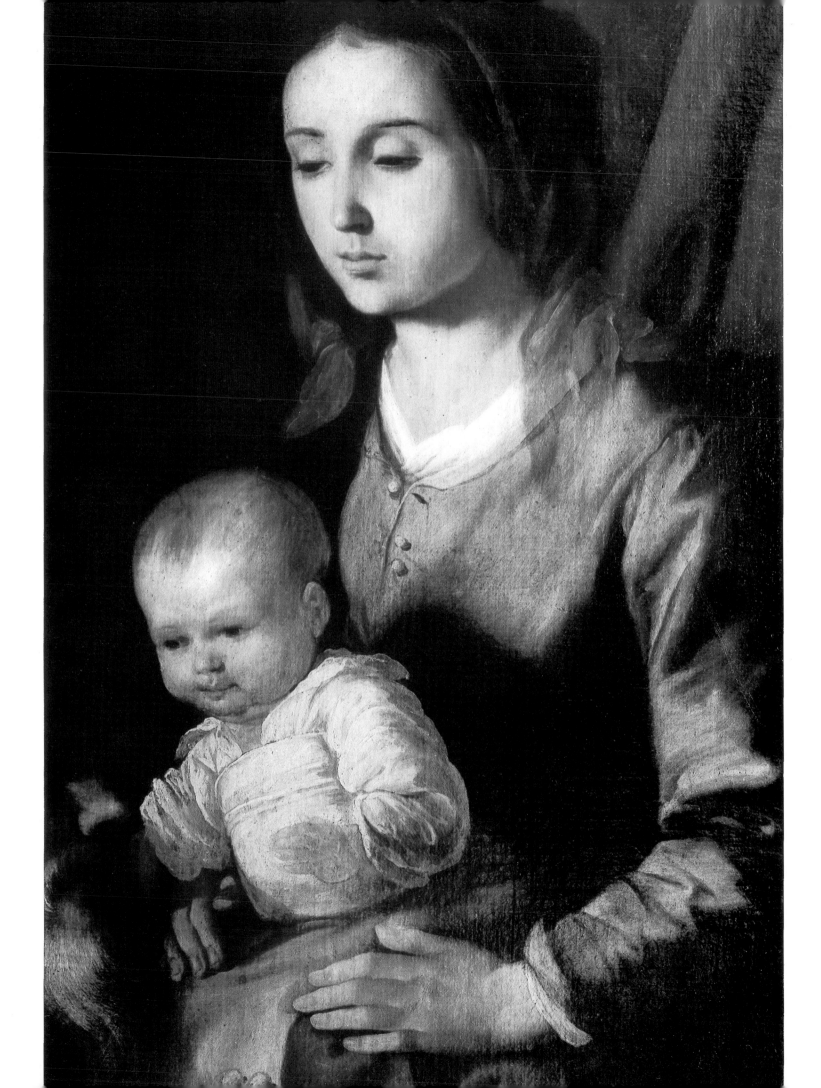

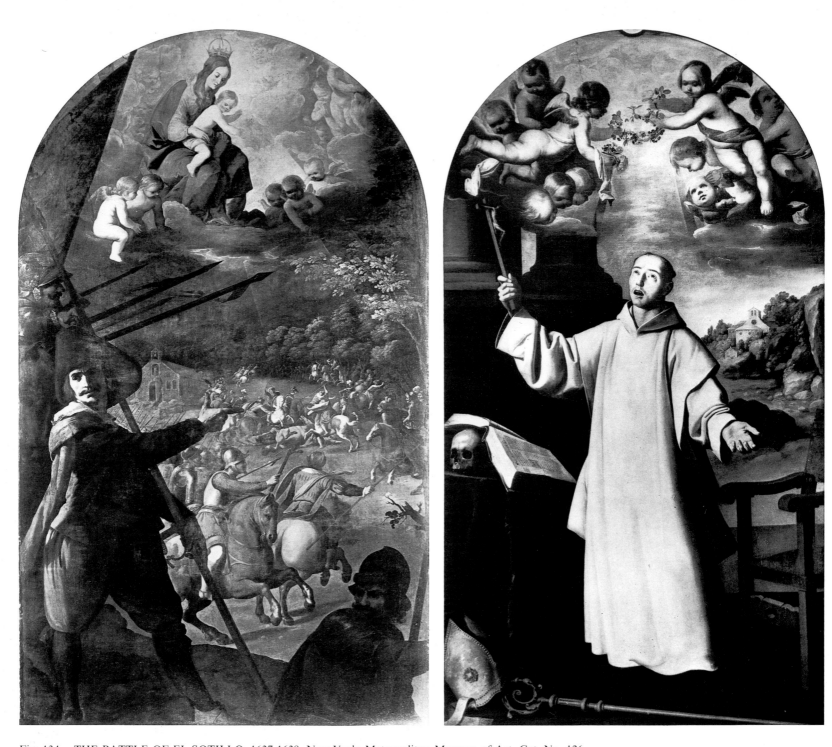

Fig. 134. THE BATTLE OF EL SOTILLO. 1637-1639. New York: Metropolitan Museum of Art. Cat. No. 126.
Figs. 135 and 136. ST BRUNO IN ECSTASY. 1637-1639. Cadiz: Provincial Museum of Fine Arts. Cat. No. 127.

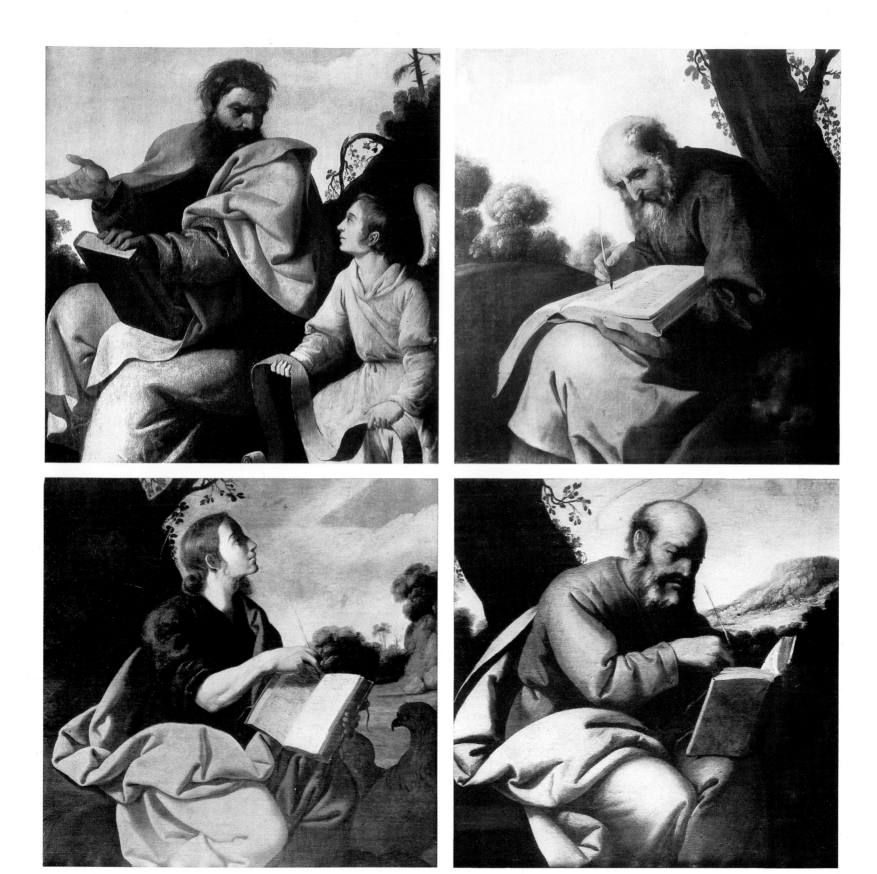

Fig. 137. ST MATTHEW. 1637-1639. Cadiz: Provincial Museum of Fine Arts. Cat. No. 128.
Fig. 138. ST MARK. 1637-1639. Cadiz: Provincial Museum of Fine Arts. Cat. No. 129.
Fig. 139. ST JOHN THE EVANGELIST. 1637-1639. Cadiz: Provincial Museum of Fine Arts. Cat. No. 130.
Fig. 140. ST LUKE. 1637-1639. Cadiz: Provincial Museum of Fine Arts. Cat. No. 131.
Fig. 141. ST JOHN THE BAPTIST. 1637-1639. Cadiz: Provincial Museum of Fine Arts. Cat. No. 132.
Fig. 142. ST LAWRENCE. 1637-1639. Cadiz: Provincial Museum of Fine Arts. Cat. No. 133.

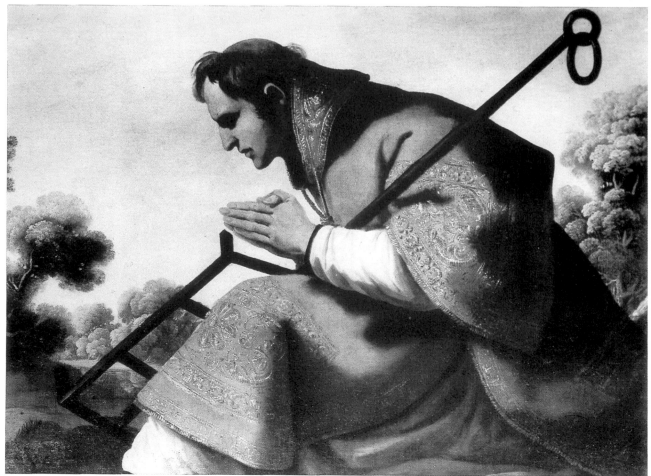

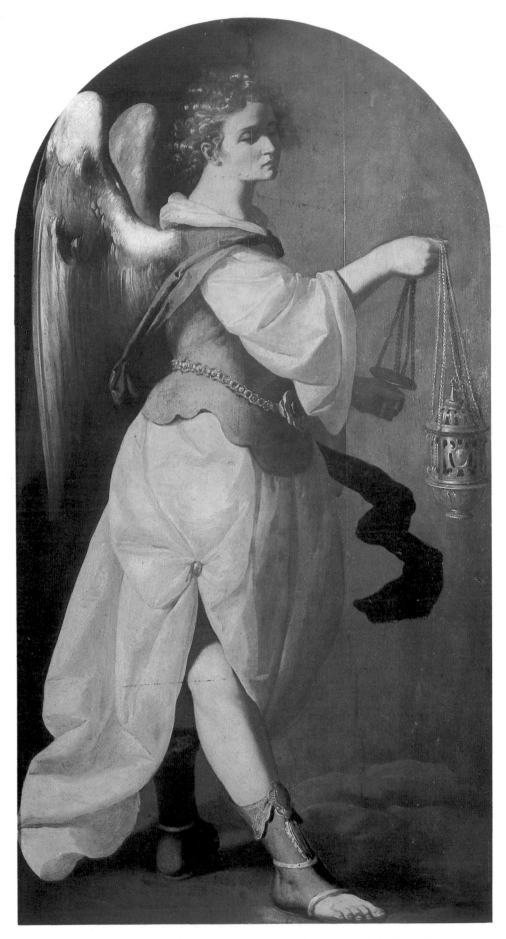

Fig. 143. ANGEL WITH THURIBLE, LOOKING RIGHT. 1637-1639. Cadiz: Provincial
Museum of Fine Arts. Cat. No. 134.

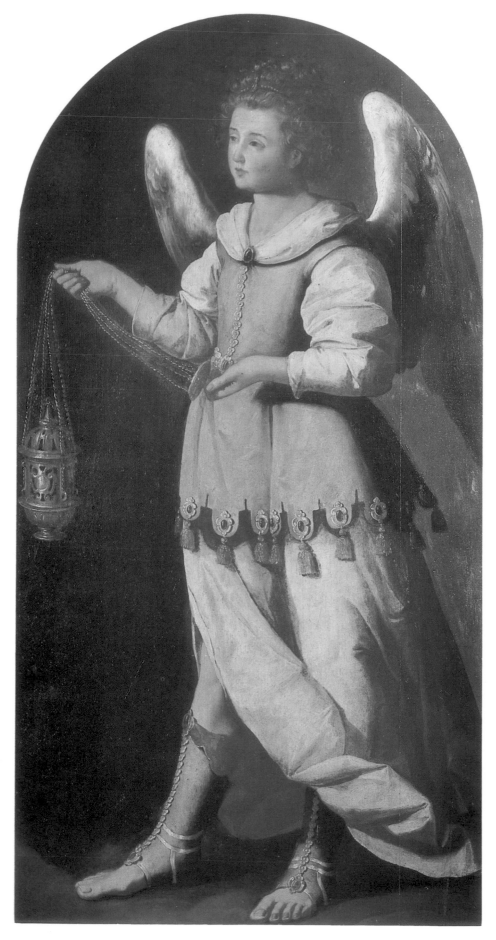

Fig. 144. ANGEL WITH THURIBLE, LOOKING LEFT. 1637-1639. Cadiz: Provincial
Museum of Fine Arts. Cat. No. 135.

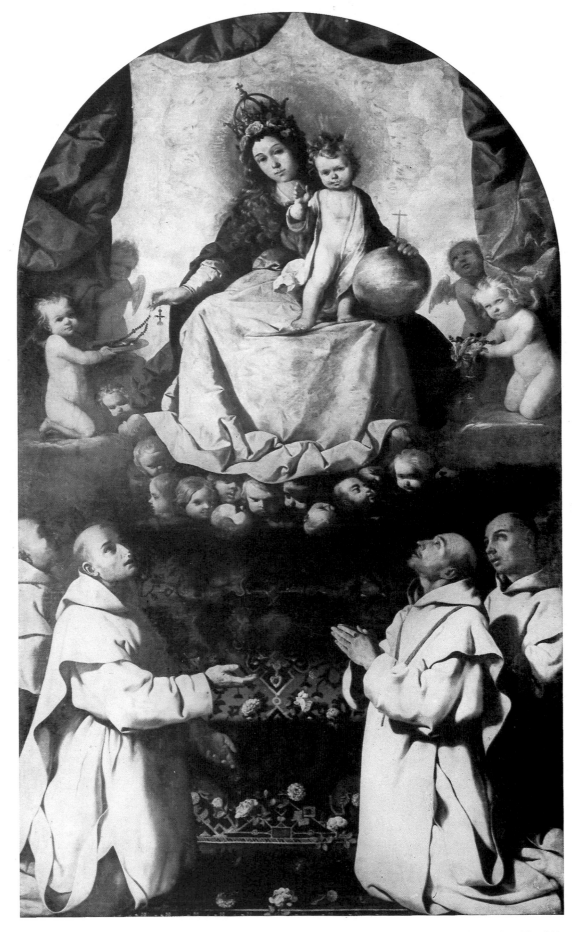

Fig. 145. OUR LADY OF THE CARTHUSIANS. 1637-1639. Warsaw: Muzeum Narodowe. Cat. No. 143.

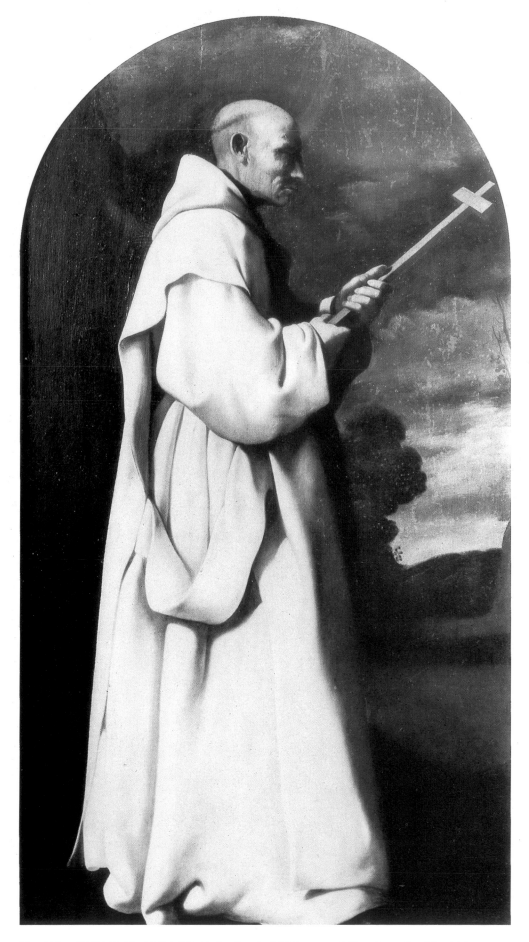

Fig. 146. ST BRUNO. 1637-1639. Cadiz: Provincial Museum of Fine Arts. Cat. No. 136.

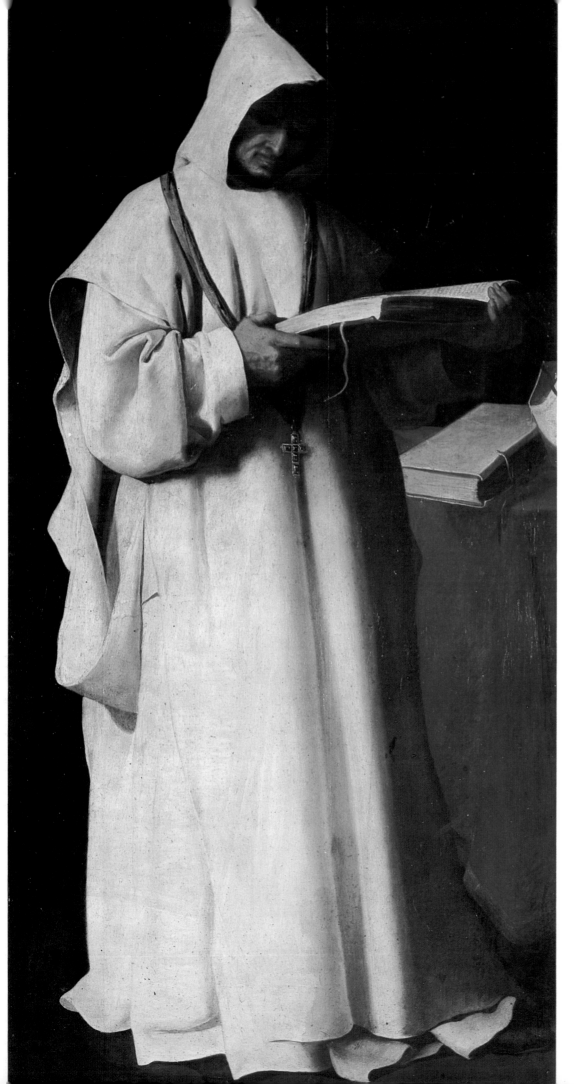

Fig. 147. ST ANSELM. 1637-1639. Cadiz:
Provincial Museum of Fine Arts. Cat. No. 137.

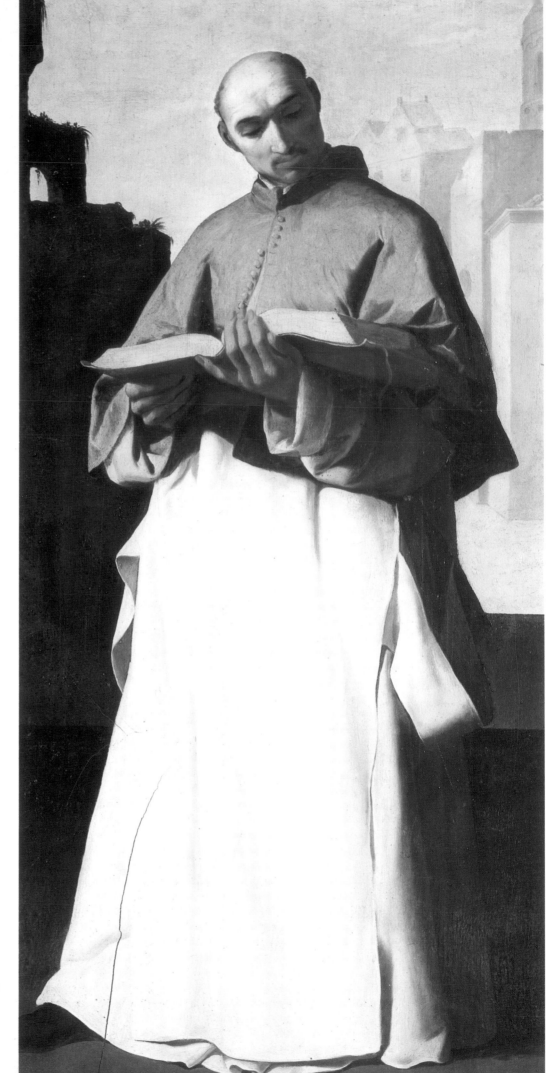

Fig. 148. ST ARTHOLD. 1637-1639. Cadiz:
Provincial Museum of Fine Arts. Cat. No. 138.

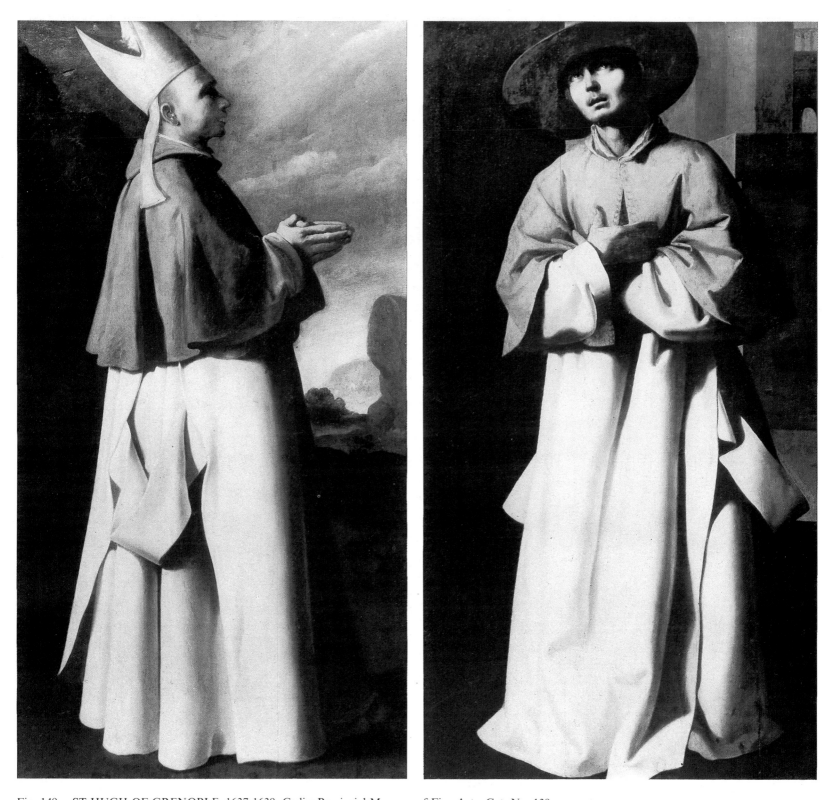

Fig. 149. ST HUGH OF GRENOBLE. 1637-1639. Cadiz: Provincial Museum of Fine Arts. Cat. No. 139.
Fig. 150. CARDINAL NICCOLO ALBERGATI. 1637-1639. Cadiz: Provincial Museum of Fine Arts. Cat. No. 140.

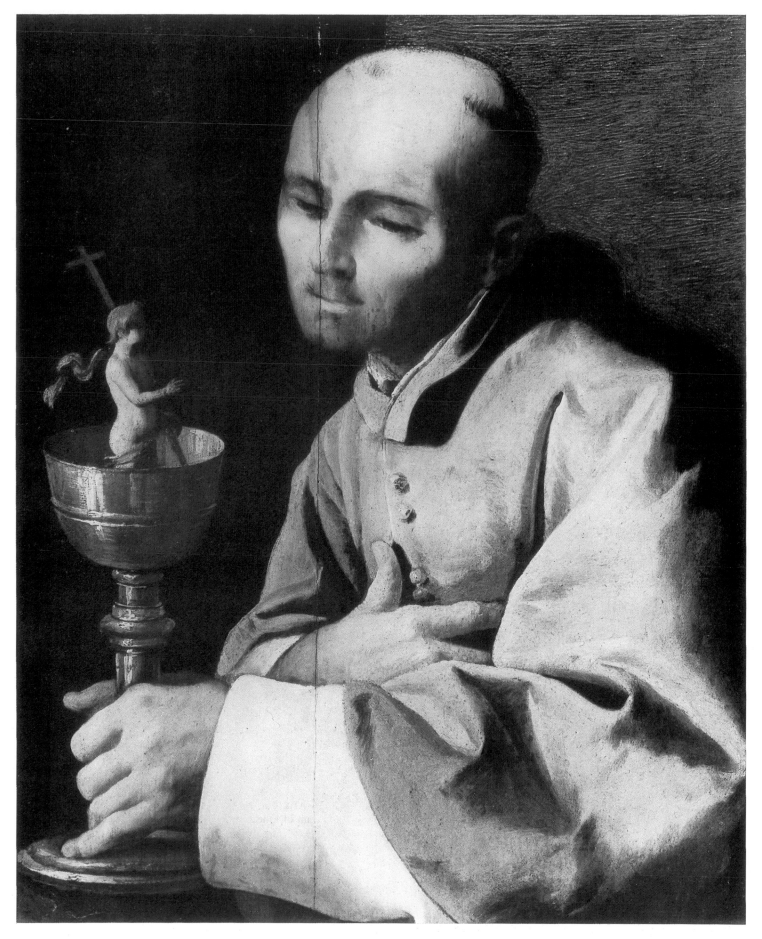

Fig. 151. ST HUGH OF LINCOLN. (detail). 1637-1639. Cadiz: Provincial Museum of Fine Arts. Cat. No. 141.

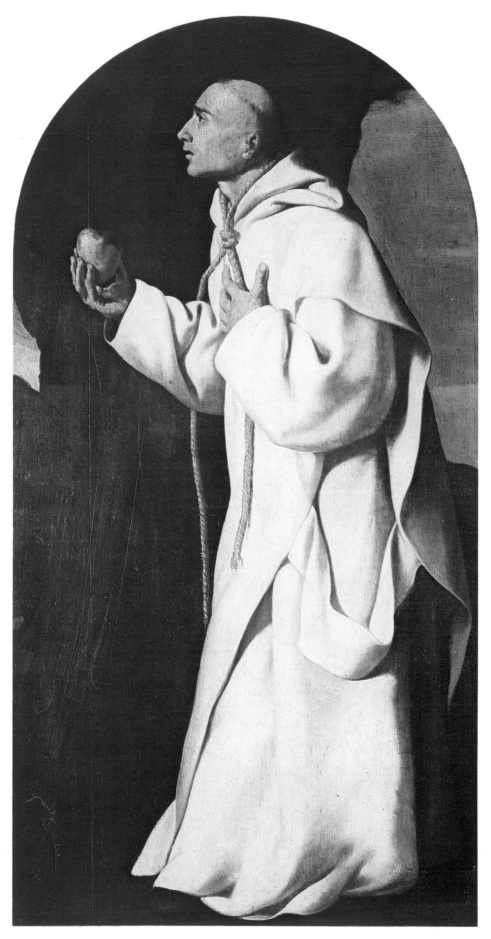

Fig. 152. ST JOHN HOUGHTON. 1637-1639. Cadiz: Provincial Museum of Fine Arts.
Cat. No. 142.

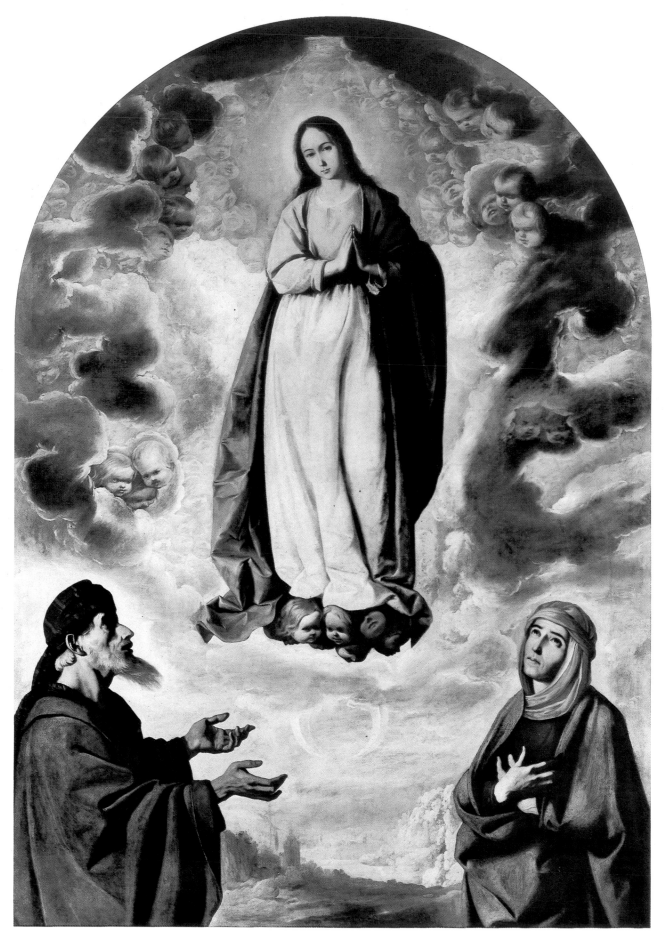

Fig. 153. IMMACULATE CONCEPTION WITH ST JOACHIM AND ST ANNE. 1637-1639. Edinburgh: National Gallery of Scotland. Cat. No. 144.

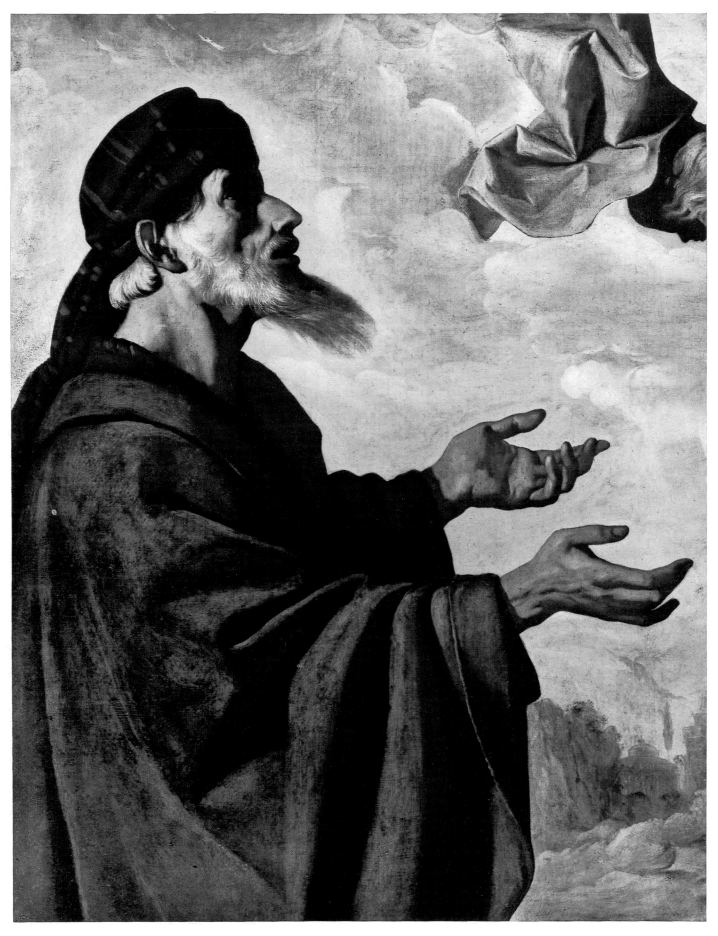

Fig. 154. IMMACULATE CONCEPTION WITH ST JOACHIM AND ST ANNE. Detail of figure 153.

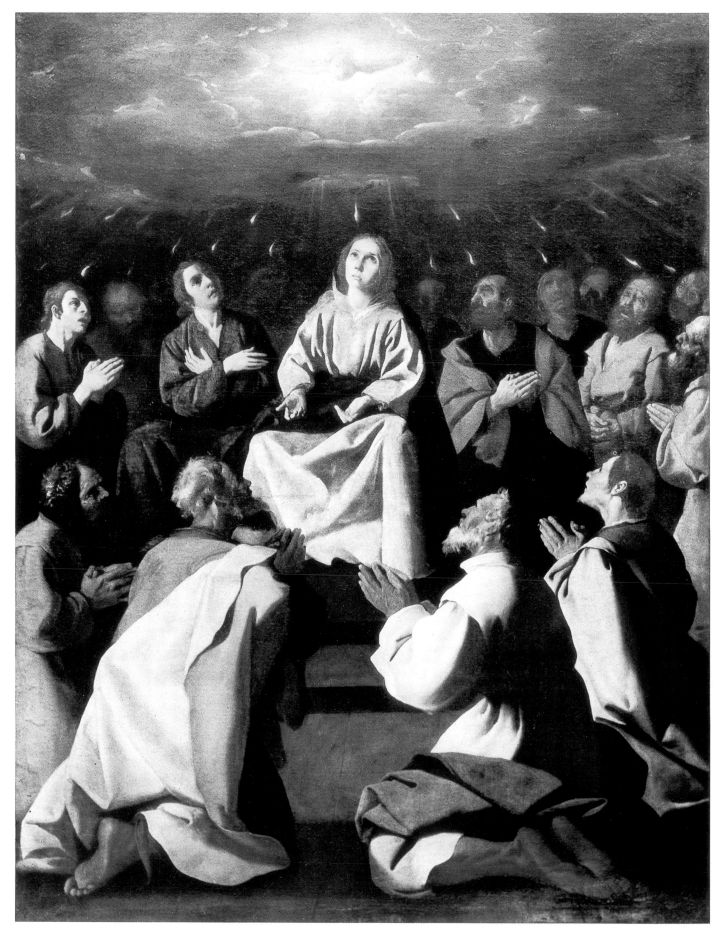

Fig. 155. PENTECOST. 1637-1639. Cadiz: Provincial Museum of Fine Arts. Cat. No. 146.

Fig. 156. Sacristy of the Monastery of San Jerónimo, Guadalupe.

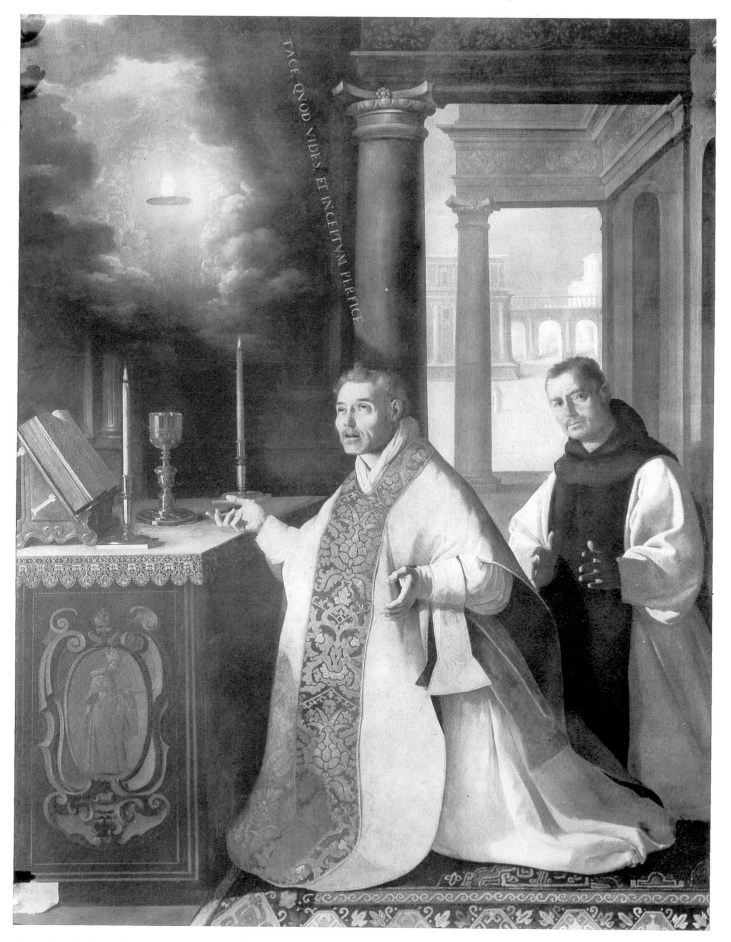

Fig. 157.　THE MASS OF FATHER CABAÑUELAS. 1638. Guadalupe: Monastery of San Jerónimo. Cat. No. 147.

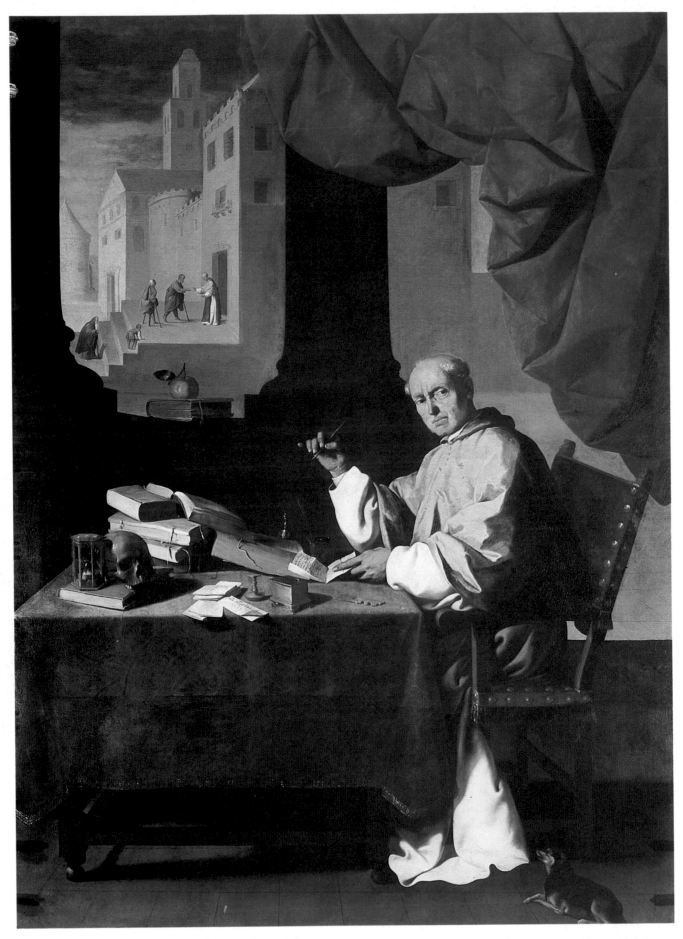

Figs. 158 & 159. FRAY GONZALO DE ILLESCAS, BISHOP OF CORDOBA. 1639. Guadalupe: Monastery of San Jerónimo.
Cat. No. 148.

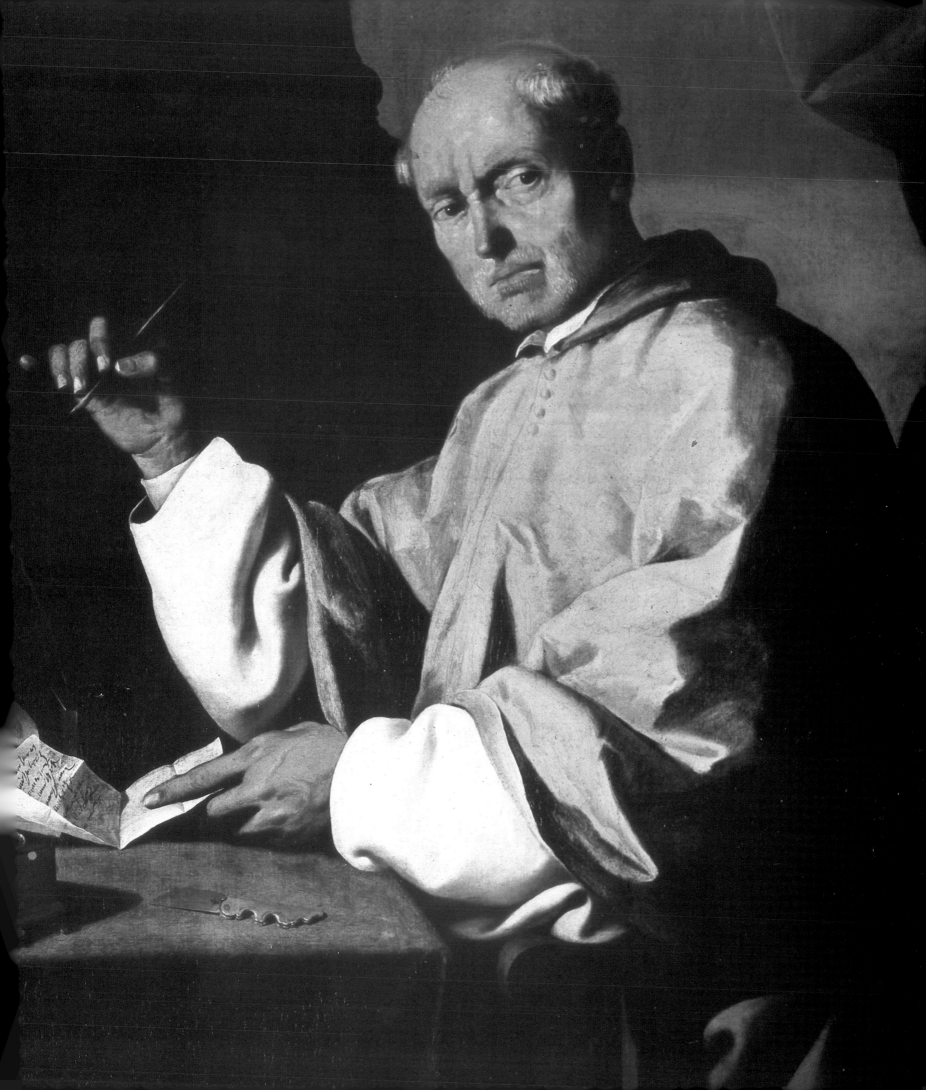

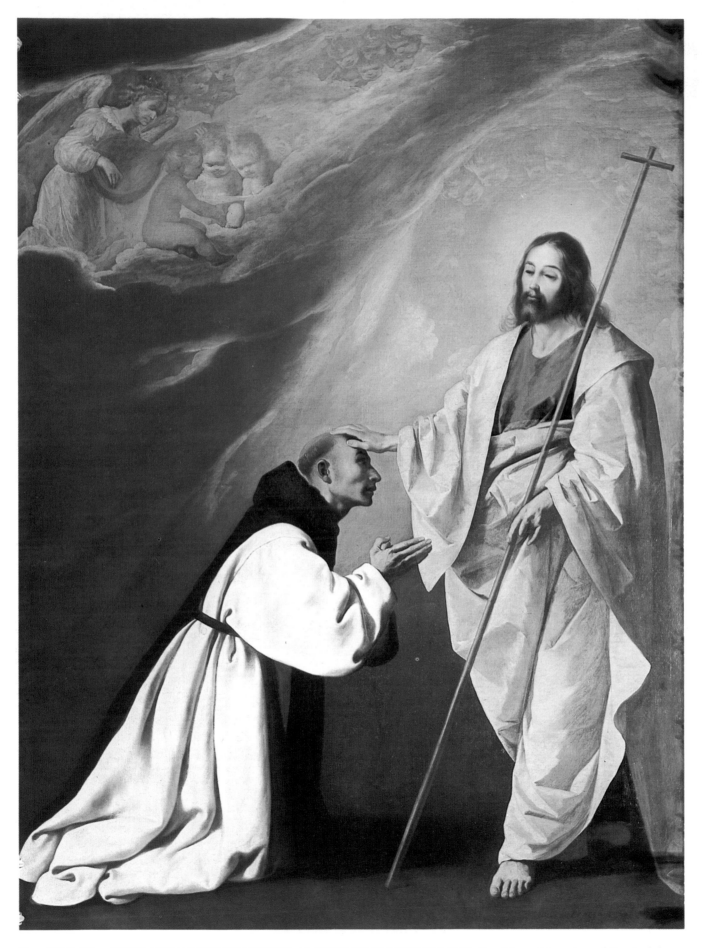

Figs. 160 & 161. JESUS APPEARING TO FATHER ANDRES DE SALMERON. 1639. Guadalupe: Monastery of San Jerónimo.
Cat. No. 149.

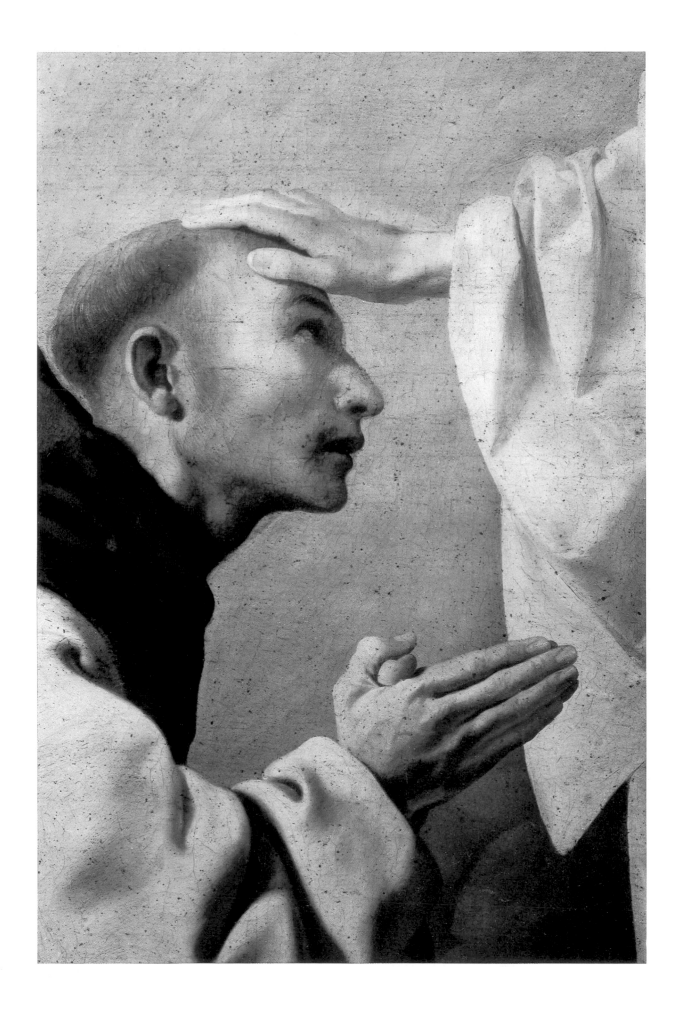

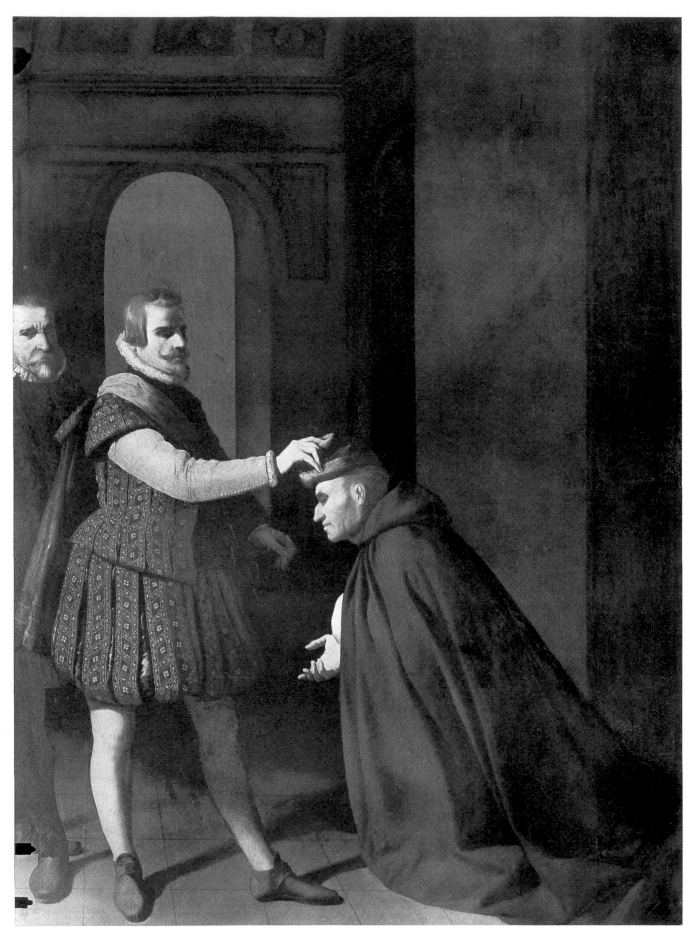

Figs. 162 & 163. ENRIQUE III CONFERRING THE ARCHBISHOP'S BIRETTA ON FATHER YAÑEZ. 1639. Guadalupe:
Monastery of San Jerónimo. Cat. No. 150.

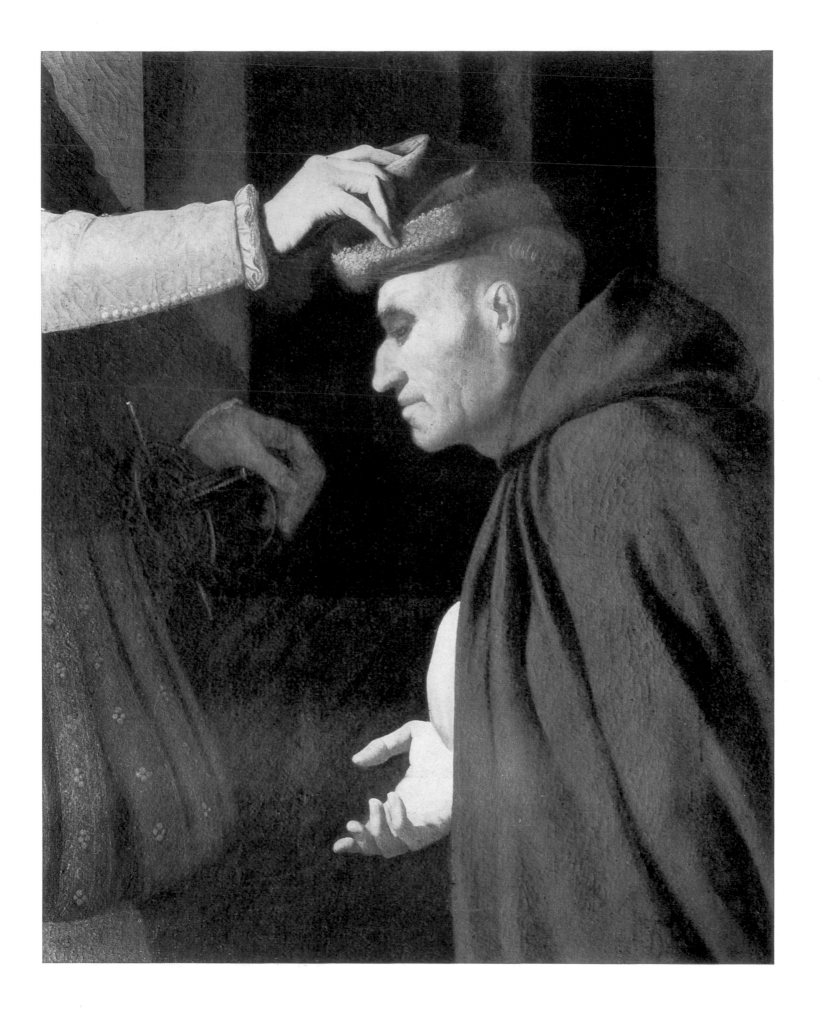

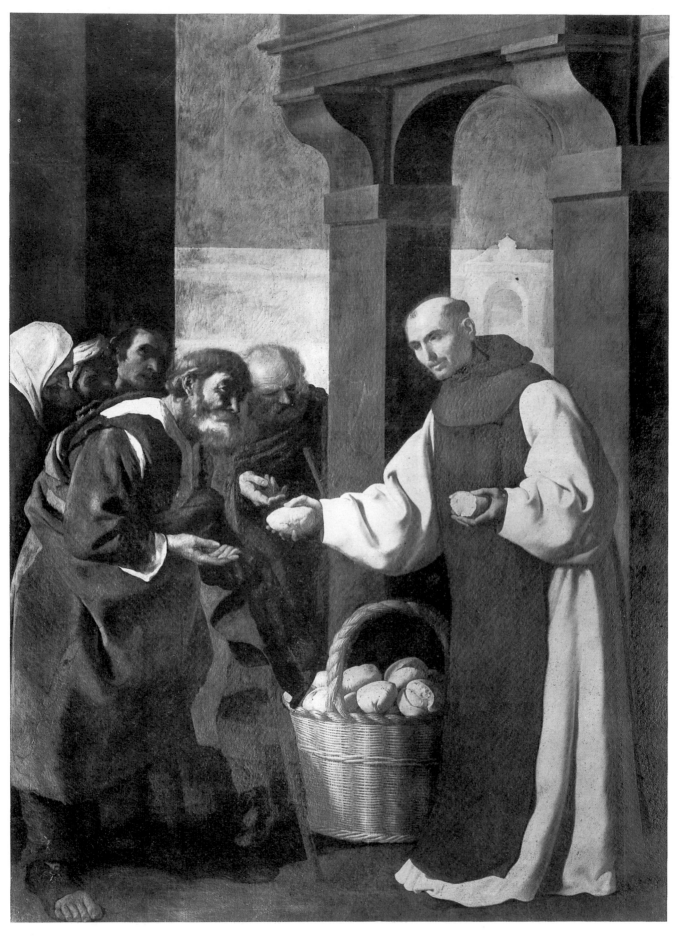

Figs. 164 & 165. FRAY MARTIN VIZCAINO DISTRIBUTING ALMS. 1639. Guadalupe: Monastery of San Jerónimo.
Cat. No. 151.

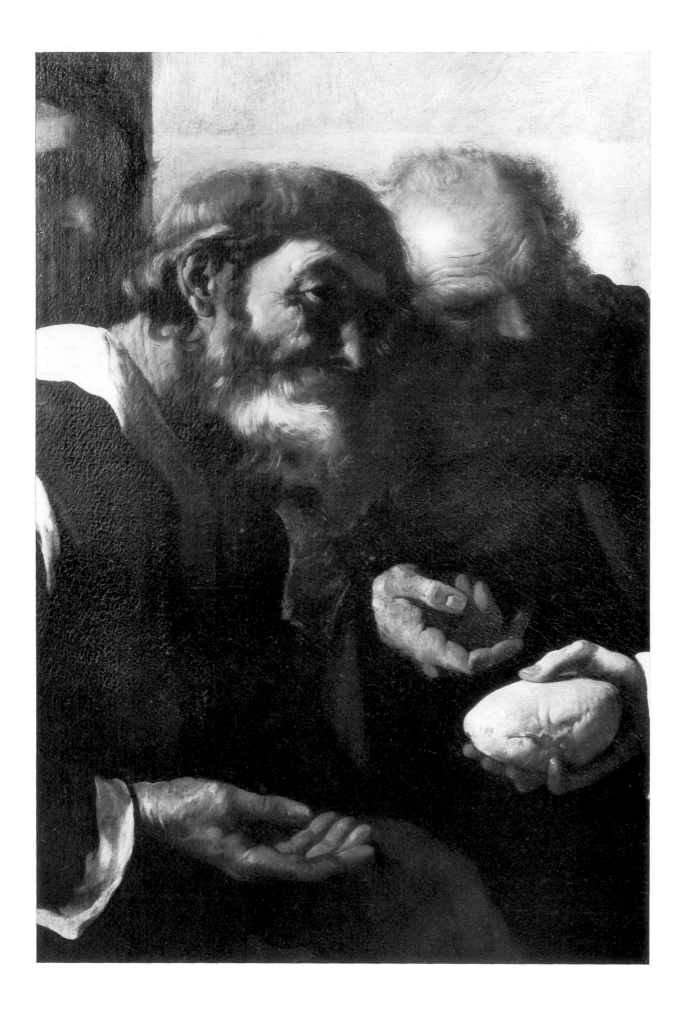

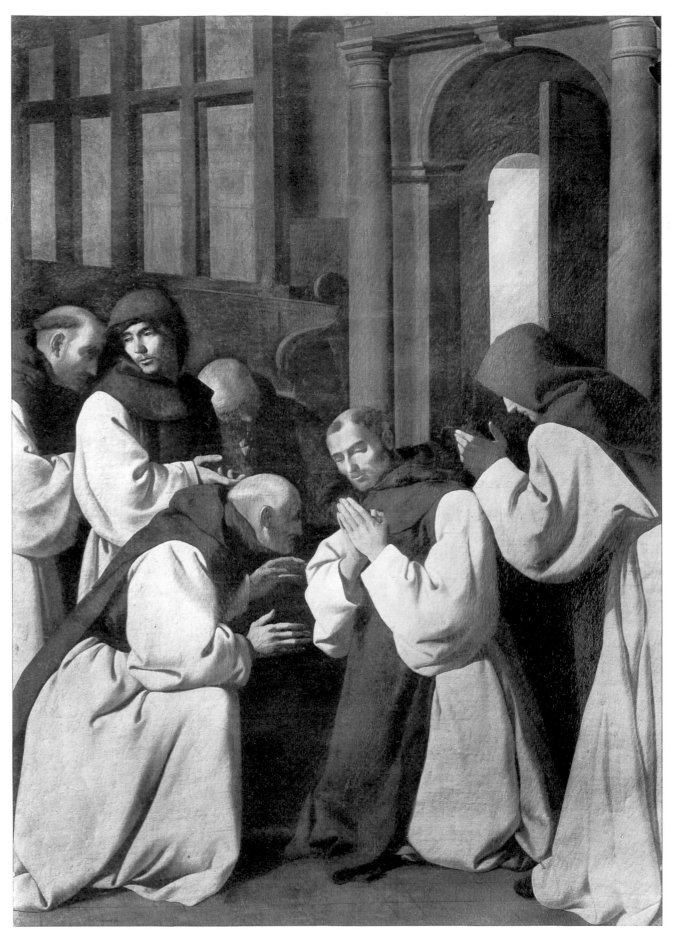

Fig. 166. FATHER JUAN DE CARRION TAKING LEAVE OF HIS FRIENDS. 1639. Guadalupe: Monastery of San Jerónimo. Cat. No. 152.

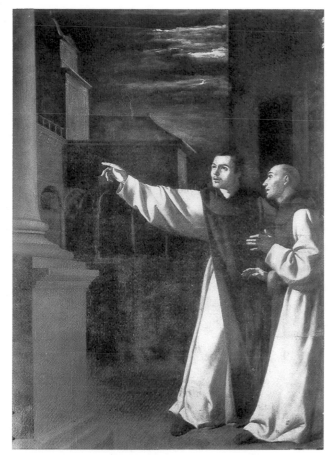

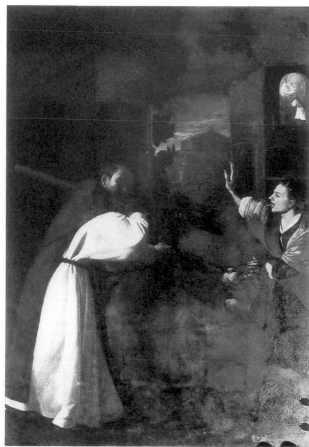

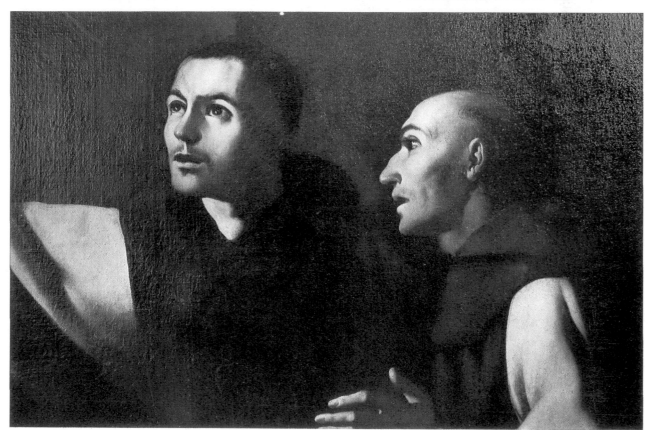

Fig. 167. VISION OF FRAY PEDRO DE SALAMANCA. 1638-1640. Guadalupe: Monastery of San Jerónimo.
Cat. No. 153.
Fig. 168. TEMPTATION OF FRAY DIEGO DE ORGAZ. 1638-1640. Guadalupe: Monastery of San Jerónimo.
Cat. No. 154.
Fig. 169. VISION OF FRAY PEDRO DE SALAMANCA. Detail of figure 167.

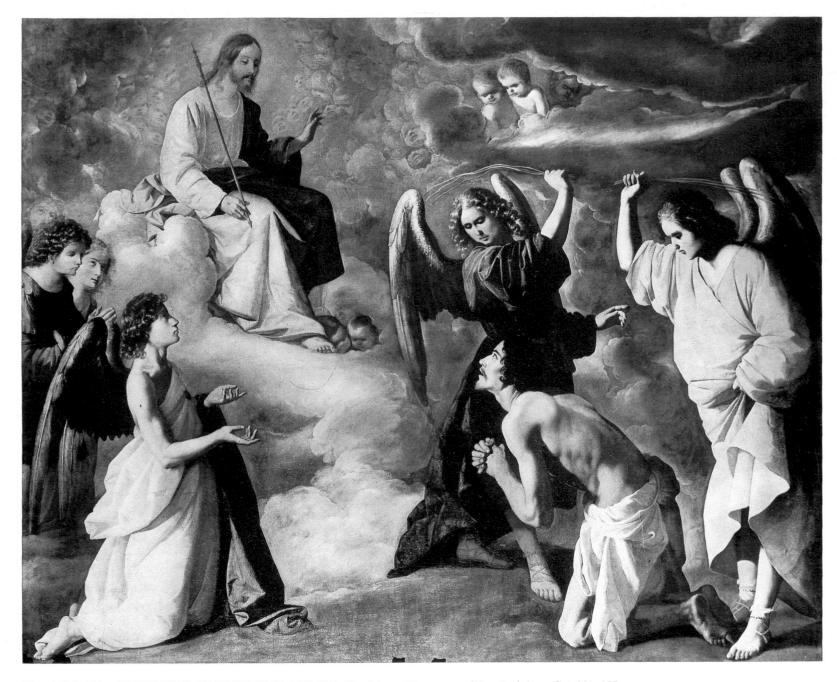

Figs. 170 & 171. SCOURGING OF ST JEROME. 1638-1640. Guadalupe: Monastery of San Jerónimo. Cat. No. 155.

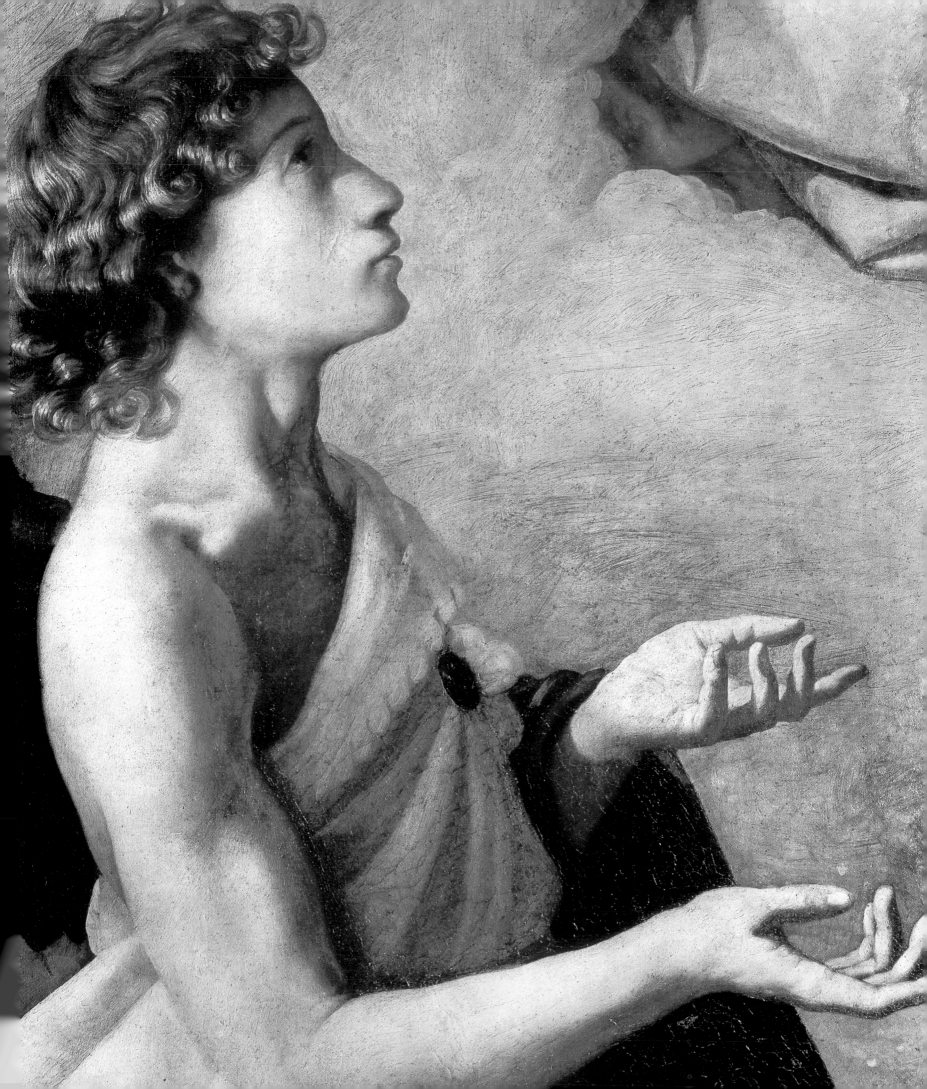

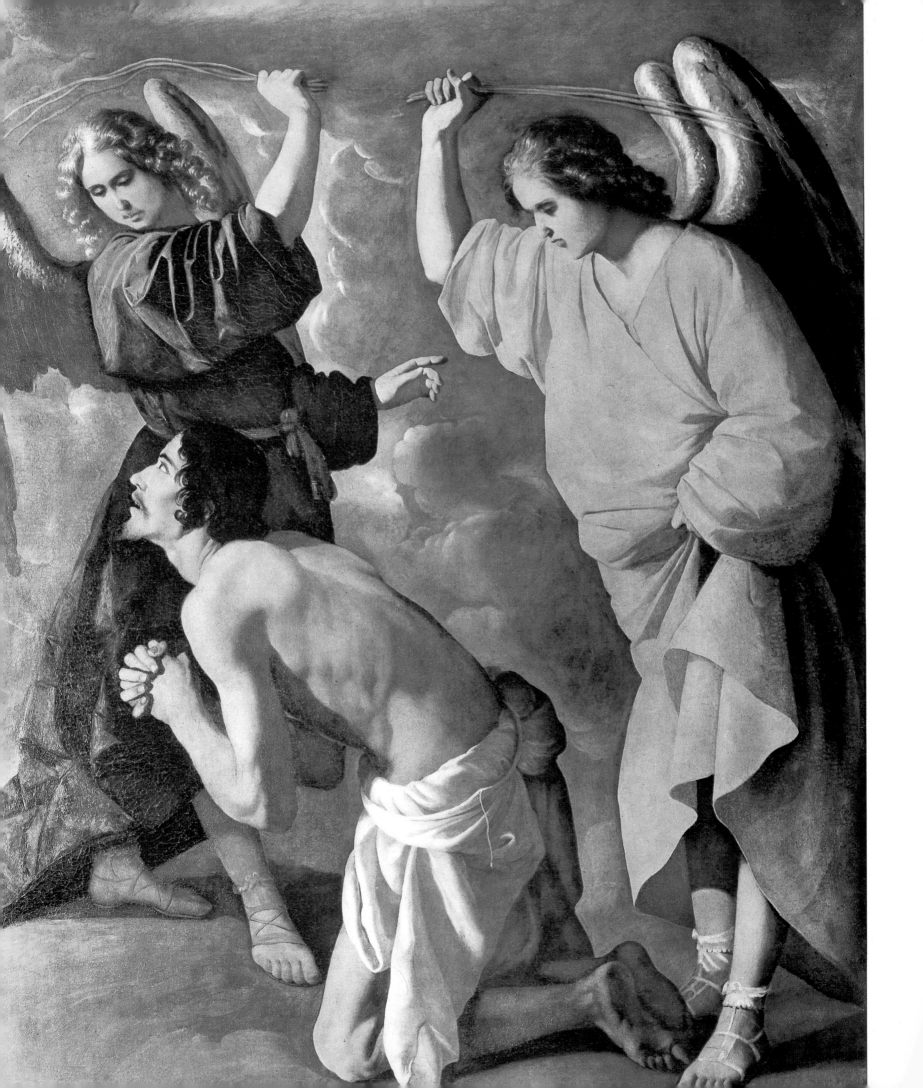

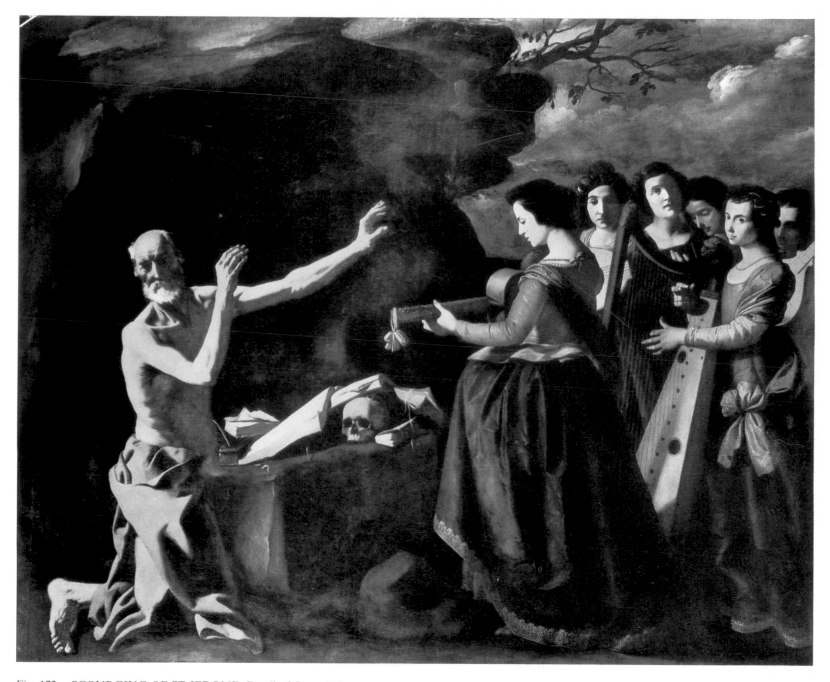

Fig. 172. SCOURGING OF ST JEROME. Detail of figure 170.
Fig. 173. TEMPTATION OF ST JEROME. 1638-1640. Guadalupe: Monastery of San Jerónimo. Cat. No. 156.

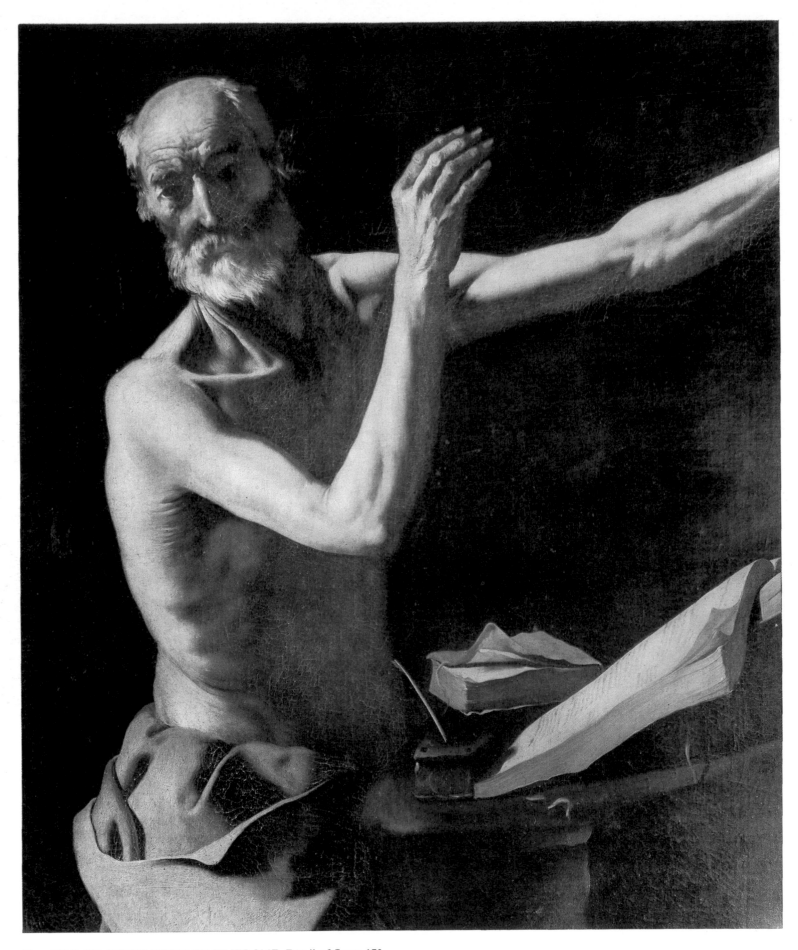

Figs. 174 & 175. TEMPTATION OF ST JEROME. Detail of figure 173.

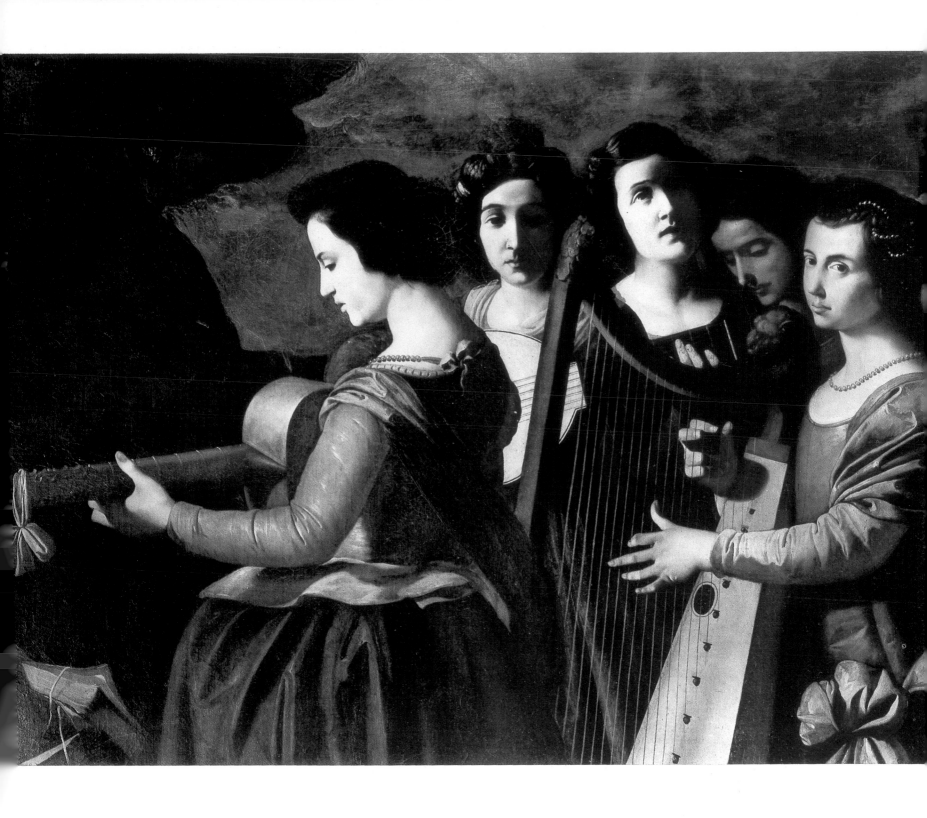

Fig. 176. Chapel of the Sacristy of the Monastery of San Jerónimo, Guadalupe.

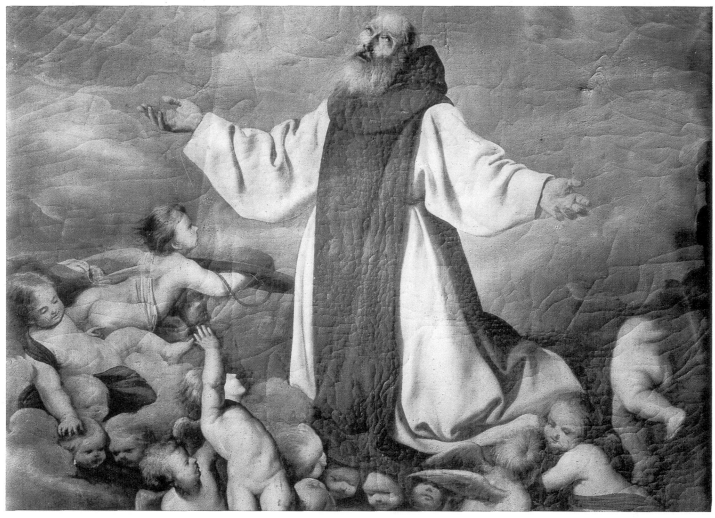

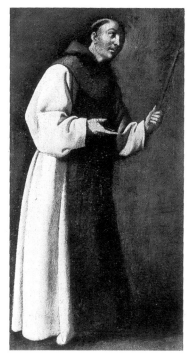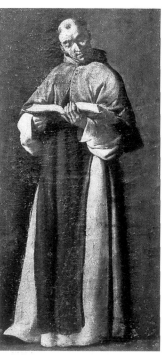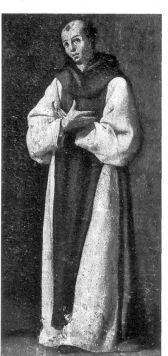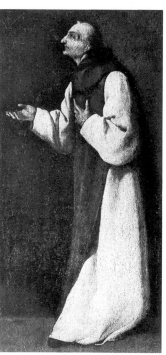

Fig. 177. APOTHEOSIS OF ST JEROME (detail). 1638-1640. Guadalupe: Monastery of San Jerónimo. Cat. No. 157.
Fig. 178. HIERONYMITE FRIAR WITH A CROSS IN HIS HAND. 1638-1640. Guadalupe: Monastery of San Jerónimo. Cat. No. 158.
Fig. 179. HIERONYMITE BISHOP READING. 1638-1640. Guadalupe: Monastery of San Jerónimo. Cat. No. 159.
Fig. 180. HIERONYMITE FRIAR WITH HIS EYES RAISED TO HEAVEN. 1638-1640. Guadalupe: Monastery of San Jerónimo. Cat. No. 160.
Fig. 181. HIERONYMITE FRIAR STANDING. 1638-1640. Guadalupe: Monastery of San Jerónimo. Cat. No. 161.

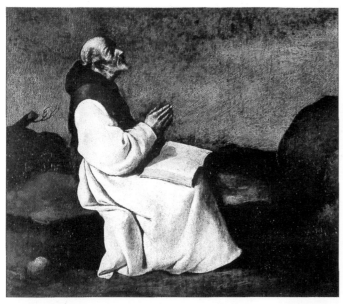
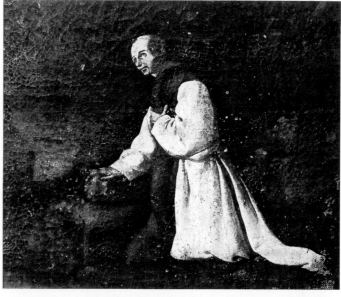
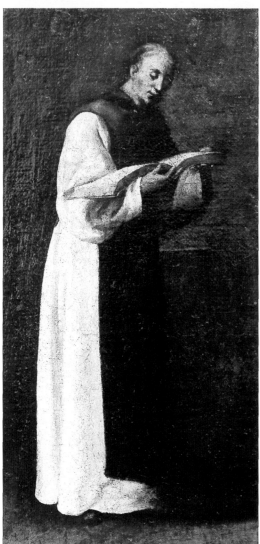
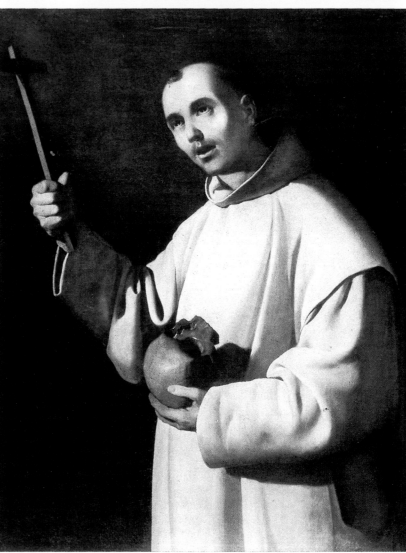

Fig. 182. HIERONYMITE FRIAR SITTING. 1638-1640. Guadalupe: Monastery of San Jerónimo. Cat. No. 162.
Fig. 183. HIERONYMITE FRIAR KNEELING. 1638-1640. Guadalupe: Monastery of San Jerónimo. Cat. No. 163.
Fig. 184. HIERONYMITE FRIAR READING. 1638-1640. Guadalupe: Monastery of San Jerónimo. Cat. No. 164.
Fig. 185. ST BRUNO. 1637-1639. Cadiz: Provincial Museum of Fine Arts. Cat. No. 145.

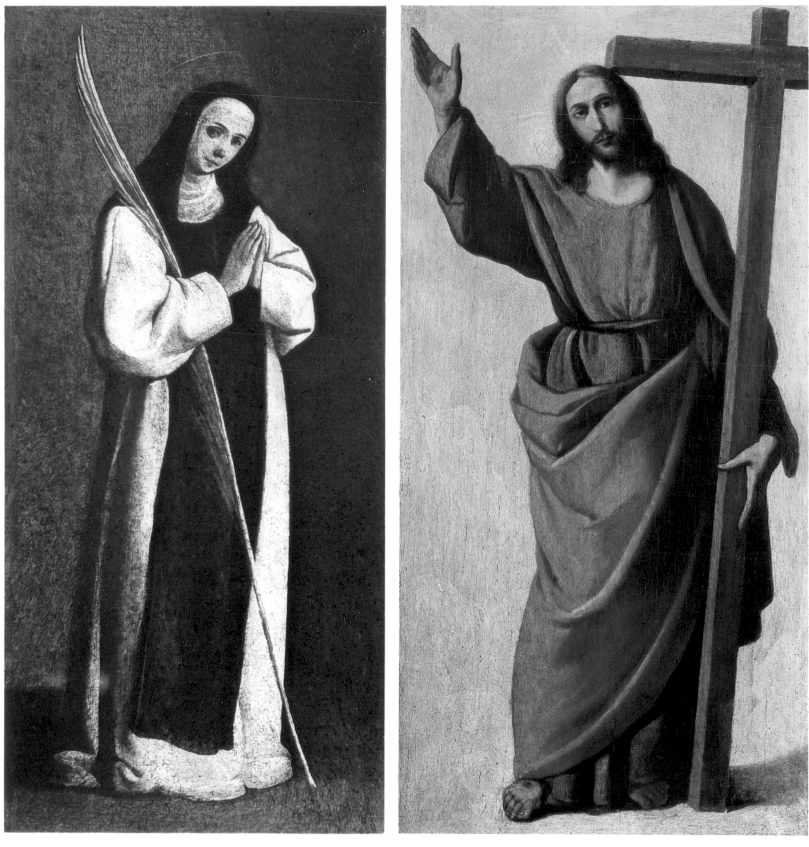

Fig. 186. MARTYRED HIERONYMITE NUN. 1638-1640. Guadalupe: Monastery of San Jerónimo. Cat. No. 165.
Fig. 187. CHRIST BLESSING. 1636-1641. Badajoz: Provincial Museum of Fine Arts. Cat. No. 166.

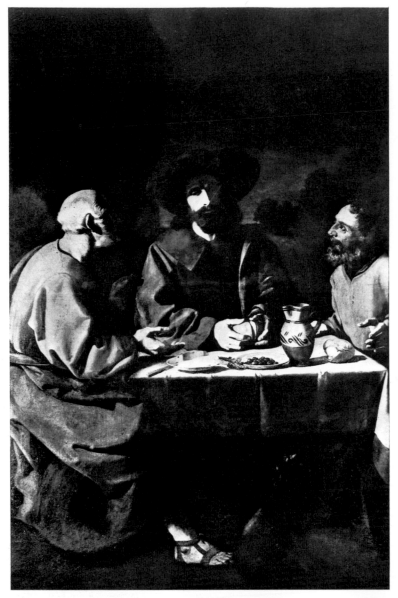
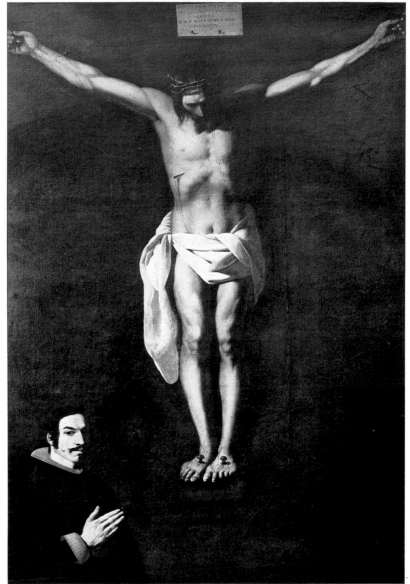

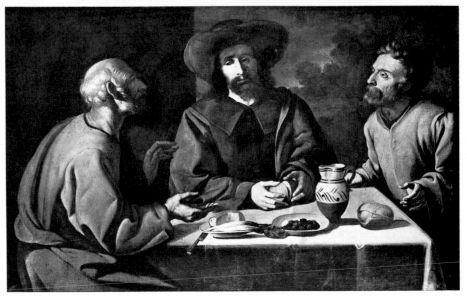

Fig. 188. CHRIST AT EMMAUS. 1639. Mexico City: Academy of Fine Arts of San Carlos. Cat. No. 169.
Fig. 189. CHRIST DEAD ON THE CROSS, WITH A DONOR. 1640. Bilbao: Lezama Leguizamón. Cat. No. 171.
Fig. 190. THE VIRGIN IN THE CLOUDS. Badajoz: Provincial Museum of Fine Arts. Cat. No. 167.
Fig. 191. CHRIST DEAD ON THE CROSS. 1636-1641. Llerena: Church of Nuestra Señora de la Granada. Cat. No. 168.
Fig. 192. CHRIST AT EMMAUS. 1631-1640. Madrid: Dr Vega Díaz. Cat. No. 172.

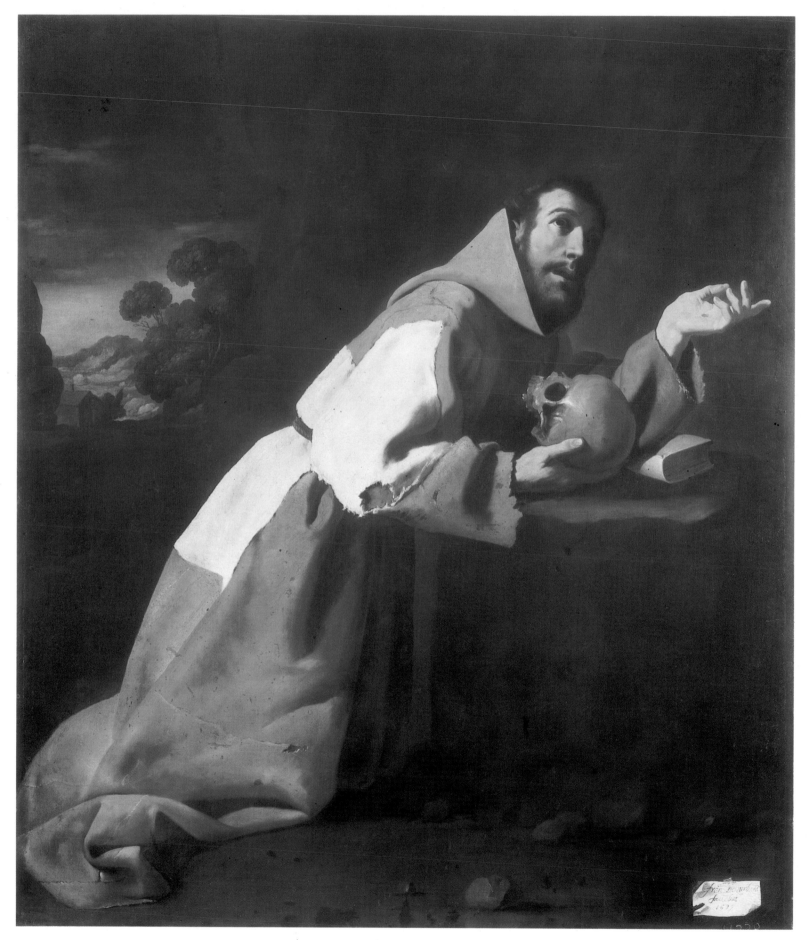

Fig. 193. ST FRANCIS KNEELING. 1639. London: National Gallery. Cat. No. 170.

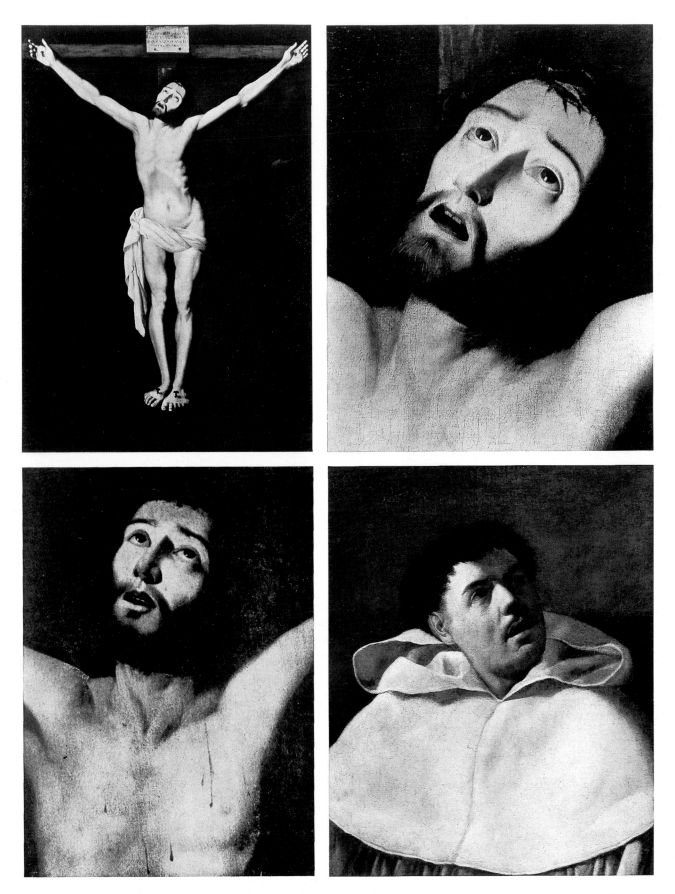

Figs. 194 & 195. CHRIST CRUCIFIED. 1631-1640. Lugano-Castagnola: Château de Rohonez Foundation (Baron Henry Thyssen-Bornemisza). Cat. No. 173.

Fig. 196. CHRIST CRUCIFIED (detail). 1631-1640. Motrico (Guipúzcoa): Parish Church. Cat. No. 174.

Fig. 197. PORTRAIT OF A MERCEDARIAN FRIAR. 1631-1640. Madrid: Rumeu de Armas. Cat. No. 178.

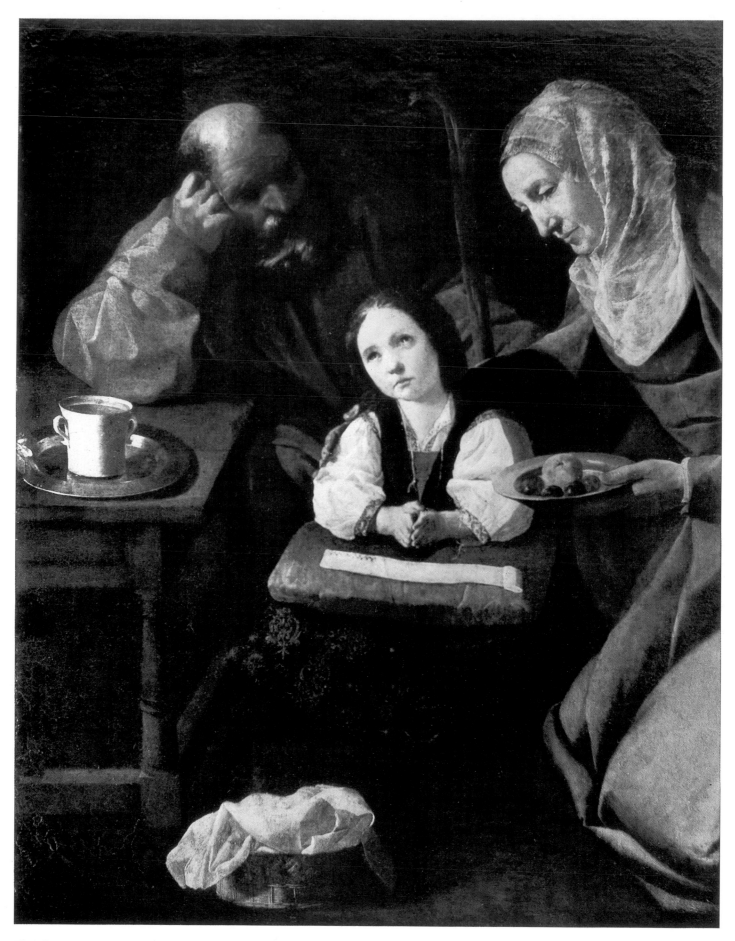

Fig. 198. THE VIRGIN AS A CHILD, WITH ST JOACHIM AND ST ANNE. 1631-1640. Florence: Contini-Bonacossi. Cat. No. 179.
Figs. 199 & 200. ST MARGARET. 1631-1640. London: National Gallery. Cat. No. 180.

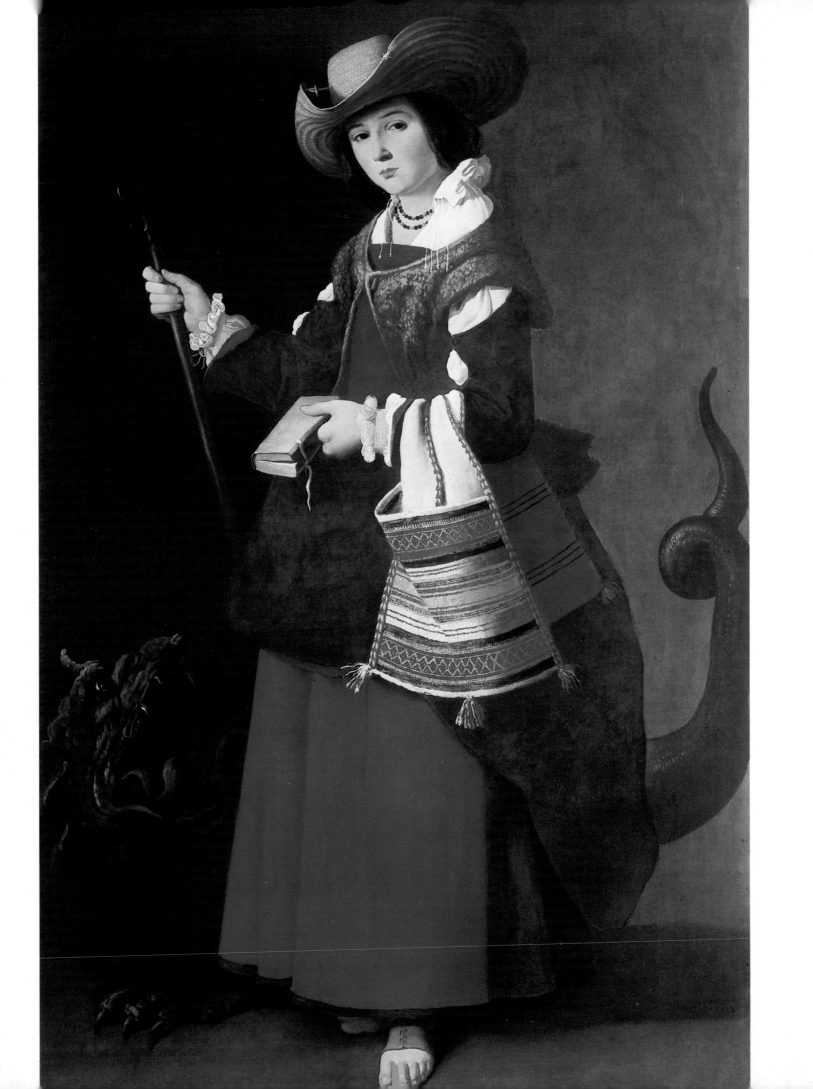

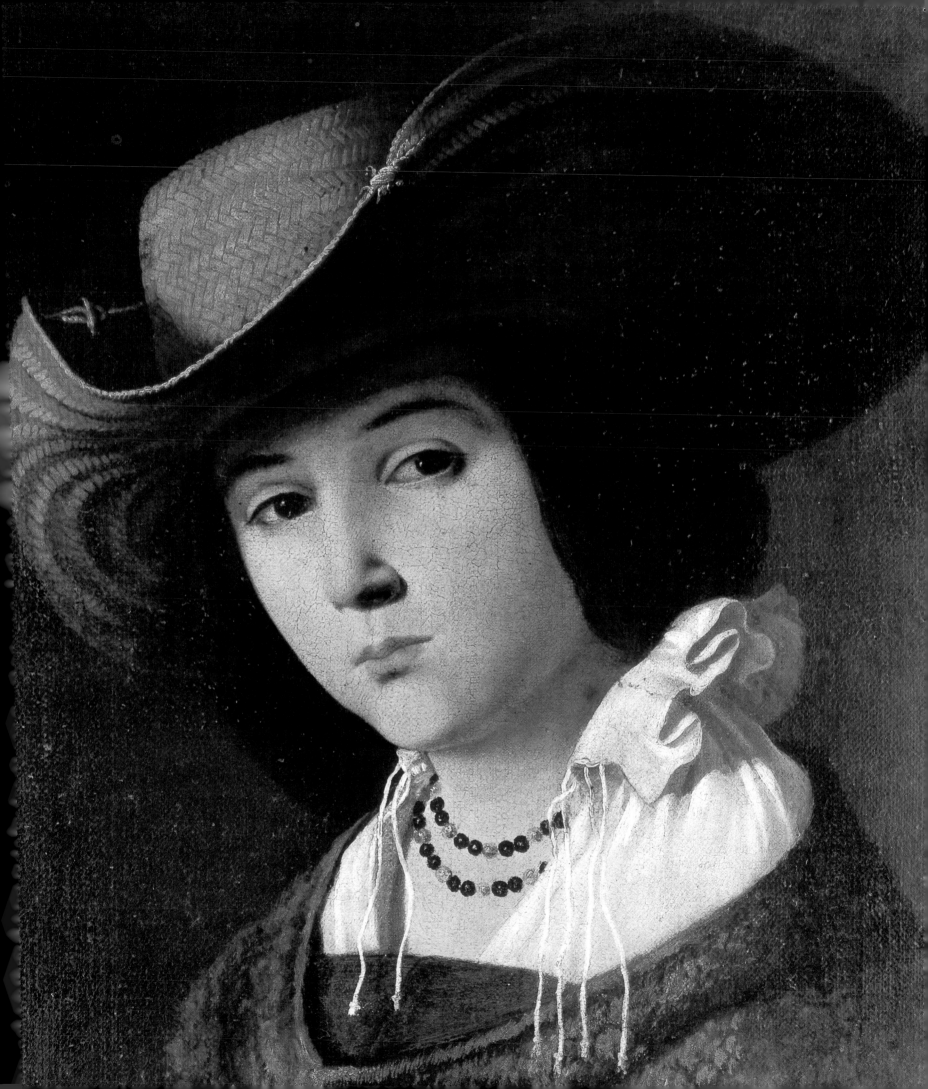

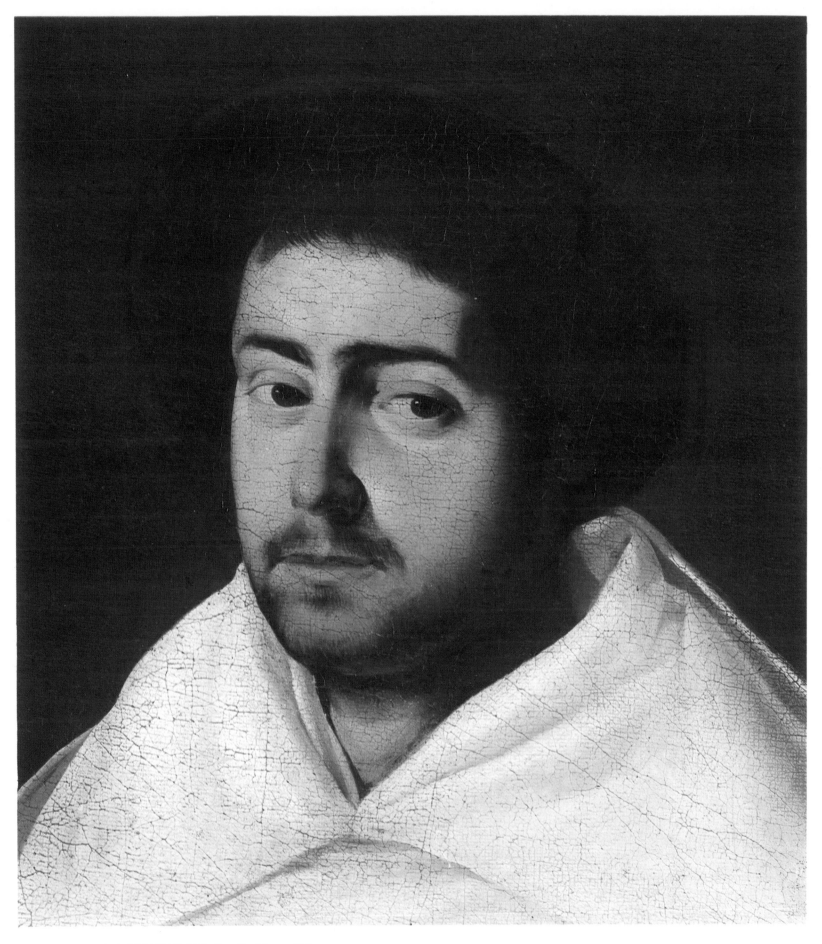

Fig. 201. MERCEDARIAN FRIAR. Detail of figure 203.

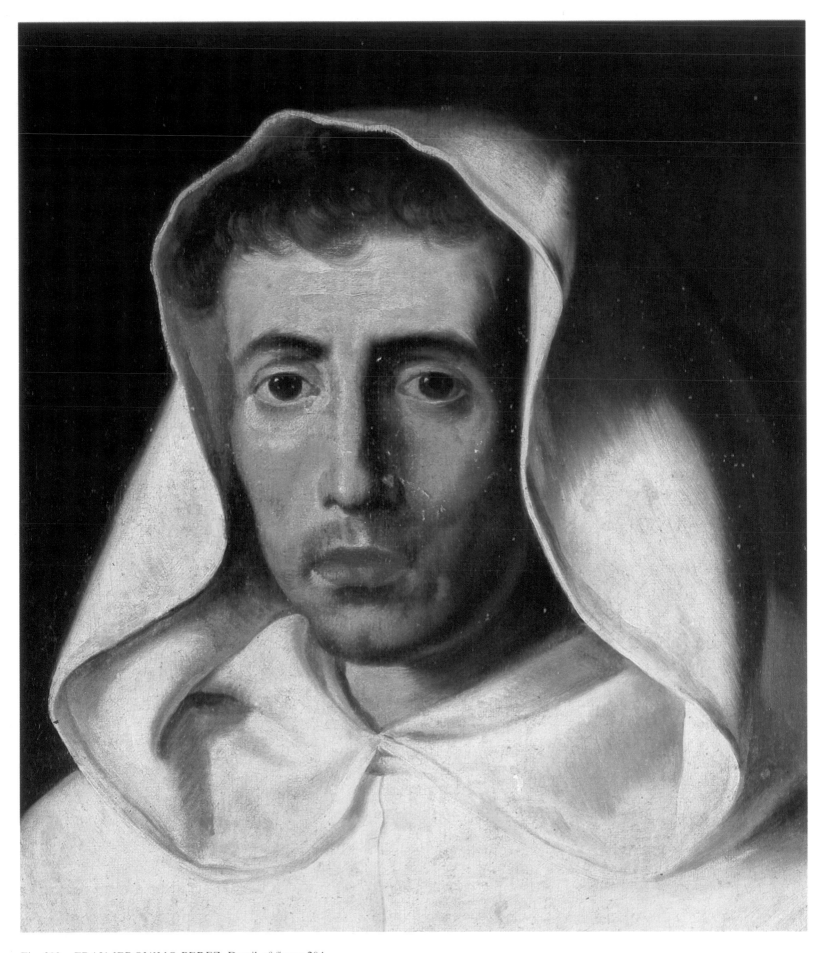

Fig. 202. FRAY JERONIMO PEREZ. Detail of figure 204.

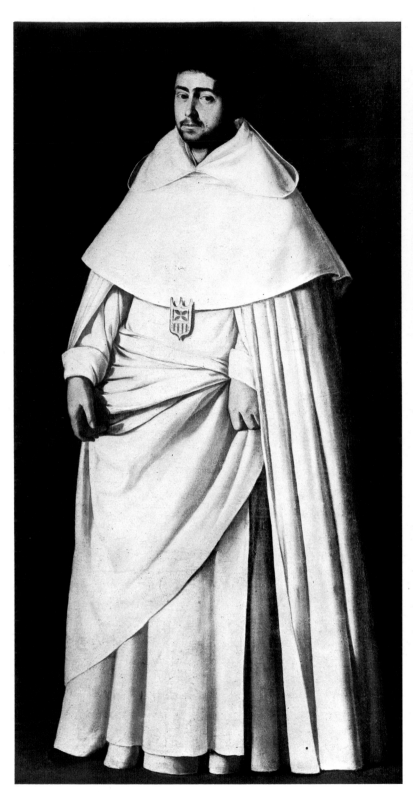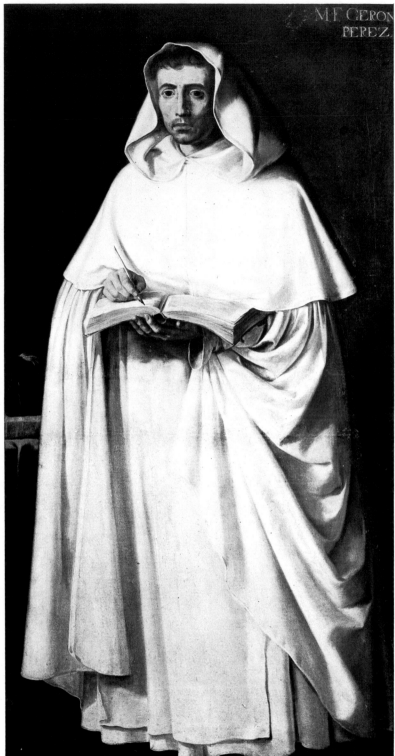

Fig. 203. MERCEDARIAN FRIAR. 1631-1640. Madrid: Academy of San Fernando. Cat. No. 181.
Fig. 204. FRAY JERONIMO PEREZ. 1631-1640. Madrid: Academy of San Fernando. Cat. No. 182.

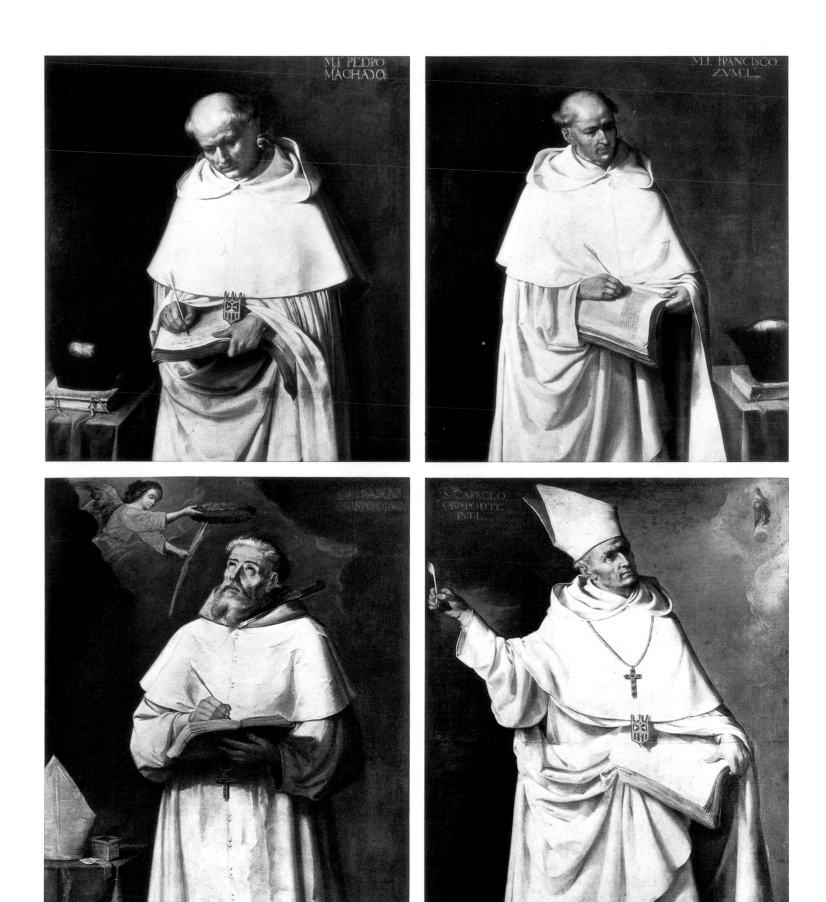

Fig. 205. FRAY PEDRO MACHADO (detail). 1631-1640. Madrid: Academy of San Fernando. Cat. No. 183.
Fig. 206. FRAY FRANCISCO ZUMEL (detail). 1631-1640. Madrid: Academy of San Fernando. Cat. No. 184.
Fig. 207. ST PETER PASCUAL, BISHOP OF JAEN (detail). 1631-1640. Seville: Provincial Museum of Fine Arts. Cat. No. 185.
Fig. 208. ST CARMELUS, BISHOP OF TERUEL (detail). 1631-1640. Madrid: Church of Santa Bárbara. Cat No. 186.

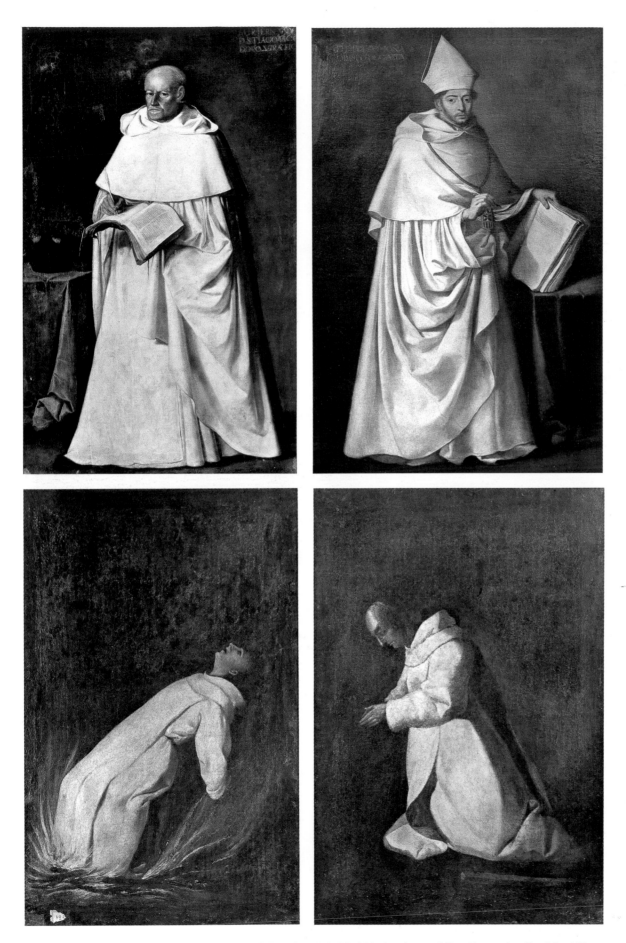

Fig. 209. FRAY FERNANDO DE SANTIAGO. 1631-1640. Madrid: Academy of San Fernando. Cat. No. 187.
Fig. 210. FRAY PEDRO DE OÑA, BISHOP OF GAETA. 1631-1640. Seville: Provincial Museum of Fine Arts.
Cat. No. 188.
Fig. 211. FRIAR FALLING ON A PYRE. 1631-1640. Madrid: Adanero Collection. Cat. No. 190.
Fig. 212. FRIAR KNEELING. 1631-1640. Toledo: Casa del Greco. Cat. No. 191.

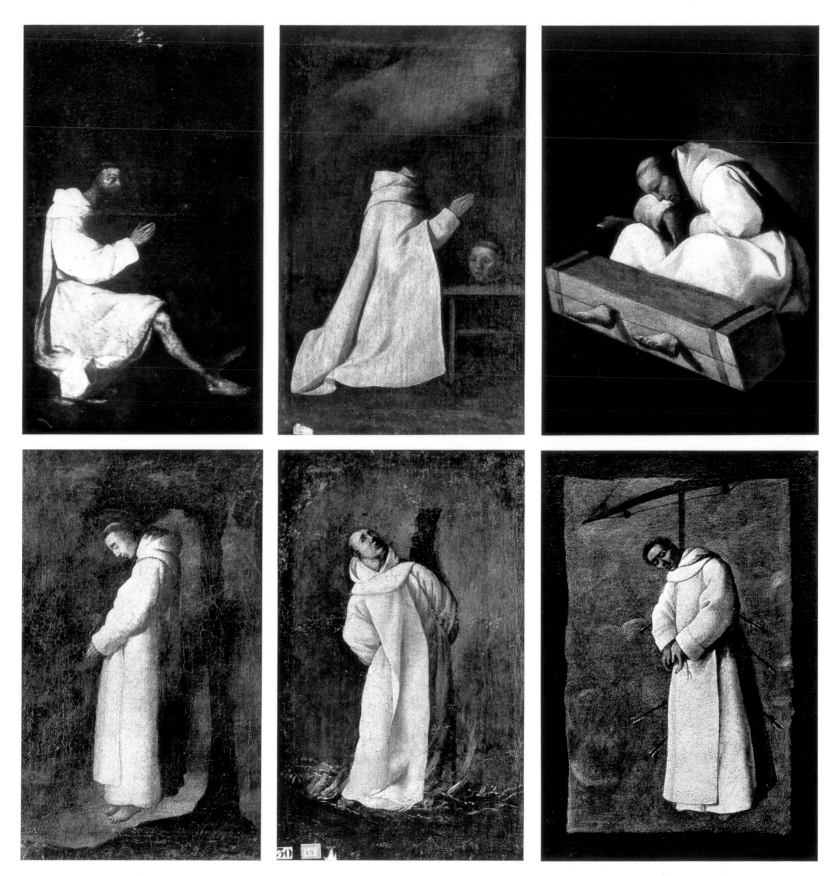

Fig. 213.　MARTYR SITTING IN PRISON. 1631-1640. Madrid: private collection. Cat. No. 192.
Fig. 214.　FRAY PEDRO DE SAN DIONISIO. 1631-1640. Madrid: Adanero Collection. Cat. No. 193.
Fig. 215.　FRAY ARNALDO DE ARECHS. 1631-1640. Santander: Emilio Botín. Cat. No. 194.
Fig. 216.　FRAY PEDRO DE ARMENGOL. 1631-1640. Madrid: Marqués de Valdeterrazo. Cat. No. 195.
Fig. 217.　FRIAR BOUND TO THE STAKE. 1631-1640. Madrid: Adanero Collection. Cat. No. 196.
Fig. 218.　FRIAR HANGED AND PIERCED WITH ARROWS. 1631-1640. Hartford: Wadsworth Atheneum. Cat. No. 197.

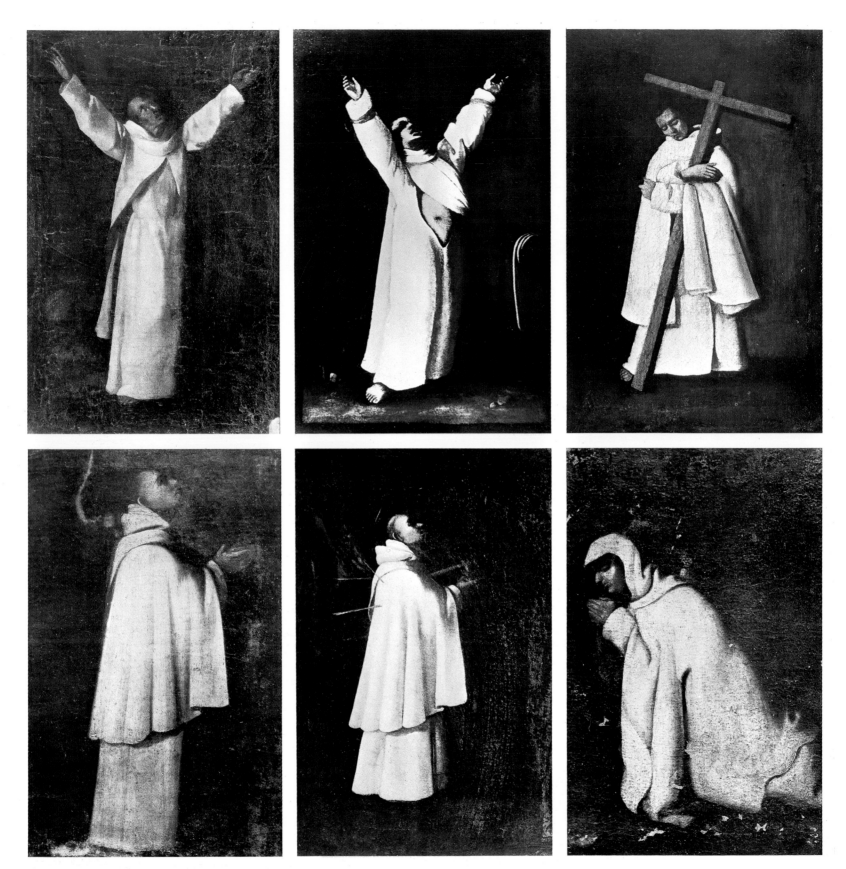

Fig. 219. CRUCIFIED FRIAR. 1631-1640. Madrid: Señora de González Bilbao. Cat. No. 198.
Fig. 220. ST SERAPION. 1631-1640. Amsterdam: in trade. Cat. No. 199.
Fig. 221. FRIAR EMBRACING A CROSS. 1631-1640. Amsterdam: in trade. Cat. No. 200.
Fig. 222. FRIAR STANDING. 1631-1640. Jerez de la Frontera: Pérez Asensio. Cat. No. 201.
Fig. 223. FRIAR PIERCED WITH ARROWS. 1631-1640. Madrid: Ceballos Collection. Cat. No. 202.
Fig. 224. FRIAR KNEELING. 1631-1640. Jerez de la Frontera: Pérez Asensio. Cat. No. 203.

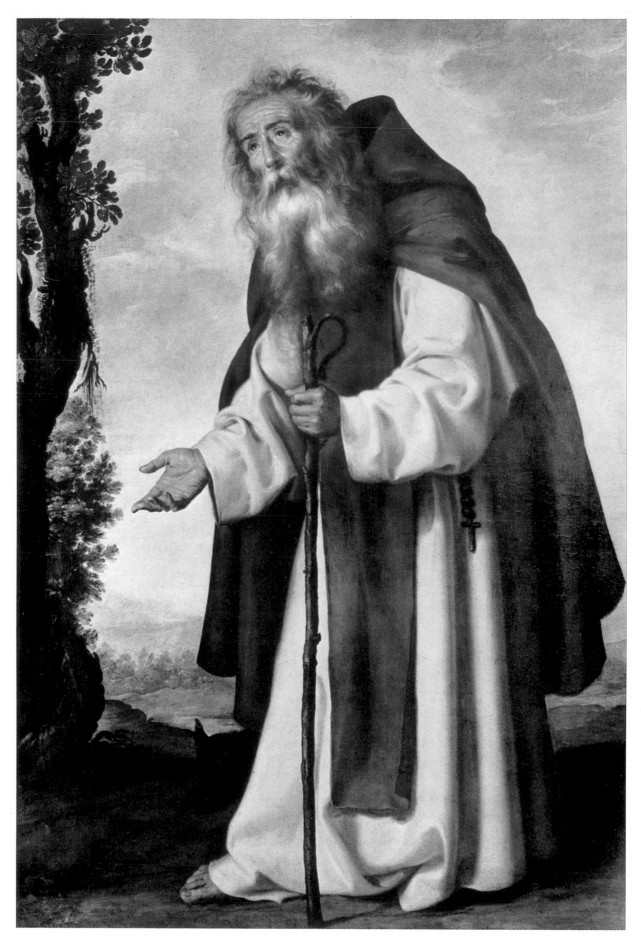

Fig. 225. ST ANTHONY ABBOT. 1631-1640. Florence: Contini-Bonacossi. Cat. No. 209.

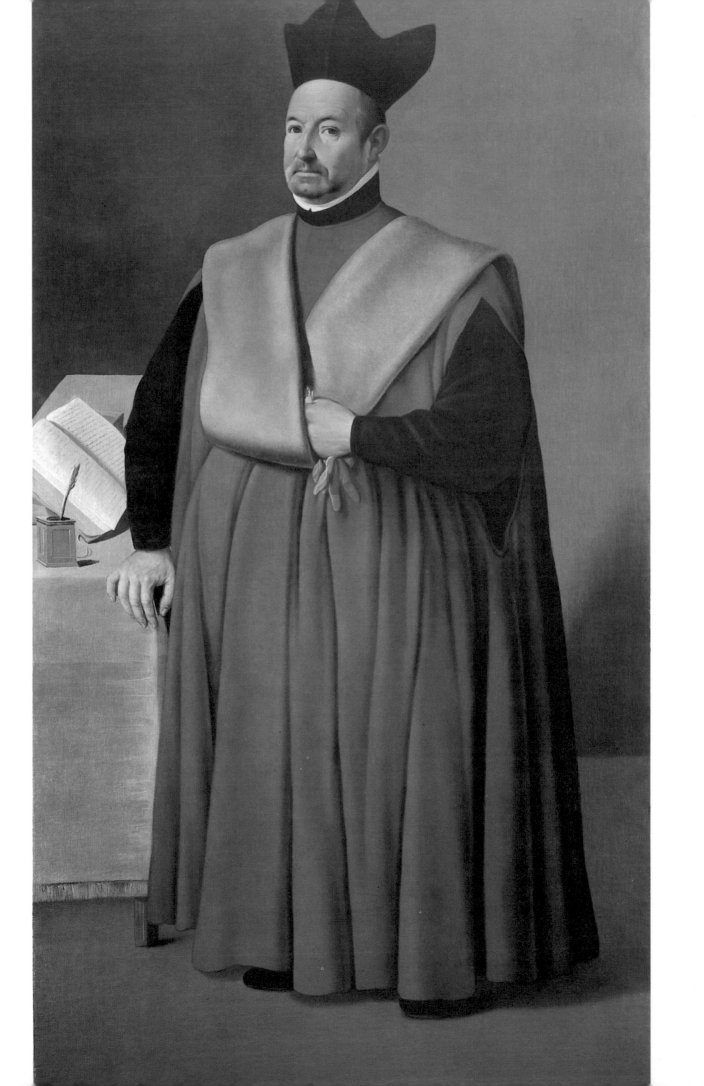

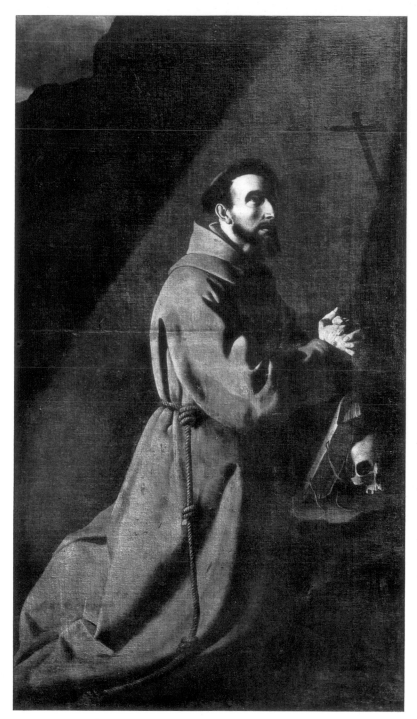 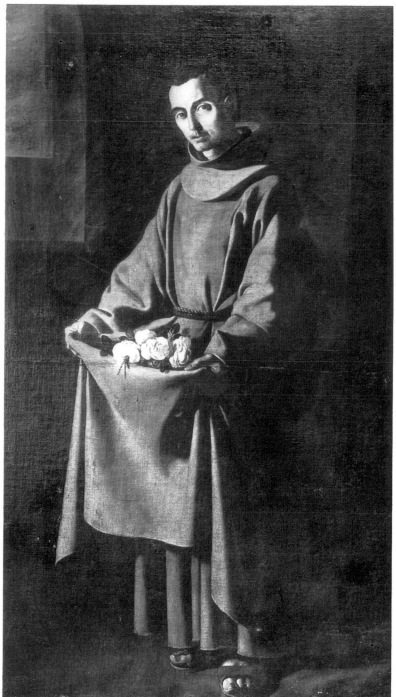

Fig. 226. PORTRAIT OF DR JUAN MARTINEZ SERRANO. 1631-1640. New York: private collection. Cat. No. 210.
Fig. 227. ST FRANCIS. 1631-1640. Madrid: Church of Santos Justo y Pastor. Cat. No. 211.
Fig. 228. ST DIEGO DE ALCALA. 1631-1640. Madrid: Church of Santos Justo y Pastor. Cat. No. 212.

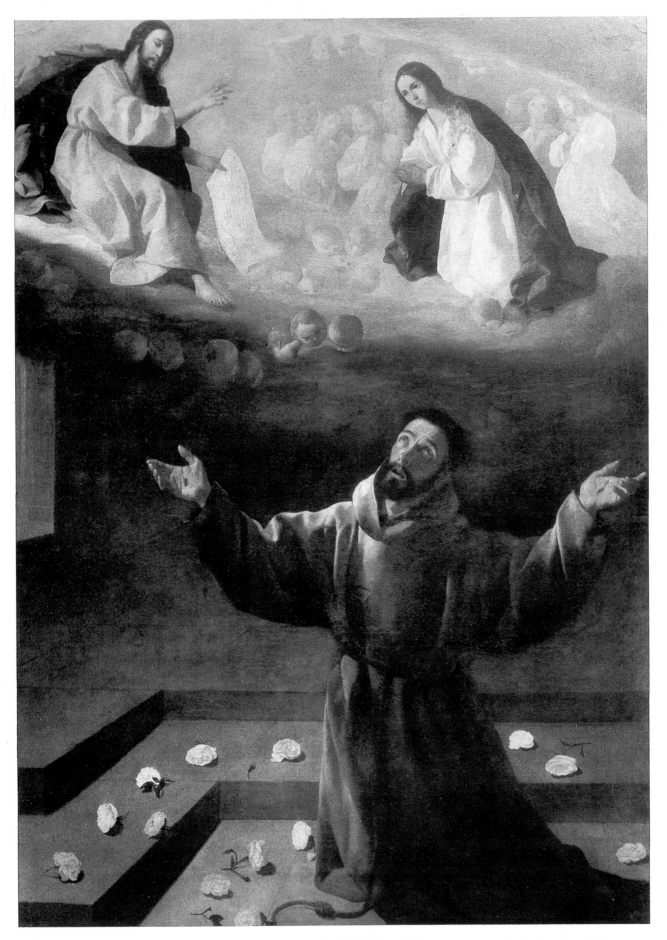

Fig. 229. ST FRANCIS IN THE PORTIUNCULA. 1631-1640. Cadiz: Provincial Museum of Fine Arts. Cat. No. 213.
Fig. 230. THE VIRGIN AS A CHILD, PRAYING. 1631-1640. New York: Metropolitan Museum of Art. Cat. No. 214.

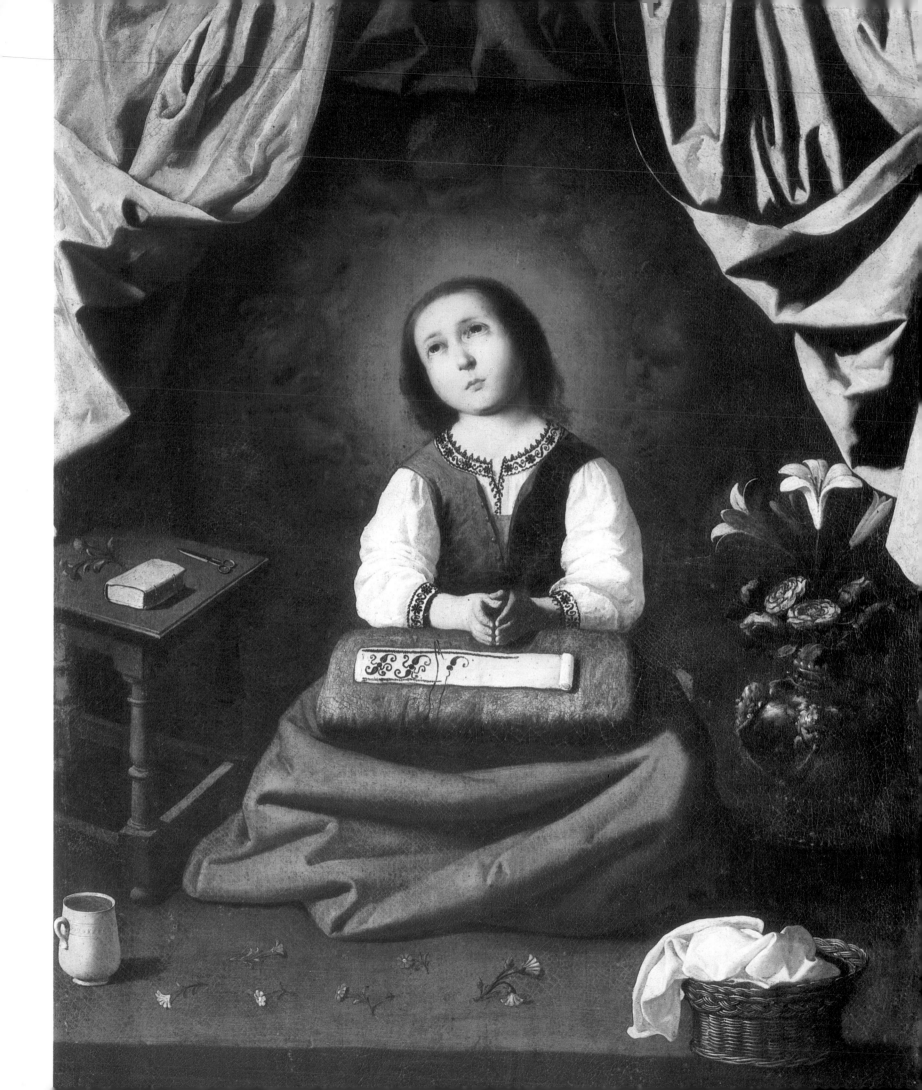

Fig. 231. ST FERDINAND. 1631-1640. Granada: Rodríguez Acosta Foundation. Cat. No. 217.
Fig. 232. ST FERDINAND. 1631-1640. Leningrad: Hermitage. Cat. No. 219.
Fig. 233. PORTRAIT OF A FRANCISCAN. 1631-1640. Seville: Millán Delgado. Cat. No. 215.
Fig. 234. VISION OF ST ANTHONY OF PADUA. 1631-1640. Wichita Falls: Midwestern University.
Cat. No. 216.

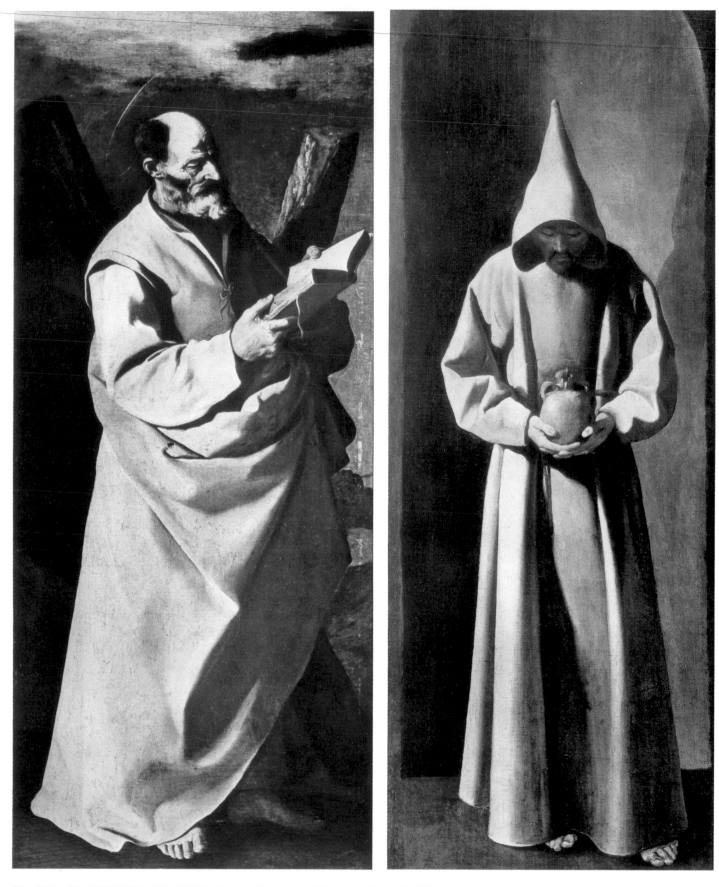

Fig. 235. ST ANDREW. 1631-1640. Budapest: Museum of Fine Arts. Cat. No. 222.
Fig. 236. ST FRANCIS. 1631-1640. St. Louis: City Art Museum. Cat. No. 226.

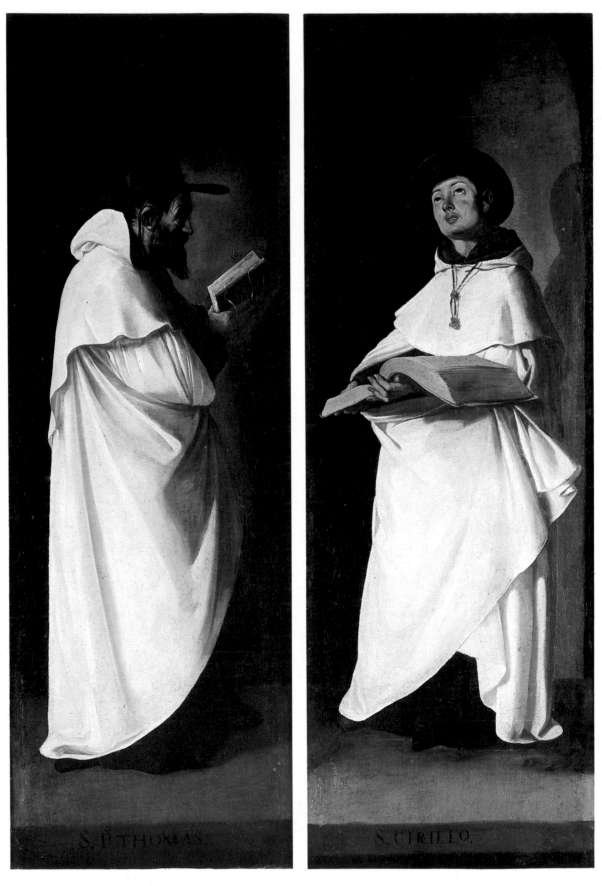

Fig. 237. ST PETER TOMAS. 1631-1640. Boston: Museum of Fine Arts. Cat. No. 224.
Fig. 238. ST CYRIL OF CONSTANTINOPLE. 1631-1640. Boston: Museum of Fine Arts. Cat. No. 225.

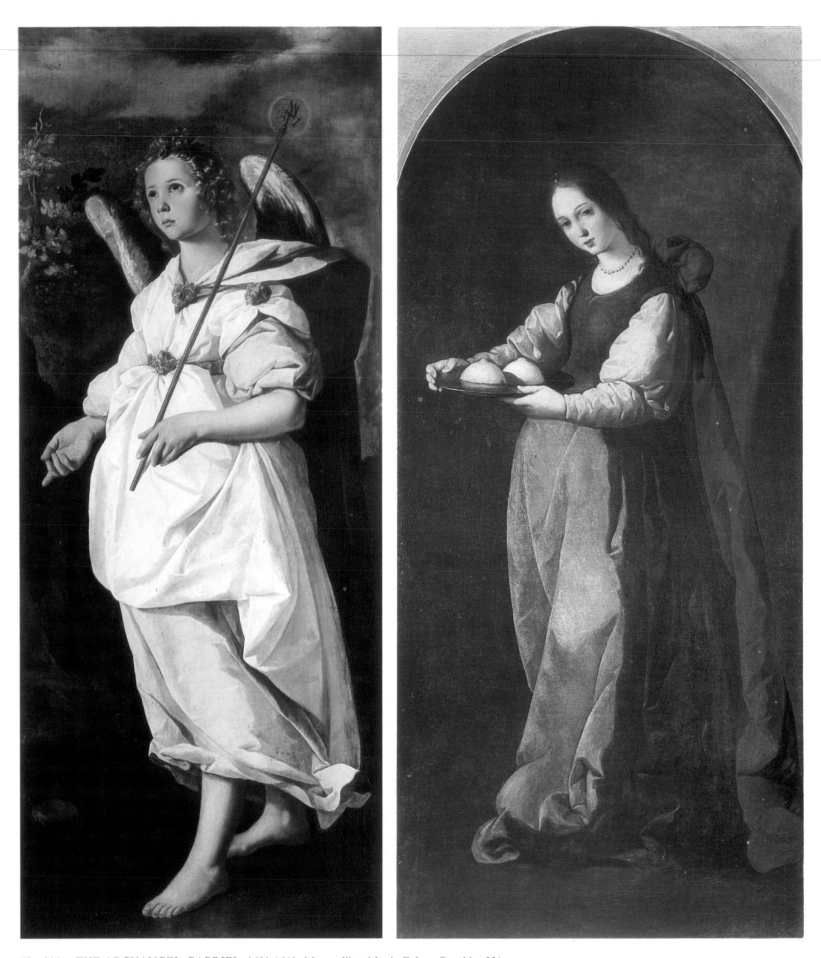

Fig. 239. THE ARCHANGEL GABRIEL. 1631-1640. Montpellier: Musée Fabre. Cat. No. 221.
Fig. 240. ST AGATHA. 1631-1640. Montpellier: Musée Fabre. Cat. No. 220.

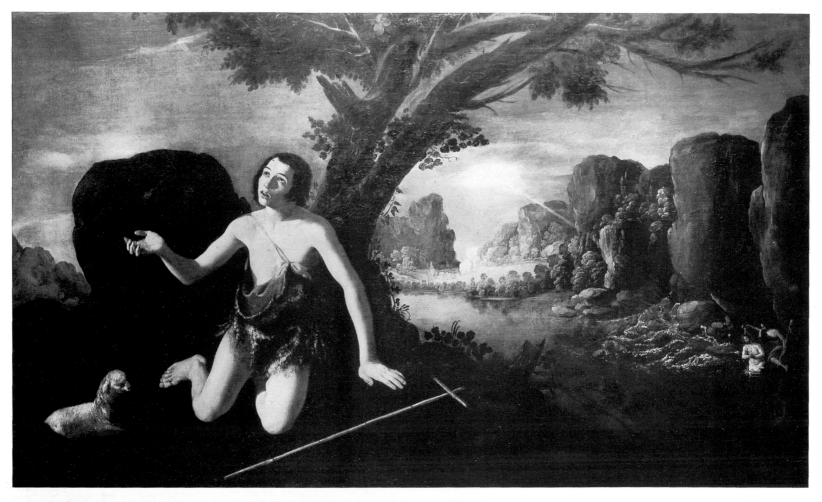

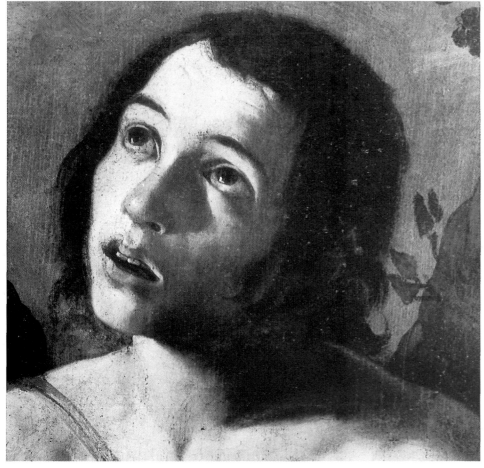

Figs. 241 & 242. VISION OF ST JOHN THE
BAPTIST. 1631-1640. Barcelona: José Rifà de Moles.
Cat. No. 227.

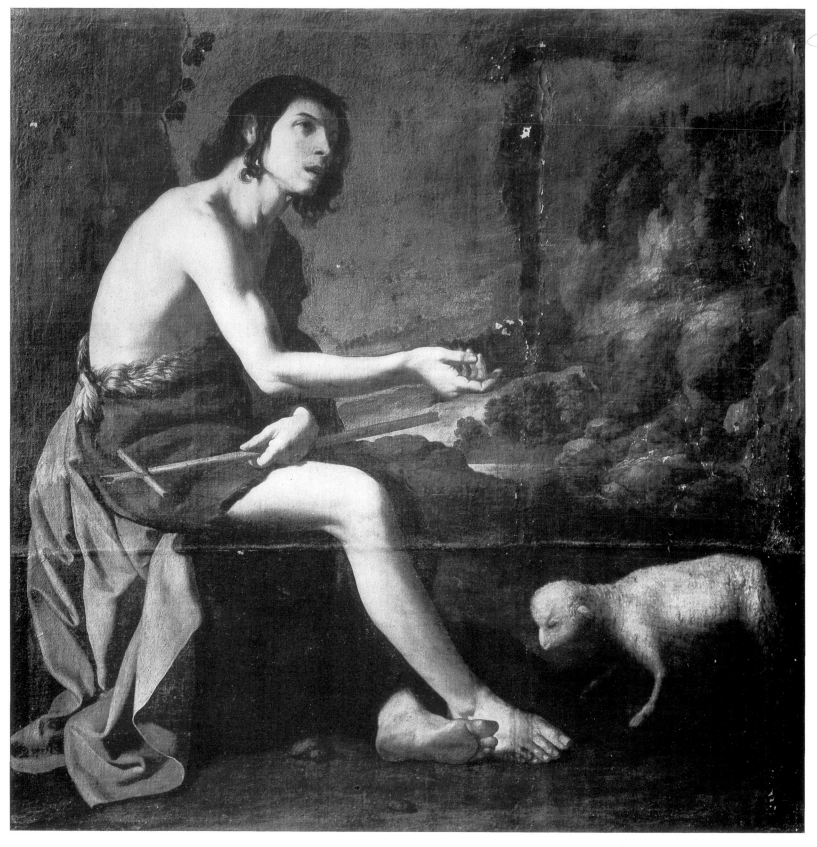

Fig. 243. ST JOHN THE BAPTIST IN THE WILDERNESS. 1631-1640. Seville: Cathedral. Cat. No. 232.

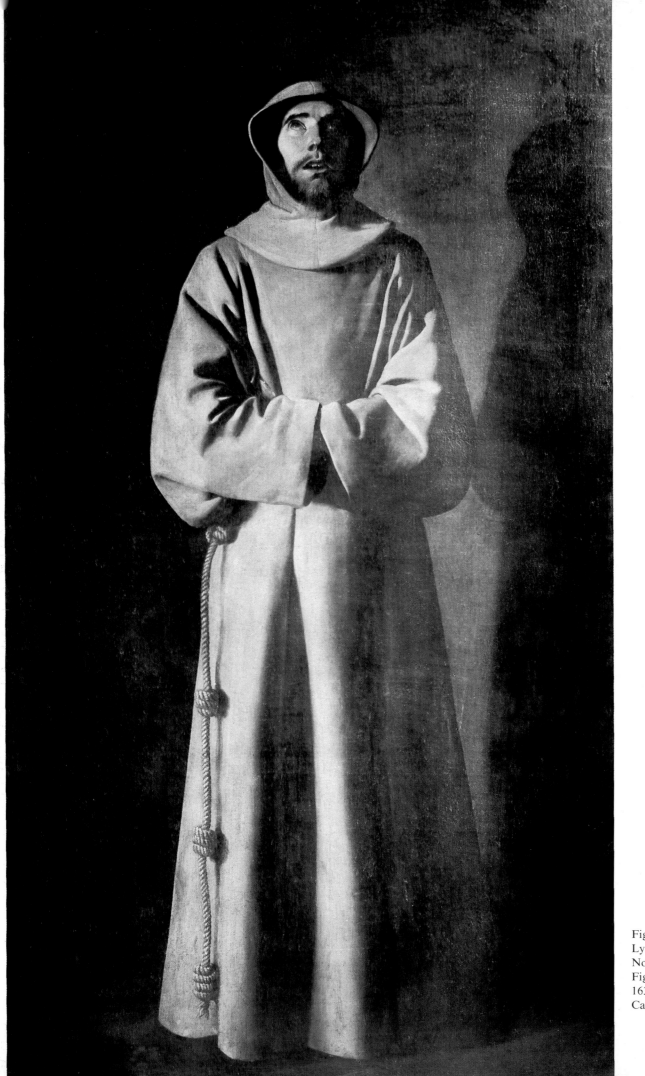

Fig. 244. ST FRANCIS. 1631-1640. Lyons: Musée des Beaux-Arts. Cat. No. 234.

Fig. 245. ST FRANCIS (detail). 1631-1640. Barcelona: Art Museum of Catalonia. Cat. No. 233.

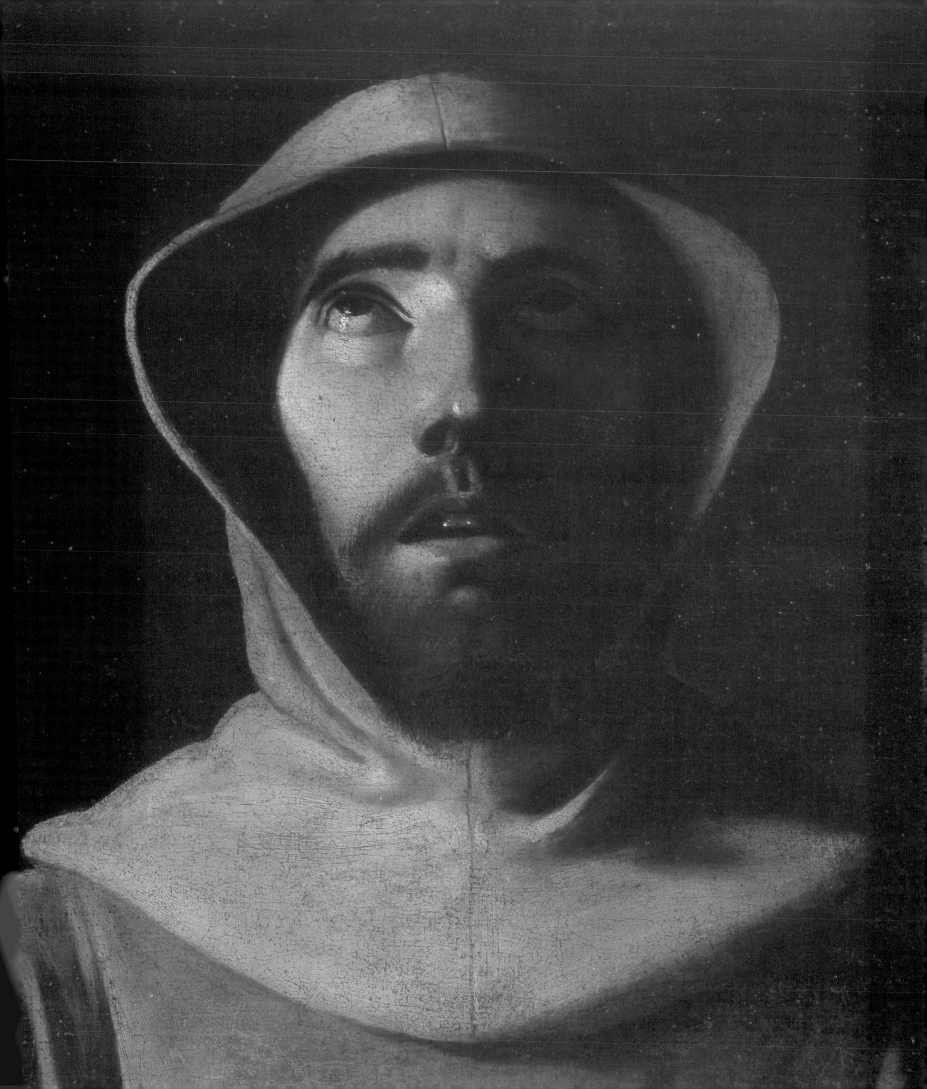

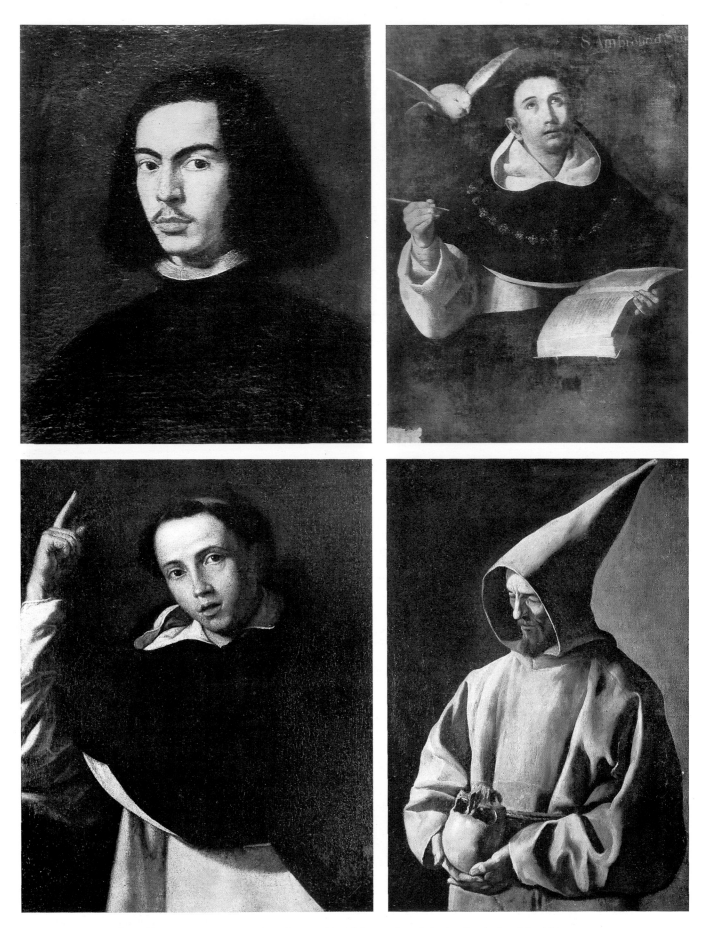

Fig. 246. PORTRAIT OF A YOUNG ECCLESIASTIC. 1631-1640. London: Brinsley Ford. Cat. No. 236.
Fig. 247. ST AMBROSE OF SIENA. 1631-1640. Córdoba: Provincial Museum of Fine Arts. Cat. No. 237.
Fig. 248. ST VINCENT FERRER. 1631-1640. Madrid: Guillermo Bernstein. Cat. No. 238.
Fig. 249. ST FRANCIS IN MEDITATION. 1631-1640. Santa Barbara: Santa Barbara Museum of Art. Cat. No. 239.

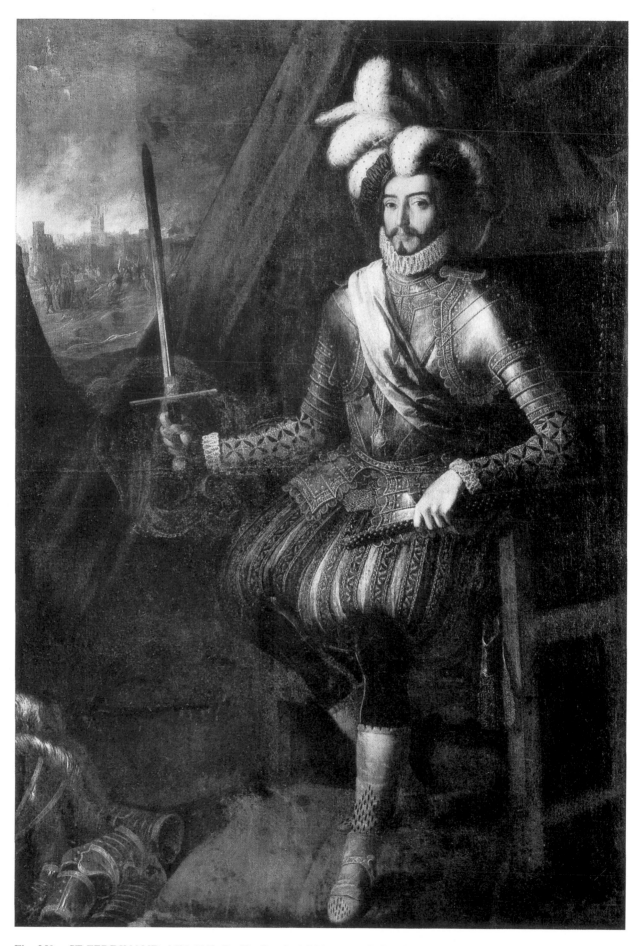

Fig. 250. ST FERDINAND. 1631-1640. Seville: Provincial Museum of Fine Arts. Cat. No. 241.

Fig. 251. THE ETERNAL FATHER. 1631-1640. Seville: Provincial Museum of Fine Arts. Cat. No. 242.
Fig. 252. THE CORONATION OF ST JOSEPH. 1631-1640. Seville: Provincial Museum of Fine Arts. Cat. No. 243.

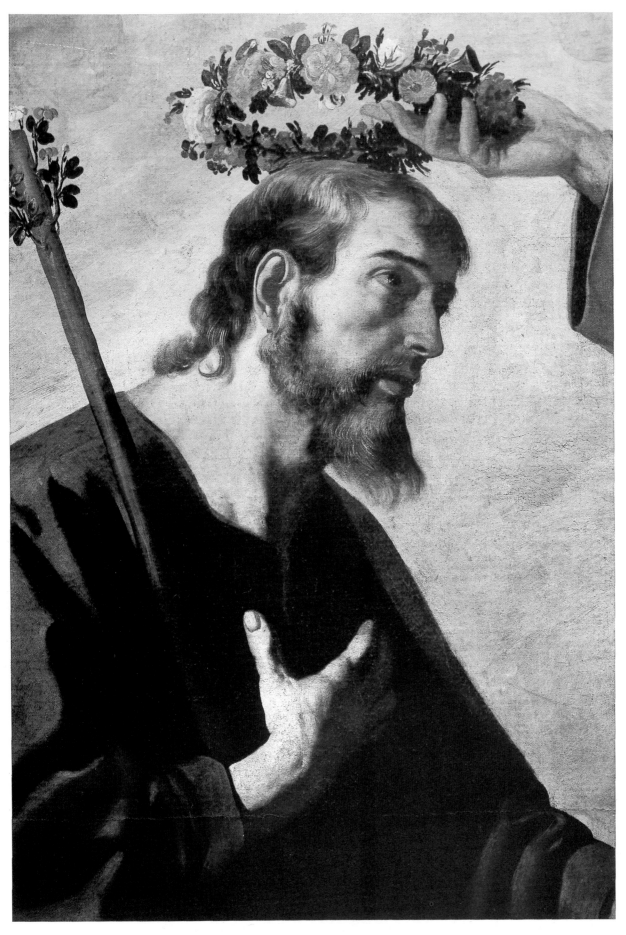

Fig. 253. THE CORONATION OF ST JOSEPH. Detail of figure 252.

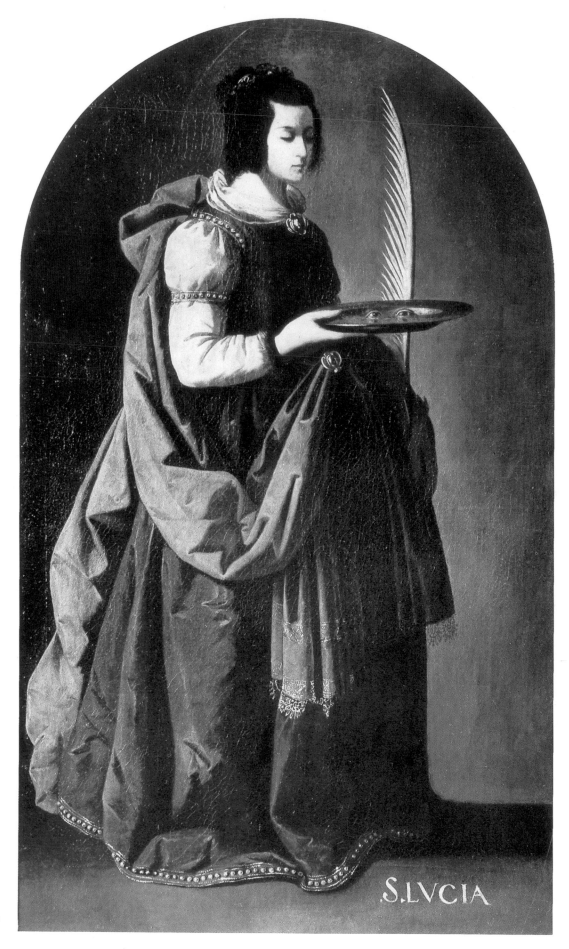

Fig. 254. ST LUCY. 1631-1640. Chartres: Musée de Chartres. Cat. No. 244.

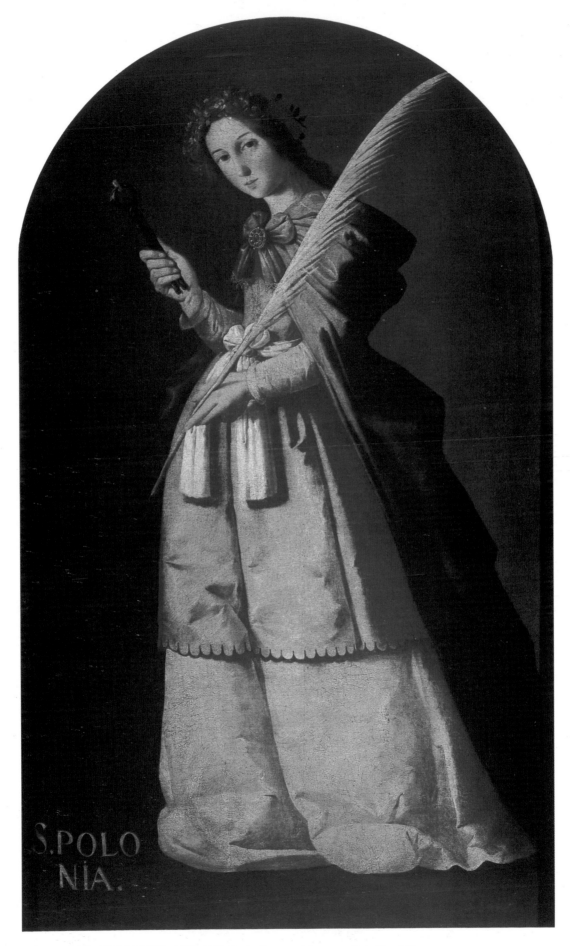

S.POLO
NIA.

Fig. 255. **ST APOLLONIA**. 1631-1640. Paris: Louvre Museum. Cat. No. 245.

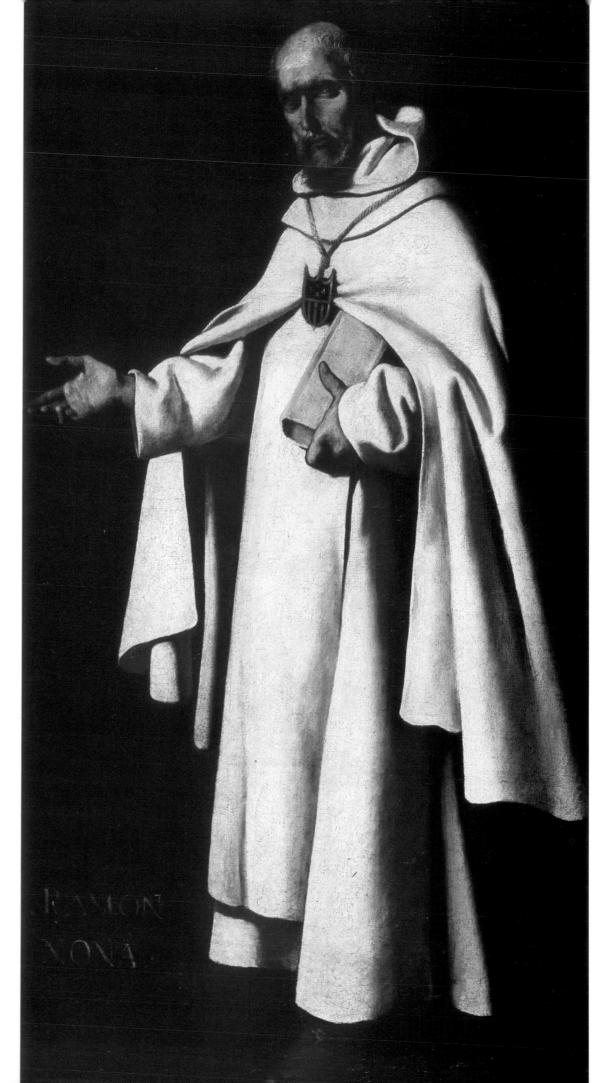

Fig. 256. ST RAYMOND NONNATUS.
1631-1640. Geneva: private collection. Cat.
No. 246.

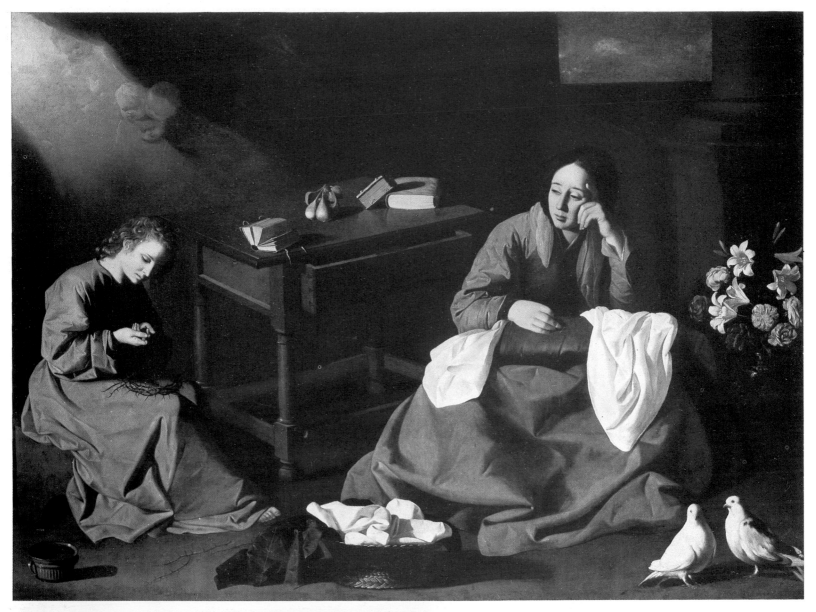

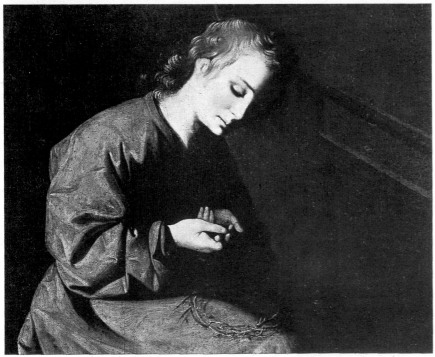

Fig. 257. THE HOLY HOUSE OF NAZARETH. 1631-1640.
Cleveland: The Cleveland Museum of Art. Cat. No. 247.
Fig. 258. JESUS AND THE CROWN OF THORNS. 1631-1640.
Barcelona: private collection. Cat. No. 248.
Fig. 259. THE HOLY HOUSE OF NAZARETH. Detail of
figure 257.

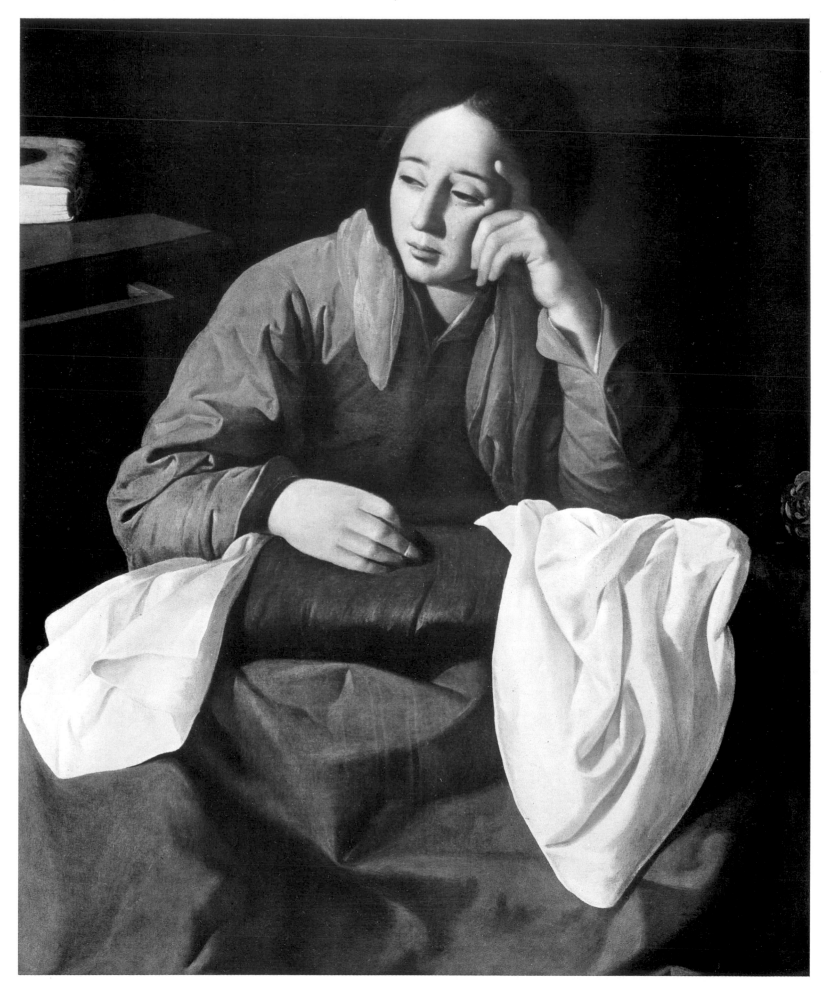

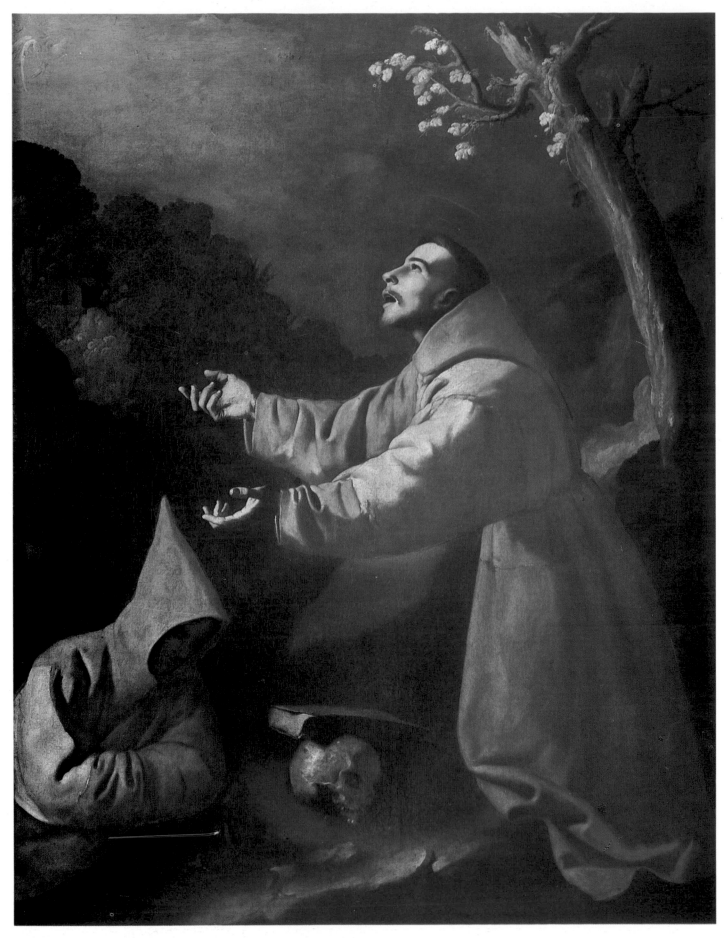

Fig. 260. ST FRANCIS RECEIVING THE STIGMATA. 1631-1640. Madrid: Alvaro Gil. Cat. No. 249.
Fig. 261. ST CASILDA. 1631-1640. Barcelona: Antonio Plandiura. Cat. No. 250.

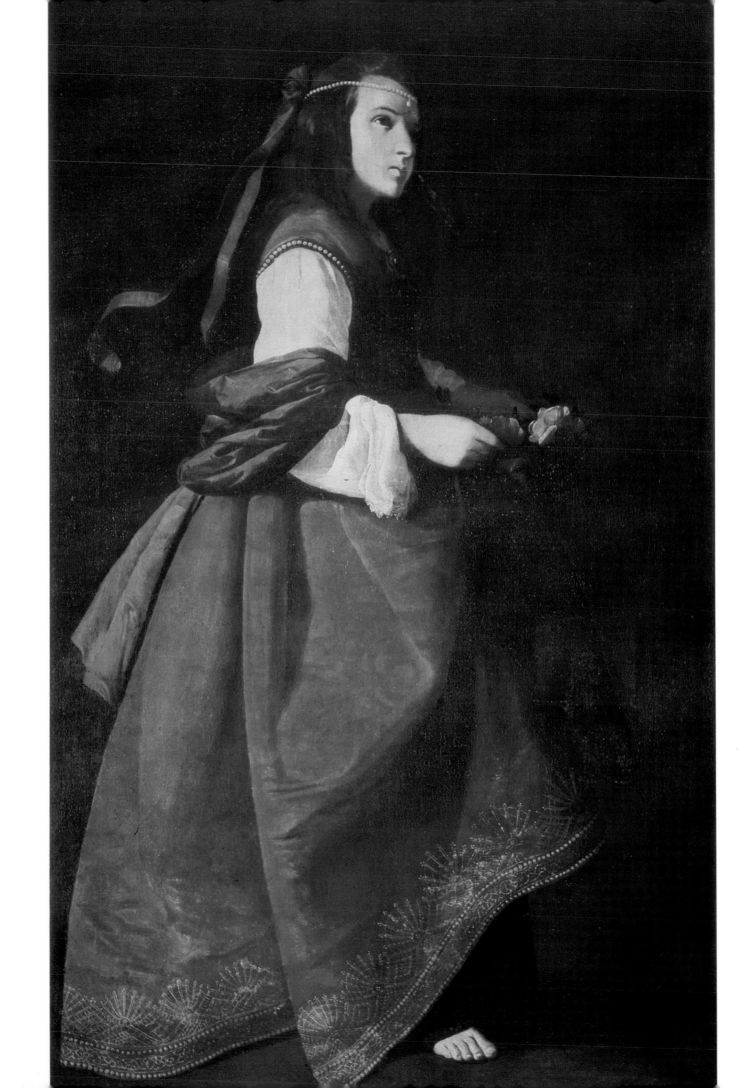

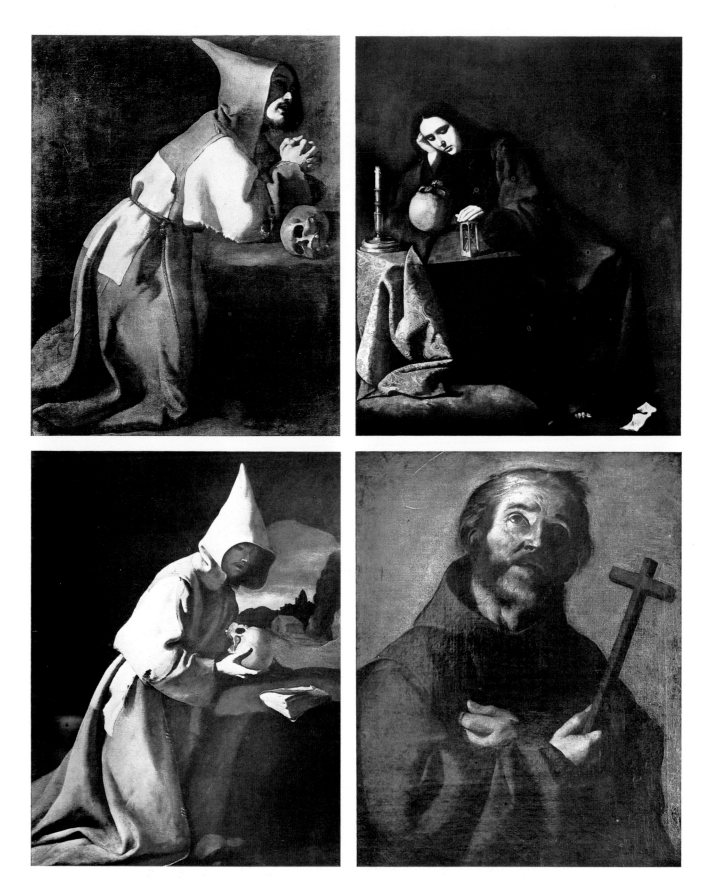

Fig. 262. ST FRANCIS KNEELING. 1631-1640. Aachen: Sürmondt Museum. Cat. No. 251.
Fig. 263 MARY MAGDALEN. 1631-1640. Mexico City: Academy of Fine Arts of San Carlos. Cat. No. 254.
Fig. 264. ST FRANCIS KNEELING. 1631-1640. Düsseldorf: Municipal Museum of Art. Cat. No. 252.
Fig. 265. ST PETER OF ALCANTARA. 1631-1640. Seville: García de Blanes Claros. Cat. No. 255.

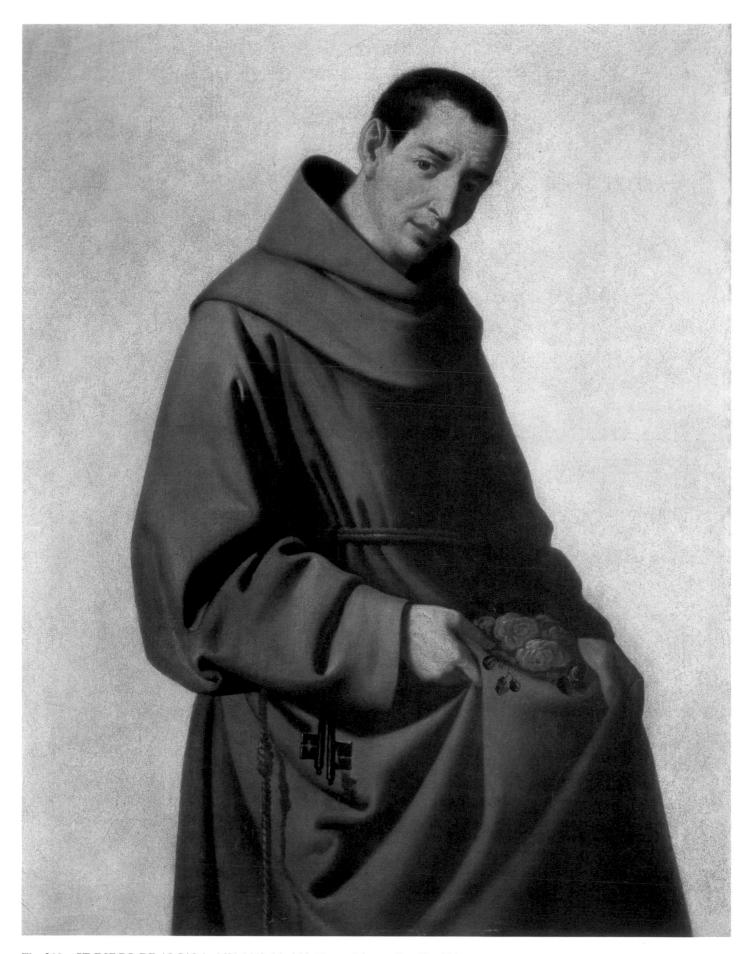

Fig. 266. ST DIEGO DE ALCALA. 1631-1640. Madrid: Museo Lázaro. Cat. No. 256.

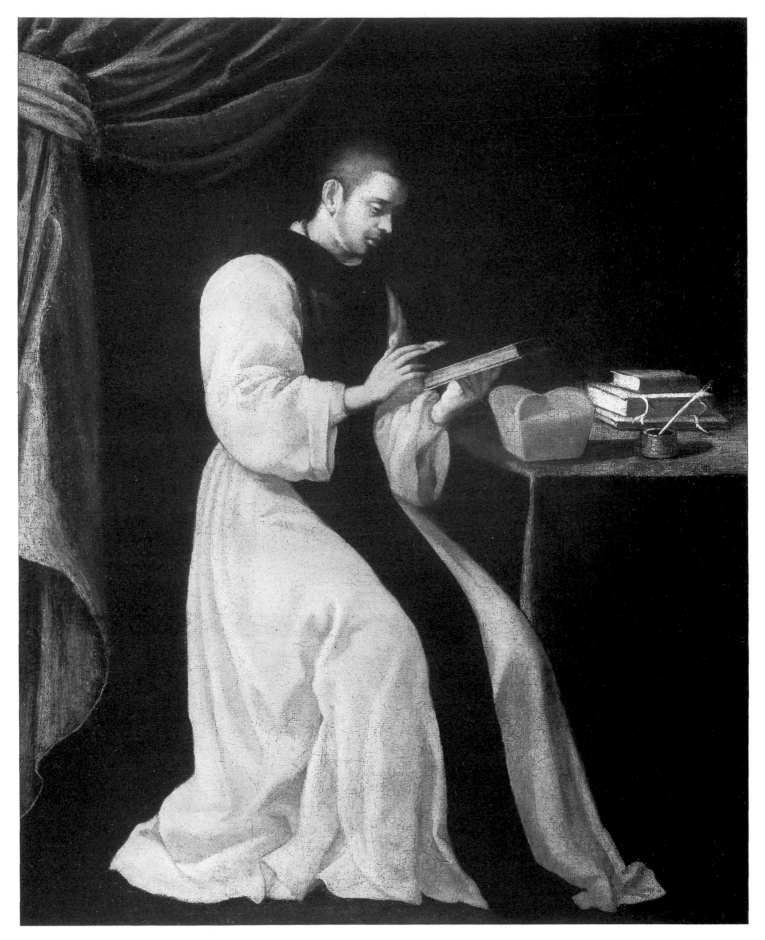

Fig. 267. HIERONYMITE FRIAR READING. 1631-1640. Barcelona: private collection. Cat. No. 257.

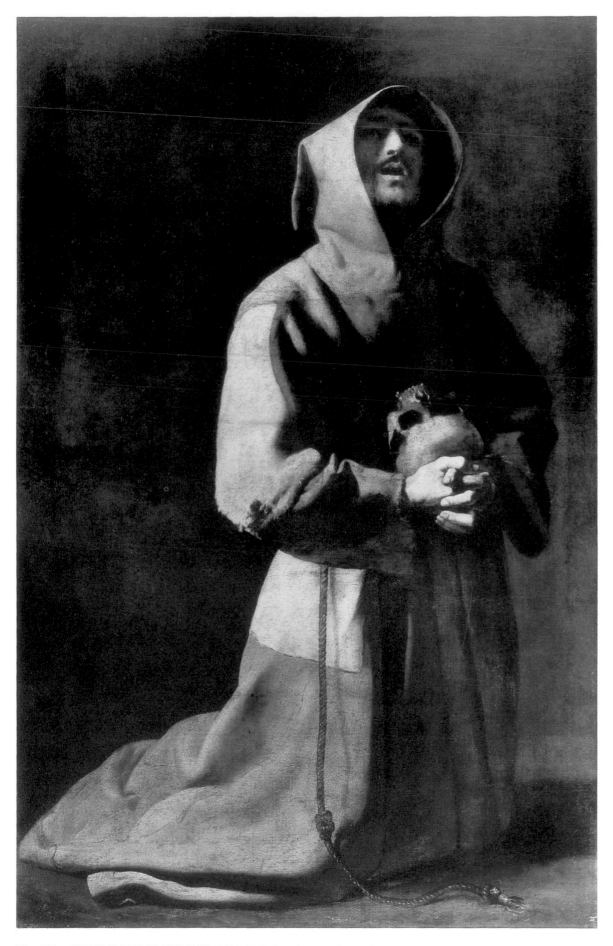

Fig. 268. ST FRANCIS KNEELING. 1631-1640. London: National Gallery. Cat. No. 258.

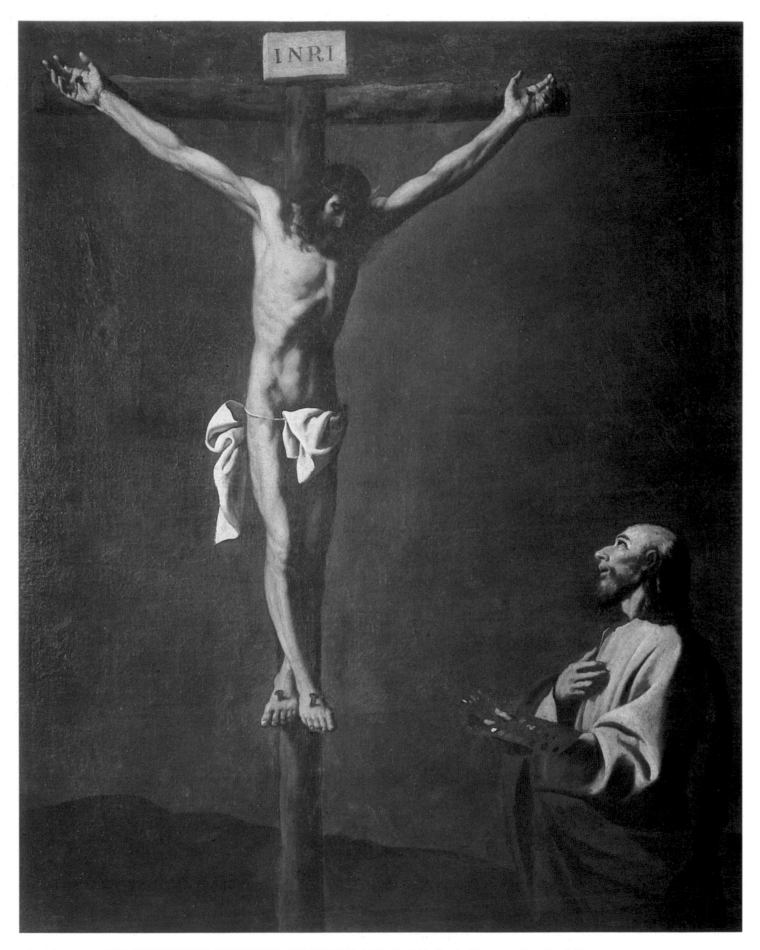

Fig. 269. ST LUKE BEFORE THE CRUCIFIED CHRIST. 1631-1640. Madrid: Prado Museum. Cat. No. 259.

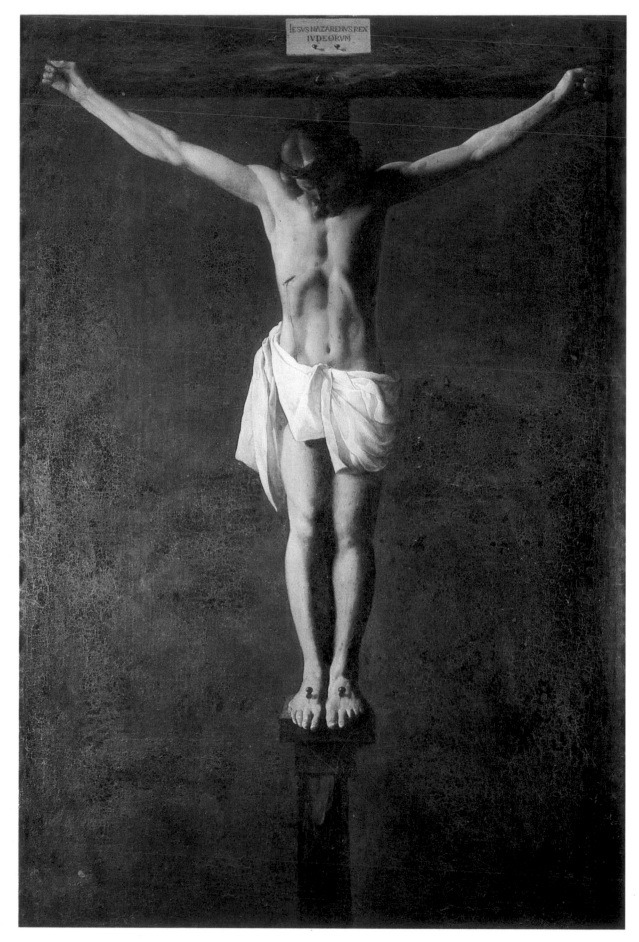

Fig. 270. CHRIST DEAD ON THE CROSS. 1631-1640. Seville: Provincial Museum of Fine Arts. Cat. No. 260.

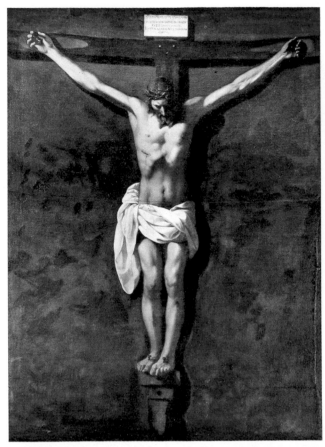

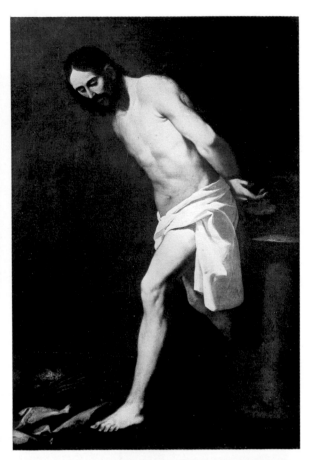

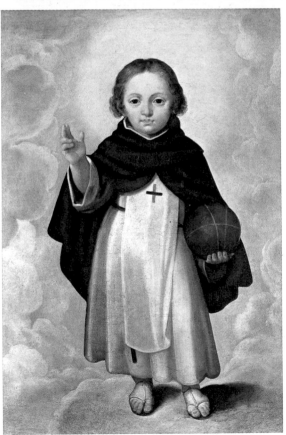

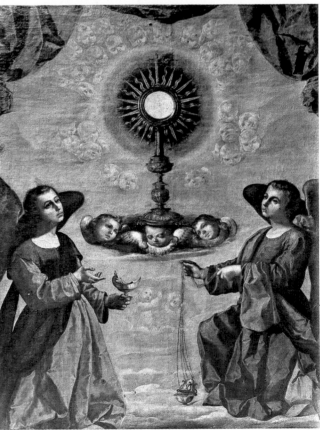

Fig. 271. CHRIST DEAD ON THE CROSS. 1631-1640. Seville: Provincial Museum of Fine Arts. Cat. No. 262.
Fig. 272. CHRIST AFTER THE SCOURGING. 1631-1640. Poznan: Muzeum Narodowe W. Poznaniu. Cat. No. 264.
Fig. 273. THE CHILD JESUS IN THE DOMINICAN HABIT. 1631-1640. Madrid: private collection. Cat. No. 266.
Fig. 274. THE ADORATION OF THE EUCHARIST. 1631-1640. Murcia: Provincial Museum of Fine Arts. Cat. No. 267.

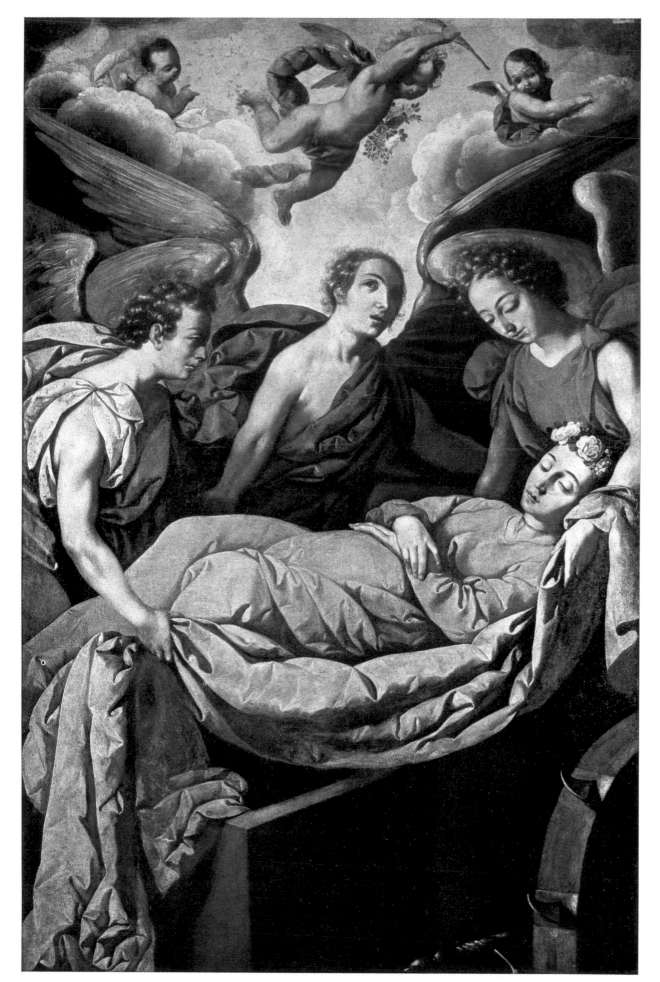

Fig. 275 BURIAL OF ST CATHE-
RINE ON MOUNT SINAI. 1613-
1640. Château de Courçon: private
collection. Cat. No. 268.

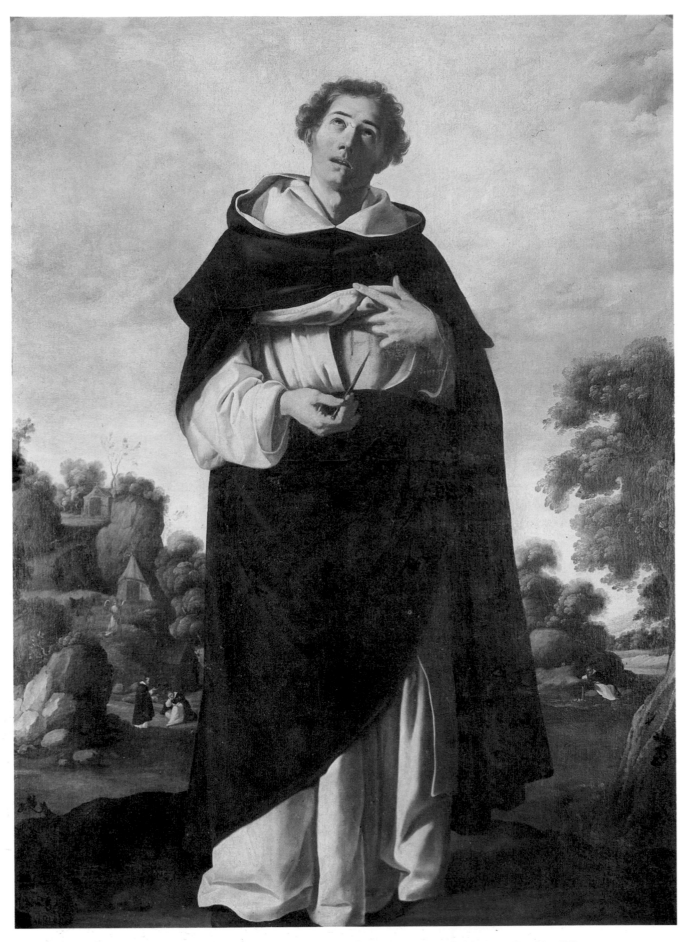

Figs. 276 & 277. BLESSED HENRY SUSO. 1631-1640. Seville: Provincial Museum of Fine Arts. Cat. No. 273.

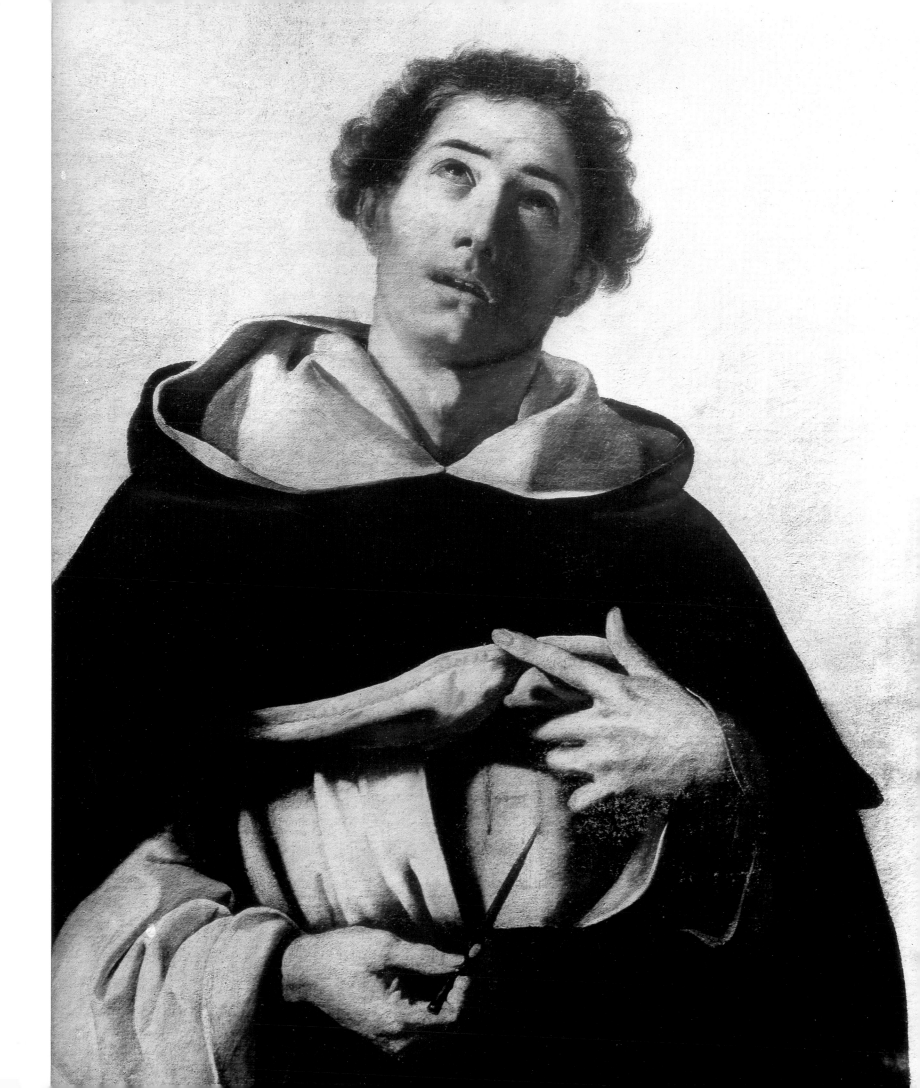

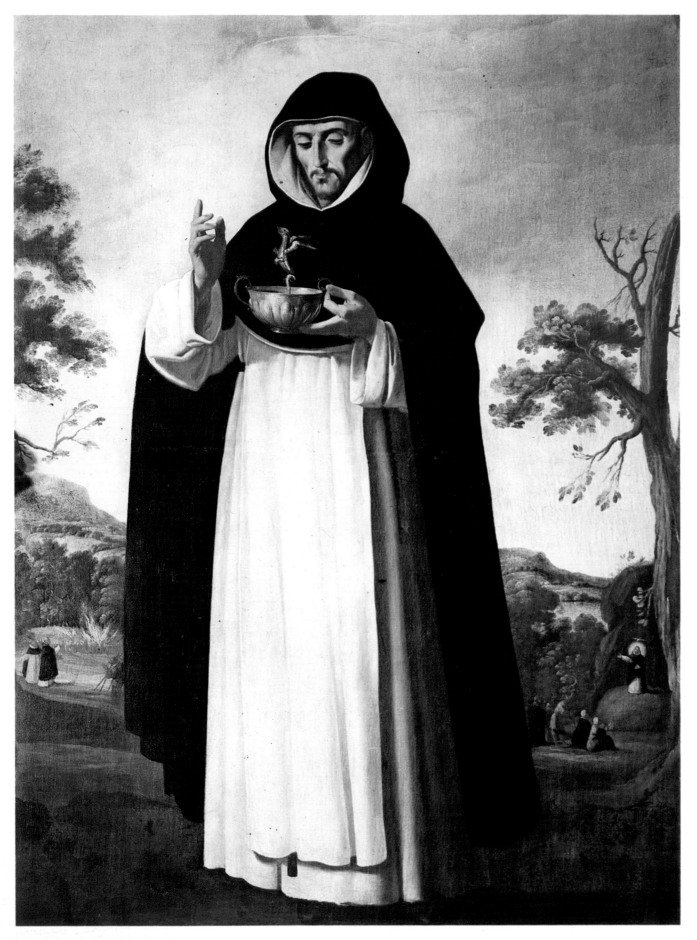

Fig. 278. ST LUIS BELTRAN. 1631-1640. Seville: Provincial Museum of Fine Arts. Cat. No. 274.

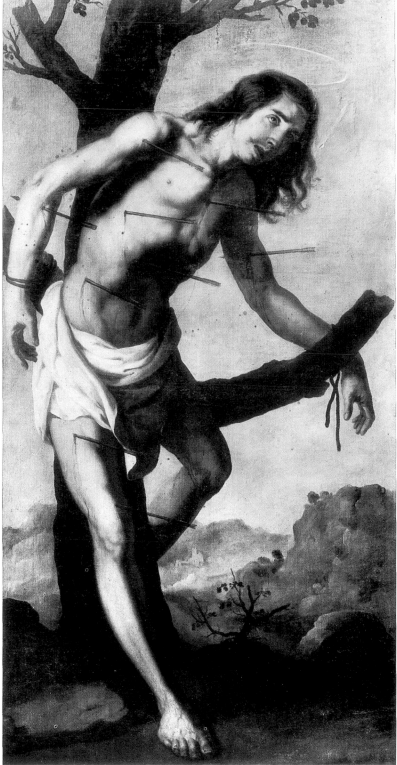

Fig. 279. ST AUGUSTINE. 1631-1640. Bilbao: Félix Valdés. Cat. No. 275.
Fig. 280. ST SEBASTIAN. 1631-1640. San Sebastián: private collection. Cat. No. 276.

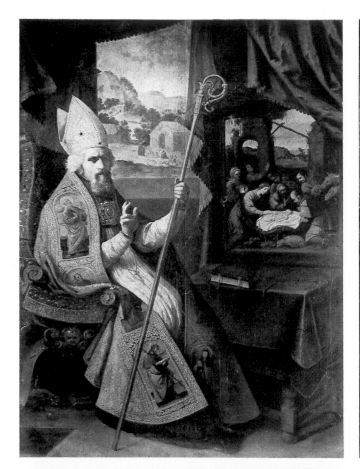

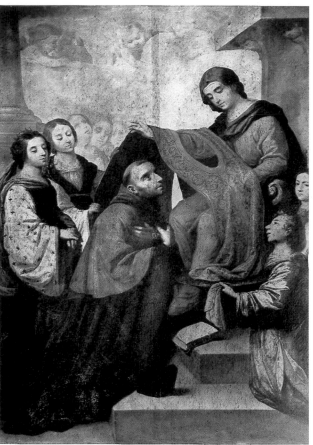

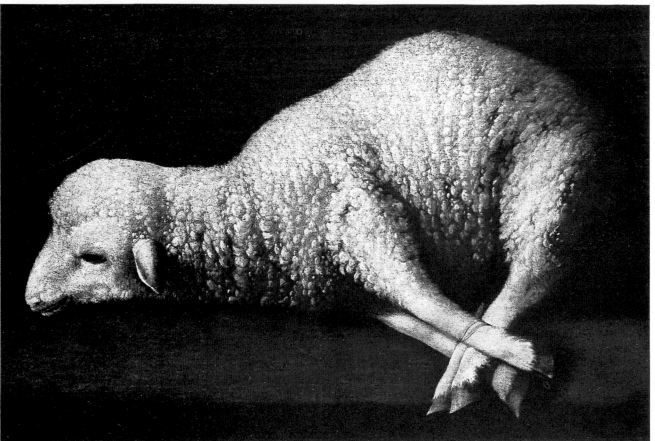

Fig. 281. ST NICOLAS OF BARI. 1631-1640. Guadalupe: Monastery of San Jerónimo. Cat. No. 277.
Fig. 282. ST ILDEFONSO RECEIVING THE CHASUBLE. 1631-1640. Guadalupe: Monastery of San Jerónimo. Cat. No. 279.
Fig. 283. LAMB. 1631-1640. San Diego: Fine Arts Gallery. Cat. No. 281.

1641. 4 May. Francisco de Zurbarán authorizes the master joiner Jerónimo Velázquez to receive the 1575 ducats owing to him out of the 3150 ducats stipulated as the total price of the structural work and painting of the retable for the principal church of Llerena, "which is done and placed in position in accordance with the deed of agreement drawn up in Llerena three years ago" (Cat. Nos. 166-168; Figs. 187, 190 & 191).

1642. 10 February. Doña Paula de Zurbarán, daughter of Francisco de Zurbarán and María Páez, authorizes Juan and Francisco Moreno to "bring suit against" the owner of the "principal houses" in the main square of Llerena, which were bequeathed to her by Beatriz de Morales and sold without her consent.

1643. 16 May. Alonso de Salas Parra, Attorney, Syndic and Perpetual Councillor of Zafra, founds the chapel of Our Lady of Remedies in the Collegiate Church of Santa María in that town. Zurbarán is commissioned to paint the canvases of the retable (Cat. Nos. 286-295; Figs. 284 & 285).

1643. Francisco de Zurbarán is paid 15,266 maravedís for the rest of the pictures he painted for the sacristy of the monastery of San Jerónimo in Guadalupe (Cat. Nos. 147-165; Figs. 157-186).

1644. 3 February. Francisco de Zurbarán signs a receipt for the dowry brought to him by Leonor de Tordera, amounting to 27,500 reales. Four days later Zurbarán is married (his third marriage) to Leonor de Tordera, the daughter and sister of goldsmiths and the widow of Diego de Sotomayor, who died in Puebla (Mexico).

1644. Tablet commemorating the completion of the retable in the chapel of Our Lady of Remedies in the Collegiate Church of Santa María, Zafra (Cat. Nos. 286-295; Figs. 284 & 285).

1645. Matías de Caviedes, prebendary of the cathedral, grants Zurbarán a life lease on a house in the Alcázares Viejos of Seville which is crown property. Zurbarán undertakes to pay 5000 reales for the improvements carried out by the previous lessee, besides the annual rent of 2000 reales.

1645. 24 May. Christening, in the cathedral of Seville, of Micaela-Francisca, daughter of Francisco de Zurbarán and Leonor de Tordera.

1645. The monastery of San Jerónimo in Guadalupe pays Francisco de Zurbarán, "painter to his Majesty", the sum of 100,670 maravedís, "as part payment for the picture of St Michael for the altar".

1646. 2 April. Christening, in the cathedral of Seville, of José-Antonio, son of Francisco de Zurbarán and Leonor de Tordera.

1646. In the monastery of San Jerónimo in Guadalupe orders are given that Francisco de Zurbarán, "painter to his Majesty and residing in the City of Seville", is to be paid 22,520 maravedís for "the picture that was painted of the Angels".

1647. 10 May. Francisco de Zurbarán signs as guarantor of José Gassó, the husband of his daughter María, in a contract for the renting of some houses.

1647. 22 May. Francisco de Zurbarán signs a document in which he acknowledges receipt of 2000 pesos from the Abbess of the convent of Our Lady of the Incarnation in the "City of the Kings" (Lima), Peru, paid through the agency of Juan de Valverde, for the which sum he is to paint the following 34 canvases for the church of the said convent: "The Tree of Jesse" (to measure 4 varas by 2 varas less two "fingers"), "Revelation of the Angel to St Joachim and Meeting at the Golden Gate" (the same size as the foregoing), "The Birth of the Virgin" ("with as many and as charming figures as possible"), "The Presentation of the Virgin", "The Betrothal of the Virgin and St Joseph", "The Annunciation", "The Nativity", "The Ascension of Christ" ("and in it the Virgin and the disciples"), "The Death and Assumption of the Virgin", "The Coronation of the Virgin" and 24 "Virgins" (full-length). All these paintings are to be completed by Easter Sunday 1648.

1647. 25 May. Through the agency of Luis López Chaburu, Francisco de Zurbarán receives 1000 pesos worth 8 reales each from Antonio Fajardo, resident in the City of the Kings, Peru, by way of payment for certain pictures the latter took to sell in America.

1647. 1 July. Francisco de Zurbarán authorizes Enrique Núñez, resident in Llerena, to receive henceforward from Juan Sánchez Moro, resident in Montemolín, the annuity of 40,000 maravedís which the latter has hitherto paid the painter. With the money he receives, Núñez is to buy 50 *fanegas* of wheat (1 *fanega* = 1 1/2 bushels) and send them to Zurbarán.

1647. 23 September. Francisco de Zurbarán authorizes Antonio de Alarcón, resident in the city of Lima (Peru), to collect payment from the naval captain Andrés Martínez for the twelve paintings of "Roman emperors on horseback" 2 3/4 *varas* in height delivered to the captain in Seville for him to sell in America.

1647. 23 September. Francisco de Zurbarán receives 300 pesos in "double silver" reales from the ship's captain Juan de Valverde, "as an advance on what I am to receive for the canvases and paintings I have been commissioned to carry out and deliver to the aforesaid captain" (see document dated 22 May 1647).

1647. 3 November. Francisco de Zurbarán receives 200 pesos from the ship's captain Juan de Valverde, as an advance on "the amount of the painted canvases which I have undertaken to execute and deliver to the said captain".

1647. From the monastery of San Jerónimo in Guadalupe Francisco de Zurbarán receives 6800 maravedís, being the part still pending of the payment for the "Angels" (see second item for 1646 above).

1648. 9 February. Christening, in the cathedral of Seville, of Juana-Micaela, daughter of Francisco de Zurbarán and Leonor de Tordera.

1648. 3 December. Francisco de Zurbarán signs a receipt for what he has been paid for some pictures delivered to the Conde de la Puebla de Maestre, Royal Governor of Seville.

1648. Francisco de Zurbarán addresses a petition to the administrators of the Alcázar, requesting that in view of the "excessive expenses" he has incurred in the house leased to him in 1645 (1000 ducats refunded to the previous lessee and 1600 ducats spent on further improvements), he may be permitted to transfer the said house to his heirs.

1649. 28 February. Felipe de Atienza and Alvaro Gómez sign a receipt in Buenos Aires for 15 "Virgin Martyrs", 15 "Kings and Famous Men", 24 "Saints and Patriarchs" (all life-size), 9 Dutch "Landscapes", six pounds of colours and several paintbrushes, all to be sold on Zurbarán's behalf. This document adds that several of the canvases have arrived in a damaged state.

1649. 8 June. Burial, in the parish church of the Holy Cross in Seville, of Don Juan de Zurbarán, son of the painter Zurbarán and son-in-law of Jorge de Quadros.

1650. 8 March. Francisco de Zurbarán is paid 600 reales for some portraits of the children of the Marqués de Villanueva del Río.

1650. 9 April. Christening, in the cathedral of Seville, of Marcos, son of Francisco de Zurbarán and Leonor de Tordera.

1651. *St John Chrysostom and Fray Luis de Granada*. Canvas inscribed: "fran co dezurbaran /faciebat 1651" (Cat. No. 296; Figs. 286, 287 and 513).

1652. 31 May. Francisco de Zurbarán transfers the lease of his house in the Reales Alcázares to Manuel Guías for 22,000 reales.

1653. 8 November. Christening, in the cathedral of Seville, of Eusebio, son of Francisco de Zurbarán and Leonor de Tordera.

1653. *Christ Carrying the Cross*. Canvas inscribed: "Fran co de Zurbar.../1653" (Cat. No. 297; Fig. 288 & 514).

1655. 2 November. Christening, in the cathedral of Seville, of Agustina-Florencia, daughter of Francisco de Zurbarán and Leonor de Tordera.

1656. 5 November. As Francisco de Zurbarán owes a year's rent on the house in which he is living, a distraint is levied on the sums he receives from three sub-letting tenants (Gaspar de Espinosa, who sub-lets the shop, Juan Porta, who has a bakery and two other rooms, and Manuel Monroy, who occupies a bedroom in the house), and some of his property is seized but finds no bidders when it is put up for auction.

1656. December. A writ is served on Zurbarán for the rent of the house due in August, besides 700 maravedís in costs.

1657. 23 May. Francisco de Zurbarán, resident in Seville, appears as guarantor for María de Rojas in the renting of a house for the sum of 22 reales a month.

1657. 14 December. The cathedral chapter of Seville grants one of Zurbarán's daughters a lease on a house in the Calle de Abades for life.

1658. Francisco de Zurbarán, his wife, a daughter and three servants are registered in the census as living in the Calle de Abades in Seville, in front of the Archbishop's Palace.

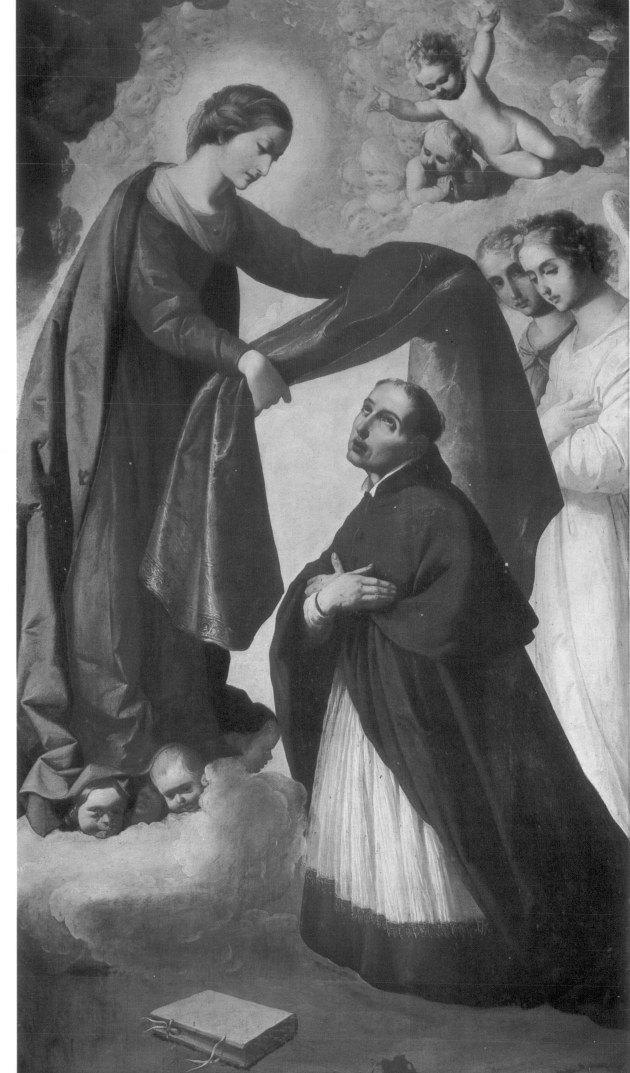

Fig. 284. ST ILDEFONSO RECEI-
VING THE CHASUBLE. 1643-1644.
Zafra: Church of Santa Maria. Cat.
No. 286.

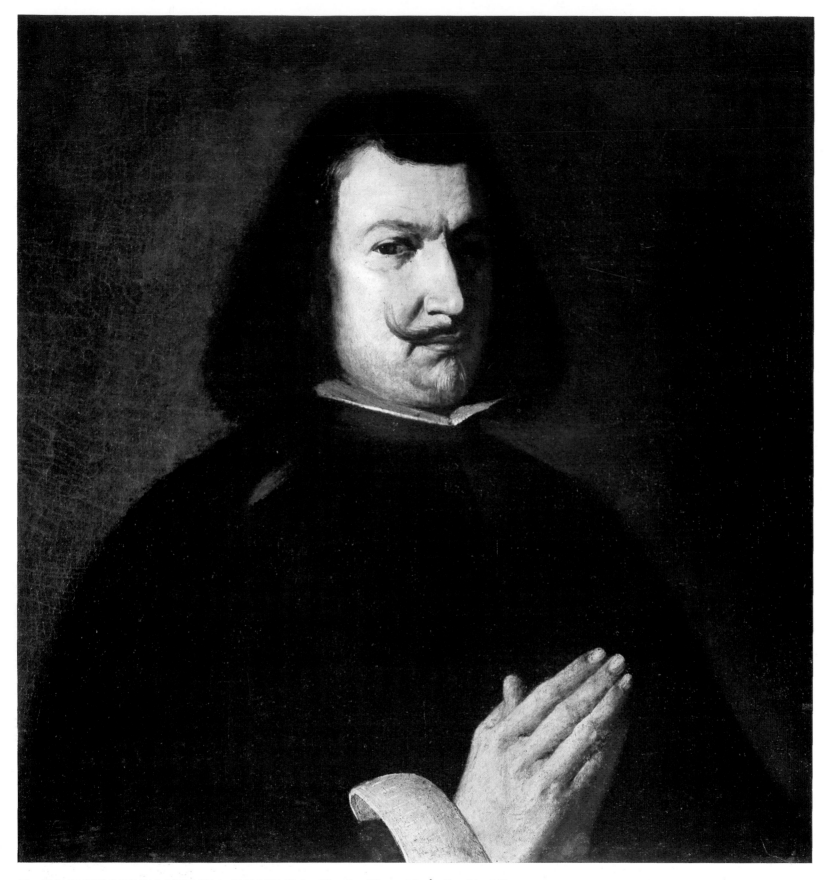

Fig. 285. **ALONSO DE SALAS PARRA.** 1643-1644. Zafra: Church of Santa María. Cat. No. 292.

Figs. 286 & 287. ST JOHN CHRYSOSTOM AND FRAY LUIS DE GRANADA. 1651. Lima: private collection. Cat. No. 296.

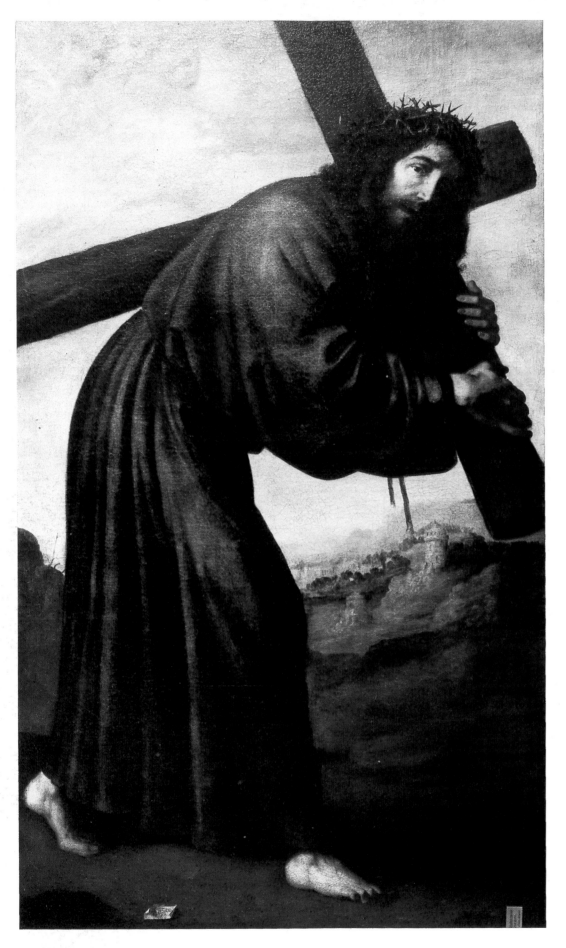

Fig. 288. CHRIST CARRYING THE CROSS. 1653. Orleans: Cathedral. Cat. No. 297.

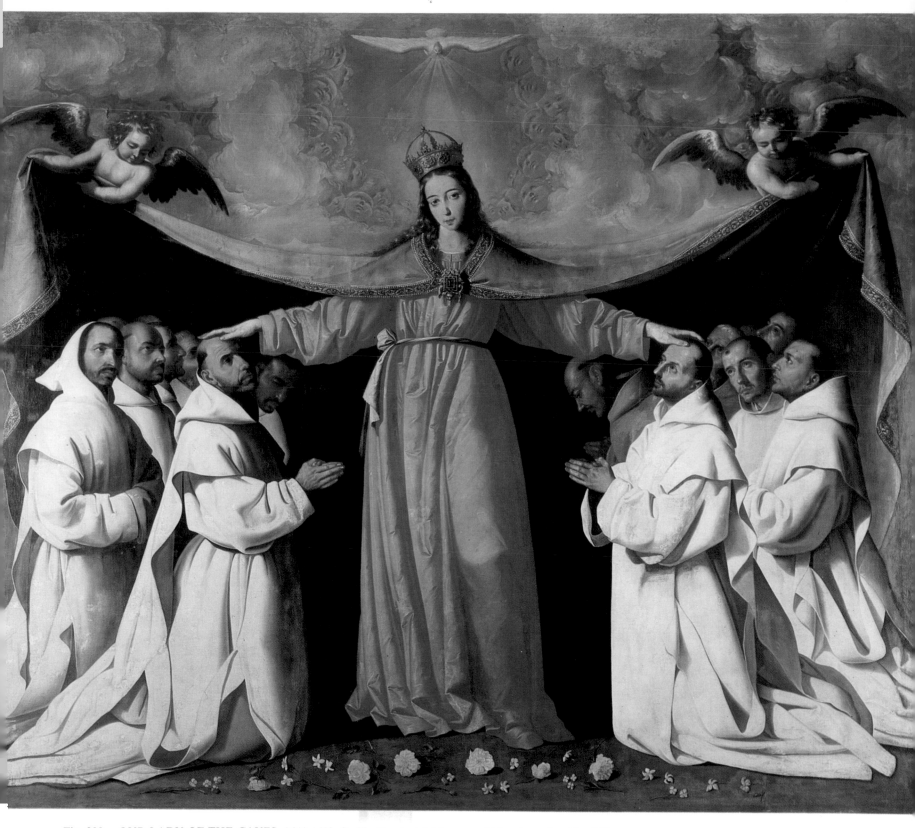

Fig. 289. OUR LADY OF THE CAVES. 1641-1658. Seville: Provincial Museum of Fine Arts. Cat. No. 298.

Fig. 290. OUR LADY OF THE CAVES. Detail of figure 289.

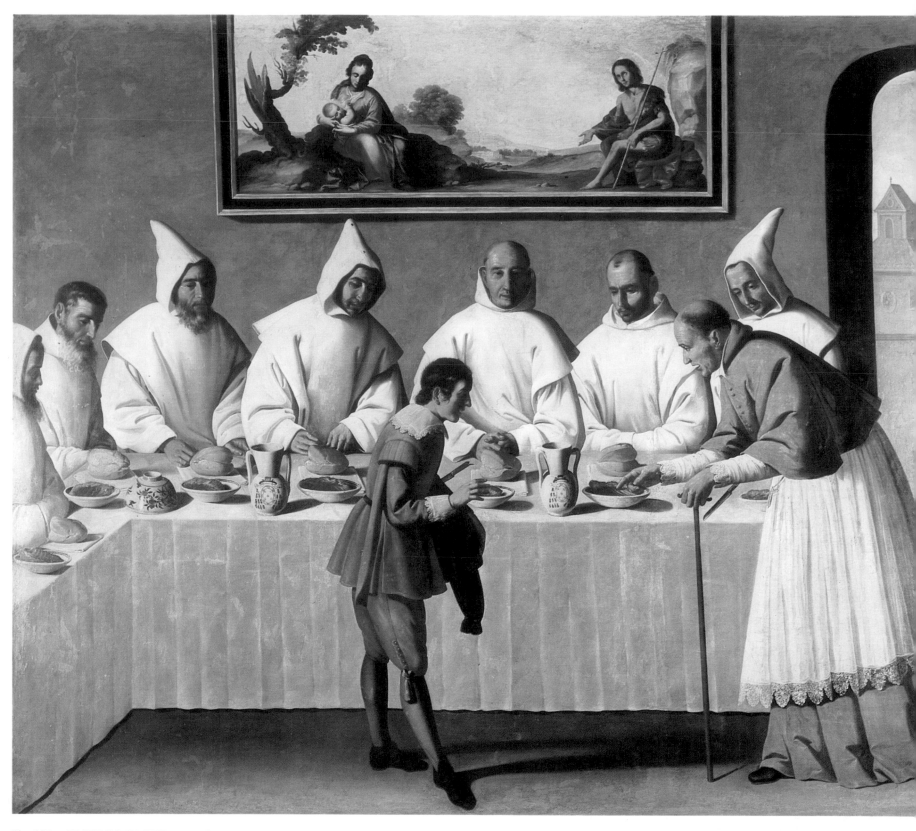

Fig. 291. ST HUGO IN THE REFECTORY. 1641-1658. Seville: Provincial Museum of Fine Arts. Cat. No. 299.

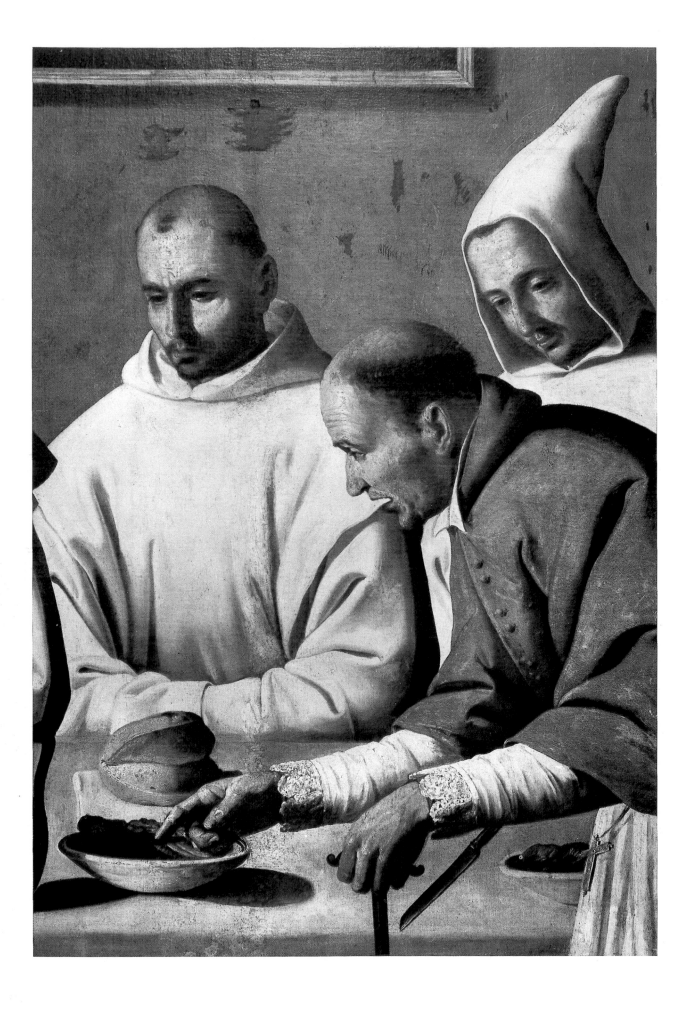

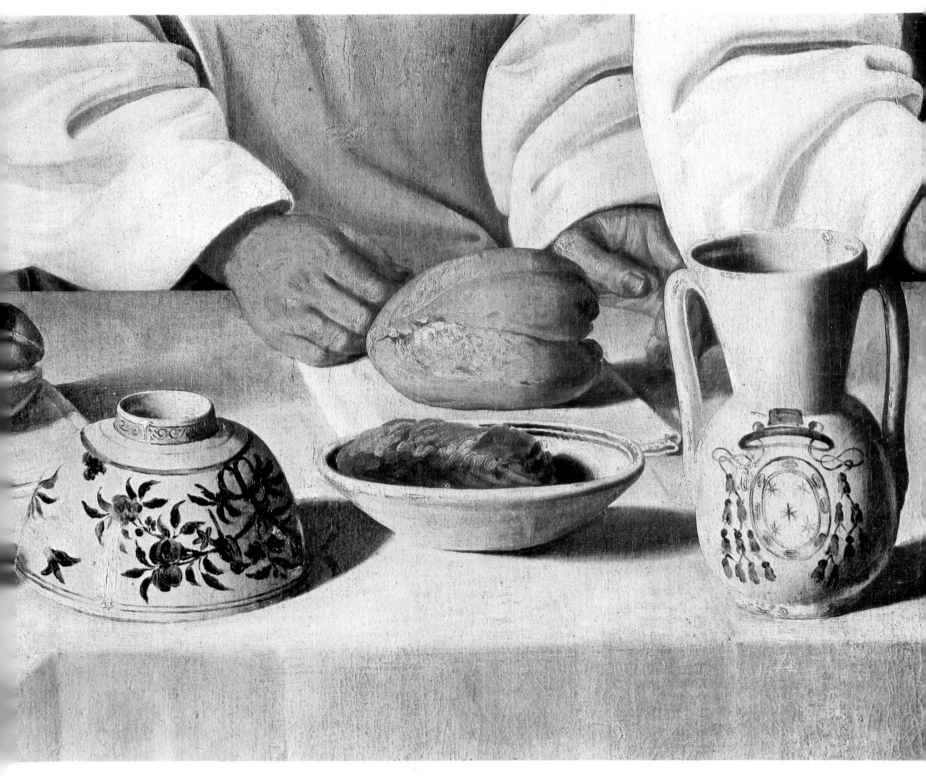

Figs. 292 & 293. ST HUGO IN THE REFECTORY. Details of figure 291.

Fig. 294. POPE URBAN II AND ST BRUNO, HIS CONFESSOR. 1641-1658. Seville: Provincial Museum of Fine Arts. Cat. No. 300.

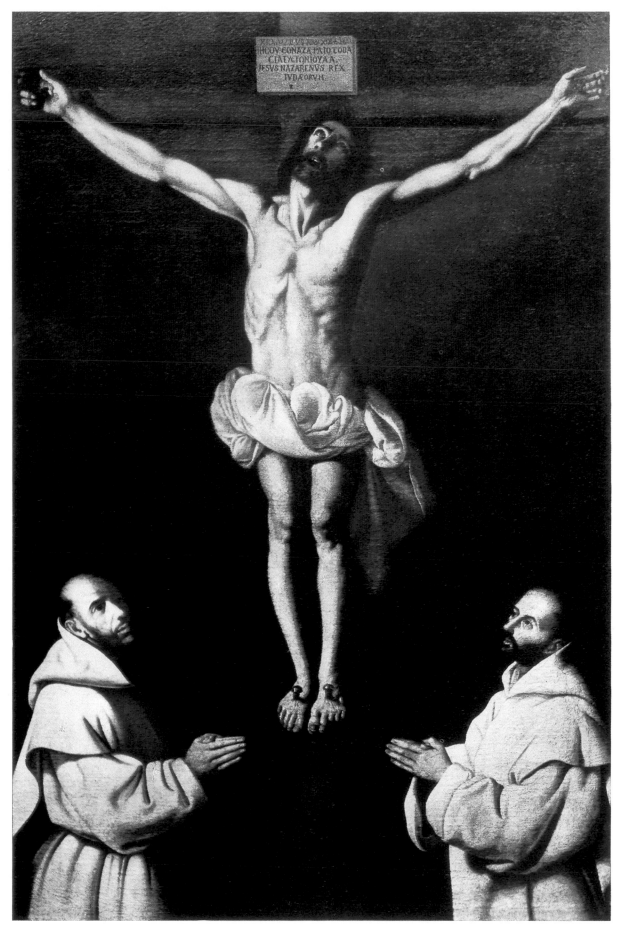

Fig. 295. CHRIST CRUCIFIED AND TWO CARTHUSIANS. 1641-1658. Ampudia: Fontaneda Collection.
Cat. No. 301.

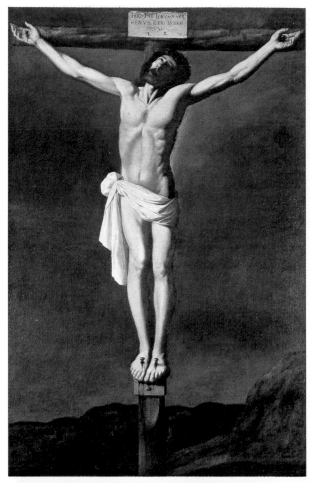

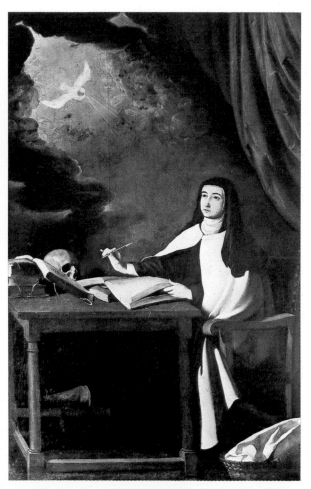

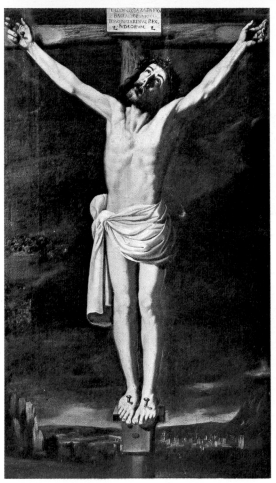

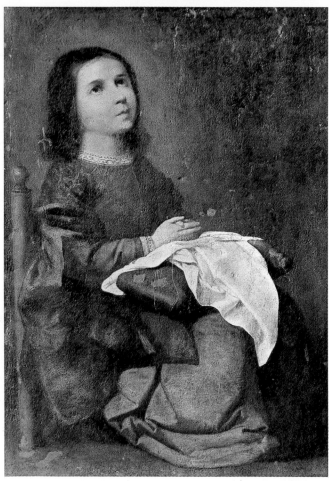

Fig. 296. CHRIST CRUCIFIED. 1641-1658. Barcelona: Art Museum of Catalonia. Cat. No. 303.

Fig. 297. ST TERESA. 1641-1658. Seville: Cathedral. Cat. No. 308.

Fig. 298. CHRIST CRUCIFIED. 1641-1658. Seville: Cathedral. Cat. No. 304.

Fig. 299. THE VIRGIN AS A CHILD, PRAYING. 1641-1658. Granada: Rodríguez-Acosta Foundation. Cat. No. 312.

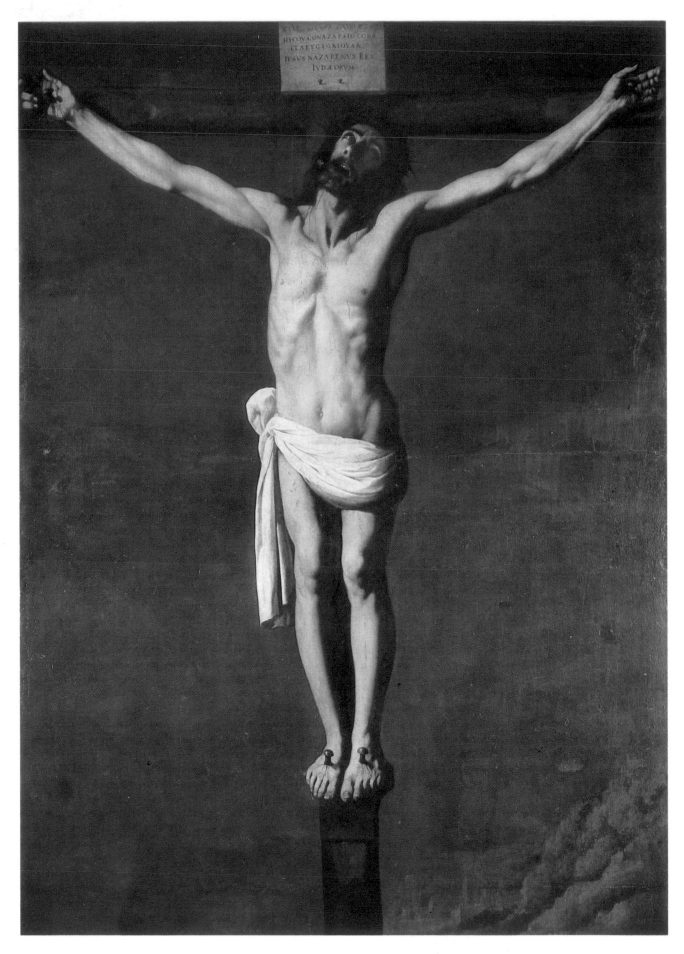

Fig. 300. CHRIST CRUCIFIED. 1641-1658. Seville: Provincial Museum of Fine Arts. Cat. No. 302.

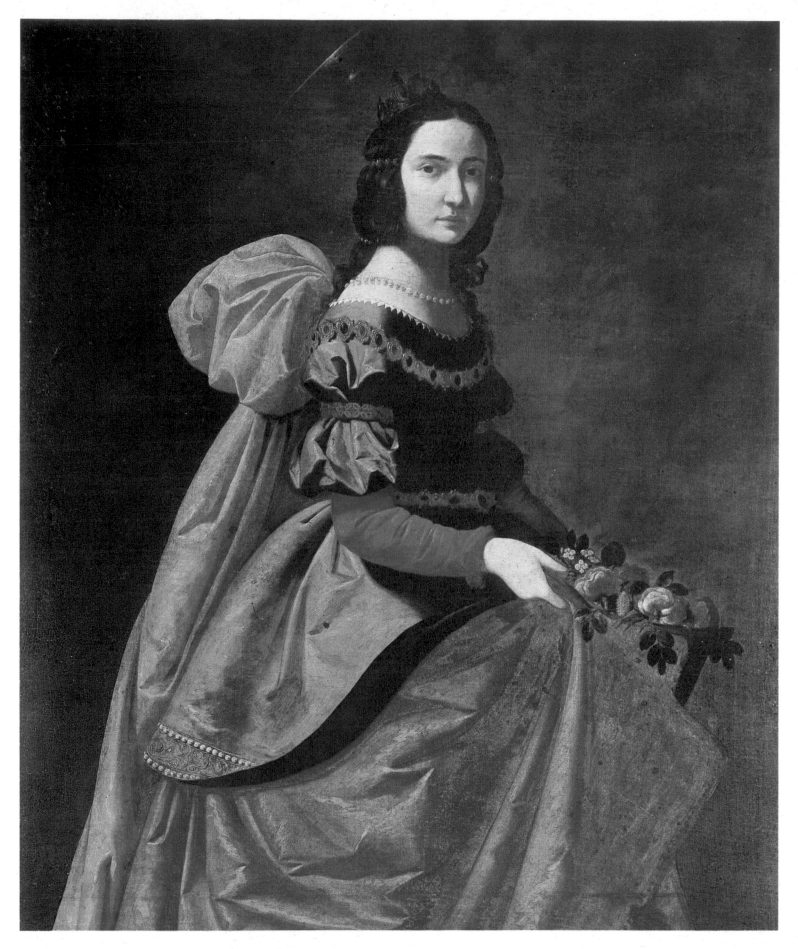

Fig. 301. ST CASILDA. 1641-1658. Madrid: Prado Museum. Cat. No. 310.
Fig. 302. THE VIRGIN AS A CHILD, PRAYING. 1641-1658. Leningrad: Hermitage. Cat. No. 311.

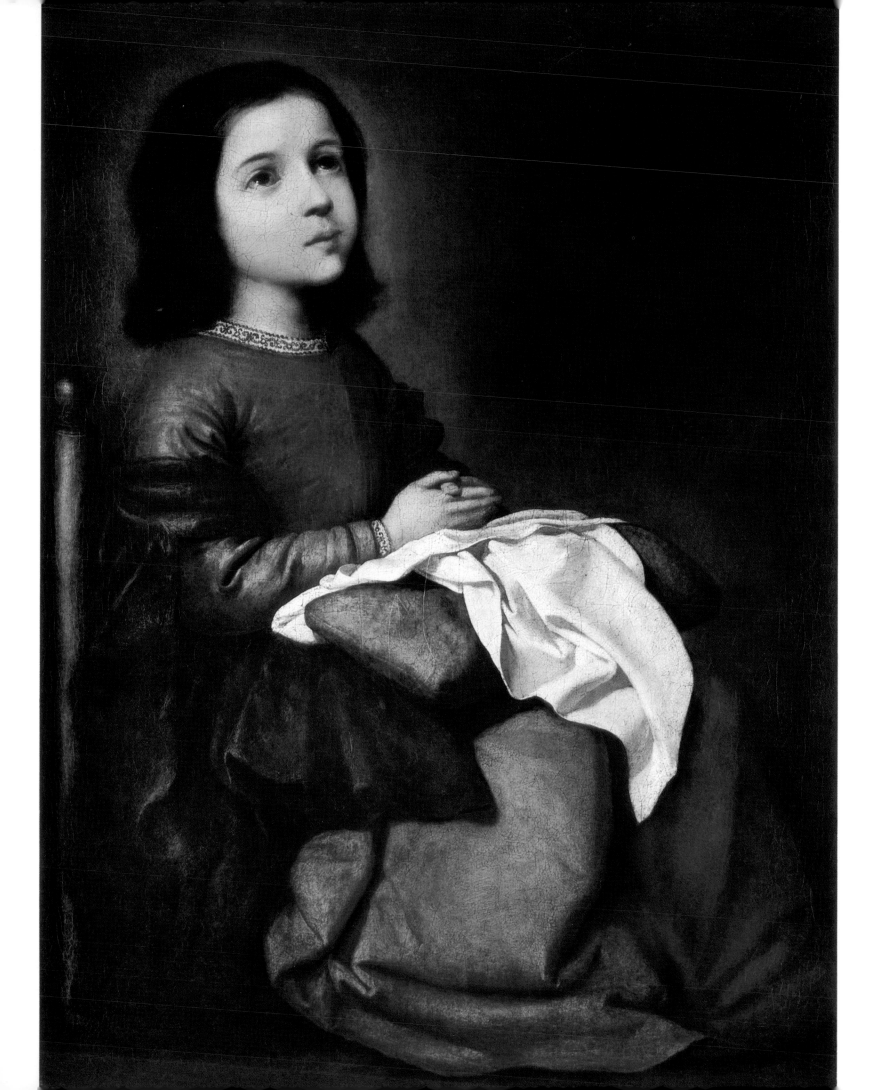

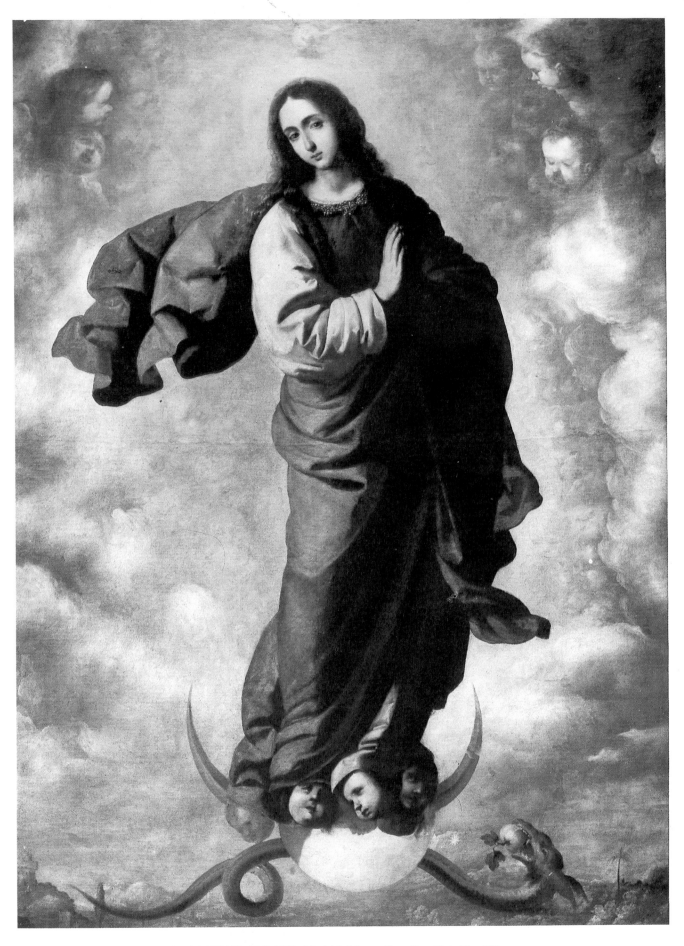

Fig. 303. IMMACULATE CONCEPTION. 1641-1658. Madrid: Museo Cerralbo. Cat. No. 313.
 Fig. 304. IMMACULATE CONCEPTION. 1641-1658. Seville: Town Hall. Cat. No. 314.

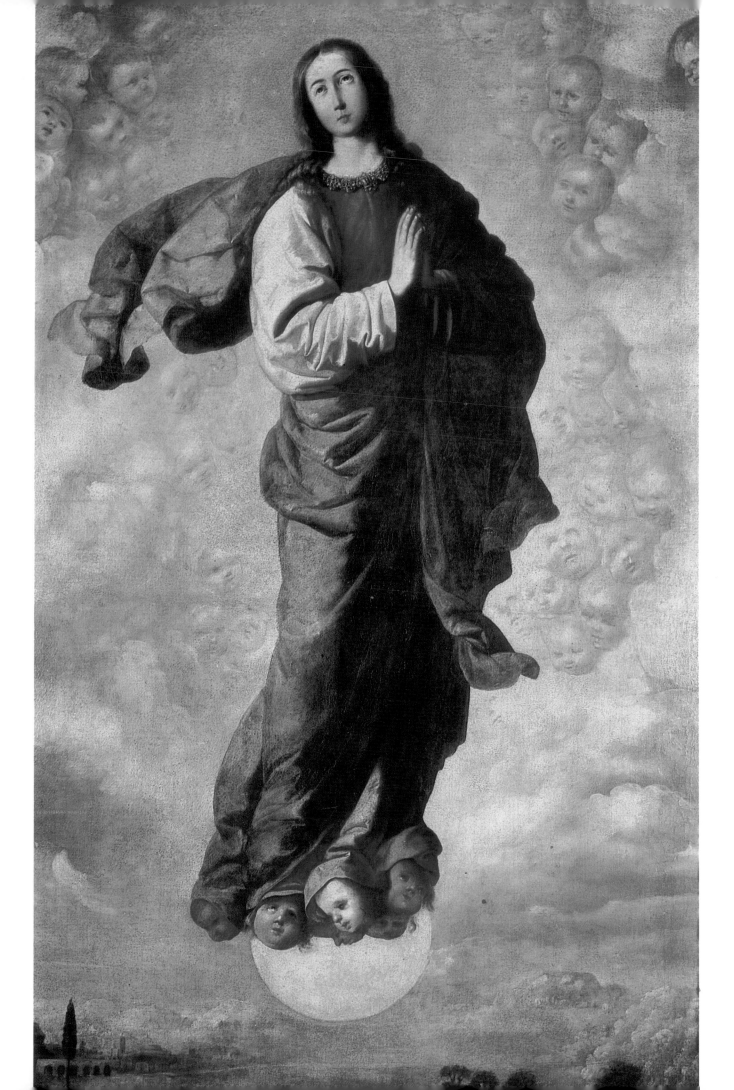

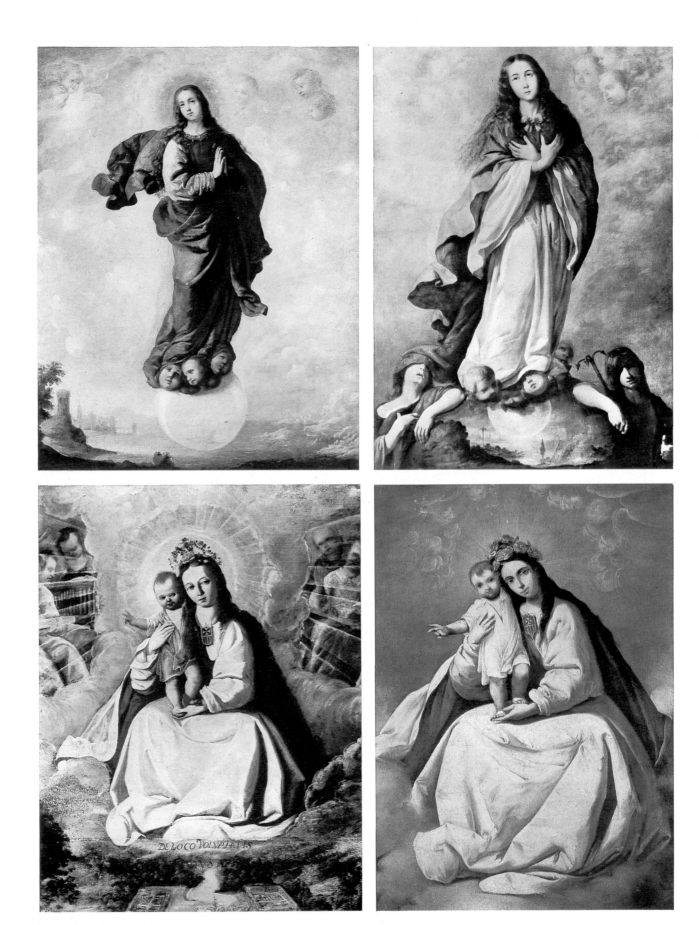

Fig. 305. IMMACULATE CONCEPTION. 1641-1658. New York: Samuel H. Kress Foundation. Cat. No. 315.
Fig. 306. IMMACULATE CONCEPTION WITH TWO ALLEGORICAL FIGURES. 1641-1658. Dublin: National Gallery of Ireland. Cat. No. 316.
Fig. 307. OUR LADY OF RANSOM. 1641-1658. Boston: The Isabella Stewart Gardner Museum. Cat. No. 317.
Fig. 308. OUR LADY OF RANSOM. 1641-1658. Madrid: Museo Lázaro. Cat. No. 318.

Fig. 309. OUR LADY OF THE ROSARY. 1641-1658. Seville: Cathedral. Cat. No. 319.

Fig. 310. OUR LADY OF RANSOM AND TWO MERCEDARIANS. 1641-1658. Madrid: Marqués de Valdeterrazo. Cat. No. 320.

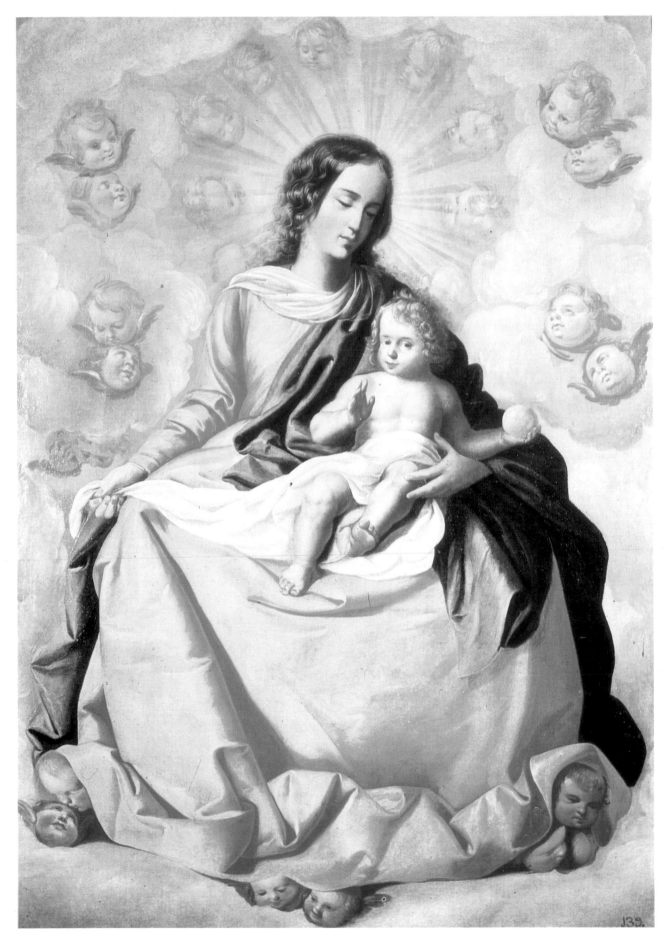

Fig. 311. VIRGIN AND CHILD IN THE CLOUDS. 1641-1658. Madrid: Duchess of Osuna. Cat. No. 321.

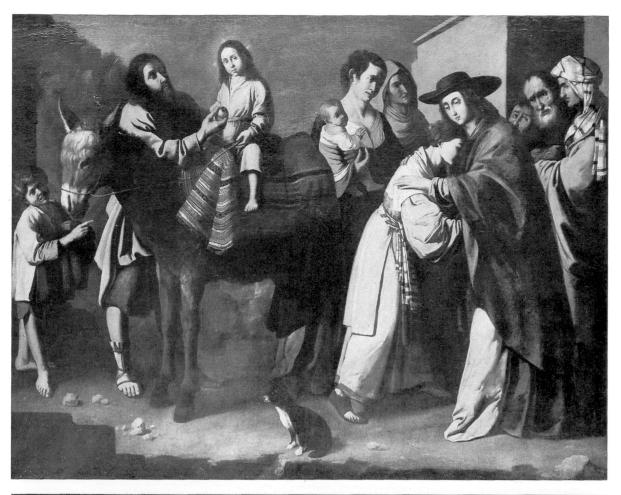

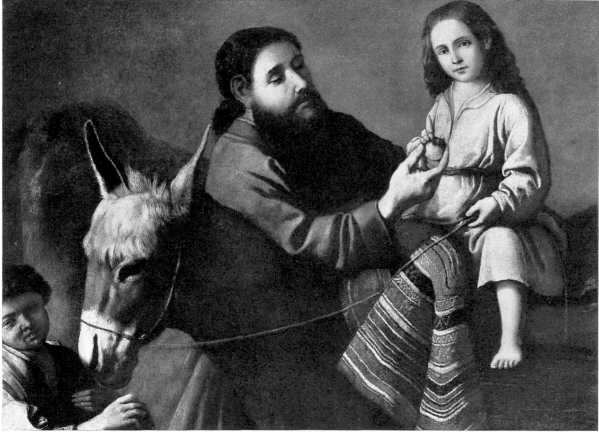

Fig. 312. RETURN OF THE HOLY FAMILY FROM EGYPT TO JERUSALEM. 1641-1658. Toledo (Ohio):
Museum of Fine Arts. Cat. No. 322.
Fig. 313. RETURN OF THE HOLY FAMILY FROM EGYPT TO JERULASEM. 1641-1658. Sarasota: The John
and Mable Ringling Museum. Cat. No. 323.

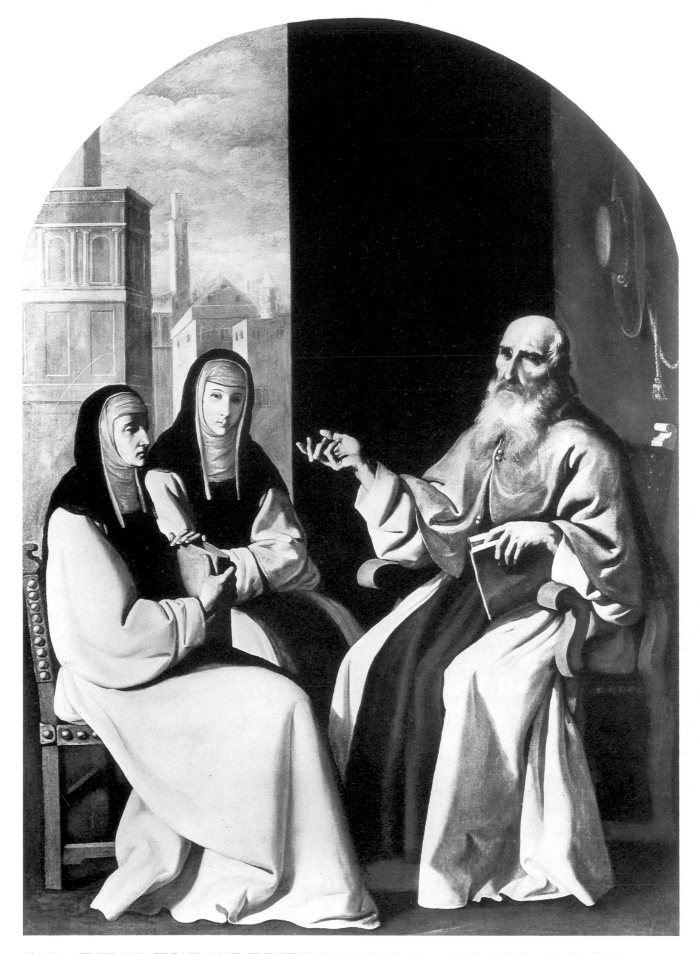

Fig. 314. ST JEROME, ST PAULA AND ST EUSTACIA. 1641-1658. Washington: National Gallery. Cat. No. 324.

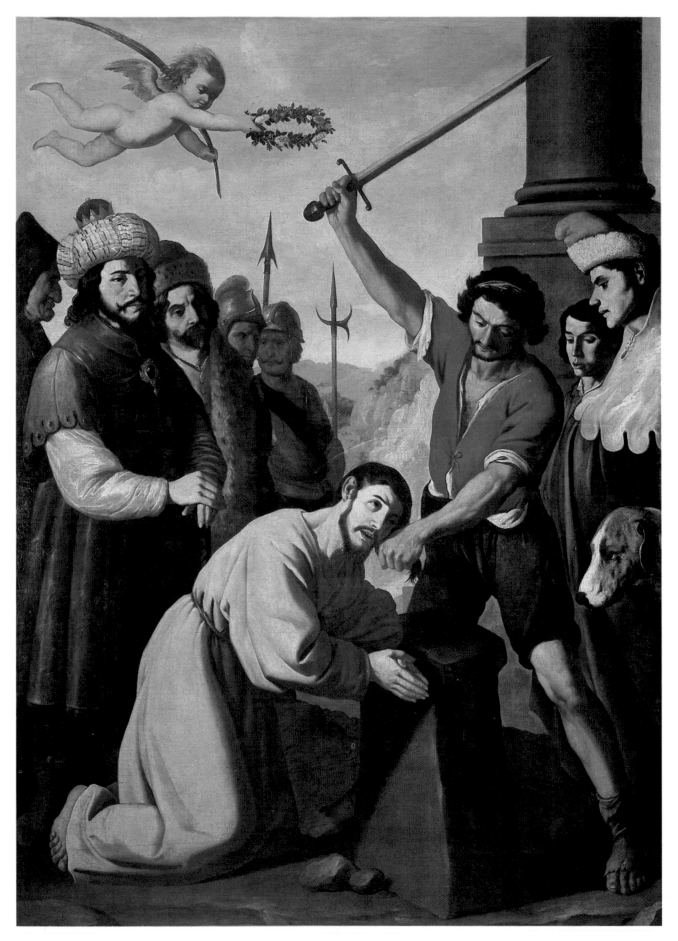

Fig. 315. MARTYRDOM OF ST JAMES. 1641-1658. Barcelona: Plandiura Collection. Cat. No. 325.

Fig. 316. ST JEROME. 1641-1658. San Diego: Fine Arts Gallery. Cat. No. 326.

Fig. 317. ST HERMENEGILDUS. 1641-1658. Seville: Church of San Esteban. Cat. No. 332.
Fig. 318. ST FERDINAND. 1641-1658. Seville: Church of San Esteban. Cat. No. 333.

Fig. 319. ST BRUNO. 1641-1658. Seville: Archbishop's Palace. Cat. No. 338.

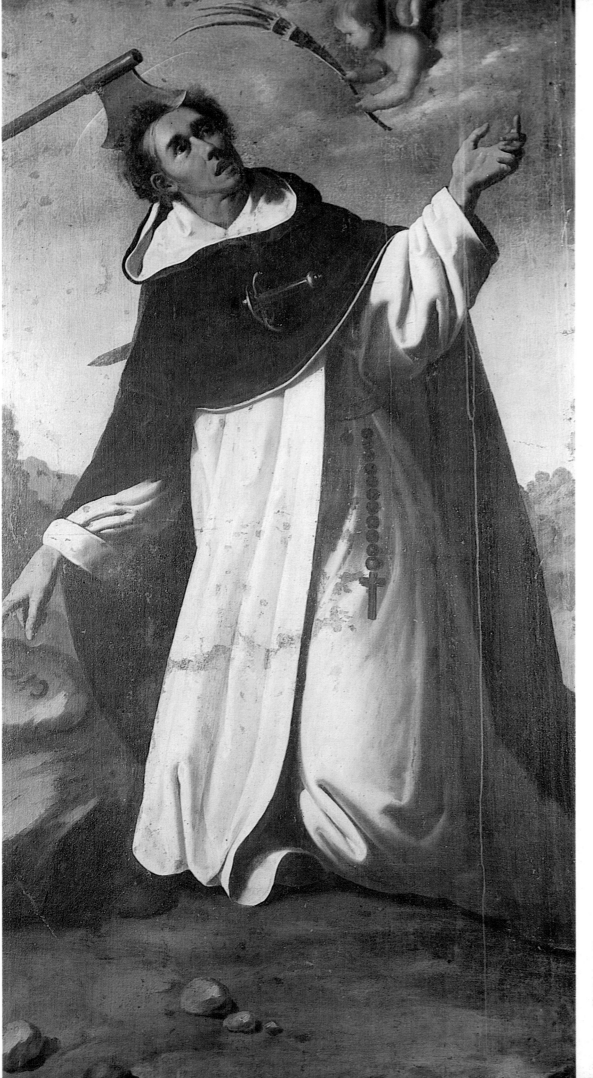

Fig. 320. ST PETER MARTYR. 1641-
1658. Seville: Archbishop's Palace. Cat. No.
339.
Fig. 321. ST DOMINIC (detail). 1641-1658.
Seville: Archbishop's Palace. Cat. No. 340.

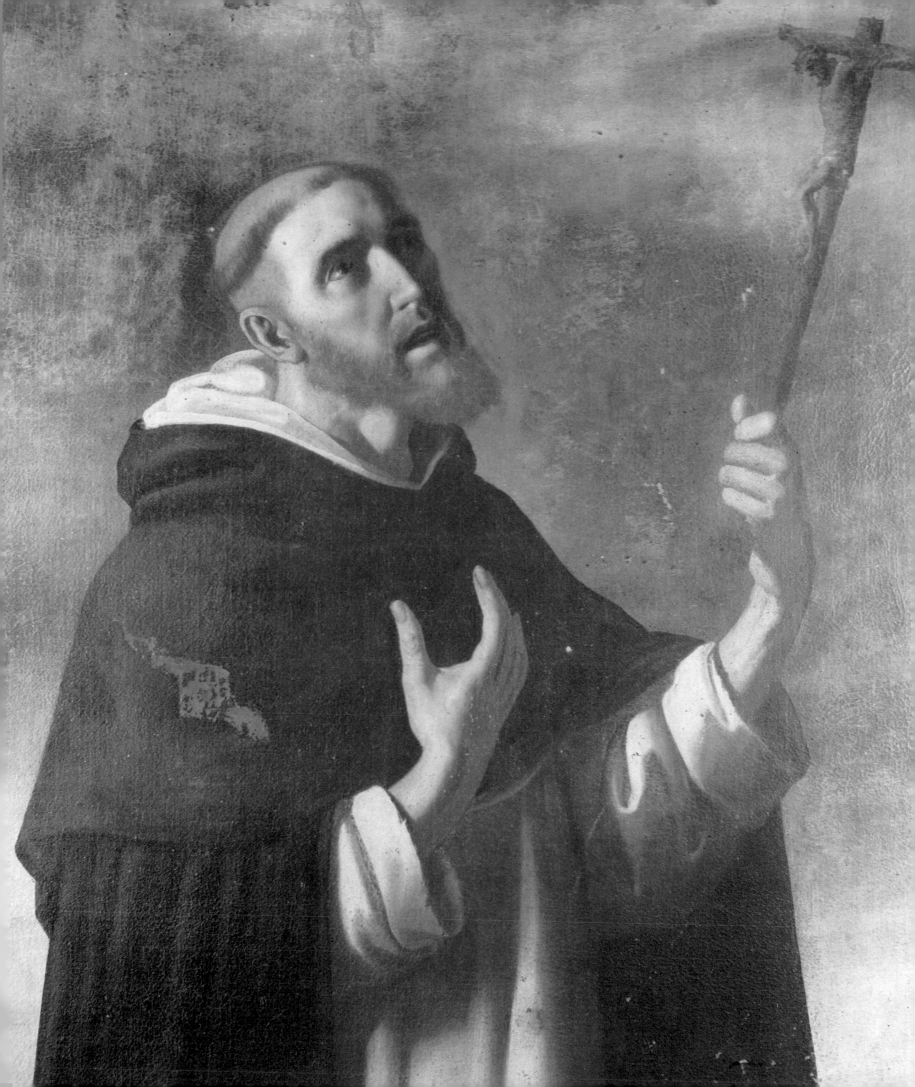

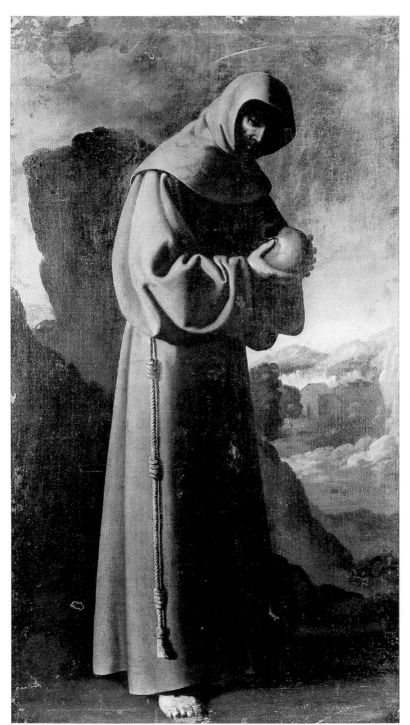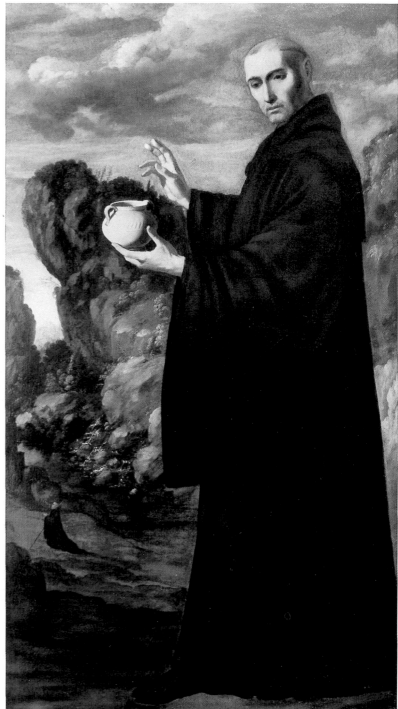

Fig. 322. ST FRANCIS. 1641-1658. Seville: Archbishop's Palace. Cat. No. 341.
Fig. 323. ST BENEDICT. 1641-1658. New York: Kleinberger & Co. Cat. No. 327.

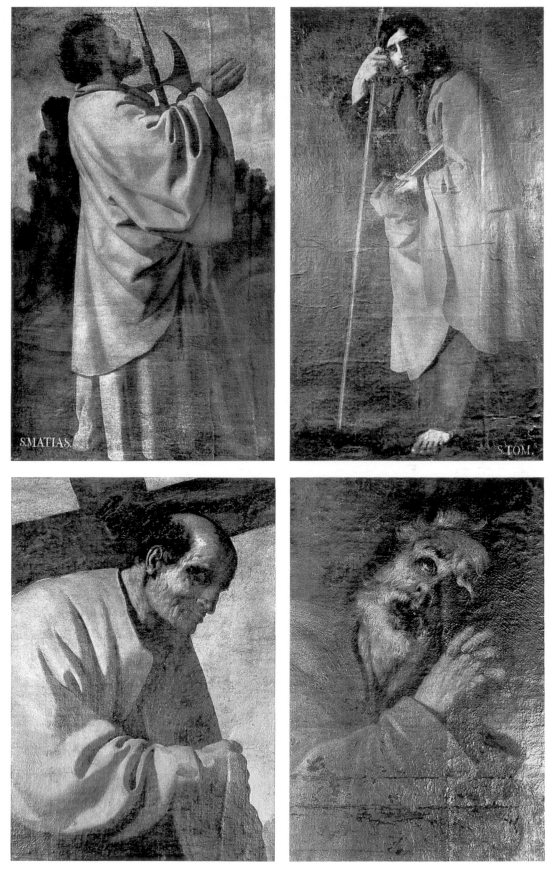

Figs. 324 to 327. ST MATTHIAS, ST THOMAS, ST PHILIP (detail), ST PETER (detail). 1641-1658. Guatemala City: Monastery of Santo Domingo. Cat. 342-345.

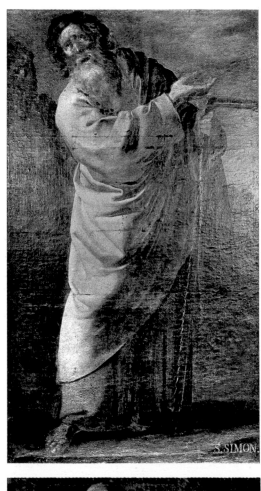

S. SIMON.

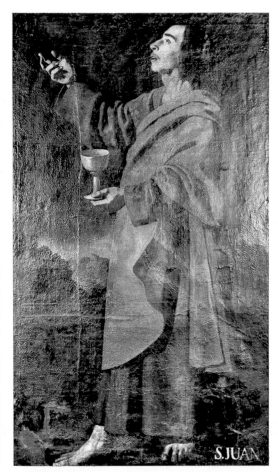

S. JUAN

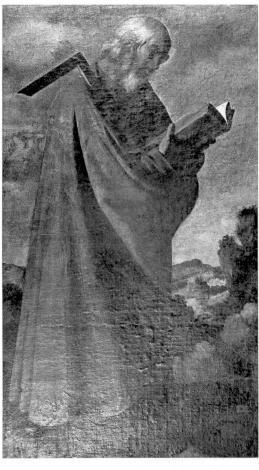

S. JUD. TAD.

NTIAGO EL MEN

S. PABLO

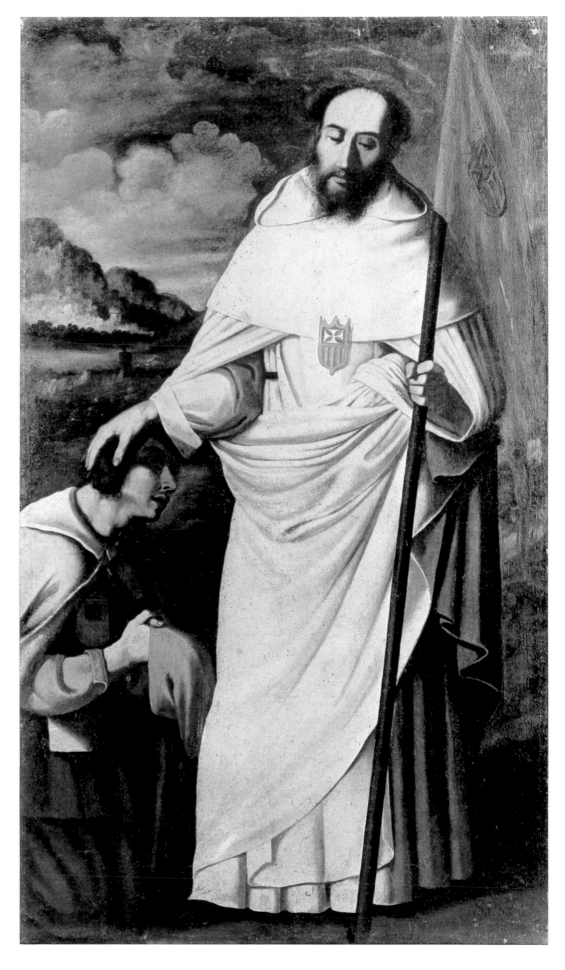

Figs. 328 to 333. ST SIMON, ST JOHN THE EVANGELIST, ST MATTHEW, ST JUDE THADDEUS, ST JAMES THE LESS, ST PAUL. 1641-1658. Guatemala City: Monastery of Santo Domingo. Cat. No. 346-351.

Fig. 334. ST PETER NOLASCO. 1641-1658. Castellón de la Plana: Convent of the Capuchin Nuns. Cat. No. 352.

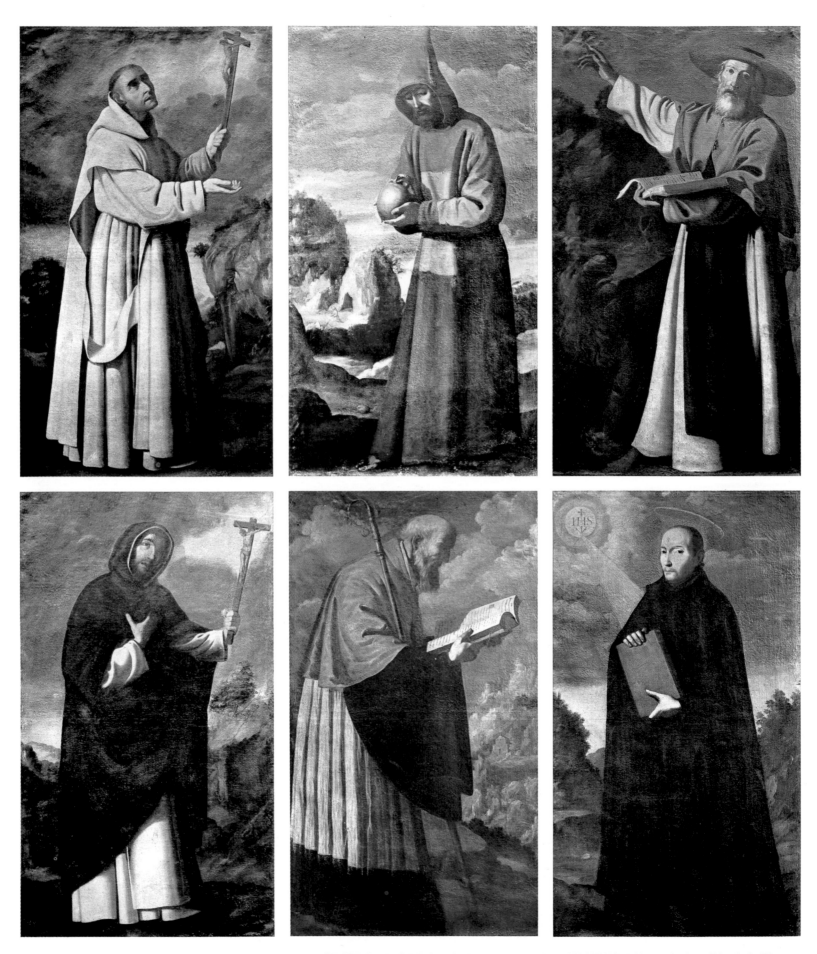

Figs. 335 to 340. ST BRUNO, ST FRANCIS OF ASSISI, ST JEROME, ST DOMINIC, ST BASIL, ST IGNATIUS. 1641-1658. Castellón de la Plana: Convent of the Capuchin Nuns. Cat. No. 353-358.

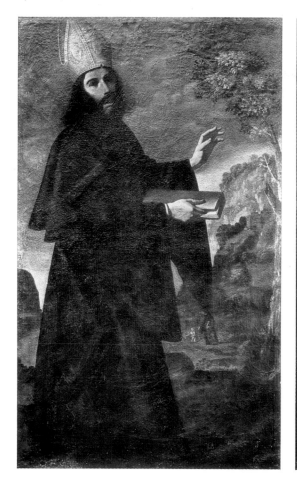
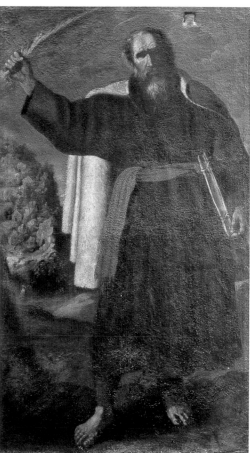
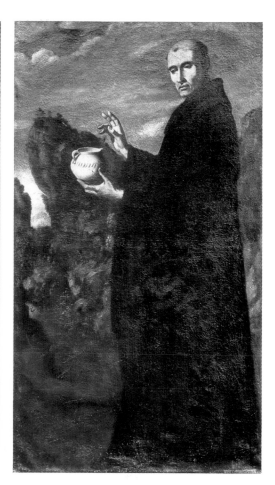
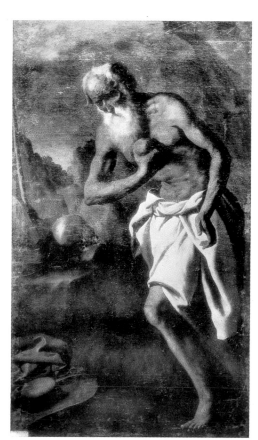
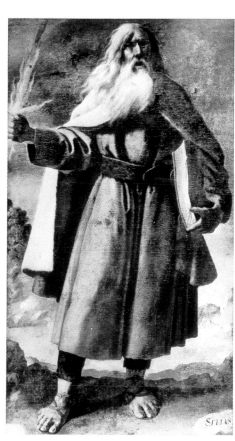
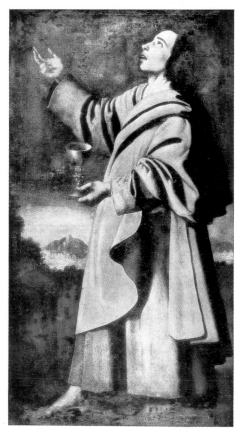

Figs. 341 to 343. ST AUGUSTINE, ST ELIAS, ST BENEDICT. 1641-1658. Castellón de la Plana: Convent of the Capuchin Nuns. Cat. No. 359-361.

Figs. 344 to 346. ST JEROME IN PENITENCE, ST ELIAS, ST JOHN THE EVANGELIST. 1641- 1658. Córdoba: Provincial Museum of Fine Arts. Cat. No. 362-364.

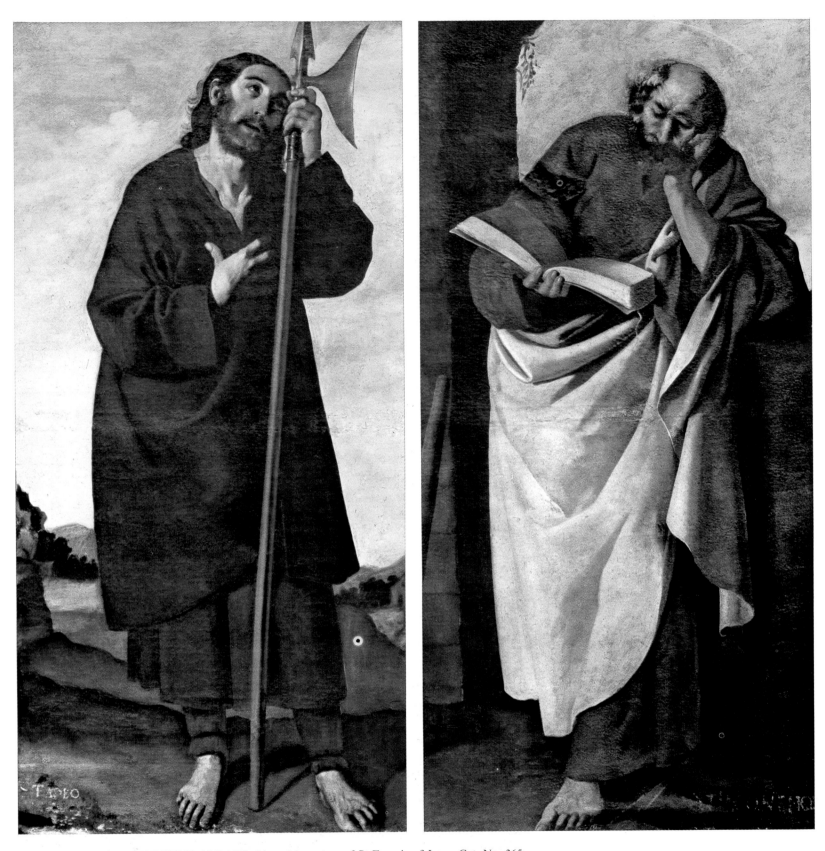

Fig. 347. ST JUDE THADDEUS. 1641-1658. Lima: Monastery of St Francis of Jesus. Cat. No. 365.
Fig. 348. ST JAMES THE LESS. 1641-1658. Lima: Monastery of St Francis of Jesus. Cat. No. 366.

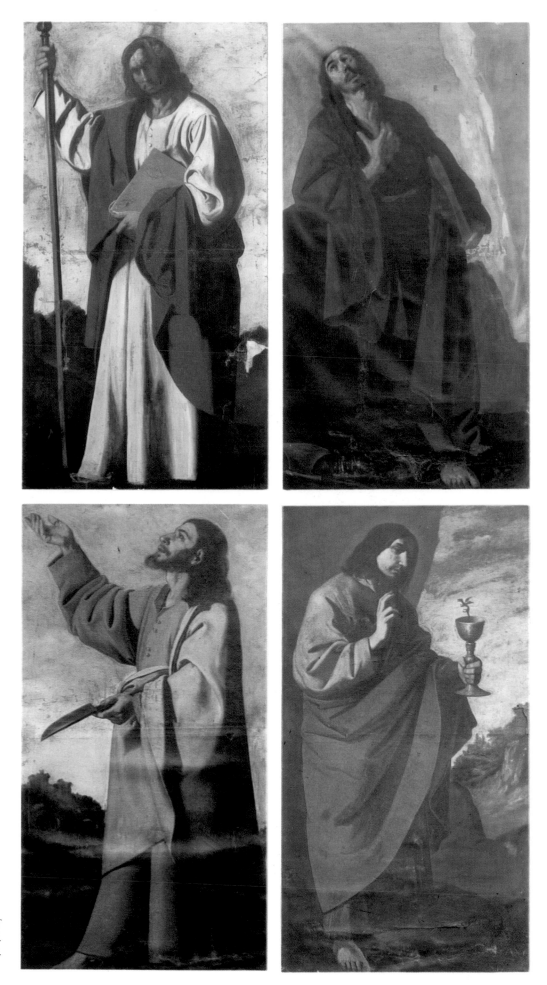

Figs. 349 to 352. ST THOMAS, ST MATTHIAS, ST
BARTHOLOMEW, ST JOHN THE EVANGELIST.
1641-1658. Lima: Monastery of St Francis of Jesus. Cat.
No. 367-370.

331

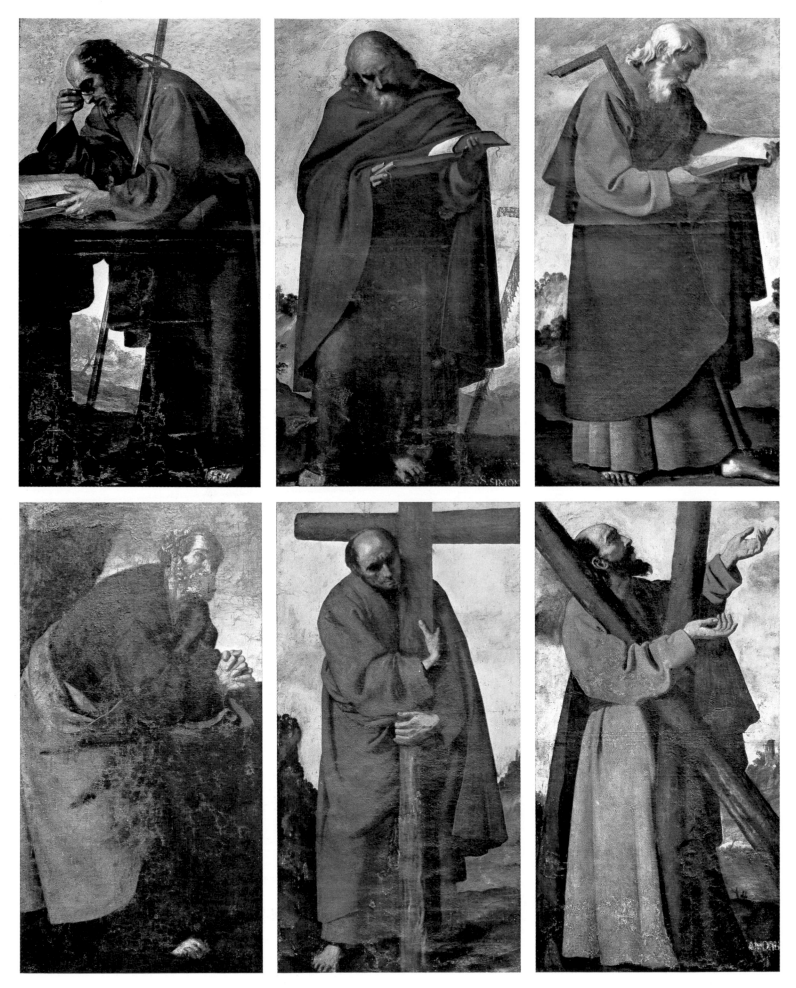

Figs. 353 to 358. ST PAUL, ST SIMON, ST MATTHEW, ST PETER, ST PHILIP, ST ANDREW. 1641-1658. Lima: Monastery of St Francis of Jesus. Cat. No. 371-376.

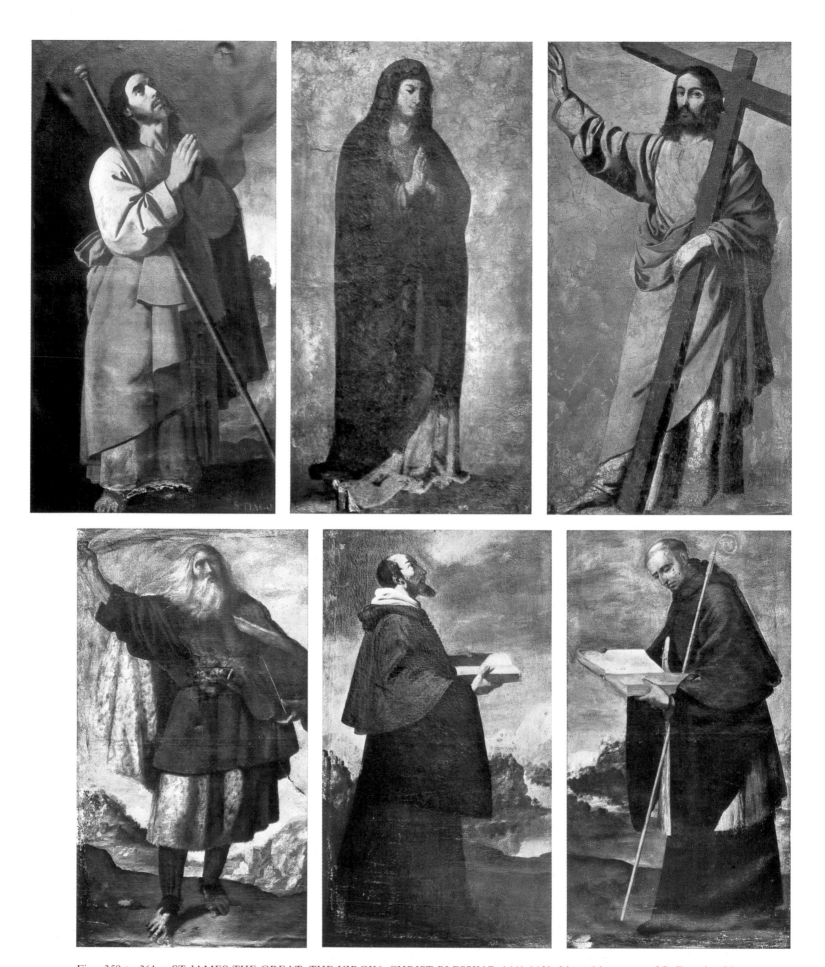

Figs. 359 to 361. ST JAMES THE GREAT, THE VIRGIN, CHRIST BLESSING. 1641-1658. Lima: Monastery of St Francis of Jesus.
Cat. No. 377-379.
Figs. 363 to 364. ST ELIAS, ST AUGUSTINE, ST BASIL. 1641-1658. Lima: Monastery of St Camillus de Lellis (or of the Holy Death).
Cat. No. 380-382.

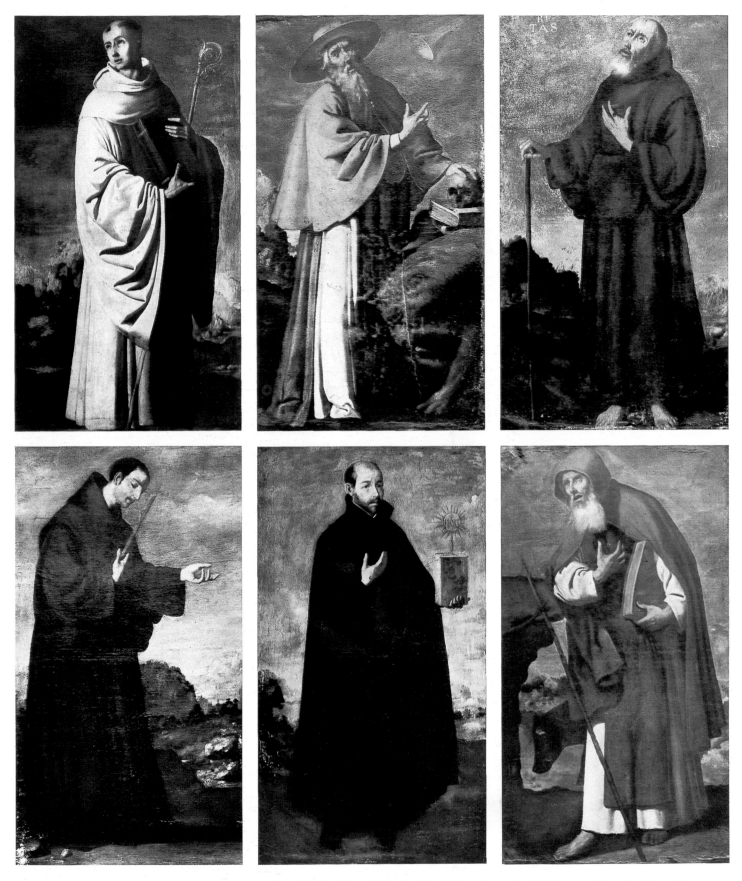

Figs. 365 to 370. ST BERNARD OF CLAIRVAUX, ST JEROME, ST FRANCIS OF PAOLA, ST JOHN OF GOD, ST IGNATIUS
LOYOLA, ST ANTHONY ABBOT. 1641-1658. Lima: Monastery of St Camillus de Lellis (or of the Holy Death). Cat. No. 383-388.

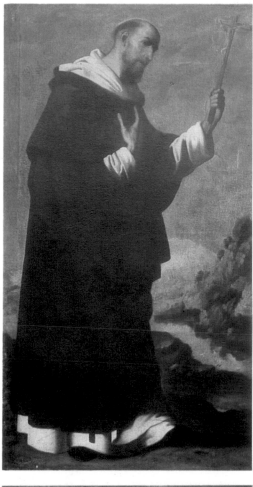

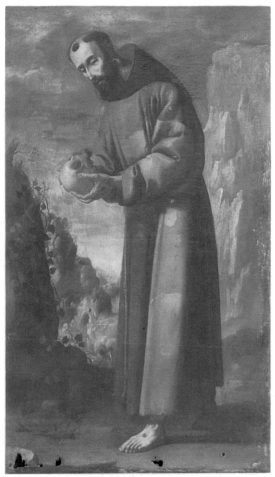

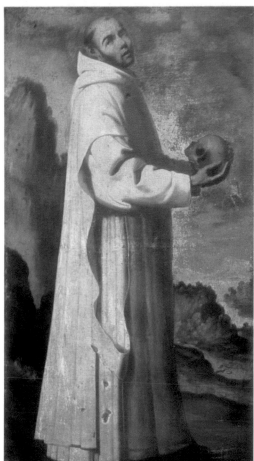

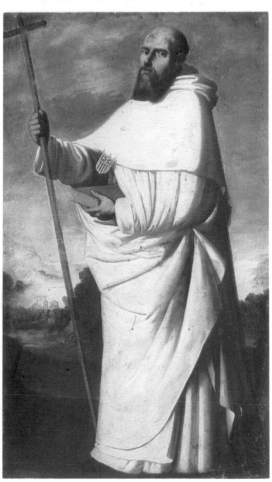

Figs. 371 to 374. ST DOMINIC, ST FRANCIS OF
ASSISI, ST BRUNO, ST PETER NOLASCO. 1641-
1658. Lima: Monastery of St Camillus de Lellis (or of
the Holy Death). Cat. No. 389-392.

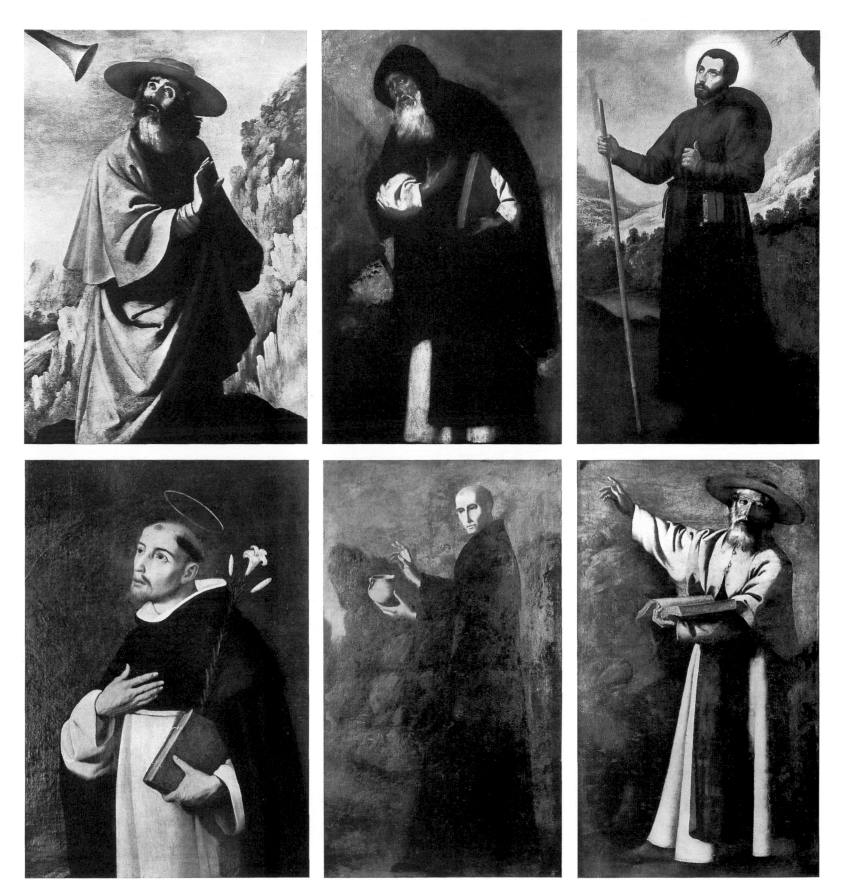

Fig. 375. ST JEROME. 1641-1658. London: T. Harris. Cat. No. 399.

Fig. 376. ST ANTHONY ABBOT. 1641-1658. Madrid: Marqués de Casa Torres. Cat. No. 400.

Fig. 377. ST FRANCIS XAVIER. 1641-1658. Madrid: Museo Románico. Cat. No. 401.

Fig. 378. ST DOMINIC. 1641-1658. Seville: University. Cat. No. 402.

Figs. 379 & 380. ST BENEDICT, ST JEROME. 1641-1658. Málaga: Provincial Museum of Fine Arts. Cat. No. 403 & 404.

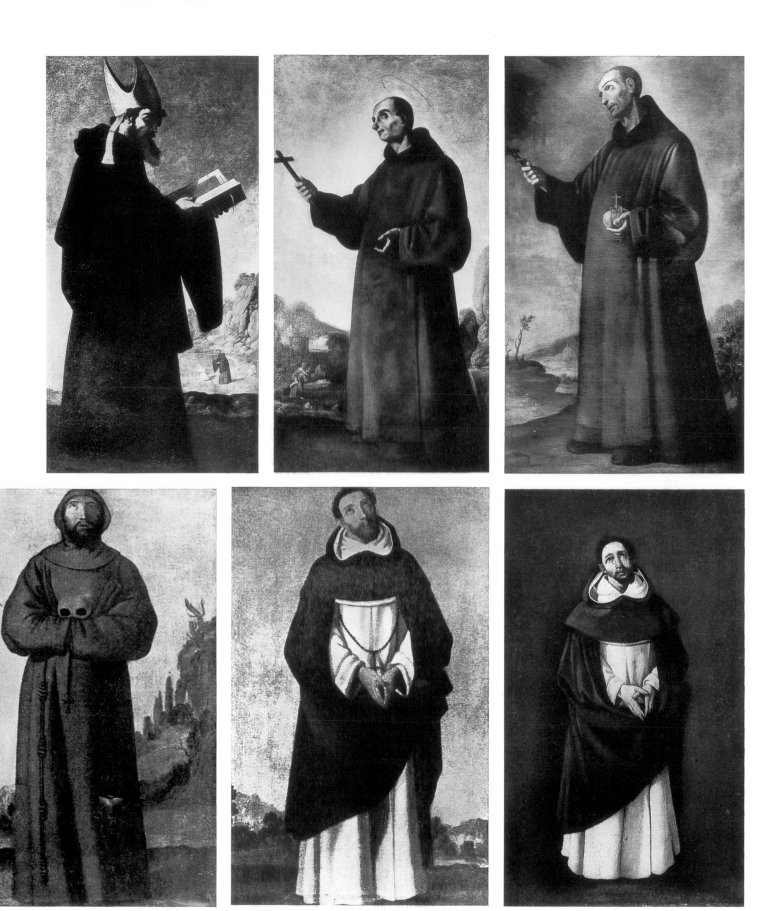

Figs. 381 & 382. ST AUGUSTINE, ST JOHN OF GOD. 1641-1658. Mexico City: Academy of Fine Arts of San Carlos. Cat. No. 405 & 406.

Fig. 383. ST JOHN OF GOD. 1641-1658. Seville: Provincial Museum of Fine Arts. Cat. No. 413.

Figs. 384 & 385. ST FRANCIS OF ASSISI, ST DOMINIC. 1641-1658. Tlaxcala: Franciscan Monastery. Cat. No. 415 & 416.

Fig. 386. ST DOMINIC. 1641-1658. Barcelona: Ricardo Viñas. Cat. No. 417.

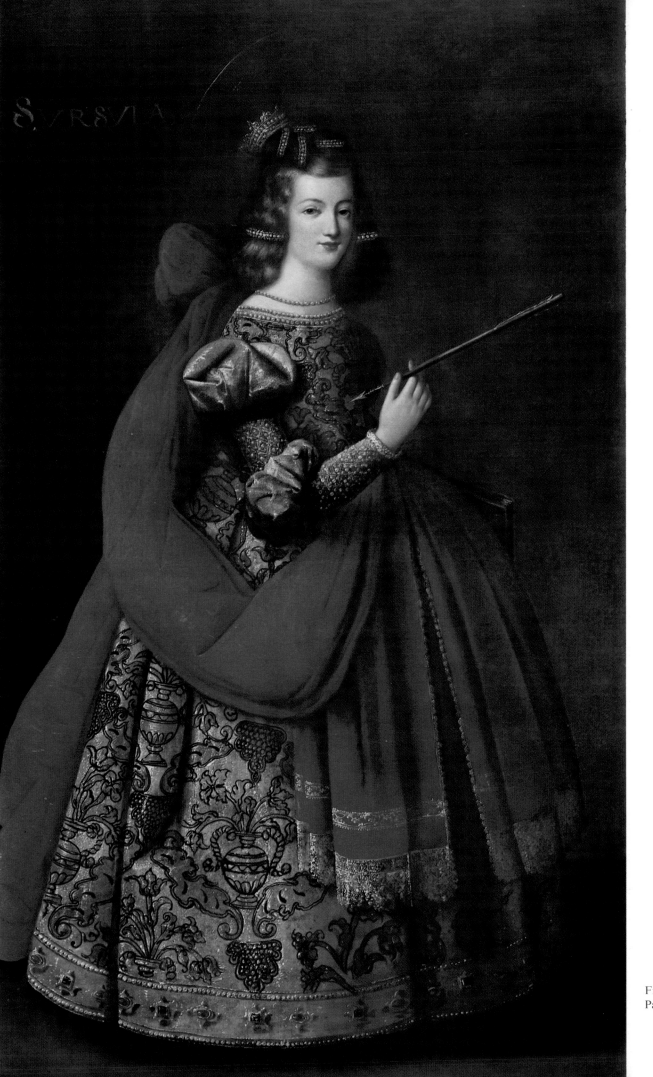

Fig. 387. ST URSULA. 1641-1658.
Paris: private collection. Cat. No. 421.

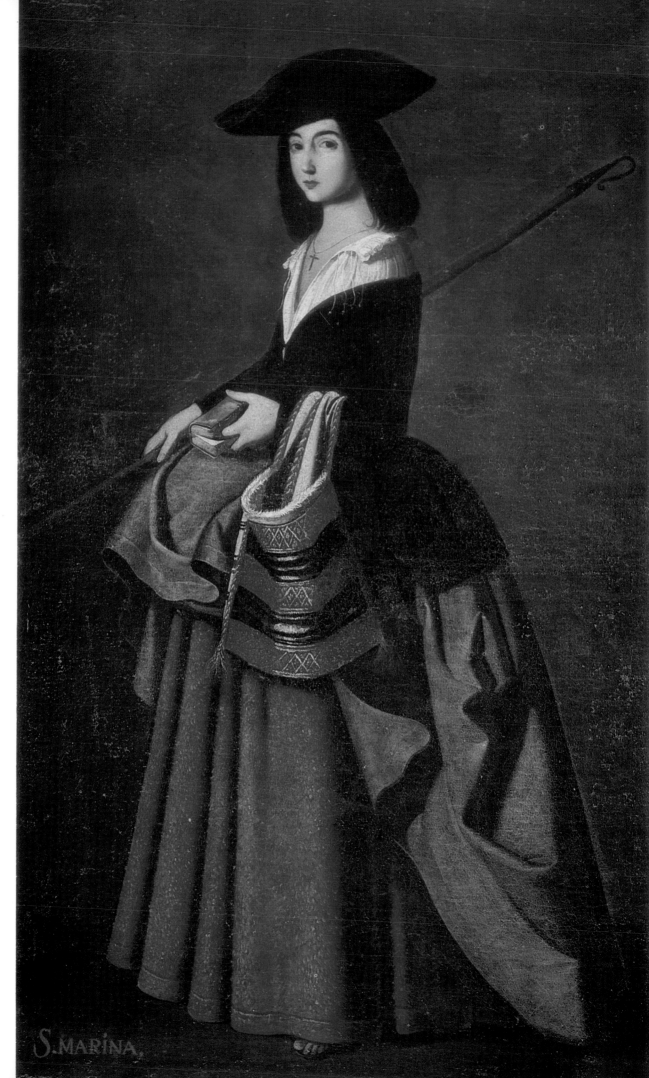

S. MARINA,

Fig. 388. ST MARINA. 1641-1658.
Seville: Provincial Museum of Fine
Arts. Cat. No. 422.

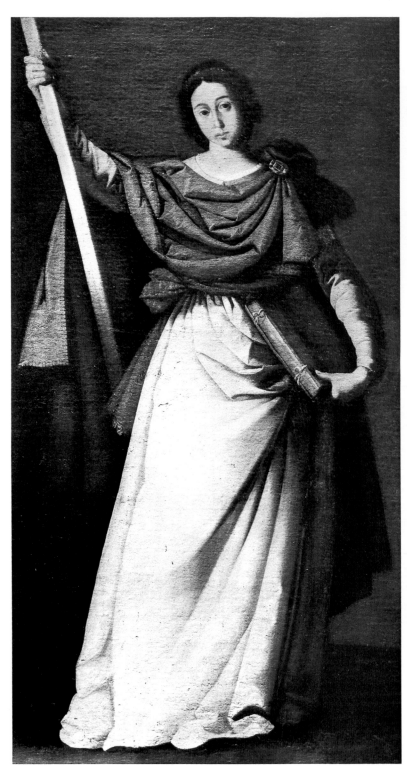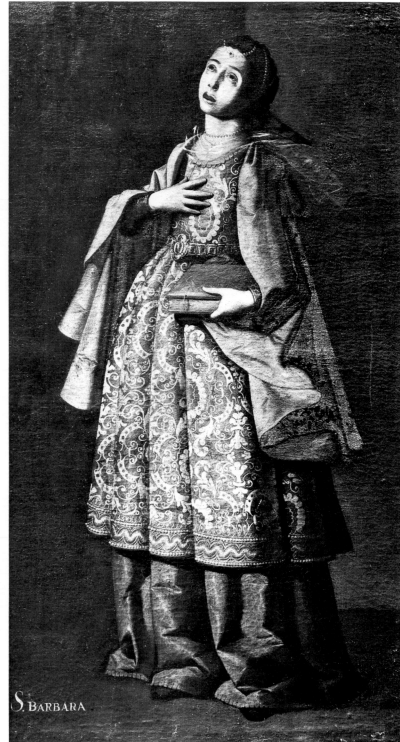

Fig. 389. ST EULALIA. 1641-1658. Seville: Provincial Museum of Fine Arts. Cat. No. 423.
Fig. 390. ST BARBARA. 1641-1658. Seville: Provincial Museum of Fine Arts. Cat. No. 424.

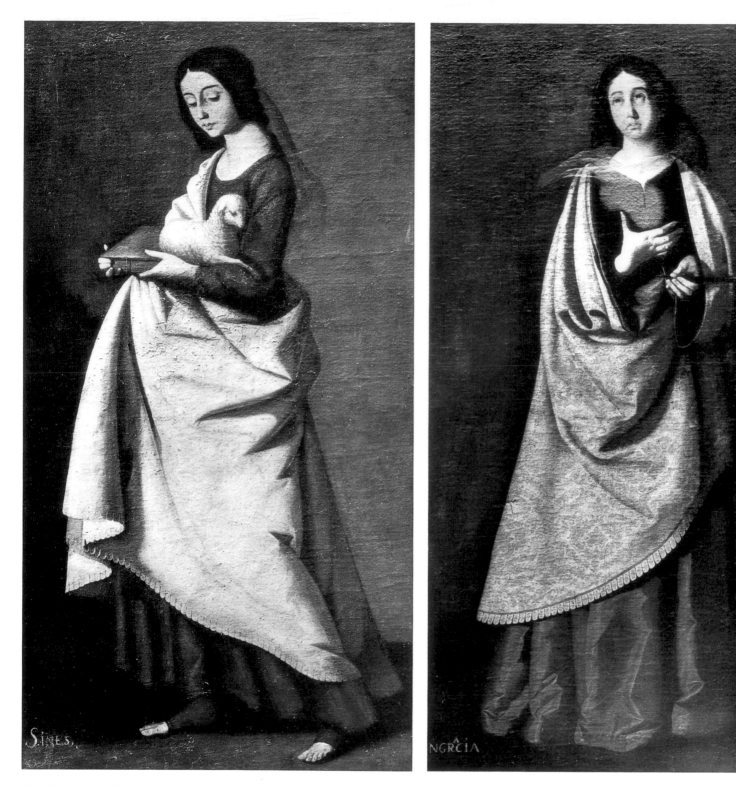

Fig. 391. ST AGNES. 1641-1658. Seville: Provincial Museum of Fine Arts. Cat. No. 425.
Fig. 392. ST ENGRACIA. 1641-1658. Seville: Provincial Museum of Fine Arts. Cat. No. 426.

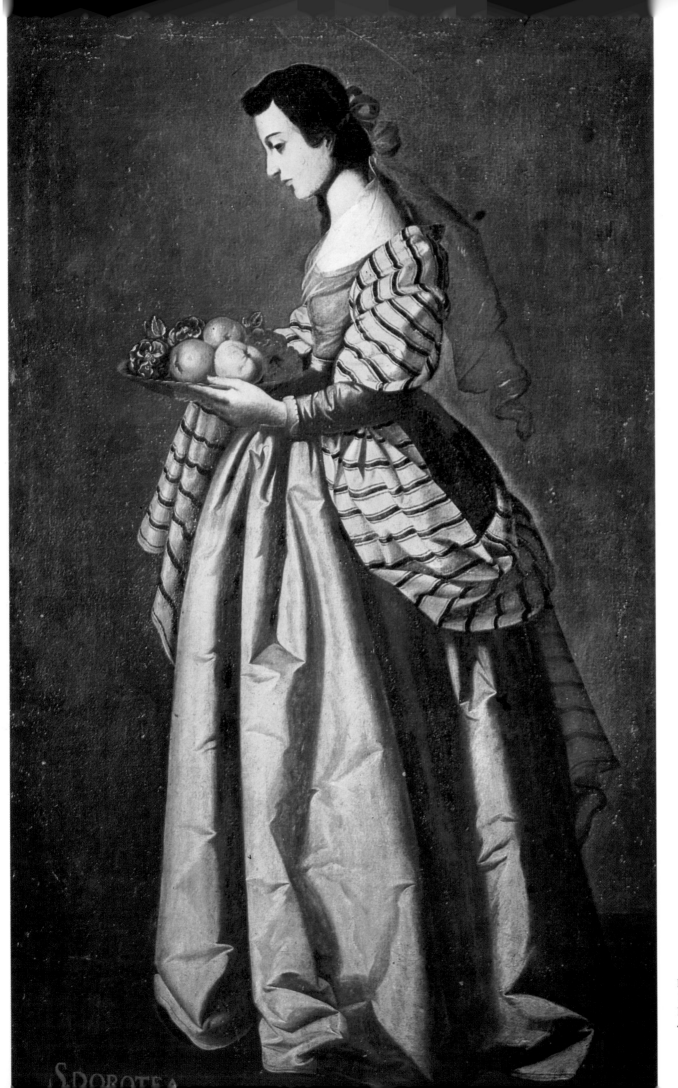

Fig. 393. ST DOROTHY. 1641-1658. Seville: Provincial Museum of Fine Arts. Cat. No. 427.

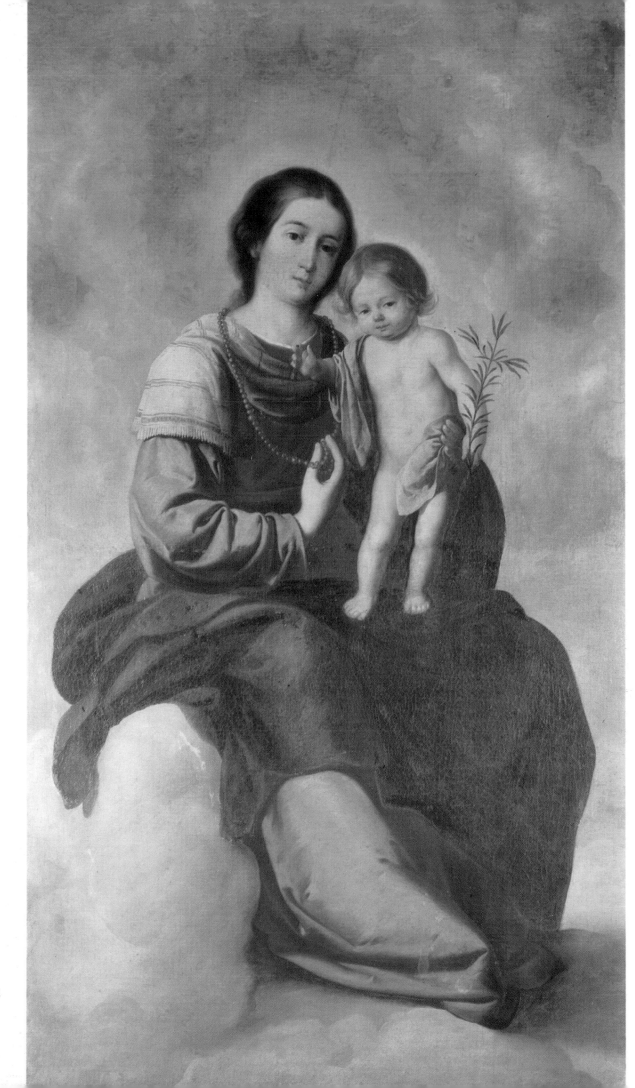

Fig. 394. OUR LADY OF THE
ROSARY. 1641-1658. Seville: Provincial
Museum of Fine Arts. Cat. No. 428.

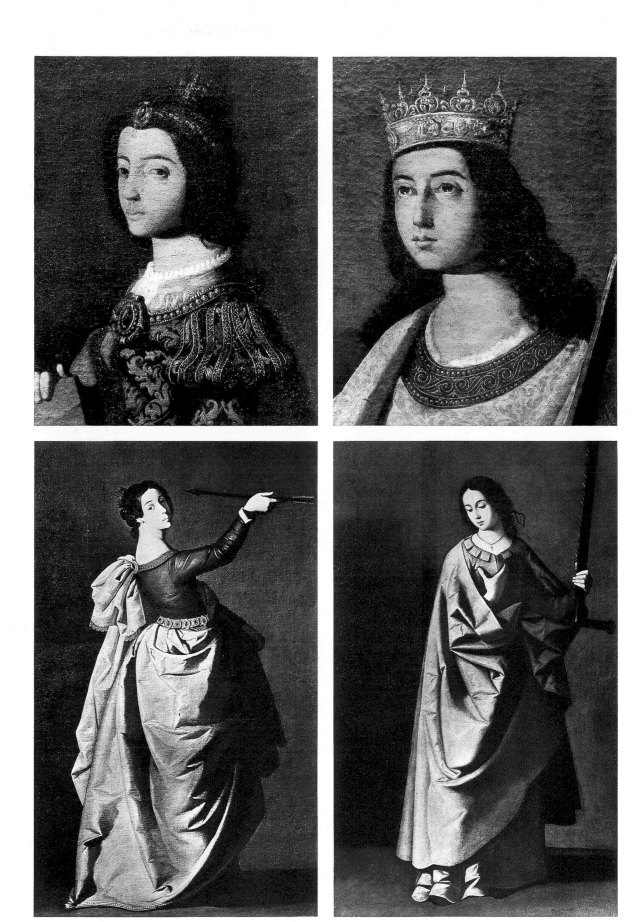

Fig. 395. ST MATILDA (detail). 1641-1658. Seville: Provincial Museum of Fine Arts. Cat. No. 429.
Fig. 396. ST CATHERINE (detail). 1641-1658. Seville: Provincial Museum of Fine Arts. Cat. No. 430.
Fig. 397. ST URSULA. 1641-1658. Genoa: Palazzo Bianco. Cat. No. 432.
Fig. 398. ST EUPHEMIA. 1641-1658. Genoa: Palazzo Bianco. Cat. No. 433.

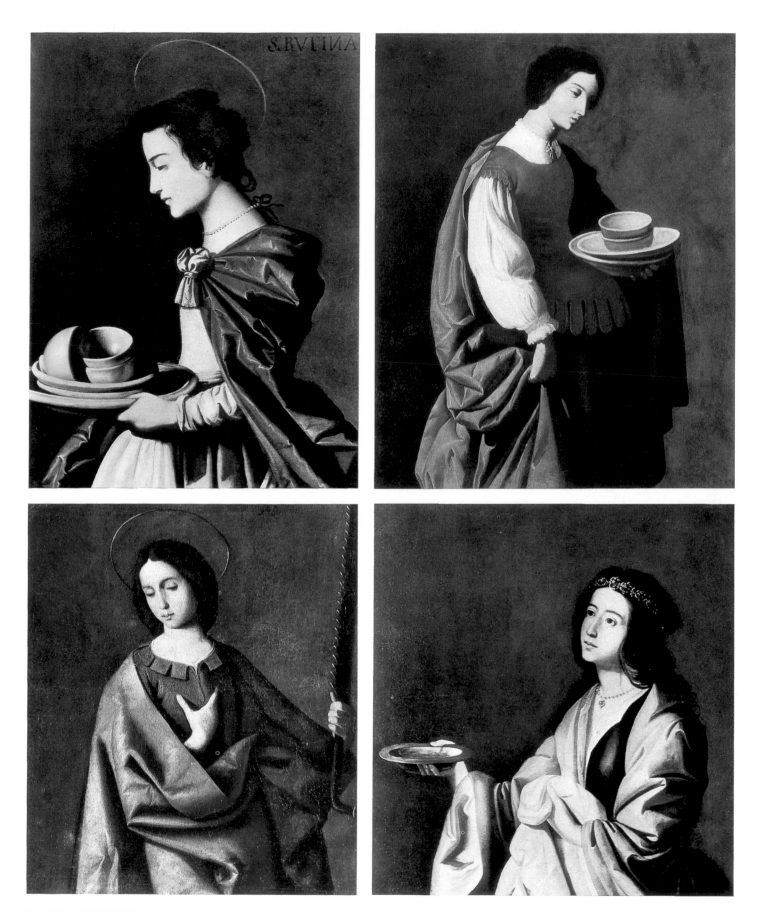

Fig. 399. ST RUFINA. 1641-1658. Cambridge: Fitzwilliam Museum. Cat. No. 434.
Fig. 400. ST JUSTA. 1641-1658. Paris: Kugel Collection. Cat. No. 435.
Fig. 401. ST EUPHEMIA. 1641-1658. Madrid: Prado Museum. Cat. No. 436.
Fig. 402. ST LUCY. 1641-1658. New York: Hispanic Society of America. Cat. No. 437.

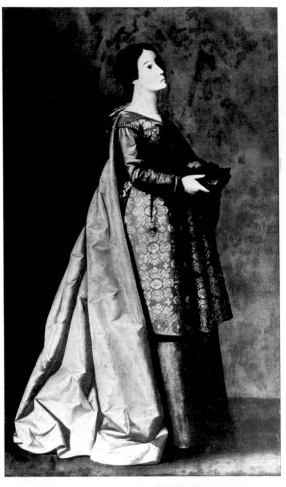

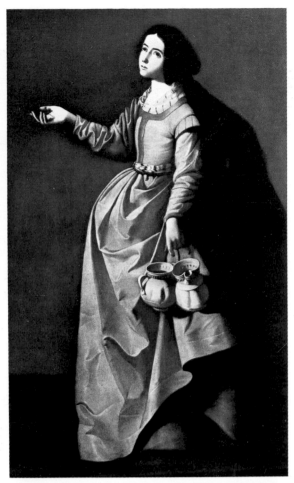

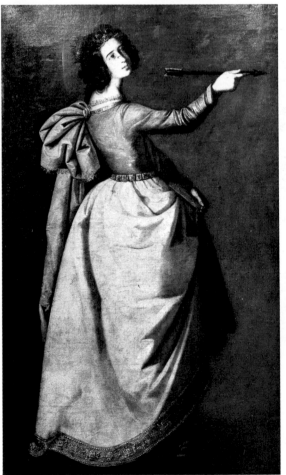

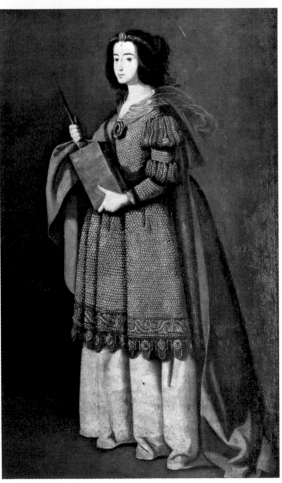

Fig. 403. ST RUFINA. 1641-1658. New York: Hispanic Society of America. Cat. No. 438.

Fig. 404. ST JUSTA. 1641-1658. Dublin: National Gallery of Ireland. Cat. No. 439.

Fig. 405. ST URSULA. 1641-1658. Strasbourg: Musée des Beaux-Arts. Cat. No. 441.

Fig. 406. ST CRISTINA. 1641-1658. Strasbourg: Musée des Beaux-Arts. Cat. No. 442.

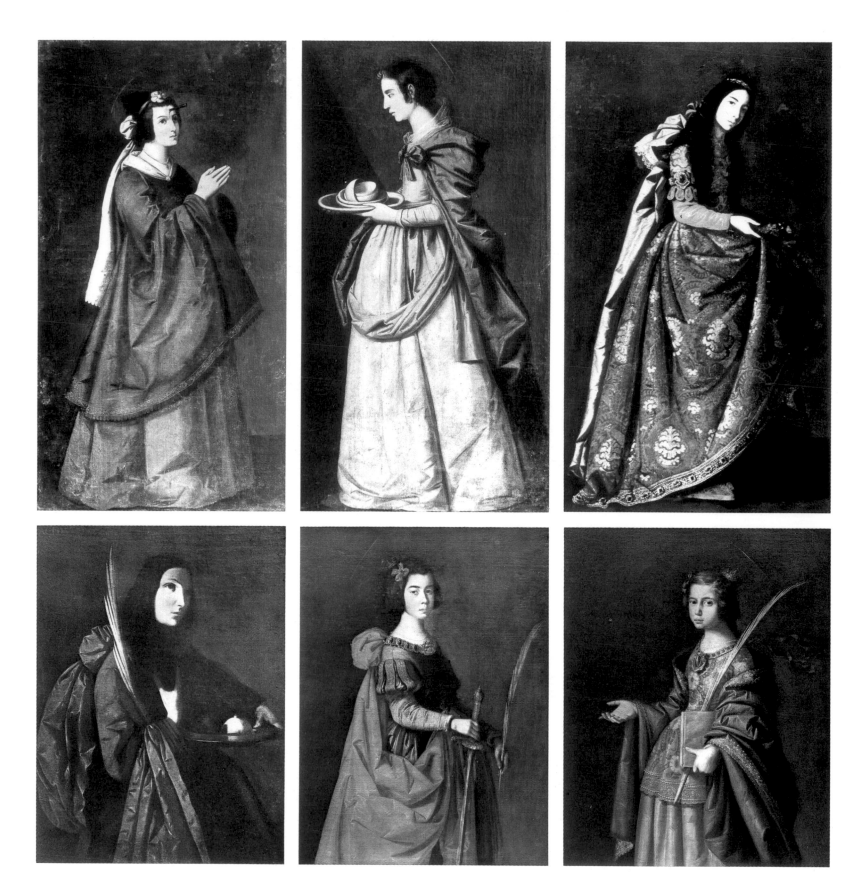

Fig. 407. ST ENGRACIA. 1641-1658. Seville: Cathedral. Cat. No. 443.

Fig. 408. ST RUFINA. 1641-1658. Seville: Cathedral. Cat. No. 444.

Fig. 409. ST ELIZABETH OF PORTUGAL. 1641-1658..Montreal: Sir William van Horne. Cat. No. 445.

Fig. 410. ST AGATHA. 1641-1658. Bilbao: Elosegui Collection. Cat. No. 448.

Fig. 411. ST CATHERINE. 1641-1658. Bilbao: Provincial Museum of Fine Arts. Cat. 450.

Fig. 412. ST ELIZABETH OF THURINGIA. 1641-1658. Bilbao: Provincial Museum of Fine Arts. Cat. No. 451.

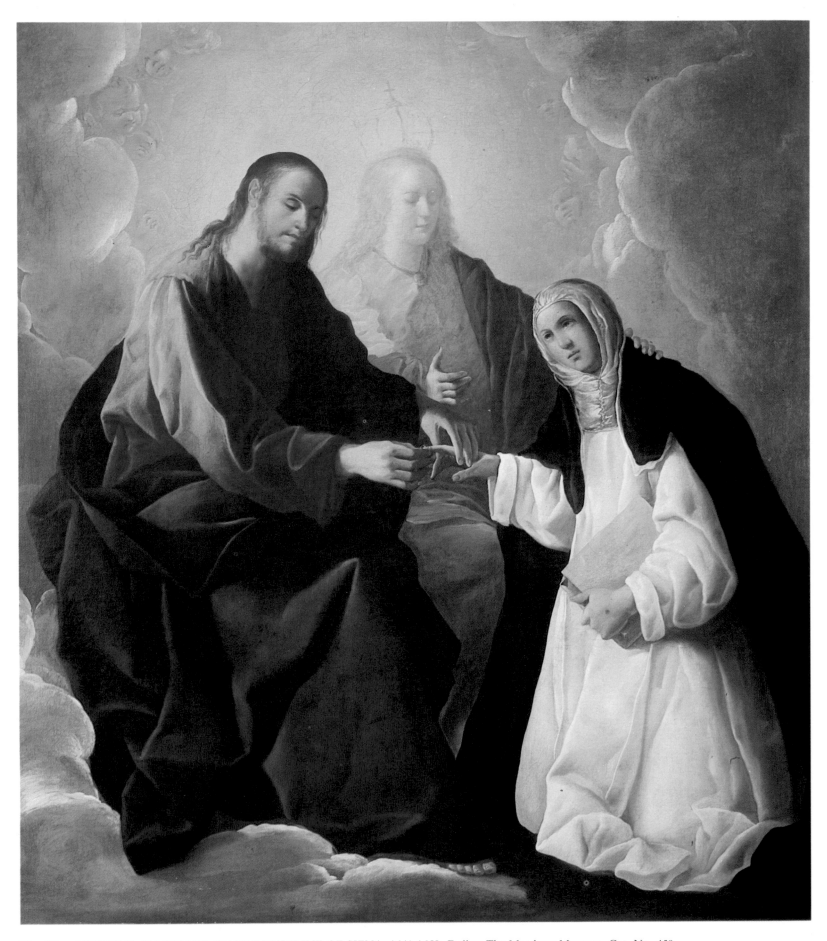

Fig. 413. MYSTICAL MARRIAGE OF ST CATHERINE OF SIENA. 1641-1658. Dallas: The Meadows Museum. Cat. No. 459.

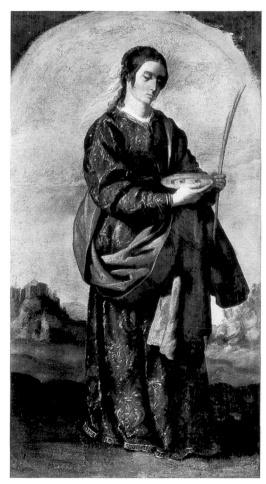
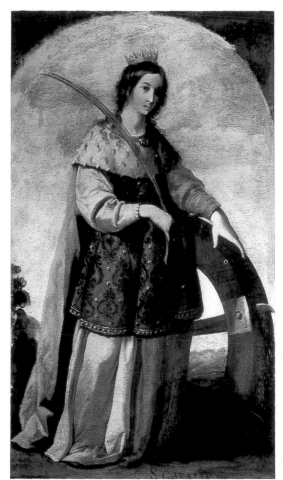
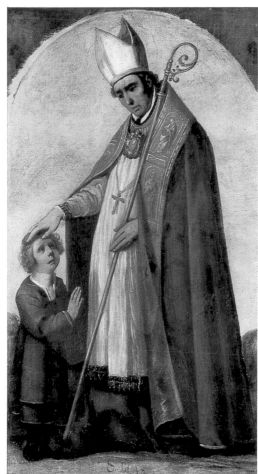
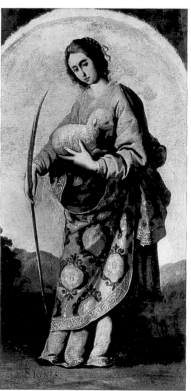
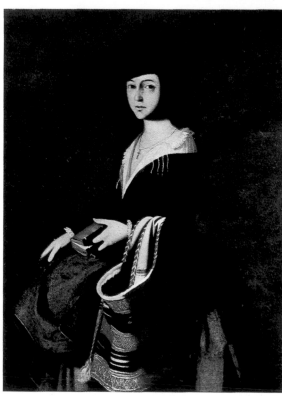
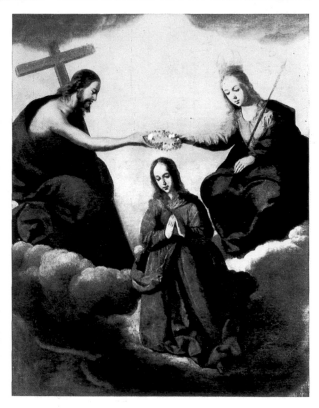

Figs. 414 to 417. ST LUCY, ST CATHERINE, ST BLAISE, ST AGNES. 1641-1658. Bolullos de la Mitación: Parish Church. Cat. No. 460-463.

Fig. 418. ST MARINA. 1641-1658. Madrid: Estate of the Duke of Tovar. Cat. No. 431.

Fig. 419. CORONATION OF ST CATHERINE. 1641-1658. Saint-Amans-Soult: Duke of Dalmacia. Cat. No. 464.

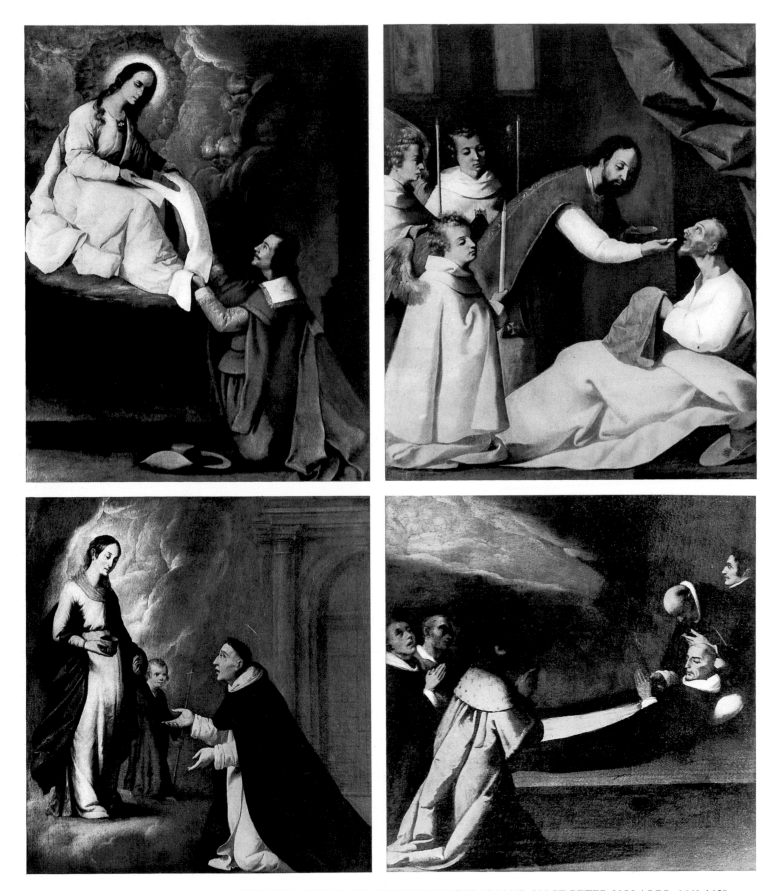

Fig. 420. OUR LADY OF RANSOM BESTOWING THE HABIT OF THE MERCEDARIANS ON ST PETER NOLASCO. 1641-1658.
Saint-Amans-Spult: Duke of Dalmacia. Cat. No. 465.
Fig. 421. MIRACULOUS COMMUNION OF ST PETER NOLASCO. 1641-1658. Saint-Amans-Soult: Duke of Dalmacia. Cat. No. 466.
Fig. 422. APPARITION OF THE VIRGIN TO ST DOMINIC. 1641-1658. Saint-Amans-Soult: Kuke of Dalmacia. Cat. No. 467.
Fig. 423. DEATH OF ST DOMINIC. 1641-1658. Saint-Amans-Soult: Duke of Dalmacia. Cat. No. 468.

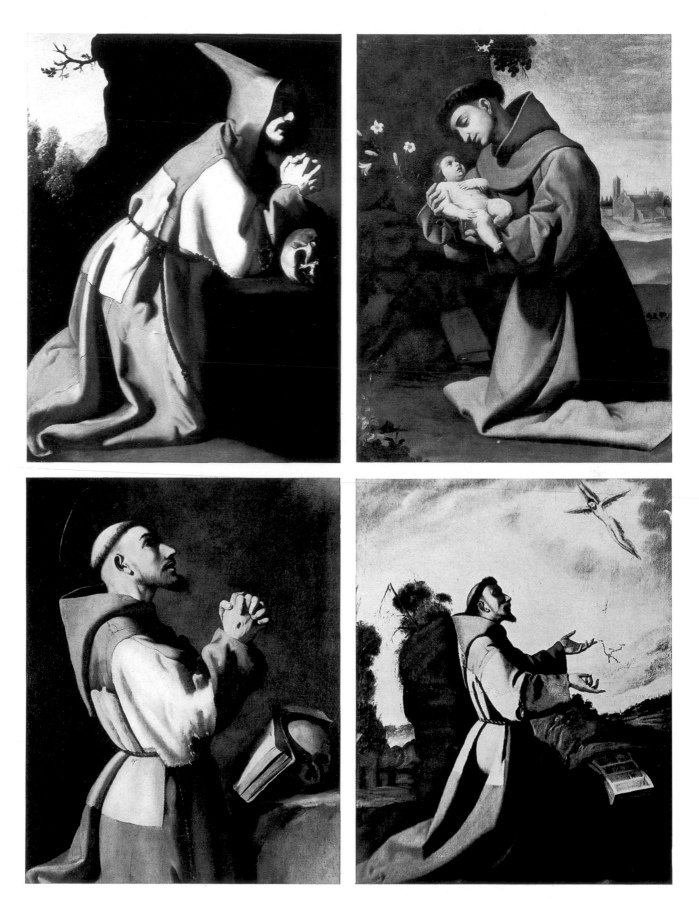

Fig. 424. ST FRANCIS KNEELING. 1641-1658. Los Angeles: The Norton Simon Foundation. Cat. No. 472.
Fig. 425. ST ANTHONY OF PADUA. 1641-1658. Madrid: Prado Museum. Cat. No. 473.
Fig. 426. ST FRANCIS IN PRAYER. 1641-1658. Barcelona: Puig Palau. Cat. No. 474.
Fig. 427. ST FRANCIS RECEIVING THE STIGMATA. 1641-1658. Bogotá: Monastery of San Francisco. Cat. No. 475.

Fig. 428. BENJAMIN. 1641-1658. Grimsthorpe Castle: Earl of Ancaster. Cat. No. 477.

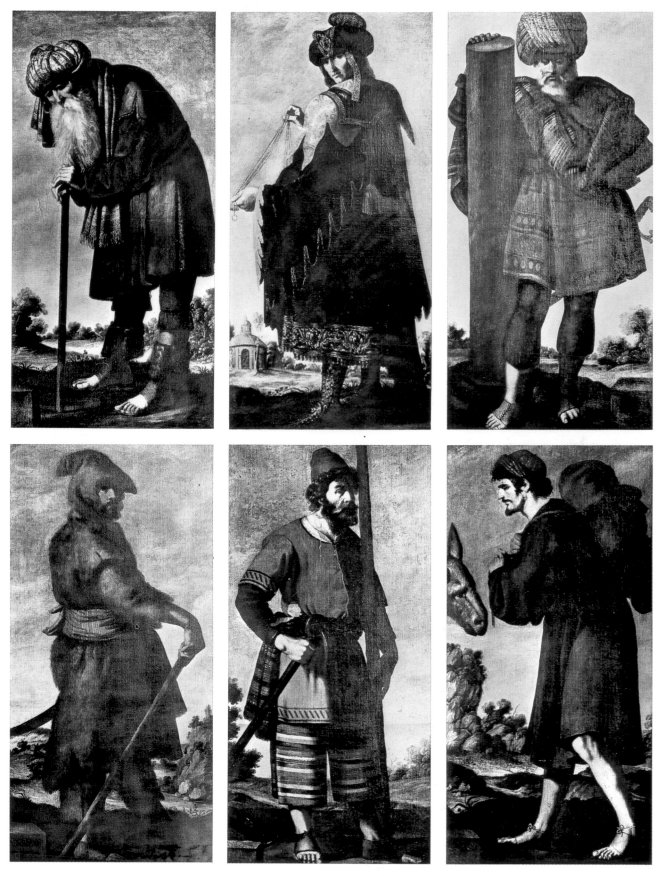

Figs. 429 to 434. JACOB, LEVI, REUBEN, SIMEON, ZEBULUN, ISSACHAR. 1641-1658. Auckland Castle:
Bishop of Durham. Cat. No. 478-483.

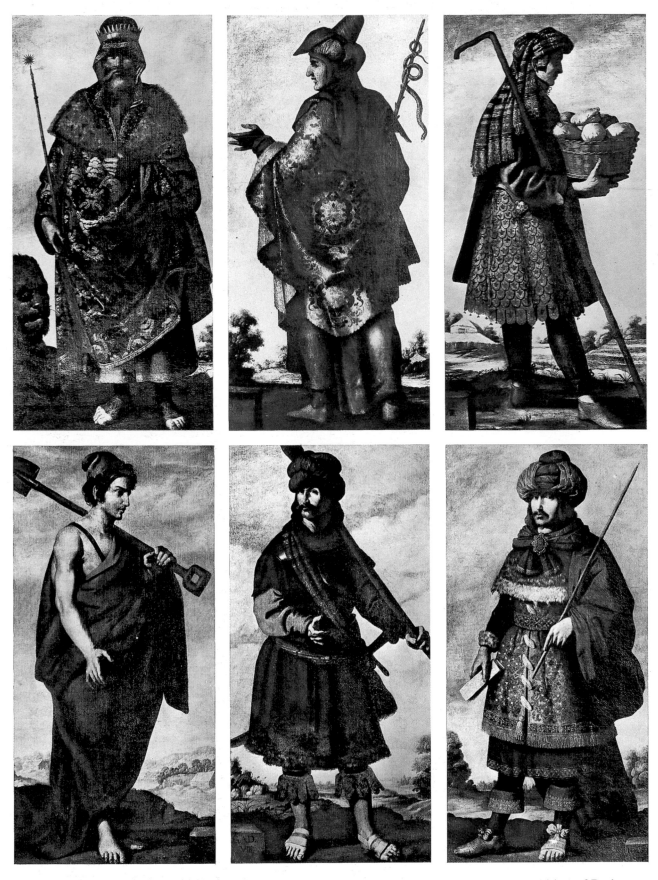

Figs. 435 to 440. JUDAH, DAN, ASHER, NAPHTALI, GAD, JOSEPH. 1641-1658. Auckland Castle: Bishop of Durham.
Cat. No. 484-489.

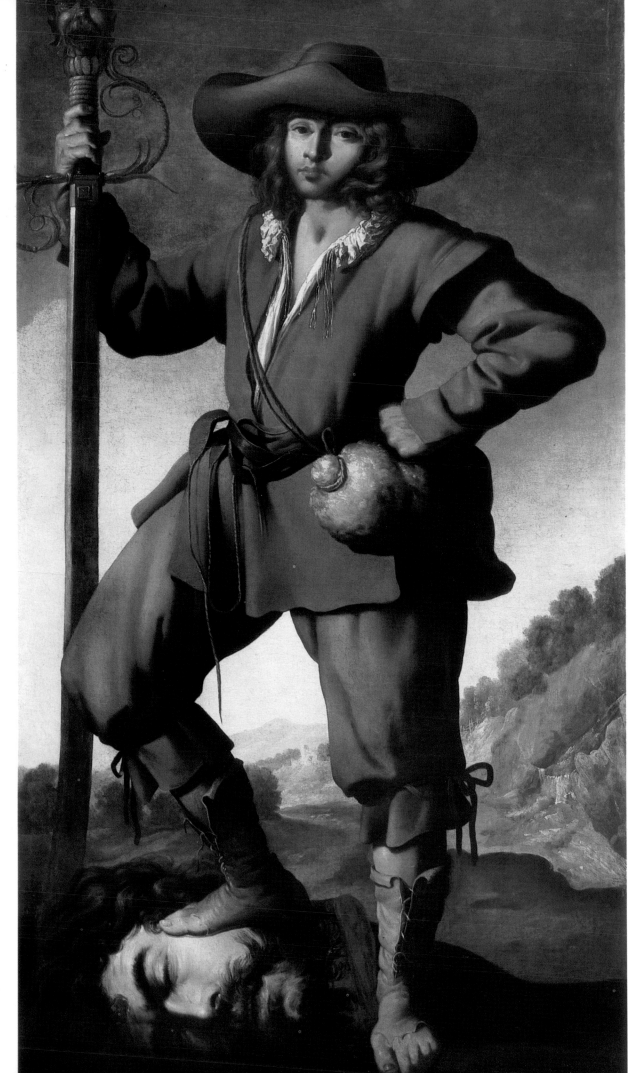

Fig. 441. DAVID. 1641-1658. Madrid: private collection. Cat. No. 490.

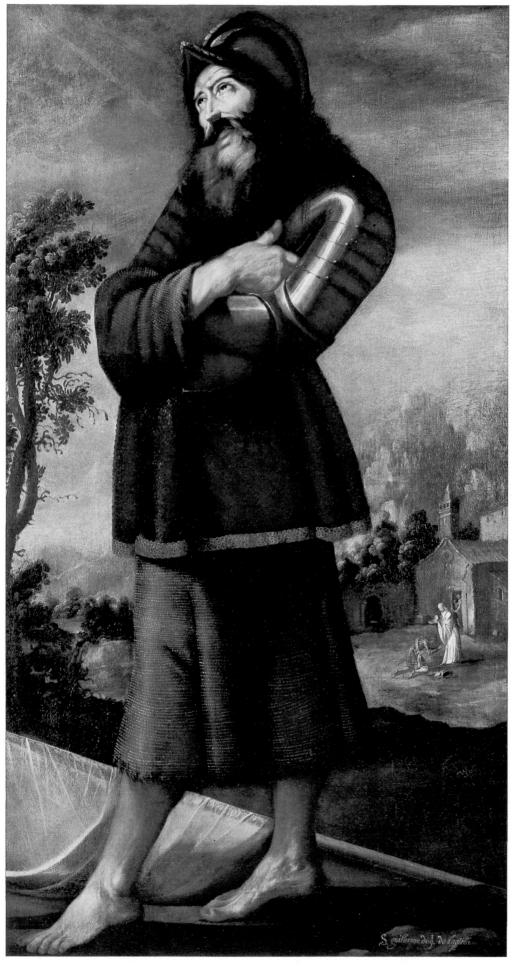

Fig. 442. ST WILLIAM OF AQUITAINE. 1641-1658.
Paris: private collection. Cat. No. 491.

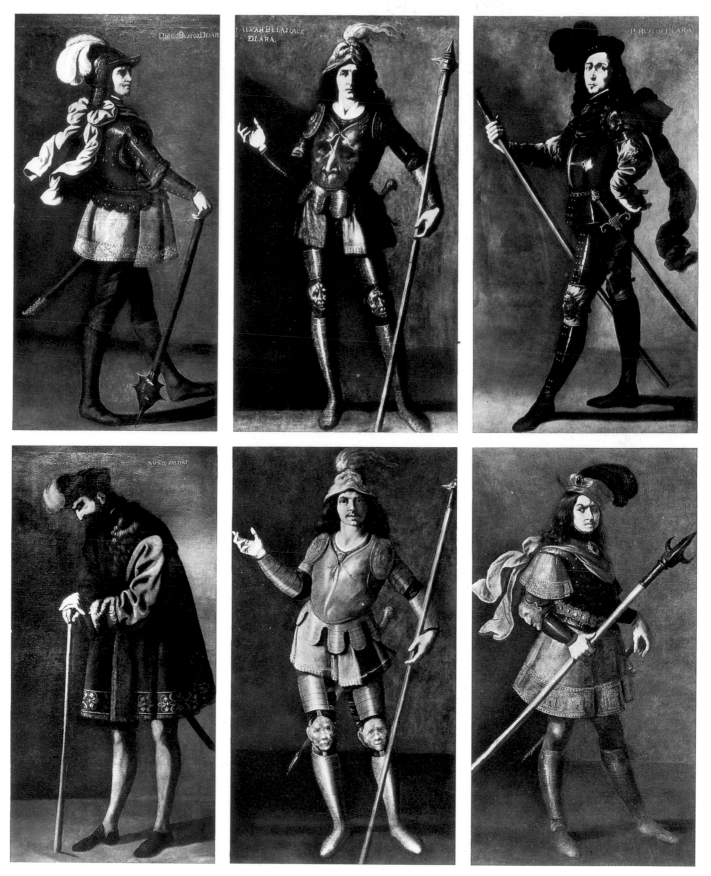

Fig. 443. DIEGO BUSTOS DE LARA. 1641-1658. Seville: Conde de Bustillo. Cat. No. 493.
Fig. 444. ALVAR BLASQUEZ DE LARA. 1641-1658. Castres: Musée Goya. Cat. No. 494.
Fig. 445. P. BUSTOS DE LARA. 1641-1658. New York: Julius Weitzner. Cat. No. 495.
Fig. 446. NUÑO SALIDO. 1641-1658. Madrid: Clara de Gaztelo y Jácome. Cat. No. 496.
Fig. 447. INFANTE. 1641-1658. Mexico City: Franz Mayer. Cat. No. 499.
Fig. 448. INFANTE. 1641-1648. Mexico City: Franz Mayer. Cat. No. 500.

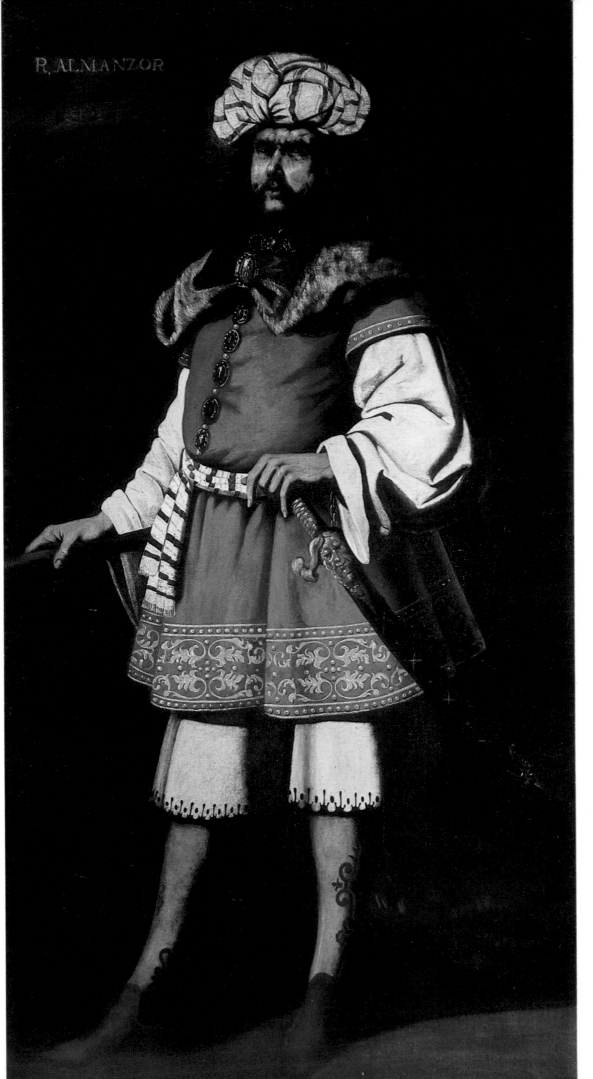

R. ALMANZOR

Fig. 449. ALMANZOR. 1641-1658. Madrid: private collection. Cat. No. 497.

1658. May. Francisco de Zurbarán moves to Madrid.

1658. 4 July. In the church fund ledgers of the parish of Peñaranda de Bracamonte the following delivery note appears: "Two large images with their frames, one a nativity and the other of the Incarnation, sent by my lord the Count" (Gaspar de Bracamonte, Conde de Peñaranda). (Cat. No. 528; Figs. 467 & 482).

1658. 23 December. Francisco de Zurbarán is called as a witness on behalf of Diego de Silva Velázquez in the proceedings initiated for the latter's admission to the Order of St James. He also declares that he has been in the capital "for the last seven months".

1658. *The Virgin and Child with St John*. Canvas inscribed: "Fran^{co} de Zurbaran/1658" (Cat. No. 513; Figs. 450 & 515).

1658. *Immaculate Conception*. Canvas signed and dated in 1658 (Cat. No. 514; Fig. 451).

1658. *The Virgin of the Milk*. Canvas inscribed: "Fran^{co} de Zurbaran 1658" (Cat. No. 515; Fig. 452).

1658. *Veil of St Veronica*. Canvas inscribed: "Fran^{co} Dezurbaran/1658" (Cat. No. 516; Figs. 453 & 454).

1659. Leonor de Tordera, Manuela de Zurbarán and two servants are registered in the census as living in the Calle de Abades in Seville.

1659. *The Repentance of St Peter*. Canvas inscribed: "Fran^{co} de Zurbaran fec/1659" (Cat. No. 517; Fig. 455).

1659. *Virgin with Sleeping Child*. Canvas inscribed: "Fran^{co} de Zurbaran/1659" (Cat. No. 518; Fig. 456).

1659. *The Holy Family*. Canvas inscribed: "Fran^{co} de Zur/baran f./1659" (Cat. No. 519; Fig. 457).

1659. *St Francis Kneeling*. Canvas inscribed: "Fran^{co} de Zurbaran/1659" (Cat. No. 520; Fig. 458).

1660. 28 September. Francisco de Zurbarán, "formerly a resident of the city of Seville and at present Residing in this Court and Town of Madrid", authorizes Martín Rico Caçerreta to collect, in Buenos Aires, all the proceeds of the sale of sixty-three canvases, six pounds of colours and several paint-brushes, sent by the artist to Felipe de Atienza and Alvaro Gómez in February 1649 (see receipt dated 28 February 1649).

1661. *The Portiuncula*. Canvas inscribed: "Fran^{co} de Zurbaran/1661" (Cat. No. 521; Figs. 459 & 516).

1661. *Christ after the Scourging*. Canvas inscribed: "Fran^{co} de Zurbarán 1661" (Cat. No. 522; Fig. 460).

1661. *Immaculate Conception*. Canvas inscribed: "Fran^{co} de Zurbarán facie/1661" (Cat. No. 523; Fig. 462).

1661. *Immaculate Conception*. Canvas inscribed: "Fran de Zurbaran f/1661" (Cat. No. 524; Figs. 463 & 517).

1661. *Christ Carrying the Cross,* half-length, signed by Zurbarán in 1661. Mentioned by Ceán as being in the sacristy of the monastery of the Discalced Carmelites in Madrid, together with a similar canvas in the chapel of St Teresa and the picture crowning the retable of St Bruno.

1662. 2 January. Letter from Zurbarán to the Bishop of Badajoz, in which he requests permission to postpone delivery of a commission (a St Anthony, two large pictures for chapels in the cathedral and another for the chapel in the Bishop's Palace) "and as regards the prices that Your Lordship offers me, though they are not very generous, we can come to an arrangement to raise them a little and thus between us do good work, for in such paintings good work cannot be done cheaply". Zurbarán also speaks of doing a great deal of work for the King.

1662. *The Virgin and Child with St John*. Canvas inscribed: "Fran^{co} de Zurbaran/1662" (Cat. No. 525; Fig. 461).

1662. Zurbarán does some paintings for the church of Santo Domingo in Atocha (Madrid).

1662. Francisco de Zurbarán grants a power of attorney in yet another attempt to recover from Felipe de Atienza and Alvaro Gómez the proceeds of the sale of sixty-three canvases, several pounds of colours and some paintbrushes sent to Buenos Aires in February 1649. One of the two people authorized this time is his brother-in-law, the ship's captain Miguel Torderas.

1662. In a manuscript work entitled *Memoria de algunos hombres excelentes en las artes del dibujo*, Lázaro Díaz del Valle writes as follows:

"Francisco Zurbarán or Sonarán, a resident of the city of Seville, won fame as a painter in our time with the many works he did, and in particular with those by his hand in the second cloister of the monastery of the Calced Mercedarians

in the said city, depicting the life of St Peter Nolasco, which is a famous work. = he is living in this town of Madrid, in the year 1662."

1663. 1 May. Francisco de Zurbarán and his wife, from Madrid, jointly grant authority to María de Zurbarán, "resident in Seville", permitting her to "transfer, grant and renounce the rights we have to certain principal houses" situated in the Calle de Abades in Seville, rights granted by the Cathedral Chapter of Seville on 14 December 1657.

1664. 13 January. Zurbarán sues Juan Martínez, "merchant trading at the Puerta del Sol", for payment of the 950 reales the latter owes him.

1664. 28 February. Francisco de Zurbarán and Francisco Rici appraise the pictures included in the estate of Francisco Jacinto Salcedo.

1664. 23 July. Francisco de Zurbarán is required to carry out an appraisal of the pictures belonging to the estate of Don Alonso de Santander.

1664. 24 July. Francisco de Zurbarán is commissioned to appraise the pictures in the collection of Francisco Bivoni, the Polish Ambassador in Madrid.

1664. 26 August. Francisco de Zurbarán executes a will in Madrid, one day before his death.

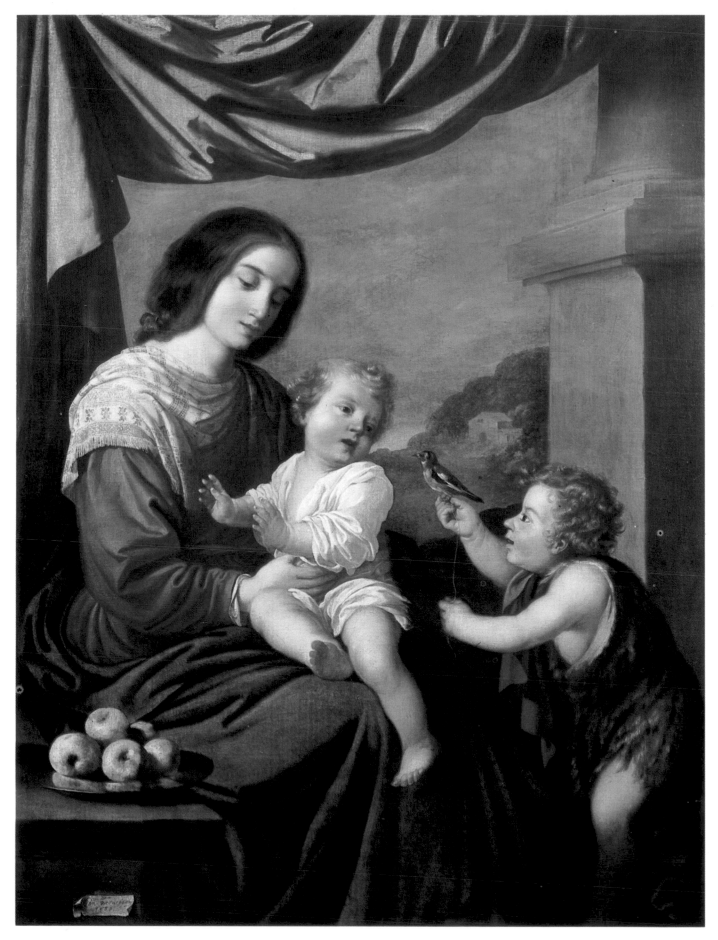

Fig. 450. THE VIRGIN AND CHILD WITH ST JOHN. 1658. San Diego: Fine Arts Gallery. Cat. No. 513.

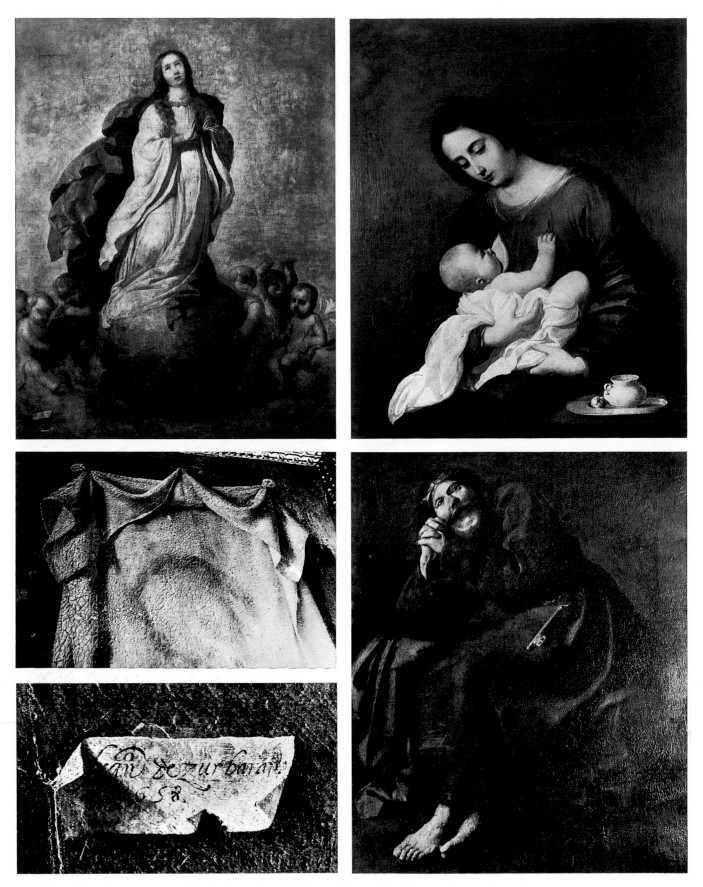

Fig. 451. IMMACULATE CONCEPTION. 1658. Private collection. Cat. No. 514.
Fig. 452. THE VIRGIN SUCKLING THE CHILD JESUS. 1658. Moscow: Pushkin State Museum of Fine Arts. Cat. No. 515.
Figs. 453 & 454. VEIL OF ST VERONICA (details). 1658. Valladolid: National Museum of Sculpture. Cat. No. 516.
Fig. 455. THE REPENTANCE OF ST PETER. 1659. Puebla: José Luis Bello. Cat. No. 517.

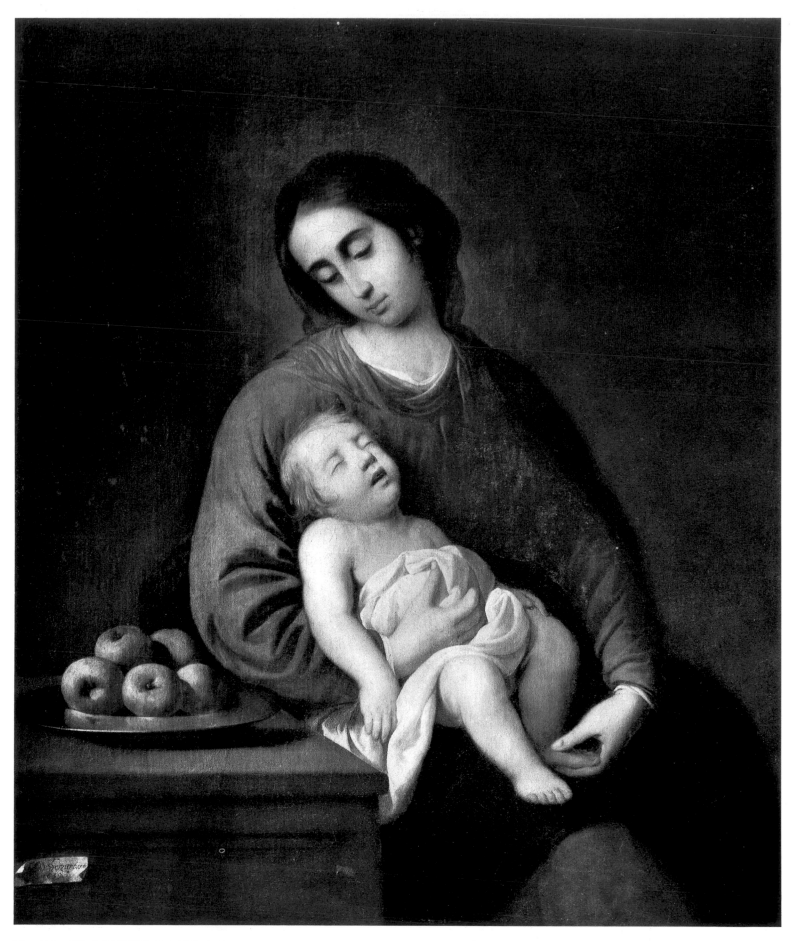

Fig. 456. VIRGIN WITH SLEEPING CHILD. 1659. Madrid: Antonio Barnuevo. Cat. No. 518.

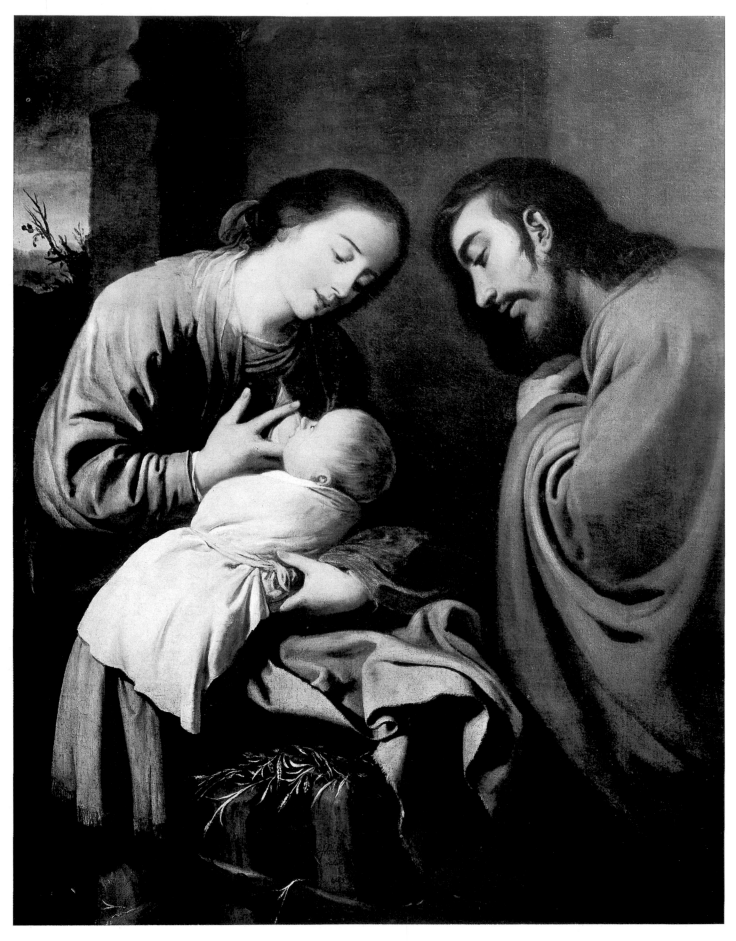

Fig. 457. THE HOLY FAMILY. 1659. Budapest: Museum of Fine Arts. Cat. No. 519.

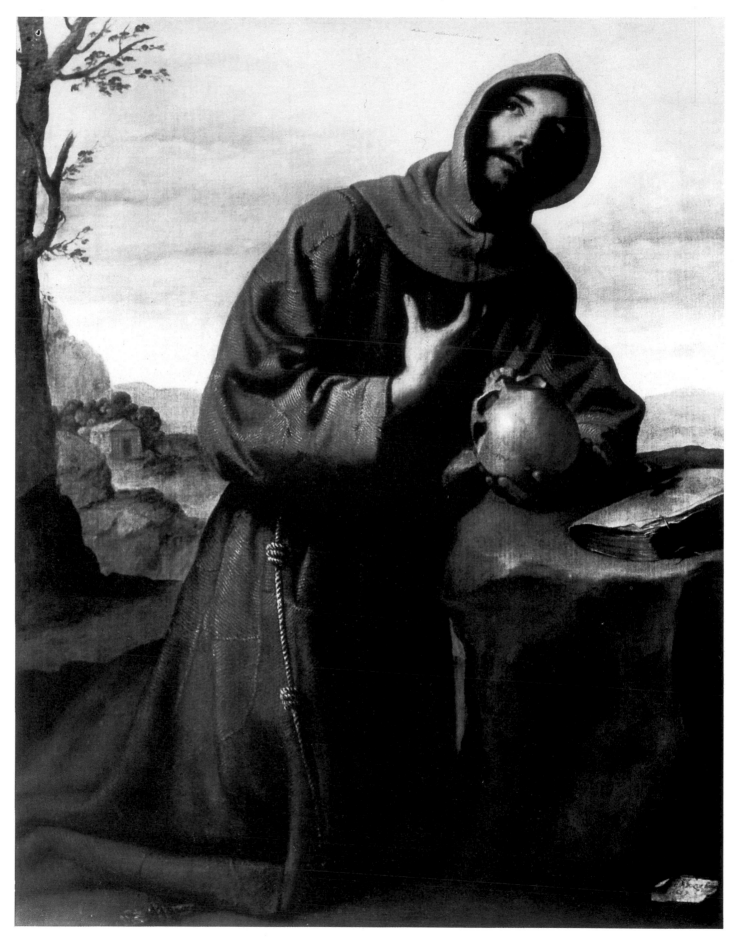

Fig. 458. ST FRANCIS KNEELING. 1659. Bilbao: Félix Valdés. Cat. No. 520.

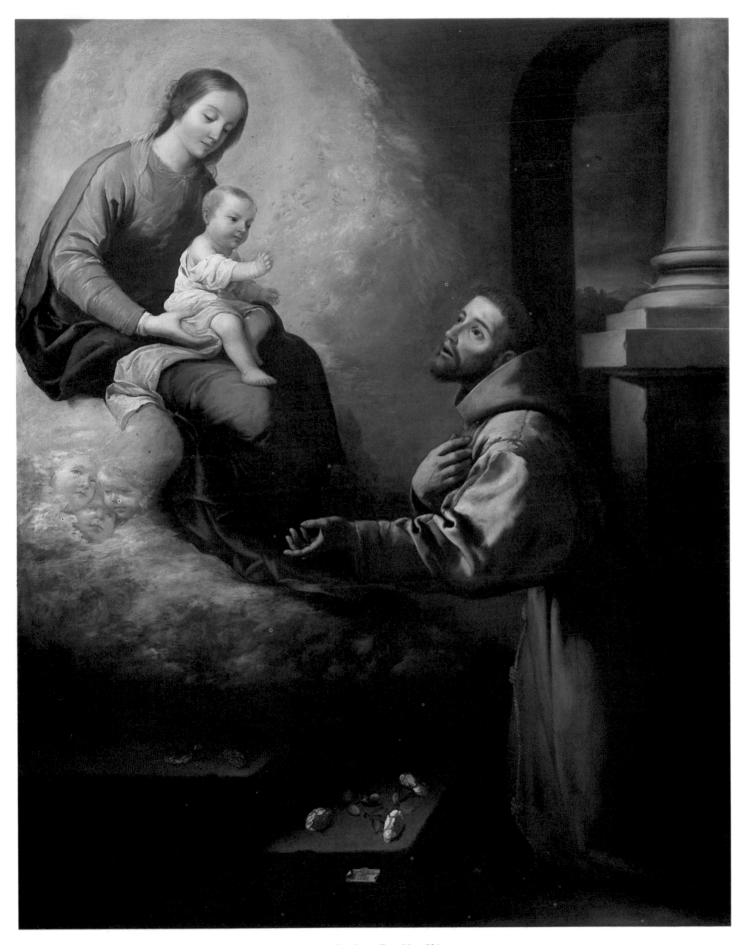

Fig. 459. THE PORTIUNCULA. 1661. New York: private collection. Cat. No. 521.

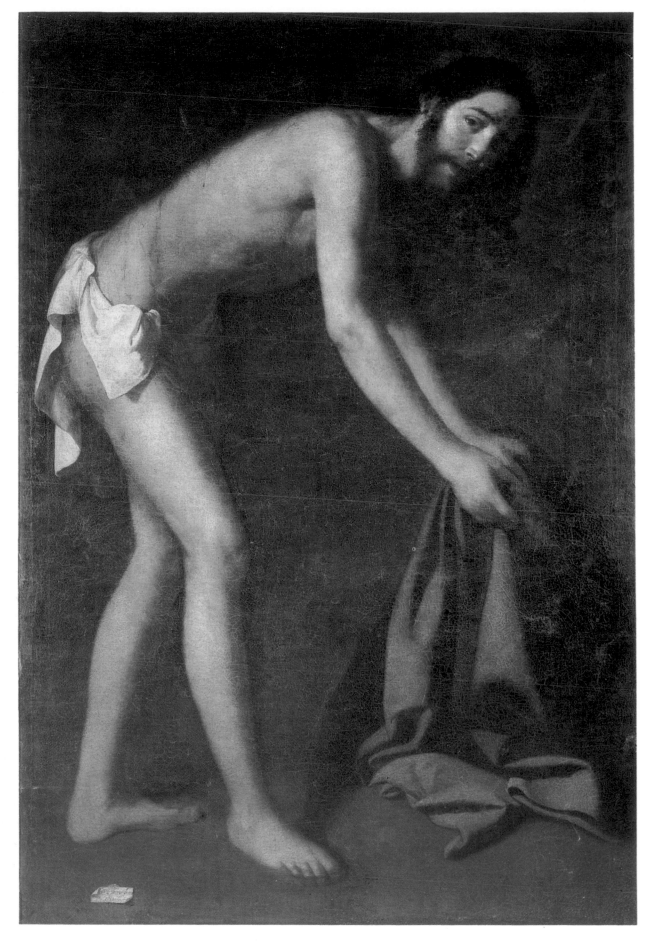

Fig. 460. CHRIST AFTER THE SCOURGING. 1661. Jadraque: Parish Church. Cat. No. 522.

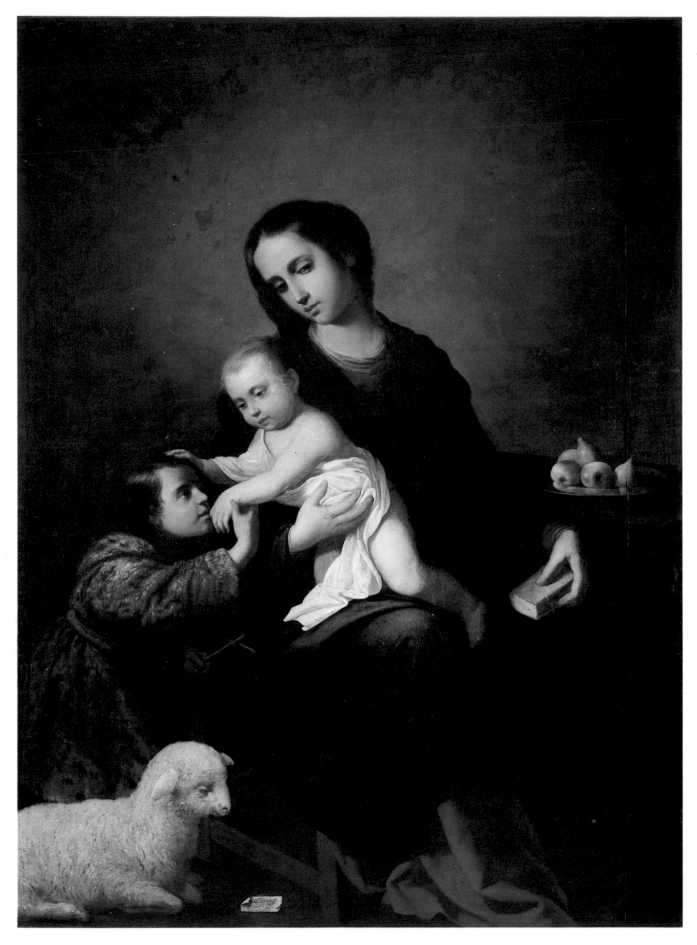

Fig. 461. THE VIRGIN AND CHILD WITH ST JOHN. 1662. Bilbao: Provincial Museum of Fine Arts. Cat. No. 525.

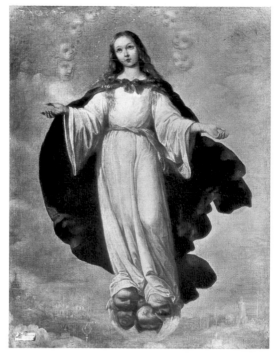

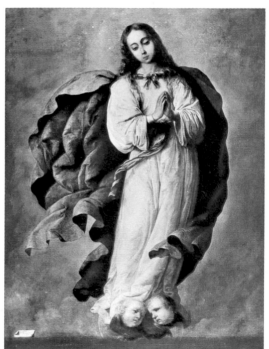

Fig. 462. IMMACULATE CONCEPTION. 1661. Budapest: Museum of Fine Arts. Cat. No. 523.
Fig. 463. IMMACULATE CONCEPTION. 1661. Bordeaux: Musée des Beaux-Arts. Cat. No. 524.
Fig. 464. ST BONAVENTURA. 1658-1664. Madrid: Church of San Francisco el Grande.
Cat. No. 526.

Figs. 465 & 466. ST JAMES OF THE MARCH. 1658-1664. Madrid: Prado Museum. Cat. No. 527.

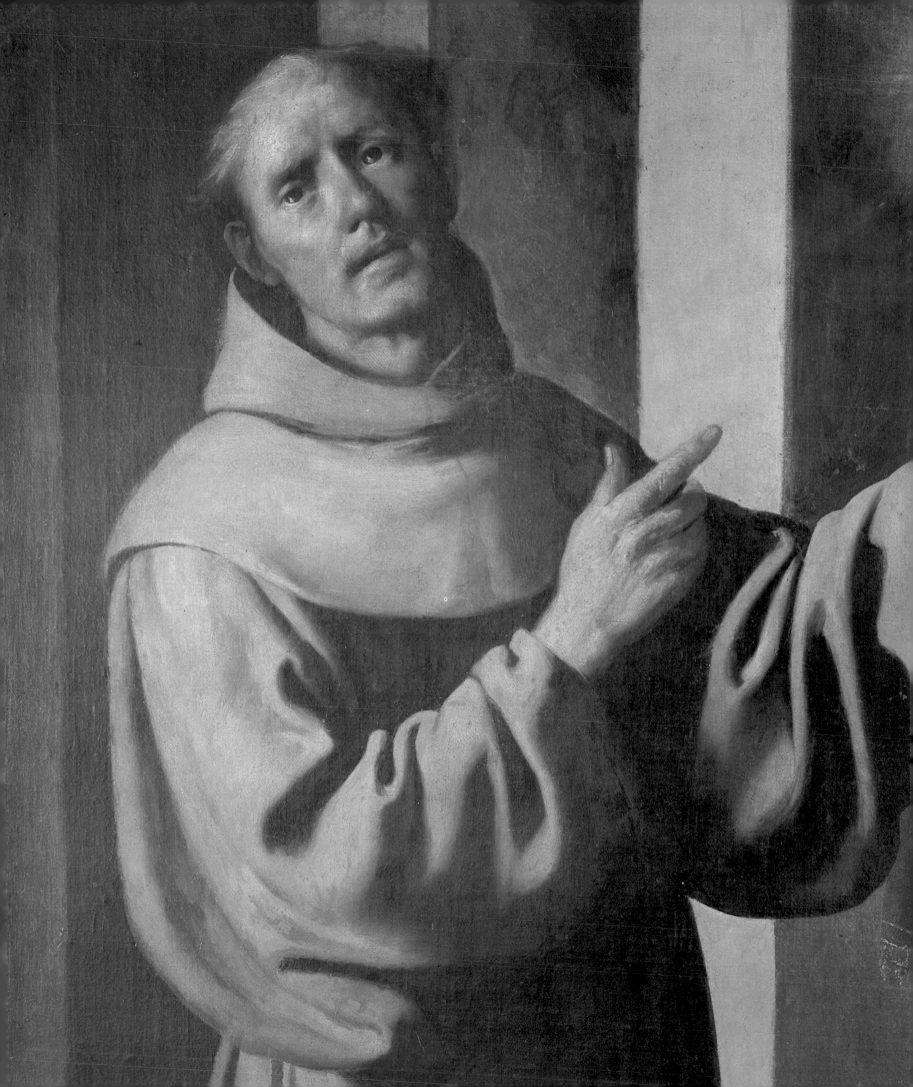

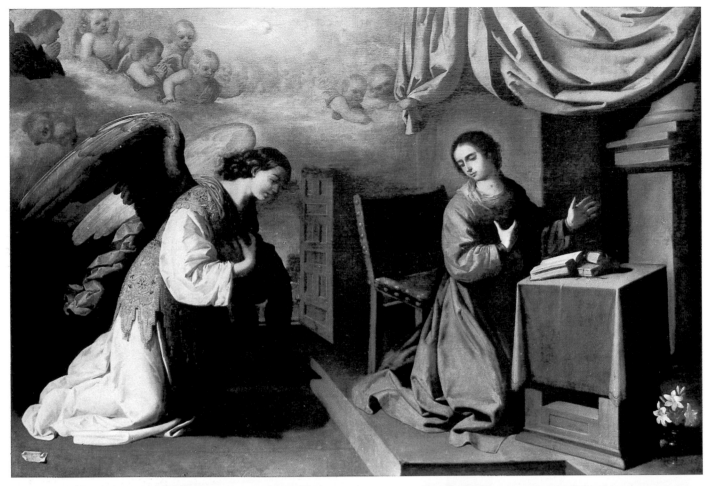

Fig. 467. THE ANNUNCIATION. 1658. Philadelphia: Philadelphia Museum of Art. Cat. No. 528.
Figs. 468 & 469. THE ANNUNCIATION (details). 1658-1664. Madrid: private collection. Cat. No. 529.

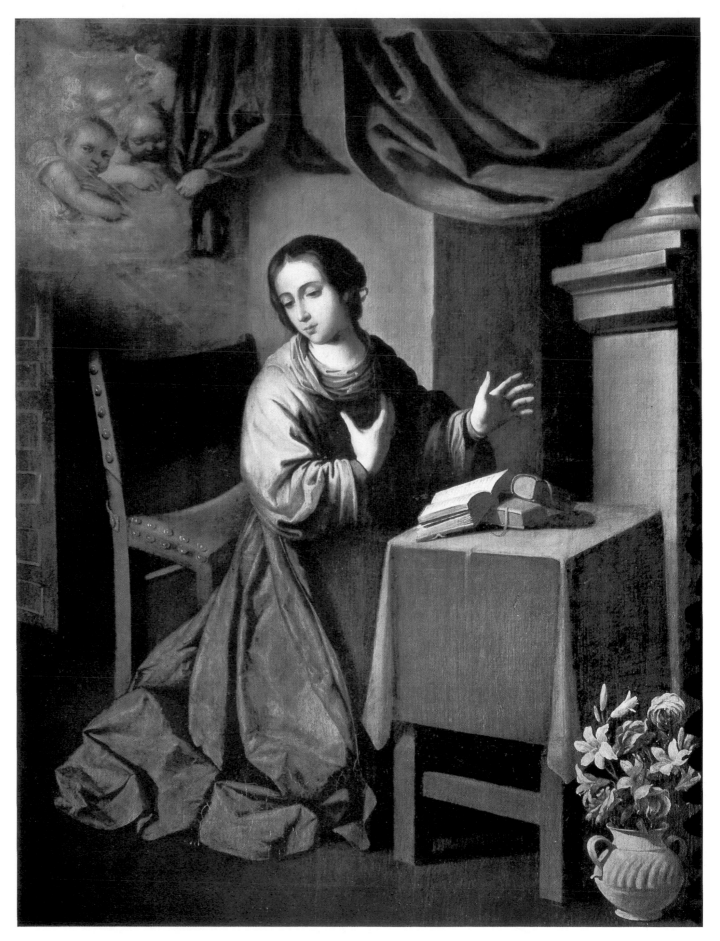

Fig. 470. THE VIRGIN OF THE ANNUNCIATION. 1658-1664. Palma de Mallorca: Juan March Foundation. Cat. No. 530.

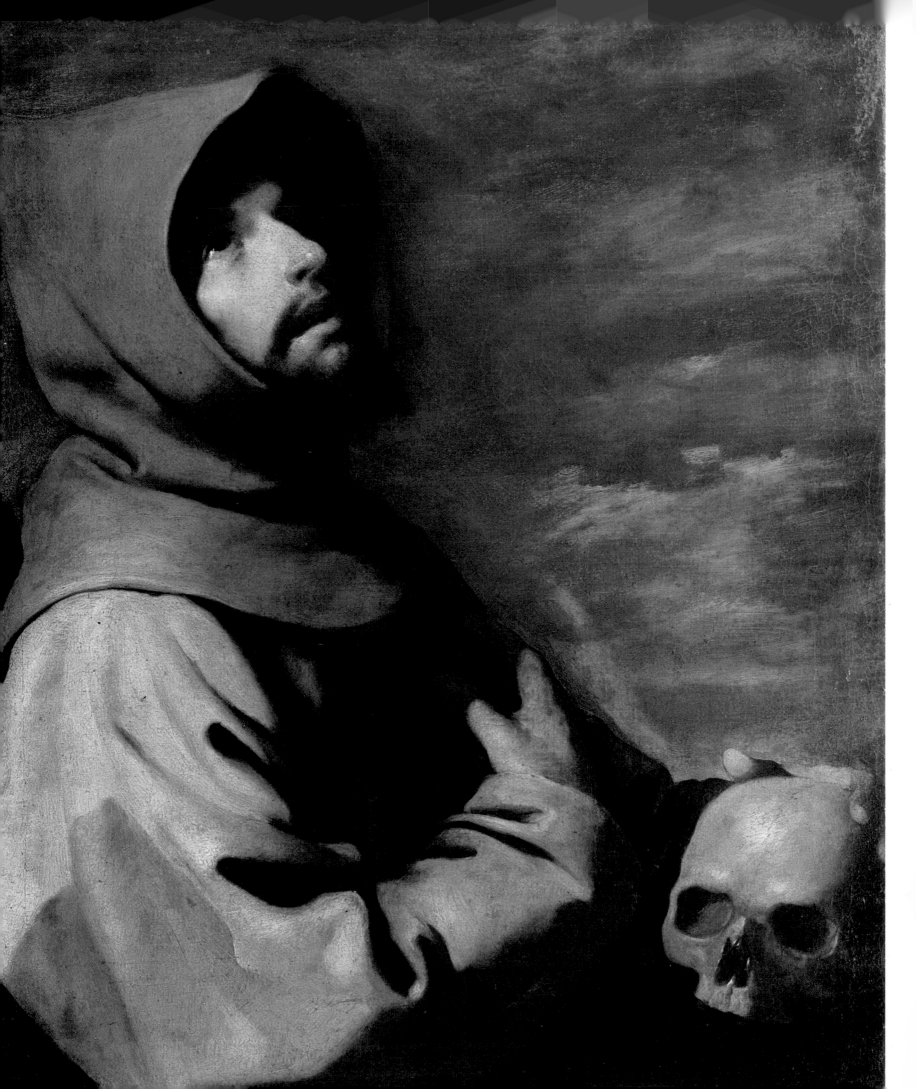

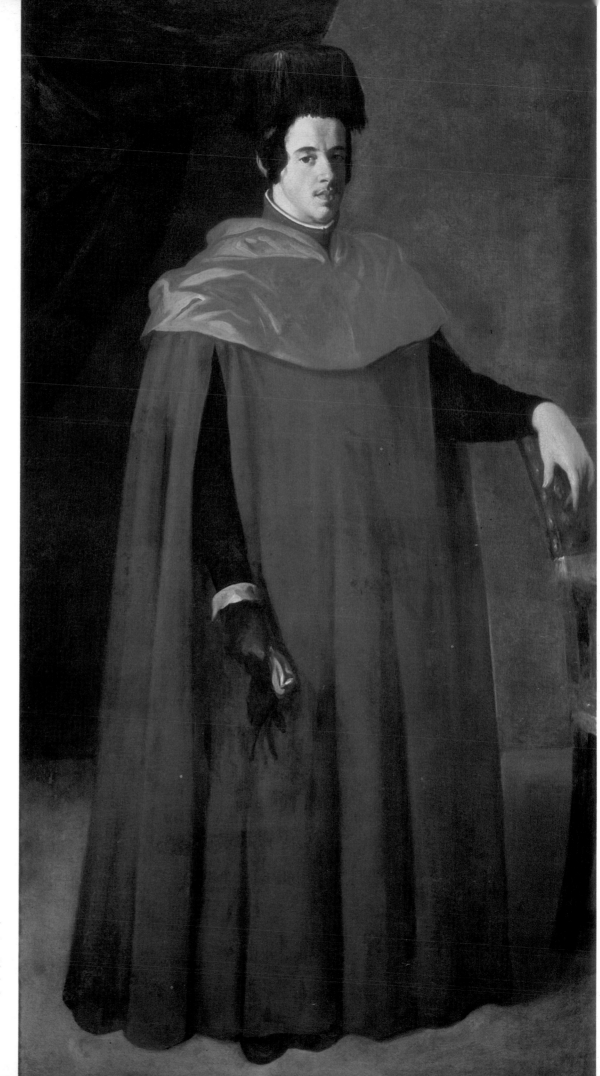

Fig. 471. ST FRANCIS IN MEDITA-
TION. 1658-1664. Munich: Alte Pinakothek.
Cat. No. 531.
Fig. 472. DOCTOR OF LAW OF THE
UNIVERSITY OF SALAMANCA. 1658-
1664. Boston: Isabella Stewart Gardner Mu-
seum. Cat. No. 533.

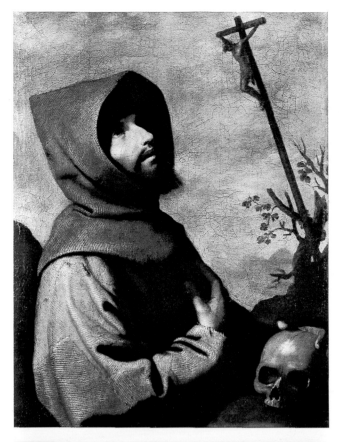

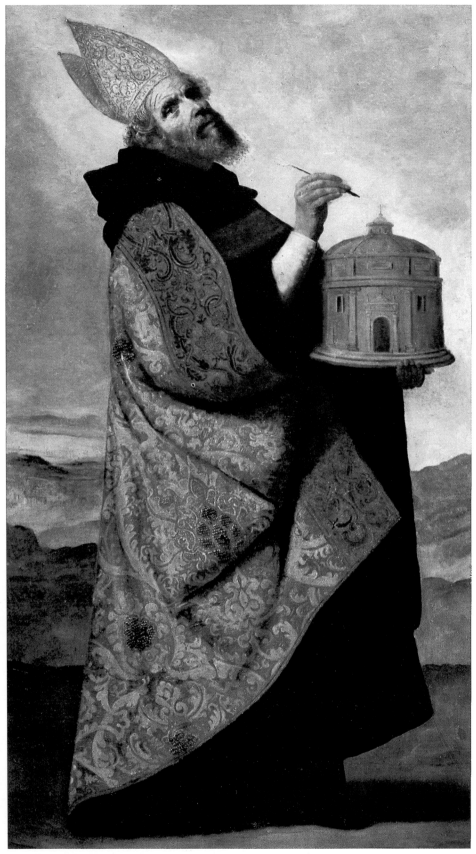

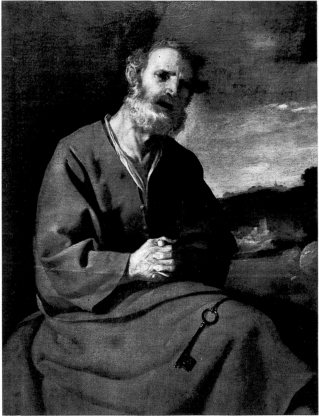

Fig. 473. ST FRANCIS IN MEDITATION. 1658-1664. Barcelona: Aguilera Collection. Cat. No. 532.
Fig. 474. THE REPENTANCE OF ST PETER. 1658-1664. Marseilles: Musée de Longchamp. Cat. No. 534.
Fig. 475. ST AUGUSTINE. 1658-1664. Madrid: Juan de Córdoba y Mirón. Cat. No. 535.
Fig. 476. ST THOMAS OF VILLANUEVA GIVING ALMS TO A CRIPPLE. 1658-1664. Madrid: Private collection. Cat. No. 536.

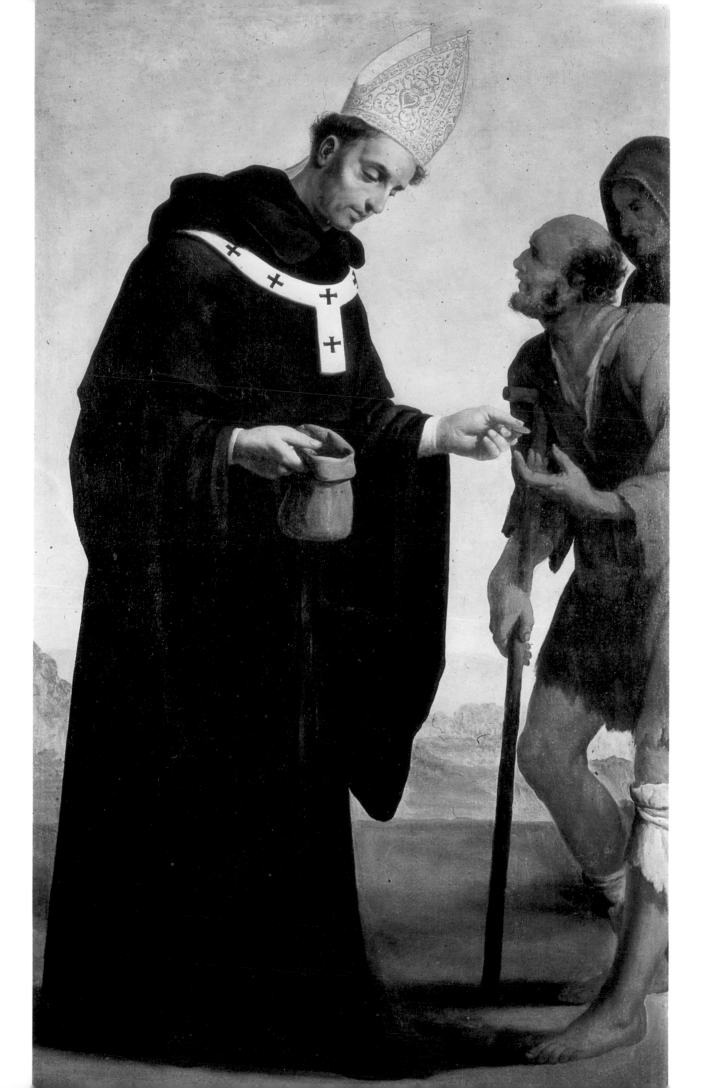

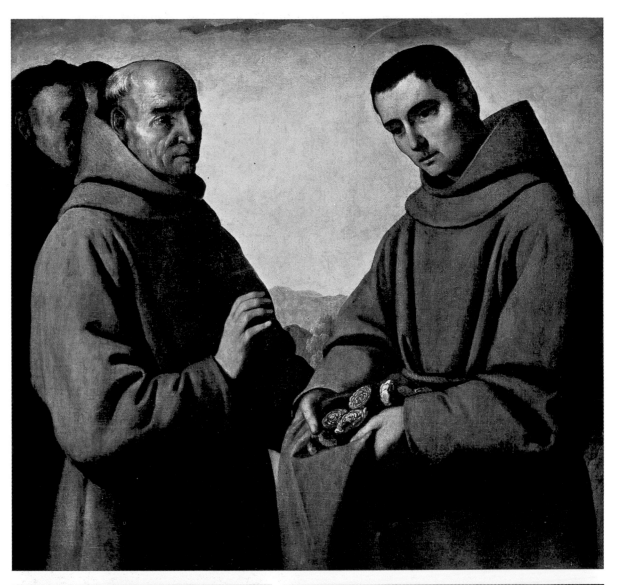

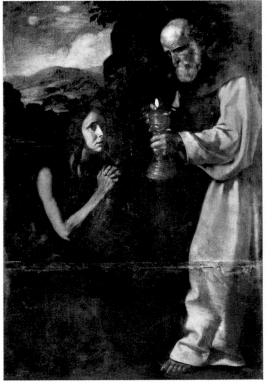

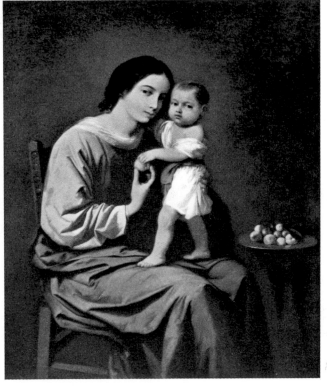

Fig. 477. ST DIEGO DE ALCALA.
1658-1664. Madrid: Prado Museum. Cat.
No. 537.
Fig. 478. COMMUNION OF ST MARY
OF EGYPT. 1658-1664. Madrid: Serrano
Collection. Cat. No. 538.
Fig. 479. VIRGIN AND CHILD. 1658-
1664. Present whereabouts unknown. Cat.
No. 539.

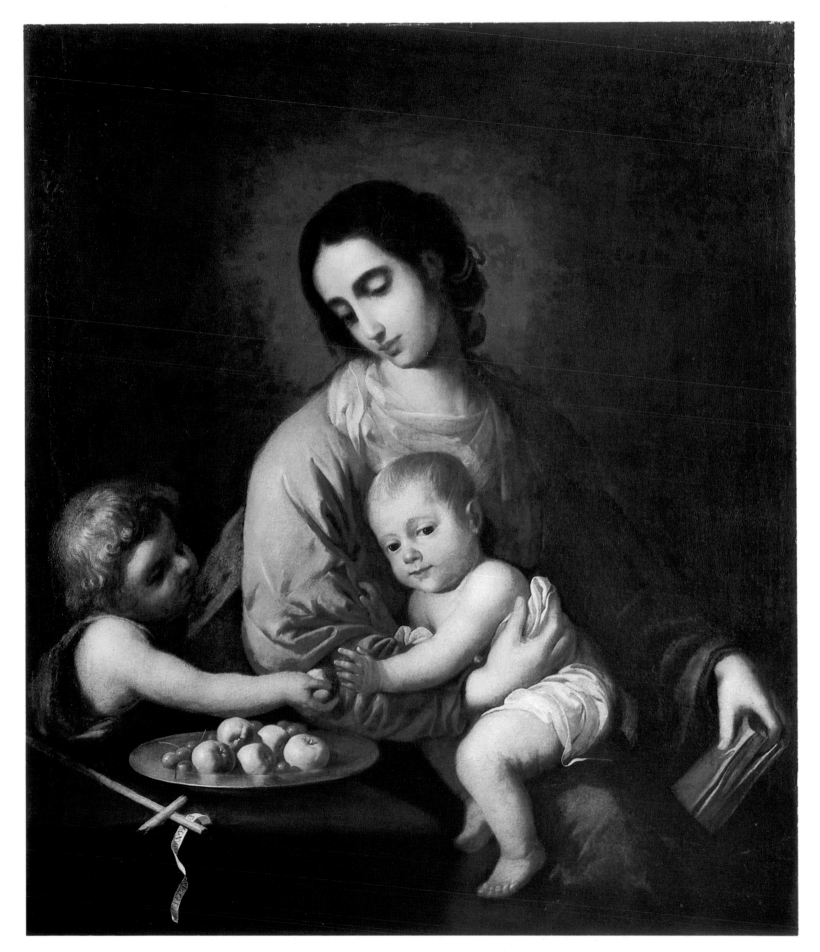

Fig. 480. THE VIRGIN AND CHILD WITH ST JOHN. 1658-1664. Zürich: Bubenberg Erlenbach Collection. Cat. No. 540.

Fig. 481. THE VIRGIN AND CHILD WITH ST JOHN. Detail of figure 480.
Fig. 482. THE ANNUNCIATION. 1658-1664. Detail of figure 467. Cat. No. 528.
Fig. 483. THE VIRGIN OF THE ANNUNCIATION. 1658-1664. Detail of figure 470.

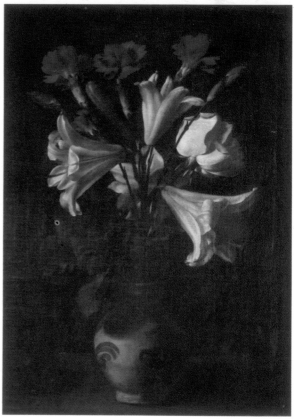

Fig. 484. STILL LIFE. Madrid: Prado Museum. Cat. No. 541.
Fig. 485. STILL LIFE (detail). Barcelona: Art Museum of Catalonia. Cat. No. 542.
Fig. 486. FLOWER-PIECE. Madrid: Prado Museum. Cat. No. 543.

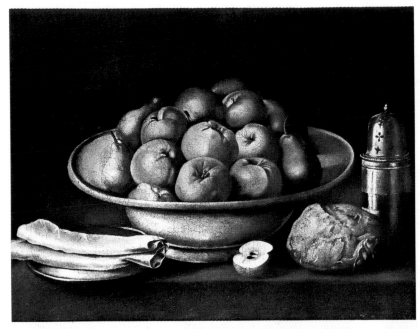
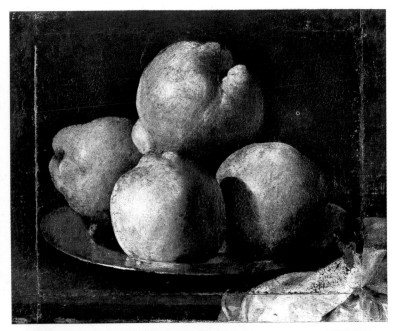
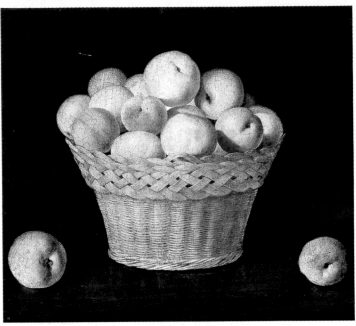
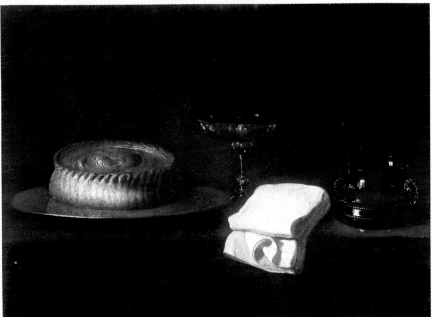

Fig. 487. STILL LIFE. Madrid: Private collection. Cat. No. 544.
Fig. 488. QUINCES ON A PLATE. Barcelona: Art Museum of Catalonia. Cat. No. 545.
Fig. 489. STILL LIFE. Madrid: Private collection. Cat. No. 546.
Fig. 490. STILL LIFE. Madrid: Javier Serra. Cat. No. 547.

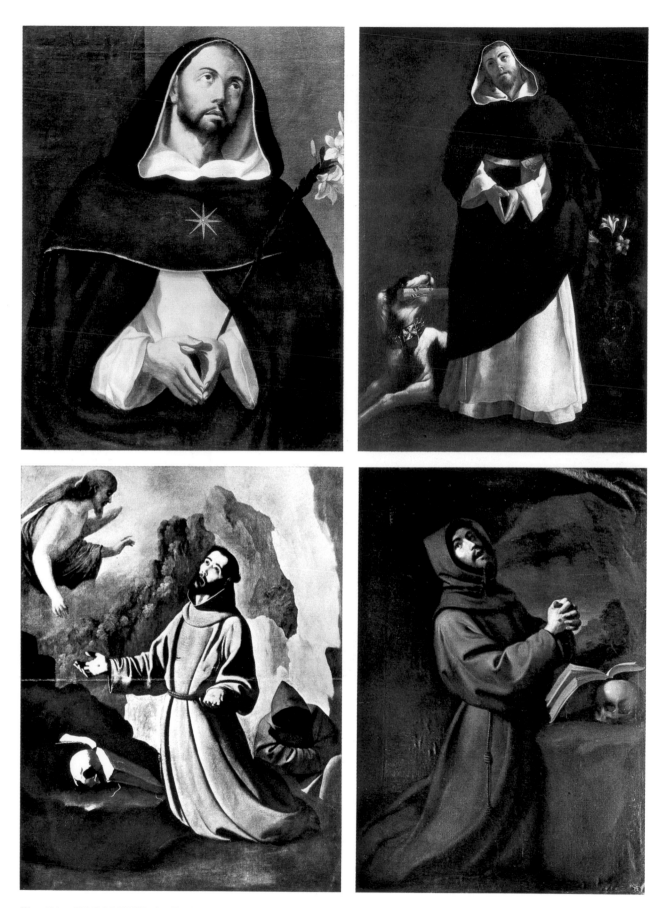

Fig. 491. ST DOMINIC. Seville: Provincial Museum of Fine Arts. Cat. No. 548.
Fig. 492. ST DOMINIC. Madrid: Duke of Alba. Cat. No. 550.
Fig. 493. ST FRANCIS RECEIVING THE STIGMATA. London: T. Harris. Cat. No. 552.
Fig. 494. ST FRANCIS. Abalos: Palacio. Cat. No. 553.

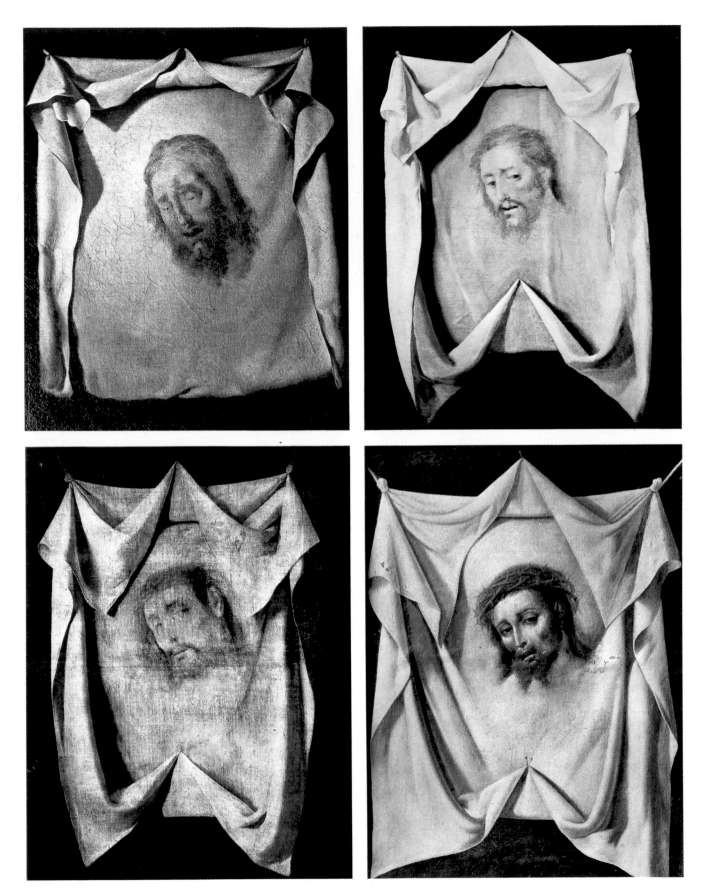

Fig. 495. VEIL OF ST VERONICA. Madrid: Juan Pereira González. Cat. No. 554.
Fig. 496. VEIL OF ST VERONICA. London: Trafalgar Galleries. Cat. No. 556.
Fig. 497. VEIL OF ST VERONICA. Madrid: Angel Avilés. Cat. No. 557.
Fig. 498. VEIL OF ST VERONICA. Jerez de la Frontera: Church of San Miguel. Cat. No. 559.
Fig. 499. VEIL OF ST VERONICA. Stockholm: National Museum. Cat. No. 558.

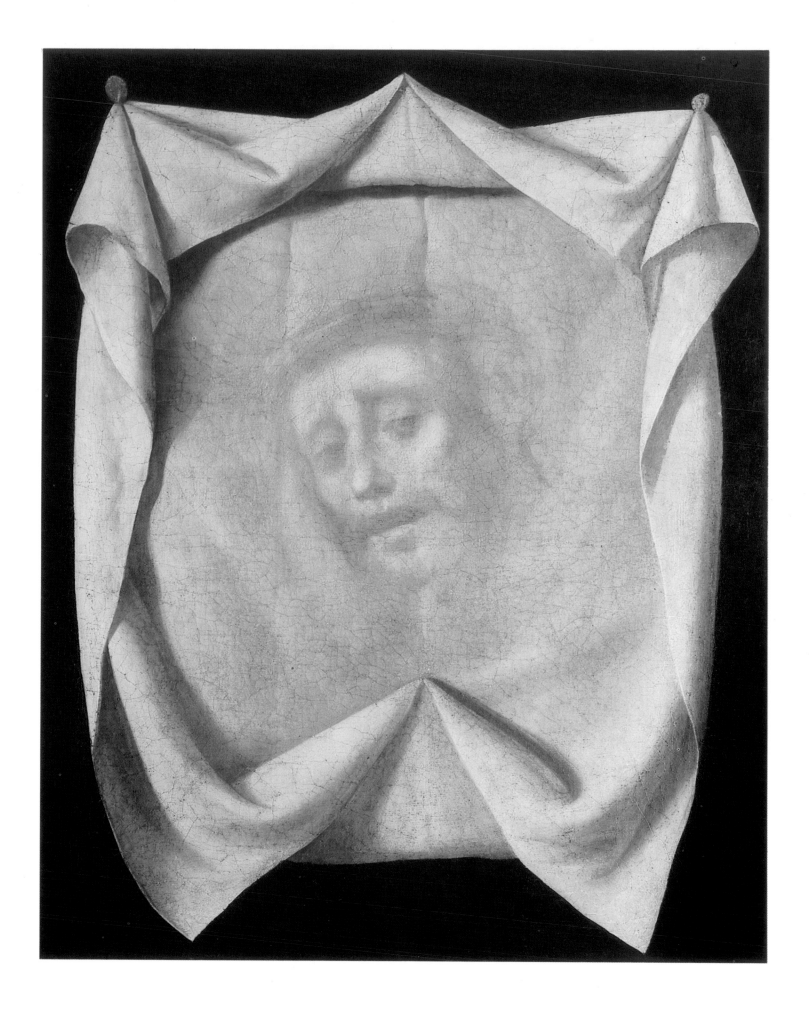

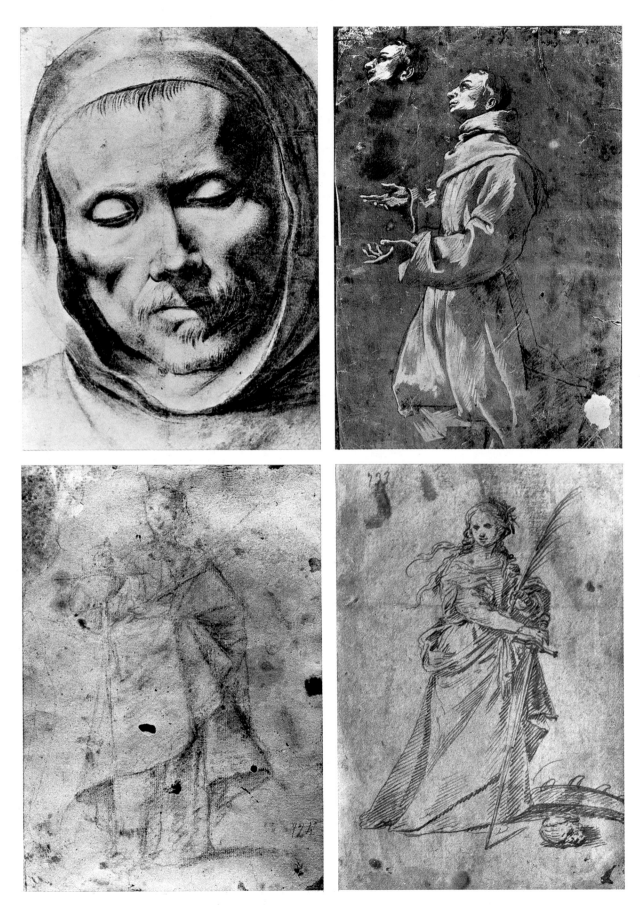

Fig. 500. PORTRAIT OF A FRANCISCAN FRIAR. Drawing in pencil on paper. London: British Museum.
Cat. No. 564.

Fig. 501. FRANCISCAN FRIAR KNEELING. Drawing in ink and chalk on paper. Destroyed during the Spanish
Civil War (1936-39). Cat. No. 565.

Fig. 502. ST CATHERINE. Drawing in pencil on paper. Córdoba: Provincial Museum of Fine Arts. Cat. No. 566.

Fig. 503. ST CATHERINE. Drawing in pen and ink on paper. Córdoba: Provincial Museum of Fine Arts.
Cat. No. 567.

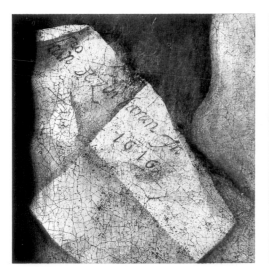

Fig. 504. THE VIRGIN AS A CHILD WITH A CHOIR OF ANGELS. 1616. Detail of figure 1. Cat. No. 1.

Fig. 505. THE CHILD JESUS BLESSING. 1624. Detail of figure 3. Cat. No. 2.

Fig. 506. APPARITION OF ST PETER THE APOSTLE TO ST PETER NOLASCO. 1629. Detail of figure 16. Cat. No. 12.

Fig. 507. IMMACULATE CONCEPTION. 1632. Detail of figure 84. Cat. No. 82.

Fig. 508. VISION OF BLESSED ALONSO RODRI-GUEZ. 1630. Detail of figure 39. Cat. No. 29.

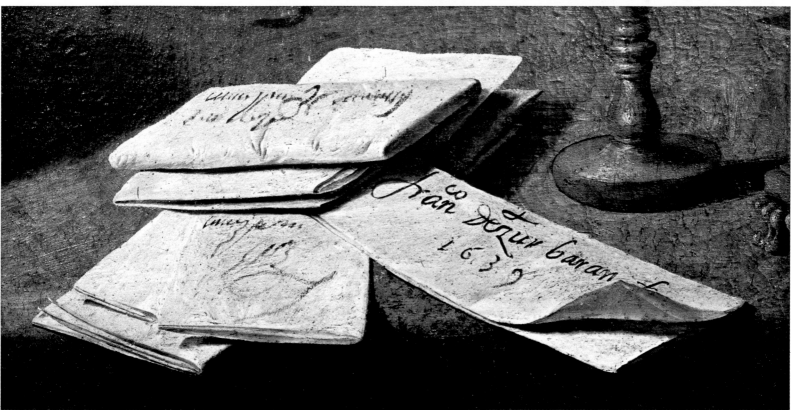

Fig. 509. IMMACULATE CONCEPTION. 1636. Detail of figure 123. Cat. No. 117.

Fig. 510. SALVATOR MUNDI. 1638. Detail of figure 126. Cat. No. 121.

Fig. 511. FRAY GONZALO DE ILLESCAS, BISHOP OF CORDOBA. 1639. Detail of figure 158. Cat. No. 148.

Fig. 512. THE ADORATION OF THE SHEPHERDS. 1638. Detail of figure 129. Cat. No. 123.

Fig. 513. ST JOHN CHRYSOSTOM AND FRAY LUIS DE GRANADA. 1651. Detail of figure 286. Cat. No. 296.
Fig. 514. CHRIST CARRYING THE CROSS. 1653. Detail of figure 288. Cat. No. 297.
Fig. 515. THE VIRGIN AND CHILD WITH ST JOHN. 1658. Detail of figure 450. Cat. No. 513.
Fig. 516. THE PORTIUNCULA. 1661. Detail of figure 459. Cat. No. 521.
Fig. 517. IMMACULATE CONCEPTION. 1661. Detail of figure 463. Cat. No. 524.

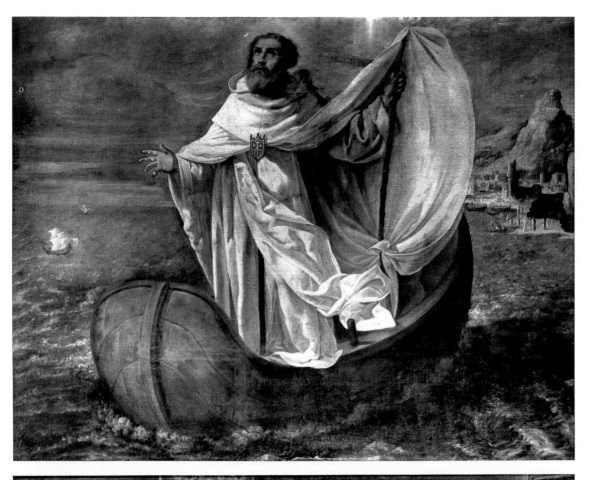

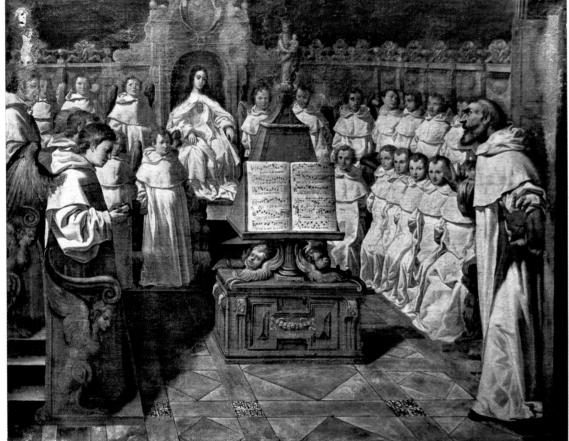

Other compositions belonging to the series of paintings dedicated to the life of St Peter Nolasco from the Principal Monastery of the Calced Mercedarians in Seville.

Fig. 518. Francisco Reina (?). MIRACLE OF THE BOAT. Seville: Cathedral.
Fig. 519. Francisco Reina (?). APPARITION OF THE VIRGIN TO ST PETER NOLASCO IN THE CHOIR OF BARCELONA'S CATHEDRAL. Seville: Cathedral.

Fig. 520. Francisco Reina (?). ST FERDINAND HANDING THE IMAGE OF THE VIRGIN TO ST PETER NOLASCO. Seville: Cathedral.
Fig. 521. Francisco Reina (?). DEATH OF ST PETER NOLASCO. Seville: Cathedral.

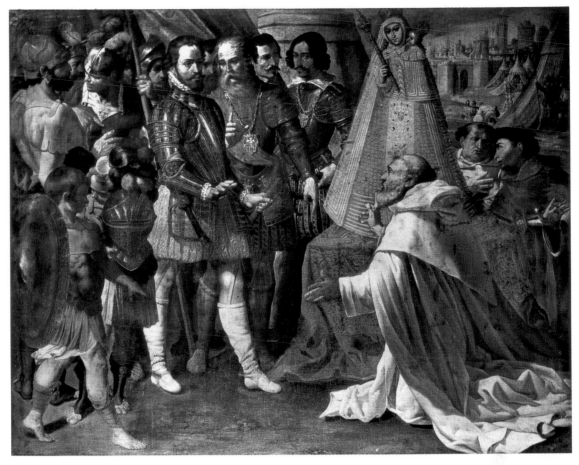

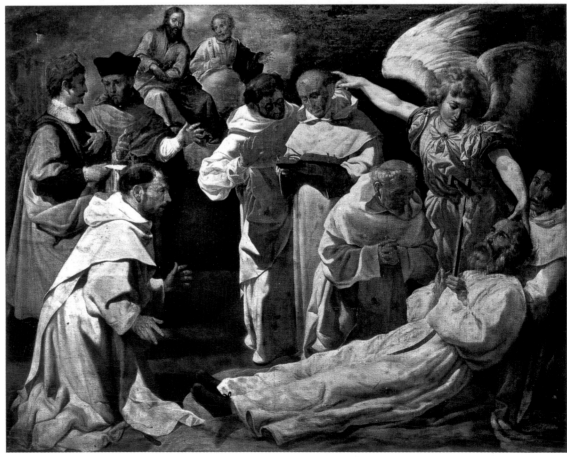

INDEX

INDEX OF NAMES

INDEX OF WORKS

Monastery of San Pablo el Real (Dominicans)
Cat. 3-8. Figs. 4-12 and 86.
Pp. 16-17, 25, 42, 48.

Monastery of the Most Holy Trinity (Outside Seville)
Cat. 20-27. Figs. 30-37. Pp. 17, 31, 46, 128.

Monastery of Santo Domingo de Porta Coeli (Dominicans)
Cat. 273-4. Figs. 276-8. Pp. 26-27, 45, 63.

Hospital of the Precious Blood
Cat. 422-30 (?). Figs. 388-96. Pp. 23, 32, 43, 66, 69.

Church of San Esteban
Cat. 328-337. Figs. 317-8. Pp. 32, 37, 69.

Church of San Román
Cat. 120. Fig. 125. Pp. 32, 48, 176.

Zafra
Parish Church of Santa María
Cat. 286-295. Figs. 284-5. Pp. 44, 293.

NEW TESTAMENT AND MYSTICAL SUBJECTS

Adoration of the Eucharist, The
Cat. 267. Fig. 274.

Adoration of St Joseph, The
Cat. 21. Fig. 31.

Adoration of the Magi, The
Cat. 22 and 125. Figs. 32 and 132-3. Pp. 28, 37, 43, 54.

Adoration of the Shepherds, The
Cat. 31, 123 and 331. Figs. 43, 129-30 and 512. Pp. 28, 37, 38, 39, 40, 50, 51, 54, 56, 57, 60, 61, 65, 68, 70, 176.

Annunciation, The
Cat. 122 and 528-9. Figs. 127-8, 467-9 and 482. Pp. 28, 38, 40, 43, 44, 54, 55, 56, 60, 61, 62.

Child Jesus Blessing, The
Cat. 2 and 27. Figs. 3, 36 and 505. Pp. 31, 46, 127.

Child Jesus in the Dominican Habit, The
Cat. 266. Fig. 273.

Child Jesus with a Thorn, The
Cat. 57-59 and 248. Figs. 64 and 258. Pp. 8, 32, 47, 51, 55, 56, 60.

Christ after the Scourging
Cat. 264, 522. Figs. 272 and 460. Pp. 20, 44, 54, 359.

Christ at Emmaus
Cat. 169, 172. Figs. 188 and 192. Pp. 44, 176.

Christ Bound to the Column, with a Dominican Donor
Cat. 265.

Christ Carrying the Cross
Cat. 297. Figs. 288 and 514. Pp. 44, 62, 294, 359.

Christ Crucified
Cat. 8, 46-9, 55, 108, 173-7 and 302-7. Figs. 12, 56-7, 62, 114, 194-6, 296, 298 and 300. Pp. 16, 48, 65, 68, 127.

Christ Crucified and Two Carthusians
Cat. 301. Fig. 295.

Christ Crucified, the Virgin and St John
Cat. 334.

Christ Dead on the Cross
Cat. 50, 168 and 260-3. Figs. 191, 270 and 271.

Christ Dead on the Cross, with a Donor
Cat. 171. Fig. 189. P. 176.

Christ Giving His Blessing
Cat. 166 and 379. Figs. 187 and 361. P. 48.

Circumcision, The
Cat. 124. Fig. 131. Pp. 28, 36, 54, 57, 60, 61, 176.

Coronation of St Joseph, The
Cat. 243. Figs. 252 and 253. Pp. 41, 45, 48, 57.

Double Trinity, The
Cat. 287. P. 44.

Eternal Father, The
Cat. 242. Fig. 251. P. 29.

Flight into Egypt, The
Cat. 24. Fig. 37.

Holy Family, The
Cat. 519. Fig. 457. Pp. 37, 55, 56, 67, 359.

Holy Family with St Anne, St Joachim and St John the Baptist, The
Cat. 56. Fig. 63. Pp. 42, 47, 48.

Holy House of Nazareth, The
Cat. 247. Figs. 257 and 259. Pp. 23, 39, 42, 45, 47, 55, 56, 60.

Immaculate Conception, The
Cat. 28, 68, 71, 73-4, 82, 116-7, 313-6, 458, 514 and 523-4. Figs. 38, 40, 73-4, 76-7, 83-4, 122-3, 303-6, 451, 462-3, 507, 509 and 511. Pp. 17, 18, 19, 23, 31, 32, 44, 46, 47, 48, 54, 57, 64, 65, 66, 128, 175, 359.

Immaculate Conception with St Joachim and St Anne, The
Cat. 144. Figs. 153 and 154. Pp. 18, 44.

Jesus among the Doctors
Cat. 25. Fig. 35.

Lamb
Cat. 281. Fig. 283. Pp. 32, 40, 50, 68, 70.

Nativity of the Virgin, The
Cat. 32. Fig. 44. Pp. 37, 42, 53, 55, 56, 57, 67.

Our Lady of Ransom
Cat. 317-8. Figs. 307-8.

Our Lady of Ransom and Two Mercedarians
Cat. 320. Fig. 310. Pp. 29, 44, 57.

Our Lady of the Carthusians
Cat. 143. Fig. 145. Pp. 18, 24, 29, 40, 44, 52, 55, 57, 59.

ANGELS AND FEMALE SAINTS

MALE SAINTS AND BEATIFIED PERSONS

ECCLESIASTICS

THEMES FROM HISTORY, MYTHOLOGY AND THE OLD TESTAMENT

PORTRAITS

SHEEP AND STILL LIFES

GEOGRAPHICAL INDEX

BIBLIOGRAPHY

Abbreviations used:
A.E.A. Archivo Español de Arte
B.S.E.E. Boletín de la Sociedad Española de Excursiones

MONOGRAPHS AND ARTICLES

ANGULO, DIEGO: "Una estampa de Cornelio Cort en el taller de Zurbarán". *A.E.A.*, 1931, pp. 65-67.

ANGULO, DIEGO: "Francisco de Zurbarán. Mártires mercedarios. San Carlos Borromeo". *A.E.A.*, 1940-1941, pp. 365-376.

ANGULO, DIEGO: "Cinco nuevos cuadros de Zurbarán". *A.E.A.*, 1944, pp. 1-9.

ANGULO, DIEGO: "El Apostolado de Zurbarán del Museo de Lisboa". *A.E.A.*, 1945, pp. 233-235.

ANGULO, DIEGO: "Tres nuevos mártires del taller de Zurbarán". *A.E.A.*, 1947, p. 146.

ANGULO, DIEGO: "El apostolado zurbaranesco de Guatemala". *A.E.A.*, 1949.

ANGULO, DIEGO: "Algunos cuadros españoles en museos franceses. Zurbarán". *A.E.A.*, 1954, pp. 315-318.

BAZIN, G.: *Les grands maîtres de la peinture à L'Ermitage.* 1958, p. 94.

BENJUMEA, JOSÉ M.ª: "Descubrimiento en Sevilla de un Zurbarán, un Herrera y un Murillo". *Bellas Artes,* No. 16, July-August 1972, p. 57.

BONET CORREA, ANTONIO: "Obras zurbaranescas en México". *A.E.A.*, 1964, pp. 159-168.

BROWN, JONATHAN: *Zurbarán.* 1973.

BUENDÍA, JOSÉ ROGELIO: "La estela de Zurbarán en la pintura andaluza". *Goya,* Nos. 64-65, 1965, pp. 276-283.

CAMÓN AZNAR, JOSÉ: "Casi todo Zurbarán". *Goya,* Nos. 64-65, 1965, pp. 316-329.

CARRASCAL, JOSÉ M.ª: *Zurbarán.* Madrid, 1973.

CASCALES MUÑOZ, JOSÉ: "Zurbarán y la exposición de sus cuadros". *España Moderna,* 1905, pp. 5-23.

CASCALES MUÑOZ, JOSÉ: *Francisco de Zurbarán, su época, su vida y sus obras.* Madrid, 1911; 2nd edition, 1931.

CATURLA, M.ª LUISA: "New facts on Zurbarán". *The Burlington Magazine,* 1945, p. 383.

CATURLA, M.ª LUISA: "Conjunto de Zurbarán en Zafra". *ABC,* 20 April 1948.

CATURLA, M.ª LUISA: *Zurbarán: estudio y catálogo de la exposición de Granada.* Granada, June 1953.

CATURLA, M.ª LUISA: "Velázquez y Zurbarán". *Varia Velazqueña,* 1960, pp. 463-470.

CATURLA, M.ª LUISA: *Vida y evolución de Zurbarán. Exposición Zurbarán en el III centenario de su muerte.* Casón del Buen Retiro. Madrid, 1964.

CATURLA, M.ª LUISA: "La Santa Faz de Zurbarán trompe-l'œil a lo divino". *Goya,* Nos. 64-65, 1965, pp. 202-205.

CATURLA, M.ª LUISA: "El conjunto Las Cuevas". *Forma y color,* No. 41, Granada, 1968.

FRANCIS, HENRY S.: "Francisco de Zurbarán. The Holy House of Nazareth". *The Bulletin of the Cleveland Museum of Art,* 1961, pp. 46-50.

GÁLLEGO, JULIÁN: "El color en Zurbarán". *Goya,* Nos. 64-65, 1965, pp. 296-305.

GÁLLEGO, JULIAN: "El Madrid de los Austrias: un urbanismo de teatro". *Revista de Occidente,* 1969.

GAYA NUÑO, JUAN ANTONIO: *Zurbarán.* Barcelona, 1948.

GAYA NUÑO, JUAN ANTONIO: *Zurbarán en Guadalupe.* 1951.

GAYA NUÑO, JUAN ANTONIO: "Zurbarán y los Ayala". *Goya,* Nos. 64-65, 1965, pp. 218-223.

GÓMEZ CASTILLO, ANTONIO: *Bernabé de Ayala, discípulo de Zurbarán.* Seville, 1950.

GREGORI, MINA & FRATI, TIZIANA: *L'opera completa di Zurbarán.* Classici dell'Arte, No. 69. Milan, 1973.

GUDIOL, JOSÉ: "Francisco de Zurbarán in Madrid". *The Burlington Magazine,* 1965, pp. 148-151.

GUINARD, PAUL: *Zurbarán et la "Découverte" de la peinture espagnole en France sous Louis-Philippe. Hommage à Ernest Martineche.* Études Hispaniques et Américains. Paris, 1939.

GUINARD, PAUL: "Los conjuntos dispersos o desaparecidos de Zurbarán: Anotaciones a Ceán Bermúdez". I, II, III. *A.E.A.*, 1946, pp. 249-273; 1947, pp. 161-201 and 1949, pp. 1-38.

GUINARD, PAUL: *Zurbarán et les peintres espagnoles de la vie monastique*. Paris, 1960.

GUINARD, PAUL: "Aportaciones críticas de obras zurbaranescas". *A.E.A.*, 1964, pp. 115-128.

GUINARD, PAUL: "España, Flandes y Francia en el s. XVII. Las sibilas zurbaranescas y sus fuentes grabadas". *A.E.A.*, 1970, pp. 105-116.

GUTIÉRREZ, PEDRO: *La Cartuja de Jerez*. Jerez, 1924.

HERNÁNDEZ DÍAZ, JOSÉ: "Los Zurbaranes de Marchena". *A.E.A.*, 1953, pp. 31-36.

HERNÁNDEZ DIAZ, JOSÉ: "El retrato de D. Andrés, Conde de Ribera, del Museo Hispalense. Análisis de un cuadro". *Anales de la Universidad Hispalense*. Seville, 1960.

JUSTI, KARL: "Das Leben des heiligen Buenaventura gemalt von Herrera dem Älteren und Zurbarán". *Jahrbuch der preussischen Kunstsammlungen*, 1883, IV, pp. 152-162.

JUSTI, KARL: "Zurbarán und sein Ende". *Zeitschrift für bildende Kunst*, 1911, p. 25.

KEHRER, HUGO: *Francisco de Zurbarán*. Munich, 1918.

KLEINSCHMIDT, R.P. BEDA: "Das Leben des hl. Buenaventura in einem Gemäldezyklus von Francisco Herrera dem Älteren und Francisco Zurbarán". *Archivium Historicum Franciscanum*, 1926, XIX.

LONGHI, ROBERTO: "Un S. Tomaso di Velázquez e la congiuntura italo-spagnola tra il '500 e il '600". *Vita Artística*, 1927, pp. 4-11.

LOZOYA, MARQUÉS DE: "Zurbarán en el Perú". *A.E.A.*, 1943.

LOZOYA, MARQUÉS DE & PÉREZ SÁNCHEZ, ALFONSO: "Los nuevos Museos en el Palacio Real de Madrid". *A.E.A.*, 1963, p. 97.

LOZOYA, MARQUÉS DE: "Zurbarán y lo zurbaranesco en las colecciones del Patrimonio Nacional". *Goya*, Nos. 64-65, 1965, pp. 214-217.

LOZOYA, MARQUÉS DE: "Varia. Más zurbaranes en el Perú". *A.E.A.*, 1967, pp. 84-86.

MALITZKAYA, K.: "Zurbarán in the Moscow Museum of Fine Arts". *The Burlington Magazine*, July 1930, pp. 16-20.

MALITZKAYA, K.: "Zurbarán en los Museos Rusos". *A.E.A.*, 1964, pp. 107-114.

MARTÍN GONZÁLEZ, J.J.: "La Santa Faz. A propósito de un inédito de Zurbarán". *Goya*, No. 97, 1970, pp. 11-12.

MARTÍN GONZÁLEZ, J.J.: "Un crucifijo con dos cartujos, de Zurbarán". *Boletín del Seminario de Estudios de Arte y Arqueología*, Vol. XXXIX, pp. 465-469. Valladolid, 1973.

MAYER, AUGUST L.: "Zurbarán in America". *Arts & Decoration*, March 1916.

MAYER, AUGUST L.: "The Education of the Virgin, by Zurbarán". *The Burlington Magazine*, 1924, p. 212.

MILICUA, JOSÉ: "El crucifijo de San Pablo, de Zurbarán". *A.E.A.*, 1953, pp. 177-186.

MILICUA, JOSÉ: "Observatorio de Angeles. Los Angeles de la 'Perla' de Zurbarán". *A.E.A.*, 1958, pp. 1-16.

OBREGÓN, GONZALO: "Zurbarán en México". *Diputación Provincial de Badajoz*. Badajoz, 1964.

OROZCO DÍAZ, EMILIO: "Un Zurbarán desconocido". *Cuadernos de Arte. Facultad de Letras*. Granada, 1937, p. 34.

OROZCO DÍAZ, EMILIO: "Sánchez Cotán junto a Zurbarán". *Catálogo de la Exposición Zurbarán*. Granada, 1953.

OROZCO DIAZ, EMILIO: "Cotán y Zurbarán, influjo y afinidad entre un fraile pintor y un pintor de frailes". *Goya*, Nos. 64-65, 1965, pp. 224-231.

PANTORBA, BERNARDINO DE: *Francisco de Zurbarán*. Barcelona, 1953.

PEMÁN, CÉSAR: "Exposición de pintura antigua en Cádiz". *A.E.A.*, 1944, pp. 180-183.

PEMÁN, CÉSAR: "Zurbarán y el arte zurbaranesco en colecciones gaditanas". *A.E.A.*, 1946, pp. 160-168.

PEMÁN, CÉSAR: "La serie de los hijos de Jacob y otras pinturas zurbaranescas". *A.E.A.*, 1948, pp. 153-172.

PEMÁN, CÉSAR: "Nuevas pinturas de Zurbarán en Inglaterra". *A.E.A.*, 1949. pp. 207-213.

PEMÁN, CÉSAR: "La reconstrucción del retablo de la Cartuja de Jerez de la Frontera". *A.E.A.*, 1950, pp. 203-227.

PEMÁN, CÉSAR: "Juan de Zurbarán". *A.E.A.*, 1958, pp. 193-211.

PEMÁN, CÉSAR: *Zurbarán en la hora actual*. Badajoz, 1961.

PEMÁN, CÉSAR: "Miscelánea zurbaranesca. Dos césares romanos a caballo. El San Francisco de Abalos. Nuevos pormenores para

la reconstrucción del retablo de la Cartuja de Jerez. Zurbarán en 1653 y Murillo en 1656". *A.E.A.,* 1964, pp. 93-105.

PEMÁN, CÉSAR: *El taller y los discípulos de Zurbarán. Exposición Zurbarán en el III centenario de su muerte.* Casón del Buen Retiro. Madrid, 1964.

PÉREZ SÁNCHEZ, ALFONSO: "Varia. Nuevas papeletas para el catálogo de Zurbarán". *A.E.A.,* 1964, pp. 193-196.

PÉREZ SÁNCHEZ, ALFONSO: "Torpeza y humildad de Zurbarán". *Goya,* Nos. 64-65, 1965, pp. 266-275.

PÉREZ SÁNCHEZ, ALFONSO: "Varia. Dos nuevos zurbaranes". *A.E.A.,* 1965, pp. 261-263.

PITA ANDRADE, JOSÉ MANUEL: "El arte de Zurbarán en sus inspiraciones y fondos arquitectónicos". *Goya,* Nos. 64-65, 1965, pp. 242-249.

RODRÍGUEZ MÉNDEZ, ANA M.[a]: *El apostolado zurbaranesco en la iglesia de Sto. Domingo de Guatemala.* Reprint from the writer's doctoral thesis.

ROMERO DE TORRES, ENRIQUE: "Los zurbaranes del Museo de Cádiz". *Boletín de la Comisión Provincial de Monumentos de Cádiz,* 1908, 4th quarter.

SALAS, XAVIER DE: "La fecha de las historias de la Cartuja y alguna minucia más sobre Zurbarán". *A.E.A.,* 1964, pp. 129-138.

SÁNCHEZ CANTÓN, F.J.: "La vida de San Pedro Nolasco; pinturas del refectorio de la Merced Calzada de Sevilla". *La Merced,* 24 January 1922.

SANTOS, REYNALDO DOS: "El Apostolado de Zurbarán en Lisboa". *A.E.A.,* 1945, pp. 189-192.

SANZ PASTOR, CONSUELO: *Catálogo de la Exposición Zurbarán en el III centenario de su muerte.* Casón del Buen Retiro, November 1964-February 1965.

SCHENONE: "Pinturas zurbaranescas y esculturas de escuela sevillana en Sucre". *Anales del Instituto de Arte Americano,* 1951, p. 63.

SEBASTIÁN y BANDARÁN, JOSÉ: "Una Inmaculada de Francisco de Zurbarán". *Archivo Hispalense,* Nos. 64-65 (1955), p. 1.

SEBASTIÁN, SANTIAGO: "Zurbarán se inspiró en los grabados del aragonés Jusepe Martínez". *Goya,* No. 128, September-October 1975, p. 82.

SORIA, MARTÍN S.: "Francisco de Zurbarán: A study of his style". *Gazette des Beaux-Arts,* 1944, pp. 33-48 and 153-174.

SORIA, MARTÍN S.: "Zurbarán, right and wrong". *Art in America,* 1944, pp. 126-140.

SORIA, MARTÍN S.: "A Zurbarán for San Diego". *The Art Quarterly,* 1947, p. 67.

SORIA, MARTÍN S.: "Sobre una Anunciación de Zurbarán". *B.S.E.E.,* 1948, pp. 149-151.

SORIA, MARTÍN S.: "Some Flemish Sources of Baroque Painting in Spain". *Art Bulletin,* 1948, pp. 249-259.

SORIA, MARTÍN S.: "German prints as sources for Zurbarán". *Art Bulletin,* 1949, pp. 74-75.

SORIA, MARTÍN S.: "Zurbarán's Altar of Saint Peter". *Art Bulletin,* 1951, pp. 164-173.

SORIA, MARTÍN S.: *The Paintings of Zurbarán.* London, 1953; 2nd edition, 1955.

SORIA, MARTÍN S.: "Algunas fuentes de Zurbarán". *A.E.A.,* 1955, pp. 339-340.

TORMO y MONZÓ, ELÍAS: *El monasterio de Guadalupe y los cuadros de Zurbarán.* Madrid, 1905.

TORRES MARTÍN, RAMÓN: *Zurbarán, el pintor gótico del siglo XVIII.* Seville, 1963.

DOCUMENTS AND SOURCES

Documentos para la Historia del Arte en Andalucía. University of Seville ('Laboratorio de Arte'), 1927.

"La Galerie espagnole au Louvre: François Zurbarán". *Magasin pittoresque,* VI, 1838, pp. 65-66.

Memoria de las admirables pinturas que tiene este Convento, casa grande de Ntra. Sra. de la Merced, redentora de cautivos de la ciudad de Sevilla. Seville, 1732 (1789 copy in the Biblioteca Colombina de Sevilla).

AMADOR DE LOS RÍOS, J.: *Sevilla pintoresca, o descripción de sus más célebres monumentos artísticos.* Seville, 1844.

CARRIAZO, J. DE M.: "Correspondencia de don Antonio Ponz con el Conde del Aguila". *A.E.A.,* 1929, pp. 157-183.

CATURLA, M.ª LUISA: "Zurbarán en el Salón de Reinos". *A.E.A.,* 1945, pp. 292-300.

CATURLA, M.ª LUISA: "Zurbarán en Llerena". *A.E.A.,* 1947, pp. 265-284.

CATURLA, M.ª LUISA: *Bodas y obras juveniles de Zurbarán.* Granada, 1948.

CATURLA, M.ª LUISA: "Noticias sobre la familia de Zurbarán". *A.E.A.,* 1948, pp. 125-127.

CATURLA, M.ª LUISA: "Zurbarán exporta a Buenos Aires". *Anales del Instituto de Arte Americano e Investigaciones Estéticas,* No. 4, 1951, pp. 27-30.

CATURLA, M.ª LUISA: "Cartas de pago de los doce cuadros de batallas para el Salón de Reinos del Buen Retiro". *A.E.A.,* 1960, pp. 333-355.

CATURLA, M.ª LUISA: *Fin y muerte de Zurbarán.* Madrid, 1964.

CEÁN BERMÚDEZ, J.A.: *Diccionario histórico de los más ilustres profesores de las bellas artes en España.* Madrid, 1800.

CRUZADA VILLAAMIL, GREGORIO: *Catálogo provisional historiado y razonado del Museo Nacional de pinturas.* Madrid, 1865.

FORD, RICHARD: *A handbook for travellers in Spain.* London, 1845 (2 volumes).

FORD, RICHARD: "Sale of Louis-Philippe and Standish Spanish Pictures". *Athenaeum,* London, March and June 1853.

GAYA NUÑO, JUAN ANTONIO: "El Museo Nacional de la Trinidad: historia y catálogo de una pinacoteca desaparecida". *B.S.E.E.,* 1947, pp. 19-77.

GESTOSO PÉREZ, J.: *Ensayo de un diccionario de los artífices que florecieron en Sevilla.* Seville, 1899-1902.

GÓMEZ IMAZ: *Inventario de los cuadros sustraídos por el Gobierno Intruso en Sevilla (año 1810).* Seville, 1896; 2nd edition, 1917.

GONZÁLEZ DE LEÓN, FÉLIX: *Noticia artística, histórica y curiosa de todos los edificios públicos sagrados y profanos de esta ciudad de Sevilla y de muchas casas particulares.* Seville, 1844 (2 volumes).

HERNÁNDEZ DÍAZ, J.: *Documentos para la Historia del Arte en Andalucía.* University of Seville ('Laboratorio de Arte'). Seville, 1927-1930 (2 volumes).

JUBINAL, ACHILLE: *Notice sur M. le baron Taylor et sur les tableaux espagnols achetés par lui d'après les ordres du roi.* 1837.

LÓPEZ MARTÍNEZ, CELESTINO: *Retablos y esculturas de traza sevillana.* Seville, 1928.

LÓPEZ MARTÍNEZ, CELESTINO: *Arquitectos, escultores y pintores vecinos de Sevilla.* Seville, 1928.

LÓPEZ MARTÍNEZ, CELESTINO: *Desde Jerónimo hasta Martínez Montañés.* Seville, 1929.

LÓPEZ MARTÍNEZ, CELESTINO: *Desde Martínez Montañés hasta Pedro Roldán.* Seville, 1932.

MADOZ, PASCUAL: *Diccionario geográfico, estadístico, histórico de España.* Madrid, 1847.

MANZANO GARIAS, A.: "Aportación a la biografía de Zurbarán". *Revista de Extremadura.* Badajoz, 1947.

MATUTE, JUSTINO: "Adiciones y correcciones al tomo IX del 'Viaje de España' de D. Antonio Ponz". *Archivo Hispalense,* 1886-1888.

MONTOTO DE SEDAS, S.: "Zurbarán, nuevos documentos para ilustrar su biografía". Seville, 1922. *Arte Español,* 1920-1921, V, pp. 400-404.

PALOMINO VELASCO, A.: *Museo pictórico y escala óptica. III: El Parnaso Español pintoresco laureado* (No. CVIII). Madrid, 1724. Madrid, 1947.

PONZ, ANTONIO: *Viaje de España.* Madrid, 1772-1794 (18 volumes). Madrid, 1947.

RALLON MERCADO, FR. ESTEBAN: *Historia de Xerez de la Frontera* (written in the second half of the 17th century). Jerez edition, 1926. Published (partially) by César Pemán in "La reconstruc-

ción del retablo de la Cartuja de Jerez de la Frontera", *A.E.A.,* 1950.

RAMÓN, FR. ALONSO: *Discursos elógicos y apologéticos empresas y divisas sobre las triunfantes vida y muerte del glorioso patriarca San Pedro Nolasco.* Madrid, 1627.

RODRÍGUEZ DE RIVAS, MARIANO: "Autógrafos de Artistas Españoles". *Revista Española de Arte,* 1932 (IX).

SALTILLO, MARQUÉS DEL: *M. Frédéric Quillet, comisario de Bellas Artes del gobierno intruso (1809-1814).* 1933.

SÁNCHEZ CANTÓN, FRANCISCO J.: *Fuentes literarias para la historia del arte español.* Madrid, 1923-1941.

SÁNCHEZ CANTÓN, FRANCISCO J.: "Zurbarán. Noticias olvidadas o desconocidas". *A.E.A.,* 1964, pp. 186-193.

TORMO Y MONZÓ, ELÍAS: "El despojo de los Zurbaranes de Cádiz, el viaje de Taylor y la efímera Galería Española del Louvre". *Cultura Española,* 1909, pp. 25-39.

WAAGEN, GUSTAV: *Treasures of Art in Great Britain.* London, 1839-1857 (4 volumes).

GENERAL WORKS

AINAUD DE LASARTE, JUAN: "Ribalta y Caravaggio". *Anales y Boletín de los Museos de Arte de Barcelona,* 1947, pp. 345-414.

ANGULO, DIEGO: *La Academia de Bellas Artes de Méjico y sus cuadros españoles.* Seville, 1935.

ANGULO, DIEGO & DORTA, MARCO: *Historia del Arte Hispano-Americano.* Barcelona, 1950 (3 volumes).

ANGULO, DIEGO: "Pintura del s. XVIII". *Ars Hispaniae,* Vol. XV, Madrid, 1958.

BATICLE, JANINE: "Les peintres de la Vie de Saint Bruno". *Revue des Musées de France,* 1958.

CAVESTANY, JULIO: *Catálogo de la Exposición Floreros y Bodegones en la pintura española.* Madrid, 1936.

GÁLLEGO, JULIÁN: *Visión y Símbolos en la Pintura española del Siglo de Oro.* Madrid, 1972.

GAYA NUÑO, JUAN ANTONIO: *La pintura española fuera de España: historia y catálogo.* 1958.

HARRIS, ENRIQUETA: *From Greco to Goya.* London, 1938.

HERNÁNDEZ DÍAZ, JOSÉ: *Catálogo arqueológico y artístico de la provincia de Sevilla.* Seville, 1939.

HERNÁNDEZ DÍAZ, JOSÉ: *La Universidad Hispalense y sus obras de arte.* Seville, 1943.

KUBLER, GEORGE & SORIA, MARTÍN: *Art and Architecture in Spain and Portugal and their American Dominions, 1500 to 1800.* The Pelican History of Art. London, 1959.

LAFUENTE FERRARI, ENRIQUE: "La peinture de Bodegones en Espagne". *Gazette des Beaux-Arts,* 1935.

LAFUENTE FERRARI, ENRIQUE: "El realismo en la pintura del s. XVII: La pintura del s. XVII en España". *Historia del Arte Labor,* Vol. XII, 1945.

LONGHI, ROBERTO & MAYER, AUGUST L.: *The Old Spanish Masters from the Contini-Bonacossi Collection.* Rome, 1930.

MARTIN-MERY, GILBERTE: "L'âge d'or espagnol: la peinture en Espagne et en France autour du caravagisme". *Catalogue de l'Exposition de Bordeaux.* Bordeaux, 1955.

MAYER, AUGUST L.: *Die Sevillaner Malerschule.* Leipzig, 1911.

MAYER, AUGUST L.: *Historia de la pintura española.* 3rd edition, 1947.

MAYER, AUGUST L.: *Handzeichnungen Spanischer Meister.*

MERCHAN, M. ª REGLA: *La colección pictórica del Deán López Cepero.* Seville, 1957 (unpublished thesis).

PÉREZ SÁNCHEZ, ALFONSO & SALAS, XAVIER DE: *The Golden Age of Spanish Painting. Catalogue Notes 33-42.* Royal Academy of Arts. London, 1976.

ROMERO DE TORRES, ENRIQUE: *Catálogo Monumental de la Provincia de Cádiz.* Vol. I, 1934.

TORMO Y MONZÓ, ELÍAS: *Las Iglesias del antiguo Madrid.* 1927 (2 volumes).

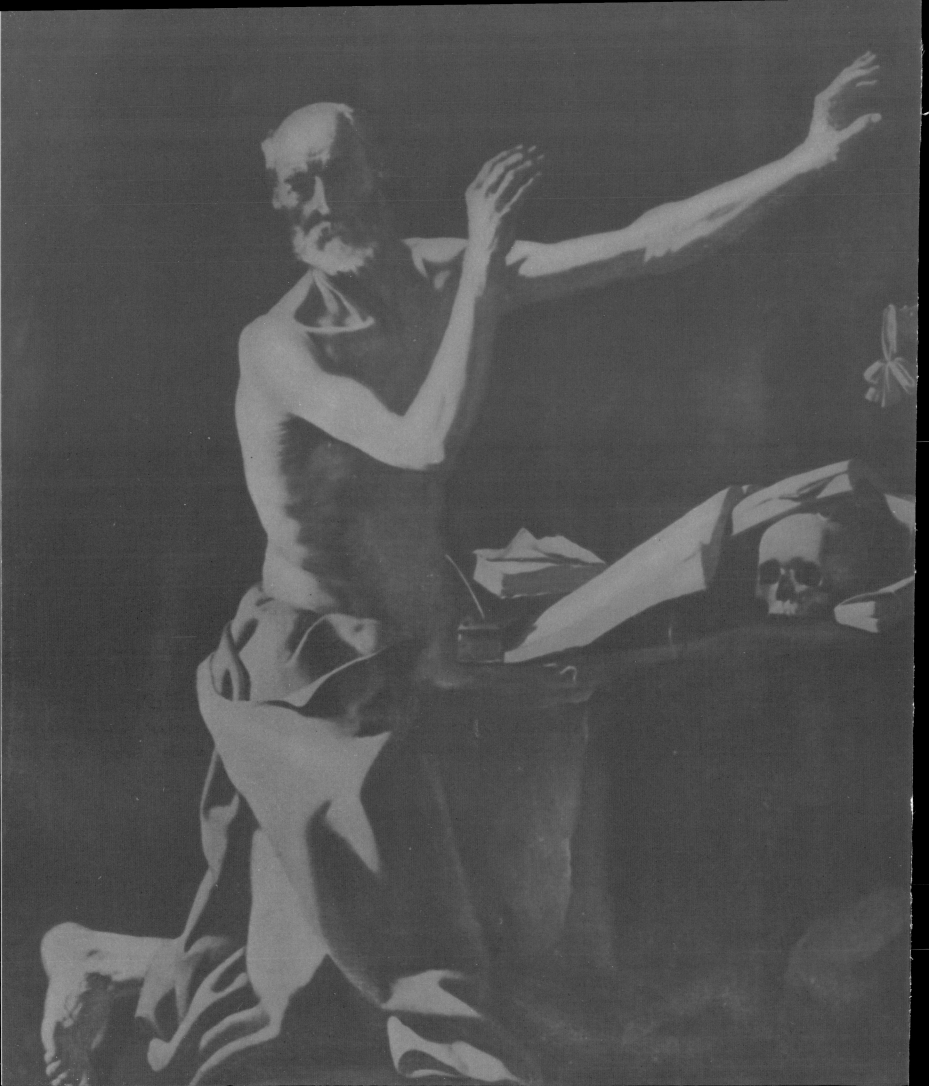